1008279927

RETHINKING HERITAGE IN PRECARIOUS TIMES

Rethinking Heritage in Precarious Times sets a fresh agenda for Heritage Studies by reflecting upon the unprecedented nature of the contemporary historical moment. In doing so, the volume calls into question established ideas, ways of working, and understandings of the future.

Presenting contributions by leading figures in the field of Heritage Studies, Indigenous scholars, and scholars from across the global north and south, the volume engages with the pressing issues of today: coloniality, the climate emergency, the Covid-19 pandemic, structural racism, growing social and economic inequality, and the ongoing struggle for dignity and restitution. Considering the impact of climate change, chapters re-imagine museums for climate action, explore the notion of a world heritage for the Anthropocene, and reflect on heritage and posthumanism. Drawing inspiration from the global demonstrations against racism, police violence and authoritarianism, chapters explore the notion of a people's heritage, draw on local and Indigenous conceptualizations to lay out a notion of heritage in the service of social justice and restitution, and detail the precariousness of universities and heritage institutions in the global south. Analysing the ongoing impact of the Covid-19 pandemic, chapters explore the changing nature of life under lockdown, describe its effects on theories of urbanity, and reflect on emergent Covid socialities and heritage-in-the-making.

Rethinking Heritage in Precarious Times argues that we need the deep-time perspective that Heritage Studies offers, as well as its sense of transgenerational conversations and accountabilities, in order to respond to these many challenges—and to craft open, creative, and inclusive futures. It will be essential reading for academics and students engaged in the study of heritage, anthropology, memory, history, and geography.

Nick Shepherd is an associate professor of heritage studies at Aarhus University, Denmark, and an extraordinary professor at the University of Pretoria, South Africa.

RETHINKING HERITAGE IN PRECARIOUS TIMES

Coloniality, Climate Change, and Covid-19

Edited by Nick Shepherd

Routledge
Taylor & Francis Group

LONDON AND NEW YORK

Cover image: Butcher Boys (1985–86) by Jane Alexander. Reinforced plaster, oil paint, bones, horns, wood. 128.5 x 213.5 x 88.5 cm. Collection Iziko South African National Gallery, ©Jane Alexander/ DALRO. Photograph: Svea Josephy.

First published 2023
by Routledge
4 Park Square, Milton Park, Abingdon, Oxon OX14 4RN

and by Routledge
605 Third Avenue, New York, NY 10158

Routledge is an imprint of the Taylor & Francis Group, an informa business

© 2023 selection and editorial matter, Nick Shepherd; individual chapters, the contributors

British Library Cataloguing-in-Publication Data
A catalogue record for this book is available from the British Library

ISBN: 978-1-032-03664-9 (hbk)
ISBN: 978-1-032-03659-5 (pbk)
ISBN: 978-1-003-18843-8 (ebk)

DOI: 10.4324/9781003188438

Typeset in Bembo
by MPS Limited, Dehradun

To my brilliant students over the years, in appreciation.

CONTENTS

List of Figures *xi*
List of Contributors *xiii*

Introduction: Rethinking Heritage in Precarious Times 1
 NICK SHEPHERD

SECTION I
'The Heritage through My Window' and Stateless
Heritage **15**

1 The Heritage through My Window: Some Reflections on
 Teaching in the Brazilian Amazon during the Covid-19
 Pandemic 17
 MARCIA BEZERRA

2 Covid Heritage Imperatives as New Pharmacologies of Care:
 Revelations of 'Heritage beyond Power' and 'What Makes
 Life Worth Living' 33
 BEVERLEY BUTLER

SECTION II
More-than-Human Heritage 55

3 Heritage and Posthumanism: Seeking Harmony in a
Precarious and Unstable World 57
JOHN SCHOFIELD AND
J. KELECHI UGWUANYI

4 River Love: Decolonizing Heritage along the Meuse 73
CHRISTIAN ERNSTEN

SECTION III
Climate Action and the Anthropocene 91

5 The Speculative and the Profane: Reimagining Heritage and
Museums for Climate Action 93
RODNEY HARRISON AND COLIN STERLING

6 Towards a World Heritage for the Anthropocene 111
CORNELIUS HOLTORF

SECTION IV
Heritage Violence and Extractivism 127

7 Rural Landscapes, Extraction, and Heritage Violence in the
Middle East 129
ÖMÜR HARMANŞAH

8 Reckoning with Extractivism: Towards an Anti-Colonial
Heritage 143
EMMA WATERTON, HAYLEY SAUL, AND
DIVYA P. TOLIA-KELLY

SECTION V
Anti-Racism, People's Heritage, and 'Difficult Heritage
at the Door' 167

9 Heritage, Social Justice and Black Lives Matter in Ireland
during Covid-19 169
LAURA MCATACKNEY

10 A People's Heritage: Engaging the Traumas of
Marginalization 186
CHRISTOPHER N. MATTHEWS

11 Difficult Heritage at the Door: Doing Heritage Research in
Precarious Times 204
DUANE JETHRO AND SHARON MACDONALD

SECTION VI
Coloniality, Peacebuilding, and Social Justice 219

12 Entries in an Apocryphal Diary: Heritage, Crisis, Turbulent
Times 221
CRISTÓBAL GNECCO

13 Heritage, Reconciliation and Peacebuilding in Australia and
New Zealand 233
CRESSIDA FFORDE, STEVE HEMMING,
MERATA KAWHARU, LIA KENT,
LAURA MAYER, DARYLE RIGNEY,
LAURAJANE SMITH, AND PAUL TAPSELL

SECTION VII
Unsettled Urbanisms and Emergent Internationalisms 261

14 Unsettling the Heritage of Urbanity: Urbanism and Urban
Space in Pandemic Times 263
SYBILLE FRANK, GEORG KRAJEWSKY, AND
JOCHEN SCHWENK

15 Covid-19, Black Lives Matter, and Heritage Futures 282
TIM WINTER

SECTION VIII
Heritage Futures and 'News from Nowhere' 297

16 Covid-19 and Heritage in Southern Africa: Precariousness,
Resilience, and the Future of Heritage 299
JESMAEL MATAGA

17 Dreaming of Utopia in Times of Trouble: *Nowherian* Heritage Inspiration and Radical Nostalgia during Lockdown 316
DAVID C. HARVEY

Conclusion: When the Taps Run Dry/Why We Need Heritage 331
NICK SHEPHERD

Index *345*

FIGURES

1.1 The "green heritage" from my balcony: a view during the Coronavirus pandemic. Photograph: Marcia Bezerra, Belém/Pará, Brazil, 2021 17

2.1 'Stateless Heritage' exhibition, DAAR–Sandi Hilal and Alessandro Petti–photographic dossier by Luca Capuano 33

3.1 List of animal species protected with local conservation principles in Igboland 61

4.1 Excerpts from the newspaper *NCR* (left) and the magazine *Vrij Nederland* (right) 77

5.1 *Existances* by Jairza Fernandes Rocha da Silva, Nayhara J. A. Pereira, Thiers Vieira, João Francisco Vitório Rodrigues, Natalino, Neves da Silva and Walter Francisco Figueiredo Lowande, one of the displays in the *Reimagining Museums for Climate Action* exhibition at Glasgow Science Centre, overlooking the main venue for COP26. Photograph by Jonathan Gardner for RMCA 103

6.1 World Heritage Properties, by number per nation (top 20, August 2022) 113

6.2 *Lego Lost at Sea*, by Tracey Williams, beachcomber and author of 'Adrift, the curious tale of the Lego lost at sea' (2022). Several of the artefacts shown are from the container lost by the Tokio Express cargo ship on February 13, 1997, others are up to 60 years old 120

6.3 Photomontage of the planned long-term repository for spent nuclear fuel at Forsmark, Östhammar Municipality, Sweden. Image: SKB/Lasse Modin 121

7.1 Eflatûnpınarı Hittite Spring Sanctuary near Beyşehir, Konya, Turkey. Photograph: Ömür Harmanşah (June 2009) 130

7.2 Şangır Mağaza Hellenistic-Roman Sinkhole Sanctuary, near Ilgın, Konya, Turkey. Photograph courtesy of Yalburt Yaylası Archaeological Landscape Research Project. August 2010 136

8.1 The Great Northern Highway as it approaches the town of Fitzroy Crossing. Photograph: Hayley Saul 152

9.1 Nineteenth-century French statue of a Nubian princess, which was removed from (and later returned to) the front entrance of the Shelbourne Hotel in Dublin in the wake of the global #BLM protests in 2020 169

10.1 Sign designating Marcus-David Peters Circle, Liberated by the People MMXX. Photograph: Christopher Matthews 196

11.1 The quotation on the building in the background, the Federal Ministry of Justice, is attributed to Albert Einstein. It says, "When it comes to truth and justice, there is no difference between small and big problems". Photograph by Duane Jethro, June 30, 2020 204

16.1 "*Do Not Touch*" by Lin Barrie. National Art Gallery Zimbabwe, 2020. Photograph: National Gallery of Zimbabwe 300

16.2 "*Hands on Hearts*" by Lin Barrie. National Art Gallery Zimbabwe, 2020. Photograph: National Gallery of Zimbabwe 300

17.1 Message in the sand, Aarhus, around March 12, 2020. Author's photograph 318

18.1 March 2018, the Spring Street water point. Photograph: Dirk-Jan Visser 331

CONTRIBUTORS

Marcia Bezerra is a professor at the Universidade Federal do Pará, in Amazon, where she teaches archaeology to the Undergraduate Program in Museology/ FAV/ICA and the MA/DSc Program in Anthropology/PPGA. She holds a BA in Archaeology (FINES/RJ), MA in Ancient and Medieval History (UFRJ), and DSc in Archaeology (USP). She is the former president (2013–2016) of the Society of Brazilian Archaeology (SAB) and Southern America Representative of the World Archaeological Congress/WAC (2008–2016). She has conducted research in the Brazilian Amazon since 2008. Her interests include material culture studies, collecting practices, ethnography of heritage, Amazonian archaeology, archaeology in popular culture, museum archaeology, heritage education, and the teaching of archaeology.

Beverley Butler, Reader in Cultural Heritage, UCL Institute of Archaeology, has directed the MA in Cultural Heritage Studies for over 20 years. She is the 'Heritage and Wellbeing' Lead at UCL Centre for Critical Heritage Studies. Her key research interests include Critical Heritage Perspectives, Heritage Care, Cultural Memory, the 'Pharmakonic Efficacies of Heritage' particularly in contexts of marginalisation, displacement, conflict, illness and extremis. Research projects: Beverley undertakes ongoing, long-term ethnographic fieldwork research in the Middle East – notably Egypt, Palestine and Jordan. In the latter Jordanian context, her work addresses the efficacies of heritage, place-making, care and memory-work in Palestinian refugee camps.

Christian Ernsten is an assistant professor in Heritage Studies in the Department of History of the Faculty of Arts and Social Sciences at Maastricht University. He is

affiliated with the Maastricht Centre for Arts and Culture, Conservation, and Heritage (MACCH) and he is a steering committee member of the Maastricht Experimental Research in and through the Arts Network (MERIAN). Christian is the co-convenor of the Walking Seminar with Aarhus University-based archaeologist Nick Shepherd and Royal Academy of Arts The Hague-based photographer Dirk-Jan Visser.

Cressida Fforde is a senior research fellow at the Centre for Heritage and Museum Studies at The Australian National University. From 2011 to 2019 she was the deputy director of the National Centre for Indigenous Studies at ANU. Since 1991, she has undertaken research within the repatriation field for Indigenous communities and institutions internationally, particularly in the location and identification of Ancestral Remains through archival research. Professor Fforde's work and publications have contributed significantly to scholarship in this area. She is recognised internationally for the knowledge she brings to repatriation practice and the analysis of the history of the removal and return of Indigenous Ancestral Remains. Since 2014, she has been the lead chief investigator for a number of Australian Research Council funded projects which undertake applied and scholarly research in repatriation. She was the primary editor of *The Dead and Their Possessions: Repatriation in Principle, Policy and Practice* (2002) and *The Routledge Companion to Indigenous Repatriation: Return, Reconcile, Renew* (2020).

Sybille Frank is a professor of Urban Sociology and Sociology of Space at the Institute of Sociology, Technical University of Darmstadt. Her research focuses on conflicts over space, place, tourism and heritage, and on urban violence. Recent publications include the co-edited books *Unsettled Urban Space. Routines, Temporalities and Contestations* (Routledge 2023); *The Power of New Urban Tourism. Spaces, Representations and Contestations* (Routledge 2022); *Urban Heritage in Divided Cities: Contested Pasts* (Routledge 2020), and a co-edited special feature of the journal *City. Analysis of Urban Change, Theory, Action* on *Urban Fallism. Monuments, Iconoclasm and Activism* (2020).

Cristóbal Gnecco is a professor in the Department of Anthropology at the Universidad del Cauca and chair of its PhD Anthropology Program, where he works on the political economy of archaeology, geopolitics of knowledge, discourses on alterity, and ethnographies of heritage. He is currently working on two research projects, both related to the effects of heritage processes: "Qhapaq Ñan, a post-archaeological ethnography" and "Heritage meanings and semiotic struggles around the Jesuit-Guarani missions".

Ömür Harmanşah is the director of the School of Art & Art History at the University of Illinois at Chicago. He is an architectural historian and landscape

archaeologist focusing on political ecology and cultural heritage in the Anthropocene. He published *Cities and the Shaping of Memory in the Ancient Near East* (Cambridge, 2013), and *Place, Memory, and Healing: An Archaeology of Anatolian Rock Monuments* (Routledge, 2015). He directed *Yalburt Yaylası Archaeological Landscape Research Project* (2010–2021) and was the Lead-PI for *Political Ecology as Practice: A Regional Approach to the Anthropocene* (2017–2019). His current book project is titled *Landscapes of the Anthropocene* (Routledge).

Rodney Harrison is Professor of Heritage Studies at the UCL Institute of Archaeology, University College London. He is (co)author or (co)editor of 20 books and guest-edited journal volumes and almost 100 peer-reviewed journal articles and book chapters. He has conducted research in Australia, Southeast Asia, North America, South America, the Middle East, the UK and continental Europe. He is the co-principal investigator of the Reimagining Museums for Climate Action project with Colin Sterling.

David C. Harvey is an associate professor in critical heritage studies at Aarhus University, Denmark. His work has focused on the geographies of heritage, contributing to some key heritage debates, including *processual* understandings of heritage, extending the temporal depth of heritage, the outlining of heritage/ landscape, heritage/scale and heritage/climate change relations and the opening up of hidden memories through oral history. Recent books include *The Future of Heritage as Climates Change* (2015); *Commemorative Spaces of the First World War* (2018); *Creating Heritage: Unrecognised Pasts and Rejected Futures* (2020); and *The Real Agricultural Revolution: the Transformation of English Farming, 1939–1985* (2021).

Steve Hemming is a researcher at the Nation Building and Collaborative Futures Research Hub in the Jumbunna Institute for Indigenous Education and Research at the University of Technology Sydney. Associate Professor Hemming was a long-time curator in the South Australian Museum's Anthropology Division and has been working with Indigenous nations in South Australia for 30 years. He has worked for Indigenous organisations as a community researcher and Native Title anthropologist. More recently, his research has focused on the colonial genealogies of cultural heritage and natural resource management and traditionalist understandings of Indigenous culture. He is also working on community development and governance programs with the Ngarrindjeri nation in South Australia.

Cornelius Holtorf is a professor of archaeology and holds a UNESCO Chair on Heritage Futures at Linnaeus University in Kalmar, Sweden. He also directs the Graduate School in Contract Archaeology (GRASCA) at Linnaeus University. His research interests include the theory of cultural heritage, future archaeology, and

archaeology in contemporary society. Holtorf recently co-edited (with Anders Högberg) the volume *Cultural Heritage and the Future* (Routledge, 2021).

Duane Jethro is a junior research fellow at the Centre for Curating the Archive at the University of Cape Town. He focuses on the cultural construction of heritage and contested public cultures in South Africa and in Berlin. Between 2019 and 2020 he worked as a researcher at the Centre for Anthropological Research on Museums and Heritage, CARMAH, at the Humboldt University, Berlin, founded by Professor Sharon Macdonald. His book *Heritage Formation and the Senses in Post-Apartheid South Africa: Aesthetics of Power* (Bloomsbury Academic) is a cultural history of heritage and sense making in the post-apartheid dispensation.

Merata Kawharu (Ngāti Whatua, Ngāpuhi) is an influential Aotearoa New Zealand writer and academic, who has held senior positions and roles at the universities of Auckland and Otago and with the United Nations, UNESCO, the New Zealand Historic Places Trust Board, and the Māori Heritage Council. Professor Kawharu's research activities have overarching themes of supporting Māori leadership, community, and education. A principal area of her research has been the concept of kaitiakitanga (or guardianship) within Māori culture. She has led multiple research projects on these and other topics. In 2012, she was made a Member of the New Zealand Order of Merit (MNZM) for her services to Māori education.

Lia Kent is an associate professor/Australian Research Council (ARC) future fellow in the School of Regulation and Global Governance (RegNet) at the Australian National University. An interdisciplinary peace and conflict studies scholar, Lia's work focuses on the myriad ways in which individuals and communities make sense of legacies of state violence and protracted conflict. She has examined these issues through long-term ethnographic research in Timor-Leste (since 2004) and more recent research in Aceh (Indonesia) and Sri Lanka. Lia is currently working on an ARC Future Fellowship project examining localized sociopolitical practices around missing persons in Timor-Leste and Sri Lanka and an ARC Discovery Project led by Cressida Fforde, *Heritage and Reconciliation*. In the latter project, she is considering the conditions under which grassroots memory-work in Australia might contribute to reconciliation between Indigenous and non-Indigenous people.

Georg Krajewsky is a postdoctoral researcher at the Institute of Sociology at the Technical University of Darmstadt (Germany). He received his PhD for a thesis on the ongoing negotiation of postcolonial heritage policies in the city of Hamburg in 2022. Between 2016 and 2022, he was an associated member of the DFG postgraduate school «Identity and Heritage» at the Technical University of Berlin and the Bauhaus University of Weimar. His research interests involve urban

sociology, heritage studies, postcolonial studies, and qualitative methods of empirical research.

Sharon Macdonald is the director of the Hermann von Helmholtz Centre for Cultural Techniques and of CARMAH (the Centre for Anthropological Research on Museums and Heritage) at the Humboldt-Universität zu Berlin, where she is a professor of social anthropology. She has written widely on questions of culture, memory, and heritage. Her books include *Difficult Heritage. Negotiating the Nazi Past in Nuremberg and Beyond; Memorylands. Heritage and Identity in Europe Today;* co-authored *Heritage Futures. Comparative Approaches to Natural and Cultural Heritage Practices,* and the edited volume *Doing Diversity in Museums and Heritage. A Berlin Ethnography.*

Jesmael Mataga is an associate professor and the inaugural Head of Humanities at Sol Plaatje University, in Kimberley, South Africa. His current research, situated in the emerging focus on critical and decolonial heritage, explores the role and place of communities in museums and heritage preservation. His work aims to contribute to new approaches to museum and heritage management practices that address the critical challenges of our time, such as poverty, inequality, conflict, decolonisation, migration, and social justice. His recent publications include *Independent Museums and Culture Centres in Colonial and Postcolonial Zimbabwe: Non-State Players, Local Communities and Self-Representation,* and *Museums as Agents for Social Change: Decolonisation at the Mutare Museum* (Routledge).

Laura McAtackney is a professor in the Radical Humanities Laboratory and Archaeology at University College Cork, Ireland, and the Department of Archaeology and Heritage Studies at Aarhus University, Denmark. She is a Docent in Contemporary Historical Archaeology at the University of Oulu, Finland. Her research focuses on contemporary and recent historical archaeological approaches to understanding post/conflict and post/colonial societies with a special focus on Ireland. She is currently the PI of an Independent Research Fund Denmark Project *Enduring Materialities of Colonialism: Temporality, Spatiality and Memory on St Croix, USVI (EMoC)* (2019–2024).

Christopher Matthews is a historical archaeologist and professor of anthropology at Montclair State University. His work is focused on the archaeology of racialized communities in North America with a focus on the mid-Atlantic region. Matthews is the author and editor of several books including *The Archaeology of American Capitalism* and *The Archaeology of Race in the Northeast.* His most recent book, *A Struggle for Heritage: Archaeology and Civil Rights in a Long Island Community,* examines how conflicting histories reinforce social and racial inequalities in both local communities as well as in professional heritage work.

Laura Mayer is a research officer at the Centre for Heritage and Museum Studies at the Australian National University. Dr Mayer has published on visitor experience and heritage interpretation, and has expertise in archaeological replicas. In 2020, Laura completed her PhD from the Centre for Rock Art Research + Management at the University of Western Australia. Her research interests include replicas, authenticity, and the values of heritage.

Daryle Rigney a citizen of the Ngarrindjeri nation, is the director of the Nation Building and Collaborative Futures Research Hub in the Jumbunna Institute for Indigenous Education and Research at the University of Technology Sydney. Professor Rigney is a board member and a deputy chair of the Australian Indigenous Governance Institute, a member of the Native Nations Institute's International Advisory Council, University of Arizona and Global Senior Fellow and Pou, Atlantic Fellows for Social Equity and the Atlantic Institute. Daryle's academic and nation work currently focuses on developments in Indigenous nation-building and governance following colonisation. In 2013, he was awarded the South Australian National Aboriginal and Islander Day Observance Committee (NAIDOC) Aboriginal person of the year. Orcid: 0000-0002-9642-9906

Hayley Saul (she/her) is a senior research fellow at the University of York and the deputy director of the Leverhulme-funded *Heritage for Global Challenges Research Centre*. She is an honorary research adjunct fellow in the School of Social Sciences at Western Sydney University, Australia. Hayley specialises in research at the intersections of archaeology, bioarchaeology, and heritage. She takes a transdisciplinary approach to investigate the novel ways that heritage can tackle the complex precarities of a changing climate in the eight countries that make up the Hindu Kush Himalayas. Her overall aim is to explore traditional, and/or (pre)historic cultural practices that support sustainable agriculture, food security, forest relations, water conservation, disaster recovery, and biodiversity in mountain environments. Working with (often Indigenous) communities and a range of non-governmental organisations, such as the International Centre for Integrated Mountain Development (ICIMOD), Hayley co-develops ways to support and "activate" these forms of heritage in the pursuit of flourishing mountain futures.

John Schofield is a professor of archaeology at the University of York where he specialises in cultural heritage and archaeologies of the contemporary world. His research is currently focussed on the various ways archaeology and heritage practice can contribute to solving some of the world's so-called wicked problems, including plastic pollution. This is the subject of his forthcoming book, with Oxford University Press.

Jochen Schwenk (Dr. Phil.) works as a lecturer at the Department of Sociology at the University of Basel. He studied sociology and political science and received his doctorate with a sociological study on the young Walter Benjamin. His research focuses on issues of general sociology and sociological theory, as well as on domination, religion, and the city.

Nick Shepherd is an associate professor of heritage studies at Aarhus University, Denmark, and an extraordinary professor at the University of Pretoria, South Africa. He has been a Mandela Fellow at Harvard University, and a visiting professor at Brown University, Colgate University, and the University of Basel. From 2017 to 2018, he was an artist-in-residence at the Amsterdam University of the Arts. His work focuses on colonial and decolonial heritage, and more recently on heritage and the climate emergency. In 2022, he was the lead author of a white paper on *Cultural and Natural Heritage for Climate Action*, commissioned by ICOMOS, UNESCO, and the IPCC.

Laurajane Smith is a professor and the director of the Centre of Heritage and Museum Studies, Research School of Humanities and the Arts, the Australian National University, and is a fellow of the Society for the Academy of the Social Sciences in Australia. She founded the Association of Critical Heritage Studies and has been editor of the *International Journal of Heritage Studies* since 2009. She is co-general editor with Dr Gönül Bozoğlu of Routledge's *Key Issues in Cultural Heritage*, author of *Uses of Heritage* (2006) and *Emotional Heritage* (2021), and editor with Natsuko Akagawa of *Intangible Heritage* (2009) and *Safeguarding Intangible Heritage* (2019) among others.

Colin Sterling is an assistant professor of memory and museums at the University of Amsterdam and a member of the Amsterdam School for Heritage, Memory and Material Culture. From 2020 to 2021, he was project co-lead on Reimagining Museums for Climate Action, a design competition and research project that sought to inspire radical change in museums to address the climate crisis. Colin is the author of *Heritage, Photography, and the Affective Past* (Routledge, 2020) and co-editor of *Deterritorializing the Future: Heritage in, of and after the Anthropocene* (Open Humanities Press, 2020). He is co-editor of the journal *Museums & Social Issues*.

Paul Tapsell (Paora John Tohi te Ururangi Tapihana) is Ngāti Whakaue and Ngāti Raukawa. Professor Tapsell is widely experienced representing Māori people and their interests including, for example, as Director Maori at the Auckland War Memorial Museum (2000–2008), co-convener of the Cultural Heritage and Museum Programme at the University of Auckland (2000–2008), and, from 2009, dean and then professor of Maori Studies at the School of Maori, Pacific and Indigenous Studies at the University of Otago. Paul has played a leadership role in the development of museum and government policy pertaining to the repatriation

of Māori human remains and Taonga (objects of high cultural significance) as well as providing advice and submissions to overseas deliberations. He was appointed as director of Research and Collections at Museums Victoria in Melbourne in 2017 and is currently a professor of Australian Indigenous Studies at University of Melbourne's School of Culture and Communication. He is currently the principal researcher with Takarangi Research in Aotearoa/New Zealand.

Divya P. Tolia-Kelly is a professor of Geography & Heritage Studies at Sussex. Her research is focused on postcolonial and anti-racist approaches to cultural geographies, migration, landscape, memory, heritage, visual culture, and material culture using participatory methodologies. Divya has published several articles on the theory and politics of "race" in relation to these themes, including decolonising the academy, ethnocentrism in cultural politics and more recently on decolonising museums and race, affect and the Anthropocene. Her books published include a monograph *Landscape, Race and Memory* (2010); *Visuality/Materiality: Objects, Images and Practices* (edited with Gillian Rose); and the co-edited volume (with Steve Watson and Emma Waterton) entitled *Heritage, Affect and Emotion: Politics, Practices and Infrastructures* (2016). Divya is currently Series Editor (with Emma Waterton) of the Routledge Book Series *Critical Studies in Heritage, Emotion and Affect* (https://www.routledge.com/Critical-Studies-in-Heritage-Emotion-and-Affect/book-series/CSHEA

J. Kelechi Ugwuanyi is a postdoctoral research fellow at the Global Heritage Lab, Transdisciplinary Research Area: Present Pasts, University of Bonn, Germany and a senior lecturer in the Department of Archaeology and Tourism, University of Nigeria, Nsukka. Kelechi had his PhD in heritage studies at the University of York, UK. His research interests are critical heritage studies, decolonial heritage, culturla landscape, museum, indigenous knowledge systems, and contemporary archaeology. His research in Bonn will revisit the originating communities of ethnographic archives in Europe collected from Africa during colonialism to re-engage members of the descendant communities to understand their changing significance and affordances in the present. He will examine these archival materials through the lens of the interations between people, culture and landscape.

Emma Waterton (she/her) is a Leverhulme International professor at the University of York, where she directs the *Heritage for Global Challenges Research Centre*. She is also an adjunct professor at Western Sydney University. Emma's research is located in the fields of heritage studies and cultural geography, where she works to challenge the systems, structures and institutions of power that continue to shape heritage, both in the United Kingdom and internationally. She is particularly interested in the following: the interface between heritage, identity, memory and

affect; anti-colonial politics and alternatives to the logics of colonialism; migrant heritage-making; and climate justice in the Anthropocene. She is the author of four monographs, including the recently published *Geographies of Commemoration in a Digital World: Anzac @ 100* (co-authored with Danielle Drozdzewski and Shanti Sumartojo, 2021, Palgrave Pivot). She is also the Series Editor (with Divya Tolia-Kelly) of the Routledge Book Series *Critical Studies in Heritage, Emotion and Affect*.

Tim Winter is Senior Research Fellow at the Asia Research Institute, National University of Singapore. He was previously an Australian Research Council Professorial Future Fellow and is a Fellow of the Australian Academy of the Humanities. Tim's interests largely revolve around understanding how the past comes to be constructed and reconstructed for public audiences and for diplomatic, geopolitical, and nationalistic purposes. He is the author of *Geocultural Power: China's Quest to Revive the Silk Roads for the Twenty First Century* (University of Chicago Press 2019) and *The Silk Road: Connecting Histories and Futures* (Oxford University Press, 2022). See silkroadfutures.net

INTRODUCTION

Rethinking Heritage in Precarious Times

Nick Shepherd

The Moment of the Now

For many of us, the years following the announcement by the World Health Organization of a 'Public Health Emergency of International Concern' on January 30, 2020, have felt like an historical hinge–a period in time that marks a clear 'before' and 'after'. The novel coronavirus pandemic and the global public health response, including lockdowns, restrictions on travel, and physical distancing regimes, have called into question many previously taken-for-granted ideas and practices (Aschwanden, 2021; Saaliq, 2021; Vinter, 2021). The human, social, economic, and political effects of the pandemic have been catastrophic (Brodeur et al., 2021; Ritchie, 2020). Originally described as a 'social leveller', it has become clear that the overwhelming effect of the pandemic has been to exacerbate already-existing social and economic inequalities (Abedi et al., 2021; Bezerra, this volume; Milne, 2020; Ruptly, 2020; Torres et al., 2021; Winter, this volume). Widely divergent national responses have exposed the different extent to which states take responsibility for the life and welfare of their citizens and have fuelled culture wars calling into question science-based policy decisions (Andrews, 2021; Hale et al., 2021; Hasson, 2021; Lam, 2021). Other, decisive events have marked the 'moment of the now'. Mid-2020 saw widespread demonstrations against racism, police brutality and authoritarianism. Organized under a variety of banners, including #BlackLivesMatter, the protests focused attention on the lingering effects of structural racism, and the fragility of democratic institutions. Globally, attention was focused on monuments and memorials, amidst a public re-assessment of histories of racial slavery and colonialism (Gnecco, this volume; Matthews, this volume; McAtackney, this volume; Paton & Dutton, 2020; Selvin & Solomon, 2020; Warren, 2020). In academic circles, the call to decolonize disciplines and

DOI: 10.4324/9781003188438-1

institutions has gained traction, and the 'colonial' has returned to relevance as a critical term, 50 years and more after formal, political decolonization in many parts of the world (Batty, 2020; Cronin et al., 2021; Erondu et al., 2021; Mbembe, 2016; Schneider & Hayes, 2020; Survival, 2021; Waterton et al., this volume).

Not least, this same period has been characterized by an unprecedented public awareness of the nature and extent of the climate emergency—with the northern hemisphere summer of 2021 being described by many commentators as the moment when climate change burst onto the public-political agenda (Clayton, 2020; Hickman, 2021; Wu, Snell, & Samji, 2020). Responses have ranged from denial and retreat, to added urgency on the part of states, social movements, researchers, and civil society organizations (Anguiano, 2021; de Moor et al., 2021; Gills & Morgan, 2020; Harrison and Sterling, this volume; Lahut, 2021; Sabherwal et al., 2021). Commentators like Bruno Latour have described the disruptions caused by the coronavirus pandemic as a 'dress rehearsal' for the coming disruptions of the Anthropocene (Latour, 2020). Joining the dots, other commentators have linked the increased likelihood of zoonotic viral epidemics to the destruction of habitats and biodiversity (Morand, 2020; Schmeller, Courchamp, & Killeen, 2020), and they have linked the rise in political authoritarianism to the social and economic disruptions caused by Anthropogenic climate change (Beeson, 2010; Fritsche et al., 2012; McCarthy, 2019; Vihma et al., 2021). With the waning of lockdown regimes in many countries in early-2022, we might have been forgiven for expecting some respite from the roller-coaster of history. However, when Russian Federation forces invaded eastern Ukraine on February 24, 2022, it marked a major escalation of a war begun in 2014 with the illegal annexation of Crimea. At the date of writing, the war has resulted in tens of thousands of casualties on both sides of the conflict and caused Europe's largest refugee crisis since the Second World War (Beaumont, 2022). The knock-on effects of the war have resulted in global food shortages and a sharp downturn in global economic growth (Wintour, 2022). The military reversals suffered by Russian forces in the autumn of 2022 have led to an escalation of nuclear rhetoric on the part of Russian President Putin, with US President Biden warning in October 2022 that the world is closer to nuclear Armageddon than at any point since the 1962 Cuban Missile Crisis (Borger, 2022).

This sense of writing and thinking from a particular historical moment—one characterized by uncertainty and danger—is a starting point for this volume. My idea for the volume was a simple one. The, in many ways, unprecedented nature of the contemporary moment calls into question accustomed ideas, ways of working, and understandings of the past and future. I contacted some of my favourite heritage scholars and practitioners—people whose work has inspired me over the years—and asked them to rethink a Heritage Studies agenda in the light of their experiences of the contemporary moment, however and where-ever they might be situated. My brief to this group of authors was to write short, punchy, future-oriented essays in which they think freely around the meanings and possible futures of heritage sites, practices, and understandings. I encouraged authors to write in ways that are more

personally engaged than is normally the case with academic publication. The fact that many of the early drafts of chapters in this volume were written under lockdown conditions adds a layer of vulnerability and intimacy to the texts. As well as 'big name' scholars–people whose work has defined the field over the last two decades–I approached new and emergent scholars, and lesser-known but indispensable thinkers and practitioners, people whose work sits slightly outside the canon. In doing so, I have drawn from my own research biography and networks, which span the global north/global south divide. Currently located in Denmark, I spent most of my early career at the University of Cape Town in South Africa, where I devised and taught a graduate programme on Public Culture and Heritage in Africa. At a personal level, moving from South Africa to Denmark has involved traversing a spectrum of social and political arrangements, in ways that are both positive and negative, and has opened-up new understandings and new possibilities. It was important to me that the authors in this volume should write and think from a range of different subject positions, life-worlds, and institutional locations, and that they should represent both Indigenous/ non-Indigenous and global south/ global north perspectives. The questions that I put to authors include the following: How have core understandings and images of heritage shifted under the weight of the experience of the last few years? What new topics and priorities have emerged? Where are you directing your current efforts in Heritage Studies and practice? What feels important as we look to a future that now seems different to what we might have predicted, even a few years ago? My hope is that the essays in this volume should speak from within the pandemic, the Anthropocene, and the ongoing struggle for social justice to set an agenda for the field of Heritage Studies for years to come.

Why Heritage?

An everyday definition of heritage is 'that which we inherit from the past and pass on to the future'. Heritage speaks to a form of connectedness across time in which we give careful consideration to all that is best and brightest and most distinctive about the variousness of human life and experience and create the conditions for this to endure. On its dark side, it also speaks to the accumulated legacies of the past that we carry with us, often as unwilling hostages–and about the way in which these legacies materially shape the present and future. Conventional understandings of heritage have tended to focus on self-consciously 'fine' productions–art, architecture, and craft–and on stylized ideas and practices from traditional life. However, a deeper and more fundamental aspect of heritage deals with meanings and values, and the kinds of ideas and frameworks that we carry forward as an ideal for human thriving. In a species sense, heritage is about human resilience and flourishing, not in a selfishly individual way but as a communal ideal. In this sometimes-overlooked sense, heritage is about a trans-generational conversation about human wisdom and ingenuity, and our ability to craft open, creative, and inclusive futures (Shepherd et al., 2022).

In interesting ways, the events of the last few years have drawn on a repertoire of heritage tropes, images, and ideas–or have caused us to rethink these images and ideas. This has been most clearly visible in the global protests against structural racism and police brutality, and the re-assessment of urban memorial landscapes entangled with histories of racial slavery and colonialism. One of the points of origin of the current wave of protest actions were the dramatic series of events in early-2015 when students at the University of Cape Town campus organized under the hashtag #RhodesMustFall to call for the removal of a statue of Cecil Rhodes, prominently sited at the major pedestrian entrance to the university (Frank and Ristic, 2020; Shepherd, 2020, 2022). In the years that followed, urban #Fallist movements spread globally across a variety of socio-political contexts: postcolonial Africa and South America, post-communist and post-Imperial Europe and Asia, and the Middle East (Frank and Ristic, 2020). However, it was in the context of the global protests against structural racism and police brutality in mid-2020, that heritage tropes fused with mass protests to constitute a decisive intervention in the public-political sphere. Precisely because of their visibility and brute materiality, statues and memorials act as powerful points of mobilization and organization. For protestors, they surface buried and disavowed histories, enabling conversations about the structural aspects of oppression and about forms of historical inequality that are normalized under dominant configurations of power and interest. The removal of these statues and memorials becomes many things: a celebration of agency, an experience of catharsis, a rupturing of dominant historical narratives, and a space-clearing gesture that allows us to think and experience outside of banal Imperial histories (Knudsen et al., 2022; Shepherd, 2020, 2022).

The global protests in support of #BlackLivesMatter and other groups mobilizing against colonialism, racial slavery, and the legacies of historical injustice remind us that the problem with a commonsense definition of heritage–'that which we inherit'–is that it hides (or elides) a second category, the category of the *disinherited* (Fforde et al., this volume; Gnecco, this volume; Waterton et al., this volume). This includes that multitude of humanity who have been stripped of land, livelihood, culture, identity, language, and life itself, by a myriad of processes: colonial conquest, dishonoured treaties, the proselytizing actions of missionaries, cynical attempts to modernize and assimilate subject populations, the adverse effects of anthropogenic climate change, and many others–that multitude whom Frantz Fanon calls in a loving and embracing formulation *les damnés de la terre* (Fanon, 2005). In this understanding, the 'we' in 'that which we inherit' is misleading, perhaps deliberately so. By interpolating (or addressing) us as inheritors, it hides the fact that the great mass of humanity divides into two groups, the inheritors and the disinherited. It also hides the fact that the writing and speaking subject in many self-consciously 'academic' settings frequently speaks from the position of the former.

These explicit mobilizations and renderings of heritage have been accompanied, in the case of the global public health response to the pandemic, by a category of what might be described as new and emergent 'heritage-in-the-making' (Holtorf &

Hogberg, 2021). Writing in the immediate aftermath of–or interregnum between–lockdown regimes and social distancing measures, it is possible to see how core aspects of our social, cultural, political, and economic lives have been thrown into question. Contact, intimacy, and touch have given way to new, more distanced relationships. The forced intimacy of lockdown in confined spaces tested our adaptability and imagination and reconfigured our understanding of home spaces (Bezerra, this volume). A new repertoire of gestures has come into being–hand washing, touchless greetings–as has an associated material culture: masks, hand-sanitizer dispensers. Increased powers of surveillance and emergency biopolitical measures have transformed the nature of citizenship and rewritten the fragile social contract between citizen and state (Butler, this volume). In ways that we are just beginning to understand, the pandemic has produced wholesale shifts in cultural meanings and values. Some developments include an accelerated shift towards digital formats and virtual socialities, and the emergence of new forms of empathy and solidarity (McAtackney, this volume). Concomitantly, they also include the emergence of discourses around the disposability of human life–including migrants, the elderly, the poor, and the immune-compromised. They also include the critical revaluation of a standard tenet of modernity, the idea that cities and urban living constitute a future ideal state (Frank et al., this volume). More abstractly, understandings of time were called into question during the pandemic. Time both accelerated (the exponential time of infection rates) and dragged under lockdown regimes, and future horizons and expectations around progress have been called into question (Harvey, this volume).

The relationship between science and society has arguably undergone a profound transformation. Seldom can science and technology have been more prominent in the public sphere, than during the public health emergency occasioned by the Covid-19 pandemic. Many of us become armchair virologists as we tracked the progress and mutation of the virus, the race to develop viable vaccines, and the struggles around equitable access and distribution. The achievement of a number of effective vaccines in record time is an extraordinary achievement, and a vindication for advocates of STEM subjects and science-based policy (Ball, 2020; Zimmer, Corum, & Wee, 2021). However, this observation is doubled by a second observation: the manner in which, at almost every turn, science-based understandings and policies have been entangled with, and mediated by, complex social, cultural, political and economic forces and dynamics–many of them with a heritage dimension. This has been true at a national level–in culture wars, denialism, and politicking around the pandemic–and it has been true at a transnational level, in uneven access to vaccines, a breakdown in trust, and the entrenching of deeply rooted animosities and inequalities (Callaway, 2020; Cornwall, 2020; Crist, 2021; Mataga, this volume; McKee et al., 2020; Osama, Razai, & Majeed, 2021; Padma, 2021; Philips, Augustin, & Collyns, 2021; Ricard & Medeiros, 2020; Sturm & Albrecht, 2021).

The economic and political consequences of the pandemic continue to shape present and future prospects. Together with the war in Ukraine, their overwhelming

effect has been to exacerbate already-existing cleavages and inequalities, within and between states, and between the global north and the global south (Bezerra, this volume; Harvey, this volume; Mataga, this volume; Winter, this volume). State-subsidized museums and university infrastructures will likely continue to be negatively impacted. Global economic recession has potentially profound consequences for the management of heritage sites and resources. The global dip in tourism, and the likely future curtailment of mass air-travel, will cause many sites of heritage tourism to rethink their business models. At the same time, a complex new political landscape is emerging out of the linked set of crises of the pandemic, the climate emergency, and the war in Ukraine (Winter, this volume). Signs point to the emergence of new forms of authoritarianism, and of populist and neo-nationalist political tendencies–many of which deploy heritage tropes as part of affect-based politics. More hopeful signs point to the revaluing of multilateralism and the emergence of forms of regional cooperation. Each one of these developments has implications for a Heritage Studies agenda.

The climate emergency is generating its own forms of heritage-in-the-making (Harrison and Sterling, this volume; Holtorf, this volume). As Harvey and Perry (2015) point out, the topic of heritage and climate change exists in a double sense: in the sense that climate change impacts already-existing heritage sites and practices, and in the sense that climate change is generating its own heritage, which will be passed on to future generations. Two–sometimes overlooked–points need to be made about the climate emergency at the outset. The first is that although frequently depicted as a disaster for natural systems and non-human species, it is also a human rights disaster and a humanitarian catastrophe. In this sense, pictures of polar bears adrift on ice floes may be misleading–accurate and tragic as these scenarios undoubtedly are. At the very least, they should be doubled by another set of images: of devastated economies, forced migrations, displaced settlements, and polluted and impoverished human living environments (Harvey & Perry, 2015; Shepherd et al., 2022). A second point concerns the need to produce socially and historically contextualized accounts of anthropogenic climate change. Anthropogenic climate change itself has a history, that has involved and impacted populations and territories across the globe in different ways, depending on their position in relation to some of the defining historical forces of our times: modernity, colonialism, imperialism, nationalism, racial slavery, industrialization, urbanization, postcolonialism, deindustrialization, and many others. While a case can be made for looking at the mounting scale of human impacts through the Holocene, understanding anthropogenic climate change as a historically situated phenomenon involves looking, in the first instance, at the 'long-500 years' post-1492: the period characterized by the expansion of Europe, the subsuming of myriad local systems of production within an increasingly global system of production and consumption, and the progressive acceleration of human impacts on social and natural worlds–and on the earth's own biophysical processes (Ghosh 2021; Shepherd et al., 2022).

This also involves understanding anthropogenic climate change as a process that, historically, has differently involved and impacted populations and territories in the

global north and the global south, such that there are those who have emerged as beneficiaries of the 'long-500 years', and those who have borne a disproportionate burden of the cost in the form of human tragedy, environmental degradation, and economic underdevelopment. In this perspective, anthropogenic climate change can itself be understood as a form of 'dark heritage', visited by overdeveloped nations, local elites, and others who have benefitted from the carbon-fuelled civilization of the long-500 years, on the rest of humanity—as well as on other non-human beings, on future unborn generations, and on the earth itself. One of the cruellest aspects of anthropogenic climate change is that, in many cases, populations and territories who bore a disproportionate burden of the costs of the long-500 years, now find themselves most at risk from global heating. In this perspective, the historical injustices of racism, sexism, coloniality, heteronormativity, and species-ism are woven into the fabric of anthropogenic climate change—not as epiphenomena, but as core logics (Shepherd et al., 2022).

If the effects of the pandemic and the climate emergency present us with the phenomenon of nascent heritage-in-the-making, then the war in Ukraine serves as a visceral reminder that historical heritage tropes and images are not so much superseded, as layered into a complex present. Some of the most affecting images from the war speak of heritage in the service of the defense of sovereignty, identity, and territory. The war has presented us with the kind of blood-and-soil rhetoric that many thought had been consigned to an earlier and discredited period of European history. While many commentators in Europe associate such images and ideas with historical conflicts—especially the Second World War—for many in the global south they are part of an immediate past and present, as witness ongoing, devastating conflicts in Ethiopia, Eritrea, Yemen, Syria, and many other locations. In this sense, ostensibly historical heritage tropes are not so much located in distant pasts as in 'other' spaces—in proxy wars and geographies of conflict located outside of Europe, or on the edges of Europe, as in the case of the war in Ukraine.

On Precariousness

If there is a single word or concept that describes our experience of 'the moment of the now' then for many it has been a heightened awareness of the precariousness of our social, political, and economic arrangements. Other affects and emotions accompany this sense of precariousness: fear, vulnerability, a sense of the fragility of hope, a certain foreclosing of future dreams and aspirations, a sense of foreboding (Harvey, this volume). Of course, for many populations in the global south, living with precariousness is nothing new. As decolonial thinkers like Walter Mignolo, Gloria Anzaldua, Enrique Dussel, Arturo Escobar, and others remind us, colonialism produced precariousness as a structural condition of being in the populations and territories that it conquered—through the genociding of populations, the extraction of resources, and the extirpation of ways of life (Fforde et al., this volume). The systematic production of precariousness is as much a part of the history of modernity as familiar narratives around

progress, development, and the advancement of science. Perhaps what distinguishes the present moment is a sense of precariousness as a universal human experience. If, previously, the logic of colonialism and extractivism has been to push the human, social, economic, and environmental costs of modernization and development 'off-shore', onto the populations and territories of the global south, the nature and scale of the challenges that we now face–like the pandemic and the climate emergency–no longer make it possible to do so, or to do so to the same degree. Faced with a problem like the climate emergency, by definition a collective action problem, or with the virulence of a virus that spreads by aerosol means, a policy of geographical off-shoring no longer works–despite attempts by some governments to institute travel bans and quarantines. Outside of the particular nature of these contemporary issues, it may be that there is a more general logic at work–one which is itself a product of the long-500 years. Historically, the capitalist/extractivist frontier closely followed the colonial frontier, in the process unleashing a world-ending violence on many of the populations and territories that it encountered (Fforde et al., this volume, Gnecco, this volume, Waterton et al., this volume). Now, as new territories for conquest and exploitation are exhausted or hard to come by, we might imagine this frontier circling the globe and returning to its point of origin in the global north–at the very moment when the notion of the Anthropocene enters public/political discourse, and precariousness enters the zeitgeist as universal human condition.

The major conceptual work on precariousness has been done by philosopher and gender theorist Judith Butler, who usefully distinguishes between precariousness and 'precarity'–where precarity 'designate[s] that politically induced condition in which certain populations suffer from failing social and economic networks of support and become differentially exposed to injury, violence, and death' (Butler, 2009: ii). The key distinction here–the manner in which populations are 'differentially exposed'–explicitly situates the production of precariousness (precarity) in modern and colonial social, political and economic histories. Butler expands this as follows: 'every political effort to manage populations involves a tactical distribution of precarity, more often than not articulated through an unequal distribution of precarity, one that depends on dominant norms regarding whose life is grievable and worth protecting and whose life is ungrievable … and thus less worthy of protection and sustenance' (Butler, 2012: 148). These sentiments, and the analysis of history and society on which they are based, resonate with the activists of #BLM protesting the disposability of black life, just as they resonate through many other contemporary events: the ongoing wars in Ukraine and Sudan, the struggle for access to vaccines at the height of the pandemic, and the many migrants who lose their lives attempting to cross into Europe, the UK, and North America.

Less often cited in this context, but no less insightful, is the work of Anna Tsing. In a much-praised book *The Mushroom at the End of the World* (2015) she writes 'Precarity once seemed the fate of the less fortunate. Now it seems that all our lives are precarious–even when, for the moment, our pockets are lined. In contrast to the mid-twentieth century, when poets and philosophers of the global north felt

caged by too much stability, now many of us, north and south, confront the condition of trouble without end' (2015: 2). Tsing continues: 'This book is not a critique of the dreams of modernization and progress that offered a vision of stability in the twentieth century: many analysts before me have dissected those dreams. Instead, I address the imaginative challenge of living without those handrails, which once made us think we knew, collectively, where we were going' (2015: 2). For Tsing, precarity is, precisely, 'life without the promise of stability'. Describing the present as 'this time of diminished expectations' (2015: 5), she writes: 'To live with precarity requires more than railing at those who put us here (although that seems useful too, and I'm not against it). We might look around to notice this strange new world, and we might stretch our imaginations to grasp its contours' (2015: 3). In Tsing's terms, we are challenged to try to make sense of 'this strange new world', a world without 'handrails' in her striking image, characterized by the failure or crisis of 'dreams of modernization and progress'—that is, of narrative frameworks that make sense of our individual lives and collective endeavours. We might note that Tsing was writing before the momentous run of events of the last few years—events which have only served to compound this sense of precarity.

Rethinking Heritage

This volume builds on the work of a number of recent volumes that set themselves the task of thinking about the manner in which conceptions of heritage are challenged by contemporary events, and of grappling with the future of heritage. The first is David Harvey and Jim Perry's *The Future of Heritage as Climates Change* (2015), a foundational text that reads like a call to arms by two eminent scholars in Heritage Studies and climate science. Challenging orthodox understandings of heritage, they write: 'We must stretch our ontological bounds and think more synthetically than has been our custom' (3). They characterize the relationship between climate change and heritage as 'a dynamic, emergent and contested political nexus of power, humility and hope' (271). Harvey and Perry close their volume on an elegiac note: 'It is within the bounds of the heritage and climate change nexus that we may discover and confront our humanity' (275). Rodney Harrison and Colin Sterling's *Deterritorializing the Future: Heritage in, of and after the Anthropocene* (2020) explores the intersection between contemporary developments in the posthumanities and the field of Critical Heritage Studies. This conceptually innovative volume opens-up conceptions of care, vulnerability, time, extinction, loss, and inheritance across the more-than-human worlds of the Anthropocene. They write of the utility of an approach of 'thinking *with* heritage in the shadow of the Anthropocene' (25), as a way of producing a differentiated understanding of the Anthropocene as a socially and historically situated phenomenon with different effects, accountabilities, and implications. Finally, Cornelius Holtorf and Anders Högberg's *Cultural Heritage and the Future* (2021) is an extended consideration of the role of heritage in future making. The quote with approval from Harvey and Perry: 'The traditional view that heritage conservation

carries a treasured past into a well-understood future must be rejected. A new view of heritage, serving society in times of rapid change, embraces loss, alternative forms of knowledge and uncertain futures' (Harvey & Perry, 2015: 3, in Holtorf & Högberg, 2021: 11). They ask: 'how can we professionally approach and prepare for a future in which many of the efforts taken in the heritage sector today may be ignored or even undone?' (2021: 11). The volume makes a powerful argument in favour of 'future literacies' amongst heritage practitioners.

One of the pleasures of being the editor of a volume like this is the prerogative one is given to arrange and frame the chapters. The usual course of action would be to group thematically similar chapters into sections. However, in this case–perhaps inevitably given the nature of the brief that was circulated to authors–two factors intervene to disrupt this course of action. First, there is a high degree of thematic overlap between the chapters, with many concerned with questions of coloniality and social justice, for example, or with the effects of the climate emergency, or with experiences of the pandemic. At the same time, they tend to be highly distinctive, both in terms of the particular concerns and approaches of the authors, and in terms of the very different worlds of practice out of which they are written. Thus, I have taken advantage of my small licence as editor to group the chapters instead into a series of conversations or dialogues, with each conversation being signalled by a thematic section heading. My hope is that in doing so the chapters not only stand alone as fully articulated statements, but also enrich one another by being read in tandem–via the sometimes surprising juxtaposition of concepts, approaches, geographical contexts, and points of commonality and difference. For me, it has been enormously pleasing to curate these conversations, in some cases between close friends and colleagues, in other cases between scholars and practitioners who may only know one another by reputation. I have written short section introductions which serve to introduce the papers and outline the logic behind their arrangement, and I have written a slightly more polemical and argumentative conclusion than would normally be the case with this kind of exercise. This extends part of the argument raised by the chapters in this volume via a case study set in Cape Town, South Africa. Finally, I have dedicated this volume to the many wonderful students that I have had the privilege to teach–and be taught by–over the years, on three continents. Whatever we make of the contemporary moment, and however our understandings of heritage shift as a result, it is clear that it will be the generations who come after us who will have to carry the weight of an ambiguous inheritance in a future that looks less and less like anything we were taught to anticipate or expect.

References

Abedi, V., Olulana, O., Avula, V., Chaudhary, D., Khan, A., Shahjouei, S., … Zand, R. (2021). Racial, economic, and health inequality and Covid-19 infection in the United States. *Journal of Racial and Ethnic Health Disparities*, 8(3), 732–742. 10.1007/s40615-020-00833-4

Andrews, T. M. (2021, August 12). They regret not getting the vaccine – and became social media evangelists for the shot. *The Washington Post.* Retrieved from https://www.washingtonpost.com/technology/2021/08/12/vaccine-regret-coronavirus/

Anguiano, D. (2021, September 14). 'It's a reality': Biden calls for urgency in California as climate crisis fuels wildfires. *The Guardian.* Retrieved from https://www.theguardian.com/us-news/2021/sep/13/california-wildfires-biden-trip-climate-crisis-links-extreme-weather

Aschwanden. (2021). How COVID is changing the study of human behaviour. *Nature.* Retrieved from https://www.nature.com/articles/d41586-021-01317-z

Ball, P. (2020). The lightning-fast quest for COVID vaccines – and what it means for other diseases. *Nature.* Retrieved from https://www.nature.com/articles/d41586-020-03626-1

Batty, D. (2020, June 11). Only a fifth of UK universities say they are 'decolonising' curriculum. *The Guardian.* Retrieved from https://www.theguardian.com/us-news/2020/jun/11/only-fifth-of-uk-universities-have-said-they-will-decolonise-curriculum

Beaumont, P. (2022). Ukraine has fastest growing refugee crisis since second world war, says UN. *The Guardian,* 2 March 2022. Accessed 17 October 2022.

Beeson, M. (2010). The coming of environmental authoritarianism. *Environmental Politics,* *19*(2): 276–294. doi:10.1080/09644010903576918

Borger, J. (2022). Boden warns world would face 'Armageddon' if Putin uses a tactical nuclear weapon in Ukraine. *The Guardian,* 7 October 2022. Accessed 17 October 2022.

Brodeur, A., Gray, D., Islam, A., & Bhuiyan, S. (2021). A literature review of the economics of COVID-19. *Journal of Economic Surveys,* *35*(4): 1007–1044. 10.1111/joes.12423

Butler, J. (2009). Performativity, precarity and sexual politics. *AIBR: Revista de Antropologia Iberoamericana,* *4*(3): i–xiii.

Butler, J. (2012). Precarious life, vulnerability, and the ethics of cohabitation. *The Journal of Speculative Philosophy* 26(2): 134–151.

Callaway, E. (2020). The unequal scramble for coronavirus vaccine–by the numbers. *Nature,* *584*(7822): 506–508.

Clayton, S. (2020). Climate anxiety: Psychological responses to climate change. *Journal of Anxiety Disorders,* *74*: 102263. 10.1016/j.janxdis.2020.102263

Cornwall, W. (2020). Officials gird for a war on vaccine misinformation. *Science, 369*(6499): 14–15. 10.1126/science.369.6499.14

Crist, C. (2021, March 25). 'Disinformation dozen' driving anti-vaccine content. *WebMD.* Retrieved from https://www.webmd.com/children/vaccines/news/20210325/disinformation-dozen-driving-anti-vaccine-content

Cronin, M. R., Alonzo, S. H., Adamczak, S. K., Baker, D. N., Beltran, R. S., Borker, A. L., ... Zavaleta, E. S. (2021). Anti-racist interventions to transform ecology, evolution and conservation biology departments. *Nature Ecology & Evolution, 5*(9): 1213–1223. 10.1038/s41559-021-01522-z

de Moor, J., De Vydt, M., Uba, K., & Wahlström, M. (2021). New kids on the block: taking stock of the recent cycle of climate activism. *Social Movement Studies, 20*(5): 619–625. 10.1080/14742837.2020.1836617

Erondu, N. A., Aniebo, I., Kyobutungi, C., Midega, J., Okiro, E., & Okumu, F. (2021). Open letter to international funders of science and development in Africa. *Nature Medicine, 27*(5): 742–744. 10.1038/s41591-021-01307-8

Fanon, F. 2005. *The Wretched of the Earth.* New York: Grove Press.

Frank, S., & Ristic, M. (2020). Urban fallism: Monuments, iconoclasm and activism. *City* 24 (3–4): 552–564.

Fritsche, I., Cohrs, J. C., Kessler, T., & Bauer, J. (2012). Global warming is breeding social conflict: The subtle impact of climate change threat on authoritarian tendencies. *Journal of Environmental Psychology, 32*(1): 1–10. 10.1016/j.jenvp.2011.10.002

Ghosh, A. (2021). *The nutmeg's curse: Parables for a planet in crisis.* Chicago: University of Chicago Press.

Gills, B., & Morgan, J. (2020). Global climate emergency: After COP24, climate science, urgency, and the threat to humanity. *Globalizations, 17*(6): 885–902. 10.1080/14747731. 2019.1669915

Hale, T., Angrist, N., Goldszmidt, R., Kira, B., Petherick, A., Phillips, T., … Tatlow, H. (2021). A global panel database of pandemic policies (Oxford COVID-19 Government Response Tracker). *Nature Human Behaviour, 5*(4), 529–538. 10.1038/s41562-021-01079-8

Harrison, R., & Sterling, C. (2020). *Deterritorializing the future: Heritage in, of and after the Anthropocene.* London: Open Humanities Press.

Harvey, D., & Perry, J. (2015). *The future of heritage as climates change: Loss, adaptation and creativity.* London: Routledge.

Hasson, N. (2021, September 14). Prominent Israeli Anti-vaxxer Dies of COVID. His followers remain unwavering. *Haaretz.* Retrieved from https://www.haaretz.com/israel-news/.premium-israeli-anti-vaxxer-dies-of-covid-but-his-followers-remain-unwavering-1.10208605

Hickman, C., Marks, E., Pihkala, P., Clayton, S., Lewandowski, R. E., Mayall, E. E., Wray, B., Mellor, C., & van Susteren L. (2021). Young people's voices on climate anxiety, government betrayal and moral injury: A global phenomenon. Retrieved from 10.2139/ssrn.3918955

Holtorf, C., & Högberg, A. (2021). *Cultural heritage and the future.* Oxford: Routledge.

Knudsen, B. T., Oldfield, J., Buettner, E.., & Zabunyan, E. (eds.) (2022). *Decolonizing colonial heritage: New agendas, actors and practices in and beyond Europe.* Oxford: Routledge.

Lahut, J. (2021, September 7). Rupert Murdoch's Australian news outlets plan to dial back climate change denial and promote net zero emissions by 2050, according to reports. *Business Insider.* Retrieved from https://www.businessinsider.com/rupert-murdoch-climate-change-news-outlets-australia-policy-change-2021-9?r=US&IR=T

Lam, M. E. (2021). United by the global COVID-19 pandemic: Divided by our values and viral identities. *Humanities and Social Sciences Communications, 8*(1): 31. 10.1057/s41599-020-00679-5

Latour, B. (2020). Is this a dress rehearsal? *Critical Inquiry, 47*(S2): S25–S27. 10.1086/711428

Mbembe, A. J. (2016). Decolonizing the university: New directions. *Arts and Humanities in Higher Education, 15*(1): 29–45. 10.1177/1474022215618513

McCarthy, J. (2019). Authoritarianism, populism, and the environment: Comparative experiences, insights, and perspectives. *Annals of the American Association of Geographers, 109*(2): 301–313. 10.1080/24694452.2018.1554393

McKee, M., Gugushvili, A., Koltai, J., & Stuckler, D. (2020). Are populist leaders creating the conditions for the spread of COVID-19? *International Journal of Health Policy and Management,* 1–5.

Milne, A. (2020, April 9). UK under fire for suggesting coronavirus 'great leveller'. *Reuters.* Retrieved from https://www.reuters.com/article/us-health-coronavirus-leveller-trfn-idUSKCN21R30P

Morand, S. (2020). Emerging diseases, livestock expansion and biodiversity loss are positively related at global scale. *Biological Conservation, 248*: 108707. 10.1016/j.biocon.2020. 108707

Osama, T., Razai, M. S., & Majeed, A. (2021). Covid-19 vaccine passports: Access, equity, and ethics. *BMJ, 373*: n861. 10.1136/bmj.n861

Padma, T. (2021). COVID vaccines to reach poorest countries in 2023–Despite recent pledges. *Nature, 595*(7867): 342–343.

Paton, C., & Dutton, J. (2020, June 11). Top 10 colonial landmarks in the sights of Europe's BLM protesters. *The National News*. Retrieved from https://www.thenationalnews.com/world/europe/top-10-colonial-landmarks-in-the-sights-of-europe-s-blm-protesters-1.1031342

Philips, T., Augustin, E., & Collyns, D. (2021, August 6). 'New wave of volatility': Covid stirs up grievances in Latin America. *The Guardian*. Retrieved from https://www.theguardian.com/world/2021/aug/06/new-wave-volatility-covid-stirs-up-grievances-latin-america

Ricard, J., & Medeiros, J. (2020). Using misinformation as a political weapon: COVID-19 and Bolsonaro in Brazil. *Harvard Kennedy School Misinformation Review, 1*(3). https://misinforeview.hks.harvard.edu/article/using-misinformation-as-a-political-weapon-covid-19-and-bolsonaro-in-brazil/

Ritchie, H. E. M., Rodés-Guirao, L., Appel, C., Giattino, C., Ortiz-Ospina, E., Hasell, J., Macdonald, B., Beltekian, D., & Roser, M. (2020). Coronavirus pandemic (COVID-19). Retrieved from https://ourworldindata.org/coronavirus. Retrieved September 15, 2021. https://ourworldindata.org/coronavirus

Ruptly (Producer) (2020, September 15). UK: "The virus does not discriminate" – Cabinet Min Gove after PM and Health Sec get coronavirus. Retrieved from https://www.youtube.com/watch?v=wPmN9H65Pcc

Saaliq, S. (2021, March 24). Many lives were changed by India's lockdown a year ago. *AP News*. Retrieved from https://apnews.com/article/pandemics-health-india-coronavirus-pandemic-new-delhi-bba32aae3ea601c2efd783174da8270a

Sabherwal, A., Ballew, M. T., van der Linden, S., Gustafson, A., Goldberg, M. H., Maibach, E. W., … Leiserowitz, A. (2021). The Greta Thunberg effect: Familiarity with Greta Thunberg predicts intentions to engage in climate activism in the United States. *Journal of Applied Social Psychology, 51*(4): 321–333. 10.1111/jasp.12737

Schmeller, D. S., Courchamp, F., & Killeen, G. (2020). Biodiversity loss, emerging pathogens and human health risks. *Biodiversity and Conservation, 29*(11): 3095–3102. 10.1007/s10531-020-02021-6

Schneider, T. D., & Hayes, K. (2020). Epistemic colonialism: Is it possible to decolonize archaeology? *American Indian Quarterly, 44*(2), 127–148. 10.5250/amerindiquar.44.2.0127

Selvin, C., & Solomon, T. (2020, June 11). Toppled and removed monuments: A continually updated guide to statues and the Black Lives Matter protests. *ARTnews*. Retrieved from https://www.artnews.com/art-news/news/monuments-black-lives-matter-guide-1202690845/

Shepherd, N., Carmen, W., Cohen, J. B., Chundu, M., Ernsten, C., Guevara, O., Haas, F., Hussain, S. T., Riede, F., Siders, A. R., Singh, C., Sithole, P., & Troi, A. (2022). *White Paper: The Role of Cultural and Natural Heritage for Climate Action*. International Co-Sponsored Meeting on Culture, Heritage and Climate Change. ICOMOS, UNESCO and the IPCC.

Shepherd, N. (2020). After the #Fall: The shadow of Cecil Rhodes at the University of Cape Town. *City: Analysis of Urban Trends, Culture, Theory, Policy and Action, 24*(3–4): 565–579.

Shepherd, N. (2022). Specters of Cecil Rhodes at the University of Cape Town. In: B. T. Knudsen, J. Oldfield, E. Buettner & E. Zabunyan (eds.) *Decolonizing colonial heritage: New agendas, actors and practices in and beyond Europe*. Oxford: Routledge.

Sturm, T., & Albrecht, T. (2021). Constituent Covid-19 apocalypses: Contagious conspiracism, 5G, and viral vaccinations. *Anthropology & Medicine, 28*(1): 122–139. 10.1080/13648470. 2020.1833684

Survival, I. (2021). Photocall: Major protest to #DecolonizeConservation to be held in Marseille, France [Press release]. Retrieved from https://www.survivalinternational.org/news/12642

Torres, T. S., Hoagland, B., Bezerra, D. R. B., Garner, A., Jalil, E. M., Coelho, L. E., … Veloso, V. G. (2021). Impact of COVID-19 pandemic on sexual minority populations in Brazil: An analysis of social/racial disparities in maintaining social distancing and a description of sexual behavior. *AIDS and Behavior, 25*(1): 73–84. 10.1007/s10461-020-02984-1

Tsing, A. (2015). *The mushroom at the end of the world: On the possibility of life in capitalist ruins.* Princeton: Princeton University Press.

Vihma, A., Reischl, G., & Nonbo Andersen, A. (2021). A climate backlash: Comparing populist parties' climate policies in Denmark, Finland, and Sweden. *The Journal of Environment & Development,* 10704965211027748.

Vinter, R. (2021, July 12). Over three-quarters of Britons re-evaluate their lives during Covid. *The Guardian.* Retrieved from https://www.theguardian.com/world/2021/jul/12/over-three-quarters-britons-re-evaluate-lives-covid

Warren, K. (2020). Who are monuments for? Considering slavery legacies in London's public statues. Retrieved from https://www.museumoflondon.org.uk/discover/who-are-monuments-for

Wintour, P. (2022). UN warns of 'looming hunger catastrophe' due to Russian blockade. *The Guardian,* 8 July 2022. Accessed 17 October 2022.

Wu, J., Snell, G., & Samji, H. (2020). Climate anxiety in young people: A call to action. *The Lancet Planetary Health, 4*(10): e435–e436.

Zimmer, C., Corum, J., & Wee, S.-L. (2021, September 13). Coronavirus vaccine tracker. *New York Times.* Retrieved from https://www.nytimes.com/interactive/2020/science/coronavirus-vaccine-tracker.html

SECTION I

'The Heritage through My Window' and Stateless Heritage

At an early stage in the production of this volume, I knew that I wanted to begin with the report by Marcia Bezerra and her students on the effects of the Covid-19 pandemic on heritage education in the Brazilian Amazon. In a beautifully written and empathetic chapter, they write that one of the effects of the pandemic in Brazil has been to exacerbate already existing social and economic inequalities. At the centre of their account is the students' creative reconfiguring of notions of heritage under lockdown conditions–the 'heritage through my window'–as a reaffirmation of everyday domestic spaces, green nature, and personal and intimate experience. Bezerra and her students–trapped at home for upwards of eight months–grappled with digital exclusion, the lack of sociality, and the challenge presented to available teaching models. Bezerra writes that her students practiced a recursive gaze 'that gathered temporalities, events, people, feelings, in a dynamic and intense way'. Following Holtorf, they came to understand that 'uncertainty is also empowering'. Bezerra writes that in a time of precarity and uncertainty 'the students have sensitively reconceptualized the notion of heritage, revealing its entanglement with their daily life, their identities, their feelings'.

Beverley Butler similarly begins her chapter by describing the pandemic as 'a profound experience of the overturning of worlds' that challenges and overturns many 'prescribed and prescriptive pre-pandemic norms'. Taking advantage of the space cleared by this overturning of norms, her chapter unfolds in two parts. In the first part, she revisits her own prior work on heritage pharmacologies drawing on the work of Derrida, Stiegler, and Deleuze, via an exploration of 'Covid heritage imperatives' and the new pharmacologies of care triggered and enabled by the pandemic. In the second, she offers a symptomatic reading of a subversive intervention by DAAR (Decolonize Architecture Art Research) in the exhibition *Stateless Heritage*: namely, the nomination of a Palestinian refugee camp as a UNESCO World Heritage

DOI: 10.4324/9781003188438-2

site. Drawing these strands together, she offers nine points for challenging and re-thinking normative conceptions of heritage, many of which connect with other chapters in this volume. These include refusing the heritage trope of the ruin, rejecting the association of refugeeness with victimhood, challenging the universalist assumptions of UNESCO heritage norms, rethinking tropes of authenticity, and many others. Butler writes 'What is imperative, therefore, is to engage with heritage as a critical quest capable of rejecting any and all repetitions of 'crimes', 'political failures', and 'ineffective' and harmful categorical statements made by power–notably manifestations of fixities/fixations with 'what heritage is'–by instead focusing on 'what heritage does'–its transformative efficacies'.

1

THE HERITAGE THROUGH MY WINDOW

Some Reflections on Teaching in the Brazilian Amazon During the Covid-19 Pandemic

Marcia Bezerra

FIGURE 1.1 The "green heritage" from my balcony: a view during the Coronavirus pandemic. Photograph: Marcia Bezerra, Belém/ Pará, Brazil, 2021.

DOI: 10.4324/9781003188438-3

From my window I see the world go round.

Where this is going, I don't know.
(Pedro Lopes, 2021)

Monday morning, 06:30 a.m.: I awoke, dressed, turned on the computer on the way to the kitchen, ate breakfast, and then crossed the corridor back into my 'home classroom' where I see a mosaic of faces (or static images), as well as a dozen other home classrooms. This has been my routine since September 2020, when the Emergency Remote Teaching (ERT) model was adopted by the universities in Brazil (MEC 2020). I have certainly shared the challenges posed by this situation with a large community of educators since remote learning was implemented around the world as a strategy to maintain educational processes during the Covid-19 pandemic (UNESCO 2020b). Over two years after the World Health Organization (WHO 2020) declared the pandemic, Brazil, unlike many other countries, has not totally returned to in-person classes as only 73% of the population has become recently doubled-vaccinated. Brazil has hit 652,143 deaths by Covid-19 and there is no sign of an end to this tragedy. In the state of Pará, the east-central part of the Amazon region, where I live, 725,727 people were infected, and 17,898 have died of Covid-19 (FIOCRUZ 2022). Furthermore, until a few months ago less than half of the population of the Pará State had been double-vaccinated as yet. This is no longer the case given Pará's current vaccination rate of 63.41%. (FIOCRUZ 2022).

The first case of coronavirus (Covid-19) in Brazil was reported in January 2020; two months later the virus reached the Amazon. The systemic effects of the pandemic in the region reinforce socioeconomic inequalities and expose the structural violence perpetrated by the government against the Indigenous people and other forest people who live in extreme vulnerability. In the last year, coronavirus has killed many Indigenous elders, threatening their histories, their rights, and their existence. Besides this, and while the Amazon Rainforest burns, the environmental licensing policy has been changed, aiming at the simplification of its rules. Therefore, the collective rights to traditional territories have diminished. At the same time, the universities—which have been under attack by the government—struggle to overcome the effects of the pandemic (Bezerra 2020). The precariousness in the Brazilian education system has increased the logic of exclusion. As an archaeologist living in the Amazon, I have been affected by these events. Based on my own experience teaching heritage education classes and on a collection of students' assignments, in this chapter I will critically discuss the adoption of remote teaching models and how this has led to new dialogue modes with students, as well as to different perspectives on cultural heritage during the pandemic in the Brazilian Amazon.

Teaching During the Pandemic

I have been teaching Heritage Education (HE) for more than a decade now. My experience involves teaching classes to schoolteachers in Amazonian rural communities, as well as undergraduate and graduate students from many fields of knowledge. These courses are taught in one of two modes: a one-week intensive course or a semester-long one. Until 2020, however, they have all taken place in-person. To highlight this difference is particularly pertinent while discussing HE. I agree with Brandão (2006, 5, transl. mine) when he states that HE is a 'vocational aspect of education (…) transdisciplinary, dialogic, open and interactive'. HE brings together two complex areas of knowledge—Heritage and Education—in which sensitive and close interconnexion with the students, their histories and experiences is invigorated and potentialised by 'being there' in the actual classroom. This academic sociability was replaced by 'pandemic sociability' (Toledo and Souza Jr 2020, 58, transl. mine) as a result of social distancing rules, demanding the 'avoidance of contact and proximity of bodies in public spaces' (op. cit.), which generated the 'hole of the hug' as student Amanda Almeida stated in her assignment. Her idiom is an attempt to express her feeling about the absence of physical connexion during the pandemic (assignment, October 2020, transl. mine). Being together is crucial for the students and for the learning process as well. Education is a collective, political, and emotionally sensitive activity.

Teaching and learning are acts of resistance in Brazil, where more than half a million people have died as a result of Covid-19 (FIOCRUZ 2022). These data were updated in March 2022, a few months after I began writing this chapter, and when I believed we would have returned to in-person teaching by now. Unfortunately, the situation has not evolved as expected. But as the number of deaths has declined, the schools and universities have been gradually returning to in-person activities, with the majority of them functioning in a hybrid model (in-person and remote classes). This is the case at my university, Universidade Federal do Pará, which is situated in Belém, Pará State, one of the largest capitals in the Amazonian region.

The Brazilian universities adopted ERT in 2020. The institutions were forced to abruptly discontinue all in-person activity. They have faced numerous challenges such as: the formation of sanitary evaluation committees, the safe functioning of the university's administrative sectors, the rearrangement of the academic calendar, and assurance that all students would have access to the virtual activities. At the university where I teach the classes were entirely suspended on March 19, 2020 (UFPA 2020). The remote activities were implemented after a six-month period without any classes. Practical disciplines (those that require the use of laboratories, for example) were allowed to return partially in-person in November 2021. In March 2022, as I review this chapter, I am still working remotely, but in-person classes are expected to begin in a few weeks.

Like most of my colleagues, I have no previous experience with remote teaching. Nevertheless, we had to totally redesign the syllabus in terms of contents, methods (teaching and evaluation), and the bibliography, overnight. There had been

considerable discussion about the new and compulsory teaching strategy. Some believed that it was just a case of converting the traditional classes to a virtual environment, employing minimal technology. Others stated that they were open to learning about distance education tools. Besides this, we were all concerned about data security and safety during online activities, and also with 'educação vigiada' (Cruz 2020, original quote in Portuguese) what we could call in English 'monitored education'.

But the profound process of digital exclusion brought to the fore during the pandemic is more crucial than these issues. Students who had historically struggled to gain access to education, suddenly faced a learning strategy that demanded high-speed internet, a computer, and other devices (microphones, cameras, etc.). In the Amazon region, 72% of households have internet access (without regard to its quality) but only 29% have a computer. In 18.9 million households in the region, neither internet nor computer are available, and most of the students have attended classes using their cell phones (CETIC, NIC, and CGI 2019, 2020). Ruth Cardoso (assignment, October 2020) while recognising that many of her colleagues do not have internet access, emphasises the importance of faculty members acknowledging each student's needs. Universities launched grants to support students with internet data packages and laptops. However, they did not include all the students that live in economically vulnerable situations. Add to that many students' families had lost their main source of income, due to family members losing their jobs or even dying of Covid (a problem that has continued). Many students were compelled to leave university to search for a job, while others abandoned academic life to take care for their families or to recover from Covid-19 themselves. Women were particularly affected, as many of them were responsible for supervising their children's online education. Pollyanna Figueira (assignment, October 2020, transl. mine) misses her daily routine at university which provided her with 'social relationships and experiences [that are] completely different from other spaces'. She describes how challenging it is to focus on remote classes whilst doing the housework. Many students attend classes while taking the bus on their way to work (temporary jobs) or to some relative's house to help with health or domestic responsibilities. They also attend classes when preparing family meals in the kitchen or in a doctor's waiting room, or even whilst standing on the side of a road with cell phone service. Furthermore, students with disabilities have been deprived of the in-person assistance services at the universities and could not be totally included in the remote teaching activities.

As the university 'invaded' all of our homes, our academic and personal lives became enmeshed. We now also share personal intimacy during online learning activities unless we turn off the cameras, the microphones, and therefore do not actively participate in class, which is not possible for educators. If these online tools of communication are kept open, however, we get to know each other's routine. When cameras are turned on, we can see the walls, the furniture, some objects deliberately selected for the remote class scenarios, the other people that live in the house, and the pets. When the cameras are turned off, but the microphones are turned on, we can hear children's voices, dogs barking, birds singing, traffic and

constructions noises, music, cell phones ringing, television sounds–a plethora of soundscapes from diverse lives. Talking to one another from these landscapes of belonging gives us a sense of emotional comfort, which paradoxically turns the cold digital space into a warm one at times. According to Faria (2020, 6), there is a 'confessional element to video interactions', as people are in 'their element' they tend to be more open since they feel in control of the situation. However, beneath the surface of comfort and safety exists a 'subtle process of digital colonisation' that provokes individual and collective suffering (Segata 2020, 168–169, transl. mine). Surveys carried in several countries have shown the impacts to student's mental health during the pandemic (UN 2021). Teachers' health have also been impacted due to lack of training in using the distance education tools, institutional pressure for the immediate adoption of technological solutions, and the search for balancing personal and academic demands (Gomes et al. 2021). The results reveal that young people have been suffering with the loss of academic routine and social interaction (UN 2021). Some of them admit that they '(…) need socialisation to remain mentally stable (as most humans like me)' says Arthur Menezes (assignment October 2020, transl. mine). Teaching and learning have been challenging for students and educators during the pandemic, and the initial evaluation of the remote mode is not really encouraging (Medeiros et al. 2021). The precariousness of education in Brazil is not a new phenomenon, but it has been overtly exacerbated in the last year.

In the Amazon, the scenario is even more dramatic. The environmental crisis induced and aggravated by Brazilian governmental policies has seriously affected the ecosystems and peoples of the Amazon Forest, whose sustainable management practises have enabled them to preserve this environment for thousands of years. The deforestation has an impact on the Amazonian biome and causes multiple forms of violence against the people. During the pandemic, the violation of human rights, especially against Indigenous collectives in the region (Rocha and Loures 2020), has compelled us to rethink education, when dealing with heritage-related content on the Amazon.

What is the point, then, of teaching HE in the face of such a situation? How could we make the students interested in this subject? What points of view should we bring to the remote classroom? I address these questions here, based on my experience with a HE discipline offered to a group of undergraduate students from an Amazonian university during the first year of pandemic. Drawing from their assignments I reflect about their perspective of heritage during the Covid-19 pandemic in the Amazon. It's worth noting that the students were very excited to have their work used and quoted in the text, for which I am deeply glad.

The Heritage from My Window: Class 2018

Since 2010, I have been teaching archaeology and Heritage Studies to undergraduate students as a component of a BA in Museology. These fields are the common ground for disciplines such as Theory and Method in Archaeology, Culture and Heritage,

Archaeology in the Amazon, and Heritage Education. Over the last decade, I have been entirely responsible for the last two courses, which were offered twice since the pandemic began. While currently preparing the classes for the current 2022 semester, I can look back at that first experience with the remote teaching, which occurred less than two years ago, from a distance. The suspension of our lives due to the impacts of the pandemic have affected our perception of time; it leads us to feel that time is moving slowly (Loose, Wittman, and Vásques-Echeverría 2021). In a short period, I was able to identify changes in the remote education mode over three semesters.

I taught HE remotely during the pandemic to a group of 20 undergraduate students. The discipline included both synchronous (30%) and asynchronous activities (70%). Since most of the students had limited access to the internet and computers, synchronous encounters were not obligated. These online activities aimed to provide an affective interaction rather than a content-learning activity. The synchronous activities were mainly dedicated to the assignments. The reflections presented here are indeed based on 59 of these assignments.

A wide range of emotions came up in October 2020. It was my first experience with the ERT, as well as the students'. On one hand, there were issues including a lack of training to deal with the technological approach to learning (for both students and teachers), the instability and/or limitation of the internet connexion, and the widespread unavailability of digital devices at the students' homes. All of these combined with our common feelings of anxiety about returning to classes, as well as loneliness, and even depression, made our first experience with remote teaching extremely difficult. Renan Lorenzo (assignment, October 2020, transl. mine) depicts the quarantine and the social distance as 'a loss of identity; I had to re-organise myself, rethink my habits and priorities, in order to get through this period of isolation in a healthier way'. Renan stresses the value of academic sociability in the construction of his identity—a thought that is shared by many students when acknowledging the significance of the university in their lives.

Some of these sentiments remained a few months later, while others emerged: most notably, discouragement and hopelessness at the continuation of social isolation. At the same time, a small number of the students had acquired access to technological devices, and the academic community became more familiar (but not better prepared) with remote learning tools. The results of a survey conducted among the professors at my university show that only 12% of them feel to be totally capable of successfully dealing with digital technology (Medeiros et al. 2021, 29). As there was no systematic training for teachers, we could structure the disciplines—in terms of remote strategies—based on our personal knowledge and preferences. Learning through varied tools and strategies[1] in a new educational environment has enabled the students to compare, evaluate, and choose among the diverse approaches available to them.

For me, remote education is a very frustrating method of teaching. Affection is an essential element of the educational process. Every time I initiate a class, I spend a few minutes observing and feeling the 'spirit of the classroom', and if I notice that the students are not in their usual mood, I try to bring the concerning issue up for

debate such as in 'problem-posing education' (Freire 2005, 40). I have been moved by the students' experiences, challenges, and feelings, on countless occasions; I have laughed and also cried with them multiple times throughout my life. These sharing moments have always been powerful and help the students become more involved in their classes. hooks[2] (1994, 154–155) questions, 'If we are all emotionally shut down, how can there be any excitement about ideas?' Ideas are not only debated in the classroom, but they are also produced by this powerful encounter of minds and hearts. Such emotions are constituent part of knowledge production. They 'create an environment of warm welcome and dialogue' by connecting different ways of seeing the world in the classroom (Cabral and Bezerra 2022, 143). This is how I approach archaeology and heritage education teaching.

Heritage education is a dimension of education that aims to sensitise people to patrimony, considering their active roles in the constitution and preservation of heritage assets. It is critical to the establishment of 'patrimonial citizenship' (Lima Filho 2019). The entanglement of education, culture, and politics provides heritage education with an emancipatory and transformative character. For this reason, in Brazil, the ideas of the educator Paulo Freire are used by many researchers, educators, and heritage professionals as their basis for a significant part of the actions, debates, and publications around HE. Nevertheless, HE is especially associated with contract archaeology in Brazil. Since 2002, the development of HE activities has been required as a component of the environmental licensing process. More than 90% of the archaeological research conducted in the country is related to preventive archaeology, which results in a substantial volume of HE projects implemented in Brazil. The asymmetries established by these development projects are often enhanced by HE activities designed from a non-critical perspective of education and heritage (Bezerra 2015). Even out of the environmental licensing context, HE has been criticised as the initiatives lack a more '(…) consistent theoretical foundation and, therefore, have repeated outdated, conservative and content-based educational approaches' (Fernandes et al. 2019, 7, transl. mine). Heritage education is an interdisciplinary field that integrates two large and complex areas of study: heritage and education. As a consequence, it is fundamental to consider what concepts of heritage and education shape HE. In this respect, the syllabus of the HE course I have been teaching for the last several years covers topics and readings that critically analyse the broader picture of HE with a focus on the Brazilian Amazon.

Prior to the pandemic, the in-person classes devoted to these topics took the form of a conversation circle. The knowledge brought to the debate during these classes emerged from each student's personal experience with education and patrimony. Group activities such as fieldwork and seminars were part of the assignments included. The purpose of the fieldwork was to select a 'thing' (here I follow Miller's 2010 broad concept of 'thing') that they perceive as heritage. They had to design and present a proposal of a HE activity at the end of the semester; its nature could vary from a single activity to a project. Individual experience was central to the debates during the conversation circle in the in-person classroom. In general,

students remember and narrate their educational trajectories whether in family or at school and university. With the majority of students being women, and a significant part of the classes composed of black women, it has been necessary to consider the intersectionality (a concept coined by Crenshaw in 1989) which permits '(…) the comprehension of the fluidity of subaltern identities imbued with preconceptions, gender, class, and race subordinations, and the structural oppressions that underpin the modern colonial matrix from which they have evolved' (Akotirene 2019, 24, transl. mine). These moments in the classroom brings to the fore a multitude of feelings and emotions that, invariably, involve accounts of pain and suffering generated by racist, ethnic, and gender-based violence intertwined with social class. Disability preconception, oppression, and exclusion also pervade heritage and education fields. The pandemic has magnified these inequalities, exposing the nerves of social injustice to a dramatic extension.

Inquiring about the role of education and heritage in the context of the pandemic reveals a shift in the students' perceptions of both heritage and education, but notably of heritage. In their assignments, the university appears as the locus of social and affectionate relationships, as a means of social mobility expectation, and as a place where they can access digital technologies on a daily basis for free. They are all concerned about the 'chasm created between those who can continue their learning process and others who do not even have an electronic device with internet con-nexion at home' (Amanda Almeida, assignment October 2020, transl. mine). Dâmaris Nogueira argues that 'For now the search for knowledge is limited to data and internet packages' (assignment October 2020, transl. mine). These sensitive reflections elicited attitudes of empathy, solidarity, and affection among the students. They kept track of each other's mental and digital situation in order to 'leave no one behind'[3] during the remote classes. Faced with such a dramatic and unprecedented circumstance, they have reflected on the relevance of Museology. First, they wondered whether their profession has any value to the society in such an extreme context. Ultimately, they realised that the museums are places where it will be possible to:

(…) studying and safeguarding of the memories and social changes that will arise from the pandemic so that we remember in the future not only the virus, the masks and social isolation, but also not forget government neglect (…) that took many of our relatives, friends and acquaintances from us (Carolina de Paula, assignment October 2020, transl. mine).

However, they have also questioned 'How do we humanise the museal experience without human contact?' (M. M., assignment October 2020, transl. mine). According to a survey undertaken by UNESCO (2020a), 90% of the museums around the world have temporarily closed due the pandemic. To mitigate the ef-fects of the institutions' closures, museums' efforts to advance online exhibitions during the pandemic have been centered on creativity and imagination. Spolar (2020) views 'the pandemic as a creative catalyst' for art museums, whereas the

students emphasise the importance of lives beyond the exhibitions and museum collections. Some claim that if there are 'no lives, no collections, no memories, no histories [then, there are] no museums', and further refer to the humanitarian actions of museums that donate masks, and other materials to health professionals during the pandemic (J.S., assignment October 2020, transl. mine).

These concerns align with the new definition of museum proposed, in 2019, at the 139th ICOM assembly (pending endorsement)[4] which states that museums aim to '(...) contribute to human dignity and social justice, global equality and planetary wellbeing' (ICOM 2020). The pandemic has, to some extent, crystallised in the students' view the connexion between the museums' mission statement and social equity. The students' current perspective on the Museology career and education has been affected, as well as their position as future museologists. After discussing Paulo Freire's ideas about education (2005), Pollyana Figueira (assignment, October 2020, transl. mine) concluded that 'museologists are both educators and learners' for they present certain worldviews about heritage, the past and the present; but also, because many museums have included community participation through online activities during the pandemic. Two prominent Amazonian museums—which also have a remarkable role in the history of science in Brazil—have offered online activities during the pandemic: Museu Paraense Emílio Goeldi (Pará) and Museu Amazônico (Amazonas), the former which hosted a virtual visit to the archaeological storeroom (Museu Goeldi 2020), and the latter, an online course about Amazonian archaeology (UFAM 2020). This last one attracted almost 7,000 people, and a second edition was released in December 2021 (Betancourt et al. 2021).

During the pandemic, the students' perceptions of heritage have also been impacted. Since it was not possible to conduct the regular fieldwork on heritage outside the home, I proposed that students write about the heritage that they see from their windows. They had to select, describe, and reflect on anything they consider to be a valuable heritage, and they could also include a photograph. The written responses, as well as those discussed in a synchronous activity by a group of students, demonstrated a strong linkage between heritage, home, nature, family, and affection.

At the time I taught the course on HE, the students had been trapped at home for almost eight months. Many of them had lost family members or were unable to see their families for a long time. Being at home deprived of their social lives, and facing fear, hopelessness, and in some cases depression, has led the students (and indeed, all of us) to tint their daily lives with different tones. The social isolation has forced us to deal with a myriad of quotidian and domestic events that are, in general, naturalised by the routine. Being immersed in this familial context has generated a deeper sense of observation at multiple levels towards the self, the family, the house, and the window. The students' assignments reveal a sensitive gaze towards their ordinary life, and this has affected their views of heritage.

Drawing from their assignments, it is suggested that resituating themselves in the home space for a long period of time has elicited different perceptions of their

domestic landscape. The Brazilian anthropologist Roberto DaMatta (1997, 14, 16), while using the house (*casa*) and the street (*rua*) as sociological categories to understand the grammar that underlies Brazilian society, proposes that the house cannot be 'defined by a metric tape, but through contrasts, complementarities, and oppositions'. In doing so, he argues that the house (*casa*) sphere is associated with the notions of love, affection, and warmth; the place where the prerogative of rights turns people into 'super citizens'. In contrast to the sentiments attached with the street which is, as he pointed out, regarded as a 'dangerous place': a distant and unknown place where the law and duties make people feel like 'subcitizens'. During the pandemic, this dichotomy has acquired new and dramatic dimensions, as the sense of protection of life is inextricably intertwined with the house, whereas being outside of home, on the street, represents a real threat to health. Windows mediate these two spaces (DaMatta 1997, 58). Balconies have also served as mediators due to movement restrictions and social isolation. Martín (2020) notes that the balconies have 'become a powerful domestic space symbolising corona-solidarity in the south of Europe', for example.

Here, in the Amazon, windows have also emerged as powerful spaces from where students could 'escape from the walls of the room where I spent most of the isolation period' as Carolina de Paula explained (assignment, October 2020, transl. mine). Looking out her window she recognises the backyard garden as a form of heritage that connects to her present life and her childhood memories. Pollyana Figueira (assignment, October 2020, transl. mine) stated that the landscape that she used to see through her window was just an ordinary image before the pandemic, but then 'has become my natural heritage'. Most of the students defined nature as a category of patrimony: birds, gardens, trees, rain, the river, the sun, and the sky being the most cited. Although the students acknowledge the settled debate around the binary opposition between nature and culture, their assignments seem to establish the old chasm between natural and cultural heritage. Nevertheless, they adopted the category 'natural' or 'nature', as a reference to green landscapes (and all the non-human components of them) as the antithesis to non-green landscapes, such as the walls of their houses, the screens of their computers or cell phones, and urban landscapes.

The city of Belém where many students live and study—the campus of UFPA is in Belém—is located near the mouth of the Amazon River and is known as the 'city of mango trees'. Since the 1980s, the city has lost a significant part of its green spaces (Figueiredo et al. 2013) and only 22.3% of Belem's public streets were still forested in 2010 (IBGE 2021). Although green landscape has became sparse, the city is surrounded by a bay and several islands and *igarapés* (tributary streams) where the vegetation is visually much denser. The campus of the university is provided with this Amazonian landscape and has an ample view of the green spaces on the other side of Guajará Bay. This means that the students experience this green landscape on a daily basis, as they have also done during their childhood when the city was much more forested. Many of them have associated trees with childhood, family and heritage: '(…) What I consider as heritage (…) I could see that several places that I frequented, or go to, had the presence of countless trees, therefore, when I come

across some place that (...) has the same trees as in my childhood or adolescence, [it] causes me to remember the most diverse affectionate events' (Ana Larissa de Andrade, assignment, October 2020, transl. mine). J.C.S.'s connexion to nature is activated by his relationships with *his* plants, some of which were given to him by his grandmother. Taking care of the plants is one of his favorite moments of the day because the plants 'teach us how to be patient'–a crucial attitude during quarantine. Archambault (2016, 247), while analysing the relationships between people and their plants in Mozambique argues that we should take the love of plants seriously. Descriptions like this were frequent among the assignments. In fact, contact with green landscapes during the pandemic has affected our mood and mental health, and in many cases has triggered memories.

Our sensitive interdependency with nature has been profoundly discussed by scholars from different fields, notions and perspectives, such as the concept of *biophilia* (Wilson 1984), the perception of nature during the XVI, XVII, and the XVIII centuries (Thomas 1983), the research about the psychological and therapeutical benefits of interaction with nature (Li and Sullivan 2016; Rathmann 2021), and recently studies about the importance of nature in city landscapes during the pandemic (McCunn 2020). Whether it is due to the loving or healing aspect of our relationships with nature, searching for green areas during the pandemic has increased throughout the world. The students' assignments demonstrate the influence of these green landscapes not only to their wellbeing, but also to their identities, their biographies as they associated plants, trees, and gardens with childhood memories, as well as people and places they love and miss during the pandemic.

Having their access to the outside world restricted has sharpened the students' perception of life. They consider their past, present, and future as they observe the passage of time from their windows. They miss both their daily and past landscapes. Clara Mártires notes that 'Stuck at home, we went through a phase of not looking at (seeing) other landscapes, other scenarios, other than what is available to us in the windows, which in some cases [is] just looking out on newly built or still under construction giant buildings' (assignment, October 2020, transl. mine). Some of them have outlined the changes they have noticed in the neighbourhood; others admit that the quarantine has caused them to perceive transformations in the landscape. Even for such young people, this has provoked a feeling of nostalgia. According to Arthur C. Menezes, from his window, he can see an old building that 'brings me back to the times when I was a child and life was easier' (assignment, October 2020, transl. mine). Ana Cecília Santos evokes '*saudade* [yearning, nostalgia] I have never experienced before' in reference to Belém's urban space. This sentiment of *saudades* has prompted the students to search for old photographs. Ana Cecília Santos says that 'looking at a photograph is like being able to return to a safe place'. Photographs are also windows, artefacts used to construct and see the world–in this case, a safe one.

The students have appropriated the category 'heritage' in a remarkably and sensitive mode. The heritage they have seen/created through their square windows combines collective value and significance elements (nature, love, peace, caring,

safety) with individual ones (family home, aunt's photographs, father's old coins, mother's bedroom, affectionate relationships). Their powerful, touching and personal thoughts voiced generously through their assignments assert an emotional bond to heritage. While describing the heritage from their window, they have practised a 'recursive gaze' (Wood 2020) that gathered temporalities, events, people, feelings, in such a dynamic and intense way. As stated by Ana Cristina Souza '(...) heritage is built/constructed with each gaze. Changing every hour, in eternal motion' (assignment, October 2020, transl. mine). The students' ideas about heritage suggest that this period of '(...) uncertainty is also empowering' (Holtorf 2020, 3). In this sense, it would not be unfounded to state that they will never view heritage in the same way in the future.

A Hug for the Future

The semester has just begun, and my discipline is scheduled for mid-March 2022. But since I supervise a few undergraduate students, I have regular contact with their routine. They are undergoing another change as the university gradually returns to in-person classes. They have demonstrated happiness about being with their friends, colleagues, professors; surprise and admiration for recognising some changes in the campus landscape (caused by infrastructure improvements or simply a trick of the memory process after nearly two years away from the university); but they still feel hopeless.

The effects of the pandemic have had a considerable impact on the learning process. As Segata (2020, 169, translation mine) points out 'the digital goes hand in hand with meritocracy and exclusion', as the technological approach of the education is not the redeemer of distance teaching; instead, it creates even more barrier between disadvantaged communities and education. Neither was the Heritage Education discipline addressed here the saviour of all these social injustices. Nonetheless, based on students' reflections (written in their assignments or presented during synchronous encounters), and their feedback in the last class, it is reasonable to conclude that we managed to promote an affective educational experience for all of us. Some students have stated that being involved in this specific discipline has kept them from dropping out of university. By opening themselves to their emotions (hooks 1994, 154–155) during the remote classes they have produced potent knowledge about the concept of heritage and its entanglement with their daily life, their identities, and their feelings.

They could also anticipate others forms of heritage, as put by Dâmaris Nogueira 'It is as if the heritage was replaced by all the relationships that were deprived' during the social isolation period imposed by the Covid-19. These affectionate relationships were pivotal to their reflections: green landscapes, photographs, memorabilia, and the houses that remind them of loved relatives, the university where they meet friends, plants and pets they care for. Archambault (2016, 250) proposes an 'anthropology of affective encounters' that considers the entanglement of humans and non-humans, thereby enhancing the affect generated by these encounters. This inspiring

perspective is extended here to recognise the heritage of these affective encounters. The 'pandemic sociability' (Toledo and Souza Jr, 2020, 58, transl. mine) and its sanitising rules has prevented us from experiencing closeness and human touch. This has created a void left by the physical and emotional absence of hugs (Amanda Almeida, assignment October 2020). Whereas the lack of social interaction has had such a profound and unprecedented impact on our humanity, it is conceivable that a hug might become a kind of heritage from this precarious time.

Monday night, 7:30 p.m.: I shut my notebooks, stack the books, organise the desktop, turned off the camera, the microphone, and the computer after participating in many online and emotionally draining meetings, and I seriously wonder when I will close my home classroom and hug my students.

Acknowledgements

Class 2018 for standing strong during the pandemic, for sharing their sensitive experiences with me, and for kindly allowing the use of their assignments.

Notes

1 Synchronous classes, asynchronous classes or both, activities on Facebook, lectures, roundtables, group seminars, individual assignments, materials such as articles, videos, games, office hours on different web conferencing softwares, especially the instant messaging platform WhatsApp (a very popular app in Brazil).
2 bell hooks claimed that the most important was the 'substance of books, not who I am' (Williams 2006, 1), therefore, she did not capitalise her name. To respect her choice, I have kept her name in lowercase letters.
3 The 2030 Agenda for Sustainable Development's pledge in favour of the eradication of poverty and the reduction of inequalities (UNPD 2018).
4 The new definition of the museum was debated by interdisciplinary groups around the world, and it will be voted on at the 26th ICOM General Conference in 2022 (https://icom.museum/en/our-actions/events/general-conference/).

References

Akotirene, Carla. 2019. *Interseccionalidade*. São Paulo: Sueli Carneiro: Polén (Coleção Feminismos Plurais).

Archambault, Julie S. 2016. "Taking Love Seriously in Human-Plant Relations in Mozambique: Toward an Anthropology of Affective Encounters." *Cultural Anthropology* 31(2): 244–271. 10.14506/ca31.2.05 https://journal.culanth.org/index.php/ca/article/view/ca31.2.05

Betancourt, Carla J., Mytle Shock, Bruno P. Maximo, Igor Rodrigues, Silvana Zuse, Mau Silva, Thiago Kater, et al. 2021. "Curso Livre de Arqueologia Amazônica." [Paper Presented at the XXI Congresso da Sociedade de Arqueologia Brasileira, SAB, Diamantina, MG, November 8, 2021].

Bezerra, Marcia. 2015. "At that Edge: Archaeology, Heritage Education, and Human Rights in the Brazilian Amazon." *International Journal of Historical Archaeology* 19 (4): 822–831. http://www.jstor.org/stable/24572819

Bezerra, Marcia. 2020. "For a Solidary and Activist [Public] Archaeology in the Amazon." *AP – Online Journal of Public Archaeology* 10: 59–64. 10.23914/ap.v10i0.295

Brandão, Carlos R. 2006. "Educação Humanista." Interview by Rafael Evangelista. *Patrimônio – Revista Eletrônica do Iphan*, 3 (Jan/Feb), 2006.

Cabral, Mariana, and Marcia Bezerra. 2022. "Covid, Afetos e a Sala de Aula Digital." *Revista de Arqueologia*, 35 (1): 139–156. 10.24885/sab.v35i1.964

CETIC, NIC, and CGI – Centro Regional de Estudos para o Desenvolvimento da Sociedade e da Informação, Núcleo de Informação e Coordenação do Ponto BR, and Comitê Gestor da Internet no Brasil. 2019. *Resumo Executivo: Pesquisa TIC Domicílios.* https://cetic.br/media/docs/publicacoes/2/20201123115919/resumo_executivo_tic_dom_2019.pdf

CETIC, NIC, and CGI – Centro Regional de Estudos para o Desenvolvimento da Sociedade e da Informação, Núcleo de Informação e Coordenação do Ponto BR, and Comitê Gestor da Internet no Brasil. 2020. *Painel TIC COVID-19: Pesquisa sobre o uso da internet no Brasil durante a pandemia do novo Coronavirus, 3 ed, Ensino Remoto e Teletrabalho.* https://cetic.br/media/docs/publicacoes/2/20201104182616/painel_tic_covid19_3edicao_livro%20eletr%C3%B4nico.pdf

Crenshaw, Kimberle. 1989. "Demarginalizing the Intersection of Race and Sex: A Black Feminist Critique of Antidiscrimination Doctrine, Feminist Theory and Antiracist Politics." *University of Chicago Legal Forum*, 1989, 1. http://chicagounbound.uchicago.edu/uclf/vol1989/iss1/8.

Cruz, Leandro R. 2020. "Educação Vigiada: O Avanço do Capitalismo de Vigilância sobre A Educação Pública Brasileira." *YouTube Channel*, 1 (36): 50, Mirante das FACS-UFPA, https://www.youtube.com/watch?v=yd8yzisrCh8, June 18, 2020.

DaMatta, Roberto. 1997. *A Casa & A Rua: Espaço, Cidadania, Mulher e Morte no Brasil.* Rio de Janeiro: Rocco.

Faria, Louise S.P. 2020. "Doing Research in a Pandemic: Shared Experiences from the Fieldwork". *Halo Ethnographic Bureau* (May 6). https://medium.com/halobureau/doing-research-in-a-pandemic-shared-experiences-from-the-fieldwork-fa1a00fc86fc

Fernandes, Gabriel de A., João L. Demarchi, and Simone Scifoni. 2019. "Apresentação: Dossiê Educação Patrimonial." *Revista CPC* 14 (27esp): 7–13. 10.11606/issn.1980-4466.v14i27espp7-13

Figueiredo, Silvio L., Mierleide C. Bahia, Patricia T.M. Cabral, Wilker R. de M. Nóbrega, and Auda E.P. Tavares. 2013. "Lazer, Esporte e Turismo: Importância e Uso das Áreas Verdes Urbanas em Belém/Brasil". *Licere* (Centro de Estudos de Lazer e Recreação. Online) 16: 30–45.

FIOCRUZ – Fundação Oswaldo Cruz 2022. "MonitoraCovid-19". https://bigdata-covid19.icict.fiocruz.br/ (accessed March 7, 2022).

Freire, Paulo. 2005. *Pedagogy of the Oppressed.* 30th anniversary ed. Translated by Myriam B. Ramos. London: The Continuum International Publishing Group Ltd.

Gomes, Nadirlene Pereira, Milca R. da S. Carvalho, Andrey F. da Silva, Carina E. Moita, Jemima R.L. Santos, Telmara M. Couto, Laís C. de Carvalho, and Lílian C.G. de Almeida. 2021. "Saúde Mental de Docentes Universitários em Tempos de Covid-19." *Saúde e Sociedade* 30 (2). 10.1590/S0104-12902021200605

Holtorf, Cornelius. 2020. "Post-Corona Archaeology: Creating a New Normal?." [keynote lecture at the 26th Virtual Annual Meeting of the European Association of Archaeologists (EAA) August 25, 2020]. https://www.e-a-a.org/EAA/Publications/Tea/Tea_66/Keynote/EAA/Navigation_Publications/Tea_66_content/Keynote.aspx

hooks, bell. 1994. *Teaching to Transgress: Education as the Practice of Freedom.* New York: Routledge.

IBGE – Instituto Brasileiro de Geografia e Estatística. 2021. *Cidades.* https://cidades.ibge.gov.br/brasil/pa/belem/panorama. (accessed December 7, 2021).

ICOM – International Council of Museums. 2020. *Museum Definition.* https://icom.museum/en/resources/standards-guidelines/museum-definition. (accessed January 10, 2021).

Li, Dogying and William C. Sullivan. 2016. "Impact of Views to School Landscapes on Recovery from Stress and Mental Fatigue." *Landscape and Urban Planning* 148: 149–158. 10.1016/j.landurbplan.2015.12.015

Lima Filho, Manuel F. 2019. "Patrimonial Citizenship." *Vibrant: Virtual Brazilian Anthropology*, 16. 10.1590/1809-43412019v16a350

Loose, Tianna, Marc Wittmann, and Alejandro Vásques-Echeverría. 2021. "Disrupting Times in the Wake of the Pandemic: Dispositional Time attitudes, Time Perception and Temporal Focus." *Time & Society* (June 2021). 10.1177/0961463X211027420

Lopes, Pedro. 2021. *Janelas Poéticas.* Author's Edition: Rio de Janeiro.

Martín, Rebeca I. 2020. "The Balcony: Normativity Lessons in Times of Crisis." *Somatosphere*, 9 (April). http://somatosphere.net/2020/the-balcony-normativity-lessons-in-times-of-crisis.html/

McCunn, Lindsay J. 2020. "The Importance of Nature City Living during the COVID-19 Pandemic: Considerations and Goals from Environmental Psychology." *Cities & Health*, 1–4. 10.1080/23748834.2020.1795385.

MEC – Ministério da Educação. 2020. Portarias MEC nº 343, de 17 de Março de 2020, nº 345, de 19 de Março de 2020, nº 473, de 12 de Maio de 2020, MEC nº 544, de 16 de Junho de 2020, MEC nº 1030, de 01 de Dezembro de 2020, and Portaria MEC nº 1038, de 07 de Dezembro de 2020. https://www.gov.br/mec/pt-br/acesso-a-informacao/institucional/secretarias/secretaria-de-regulacao-e-supervisao-da-educacao-superior/portarias. (accessed March 8, 2020)

Medeiros, Luciene M., Benedito P. Ferreira, Gilberto de S. Marques, and Edivania S. Alves. 2021. *Ensino Remoto Emergencial na Percepção de Docentes da UFPA.* Belém: ADUFPA.

Miller, Daniel. 2010. *Stuff.* Cambridge: Polity Press.

Museu Goeldi. 2020. "Política de Acervo da Coleção Arqueológica e o Projeto Replicando o Passado. Campanha: IV Fórum Acervos Arqueológicos nas Redes- MPEG". *Facebook video, 5:26, Fórum de Acervos Arqueológicos,* https://www.facebook.com/forumacervosarqueologicos/videos/campanha-iv-f%C3%B3rum-acervos-arqueol%C3%B3gicos-nas-redes-mpeg/325003141828215/, June 23, 2020.

Rathmann, Joachim. 2021. *Therapeutic Landscapes – An Interdisciplinary Perspective on Landscape and Health.* Springer.

Rocha, Bruna, and Rosamaria Loures. 2020. "A Expropriação Territorial e o Covid-19 no Alto Tapajós, PA". In *Pandemia e território*, edited byAlfredo W.B. de Almeida, Rosa E.A. Marin, and Eriki E. Aleixo, 337–367. São Luis: UEMA Edições PNCSA.

Segata, Jean. 2020. "A Colonização Digital do Isolamento." *Cadernos de Campo* 29 (1): 163–171. 10.11606/issn.2316-9133

Spolar, Christine. 2020. "When the World Reopens, Will Art Museums Still Be There? Travel I – Coronavirus Coverage." *National Geographic*, December 30, 2020. https://www.nationalgeographic.com/travel/article/how-museums-are-staying-alive-during-coronvirus

Thomas, Keith. 1983. *Man and the Natural World: Changing Attitudes in England 1500-1800.* London: Penguin Books.

Toledo, Luiz H. de, Roberto de A. P. Souza Junior 2020. "Sociabilidade Pandêmica? O que uma Antropologia Urbana Pode Dizer a Respeito da Crise Deflagrada pela COVID-19". *Cadernos de Campo*, 29 (supl): 53–56. 10.11606/issn.2316-9133.v29isuplp53-64

UFAM – Universidade Federal do Amazonas. 2020. "Curso Livre de Arqueologia Amazônica – UFAM", Youtube Channel, Laboratório de Arqueologia da UFAM.

UFPA – Universidade Federal do Pará. 2020. "Resolução N. 5.294, de 21 de agosto de 2020". https://sege.ufpa.brboletim_interno/downloads/resolucoes/consepe/2020/Resolucao_5294_2020_CONSEPE.pdf

UN – United Nations. 2021. Policy Brief: COVID-19 and the Need for Action on Mental Health 13 MAY 2020. https://unsdg.un.org/sites/default/files/2020-05/UN-Policy-Brief-COVID-19-and-mental-health.pdf

UNESCO – United Nations Educational, Scientific and Cultural Organization. 2020a. *Museums around the World in the Face of Covid-19*. UNESCO Report, May 2020. https://unesdoc.unesco.org/ark:/48223/pf0000373530

UNESCO – United Nations Educational, Scientific and Cultural Organization. 2020b. *Covid-19 Response – Remote Learning Strategy – Remote Learning Strategy as a Key Element in Ensuring Continued Learning*, July 2020. https://en.unesco.org/sites/default/files/unesco-covid-19-response-toolkit-remote-learning-strategy.pdf

UNPD – United Nations Development Programme. 2018. *What Does It Mean to Leave No One Behind? A UNPD Discussion Paper and Framework for Implementation*. https://www.undp.org/publications/what-does-it-mean-leave-no-one-behind#modal-publication-download

WHO – World Health Organization. 2020. WHO Director-General's statement on IHR Emergency Committee on Novel Coronavirus (2019-nCoV). January 2020. https://www.who.int/director-general/speeches/detail/who-director-general-s-statement-on-ihr-emergency-committee-on-novel-coronavirus-(2019-ncov)

Williams, Heather. 2006. "bell hooks speaks up". *The Sandspur* 112 (17): 1–2. https://stars.library.ucf.edu/cfm-sandspur/2685/

Wilson, Edward O. 1984. *Biophilia: The Human Bond with Other Species*. Harvard University Press.

Wood, Andrew F. 2020. "Haunting Ruins in a Western Ghost Town: Authentic Violence and Recursive Gaze at Bodie, California." *Western Journal of Communication* 84 (4): 439–456. 10.1080/10570314.2020.1721556

Assignments cited in the text

Amanda Saraiva de Almeida, Ana Cecília da Cunha Santos, Ana Cristina Silva Souza, Ana Larissa Brito de Andrade, Carolina Barros de Paula, Clara Affonso Mártires, Dâmaris Pereira Nogueira, Elber Arthur Costa Menezes, J.S., M. dos S. M., Pollyanna Naomi Kato Figueira, Renan Dantas Lorenzo, and Ruth Macedo Cardoso.

2

COVID HERITAGE IMPERATIVES AS NEW PHARMACOLOGIES OF CARE

Revelations of 'Heritage Beyond Power' and 'What Makes Life Worth Living'

Beverley Butler

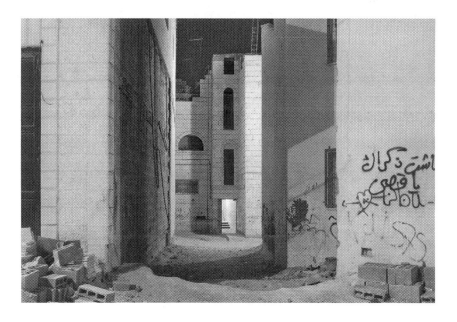

FIGURE 2.1 'Stateless Heritage' exhibition, DAAR–Sandi Hilal and Alessandro Petti–photographic dossier by Luca Capuano.

DOI: 10.4324/9781003188438-4

Introduction: Covid Heritage Imperatives as Overturning

The pandemic has been, and, for many, continues to be, a profound experience of the overturning of worlds. Writ large, there has been an overturning of prescribed and prescriptive pre-pandemic norms that–while acknowledging the equally profound inequalities at play–has been experienced, again by many, as unexpected individual-collective experiences and confrontations with conditions of precarity and extremis on an unprecedented scale. Thus iterating that, 'As human beings we are fragile biological entities who will die unless we take care of each other' (Graeber quoted in Komlik 2020).

The journey-quest of this chapter is to grasp within these pandemic conditionalities the accompanying overturning of prescribed and prescriptive pre-pandemic heritage norms as the exposure of 'Covid heritage imperatives.' I argue that these are best understood as the revelation of 'new pharmacologies of care' that, in turn, reveal accompanying, mutually constitutive 'Covid heritage imperatives,' that I further couch as 'heritage beyond power' and 'what makes life worth living.'

My journey-quest adopts a dual framework, I place my own on-going, long-term work on 'heritage pharmacology' in critical conversation with a subversive intervention by DAAR (Decolonize Architecture Art Research) showcased at the Mosaic Rooms in London that took the form of an exhibition 'Stateless Heritage' (13/10/21–30/01/22). As the first exhibition I visited during what can tentatively be called the post-lockdown period, it had a particular impact. This exhibition and DAAR's wider interventionisms find points of synergy that take us further into the radical overturning of prescribed and prescriptive heritage norms. This is crystallised in DAAR's acknowledgement of 'Walter Mignolo [who] has suggested, that it is not enough to change the content of the conversation: we must change its terms' (Petti 2021, 30). More particularly, DAAR's core act of subversion and overturning is that of nominating a refugee camp as a UNESCO (United Nations Educational, Scientific and Cultural Organisation) World Heritage Site. This nomination took the form of two mutually constitutive interventions: the exhibition as an immersive visual-material manifestation of the process of nomination and DAAR's accompanying nomination 'book-dossier' as underpinning critical text (Hilal and Petti 2021).

The UK Guardian newspaper's review of the exhibition reiterates DAAR's act of overturning and problematisation of 'World Heritage' by reiterating the question of: 'Why is this "heritage of exile" not enough for UNESCO to grant it the status it gives Macchu Picchu and Venice?' (Wainwright 2021). Writ larger still, the underpinning quest of DAAR (whose name in Arabic also means home) is that of 'destabilizing dominant frameworks and categories,' while simultaneously 'reorient[ing] heritage towards nonhegemonic forms of collective memory.' Thus, by critically and creatively 'misusing and redirecting UNESCO World Heritage guidelines and criteria' and galvanising collective action DAAR's interventionism ultimately seeks to be 'mobilised as an agent for political transformation' (DAAR 2021).

In what follows, I pursue a dual framing. I explore how my work on 'heritage pharmacology' has been thrown into sharp relief by Covid-19, while subsequently offering a symptomatic reading of DAAR's interventionism. Moreover, I argue, a series of doublings emerge: in a Deleuzian sense (1998) just as Covid has seen the recasting of citizens as 'diagnosticians-symptomatologist' increasingly engaging with new regimes of care that have been, in turn, increasingly mobilised by and pressed into the service of the old hegemonic power blocks of the nation-state and UN agencies notably WHO (World Health Organisation); the DAAR exhibition and accompanying nomination 'book-dossier' (Hilal and Petti 2021), by way of contrast, powerfully recasts refugee-stateless-exiled, 'nonhegemonic' actors-actants as alternative 'diagnosticians-symptomatologists.'

In what follows, I 'read' DAAR's interventionism as it exerts its own efficacies capable of revealing a dominant heritage pharmacology of care that I couch as a specific 'UNESCO Syndrome' that, writ larger still, is a particularly florid manifestation of the embedded dysfunction and pathologised states that have been fixed/fixated upon and presented by power as normative, routinised, prescribed, and prescriptive heritage care regimes. This virulent UNESCO strain can be distilled and crystallised further as symptomatic of what DAAR (2021) refers to as the 'dominant western notion of heritage' that, post-second world war, has been projected and prescribed globally as master-narrative of care in collusion with UN agencies and associated NGOs. These 'actors' notably include not only UNESCO and WHO, but UN refugee agencies UNHCR (United Nations High Commissioner for Refugees) and UNRWA (United Nations Relief and Works Agency for Palestine Refugees), while this mutually constitutive hegemony is underpinned by nation-states. Crucially too, I argue that such pharmacological diagnostics and DAAR's interventions recast as 'symptomatologies' not only expose the 'failure' of such normative regimes of 'heritage care' but alternatively and/or simultaneously powerfully provide the basis for new pharmacologies of care that demand recognition within new heritage imperatives.

Imperative 1: New Heritage Pharmacologies of Care

To provide context here, my own work on heritage pharmacology sees me draw from critics—notably Derrida, Stiegler, Deleuze—who sought to open-up and critically overturn medical/clinical discourses (particularly, pharmacology and the psy-sciences)—in order to deploy these across alternative registers, that map metaphysical-philosophical-deconstructionist interventionisms, and collapse into, amongst others, cultural-social, artistic-creative, psycho-spiritual-political domains (Butler Forthcoming a/b). The objective of opening up medical/clinical discourses beyond their prescribed and prescriptive scientisms, authoritative hegemonic power-bases, and accompanying promises of fulfilment is thus undertaken in order to better understand 'heritage health,' well-being and care as it operates across diverse registers and as its diverse efficacies and meanings are grasped and manifested within the 'realpolitik.'

To date, my own lexicon of 'heritage pharmacology' has exposed and recast such hybrid tangible and intangible heritage forms and forces as: pharmakonic efficacies (thus following Derrida in drawing out the ambivalent qualities of the 'pharmakon' within ancient Greek etymology as alternatively and/or simultaneously '*poison-cure*'), as syndromes, symptomatologies, pathologies, complexes, redemptive formulas and as fevers, enchantments, magics, healing, and as heightened states of being (Butler 2011, 2016, 2018; 2019a/b, 2020a/b, 2021, 2022, forthcoming a/b; Butler and Al-Nammari 2016, 2018, Butler, Francis and Pavey 2021). I further argue that during the pandemic, such terminologies took on further salience and urgency, thus crystallising as the aforementioned 'new pharmacologies of care': these in turn amplify the imperative that novel situations require novel responses and the articulation of new 'truth value(s)'. These novel pharmacological situations, in turn, expose new synergies operating across conceptual-operational worlds and crucially again within the 'realpolitik.'

Here, for example, synergies emerged with what UK critics dubbed as '#CORONASPEAK' (Thorne, T 2020) synonymous with the deployment of new medical vocabularies into public spheres–notably social media–that are regarded as indicative of the 'viral' nature of widespread engagements and attempts to grapple with discourses of health care and protection. Indeed, the word 'efficacy,' its usage typically synonymous with medical pharmacology and the scientific testing and measurement of drug interactions and their effects, was centre-staged. By recasting 'efficacy' as a core element within novel pharmacologies of care, the pandemic transformed 'us all' into 'diagnosticians-symptomatologists' (cf. Deleuzian logics (1998)) of sorts, whether in attempts to grasp the signs/symptoms of Covid-19 and the efficacies of various PPE (personal protective equipment) and vaccines that emerged, and/or in how to gain equal access to, or in some cases reject, these. As critics argue, at its best the efficacies of '#CORONASPEAK' enabled a crucial mastery of 'unknown experiences,' a means to 'build coping strategies,' and foster resilience while also taking on the capacity to act back on power as official state-discourse by means of popular subversions, overturnings, and additions that took on imagination, creativity, and humour (Thorne 2020).

The pharmakonic underside, however, saw '#CORONASPEAK' reach levels of overdetermination and saturation points. It was in this context that the World Health Organisation (WHO), and nation-states that constitute the UN in mutually enabling hegemonic relationships of power and influence, quickly emerged centre-stage to consolidate their position, as sovereign 'masters of the pharmakon' (cf Derrida 2004) within the pandemic as moment of 'crisis.' As these pharmakonic efficacies took hold, so did recourse to war imagery/metaphors (Bernhard 2020). Far too easily, such 'Covid Wars' were nationalised too, not only was access to care in the form of vaccinations and hospital treatment largely authorised by nation-states, but in the UK, for example, heritages synonymous with 'Blitz spirit' and 'Brexit spirit' were mined as a resource within which to embed citizens. As such, 'Covid spirit' went viral within the media (Pinkus and Ramaswamy 2020).

My own interest in context is in how Covid-19 and its languages were accompanied by care in the form of new ritual behaviours: the efficacies of the latter, whether hand-washing, mask-wearing or lock-down were a matter of life or death. Writ large, beyond the exclusively medical, one can recast the pandemic as an alternative non-medicalised 'Covid syndrome' revolving around access to care. 'Syndromes' as conditionalities based on 'gaps' between 'imagined worlds' and the 'real,' emerged as the pandemic profoundly overturned any 'idealised' image of 'ourselves' within secure worlds of care and protection (see Butler 2019a). This particular bubble was burst by new realities of precarity that thus exposed the heightened sense of the essential need for care, without which, to reiterate David Graeber's words, human beings are exposed as 'fragile biological entities' existing within, we can add, equally fragile macro-micro ecologies and non/extra-human life-ways. Care, thus emerges as the promise of protection from extremis, and as synonymous with the 'clothing of bare-life' (Butler and Al-Nammari 2016) and ultimately confrontation with mortality that is realised through mutualities of action.

Indeed the behaviours, most visibly those accompanying '#CORONASPEAK,' can be seen as active and oft-creative ritual attempts to bridge 'gaps' between 'imagined' and 'real' worlds and assert sovereignty as these overturn and collapse. As profound episodes of 'breakdown'–'depersonalisation' and 'derealisation'–the pandemic also triggered both 'catastrophic thinking' and 'magical thinking.' The latter, seeking to expose 'truth values' about pre-pandemic and pandemic worlds that could be acted on in the promise of better futures (Barker 2022, Georgieva 2020) and as a realignment to that which within Stiegler's iteration of critical philosophical pharmacology is inextricably bound up in the quest for and promise of 'what makes life worth living' (2013). A key point here being, that from the more immanent ritual behaviours of hand washing and mask-wearing the pandemic prompted extended and extensive 'cosmologies and constellations of care and protection' that engaged with the 'otherwise' and 'elsewhere' (cf. Butler forthcoming b) and revealed the transcendent efficacies of heritage as moving force of overturning that resist power.

Stateless Heritage: *Not* 'In It Together'

It is here too that in DAAR's *'Stateless Heritage'* exhibition this moving force of heritage as extended and extensive 'pharmacologies of care' and as the dynamic overturning of prescribed and prescriptive heritage norms is manifest. Visiting in the 'post-lockdown' period, its efficacies took on a particular import. Moreover, amid concerns over new Covid variants, notably that of Omicron, that took on unprecedentedly high rates of infection, the realities of Covid 'health' inequalities and 'differential vulnerabilities' operating within UK, and globally, the UK government's mantra of us being *'In It Together'* was itself overturned as were other 'lies of solidarity' (Whitehead 2020, Nolan 2021). This exhibition similarly powerfully fore-fronted inequalities and the 'elsewhere' and 'otherwise' in terms of centre-staging communities and constituencies 'outside'/'beyond' the refuge of the

nation-state for whom extremis and precarity is not a new but a long-standing, on-going conditionality. Within 'heritage pharmacology' these 'stateless' forms and forces are those typically fixed by power-led 'masters of the pharmakon' as 'scape-goats' or pharmakos (cf. Derrida 2004). The exhibition, in turn, provoked synergies with my own joint-fieldwork in Palestinian refugee camps (Butler and Al-Nammari 2016, Chatterjee et al. 2020) and my own concern with the latter actors-actants as 'diagnosticians-symptomatologists' exposing subversive pharmacologies of care synonymous with 'heritage beyond power.' A Covid heritage care imperative that is explored in more depth later in this chapter.

In order to explore the implications of DAAR's acts of inversion and overturning for critical heritage, I want to briefly flesh out how 'heritage pharmacology' as overarching framework is uniquely placed to grasp diverse manifestations of care. Indeed, building on Derrida's work Stiegler's (2013) recasting of 'pharmacology' as an alternative model of dynamic psycho-cultural-political interactions and efficacies is crucial in crystallising the foundational role that pharmacology has in terms of instituting care. As he has it:

> The question of the *pharmakon*, first arose in contemporary philosophy with Jacques Derrida's commentary on the Phaedrus in *'Plato's Pharmacy'* ... The *pharmakon* is at once what *enables* care to be taken and of *which* care must be taken ... a pharmacology – that is the discourse on the pharmakon understood *in the same gesture* in its curative and toxic dimensions.
>
> (Stiegler 2013, 2–4)

By positioning the 'pharmakon' as precisely that which is 'at once what enables care to be taken and of which care must be taken,' Stiegler subsequently argues that, 'pharmacology' in this sense is a concern with responding to experiences and feelings of loss. Ultimately, loss is that which establishes mutually constituted modes of care and protection. These manifest as diverse expressions of spirit, creativity, and diverse modalities of resilience that are inextricably linked to 'object-work.' Crucially, loss is a–or perhaps *the*–core dynamic that marks both heritage dis-courses and 'stateless heritage' tropes. For the latter, loss is a condition of enforced displacement and/or encampment that originates from and is exacerbated by power. For the former, notably within the UNESCO/nation-state frameworks, the redemption of loss underpins its promises of fulfilment and legitimates and legit-imises its own power and sovereignty over care and protection.

Heritage Care and/as Object-Work

Drawing further on the efficacies of Stiegler's thesis, and his own commitment to overturning power, I argue that the pursuit of the quest/ion of how 'heritage pharmacology' can be best grasped is as a highly potent psychodynamic field of 'object relations.' In an alignment with Winnicott's work, Stiegler (2013, 4) argues that

encounters with the 'pharmakon' and 'pharmakonic object(s),' are the lynch pin of object-relations and of transitional, psychic, developmental pathways. As engagements and responses to 'loss,' the 'pharmakon' introduces 'us/the psyche/mental life' to social worlds and invests us in them. In the wider sense, it inculcates in us the pharmakonic efficacies of 'cultural things' and creative acts synonymous with heritage and/as 'memory-work.' Care is thus the bulwark around which loss, recovery, memory-work, psychic-bodily health, identity, relationships and creativity, and spirit are simultaneously forged and embedded within dynamic 'pharmakonic milieu' and in tropes of care that manifest as particularly potent strains of 'arche-pharmacologies' (Stiegler 2013) (see also Butler forthcoming a).

In recasting heritage care as a field of complex pharmakonic 'moving objects,' one would wish that 'we' 'all' could have at our disposal the 'nonhegemonic' combined efficacies of the imaginative-practical 'object-work'/'object-relations' outlined by Stiegler, that crystallise as powerful ritual acts/actions of attachment, detachment and praxis. Within its own imaginative-operational fields UNESCO has established its own 'arche-pharmacologies': its notable manifestation being that of prescribing and fixing the prescription of World Heritage Status and World Heritage Listing. By means of such scripting: lists, inventories, and conventions in collaboration with its related NGOs and associated agencies such as ICOM, ICOMOS, ICROM; UNESCO establishes sovereignty via the ritual-bureaucratic transformation of certain entities into iconic heritage objects thus bestowing them the aura of World Heritage status.

By these means too, UNESCO, its agencies, and nation-state membership renew their own sovereign status as 'masters of the pharmakon' and their own efficacies vis-à-vis the power to inscribe such 'objects' on the global stage thus interpolating themselves and 'self-group(s)' into the world map of sovereign 'object relations.' As such within this grand narrative ritual 'sacred drama,' scripted and made operational at political-diplomatic level, UNESCO, its agencies, and its constitutive nation-states, exhibit their own sovereignty and power–their 'sacred duty' over a profoundly iconic mode of 'object-work'/'object-relations' that is purposefully and symbolically inscribed and played out on the 'World Stage' (see Butler 2007; 2011).

By way of contrast, DAAR's interventionism imaginatively, and equally symbolically, overturns this sovereign drama in an alternative scenario in which 'stateless' actors–as recast, and resistant 'pharmakos'–take on agency by means of their nomination of an (alleged) 'non-place' of the refugee camp as World Heritage Site while simultaneously placing this process of nomination and accompanying UNESCO heritage logics on public exhibition.[1] This alternative strategy thus makes explicit and gives recognition to the efficacies and centrality of diverse forms and forces of 'object-work/relations' operative not only within UNESCO but within all heritage care repertoires–including 'stateless heritage' and other conditionalities 'beyond power'–as a means to bring 'healthy' change and transformation to 'pluriversal' worldings. As such, DAAR requires 'us' to give recognition to alternative 'nonhegemonic memory,' that I argue, to be the distillation and

crystallisation of 'heritage pharmacologies' that are symptomatic of the ways in which the majority of 'object-work' and 'object-relations' is engaged with globally, notably at popular level and in ritual behaviours that embrace both everyday life and extremis. These are, however, largely dismissed by existing dominant prescribed and prescriptive heritage agencies.

'Object-work' in this sense thus has the capacity to open up the efficacies of communion to alternative diverse cosmologies of care, whether recast as spiritual/ ontological, existential/esoteric, magical/political constellations, and/or engagements with and recognition of counter-cultural 'relationalities' etc. Crucially too, heritage as 'moving object-relations', recalls Derrida's point that the vital state of the pharmakon is that of liquidity and/of movement. It also recognises the potency of heritage to 'move us' and 'move with us' in often unexpected and creative ways, notably exposing efficacious 'heritages of exile.' Crucially too, such pharmacologies of care resist being pressed into the exclusive service of power: including that of UN/UNESCO, WHO, UN humanitarian agencies (UNHCR/UNRWA), and nation-states as authorised heritage discourse and sovereign care-givers. However, the pharmakonic underside here is manifest in how the realities of experiences of enforced displacement and encampment too often block, obstruct and/or traumatically break with, and thus banalise, the efficacies of such alternative object-work/relations. Here, then emerges not only the need to acknowledge more fully the pharmakonic ambivalences of heritage but to act on these to form new relationalities with 'stateless' heritage care forms and forces.

Here too, it is worth reiterating yet again Deleuze's (1998) recasting of 'artists' (captured within a wide brief of creativity) as 'astonishing diagnosticians and symptomatologists'. The DAAR collective of 'diagnosticistians-symptomatologists' drawing upon and constitutive of the lived experiences of heritage in camps, establish a paradoxical positionality in which the pharmakonic efficacies of 'stateless heritage' are both situated and are able to act back. Thus, while this chapter adopts, adapts, and reiterates Stiegler's view that 'heritage pharmacology' is not only a philosophic-academic concern but 'obsesses each and every one of us' (Stiegler 2013, 4) within a pluriverse of realities and imaginative trajectories, I reiterate the imperative of alignment with, and the need to grasp the specific conditionalities of, 'heritage beyond power.'

Imperative 2: Heritage Beyond Power

> At the outset, our motivation to nominate Dheisheh Refugee Camp as a World Heritage site was mainly one of provocation, but the nomination became an arena wherein dominant notions of refugee camps, refugeeness, and heritage were able to be radically challenged ….
>
> (Petti 2021, 29)

In order to grasp more fully, 'heritage beyond power' as the second 'Covid heritage imperative,' exposed in pandemic acts of overturning, I explore in more depth the

implications of DAAR's powerful 'provocation' through the lenses of the immersive exhibition and 'book-dossier.' Both act as 'sites' of subversion and arenas of radical challenge, change, and transformation. Reiterating DAAR's own efficacies in exposing how the 'heritage of exile' can 'take us *beyond* the limitations of the nation state,' (DAAR 2021 my emphasis) and simultaneously, we can add, 'beyond' UN and thus normative regimes of care: I see my own 'provocation' to grasp 'heritage beyond power', as itself possessed and constituted by pluriversal-nonhegemonic pharmakonic efficiacies that exists in nonsovereign mutualities as another powerful dualism. Thus, 'heritage beyond power' is that which is being excluded from sovereign hegemonic power, in the sense of being 'beyond'/'outside' sovereign power networks, and is simultaneously revealed and apprehended as complex heritage conditionalities that resist power. In this sense, they are 'beyond' the grasp of power.

DAAR's 'provocation,' as a self-identified exercise in 'serious-play' and in 'misusing and redirecting UNESCO World Heritage guidelines and criteria,' (DAAR 2021) is, therefore, ultimately an alignment with the 'condition of the refugee' and 'lived experience' of 'heritage of exile' that in turn crystallises-distils 'heritage beyond power,' as that which evokes and exerts its own multiple efficacies. As previously stated, such forms and forces of heritage care hold the capacity to further expose 'UNESCO syndrome' as symptomatic of the unhealthy, if not poisonous, pathological tropes manifest within the hegemonic triad of UN/UNESCO/its 'humanitarian' care regimes and of the nation-state. These can be 'read' as dysfunctional, mutually harmful fantasies exposed as attempts by power to possess the 'other' and subject it to oppressive inequalities. These in turn need to be set alongside the transformative efficacies activated by DAAR's question of: 'how should the concept of heritage change in order to acknowledge the camp's condition?' (Petti 2021, 29). Itself a powerful act of overturning.

Exhibiting Stateless Heritage

The immersive exhibition as a potent public site of representation powerfully gives form and force to both imminent 'lived experiences' of the camp and more extended, transcendent 'constellations and cosmologies of heritage care' that ultimately reflect the trope of refugee wish-fulfilment and the as yet unfulfilled political promises vis-à-vis the 'right of return' and accompanying grounded directionalities by following the structure of a highly symbolic 'Journey of Return.' This journey is projected into three sections. The first gallery, located on the ground floor of the Mosaic Rooms, initiates this movement by means of a 'large light box installation of photographs of the camp' that evocatively and imaginatively situate the visitor within the living contemporary 'stateless' space of Dheisheh. Interestingly, DAAR purposefully commissioned Luca Capuano, who 'previously photographed Italy's World Heritage Sites for UNESCO' to undertake this task in a gesture that saw him, 'take the *same care* to document Dheisheh, as a living monument of 'permanent temporariness'" (DAAR 2021, my emphasis). A highly visual statement that care matters.

The second gallery, emotively situated below the first, and thus requiring the visitor to descend downstairs in the Mosaic Rooms depicts: 'the villages that the refugees of Dheisheh were forced from' as 'represented through a series of photo-books.' Potently and poignantly too, an elegiac memorial, in the form of a recitation of names of the villages of origin can be heard. A ritual trigger too perhaps vis-à-vis renewed calls for grounded return. What might be seen as a form of Ur-heritage sees 'photo-books' purposefully 'displayed on plinths of varying heights, recalling a landscape or ruin' (DAAR 2021). Indeed, these '44 villages of origin'–powerfully made manifest in this form as underpinning heritages–simultaneously represent loss and wholeness (thus blurring boundaries, directionalities, and relationalities of past/ future/present, imagination/reality/future/promise). The exhibition as a visual-material manifestation and exposure of the key elements of DAAR's nomination process enables, 'Visitors reading these [photo-]books ... [to] see photographs and records' of these villages thus evoking images of these places 'before' and 'after.' The visitor is therefore encouraged to, 'find out what, if anything, remains' (DAAR 2021). The presence of the villages within the exhibition and 'book-dossier' thus acts as a powerful and subversive means to recognise, project, and essentialise them as part of DAAR's nomination of the camp for World Heritage status.

The final section 'The Living Room (Al-Madafeh)' provides a 'social gathering space' that 'in the spirit of Dheisheh refugee camp's culture' offers a place 'where people can socialise, read, relax and hopefully organise.' Here visitors can also read DAAR's 'book-dossier.' The exhibition in bringing Palestine, and more specifically Dheisheh to London, is achieved more fully as each Sunday 'camp resident Omar Hamidat "hosted the space"' and thus by 'welcoming visitors to the space' acts as conduit and portal between worlds (DAAR 2021).

Book-Dossier: Right to Nominate

Turning to the accompanying 'book-dossier,' (Hilal and Petti 2021) DAAR can similarly be seen to take the 'same care' given to other nominees in terms of their engagement with 'Annex 5': 'the official document template required by UNESCO in order to nominate a site to be listed as World Heritage' (Petti 2021, 31). Particular care is given to instrumentalising this template in a critical, subverted, transformed state. This provides the script in terms of the structure and content of the exhibition and 'book-dossier.' DAAR in the persona of 'diagnosticians-symptomatologists' thus recast Annex 5 as the portal to isolate the prescribed and prescriptive and related bureaucratic-persona of the UN/UNESCO; and entry into DAAR's own re-reading and re-writing–as the 'rejection' and 'refusal'–of such logics and scriptings.

As my own critical journey-quest into the powerful efficacies of pharmacologies of care synonymous with 'heritage beyond power' in what follows, I engage, more specifically still, in a close reading of the 'prelude' of DAAR's 'book-dossier.' The 'prelude' exerts particular efficacies when recast as 'symptomatology' as it is here that DAAR isolates the core 'pillars' upon which UNESCO/UN humanitarian care logics

and nation-state power grasp their 'sovereignty' over the pharmakon. These 'pillars' recast as 'symptoms' can again be 'read' in two contrasting ways. First, as symptom-atologies that isolate the constellation of symptoms synonymous with 'UN/UNESCO Syndrome' and wider still with 'Dominant or Normative Heritage' Syndrome. Secondly, these 'pillars' as viewed through the lens of 'stateless' heritage forms and forces demand to be 'read' as DAAR's calls for radical transformation–synonymous with 'freedom and liberation' (Petti 2021)–that, can only ultimately be achieved via radically recast 'object-work/relations,' detachments and care practices, if not the wholesale demolition of such pillars.

These nine 'pillars/symptoms' apprehended by DAAR in their 'dossier-book' 'prelude' are: Ruins, Heritage, Refugeeness, Recognition, Universalism, Authenticity, Tangible and Intangible Heritage, Trajectories, and finally Positions.

'Ruins'

The first 'pillar'/'symptom' that DAAR isolates and overturns, is that of 'ruins' (Petti 2021, 26). The immersive experience of the exhibition spaces is evoked as DAAR grasps the alternative pharmakonic efficacies of the refugee camp as 'ruins.' As DAAR has it: 'Refugee camps should not exist in the first place: they represent a crime and a political failure.' The camp as alternative 'ruins' is firstly exposed by DAAR as manifestation of a 'crime' perpetrated and perpetuated by sovereign care-givers and ultimately is read as a symptom of 'failure.' The paradoxes and realities of the 'refugee condition' thus powerfully subvert and overturn the logics and logistics of normative–prescribed and prescriptive–preservational paradigms of the kind that underpin nomination to UNESCO World Heritage Status (i.e. auratic monumental sites safeguarded for the future as archetypal World Memory): 'Camps are established with the intention of being demolished. They are meant to have no history and no future; they are meant to be forgotten' (Petti 2021, 26).

Writ larger still, DAAR reveals that the very same 'masters of the pharmakon' and 'failed' sovereign care-givers actively perpetuate this forgetting: 'the history of refugee camps is constantly being erased and dismissed by states, humanitarian organizations [and] international agencies.' Rejecting this ritual-bureaucratic cleansing of history that in turn fix and fixate on 'refugee camps' as manifestations and systems of 'suffering', 'humiliation,' and 'victimhood' and/or as 'non-places' bereft of heritage, DAAR reit-erates the doublings of heritages/origins that manifest in the camp and feature in the immersive exhibition, 'To inhabit a refugee camp means to inhabit the ruins of a destroyed city or village, to live in a space whose origin lies in forced displacement' (Petti 2021, 26). The excluded 'stateless heritage' actors-actants as 'scape-goat'/'pharmakos' thus implicitly and explicitly act back on the sovereign 'masters of the pharmakon,' exposing truth in terms of recasting the latter as poisonous, harmful agency.

Despite and/or because of this, and by inverting usual fixations with and hierarchies of power, DAAR argues that the camp, haunts the nation-state and their exclusionary regimes of care, notably, vis-à-vis the semblance of civility: 'For over a century, the

existence of camps has undermined the western notion of the city as a civic space in which the rights of citizens are inscribed and recognized.' As DAAR reiterate, 'At the same time, after so many decades, the enforced condition of permanent temporariness that characterises camps has led to the production of a range of social and political structures, which operate *beyond* the nation-state' (Petti 2021, 26 again my emphasis). Here, the Covid heritage imperative of 'heritage beyond power' can be crystallised further in alternative heritage pharmacologies of care that operate *beyond* the nation-state—and again we can add—*beyond* UN/UNESCO and other dominant heritage and care structures to take on further subversive efficacies. These culminate in the camp being further recast by DAAR as 'rich with lived experiences and stories, which are narrated through its urban fabric' (Petti 2021, 26) and as such emerges as site of alternative intense, intensive, extensive, and extended heritage-making.

Heritage

Writ larger still, DAAR moves on to powerfully position prescriptive and prescribed 'heritage' itself as a symptom of 'failure.' This 'failure' is identified in DAAR's exposure of the routinised patriarchal etymologies and normative definitions and discourses that 'roots heritage firmly in a European, nationalist, and materialist set of values that are in turn presented as universal,' notably with UNESCO's collusion (Petti 2021, 27). Yet, these structures and strictures are regarded by DAAR as symptomatic of the fundamental and foundational 'ineffectiveness' of these actors to apprehend the complex conditionalities of any heritage beyond their closed mindset. As such it is 'beyond' power to comprehend these. DAAR argues, 'at best' 'refugee heritage' gets placed in categories of 'difficult heritage,' 'dissonant heritage,' 'native heritage,' or simply completely dismissed as 'non-heritage' (Petti 2021, 27). This unhealthy and ineffective urge to fix and/fixate upon categories/categorisations by UNESCO/states-parties, despite important critical recastings by heritage critics, exposes further failure. By way of contrast, DAAR argues that their 'book-dossier' seeks to mobilize the notion of 'refugee heritage' in 'challenging hegemonic westernised discourses and categories in order to draw out possibilities to emancipate the notion of heritage itself' (Petti 2021, 27).

Indeed, this Benjamin-like imperative is manifest in the transformative efficacies of the structure of the 'book-dossier' itself: DAAR reiterates:

> This double task is approached on the one hand by destabilizing dominant frameworks and categories, and on the other by referring to a pluriversal approach to histories, incarnated in the bilingual nature of the book-dossier, whereby the English and Arabic sections are not translations but are rather designed to argue and flow quite differently, complementing rather than mirroring each other directly. Moreover, the book-dossier is produced in conversation with individuals and organizations in the camp and outside the

camp. Fragments of ongoing dialogues and the multiplicity of voices that have together produced this book-dossier are documented in the Appendices, which reveals the collective nature of this work.

(Petti 2021, 27)

Refugeeness

This subversive quality of 'beyondness' and the specific pharmakonic qualities of 'refugee heritage,' the 'refugee condition' and 'refugeeness' is manifest in this way. Not only do DAAR 'reject' and 'refuse' the 'exclusive association of refugeeness with victimhood' but recast categorisation again as acting back: 'A refugee is by definition a threat to the nation-state and the camp is the space that modern nation-states create in order to contain, manage, and deactivate the political fallout of a promise that in reality negates the notion of equality among all human beings' (Petti 2021, 29).

DAAR's 'book-dossier' draws on the work of Arendt and Agamben to recast 'refugeeness' as synonymous with 'the radical political figure of the present that destabilizes the nation-state world order as it is understood and practiced in Palestinian refugee camps' (Petti 2021, 29). They powerfully draw out how: 'the refugee in Dheisheh Refugee Camp is *laje*,' a word in Arabic for 'refugee' that describes not only the historical injustice committed against her but also her present status of waiting and the active political nature of her subjectivity, which refuses normalization and challenges the status quo. Being *laje* in Dheisheh is also to take pride in being a freedom fighter' (Petti 2021, 29).

Moving beyond normative characterisations of refugee camps as that of 'political voids that are created by nation-states in order to "manage" refugees' DAAR iterates that 'Dheisheh Refugee Camp' has 'been transformed by the refugees into an active political space that refuses normalization' thereby ultimately establishing its identity-persona as 'an urban centre where social and political structures are invented outside of the nation-state framework' (Petti 2021, 29). As such, 'refugeeness' located 'beyond power' thus effectively demolishes the UN/UNESCO 'pillar' that banalises and cleanses heritage care of its grounded political efficacies and agency.

Recognition

'Recognition' emerges as a fourth 'pillar' bound up in pharmakonic efficacies. DAAR are keen to highlight, acknowledge, and crucially to instrumentalise, the fact that their collective authorship and submission of the nomination 'book-dossier' creatively contravenes normative power relations – i.e. the fundamental 'right to nominate'. Thus themselves recognising that: 'This nomination-dossier cannot even exist in the framework of UNESCO, because only states are permitted to prepare the nomination' and by acknowledging that, they approached 'Annex 5', as 'new inhabitants entering an old colonial architecture' that 'should have been prepared and

commissioned by a state'. Here they reiterate Mignolo words 'it is not enough to change the content of the conversation: we must change its terms' (Petti 2021, 30).

Here too the participants in DAAR's nomination project, as a collective that includes, 'camp organizations and individuals, politicians, conservation experts, activists, governmental and non-governmental representatives, and residents of surrounding areas' ultimately express their 'ambivalent' attitude to nomination as recognition:

> [O]n the one hand, it was feared that the nomination would change the status quo and undermine legally recognized rights of return; on the other hand, it was understood that acknowledging refugee history as part of humanity's heritage would place the right of return back at the centre of political discussions.
>
> (Petti 2021, 30)

In many ways, this crystallises/distils how such UNESCO recognition of Palestinian refugees, in particular, threatens to force them into a situation within which they confront the ambivalent, unknown outcomes of preserving and/or moving beyond the existing 'status quo.' As such, pathologies of power are in operation as exclusion goes hand-in-hand with self-exclusion. Wider promises of fulfilment–especially that of heritage as the redemption of loss–is looked to, as a vision and grounded politics that reiterates the exhibition structure as a highly symbolic 'Journey of Return' while attachments are made manifest in DAAR's insistence that: 'Above all, we hope that the book-dossier will be used as a concrete instrument in the task of making the right of return a political practice in the present' (Petti 2021, 35).

Universalism

Approaching another key 'pillar' of UNESCO prescriptive heritage norms, DAAR takes on the pivotal symptom of 'universalism'. DAAR brings into sharp relief how the 'concept of universalism cannot be separated from its colonial and imperial ambitions and the homogenizing rationales of Eurocentric doctrines' (Petti 2021, 32). The UNESCO World Heritage Convention (WHC) being a symptom/manifestation and harmful afterlife of such ambitions: 'It is not a coincidence that the Convention, which overtly promotes a universal approach to heritage, emerged at the time when European countries were losing their colonial hold on vast territories across the world. The Convention aimed to perpetuate, quite simply, cultural domination through other means' (Petti 2021, 32).

In addition, DAAR effectively exposes the limits, and dysfunctional logics of the World Heritage List as pharmakonic object-work, object-attachments/detachments, and relations mapped out by sovereign power:

> The foundational principles for inscription on the World Heritage List contain a series of unavoidable paradoxes and contradictions–for instance, demanding that sites be at the same time "universal" and "unique," despite the fact that if they

are unique, they obviously cannot be universal; or stipulating that only nation-states can nominate a site, effectively embedding nominations in that state's national rhetoric, which is the opposite of universal.

(Petti 2021, 32)

Given UNESCO's power and reach, both historically and in the present moment, vis-à-vis the globalisation of 'Eurocentric doctrines,' this trope thus becomes a harmful self-fulfilling prophecy or 'echo chamber.' DAAR's subversive and symbolical response being: 'But which state is interested in recognizing refugee heritage, since states continue to negate refugee rights?' (Petti 2021, 32).

Authenticity

Another 'pillar' and/or emergent recurring symptom picked up by DAAR is that of 'authenticity.' DAAR rehearse how,

Authenticity is defined in UNESCO's guidelines by recourse to four criteria (materials, workmanship, design, and the setting of the property). It has been mainly understood in terms of the preservation of an alleged "original status," thereby invoking a purist origin based on authorship and calling for the preservation of the object in the "original style."

(Petti 2021, 33)

The harmful aspects of authenticity as 'the cage used to lock historical processes into definitional stasis' is drawn out, as too, are the 'similar cages' within which 'indigenous populations … have been compulsorily subjected to essentialist notions of indigeneity in order to erase the claims and rights that they might assert in relation to their land.' While acknowledging the 1994 Nara Conference as marking 'a point of rupture in the "material fetishist" understanding of heritage,' key questions still remain:

Since the camp is a self-organized built environment, how does the perpetual organic transformation performed by its inhabitants constitute a right that can be preserved through strategic recourse to the notion of authenticity? And how can the notion of perpetual transformation, and not the freezing of time, be used to redefine authenticity?

(Petti 2021, 33)

Tangible and Intangible Heritage

DAAR goes on to lament that, 'in spite' of UNESCO's various attempts to reinvent itself by means of the additions of new categories of heritage, profound and protracted inequalities persist within these. Here, the 'hierarchical dichotomy between tangible and intangible heritage' is highlighted as a symptom of the inability of UNESCO to

transform itself in order to reflect the global diversities of heritage when grasped as realities on the ground. Thus, 'Monuments continue to be things that exist in western countries, while intangible heritage–which is deemed "second-class" (folklore)–is recognized in the rest of the world.' Iterating the point that such a 'separation is completely artificial' especially given the argument that 'all forms of heritage are intangible since material heritage is a construction' (Petti 2021, 34).

While making a commitment to 'understanding refugee heritage as being both tangible and intangible' the collective effects of the repetition of such dysfunctional motifs/symptoms DAAR positions UNESCO/nation state sovereigns as enablers of mutually binding pathologies:

> The fact that World Heritage status is defined through a framework of universality, authenticity, and tangible and intangible heritage, beneath a veneer of depoliticised language, makes it very attractive to nation-states. Nationalist and political motivations can be easily white-washed … In reality, World Heritage listings are used to uphold a specific version of national memory, while disempowering and silencing the memories and heritages of minority groups.
>
> (Petti 2021, 34)

It is here DAAR declares the need to 'deactivate the claim of objectivity that is present in the concept of *heritage*' and to 'reorient heritage towards nonhegemonic forms of life and collective memory' beyond power (Petti 2021, 34).

Trajectories

The need to overturn and detach from unhealthy, harmful, and virulent heritage norms ultimately manifests in DAAR's claims that their 'book-dossier' should not be 'a definitive "document"' but rather be understood as 'the documentation of an ongoing process of transformation.' Adding that in contrast to normative ritual behaviours and protocols vis-à-vis the submission of WHS nominations, 'Instead of erasing the different phases of the process, we left intact texts and materials in order to preserve self-critical reflection on the project and to acknowledge its never-ending character' (Petti 2021, 35).

This, and other alternative trajectories taken by DAAR sees the 'book-dossier,' like the 'right of return' and heritage itself, being recast as a 'radical call for an extended freedom of movement.' Adding:

> If the "camp form," the most extreme border device ever created, was conceived to strip people of their political subjectivity and transform them into bare life, our task is to reunite biological life and political life not by calling for the cancelling of borders but rather by multiplying the forms of transgression and profanation performed in relation to these lines of separation.
>
> (Petti 2021, 35)

Opening up the trajectory, DAAR clarifies: 'This nomination dossier focuses on Dheisheh, but we hope that this approach and spirit could be extended to other refugee camps and expanded to include other forms of minority and subjugated heritage' (Petti 2021, 35).

Positions

At the end of the 'Prelude'/'symptomatology' Alessandro Petti, co-founder of DAAR, fuses collective-individual personas and positionalities in a vignette that again further distils the efficacies of 'heritage beyond power.' He begins by discussing the documentary, 'Seeking Locations in Palestine for the Film "The Gospel According to Matthew" (1965),' in which the Italian film director Pasolini 'discovers that Palestine is not the majestic biblical landscape that he had in mind.' Petti draws out how, 'Pasolini's documentary stumbles from stereotype to stereotype' (Petti 2021, 36). Interestingly, this reaction and response are synonymous with the phenomenon of 'Jerusalem Syndrome' (JS) the paradigm from which I first developed my work on 'heritage syndromes' (Butler 2016) and writ larger still 'heritage pharmacologies of care.' Ironically, as per JS, Pasolini's cure is to reject Palestine and move 'the location of his film to the Sassi of Matera in southern Italy' which with more irony still are 'ancient cave dwellings that a few decades later would be inscribed on the UNESCO World Heritage List' (Petti 2021, 36).

Petti subsequently crystallises how his own Italian heritage and positionality is bound up in a quite different experience: '[a] specific peripheral position within the hegemonic idea of Europe'. Adding that 'Thinking from the camp means thinking from the border–inhabiting at least two spaces at the same time, the inside and the outside, the normal and the abnormal. It means seeing more than one thing at the same time, recognizing separations, and witnessing the aberrations of nation-state' (Petti 2021, 36).

'Heritage Beyond Power'

Bringing together these different threads, I want to further crystallise/distil my own 'provocation' to grasp 'heritage beyond power'. Learning from and taking on the truth-values exposed by DAAR as alternative 'diagnostician-symptomatologists', I see 'heritage beyond power' writ larger still, as the embodiment of an ideal of freedom and liberation and/as care. Moreover, I see this as the pharmakonic effect of care synonymous with nonhegemonic forms and forces of action that promote the freedom of others as mutuality and thus as the shared pursuit of the benefits of care beyond power. Interestingly, the words for 'beyond' in Arabic, notably '*ma wara*' and '*fawq*' combine connotations of spiritual and metaphysical understandings of 'above' and/as 'beyond' with more grounded expressions of resistance (Al-Nammari 2022).

Conclusions: What Makes Life Worth Living

'We [DAAR] initiated Refugee Heritage before the advent of the so-called "refuge crisis," when millions of refugees fled the western-fuelled war in the Middle East, arriving in Europe. At the time of writing, in the middle of the COVID-19 pandemic, the issue of refugees seems to have faded from the public discussion' (DAAR 2021).

'We have on this land that which makes life worth living' (Darwish)[2]

In my conclusions, I want to reconnect my journey-quest to the wider question of how the pandemic and DAAR's interventionism as forms and forces of over-turning, have exposed the 'Covid heritage imperatives' isolated in this chapter. These are revealed as equally potent forms and forces of heritage care that exist and resist, within the condition of being 'beyond' power and 'beyond' prescribed and prescriptive norms. More cogently still, through actions taken as fusions and mutualities of individual-collective forms of heritage care, these alternative mani-festations transform heritage and its efficacies, into a means of 'making life worth living' within diverse yet distinctive pluriverses. A claim that is iterated by Stiegler's (2013) assertion that the 'question of pharmacology' is ultimately bound up in the quest for 'what makes life worth living': and echoed by Mahmoud Darwish–'stateless' Palestinian poet-laureate–in his famous refrain: 'We have on this land that which makes life worth living,' the latter being an ode to the particular efficacies of Palestine for its people and their heritage.

Endowing heritage with such possibilities is the aspiration of my recast of 'heritage pharmacologies of care' and of DAAR's interventionism. Thus, initiating the possi-bility of novel forms and forces of recognition for 'refugee heritage' from 'within' that embody the ideals of a 'refugeeness,' 'statelessness,' and 'freedom' that, in turn, are located 'beyond' the ability of sovereign power hegemonies to grasp. More specifi-cally, DAAR is committed to radically transformative efficacies of care that promise to move 'beyond'–liberate themselves/'us' from–present conditionalities and patho-logical states that fix and fixate on certain 'pillars' as dysfunctional behaviours/values/beliefs and morbid symptoms. Heritage as housed/'caged' within prescribed and prescriptive norms, is at present, far beyond such possibilities. Indeed, power is the ultimate pollutant that, since 1947, monopolised by state-power, heritage has been subordinated to the demands of the sovereign global entities discussed in this chapter.

Mobilised by power to explicitly justify their monopoly of control of coercion and violence–and perversely care–heritage emerged as an aspect of this in terms of conventions and protocols that define the value of boundaries and the legitimacy of cultural property and ownership. Whilst the modern state, and similarly the UN and its agencies, claim to be the encompassment and embodiment of care, they are quite obviously outside–'beyond' as in 'ineffective' and 'failed'–and as such irrelevant to most people's everyday concerns and needs. The encompassment and embodiment of care are clearly manifest most vibrantly within non-hegemonic

conditionalities. Yet, despite and/or because of this, hegemonic power-structures perpetrate and perpetuate vast inequalities in terms of those constituencies, notably 'stateless' entities, unable to gain access to conditions that make their lives worth living. Here synergies and new 'object-work/relations'–as attachments and detachments 'beyond' the norm–demand to be set in play vis-à-vis DAAR's commitment to, 'cultivate the ambition to work on subjects that we deem politically relevant, regardless of whether such subjects are part of mainstream public discussion or not' (Petti 2021, 39).

What is imperative, therefore, is to engage with heritage as a critical quest capable of rejecting any and all repetitions of 'crimes,' 'political failures,' and 'ineffective' and harmful categorical statements made by power–notably manifestations of fixities/fixations with 'what heritage is'–by instead focusing on 'what heritage does'–its transformative efficacies. The emergence and confrontation with 'Covid heritage imperatives' and DAAR's interventionism make it clear that we need to engage in further object-work/attachments and detachments and break-with the unhealthy poisonous pathological hold of certain moribund strains of sovereign 'heritage pharmacologies of care.'

Given that this chapter is written at a time in which 'new' normals are being established, we do not want the momentum to be lost in grasping 'new pharmacologies of care' synonymous with 'heritage beyond power.' Nor allow the experiences both of suffering and the overturning of worlds to be forgotten at a time when power-structures are active in both re-instating themselves through various acts of (so-called) normalisation and/or (for them advantageous) 'new normals.' DAAR, for example, argues that the Covid-19 pandemic has led to the 'issue of refugees' (who have also suffered disproportionately during the pandemic) fading from 'public discussion' despite now being even more necessary following the outbreak of war in Ukraine.

Crucially, I want to argue here that we need to learn from DAAR in terms of opposing such 'normalisation' as that which only further pathologises care within inequalities and unhealthy dependencies. DAAR iterates: 'There is a fundamental question that emerged from our projects in refugee camps: what are the techniques to oppose normalization? Refugees in Palestine have developed extraordinary ways to refuse normalization, to avoid being captured by the regime that wants to impose an unjust reality' (DAAR 2021). Indeed, 'beyond' this, perhaps the only moral-ethical point of departure for novel, radical recastings of heritage care is to argue the assertion that – '"we" don't know what heritage is.'

Only then can heritage quests reorientated towards shared mutualities in relationship to 'heritage beyond power' be grasped. These in turn demand 'new prescriptions'–as techniques and engagements with efficacious pluriverses–that oppose and refuse 'unjust realties' in order to fully detach from sovereign 'masters of the pharmakon' and thus displace UN/UNESCO/nation-state as failed protector-deities and purveyors of harmful master-narrative. Recalling Graeber's call to care, and Mignola's call to change, it is to move 'beyond' and to make new alliances with the

life-ways and care diversities of 'heritage beyond power' currently being obscured from 'our' vision. To go forward with a new spirit synonymous with creative alliances that promise not only to interpolate us in the quest/question of 'what makes life worth living' but is a trajectory that is about positioning oneself on the right side of history.

Acknowledgements

I wish to thank Siegrun Salmanian, Assistant Curator, at the Mosaic Rooms, London, and the DAAR collective for the round-breaking exhibition and also for giving their kind permission to use the image that accompanies this chapter. My thanks too to Dr Fatima Al-Nammari, Architecture Faculty, Petra University for her insights into Arabic terms for 'beyond'. Finally, I am grateful to Dr Nick Shepherd for his invaluable comments.

Notes

1 In a further overturning DAAR held a Common Assembly where participants expressed their reasons for or against endorsing the nomination of Dheisheh Refugee Camp and the 44 villages of origin as World Heritage Sites https://www.e-flux.com/announcements/393745/common-assembly-refugee-heritage-nomination/
2 https://asitoughttobe.wordpress.com/2010/08/24/on-this-earth-what-makes-life-worth-living-3/

References

Al-Nammari, F., 2022, Pers Comm. 10/04/2022.
Barker, P.C., 2022, We can't go back to normal: How will coronavirus change the world? https://www.theguardian.com/world/2020/mar/31/how-will-the-world-emerge-from-the-coronavirus-crisis (visited 20/04/2022).
Bernhard, A., 2020, Covid-19: What we can learn from wartime efforts, https://www.bbc.com/future/article/20200430-covid-19-what-we-can-learn-from-wartime-efforts BBC Global News (visited 19/04/2022).
Butler, B., 2007, *Return to Alexandria: An Ethnography of Cultural Heritage Revivalism and Museum Memory*. UCL Institute of Archaeology Publications. Left Coast Press. California, Walnut Creek.
Butler, B., 2011, Heritage as Pharmakon and the Muses as Deconstruction: Problematising Curative Museologies and Heritage Healing, in S. Dudley (ed), *Material Worlds*, pp. 354–471. Leicester. Leicester University Press. Ashgate Publishers.
Butler, B., 2016, The Efficacies of Heritage: Syndromes, Magics, and Possessional Acts, *Journal of Public Archaeology*, Volume 15, Issue 2–3: 113–135, Leeds: Manley Publishing.
Butler, B., 2019a, Rome Syndrome – Tourism, Heritage and Guidebooks at the Crossroads of the Real and the Idea. In Proceedings of the Topoi, Topographies and Travellers Conference, edited by Stefano Fogelberg Rota and Anna Blennow, 9–27. The Swedish Institute in Rome: Rome, Italy.
Butler, B., 2019b, Obligations towards 'Re-Housing' 'Memory-In-Exile' and 'Persons and Heritage-In-Extremis': From Archons to Besieged Subjects and Beyond, in Open Access Journal of Archaeology & Anthropology, Iris Publishers LLC.

Butler, B., 2020a, Jericho Syndromes: 'Digging Up Jericho' as Ritual Dramas of Possession, in R. Sparks, B. Finlayson, B. Wagemakers and J.M. Briffa (eds), *Digging Up Jericho - Past, Present and Future*. Oxford: Archeopress.

Butler, B., 2020b, Archives 'Act Back': Re-configuring Palestinian Archival Constellations and Visions of Social Justice, in D. Wallace, W. Duff, R. Saucier, and A. Flinn (eds), *Archives, Recordkeeping and Social Justice*. London: Routledge.

Butler, B., 2021, Encountering Virginia Woolf in Dashalar: Heritage Quests and Local Efficacies, in H. Evans and M. Rowlands (eds), Grassroots Values: Local Perspectives on Cultural Heritage in China, pp. 37–68. London: Lexicon Books.

Butler, B., Francis, D., and Pavey, E., 2022, Heritage Questing with Virginia Woolf: UCL Institute of Archaeology's 'Spirit of Place' and New Pedagogies of the Pandemic. *Archaeology International*, 24(1): 99–133. DOI: 10.14324/111.444.ai.2021.07

Butler, B., Forthcoming a, Reimagining Heritage Conservation 'after Modernity' as Constellations and Cosmologies of 'Object' Relations and Attachments:-Transforming Theory from Mexican Memory-work, Alexandria's Redemptive Memory to Palestinian Rites of Resilience, Care and Protection. Proceedings of International Congress: Theories, History, Conservation held in Mexico City, 2018. National Museum of Ethnography Publications, Mexico.

Butler, B., Forthcoming, b, On Heritage Pharmacology - Rethinking 'Heritage Pathologies' as Tropes of Care, in *Journal of History of Human Sciences*.

Butler, B., and Al-Nammari, F., 2016, "We Palestinian Refugees" – Heritage Rites and/as the Clothing of Bare Life: Reconfiguring Paradox, Obligation, and Imperative in Palestinian Refugee Camps in Jordan. Special Edition - Archaeologies of Forced and Undocumented Migration. *Journal of Contemporary Archaeology* 3.2 (2016).

Butler, B., and Al-Nammari, F., 2018, "We Palestinian Refugees" – Heritage Rites and/as the Clothing of Bare Life: Reconfiguring Paradox, Obligation, and Imperative in Palestinian Refugee Camps in Jordan. Reprinted, in Y. Hamilakis (ed.) 2018. *The New Nomadic Age: Archaeologies of Forced and Undocumented Migration*. Sheffield: Equinox.

Chatterjee, H., Clini, C., Butler, B., Al-Nammar, F., Al-Asir, R., and Katona, C., 2020, Exploring the Psychosocial Impact of Cultural Interventions with Displaced People, in ed.E. Fiddian-Qasmiyeh (ed.), *Refuge in a Moving World. Tracing Refugee and Migrant Journeys Across Disciplines*. London: UCL Press.

DAAR, 2021, Press Release. Stateless Heritage, https://mosaicrooms.org/event/daar-stateless-heritage-preview/ (visited 20/04/2022).

Deleuze, G., 1998, Essays Critical and Clinical. London and New York: Verso.

Derrida, J., 2004, *Dissemination*. London: Continuum E-flux Architecture, 2021, https://www.e-flux.com/announcements/393745/common-assembly-refugee-heritage-nomination/ (visited 20/04/2022).

Georgieva, K., 2020, After the Pandemic - a Chance to Build Forward to a Better Future, https://www.kcl.ac.uk/news/coronaspeak-the-language-of-covid-19-goes-viral (visited 20/04/2022).

Komlik, O., 2020, Rest in Power, David Graeber – The Activist-scholar Who Lived the Coupling of Theory and Praxis, https://economicsociology.org/2020/09/04/rest-in-power-david-graeber-were-indebted-for-your-scholarship-and-activism/ (visited 20/04/2022).

Nolan R., 2021, We are All in this Together!' Covid-19 and the Lie of Solidarity. *Irish Journal of Sociology*, 29(1): 102–106.

Petti, A., 2021, Prelude, in Hilal, S. and Petti, A. (eds),*Refugee Heritage – World Heritage Nomination Dossier*. Riga. Livonia Print Ltd.

Pinkus, G., and Ramaswamy, S., 2020, The 'War' on COVID-19: What Real Wars Do (and Don't) Teach Us about the Economic Impact of the Pandemic, https://www.mckinsey.com/business-functions/strategy-and-corporate-finance/our-insights/the-war-on-covid-19-what-real-wars-do-and-dont-teach-us-about-the-economic-impact-of-the-pandemic (visited 20/04/2022).

Stiegler, B., 2013, *What Makes Life Worth Living: On Pharmacology*. London: Polity.

Thorne, T., 2020, #CORONASPEAK – The Language of Covid-19 Goes Viral, https://www.kcl.ac.uk/news/coronaspeak-the-language-of-covid-19-goes-viral (visited 20/04/2022).

Wainwright, O., 2021, As Important as the Taj Mahal? The Palestinian Refugee Camp Seeking Unesco World Heritage Status, https://www.theguardian.com/artanddesign/2021/oct/14/dheisheh-palestinian-refugee-camp-stateless-heritage-world-status-unesco-taj-mahal-macchu-picchu (visited 20/04/2022).

Whitehead, M., 2020, https://blogs.bmj.com/bmj/2020/05/22/covid-19-we-are-not-all-in-it-together-less-privileged-in-society-are-suffering-the-brunt-of-the-damage/ (visited 20/04/2022).

SECTION II

More-than-Human Heritage

The notion of the more-than-human was coined by ecologist and philosopher David Abram in an influential work *The Spell of the Sensuous: Perception and Language in a More-than-Human World* (1997). As interpreted in influential works by Anna Tsing (2015), Donna Haraway (2016), and many others, it centers on ideas of relationality and entanglement, and acts as an antidote to embedded ideas about human exceptionalism and the duality of nature and culture. In their chapter, John Schofield and J. Kelechi Ugwuanyi use a posthumanist lens to 'interrogate the role of heritage in times of uncertainty' via two widely geographically separated case studies. The first of these looks at informal, community-based, de facto heritage conservation ideas and practices in Igboland in south-eastern Nigeria. These local heritage practices and conceptualizations are able to extend relationships of care to plant and animal species, and adapt to change, through conceptions of mutual obligation and entanglement in a 'living community' of human and non-human beings. The second case study explores posthumanist management philosophies at the iconic site of the Galapagos archipelago, demonstrating deep histories of entanglement between natural and cultural heritage. They write: 'Today we position ourselves within the precarity of the posthuman and Anthropocene ages. This is an era in which we (as members of a society and as people working within the heritage field) have come to understand that a conservation principle based on the separation of human and non-human, culture and nature, matter and mind, or material and non-material is unable to prevent unwelcome change and adaptation'.

Focused on the River Meuse, Christian Ernsten frames his chapter as a call 'for unlearning and fundamentally changing our understanding of what we share with the river'. Modern interventions into the management of the river and its floodplain turned the river into a 'techno-river' and an 'organic machine'. As climates change, such conceptions of the river fail to the extent that they destroy embedded

DOI: 10.4324/9781003188438-5

relationships to the river and its waters, and to the extent that they no longer meet their initial management objectives–as witness periodic, devastating floods. Drawing on a wide array of thinkers, including anthropologist Veronica Strang, decolonial thinkers Walter Mignolo and Madina V. Tlostanova, and political ecologist Arturo Escobar, Ernsten offers frameworks and conceptualizations through which we can think and practice towards the river and its waters outside of these inherited tropes. At the core of his chapter is postcolonial feminist Chela Sandoval's conception of love 'as a "rupturing" in one's everyday world that permits crossing over to another'. Ernsten writes: 'River love … implies that the river is part of our community; it is the sphere in which we live, it is a living organism, it is a network of the combined lifeworlds of diverse, hybrid, feral and queer plants, animals, technologies and more'.

References

Haraway, D. 2016. Staying with the Trouble: Making Kin in the Chthulucene. Durham, North Carolina: Duke University Press.

Tsing, A. 2015. *The Mushroom at the End of the World: On the Possibility of Life in Capitalist Ruins*. Princeton: Princeton University Press.

3

HERITAGE AND POSTHUMANISM

Seeking Harmony in a Precarious and Unstable World

John Schofield and J. Kelechi Ugwuanyi

Introduction

The Anthropocene presents all 'beings' (humans and nonhumans) with an uncertain present and future, yet heritage preservation is a present and future-driven activity that takes no account of this uncertainty. This chapter interrogates how and in what form things, places, and practices might survive into the future, whether formally preserved or subject to conservation measures, or given no protection or treatment at all. We begin with a discussion on how anthropocentric subjection of other 'beings' works against the purpose of heritage preservation before examining two seemingly unrelated case studies, one in West Africa (the Igbo of southeast Nigeria) and the other in South America (the Galápagos World Heritage Site, Ecuador) to question some histories of preservation alongside the natural resilience of things. We recognise that both cases derive conservation principles from informal and formal methods of preservation respectively. We conclude by demonstrating that things (human and nonhuman) resiliently survive in a way of 'mediated living' which offers opportunities for change and adaptation.

The idea of formal conservation originated from universal thinking rooted in a Western tradition with principles aimed at preserving the 'common heritage of mankind' (Arnold 1975) for future generations. Other than taking centre stage in global heritage conservation discourses, the Western tradition has since permeated national and regional heritage management approaches the world over (Smith 2006). However, prioritising conservation interests for 'humankind' silences the gains of conservation to nonhumans, therefore exhibiting the anthropogenic subjection of other species. In this subjection, human interest directs conservation in a manner that can endanger the nonhumans (see Harrison and Sterling 2020). On the other hand, the informal ways of keeping things often comprise local knowledge

DOI: 10.4324/9781003188438-6

systems that are particularised from one geographical space to another. People in different locations have established conservation knowledge systems that are different from the hegemonic Western traditions; and their approaches have survived change in an informal way as part of a 'living community' of humans and non-humans (Ugwuanyi 2020). But the separation of human and nonhuman, culture and nature, material and non-material in heritage management became especially prominent with the UNESCO World Heritage conventions of 1972 (*Convention Concerning the Protection of the World Cultural and Natural Heritage*) and 2003 (*Convention for the Safeguarding of Intangible Cultural Heritage*); both of which have been critically and recently examined within the heritage literature (e.g. Meskell 2007; 2009; Vining, Merrick and Price 2008). At the 1972 Convention, culture was disassociated from nature. Because culture is a human product, nature, which in this sense is a conglomerate of the nonhumans, is considered a separate heritage that must be protected on its own. It was intended that the separate protection of nature (nonhuman) from culture (human) would arrest change (usually introduced by humans) to ensure that both aspects survive into the future. Secondly, much interest was earlier paid to antiquity, monuments, and materiality, therefore, side-lining non-material heritage and separating matter and mind. Such a divide was further strengthened when, during the 2003 UNESCO Convention, a separate World Heritage List was created for intangible (non-material) heritage to emphasise the point that it was somehow different from material heritage.

The point about a 'living community' draws attention to the claims that heritage, whether human or nonhuman, has a 'life' that brings them together. Of course, all plant and animal species have life, but Jones (2006) has also recognised the 'monument as a living thing.' In her study of the Hilton of Cadboll cross-slab in Scotland, she found not only was this monument a 'living thing' but, further, that it was a 'living member of the community' (Jones 2006). In a similar argument, Ugwuanyi (2020) posits that both human and nonhuman heritage are born, live in a community, and die to regenerate the earth. These comparable views of Jones and Ugwuanyi explain the bond between the living human and the life attributed to the nonhuman that gives them life as well (see Shanks 1998; 2007; Witmore 2007; Sørensen 2013). In this sense, every heritage has a 'life' which could be social, natural, or utilitarian. Equally, scholars like Poulios (2014, 133) help us to understand that conservation could take a 'living heritage' approach in which the 'present is seen as the continuation of the past into the future, and past and present-future are unified into an ongoing present.' This process highlights the common attribute of resilience theory that, 'emphasises the inevitability of stability and transformation' (Redman 2005, 72); the inevitability of loss and change (DeSilvey and Harrison 2020; Seekamp and Jo 2020). In the heritage cycle, this adaptive approach takes the form of an endless process of becoming that carries human and nonhuman beings into a generation of continuities (Harrison and Rose 2010; Harrison 2015). Today, we position ourselves within the precarity of the posthuman and Anthropocene ages. This is an era in which we (as members of a society and as people working

within the heritage field) have come to understand that a conservation principle based on the separation of human and nonhuman, culture and nature, matter and mind, or material and non-material is unable to prevent unwelcome change and adaptation. The past subjection of nonhumans has created Anthropogenic stressors that threaten both the human and nonhuman 'life' forms. In such precarious times, we must therefore urgently rethink contemporary heritage conservation principles.

Consequently, posthuman thinking would help us negotiate this tension between the de-centring and re-centring of human beings (Miah 2008; Wolfe 2009) in order to find solutions to Anthropogenic stressors created by humans, especially in the precarious present. The posthuman idea that things have agency beyond the overbearing human (De Landa 1997) speaks to our case studies which present alternative ways of knowing that draw on the inseparability of human and non-human life forms for sustainable heritage conservation. Posthumanism, according to Sundberg (2011, 321), is 'a relational ontological approach framing the human and nonhuman as mutually constituted in and through social relations' in which human is viewed as a form of life among many (see also Sunderbeg 2013; Engert and Schürkmann 2021). It is therefore a hybridization of 'naturecultures' (Haraway 2003). In heritage parlance, Harrison (2015) recognised this synthesis as 'connectivity ontologies.' And in his 'posthuman prehistory,' Ingold (2021) traced this interconnectivity of nature and culture and humans and nonhumans to a perpetual co-creation in which, according to Engert and Schürkmann (2021, 7), 'the prehistoric relation to the terrains that we share with other inhabitants is based on our returning to soil.' This explains why the dichotomies we create in heritage may not always favour conservation. In the two case studies that follow, we attempt to flesh out this perpetual co-creation inherent in posthuman theorisation with interest in the ways they play out in both formal and informal approaches to heritage conservation.

Conservation is a Living Exercise! Culture, Taboo, and the Resilience of Things among the Igbo

Traditionally, conservation is an organised way of ensuring that heritage assets (in the form of historic sites and buildings, for example) survive. Yet in recent times this traditional approach to heritage management has proved inadequate because of the uncertainty of the times we live in. This is because organised conservation often hinders the adaptation of things to the changing world (Ugwuanyi 2020; see also Nelson et al. 2007). In places where organised conservation hasn't occurred or is not present, professionals almost always believe that heritage is 'unprotected' (see Chalana and Krishna 2020). That perception may not be mirrored amongst local communities, who often identify themselves as caretakers of such locally recognised (and valued) heritage assets. In Nigeria, many such 'unprotected' materials, monuments, and sites exist in rural and urban settings that have encountered development on a scale which would usually account for the destruction of local culture and nature. Equally, within

local heritage conservation, many professionals still believe that culture is separate from nature (Brockwell et al. 2013), and that human activities have depleted the natural environment in ways that threaten the survival of both (Freedman 2018). However, heritage ontologies of the Igbo of southeast Nigeria view culture and nature to be inseparable, and there are local mechanisms that help heritage assets to survive despite the unpredictable changing conditions caused by development and the effects of climate change (Ugwuanyi 2020, 2021). One such mechanism is the focus of this case study. We examine how local communities associate with animal species and forests in ways that ensure their survival despite the threat of development and the absence of formal conservation plans.

The Igbo are one of the three major ethnic groups in Nigeria, West Africa. They are found in the southeastern part of the country, the geography of which formed the Republic of Biafra between 1967 and 1970. In their entangled ontology between nature and culture, Igbo communities have for one reason or the other built taboos, myths, and narratives to explain their common relationship with different species of animals (Oriji 2009). These taboos, myths, and narratives have become unconscious ways of protecting those species; and these principles of local conservation of animals extend to the preservation of landscapes that constitute their habitat (see Baker 2017; Baker et al. 2018). By implication, the presence of sacred groves and forests preserves plants and other animal species. More than 50 towns and villages have been identified that relate to about 13 different species of animals in Igboland (Figure 3.1). Here, we focus specifically on local preservation principles that protect some species of monkey–sclater guenon (*Cercopithecus sclateri*), mona (*Cercopithecus mona*), and tantalus (*Chlorocebus tantalus*)–all of which are locally called *enwe*, as well as the green snake (*Opheodrys*), locally called *aka* (note that snake is generally called *agwọ* but this species is sacred and occupies sacred groves in some communities in Igboland). We interrogate the ways in which local approaches have ensured the survival of these species and the associated cultural practices in a changing world.

Awka, Akpugoeze, Lagwa, Imerienwe, and many other communities in Igboland have developed taboos, myths, and narratives that protected (and continue to protect) monkeys through generations. In Awka, the narrative is that, in the past, monkeys saved the people from an invasion that may have wiped out the entire population. The monkeys that inhabit the grove belonging to their ancestral shrine came to inform the people about the planned invasion by their enemies who were already hiding in the grove. Following the role of monkeys in saving the people from this invasion and possible elimination, taboo was set in the deep past to protect these monkeys. Awka is the capital of Anambra state and monkeys are seen roaming some areas of the city. Yet, if someone intentionally kills one, he/she is to bury it by observing the same rites accorded to humans. Similar stories are told about human-monkey relationships in Akpugoeze. But here, in another narrative, the monkeys are said to have some relationship with two major deities in the community. Because the declaration of taboos that protect the monkeys were made by their ancestors, it is believed that killing them

	Animal species		Igbo Community (village/town) where it is sacralised/revered
	English/common name	**Local name**	
1	Monkey	*Enwe*	*Awka & Ojoto, Anambra state *Akpugoeze, Inyi & Amuri, Enugu state *Lagwa, Imerienwe, Awomamma, & Orodo, Imo state *Okposi, Ebonyi state
2	Python	*Eke* (called *Eke Idemili* in Anambra area)	*Idemili areas (Uke, Neni, Umuoji, Abatete, Nnobi, Awka-etiti, Oba, Ojoto, Obosi, Ogidi, Urukwu, Eziowelle, Nkpor, Ideani, Uke, Abacha), Aguata area, Njikoka area, & Nnewi area, Anambra state *Mgbidi, Njaba, & Awo-Idemili, Imo state
3	Green snake	This species of snake is called *Aka*, but snake is generally called *Agwọ*	*Okposi, Ikwo, Ishiagu & Ndukwe Afikpo, Ebonyi state *Mpu & Nenwe, Enugu state *Uturu, Abia state
4	Crocodile	*Agụ iyi*	*Agulu, Anambra state *Ozalla in Nkanu, Enugu state
5	Cart fish	*Azụ okpo*	*Uturu, Abia state *Ukpor, Anambra state
6	Bush fowl	*Ọkwa*	*Ngwaukwu & Akpa Osokwa in Aba, Abia state *Ikem, Enugu state *Amaigbo in Mbaise, Imo state *Nnokwa, Anambra state
7	Grasscutter	*Nchi*	*Ichida, Anambra state
8	Puff adder snake	This species of snake is called *Evu*, but snake is generally called *Agwọ*	*Iheakpu Awka, Enugu state
9	Cane rat	*Ewi/Eyi*	*Nnewi, Anambra state
10	Barbary ground squirrel	*Uriri/Ururu*	*Orba, Enugu state
11	Lizard	*Ngwere*	*Okposi, Ebonyi state
12	Tortoise	*Mbe*	*Okposi & Ikwo Ebonyi state *Awo-Idemili, Imo state *Nkanu west, Enugu state
13	Snail	*Ejula/Njila*	*Ede-Oballa, Enugu state
14	Vulture	*Udele/Udene*	*All communities in Igboland

FIGURE 3.1 List of animal species protected with local conservation principles in Igboland.

would be a disturbance to their spirits. Census records of monkeys in 2004 and 2006 (Baker et al. 2009), 2010 (Baker et al. 2014), and 2016 (Baker et al. 2018) in Akpugoeze have shown a continuing increase in their population. This, according to Baker et al. (2018), is a result of the taboos that protect them.

In Lagwa, monkeys were said to be the property of the Arukwu-Lagwa deity. Yet few members of the community still remember the folklore that links the monkeys to Agwa, the founding ancestor of Lagwa. Agwa, who would always leave his pregnant wife at home to farm, returned one day to find that some monkeys had brought fruits to his wife. The monkeys continued to assist the wife each time he was not at home. Following their kindness, Agwa pronounced that monkeys are part of them (human) and should never be harmed by any of his generation. The Imerienwe community presents this same narrative: monkeys provided food for the pregnant wife of their founding ancestor in the deep past and have continuously protected and saved babies from harm in the Imerienwe community. In many of these communities, monkeys share space with humans without ever being harmed.

Aka (green snake) is protected in Igbo communities of Okposi, Ikwo, Ishiagu, and Mpu. These communities share a common geographical boundary and have related cultural histories. It is based on this relationship that the taboo and narratives that protect *Aka* are the same in all the communities. The narratives around this human relationship with green snakes revolve around help that *Aka* provided to the people in the past. It is either that it saved the people during ancient village wars by cleaning the footprints with which their enemies would have located them in their hiding places, or that the *Aka* led them away from their previous place of settlement to their current territory to save the people from a looming calamity. This experience was recorded by different people on different occasions thus prompting the elders to make a pronouncement that it had become necessary to protect *Aka* as part of humanity. This taboo was to be sanctioned under the principles of life guided by *Ala*, the Earth goddess, the Mother Earth (cf. Ugwuanyi 2020). Subsequently, if one intentionally kills the *Aka*, he/she will have to bury it following the same burial rites observed when burying a dead person in the community. It is perceived by the present generations in those communities that *Aka* is related to their ancestors and must be protected. Therefore, killing *Aka* means tampering with the spirits of the ancestors. Where the killing is not intentional, a minor rite is observed by the defaulter to pacify the ancestors. In any case, *Aka* shares human spaces; it could enter people's houses, even rooms without being killed or harmed. Usually, members of the villages have developed some enchantment known to *Aka* with which it is guided or taken away from people's houses. Of course, this taboo was set by different communities at different times, but the contiguous nature of their settlement suggests they share cultural affinity.

An example of a sacred grove that presents something alongside these thoughts on living and the resilience of things is the *Odo* forest (*Ohamu Odo*) in Ogor village in Ikem town, Isi-Uzo local government area, Enugu state. Sacred groves are found in Igbo communities and have been preserved because of the cultural practices

associated with them (Barker 2017; see also Onyekwelu and Olusola 2014). In places where those cultural practices have been abandoned for whatever reason, the space is transformed to meet the new living realities. There are sacred groves belonging to deities and different masked spirits at different Igbo villages. The *Ohamu* is a habitat for different plants and animal species that naturally live within the space. *Ohamu* is the forest of the *Odo* masked spirit (commonly called masquerade) from where they emerge every two, three, or four years (depending on the community) to perform in the village setting for some months before returning to the grove (see Ugwuanyi et al. 2021). Ogor had an *Ohamu* from where the *Odo* masked spirit has traditionally emerged. Recently, the grove was threatened by an envisaged encroachment of the Isi-Uzo local government secretariat in Ikem town. Reasoning that the activities that happen in *Ohamu* are reserved for the initiates and few privileged others, a secret about to be exposed to the uninitiated as a result of the daily engagements that would take place in the secretariat, the people had to relocate the *Ohamu* to another site. The process of relocating the grove involved some rites to take away and install the spirit of *Odo* in the old and new *Ohamu* respectively. This way, the narratives of both the *Odo* and the grove will continue to live in another space despite the fact that the *Ohamu* was relocated due to the changing circumstances of the time. In 2016, one of us was told that the old site of *Ohamu* is mapped out for construction of a community civic centre for Ogor people.

What these Igbo examples demonstrate is how heritage is protected in places without any formal conservation plan or method. It reflects the ways in which things adapt as part of a living/continuing community of humans and nonhumans without applying a conscious approach to protect them. In the following example, we examine a heritage site that receives significant high levels of formal protection while demonstrating both the resilience and adaptability of the things that characterise that site in a fast-changing world.

Living is a Conservation Exercise! Envisioning New Posthumanist Management Philosophies in Galápagos

In this second example, we turn our attention to the Galápagos archipelago, situated some 1000 km west of the Ecuadorian coast of the South American mainland. In this iconic location, with a significant place in the history of evolution and renowned for its many endemic marine and terrestrial species, we explore ideas around heritage preservation and curation in the context of Charles Darwin's (1859[2008]) Theory of Evolution and its propositions and hypotheses around humans and nature, deep time and the gradual but inevitable process of change.

The diversity of species in Galápagos is largely what makes the archipelago special and worthy of its UNESCO World Heritage status. This diversity is due to a combination of the archipelago's volcanic origins and continuing volcanic activity which render it a highly dynamic landscape, and its unique position in relation to ocean currents, specifically upwelling, with cold water currents bringing rich

nutrients from deeper waters, likely the result of local interactions between the atmosphere and the ocean (Forryan et al. 2021). The diversity of species that makes Galápagos so distinctive exists both within the marine and the terrestrial ecosystems which overlap in interesting ways. Iguanas are an example. Normally land-based, here Iguanas have learnt to swim, feeding on carpets of seaweed often at significant depth, a strategy developed out of necessity given the shortage of vegetation on the islands that they inhabit. The number of islands in the archipelago and the distances between them further contribute to this diversity through particular adaptations to the different habitats the islands support. The Galápagos finches are a well-known example of this local adaptation and form the basis of Darwin's theory of evolution, inspired by his visit to Galápagos in 1835 (Darwin 1859[2008]). Darwin defined evolution as 'descent with modification,' the central thesis being that species change over time, eventually giving rise to new species, while sharing a common ancestor. The finches famously adapted in different ways on different islands, sometimes very quickly to survive particular (even seasonal) food shortages. The speed, the causes, and the inevitability of these changes provide a helpful framework for assessing the role of heritage management within Galápagos, not least its often-stated intention to arrest the process of change rather than manage or even encourage it. It is relevant also to state that Darwin was certain that humans were part of the world of nature (and see Padian 2008 and Ruse 2009 for overviews).

As a World Heritage Site, the archipelago meets all of the UNESCO Criteria vii–x. As an example, and as a helpful contextual summary, its integrity is summarised as follows:

> The Galápagos archipelago is composed of 127 islands, islets and rocks, of which 19 are large and 4 are inhabited. 97% of the total emerged surface (7,665,100 ha) was declared National Park in 1959. Human settlements are restricted to the remaining 3% in specifically zoned rural and urban areas on four islands (a fifth island only has an airport, tourism dock, fuel containment, and military facilities). The islands are surrounded by the Galápagos Marine Reserve which was created in 1986 (70,000 km sq) and extended to its current area (133,000 km sq) in 1998, making it one of the largest marine reserves in the world. The marine reserve includes inland waters of the archipelago (50,100 km sq) in addition to all those contained within 40 nautical miles, measured from the outermost coastal islands. Airports on two islands (Baltra and San Cristobal) receive traffic from continental Ecuador with another airport on Isabela mostly limited to inter-island traffic. All the inhabited islands have ports to receive merchandise. The other uninhabited islands are strictly controlled with carefully planned tourist itineraries limiting visitation. Around 30,000 people live on the islands, and approximately 170,000 tourists visit the islands each year. (Ibid.)

Given its World Heritage status and the constraints that inevitably accompany it, working in and with Galápagos brings challenges as well as opportunities. Beyond

simple logistics, the challenge is partly the weight of expectation, resulting from the history of scientific research and advancement dating back over 150 years. The opportunity is to work in such a vibrant, creative, and successful research environment and in such an iconic location. But there is a further opportunity that Galápagos provides, and that involves the possibility of actively shaping a very different research environment by shifting paradigms and creating entirely new agenda, both for Galápagos and beyond. Galápagos may be iconic, special, and worthy of its World Heritage status. But that doesn't necessarily require everything to stay within the same established conservation parameters, or to preclude the reframing of research agendas for alternative ecological futures. Indeed the whole point of Darwin's research was the inevitability of change ('descent with modification') so where better to study change and closely examine its impacts than Galápagos?

To take a simple example, Galápagos is currently managed as a World Heritage Site, listed entirely for its natural qualities. Yet it is also a cultural landscape in which people live and work (many for the National Park that services the World Heritage Site). The commonly held view is that cultural influences on Galápagos exist in the background, almost as a necessary evil–tourism for instance, and the people who facilitate tourism by providing tours as well as running hotels, bars, and restaurants for the many visitors who travel to Galápagos every year. There are also the external cultural influences impacting the islands: plastic pollution, for example. All of these factors together provide Galápagos with many alternative futures. The status quo may be one of those alternatives, but that is not to deny others.

Some of these alternative futures are the subject of multidisciplinary research on plastic pollution being coordinated by Galapagos Conservation Trust, a process that began with its Science to Solutions workshop in 2018 (Schofield et al. 2020). A key difference between this and other multidisciplinary collaborations seeking to tackle various aspects of environmental pollution is the partnership of scientists working across natural *and* cultural heritage conservation, branches of conservation that have traditionally maintained a friendly separation. Yet these boundaries are fast dissolving (and see the recently concluded Heritage Futures programme as an example, Harrison et al. 2020). According to DeSilvey (2020: 289): 'with our human imprint now penetrating deep into global ecologies and geologies, the distinction between nature and culture - and natural and cultural heritage–is an artefact of a world we no longer inhabit.'

A simple example of what we might refer to as the entanglement of nature and culture involves American troops stationed in Galápagos in the Second World War, at what is now the site of Baltra Airport. In this instance, culture (now in the form of redundant wartime buildings) and nature (black rats, and the wider impact of chemicals used to attempt their eradication) have become inseparable. An example is the pesticide dichlorodiphenyltrichloroethane (DDT) used to eliminate the black rats (*Rattus rattus*) introduced during the military occupation (Alava et al. 2011). Its use has created a legacy that has persisted, as illustrated by the biomagnification of DDT in the

Galápagos sea lion (*Zalophus wollebaeki*) food chain (Alava and Gobas 2012), but also affecting the Galápagos fur seals (*Arctocephalus galapagoensis*) and several fish species (e.g. mullet, *Mugil curema* and thread herring, *Opisthonema berlangai*).

A core and traditional principle of heritage conservation, both cultural and natural, is the idea of preserving the best of our heritage for the future. But with changes in the way we think about heritage and the dissolution of boundaries between culture and nature also come changes in how we prioritise and seek to manage that heritage for future generations. Such was the case with the black rat. With new ideas emerging about cultural heritage (e.g. its future focus, as opposed to the past/present focus that has existed previously), there are opportunities to critically reexamine our approach to places like Galápagos, not least in the context of Darwin's own evolutionary principles of change and adaptation. Within the field of Critical Heritage Studies, this new situation is described by DeSilvey as one in which,

> the wider recognition of inevitable transformative change has been paralleled by the emergence of new theoretical approaches, which understand heritage as a socially-embedded, future-oriented process through which the past is brought into the present to shape novel environments and practices. … These alternative approaches see change and transformation as an integral element of heritage, with the potential to generate new connections between people, the past and the future. (2020: 289)

This is the context within which the 'Plastic Pollution-free Galapagos' initiative emerged, with contemporary archaeology and cultural heritage closely aligned to its primary goals of reducing plastic pollution in the archipelago (Schofield et al. 2020, Schofield et al. 2021). Rather than merely viewing the impacts of plastic on the UNESCO-listed heritage landscape, this project recognises the plastic as heritage in its own right, and as archaeological material culture, with each plastic item holding the clues to a story that can help reveal its origins. This way, by creating these stories from the evidence the individual items contain, a clear view of the problem and its origins might emerge. Many of the stories revealed thus far include forms of en-tanglement (often literally) with the natural world, whether it be crustaceans co-lonising the insides of plastic containers, animals making homes within them, or mistaking pieces of plastic for food. One wonders, with a confusion of timelines, how Darwin's research might have developed had he experienced the impacts of plastic during his first encounters with the archipelago. It raises the contentious questions: to what extent do we accept the inevitability of change as evident through these toxic impacts; and to what extent should we intervene.

Galápagos is changing, and while most would argue that many changes are unwelcome (not least plastic pollution), is it the responsibility of scientists and re-searchers, policymakers, and politicians, to seek to *preserve*, by arresting that process of change and ultimately to prevent it, or is it their role to *curate*, by managing the change and transformation that inevitably occurs, treating it instead as an

opportunity? This second approach would allow those responsible for places like Galápagos to go even further, as Breithoff and Harrison (2020, 179) suggest, and 'acknowledge the ways in which … practices not only preserve but actively *remake* nature in the Anthropocene, building new, divergent worlds and significantly enhancing their futures' (italics in original)?

Current work in Galápagos, including bringing an archaeological perspective to the natural world, creates an opportunity to hold this debate. Like everywhere, Galápagos is under pressure from anthropogenic stressors. Archaeology ultimately involves the close examination of a changing world, recognising how and why change happens, and understanding its implications often in relation to human adaptation. As seems likely, Darwin may not have factored in these anthropogenic stressors to his theory of evolution. But he did recognise the inevitability (even the necessity) of change.

Discussion and Conclusion

Life exists within human and nonhuman, material and non-material worlds (e.g. Harrison and Sterling 2020). Beings, in the form of things, places, and practices, each have histories, lives, and futures that map onto the world and are entangled with one another in complex ways. We can see this, amongst other places, in the way we have come to view nature as not so much threatened by, but *thriving in* an age of extinction (e.g. Thomas 2017), mirroring a controversial cultural heritage viewpoint of some years ago that we are constantly making material heritage as well as destroying it (Bradley et al. 2004). Through the lens of posthumanism, histories of preservation can follow unforeseen pathways to reach very different destinations. Like buildings and monuments, beings live individual lives comprising journeys along which various points of intersection and divergence will inevitably occur. All of these journeys have common elements in the way we think about heritage in an age of precarity. In terms of the past, living beings may have a strong sense of where they have come from; where their journey began. In humans this sense of time past is highly developed, and enhanced by archaeological work and historical research, concerning both themselves and other beings which they have encountered. Material things also have biographies that can be revealed through investigation, to tell their own stories (e.g. Jones 2006; Olsen 2003; Schofield et al. 2020). The present is an existence of the world in its current precarious state. The future is what happens next, and it is the future where the greatest uncertainty lies. But like archaeological investigations of the past, the future is also the realm of endless possibilities and opportunity. It is in this realm that the idea of posthumanism can be applied and viewed within our two scenarios in two very different but complementary ways: heritage encounters which shape a new reality; and the idea of new realities shaping the way we conceive of (in this case World) heritage.

Within our Igbo case study, we understand that changes occasioned by uncertainty do not end the life of heritage; nor do they divide the heritage past from its present. Whether human or nonhuman, heritage encounters provide the

opportunity to adapt to new realities. To support this point, some years ago, Oates and Anadu (1987) observed that the forests that supported the existence of monkeys in the Lagwa community had been cleared. Baker Tanimola and Olubode (2018) also found that similar sacred forests in Akpugoeze were cleared and were being farmed in 2017. Yet, past and recent census figures have shown a growing and continuing population of monkeys at both sites. We corroborate these findings with what we found in Awka about monkeys, green snake protection in Mpu, and the relocation of sacred forest in Ogor each suggesting that change and development have allowed the monkeys, the green snakes, and the forest to continue to move closer to human space as a process of mediation and adaptation. In our reading, this is resilience in which the lives of humans and nonhumans adapt to changing circumstances in a harmonised living community, where nature and culture coalesce. Such types of resilience create new or additional narratives about a heritage that we might describe as being 'conserved as a living exercise.'

In the second example, which we describe in terms of 'living as a conservation exercise,' Galápagos presents opportunities to manage the impact of anthropogenic stressors on an iconic World Heritage listed environment, while recognising how these stressors also form part of the islands' story, both past and present, but notwithstanding futures in which Galápagos presents unrivalled opportunities to think creatively about these impacts and how best to approach them. A cultural heritage lens alongside and in partnership with environmental and biological sciences is an example of how this can be achieved (Schofield et al. 2020; Schofield et al. 2021), while from a philosophical standpoint comes the suggestion to step back from any tendency towards conventional conservation thinking and practice to recognise instead an opportunity for paradigm shift at least in terms of managing change.

Bridging cultural with natural heritage provides one particular approach towards a future-oriented agenda for Galápagos. Prioritising 'remaking nature' over 'preservation' may be another. Whatever is decided, nature and culture are stronger together than they are apart, providing opportunities for the bold new thinking historically associated with the archipelago. What better place, then, to hold this conversation than in Galápagos, where the theory of evolution and the core concepts of adaptation and change have their origin?

In recognising the transferability of Darwin's thinking, and the impact across both sciences and humanities, we can recognise also the benefits of bold and visionary thinking, ideas that inspire new agendas that dismantle and discard boundaries as opposed to reinforcing existing ones, or finding new places to construct them. The world is increasingly one that recognises entanglement across the entire intellectual landscape, yet it seems ironic that the comparatively new field of Heritage Studies has been slow to realise this. This situation is changing, not least through the Association of Critical Heritage Studies and the ground-breaking Heritage Futures project (Harrison et al. 2020), but many of the conventional boundaries still remain, at least in terms of heritage practice, creating obstacles to new visionary thinking. In this chapter, we have proposed two examples where the

benefits of boundless research are being realised, alongside their relevance if not their urgency in times of precarity.

We close with Charles Darwin, but not in a conventional way. We end with a quotation from Kevin Padian highlighting a particular aspect of Darwin's enduring legacy and the advantages of recognising how his thinking can shape how we see the world:

> Happily, in one non-scientific arena at least, an honest, almost organic understanding and appreciation of Darwin has flourished. This is in literature, where authors from George Eliot to John Fowles have consciously or unconsciously absorbed his precepts and insights, nourishing beautiful prose and poetry. None, perhaps, more so than Thomas Hardy, who intuitively understood Darwin's layers of deep time, historical contingency, hereditary predilections and weaknesses, environmental opportunities, the various scales of change that comprise evolution, the constant need to adjust–and especially the insignificance of individuals against the great flow of life and time. As Hardy put it: "Let me enjoy the earth no less / Because the all-enacting Might / That fashioned forth its loveliness / Had other aims than my delight." This child of the Enlightenment was well aware of more ancient world views, and humbled by what the new investigations of the cosmos revealed. Humans are animals, one species of many on the planet, bound by common ancestry to all other species, part of an ages-old dance of reproduction, accommodation, survival and alteration. (2008: 634)

Aligning this quote with what we conclude from our seemingly unrelated case studies, we suggest that the formal (e.g. Galápagos) and informal (e.g. Igbo environment) principles of conservation are boundless in both purpose and intent. Both examples express the continuity that results from change, development, and adaptation which the harmony of nature and culture affords every being. In this sense, we conclude that conservation and living are indelibly linked or 'entangled.' Therefore, managing the anthropocentric subjection of other beings requires a rethink of the dichotomies of human and nonhuman, culture and nature, material and non-material, mind, and matter as they relate to heritage discourse. In times of precarity, when everything comes under closer scrutiny, this seems an appropriate time to address what we think about heritage and how it could work better for the benefit of all beings.

References

Alava, J.J., Ross, P.S., Ikonomou, M.G., Cruz, M., Jimenez-Uzcátegui, G., Dubetz, C., Salazar, S., Costa, D.P., Villegas-Amtmann, S., Howorth, P. and Gobas, F.A.P.C. 2011. DDT in Endangered Galápagos sea lions (*Zalophus wollebaeki*). *Marine Pollution Bulletin*, 62(4): 660–671.

Alava, J.J. and Gobas, F.A.P.C. 2012. Assessing Biomagnification and Trophic Transport of Persistent Organic Pollutants in the Food Chain of the Galápagos sea lion (*Zalophus wollebaeki*): Conservation and Management Implications. In Romero A. and Keith E. (eds), *New Approaches to the Study of Marine Mammals*, 77–108. IntechOpen.

Arnold, R.P. 1975. The Common Heritage of Mankind as a Legal Concept. *The International Lawyer*, 9(1): 153–158.

Baker, L.R. 2017. Sacred Forests. In Fuentes A. (ed.), *The International Encyclopaedia of Primatology*, 1242–1243. Oxford: John Wiley & Sons.

Baker, L.R., Olubode, O.S., Tanimola, A.A. and Garshelis, D.L. 2014. Role of Local Culture, Religion, and Human Attitudes in the Conservation of Sacred Populations of a Threatened 'Pest' Species. *Biodiversities and Conservation*, 23: 1895–1909.

Baker, L.R., Tanimola, A.A. and Olubode, O.S. 2018. Complexities of Local Cultural Protection in Conservation: The Case of an Endangered African Primate and Forest Grove Protected by Social Taboos. *Oryx*, 52(2): 262–270.

Baker, L.R., Tanimola, A.A., Olubode, 0. S. and Garshells, D.L. 2009. Distribution and Abundance of Sacred Monkeys in lgboland, Southern Nigeria. *American Journal of Primatology*, 71: 574–587.

Bradley, A., Buchli, V., Fairclough, G., Hicks, D., Miller, J. and Schofield, J. 2004. *Change and Creation: Historic Landscape Character 1950–2000*. London: English Heritage. Available online at: https://users.ox.ac.uk/~arch0217/changeandcreation/changeandcreation.pdf

Breithoff, E. and Harrison, R. 2020. Making Futures in End Times: Nature Conservation in the Anthropocene. In Harrison R. and Sterling C. (eds), *Deterritorializing the Future: Heritage in, of and after the Anthropocene*, 155–187. London: Open Humanities Press.

Brockwell, S., O'Connor, S. and Byrne, D. (eds.) 2013. *Transcending the Culture-Nature Divide in Cultural Heritage: Views from the Asia-Pacific Region*. Canberra: ANU E Press.

Chalana, M. and Krishna, A. (eds.) 2020. *Heritage Conservation in Postcolonial India: Approaches and Challenges*. London: Routledge.

Darwin, C. 1859 [2008] *On the Origin of Species*. Oxford: Oxford University Press.

De Landa, M. 1997. *A Thousand Years of Nonlinear History*. Brooklyn: Zone Books.

DeSilvey, C. 2020. Ruderal Heritage. In Harrison R. and Sterling C. (eds), *Deterritorializing the Future: Heritage in, of and after the Anthropocene*, 289–310. London: Open Humanities Press.

DeSilvey, C. and Harrison, R. 2020. Anticipating Loss: Rethinking Endangerment in Heritage Futures. *International Journal of Heritage Studies*, 26: 1–7.

Engert, K. and Schürkmann, C. 2021. Introduction: Posthuman? Nature and Culture in Renegotiation. *Nature and Culture*, 16(1): 1–10.

Forryan, A., Naveira Garabato, A.C., Vic, C., Nurser, A.J.G. and Hearn, A.R. 2021. Galápagos Upwelling Driven by Localized Wind–Front Interactions. *Scientific Reports*, 11: 1277. 10.1038/s41598-020-80609-2

Freedman, B. 2018. *Environmental Science: A Canadian Perspective* (6th edition). Halifax, Canada: Dalhousie University Libraries Digital editions.

Haraway, D.J. 2003. *The Companion Species Manifesto: Dogs, People, and Significant Otherness*. Chicago: Prickly Paradigm Press.

Harrison, R. 2015. Beyond "Nature" and "Culture" Heritage: Toward an Ontological Politics of Heritage in the Age of Anthropocene. *Heritage and Society*, 8(1): 24–42.

Harrison, R. and Rose, D. 2010. Intangible Heritage. In Benton T. (ed.), *Understanding Heritage and Memory*, 238–276. Manchester: Manchester University Press.

Harrison, R. and Sterling, C. (eds.) 2020. *Deterritorializing the Future: Heritage in, of and after the Anthropocene*. London: Open Humanities Press.

Harrison, R., DeSilvey, C., Holtorf, C., MacDonald, S., Bartolini, N., Breithoff, E., Fredheim, H., Lyons, A., May, S., Morgan, J. and Penrose, S. 2020. *Heritage Futures: Comparative Approaches to Natural and Cultural Heritage Practices*. London: UCL Press.

Ingold, T. 2021. Posthuman Prehistory. *Nature and Culture*, 16 (1): 83–103.

Jones, S. 2006. 'They Made It a Living Thing Didn't They … .': The Growth of Things and the Fossilization of Heritage. In Layton R. and Stephen S. (eds.), *A Future for Archaeology*, 107–126. London: UCL Press.

Meskell, L. 2007. Falling Walls and Mending Fences: Archaeological Ethnography in the Limpopo. *Journal of Southern African Studies*, 33(2): 383–400.

Meskell, L. (ed.) 2009. *The Nature of Culture in Kruger National Park. In Cosmopolitan Archaeologies*, 89–112. Durham and London: Durham University Press.

Miah, A. 2008. A Critical History of Posthumanism. In Gordijn B. and Chadwick R. (eds.), *Medical Enhancement and Posthumanity*, 71–94. Dordrecht, Netherlands: Springer.

Nelson, D.R., Adger, W.N. and Brown, K. 2007. Adaptation to Environmental Change: Contribution of a Resilience Framework. *Annual Review of Environmental Resource*, 32: 395–419.

Oates, J. and Anadu, P. 1987. Sclater's Guenon: First Field Observation. *International Journal of Primatology*, 8(5): 555.

Olsen, B. 2003. Material Culture after Text: Re-membering Things. *Norwegian Archaeological Review*, 36: 87–104.

Onyekwelu, J.C. and Olusola, J.A. 2014. Role of Sacred Grove in In-situ Biodiversity Conservation in Rainforest Zone of South-west Nigeria. *Journal of Tropical Forest Sciences*, 26(1): 5–15.

Oriji, J.N. 2009. Transformation in Igbo Cosmology during Slavery: A Study of the Geneses of Place-Names, Totems and Taboos. *Cahiers d'etudes africaines*, 196: 953–968.

Padian, K. 2008. Darwin's Enduring Legacy. *Nature*, 451: 632–634.

Poulios, I. 2014. *The Past in the Present: A Living Heritage Approach – Meteora, Greece*. London: Ubiquity Press.

Redman, C.L. 2005. Resilience Theory in Archaeology. *American Anthropologist*, 107(1): 70–77.

Ruse, M. 2009. The Darwinian Revolution: Rethinking Its Meaning and Significance. Proceedings of the National Academy of Sciences 106 (Supplement 1) 10040–10047. DOI: 10.1073/pnas.0901011106

Schofield, J., Wyles, K.J., Doherty, S., Donnelly, A., Jones, J. and Porter, A. 2020. Object Narratives as a Methodology for Mitigating Marine Plastic Pollution: Multidisciplinary Investigations in Galápagos. *Antiquity* 94(373): 228–244.

Schofield, J., Aylmer, J., Donnelly, A., Jones, J., Muñoz-Pérez, J.P., Perez, E., Scott, C. and Townsend, K. 2021. Contemporary Archaeology as a Framework for Investigating the Impact of Single-use Plastic Bags on Environmental Pollution in Galápagos. *Journal of Contemporary Archaeology* 7(2): 276–306.

Seekamp, E. and Jo, E. 2020. Resilience and Transformation of Heritage Sites to Accommodate for Loss and Learning in a Changing Climate. *Climatic Change*, 162: 41–55.

Shanks, M. 1998. The Life of an Artifact in an Interpretive Archaeology. *Fennoscandia Archaeologica*, XV: 15–30.

Shanks, M. 2007. Symmetrical Archaeology. *World Archaeology*, 39(4): 589–596.

Smith, L. 2006. *Uses of Heritage*. London: Routledge.

Sørensen, T.F. 2013. We Have Never Been Latourian: Archaeological Ethics and the Posthuman Condition. *Norwegian Archaeological Review*, 46(1): 1–18.

Sundberg, J. 2011. Diabolic Caminos in the Desert and Cat Fights on the Rio: A Posthumanist Political Ecology of Boundary Enforcement in the United States – Mexico Borderlands. *Annals of the Association of American Geographers*, 101(2), 318–336.

Sundberg, J. 2013. Decolonizing Posthumanist Geographies. *Cultural Geography*, 21(1), 33–47.

Thomas, C. 2017. *Inheritors of the Earth: How Nature Is Thriving in an Age of Extinction*. London: Allen Lane.

Ugwuanyi, J.K. 2020. "Human-nature Offspringing": Indigenous Thoughts on Posthuman Heritage. In Harrison R. and Sterling C. (eds.), *Deterritorizing the Future: Heritage in, of and after the Anthropocene*, 266–288. London: Open Humanities Press.

Ugwuanyi, J.K. 2021. Time-space Politics and Heritagisation in Africa: Understanding Where to Begin Decolonisation, *International Journal of Heritage Studies*, 27(4): 356–374.

Ugwuanyi, J.K., Ugwu, C. and Okwueze, M. 2021. Masking and Oral Tradition in the Re-enactment of Village-based Hierarchy among the Acephalous Igbo of Southeastern Nigeria.*World Archaeology*, 52(5): 746–764, DOI: 10.1080/00438243.2021.1938197.

Vining, J., Merrick, M.S. and Price, E.A. 2008. The Distribution between Humans and Nature: Human Perceptions of Connectedness to Nature and Elements of the Natural and Unnatural. *Human Ecology Review*, 15(1): 1–11.

Witmore, C.L. 2007. Symmetrical Archaeology: Excerpts of a Manifesto. *World Archaeology*, 39(4): 546–562.

Wolfe, C. 2009. *What Is Posthumanism?* Minneapolis: University of Minneapolis Press.

4

RIVER LOVE

Decolonizing Heritage along the Meuse

Christian Ernsten

> Zombies are the millions of bodies that exist between life and death in this era of impending extinction. They are the pets we live with, the animals we have hounded in extension, the world we have tethered to human concerns.
>
> (Halberstam 2020, 173)

Love or Breakup

This chapter about river love is not a love letter. In fact, it intends to disrupt an ongoing relation with the river and conversation about the river. I will share some thoughts on why it is that we have produced a certain type of river heritage, and how this has resulted from a particular human-river relation. As a kind of position paper, this chapter proposes a strategy for how this relation could change: how we could delink from our previous way of being with the river. In that respect, this chapter is also not a breakup letter. It is a call for unlearning and fundamentally changing our understanding of what we share with the river. Because, in fact, I really like the river. I live in the watershed of the Meuse, near Maastricht. As part of my daily routine, I cycle to the university through the valley of the Jeker, one of the tributaries of the Meuse. The Jeker meanders beautifully through this part of the Limburg landscape before it[1] drains into the Meuse at the center of Maastricht. On my ride along these bucolic river scenes, this rivulet sometimes gestures to what river landscapes were like in the past. It inspires feelings of nostalgia and a desire to engage with riverine beings and their pasts.

The main course of the Meuse—one of the major rivers in Europe—is a different creature than the Jeker, though. The Meuse originates in France, flows through Belgium and the Netherlands, and eventually drains into the North Sea. Contrary to the Jeker, the Meuse hides few reminders of a past natural life. In fact, like most

DOI: 10.4324/9781003188438-7

modern rivers, it can be understood as the result of a 'conquest of nature.' Environmental historian David Blackbourn has shown how human mastery over the river ecology took place through 'maps, charts, inventories, scientific theory [and] the expertise of hydraulic engineers' (Blackbourn 2006, 7). As a consequence, the twenty-first-century Meuse is now something of an 'organic machine' (White 1995), an 'envirotechnical landscape' (Pritchard 2011), or 'a techno-river' (Cioc 2002, 14). Rhine biographer Marc Cioc makes a striking observation: namely, that humans live along rivers for more or less the same reasons that other beings do. Rivers provide humans and all others in the river community with 'a ready supply of nourishment and a convenient mode of transport' (Cioc 2002, 6). Only it was us, humans, who fundamentally altered the face of the river. Cioc writes about the state of the Rhine in 1975:

> nearly nine-tenths of this floodplain had been usurped by farmers, industrialists, and urban planners. The remaining one-tenth, too meager to function as a continuous corridor, consisted of small patches in a riverscape otherwise dominated by human enterprise. With the alluvial corridor went the living space upon which the river's nonhuman inhabitants depended for their survival, resulting in the loss or near-loss of beaver, otter, salmon, shad, sturgeon, plover, sandpiper, tern, dunlin, heron, tree frog, dice snake, Rhine mussel, mayfly, oak, ash, elm, willow, and hundreds of other animal and plant populations.
>
> (Cioc 2002, 16)

I write this chapter against the backdrop of well-developed conversations in the adjacent fields of environmental history, environmental humanities, and Heritage Studies, which take first steps beyond the technoscience idea of a river. Since the 1990s scholars have attempted to document more-than-human life stories of the modern river (White 1995; Cioc 2002; Strang 2009; Pritchard 2011). Concerning the Meuse, historical geographer Hans Renes was the first to make a concerted effort to write about the various life stories that could be traced back to the landscape (J. Renes 1999; H. Renes 2021). While the academic conversation about the river has changed, anthropologist Veronica Strang points out that much of our historical understanding of rivers remains informed by a 'dualistic cosmology in which abstract scientific and technical views define social and economic systems as culture and ecological systems as nature' (Strang 2009, 277). Moreover, a recent study published by the United Nations Educational, Scientific and Cultural Organization International Hydrological Programme (UNESCO-IHP) and co-authored by political ecologist Barbara Rose Johnston and colleagues points to an urgent crisis in river heritage. The authors of the volume argue that our historical and contemporary footprint on the river has resulted in a very precarious situation: about 80% of the world's population live in river landscapes that are in danger (Johnston et al. 2012, xiii).

In light of what has been termed a crisis of our own making, landscape, and heritage scholars have begun to use the term 'the Anthropocene': that is to say, the geological time period defined by humankind (Harrison 2015; Kelly et al. 2018; Saul and Waterton 2018). This growing sense of urgency with regard to issues of environmental sustainability has also inspired a recent landmark research and exhibition project by the Haus der Welt Kulturen, the Max Planck Institute for the History of Science, and several universities in the United States titled *Mississippi: An Anthropocene River* (2019). This ongoing project brings together artists, activists, and scholars to foreground how human-river relationships hold together and contain 'multiple forms of culpability, responsibility, agency and association' (HDW 2019). As such, the project addresses an issue first articulated by Dipesh Chakrabarty in his suggestion that the crisis of the Anthropocene is first and foremost a crisis of knowledge (Chakrabarty 2009). If, then, we understand the contemporary Meuse as above all a human artifact, what does this mean in terms of our river care? This chapter begins from a similar understanding: namely, that our river relation is in serious trouble and, clearly, that romantic poetry alone will not save it.

Yet writing a love or breakup letter is no longer just about dreamy romance. It is an actual design thinking method out of the Digital Society School's Design Method Toolkit. The intention behind this method is to give insights into our perception about issues or items 'by eliciting feelings based on real-life experiences and interactions through writing a love or breakup letter' (Method 2022). Along these lines, I will describe in this chapter a series of moments from my own research archive in relation to the river Meuse. The Maastricht University-based teaching project *River Care: Policy, Participation and Protest* that I have run since 2020 with Nico Randeraad of the Center for the Social History of Limburg provides the context for these research fragments. The latter includes material based on media reports, a series of river walks, and archival documents. Yet the vignettes below are ultimately also personal experiences that have altered my thinking about and engagement with river heritage.

In discussing my fragments, I think through how we in the Global North captured or colonized the river. Indeed, aligned to decolonial thinkers Walter Mignolo and Madina V. Tlostanova, who write that there is 'no modernity without coloniality' (Tlostanova and Mignolo 2009, 130), this chapter asserts that the modernity of the river also implies a coloniality of the river. As we engineered and developed the river we also disregarded or disavowed it. Recently, various heritage researchers working on river landscapes have highlighted the diverse ways in which communities have articulated body, landscape, and place as part of histories of colonial encounter (Head, Atchison, and Fullagar 2002; Daehnke 2007; Gibson 2017). Here, I find the term 'coloniality of nature' from Colombian-American anthropologist Arturo Escobar useful. Escobar criticizes the dominant modern and Eurocentric understanding of nature, which is centrally based on failings binaries such as mind-body, nature-culture, and reason-emotion (Escobar 2008, 120). Echoing Enrique Leff and Tim Ingold, he argues for a break from the capitalist

technoscientific approach to nature. In the same vein, I ask what river heritage would look like if nature functioned as an *agent* (Escobar 2008, 153–155). I will propose some ideas for a different human-river relation, and a different heritage–namely, one based on love. As a starting point, which illustrates the crisis of the Anthropocene along the Meuse, I will discuss my engagement with a Network Historical and Cultural Landscapes event as a first fragment.

Ruined River

In 2019, a meeting entitled 'De Maas en zijn werken' [The Meuse and his works], organized by the Network Historical and Cultural Landscapes and supported by Dutch Cultural Heritage, took place in the Meuse village of St Agatha in the province of Limburg. It dealt centrally with the challenge of how to preserve the cultural landscape of the Meuse and was aimed at presenting state-of-the-art research on the Meuse landscape. I was asked to reflect on the question 'Hoe nu verder met de Maas?' [What lies in the future in terms of Meuse research?] (HHCL 2019). The Meuse in the Netherlands is an integral part of the Rhine–Meuse–Scheldt delta. This delta encompasses most of the Dutch landmass, which, in turn, is protected by the Delta Works–a complex network of dams, sluices, locks, dykes, levees, and storm surge barriers. Against this backdrop, I addressed two questions in my presentation. First, what do we mean when we talk about the future of a river landscape like the Meuse, or of the Dutch river delta in general? And second, what does this future imply in terms of heritage research surrounding the river? I started with a discussion of how the future landscape figures in our everyday lives.

According to many Dutch news outlets, the future of the Dutch landscape is a point of major concern. Many media sources have started to refer to the future landscape in terms of crisis or emergency. A recent example I showed is Figure 4.1. The map on the left, titled 'The Netherlands under sea level in 2100,' was published in the quality Dutch newspaper *NRC*. It shows 50% of the Dutch delta under water if the International Panel for Climate Change's prediction of an 84 cm sea level rise becomes true. The subscript reads:

> The rising sea levels mean for the Netherlands that there is little time for the necessary adjustments … it might very well be even worse than we are anticipating now.
>
> (Aan de Brugh and Van der Walle 2019)

Another example I showed was the map on the right. This map from the *Vrij Nederland* magazine portrays the Netherlands in 2300 and was drawn by physical geologist Kim Cohen of Utrecht University. In the accompanying article, Cohen asks somewhat cynically whether German should 'become a mandatory language' in the Netherlands (Schuttenhelm 2019).

FIGURE 4.1 Excerpts from the newspaper *NCR* (left) and the magazine *Vrij Nederland* (right).

As a small side-step, and to relativize the Dutch predicament: while in the Netherlands there might still be some time for adjustments, the picture the media paints of countries in the Global South, and particularly in the Asian river deltas, is far bleaker. *The Guardian*, for example, predicts that in 2050–or in less than 30 years–300 million people in Asia will experience what the Netherlands can expect in 50 years: a high risk of floods that will demand giving up living areas, with mass migration as a result. Benjamin Strauss, Climate Central's chief scientist and CEO, is quoted as saying: 'An incredible, disproportionate amount of human development is on flat, low-lying land near the sea. We are really set up to suffer' (Watts 2019).

Back to the Meuse in Limburg, and back to Maastricht. Here, the news reporting and predictions around the future of the Meuse do not project suffering on a comparable scale, but neither are they particularly comforting. In one local news source, an alderman of Maastricht is quoted as saying:

> In the future we can expect higher peaks in terms of water levels. The Meuse is a rain river, and our city has at such a short distance from the mountains of the Ardennes little time to prepare for high water.
>
> (Schreuder 2019, translated from Dutch to English by author)

Elsewhere in the province, the citizens' group No Against the Tidal Wave project a worst-case scenario in the case of a Meuse peak: 'The water enters home

with great power and rises in some places up to maybe four meters and it will stay for months' (Steen 2019, translated from Dutch to English by author).

On top of that, others point out that very dry summers–like the ones experienced in 2019 and 2020–produce a new urgent scenario for the Netherlands. With the Meuse as an important source of drinking water, extremely low river water levels could present a second crisis. RIWA-Maas, the network of water companies in Belgium and the south of the Netherlands, warn that low river water levels impact drinking water services for 7 million Dutch and Belgium people (Musch 2019). In addition, the Stichting Natuur en Milieu (Foundation for Nature and the Environment) stated recently in the Dutch daily newspaper *De Volkskrant* that, according to European Union standards, only 1% of Dutch waters has the right quality (Smit 2019).

Here I will pause and turn to the second question of my presentation: What lies in the future in terms of Meuse research? How do these clustered and entangled crises, this ruined river landscape, inform our future research engagements?

Anthropologist Anna Tsing explains that, 'first nature' is a relatively balanced set of ecological relations in which humans also take part; 'second nature' is the modern intervention in these ecological relations; and, finally, 'third nature' is the ruins or leftovers of conquered nature in the wake of capitalism (Tsing, 2015). In other words, nature is everything surrounding us right now. In reference to the Rhone, Sara Pritchard speaks of the 'concreteness' of the river's dams and nuclear plants: the grandeur of the nation-state materialized in a cemented nature (Pritchard 2011, 8). The engineering successes of the past have produced the contemporary ruined landscape, with climate change, decreasing biodiversity, and a lack of clean drinking water as its consequences. I propose that future heritage research must engage with these ruins. For archaeologist Rodney Harrison, this includes examining the individuals who inhabit river landscapes, their associations, and discourses, as well as the arrangements of materials, texts, and technologies related to the landscape, and how these have changed over time (Harrison 2020). Yet such a relational or entangled approach so far remains a counter-discourse.

Indeed, a different historical narrative surrounding the Meuse is dominant. A regional newspaper recently published a piece with the title 'Benefiting from a Wild Meuse,' written in response to a visit to the area by Peter Glas, the Delta program commissioner in the Netherlands. Glas, who is also an official of the Ministry of Infrastructure and Water Management, visited the Limburg region to discuss, among other things, the 'climate robustness' of the Meuse. Covering the event, journalist Vikkie Bartholomeus of the regional newspaper *De Limburger* wrote:

> The Meuse as friend or foe. In the face of climate change, drastic measurements are required to curb the Meuse river in the long term. Costly and radical. Yet, they also present an opportunity to optimize our usage of the river.
>
> (Bartholomeus 2019, translated from Dutch to English by author)

Interestingly, to draw attention to her report of the event, the journalist forecasts a dystopian scene somewhere in December 2049:

It has been raining for days in the Ardennes and the north of France. Almost like tropical thunderstorms in the winter, it keeps on pouring and pouring. Storm, hail and landslides, and the end of this merciless heavy weather is not yet in sight. The province of Limburg is bracing itself for extreme high-water levels in the Meuse. The first predictions are disturbing: 4,600 cubic meters per second will pass through the river. One and a half times as much as during the floods of 1993 and 1995.

(Bartholomeus 2019, translated from Dutch to English by author)

In her depiction of the future Meuse in Limburg, the journalist harks back to events in the early nineties. In those years, inhabitants of the province experienced the wildness of the river firsthand. The flooding of the Meuse during the winter period in 1993 meant that 12,000 people in Limburg–and 250,000 people in the winter of 1995–were evacuated throughout the Netherlands (Wikipedia 2019; Wikipedia 2019). In response to these events, the Ministry of Infrastructure and Water Management embarked in 2005 on the 'Maaswerken'–the Meuse Works–a project that would constitute the largest river engineering effort ever undertaken in the Netherlands. The Ministry of Infrastructure and Water Management worked on the Meuse at 52 sites over a total length of 222 kilometers to reduce the risk of uncontrolled flooding. In addition to the transformation in terms of water safety, the Meuse Works also included significant landscape design efforts and a large number of archaeological excavations (Ball, Tebbens, and Linde 2018). As such, in the province of Limburg, the Meuse Works project involved a wholesale reconceptualization and redesign of both the cultural and natural heritage of the river. The area came to be known as the emerging tourist destination 'Rivierpark Maasvallei' (Meuse Valley River Park)–a 'natural and cross border river landscape where inhabitants and visitors can find rest' and 'a landscape of good living, working and relaxing' (Maasvallei 2019).

Peaceful relaxation while disaster awaits. Rereading these newspaper clippings, I am made to think of last year's apocalyptic black comedy movie *Don't Look Up*. 'I hear there is something happening you don't like the looks of?' asks Meryl Streep's character, the president of a fictional United States (Netflix 2021). According to the article in *De Limburger*, weather extremes as a result of climate change might flood the city of Maastricht. Nevertheless, instead of despair in the face of this potential apocalypse, the journalist echoes the Delta commissioner's suggestion to think in terms of opportunity. A wild and dangerous Meuse could also potentially bring the chance to restore the human connection with the water flow. The necessary anti-flood measurements could make the Meuse valley more attractive. The journalist describes a potential Meuse 'experience,' including a river park like the Loire in France or cultural entertainment such as the London

Eye and a spectacular aquatic 'eldorado' (Bartholomeus 2019). This discourse of the future wild Meuse is both attractive and persisting, but it is clearly far from a reset of the human-river relation. Instead, this interpretation of the wild Meuse seems to reinforce the modern technoscience approach. What is the backstory to the river park? This is what I will explore in the next section, my second fragment.

Fantasy Landscape

A newly designed 52 km-long walk through the Rivierpark connects the 15,000-hectare area that starts north of Maastricht and ends just north of the Belgium city of Maaseik and just south of the Dutch town of Maasbracht. This part of river between Belgium and the Netherlands is often referred to as 'the most natural' river landscape of the Meuse (Asselman et al. 2018). Interestingly, though, alongside this now-meandering riverscape lies the 36 km-long Julianakanaal, which opened in 1935 as part of the Maasverbetering (Meuse improvement) project (1870–1942), allowing ships to continue from Maastricht to Maasbracht. From the 1950s onwards, the Grensmaas area was used for gravel mining. The gravel pits, in turn, were used for agriculture and leisure activities. Since 2005, as part of the abovementioned Maaswerken project, agriculture has been replaced by nature development (NRC 1991). Initially, the Maaswerken plans and its massive gravel mining project–emerging from the government's deal with the mining companies to fund the nature development–mobilized substantial civil and political protest (Trouw 2001; Dohmen 2001; FD 2001; De Graaf 2001b, 2001a). Inhabitants argued that '[the] scale of such a massive intervention in the landscape is out of sync with the measure of safety that is desired. Gravel is just a currency for financing the whole undertaking' (De Graaf 2001b).

Eventually, though, after ten years of public debate, the province of Limburg approved the plans in 2001. A provincial politician is quoted as saying: 'Enough talking. We're going for it, for safety and nature' (VK 2001). The gains in terms of natural wealth have been significant: 52 million tons of gravel. When walking parts of the 52 km river park route today, one encounters Scottish Galloway cattle, Konik horses, and lots of pioneer plants in a freshly designed riverscape, which the river park leaflet calls 'a natural piece of art' (RPM 2015).

The backstory to the river park project comes partly in the form of a report published in 1991, titled *Future for a Gravel River*, written by, among others, ecologist Wouter Helmer, the former director of Rewilding Europe, a successful international rewilding NGO. The publication date is important here: 1991 was before the large flooding of 1993 and also before the contemporary awareness of climate change or the discussion with regard to the Anthropocene kicked off. The report was commissioned by the provincial government of Limburg to examine the possibilities for nature developing in relation to gravel mining along the Meuse in Limburg (Helmer, Overmars, and Litjens 1991, 7; Schmit 1992). In other words, it

concerned a proposal for nature development as a way of repairing a post-gravel mining landscape. The report read:

> The authors write that this study can be seen as an orientation of the future meaning of the Meuse valley for Limburg. Ecological restoration is taken as a guideline, but increasingly in connections with strong economic functions. As part of a sustainable interplay, [the proposed intervention] an re-embed the Meuse in the landscape of Limburg.
>
> > (Helmer, Overmars, and Litjens 1991, 12, translated from Dutch to English by author)

Thus, gravel is perceived as being of value for nature development as well as of economic importance.

Interestingly, the authors write that 'humans [play] only a modest role—notwithstanding the success of our landscape design: nature is not makeable' (Helmer, Overmars, and Litjens 1991, 14, translated from Dutch to English by author). And also:

> Especially characteristics of nature like spontaneity, unpredictability and change-ability are highly appreciated by our contemporary society. The point of departure for this study therefore is to allow a wide audience to enjoy the nature in development in the Meuse valley. Simultaneously, an intelligent zoning and accessibility plan will prevent visitors from disturbing what they come for.
>
> > (Helmer, Overmars, and Litjens 1991, 15, translated from Dutch to English by author, translated from Dutch to English by author)

Helmer and his associates' plan envisions more space for what they call 'river dynamics': big grazers and seepage water (Helmer, Overmars, and Litjens 1991, 18). In order to realize the exchanges between different biotopes, breeding, and foraging areas, the river landscape should as much as possible be an interconnected environment. This would establish the border Meuse as 'a free river' (Helmer, Overmars, and Litjens 1991, 19). In a 2001 piece on the Meuse, environmental law researchers Frans van der Loo, Marjan Peters, and Marleen van Rijswick point out in a side note that the reconstruction or rebalancing of a river hydrologically, morphologically, and ecologically has never been attempted before in such a way (Van der Loo, Peeters, and Van Rijswick 2001).

In order to imagine such a future river, Helmer and his associates make reference to river heritage in interesting ways. They propose a journey through time and place. Their first reference is the Tranchot map of 1805 showing the border Meuse near the village of Borgharen—a depiction of a Meuse that is not yet engineered for shipping. Their second reference is the Allier, a river in central France. 'It all started in the summer of 1985,' reported the Dutch newspaper *NRC Handelsblad*, when Willem Overmars, a colleague of Helmer's, went

camping near where the Allier meets the Loire (De Ruiter 1995). A short documentary produced by Overmars, Helmer, and others on the subject–referred to as a 'dwaalfilm,' or wandering film–projects the Allier as the river of the future (Ark 2022). The Allier, though, is a river with little economic significance that meanders without interference in a region that is hardly populated. As such, it is–as the producers themselves acknowledge–hardly comparable with the Meuse (Helmer, Overmars and Litjens 1991, 26–27). Nevertheless, the images of the Tranchot map and the Allier become a central part of the fantasy and the design of the new Meuse landscape. Interestingly, this report and its desired river vision are hardly problematized.

The importance of the report lies not only in the current transformation of the Meuse, with the river park as its consequence. The study also laid the groundwork for the 'Living Rivers' vision published by the World Nature Fund (WNF) and supported by six nature organizations that work on rivers in the Netherlands. The efforts of creating a living river surrounding the border Meuse became part of a method of 'rewilding' nature (WWF 2020; RLR 2019). Indeed, the Limburg Meuse post-gravel mining landscape came to be seen an 'exemplary landscape' of a more free or wilder river. Reiterating Nick Shepherd, I argue that its purpose was partly didactic, partly the celebration of a particular kind of visionary power, and partly it was playful–'a fantasy landscape of dreams and imaginaries' (Shepherd 2020, 67). The river Meuse became another site for what environmental geographer Jamie Lorimer and human geographer Clemens Driessen refer to as a 'wild experiment' (Lorimer and Driessen 2014).

Rewilding as a concept was introduced in the late 20th century as a large-scale conservation strategy, focused on the 'establishment of core wilderness areas, enhanced connectivity, and restoration of keystone species' (Svenning et al., 2016). Even though there are contesting approaches and practices, dominant forms of rewilding are premised upon an idea of nature that excludes human interventions. Among them, 'Pleistocene rewilding' advocates to restore an ecosystem of some 13,000 years ago, which entails rich megafauna not yet seriously affected by a human footprint. In the Netherlands, this idea is associated with the Dutch biologist Frans Vera and its most famous expression is the Oostvaardersplassen (about 50 km from Amsterdam). The critique of creating new natural wildernesses is well formulated and argues that rewilding reproduces binaries between nature and culture and suggests a self-sustaining autonomy of non-human nature (Cronon 1995; Braverman 2015; Jørgensen 2015; Drenthen 2018). While distinguishing between Nazi and colonial rewilding as antimodern and contemporary rewilding as a form of ecomodernism, Lorimer and Driessen point to a discursive entanglement between wild experiments and the fantasy of 'a pure domain marked … by the absolute absence of human impacts' (Driessen 2016, 17).

Nevertheless, the concept of river rewilding remains powerful and attractive. As a strategy, it has been implemented in the Netherlands on several river sites and also exported abroad. Helmer has summarized the goals of rewilding as follows:

- 'restore ecosystem processes and dynamics (biotic and abiotic)'
- 'take inspiration from the past to shape future natures'
- 'move up a scale of rewilding within the constraints of what is possible'
- 'work towards the ideal of passive management'
- 'create new natural assets that connect with modern society and economy'
- 'work with restored forces of nature to find solutions to societal problems'
- 'reconnect conservation policy with public conservation sentiment.' (excerpted from Jepson et al., 2018, translated from Dutch to English by author)

When retiring from Rewilding Europe, Helmers said in an interview:

> wild nature and rewilding offer solutions to so many of the ecological and socio-economic problems and challenges that we face at the moment, such as climate change, biodiversity decline, better healthcare, and the need for sustainable rural economies.
>
> (RW 2022, translated from Dutch to English by author)

While it presents itself as an alternative to modern river engineering discourse, contemporary rewilding provides in some ways a hyper-modern vista on the human-river relation. In this discourse, curating nature is even more mechanistic, as it is expected to solve natural, social, and economic problems. And its ability to do so is presented as completely normal and natural. This adds further to what Escobar describes as the 'managerial rationalization of the environment' (Escobar 2008, 121).

Escobar questions whether we can understand the full complexity of nature since modern knowledge production of a river is so compartmentalized. Each of our sciences focuses on a particular aspect of the natural entity. In order to unlearn how we know the river, he argues for a focus on ecological difference and diverse ecologies, which would encapsulate 'imagining diverse ways to engage with body, landscape, and place; place and culturally rooted conservation and sustainability.' As such we might come to understand the complexity of nature, which is 'inextricably hybridized' with economic and cultural technologies. Writing with reference to the Global South context, he suggests privileging subaltern, local or activist knowledges of nature that pose questions of diversity, difference, and interculturality (Escobar 2008, 121, 130, and 155; 2005). In the next paragraph, I will discuss what this could mean in terms of doing heritage research on the river Meuse.

Drinking the River

How do we research the Meuse's living history without producing knowledge that will only be used in the future to further colonize it? How can we understand the 'deep inscription' of coloniality in the Meuse's landscape? (Shepherd 2020, 66) Here I find particularly instructive a question that was raised by drinking water company

RIWA-Maas director Maarten van der Ploeg in conversation with my teaching colleague Nico Randeraad. Van der Ploeg asked: 'How can we learn how to love the river again?' (Randeraad 2020, translated from Dutch to English by author).

I want to propose taking this question seriously as a pointer for coming to a different ontology of water, one that is based on relationality. I don't want to discuss love of or for nature in a kind of hippy-dippy way. Love and science do not seem logical partners, but Tsing shows in her book that many scientists have a great love for their research objects (Tsing 2015, 228). I believe we should actually rediscover that kind of love. I'm interested in river love as a heuristic device. Theorist Chela Sandoval, in her book *Methodology of the Oppressed*, speaks of love as 'a "rupturing" in one's everyday world that permits crossing over to another' (Sandoval 2000, 139). Along these lines I'm interested in river love as a different way of sensing, imagining, seeing, and producing knowledge in partnership with the river. What does that mean concretely? As a first step, I want to refer to the work of Dutch activist Li An Phoa.

I was introduced to her in the spring of 2018. The following summer, from May 15 to July 15, Phoa walked 1,061 km along the river Meuse. She started at its spring on the plateau Langres in France and she followed the river all the way through Belgium and the Netherlands to its mouth in the North Sea. Over five hundred people joined Phoa on different parts of her walk. More than two hundred people supported her journey in one way or the other. Phoa referred to them as her 'Meuse Angels' (Phoa 2019). On her website, Phoa explains why she walks the river Meuse. She tells a story of canoeing the Rupert River in northern Quebec Canada for a month in 2005 and how she could and did drink this river's water. Then she also writes:

> Witnessing how only three years later this river was not drinkable as a result of our choices of "economic developments", underlined the vulnerability of the health of living systems and the need for us to care. (Phoa 2019)

She continues:

> I long for a world where rivers are drinkable. A few generations ago, all rivers were drinkable. Now almost none are. This is a sign of how we live. The current pollution and destruction, is a reflection of how we live and our health. With our care, Drinkable Rivers are possible again. (Phoa 2019)

With her project, named Drinkable Rivers, Phoa intends to address the consequences of human interventions in the river: pollution, dams, and mining. A drinkable river according to her is an indicator of healthy human living and of the whole ecosystem being in balance. During her Meuse walk she and her fellow walkers measured the chemical properties (temperature, pH, dissolved oxygen and oxygen saturation and turbidity), the conductivity (salts), E-coli bacteria, and heavy

metals (Phoa 2020). Not surprisingly, perhaps, the Meuse—a river that provides drinking water only after purification—is far from a drinkable river.

Coming back to my earlier question—how can we delink from the modern and colonial way of relating to the river?—I believe Phoa's project might present such a case of rupture. Her plea for a Meuse that is drinkable is so incredibly simple and seemingly reasonable, yet at the same time so hard to imagine arriving at. Moreover, her project does not disavow the toxic truth of the river. She does not disregard what gender studies scholar Jack Halberstam calls in the opening quote the 'zombies': 'the millions of bodies that exist between life and death in this era of impending extinction' (Halberstam 2020, 173). Thinking about the living history of the Meuse in terms of its drinkability, and the bare life that is associated with its current state, opens up the potential to imagine radical, new and diverse ways of engaging with body, landscape, and place—a path that possibly leads away from a further coloniality of nature.

As such, a decolonizing of river heritage would need to entail the conceptualization of different research methods. Here I enter the realm of speculation: What if we foreground not the visuals of the river, but rather start using all our senses: smell, hearing, feeling—what if we use a fully embodied observation of the perception, the place, the memory, the imagination, and the traces of the river? And what if, in heritage research, text because less prominent—what if we focus more on the historical river as a soundscape and smellscape and how these scapes trigger memories and imaginations? In addition, decolonizing river heritage would entail taking a different research perspective: What if start thinking from the river—from the waterside, from an underwater perspective, from the perspective of its animals and plants? Thus, no more bird's eye view, no more bystander's perspective, no more image of the river as curving line in the landscape, but an understanding of the river (or sections of it) as performing community or as constellations that include humans besides many other animals. Decolonizing river heritage could also include a different attitude or conceptual approach: what if we think of the river in terms of reciprocity and of the river as sharing one health? River love, I would argue, implies that the river is part of our community; it is the sphere in which we live, it is a living organism, it is a network of the combined lifeworlds of diverse, hybrid, feral, and queer plants, animals, technologies, and more. We share the river with others, and we have to make amends with these others in order to redeem ourselves. That could be a first step in dealing with the condition of the crises of Anthropocene. When my family and I had to evacuate our house at midnight last June due to the potential flooding of the Meuse and the Jeker, I found myself thinking of something else that Halberstam wrote:

If the wild has anything to tell us, it is this: unbuild the world you inhabit, unmake its relentless commitment to the same, ignore the calls for more, and agree to be with the wild, accept the wild, give yourself to the wild, and float or drown in its embrace.

(Halberstam 2020)

Note

1 The usage of pronouns in relation to natural phenomena needs critical reflection. The Meuse is often referred to with the pronoun she/her, referencing a problematic gendered version of history in which femininity and wildness are closely associated. Here, I have chosen to use refer to the river as 'it,' which also has its flaws, as it adds to the objectivation of the natural world, robbing it of its selfhood and kinship.

References

Aan de Brugh, Marcel, and Erik Van der Walle. 2019. "Zeespiegelstijging van 84 centimeter? De Deltawerken beschermden tegen 40 centimeter." NRC. Accessed 3-11-21. https://www.nrc.nl/nieuws/2019/09/25/een-stijging-van-84-cm-a3974655

Ark. 2022. "25 JAAR ARK: Dwaalfilm." Accessed 14-2-2022. https://www.ark.eu/over-ark/ark-organisatie/25-jaar-ark/25-jaar-ark-dwaalfilm

Asselman, Nathalie, Hermjan Barneveld, Frans Klijn, and Alphons Van Winden. 2018. *Het verhaal va de Maas. De Maas uit balans?* Platform Rivierkennis van Rijkswaterstaat.

Ball, E.A.G., L.A. Tebbens, and C.M. van der Linde, eds. 2018. *Het Maasdal tussen Eijsden en Mook. De bewonings- en gebruiksgeschiedenis van het Maasdal op basis van archeologisch onderzoek in het Malta-tijdperk.* Amersfoort: Rijksdienst voor het Cultureel Erfgoed.

Bartholomeus, Vikkie. 2019. "Profiteren van de wilde Maas." *De Limburger*, 29 March 2019, 2019.

Blackbourn, David. 2006. *The Conquest of Nature: Water, Landscape, and the Making of Modern Germany.* New York and London: W.W.Norton

Braverman, Irus. 2015. *Wild Life: The Institution of Nature.* Stanford: Stanford University Press.

Chakrabarty, Dipesh 2009. "The climate of history: Four theses." *Critical Inquiry* 35 (2): 197–222.

Cioc, Mark. 2002. *The Rine: An Eco-Biography, 1815–2000.* Seattle London: University of Washington Press.

Cronon, William. 1995. "The trouble with wilderness." In *Uncommon Ground: Rethinking the Human Place in Nature*, edited by William Cronon, 69–90. New York: W.W. Norton.

Daehnke, Jon D. 2007. "A 'strange multiplicity' of voices. Heritage stewardship, contested sites and colonial legacies on the Columbia River." *Journal of Social Archaeology* 7 (2): 250–275.

De Graaf, Peter. 2001a. "Limburg in ban van grindstrijd; Milieubeweging bang voor saaie 'badkuip'." *de Volkskrant*, February 13, 2001, 2001a.

De Graaf, Peter. 2001b. "Ook minder grindwinning wekt weerzin." *de Volkskrant*, November 6, 2001, 2001b.

De Ruiter, F.G. 1995. "Groen voor grind." *NRC Handelsblad*, May 24, 1995, 1995.

Dohmen, Joep. 2001. "Groeiend verzet tegen Maasplan en grindwinning." *NRC Handelsblad*, February 6, 2001, 2001.

Drenthen, M. 2018. "Rewilding in layered landscapes as a challenge to place identity." *Environmental Values* 27 (4): 405–425.

Driessen, Jamie Lorimer, and Clemens. 2016. "From "Nazi cows" to cosmopolitan "ecological engineers": Specifying rewilding through a history of heck cattle." *Annals of the American Association of Geographers*: 1–22. 10.1080/00045608.2015.1115332

Escobar, Arthur. 2005. "An ecology of difference. A Latin American Approach to Sustainability." Panel on Ecological Threats and New Promises of Sustainability for the 21st Century. Queen Elizabeth House 50th Anniversary Conference, Oxford University, 3–5 July 2005.

Escobar, Arthur. 2008. *Territories of Difference. Place, Movements, Life, Redes.* Durham: Duke University Press.

FD. 2001. "Oppositie valt provincie aan wegens Grensmaas." *Het Financiele Dagblad,* December 3, 2001, 2001.

Gibson, Erin. 2017. "Returning home: heritage work among the Stl'atl'imx of the Lower Lillooet River Valley." *International Journal of Heritage Studies* 23 (3): 183–199. 10. 1080/13527258.2016.1261921

Halberstam, Jack. 2020. *Wilde Things. The Disorder of Desire.* Durham: Duke University Press.

Harrison, Rodney. 2020. "Heritage as future-making practices." In *Heritage Futures. Comparative Approaches to Natural and Cultural Heritage Practices,* edited by Rodney Harrison, Caitlin DeSilvey, Cornelius Holtorf, Sharon Macdonald, Nadia Bartolini, Esther Breithoff, Harald Fredheim, Antony Lyons, Sarah May, Jennie Morgan, and Sefryn Penrose, 20–50. London: UCL Press.

Harrison, Rodney 2015. "Beyond "natural" and "cultural" heritage: toward an ontological politics of heritage in the age of the Anthropocene." *Heritage and Society* 8 (1): 24–42.

HDW. 2019. "Mississippi. An Anthropocene River. Exhibition at Haus der Weltkulturen." Accessed 1-12-2019. https://anthropocene-curriculum.org/contribution/in-situ-anthropocene

Head, Lesley, Jennifer Atchison, and Richard Fullagar. 2002. "Country and garden. Ethnobotany, archaeobotany and Aboriginal landscapes near the Keep River, north-western Australia." *Journal of Social Archaeology* 2 (2): 173–196.

Helmer, Wout, Willem Overmars, and Gerard Litjens. 1991. *Toekomst voor een grindrivier. Hoofdrapport. Studie in opdracht van de provincie Limburg.* Stroming. Bureau voor natuur - en landschapsontwikkeling B.V.

HHCL. 2019. "De Maas en zijn werken." Accessed 28-7-21. https://www.historischegeografie. nl/blank-urlfc

Jepson, P., Schepers, F., and Helmer, W. 2018. "Governing with nature: a European perspective on putting rewilding principles into practice." *Philosophical Transactions of the Royal Society B: Biological Sciences* 373: 20170434. 10.1098/rstb.2017.0434

Johnston, Barbara Rose, Lisa Hiwasaki, Irene J. Klaver, and Ameyali Ramos Castillo, eds. 2012. *Water, Cultural Diversity and Global Environmental Change. Emerging Trends, Sustainable Futures.* Paris: Springer. United Nations Educational, Scientific and Cultural Organization.

Jørgensen, Dolly 2015. "Rethinking rewilding." *Geoforum* 65: 482–488.

Kelly, Jason M., Philip V. Scarpino, Helen Berry, James Syvitski, and Michel Meybeck, eds. 2018. *Rivers of the Anthropocene.* Oakland: University of California Press.

Lorimer, Jamie, and Clemens Driessen. 2014. "Wild experiments at the Oostvaardersplassen: rethinking environmentalism in the Anthropocene." *Transactions of the Institute of British Geographers* 39: 169–181.

Maasvallei, Projectbureau RiverPark. 2019. "Rivierpark Maasvallei. Evaluatie en toekomst." Accessed 13-2-2022. https://www.rivierparkmaasvallei.eu/sites/default/files/evaluatie_en_toekomst_lay_out.pdf

Method, Design Toolkit. 2022. "Break up/Love letter." Accessed 9-2-2022. https://toolkits.dss.cloud/design/method-card/break-uplove-letter/

Musch, Steven 2019. "'Maas als drinkwaterbron kwetsbaarder door droogte'." Accessed 12-2-2022. https://www.nrc.nl/nieuws/2019/09/11/de-maas-als-bron-van-drinkwater-kwetsbaarder-door-droogte-a3972921

Netflix. 2021. "Don't look up. Leonardo DiCaprio, Jennifer Lawrence. Official Trailer." Accessed 15-2-2022. https://www.youtube.com/watch?v=RbIxYm3mKzI

NRC. 1991. "Natuurbestemming voor grindrivier." *NRC Handelsblad*, October 14, 1991, 1991.

Phoa, Li An. 2019. "If we have drinkable rivers, it means that all relations in the watersheds are healthy.". Accessed 13-4-2019. https://drinkablerivers.org/

Phoa, Li An. 2020. "Meuse 2018–results." Accessed 24-7-2020. https://drinkablerivers.org/what-we-do/river-walks/meuse-2018/meuse-2018-people-led-research-results/

Pritchard, S.B. 2011. *Confluence: The Nature of Technology and the Remaking of the Rhone.* Cambridge: Harvard University Press.

Randeraad, Nico. 2020. "Personal Communication about conversation with Maarten van der Ploeg." Maastricht.

Renes, Hans. 2021. "Habetslezing. Landschap en identiteit in Limburg. 22 June 2021." Accessed 12-2-2022. https://www.youtube.com/watch?v=Rc6O4CB8QNM

Renes, J. 1999. *Landschappen van Maas en Peel. Een toegepast historisch-geografisch onderzoek in het streekplangebied Noord–en Midden-Limburg.* Leeuwarden Maastricht: Uitgeverij Eisma bv Maaslandse Monografieen.

RLR. 2019. "Ruimte voor Levende Rivieren." Accessed 13-2-2022. https://www.levenderivieren.nl

RPM. 2015. "RivierPark Maasvallei. Lange afstandswandeling. 52 km wandelplezier in het RivierPark Maasvallei." edited by Regionaal Landschap Kempen en Maasland.

RW. 2022. "An interview with Wouter Helmer." Accessed 13-2-2022. https://rewildingeurope.com/blog/an-interview-with-wouter-helmer/

Sandoval, Chela. 2000. *Methodology of the Oppressed.* Minneapolis: University of Minnesota Press.

Saul, Hayley, and Emma Waterton. 2018. "Anthropocene landscapes." In *The Routledge Companion to Landscape Studies*, edited by Peter Howard, Ian Thompson, Emma Waterton, and Mick Atha, 131–159. London: Routledge.

Schmit, Hans. 1992. "Limburg gezegend of behept met veel delfstoffen?" *Trouw*, April 16, 1992, 1992.

Schreuder, Arjen. 2019. "Maastricht is niet bang voor hoogwater." nrc.nl. Accessed 1-12-2019. https://www.nrc.nl/nieuws/2018/01/25/maastricht-is-niet-bang-voor-hoogwater-a1589866?utm_source=NRC&utm_medium=banner&utm_campaign=Paywall&utm_content=paywall-mei-2019

Schuttenhelm, Rolf 2019. "De zeespiegelstijging is een groter probleem dan we denken. En Nederland heeft geen plan B." VN. Accessed 3-11-21. https://www.vn.nl/zeespiegelstijging-plan-b/

Shepherd, N. 2020. "Spectres of Cecil Rhodes at the University of Cape Town." In *Decolonizing Colonial Heritage: New Agendas, Actors and Practices in and beyond Europe*, edited by B Timm Knudsen, J.R. Oldfield, E. Buettner and E. Zabunyan, 63–80 New York: Routledge.

Smit, Pieter Hotse. 2019. "Nederlandse sloten, beken en grachten zijn een stuk vuiler dan we denken." Accessed 12-2-2022. https://www.volkskrant.nl/nieuws-achtergrond/nederlandse-sloten-beken-en-grachten-zijn-een-stuk-vuiler-dan-we-denken~b07c081c/

Steen, Paul van der 2019. "In Noord-Limburg zien ze het hoge water al komen." nrc.nl. Accessed 1-12-2019. https://www.nrc.nl/nieuws/2019/09/13/in-noord-limburg-zien-ze-het-hoge-water-al-komen-a3973213

Strang, Veronica. 2009. *Gardening the World. Agency, Identity and the Ownership of Water.* New York Oxford: Berghahn.

Svenning, Jens-Christian, Pil B.M. Pedersen, C. Josh Donlan, Rasmus Ejrnæs, Søren Faurby, Mauro Galetti, Dennis M. Hansen, Brody Sandel, Christopher J. Sandom, John W. Terborgh, and Frans W.M. Vera. 2016. "Science for a wilder Anthropocene: Synthesis and future directions for trophic rewilding research. *PNAS* 113(4): 898–906.

Tlostanova, Madina V., and Walter Mignolo. 2009. "Global Coloniality and the Decolonial Option." Kult 6. Accessed 18 December 2013. http://www.postkolonial.dk/artikler/MIGNOLO-TLOSTANOVA.pdf

Trouw. 2001. "Onbeperkte grindwinning; Natuurmonumenten vreest voor verlies aan natuur en stapt uit plan Grensmaas; Veilig Limburg." *Trouw*, February 7, 2001, 2001.

Tsing, Anna Lowenhaupt. 2015. *The Mushroom at the End of the World. On the Possibility of Life in Capitalist Ruins*. Princeton: Princeton University Press.

Van der Loo, F., M. Peeters, and H. Van Rijswick. 2001. "De Maaswerken. Over de juridische complexiteit van een grootschalig omgevingsproject." *TO* 2: 40–54.

VK. 2001. "Limburg na tien jaar akkoord met plan Grensmaas." *de Volkskrant*, December 22, 2001, 2001.

Watts, Jonathan. 2019. "Rising sea levels pose threat to homes of 300 m people – study." The Guardian. Accessed 24-7-2020. https://www.theguardian.com/environment/2019/oct/29/rising-sea-levels-pose-threat-to-homes-of-300m-people-study

White, Richard. 1995. *The Organic Machine. The Remaking of the Columbia River*. New York: Hill and Wang.

Wikipedia. 2019. "Overstroming van de Maas (1993)." Accessed 14-4-2019. https://nl.wikipedia.org/wiki/Overstroming_van_de_Maas_(1993)

Wikipedia. 2019. "Evacuatie van het Rivierenland." Accessed 14-4-2019. https://nl.wikipedia.org/wiki/Evacuatie_van_het_Rivierenland

WWF. 2020. "Living Rivers Europe." Accessed 13-2-2022. https://www.wwf.eu/what_we_do/water/living_rivers_europe/

SECTION III

Climate Action and the Anthropocene

Initially proposed by atmospheric scientist Paul Crutzen and limnologist Eugene Stoermer in 2000, and developed in the influential work of Dipesh Chakrabarty, Amitav Ghosh, and many others, the Anthropocene has gained widespread currency as a term that names not only a geological epoch, but also a cultural and political moment when taken-for-granted ideas and assumptions are placed in doubt or fall away. At the heart of the Anthropocene is the escalating crisis of the climate emergency. Several chapters in this volume deal with aspects of the climate emergency, but there are two that focus in detail on climate action and the Anthropocene written by key thinkers in the field of heritage studies. Rodney Harrison and Colin Sterling's chapter describes some of the conceptual thinking behind the Reimagining Museums for Climate Action project, an international design and ideas competition and associated exhibition curated by the authors in 2021. They draw on the work of Foucault and Agamben to think about museums as apparatuses of various kinds that intervene in process of subjectification. As part of the process of reimagining the museum, they explore the value of speculative thinking and profane methodologies. Amongst the rich offerings presented to us in this chapter is an extended engagement with Amitav Ghosh's searing and influential account of the climate crisis *The Great Derangement* (2016). Harrison and Sterling write: 'If heritage is to matter in a world beset by pandemics, extinction, rising seas, mass migrations and biodiversity loss, then it must do two things simultaneously: it must recognise its own complicity in many of the forces that have brought the planet to the brink of ecological collapse (modernity, capitalism, colonialism, nationalism, extractivism), and it must focus critical and creative attention on the urgent task of shaping more just and sustainable futures.'

Cornelius Holtorf's chapter sets out to update conceptions of world heritage for the Anthropocene epoch. Arguing that the kind of object-centered and nation-state-focused conceptions of world heritage set out in the 1972 UNESCO World

DOI: 10.4324/9781003188438-8

Heritage Convention, and reproduced through numerous statutes and conventions, are no longer fit for purpose, he discusses 'what could be done to adopt a more people-centered approach to world heritage.' He argues that one measure would be to introduce participatory decision-making in the selection process. A second measure would be to adopt new criteria for world heritage sites, objects, and practices that better reflect 'a global world heritage.' He gives examples of three emergent Anthropocenic global world heritages: Lego and other plastic trash from the world's beaches; repositories for nuclear waste; and space messages of the type sent on the board the NASA spacecraft Pioneer 10 and 11, and Voyager 1 and 2. He writes: 'Never has the potential of heritage to contribute actively to managing the relations between present and future societies been more important than now. It seems as if the very existence of a future humanity is at stake in the Anthropocene—whether that may be due to conflicts resulting from climate change, environmental pollution, global inequalities, artificial intelligence, nuclear weapons, or new viruses.'

5

THE SPECULATIVE AND THE PROFANE

Reimagining Heritage and Museums for Climate Action

Rodney Harrison and Colin Sterling

Introduction: Heritage, Museums, and Precarity

Natural and cultural heritage has always existed in a symbiotic (or, as some might argue, parasitic) relationship with different forms of precarity and uncertainty. Age, physical decay, targeted destruction, neglect, the loss of habitat, the erosion of cultures and languages, and many other phenomena besides can be seen to have motivated the emergence and spread of heritage over the past two centuries (see discussion in Harrison 2013). Far from being an inevitable response to cultural, political, economic, and environmental shifts, however, the 'endangerment sensibility' (Vidal and Dias 2016) underpinning heritage practice should be understood as a contingent and in many ways highly inequitable moral and ethical framework for the field. Who gets to decide what counts as 'precarious,' and what kinds of activities might be enacted to protect or stabilise the things (objects, sites, people, ways of life) brought under this banner, remains a vital point of debate for heritage theorists and practitioners alike.

From one perspective, the various crises currently impacting on populations around the world would seem to occasion a doubling-down of the endangerment sensibility. With the planet itself now categorised as 'at risk,' the urgent need for conservation, preservation, and sustainable 'stewardship' of the Earth system has gained serious traction in many areas of the social and natural sciences (e.g. Steffen et al. 2018). At the same time, the intersecting crises of climate breakdown, mass extinction, the pandemic, and widespread inequality have reinforced movements for radical change. Crucially, this has often involved a critical engagement with the legacies of the past in the present, particularly in response to the racialised violence of colonialism, imperialism, and slavery (e.g. Azoulay 2019; Yusoff 2018). While traditionalist voices continue to advocate for stability

DOI: 10.4324/9781003188438-9

or–at best–incremental change, the very ground on which such decisions might be made has shifted. This has brought the moralising power of the endangerment sensibility into sharp focus, not least in relation to the nativist desire to protect obsolete monuments and uphold nationalist myths.

Against this backdrop, it is disconcerting to realise that perhaps the most visible response to the Earth crisis emerging from heritage practice over the past decade has been a renewed call for greater conservation, rather than any fundamental questioning of the purpose of heritage in an age of ecological collapse. Initiatives such as ICOMOS's 'Future of Our Pasts' report and Europa Nostra's 'European Cultural Heritage Green Paper' ostensibly position heritage (broadly understood) as a vital tool in the fight against climate change, but the moral framework underpinning such work continues to prioritise preservation in the face of precarity (real or imagined). As consciousness of climate change and its impacts has grown, and as museums and the wider heritage sector have responded to this emergency, activity has largely focused on familiar processes of documentation, assessment, collecting, management, and conservation–only done faster, or with more resource allocation. Recent comparative work on natural and cultural heritage practices has suggested that such activities are largely unsustainable from an economic, ecological, or material perspective, especially when current predictions of future change are taken into account (see Harrison et al. 2020). Here, we join others in arguing that heritage and museums need to begin to imagine new ways of valuing, caring for and conserving the past in the present; ways that might take us 'beyond saving' and explore whole new forms of heritage thinking and practice (see DeSilvey 2017; DeSilvey and Harrison 2020; Harrison et al. 2020; Sterling and Harrison 2020).

This chapter introduces two key concepts that seem vital to any project of 're-thinking' heritage and museums in precarious times. The first of these is the idea of *the speculative*, a broad theme in literature and creative practice that we explore with specific reference to Anthony Dunne and Fiona Raby's work on speculative design (2013). The second is *the profane*, a term borrowed from Agamben's work on the apparatus (2009), itself an extension of Foucault's definition of the *dispositif* (1980).[1] Where the speculative gestures towards possible worlds that might take us beyond the conventions of current social, economic, or political systems, the profane seeks to undo the varied processes of subjectification that define the workings of any apparatus (an expansive term in Agamben's reading). We will develop this distinction below, but the key point to note here is that while the speculative is always turned towards the future, the profane is ultimately concerned with unravelling and reconfiguring those innumerable ideas, practices, and phenomena inherited from the past that continue to structure the present. It is our contention that critical thinking in heritage and museums must embrace both these trajectories to envisage alternative forms of care and resilience fit for an era of rapid change and profound uncertainty.

To help ground this discussion, the chapter focuses on a recent project that aimed to rethink and reimagine heritage and museums in response to the climate crisis. Launched in May 2020, Reimagining Museums for Climate Action was developed as part of the UK Arts and Humanities Research Council's contribution to COP26, held in Glasgow in November 2021. The project began life as an international design and ideas competition–one that aimed to open the discussion around this subject to new publics and new constituents. Elsewhere, one of us (Harrison 2013) has drawn on the work of Michel Callon, Pierre Lascoumes, and Yannick Barthe in *Acting in an Uncertain World: An Essay on Technical Democracy* (2009) to argue for the importance of hybrid forums in the establishment of more democratic models of decision making in heritage. By expanding the conversation around museums and climate action to include designers, artists, philosophers, Indigenous groups, activists, and others (alongside curators, scholars, and heritage practitioners), we hoped to unsettle the foundations of museological thinking and recognise alternative ways for heritage and museums to become engaged in the urgent project of building worlds and resourcing futures (see Bennett et al. 2017; Breithoff 2020; Harrison et al. 2020). An exhibition, website, and toolkit were produced to explore these themes, alongside an open-access book bringing together a multitude of ideas and perspectives on possible futures for the field (Harrison and Sterling 2021). This chapter gathers some of our initial reflections on the project, with a view to retheorising heritage and museums in and for the climate change era.

Museum Climates

From Anchorage to Sydney, museums globally have mobilised in recent years to address the challenges of a warming world through curatorial work, collecting programmes, public engagement activities, and new development strategies that do not shy away from the profound consequences of the climate emergency (see Brophy and Wylie 2013; Cameron and Neilson 2014; Newell, Robin and Wehner 2016; L'Internationale 2016). At the same time, a broad range of initiatives have sought to test the familiar idea of the museum in direct response to the climate crisis. These include activist-oriented climate museums in New York and the UK, but also the proposed Museum for the United Nations, whose first project–*My Mark, My City*–aimed to galvanise climate action in communities around the world. Alongside these, we cannot fail to mention the urgent work of protest groups such as *Culture Unstained* and *BP or Not BP?*, who seek to end fossil fuel sponsorship across the cultural sector. As the editors of the volume *Ecologising Museums* note, 'the museum' is not just a 'technical operation, but is also imbued with a certain (modern) mindset which itself raises questions of sustainability' (L'Internationale 2016: 5). Acknowledging the pervasiveness of this mindset leads to an important follow-up question: 'To what degree are the core activities of collecting, preserving and presenting in fact attitudes that embody an unsustainable view of the world and the relationship between man [sic] and nature?' (ibid).

Reimagining Museums for Climate Action aimed to explore this further through participatory and design-led enquiry: an approach that still seems lacking in much critical work in the field.

In developing the project we were also inspired by a growing sub-field of climate-related publications in museums studies, including three special issues on the subject in 2020 alone (Davis 2020; Sutton and Robinson 2020; Þórsson and Nørskov 2020). The breadth of case studies, creative interventions, and conceptual approaches found across this literature provides a valuable overview of the manifold ways in which museums intersect with climate action. Some of the main dimensions of this work include the idea that museums are 'trusted spaces' in which different publics can engage with the science of climate change (Cameron, Hodge and Salazar 2013); the possibility for collections—especially natural history collections—to inform new approaches to biodiversity conservation (McGhie 2019a); the need for museums to promote alternative forms of consumption (Arfvidsson and Follin 2020); the opportunities for cross-cultural engagement that may emerge around specific objects and narratives related to climate change (Newell, Robin, and Wehner 2016); and the potential to break down the boundaries between nature and culture through different modes of conservation and curating (Þórsson 2018). What such work highlights most clearly is the fact there is no single pathway or theory of change for the sector in relation to climate issues—addressing this crisis involves new imaginaries, new practices, new concepts, and new strategic alliances.

There are important parallels and intersections here with initiatives that aim to address the ongoing role of museums and heritage in supporting systemic forms of racism and inequality. In the UK and the US, campaign groups and forums such as *Museum Detox, Museums Are Not Neutral, Museum as Muck,* and *Decolonize This Place* have drawn attention to the historical and contemporary injustices of the field in ways that often coalesce with the political dimensions of climate action. Such work helps to surface the dense entanglement of museums with many of the forces that have brought the planet to the brink of ecological collapse, not least colonialism and the extractivist methods of industrial capitalism. Museums have never been isolated from the injustices of the world, but their complicity in a range of oppressive and damaging structures is now being thrown into sharp focus on multiple fronts.

This brings us to an important point in understanding the roots of the RMCA project, which at its core aimed to inspire radical change in museums to address the climate crisis. The key point here is that, in many ways, this change is already upon us. As authors such as Timothy Morton (2013), David Wallace-Wells (2019), and Andreas Malm (2018) highlight, the climate crisis is more than simply a problem to be overcome so that we can get back to business as usual—it is, potentially, a knowledge system or condition as all-encompassing as modernity or post-modernity. Such a perspective recognises that the impacts of climate change are felt not just in rising temperatures, biodiversity loss, and other environmental consequences, but in psychic experience, cultural responses, business, politics, and our relationship to time and history (Wallace-Wells 2019: 155; Malm 2018: 11). *This* is

the change museums are currently navigating, just as much as they are confronting the damaging effects of a warming world. This vastly expands the scope of museological 'reimagining,' which in our view can no longer be left to museologists alone.

Here it should be noted that speaking generally about museums is in many ways a fool's errand. Despite sharing a common genealogy and being united (to some degree) through international networks and 'best practice' guidelines, the sheer diversity of museums globally works against universalising definitions. As anthropologist James Clifford wrote some time ago, museum practices have proven remarkably 'mobile' and 'productive' in different locations around the world (1997: 217). Clifford traces this malleability to the various ways in which museums echo and formalise vernacular activities of collecting and display, arguing that processes of accumulation and exhibition are 'a very widespread human activity not limited to any class or cultural group' (ibid). As Clifford suggests,

> Within broad limits, a museum can accommodate different systems of accumulation and circulation, secrecy and communication, aesthetic, spiritual and economic value. How its "public" or "community" is defined, what individual, group, vision, or ideology it celebrates, how it interprets the phenomena it presents, how long it remains in place, how rapidly it changes – all these are negotiable.
>
> (ibid: 218)

Responding to this heterogeneity, attempts to define the term museum always encounter difficulty because—as Fiona Candlin and Jamie Larkin put it in a recent article—museums are 'different all the way down' (2020: 123). They are typically 'composite venues' with 'multiple, interlocking identities' (ibid), ranging from education and research to recreation and fine dining. The sector as a whole also comprises different types of organisations that 'intersect in non-predictable and complex ways' (ibid). This is something museologist Robert Janes identifies as a strength of the field, with the 'vast network' of museums globally seen to offer 'untold potential for nurturing both museum and societal renewal' (2009: 180). Clearly our desire to 'reimagine museums' picks up on this potentiality, but it also asks for a deeper questioning of 'the museum' as a specific form of institution or entity.

For Janes, the contemporary museum field may be understood as a kind of global 'franchise' in the same vein as McDonald's or Starbucks, only 'it is self-organised, has no corporate head office, no board of directors, no global marketing expenses, and is trusted and respected' (ibid: 179). This optimistic picture needs to be offset however by acknowledging the precarity of individual institutions and of the museum workforce. An international survey of museums undertaken by ICOM discovered that almost 95% of museums had been forced to close temporarily during the first wave of the pandemic (ICOM 2020; see also UNESCO 2020). In the UK, while only nine museums closed permanently in 2020 (Candlin 2021),[2] the

pandemic resulted in over 4,000 proposed or confirmed redundancies across the sector (Kendall Adams 2021). These stark figures remind us that the 'resilience' and adaptability of the sector all-too-often relies on a staffing model built around volunteering, low pay and casual contracts.[3]

We remained mindful of these concerns as we developed the brief for the Reimagining Museums for Climate Action competition, which explicitly sought to expand the conversation around the future of museums. A number of different research trajectories came together in co-authoring the brief, including Henry McGhie's policy-oriented work on museums and the Sustainable Development Goals (McGhie 2019b), Harrison's speculative approach to heritage as a future-making practices (Harrison 2013, 2015, Harrison et al. 2020), and Sterling's interest in critical-creative design practices in heritage and museums (Sterling 2019, 2020). While these trajectories overlap in some ways, the gaps and tensions between research that is quite theoretical in outlook and work that is more concerned with policy and practice created a useful foundation for thinking holistically about museums and climate action. To this end, the brief encompassed issues of collecting, conservation and exhibition making, the links between decolonisation and decarbonisation, the need to challenge foundational principles, the desire for speculative ideas about what museums could be, and the relationship between museums and climate justice. As an activity linked to the UK's hosting of COP26 in Glasgow, the brief also paid particular attention to the various UN programmes connected to museums, including Action for Climate Empowerment. Indeed, developing the competition brief constituted a kind of participatory thought experiment, bringing to mind architect Jeremy Till's comments on the brief writing process:

> The creative brief is about negotiating a new set of social relations, it is about juxtapositions of actions and activities, it is about the possibility to think outside the norm, in order to project new spatial, and hence social, conditions. This process of evolving a brief may not provide the immediate rush of visual stimulation that is associated with the creative design of an object ... but it does have a much longer-term and profound effect.
>
> (2009: 169)

While it is too early to claim any such long-term effects, the intersecting problems the brief aimed to address explicitly sought to 'think outside the norm' to develop new spatial and social conditions. More specifically, we aimed to push forwards critical and creative thinking in a number of key areas. First, by recognising that museums are densely entangled with the *problem* of climate change, we sought to underline the need for an epistemic shift in museological thinking and practice to bring about meaningful climate action. Second, by highlighting the manifold ways in which museums are to some extent already embedded in the work of climate action, we hoped to draw together disparate strategies and approaches from across the sector. Third, by expanding the

conversation around this problem to those outside the rather narrow field of 'museum studies,' we sought to encourage transdisciplinary perspectives and imaginaries. Finally, by embracing design as a creative methodology for the field, the project as a whole aimed to challenge preconceptions about what a museum could or should be.

The competition attracted over 500 expressions of interest, resulting in 264 submissions from 48 countries around the world. Eight teams were then invited to be part of an exhibition at Glasgow Science Centre, the official 'Green Zone' for COP26. The exhibitors included established designers, curators, academics, sound artists, digital specialists, Indigenous filmmakers, emerging architectural practices, and museum managers–a good example of the transdisciplinary conversations and alliances required to 'reimagine' museums in any meaningful way. The international scope of the competition also underlined the fact critical and creative thinking about museums often involves moving between different scales and contexts, from the hyper-local to the planetary, from city centres to forest ecosystems.

As a compendium of possible futures, the ideas presented in the exhibition (and the 'further concepts' available on the project website) opened a range of alternative pathways for the museum field. In the rest of this chapter, we sketch out the main implications of this work around the two key themes of speculation and profanation: an alignment that offers valuable lessons in the need for creation and imagination to be part of critical museological thinking.

Speculative Worlds

The climate crisis is also a crisis of culture, and thus of the imagination.

(Ghosh 2016: 9)

What does it mean to understand precarity as an 'earthwide condition,' as Anna Tsing invites us to do in her multi-species ethnography *The Mushroom at the End of the World*? (2015: 5) What do we gain from this planetary (re)alignment, and what might it obscure? For Tsing precarity is the 'condition of being vulnerable to others,' a relational state in which 'we are thrown into shifting assemblages' and 'everything is in flux, including our ability to survive' (ibid: 20). Risk, endangerment, and loss all flourish in precarious times. But so too does indeterminacy: the sense that other futures might be possible. As banners held aloft at climate marches around the world attest: BUSINESS AS USUAL IS KILLING US ALL. 'Earthwide' precarity shares something with Dipesh Chakrabarty's 'negative universal history,' which calls for a 'global approach to politics without the myth of a global identity' (2009: 222), but it also means embracing what Tsing describes as the 'patchy unpredictability' of our current condition (2016: 5). If precarity can be understood as the realisation–sometimes slow, sometimes sudden–that we can no longer rely on the status quo, then it is also a moment in which thinking beyond current parameters becomes the very opposite of abstract or introspective. When

business as usual means crisis without end, imagining otherwise becomes an urgent task of collective repair and resilience.

As Amitav Ghosh writes in his searing book *The Great Derangement*, the climate crisis is shadowed by a broader 'imaginative and culture failure' (2016: 8), one in which art and literature can be seen to have capitulated with the narratives of progress and individualism that undergird industrial modernity. Indeed, the 'derangement' Ghosh outlines is as much about the conventions and orthodoxies of certain cultural practices as it is about biodiversity loss, a warming climate, melting permafrost, or rising sea levels. Early in his book Ghosh poses the following thought experiment to tease out the strangeness of this situation:

> In a substantially altered world, when sea-level rise has swallowed the Sundarbans and made cities like Kolkata, New York, and Bangkok uninhabitable, when readers and museum-goers turn to the art and literature of our time, will they not look, first and most urgently, for traces and portents of the altered world of their inheritance? And when they fail to find them, what should they – what can they – do other than to conclude that ours was a time when most forms of art and literature were drawn into the modes of concealment that prevented people from recognising the realities of their plight? Quite possibly, then, this era, which so congratulates itself on its self-awareness, will come to be known as the time of the Great Derangement.
>
> (2016: 11)

A question that lingered at the back of our minds as we developed the Reimagining Museums project was this: to what extent might heritage and museums constitute a 'mode of concealment' in the same vein as art and literature? For museums in particular, this question opens up an important counter-narrative that challenges the centrality of display, education, and knowledge production to the field. While individual museums may seek to 'tell the story' of climate change, the broader social and cultural frameworks in which museological thinking and practice are embedded can equally be understood as a manifestation of the Great Derangement. This raises an interesting problem for imagining 'museum-goers' of the future, as Ghosh asks us to do in the above passage. Most people who embark on this mental journey are likely to conjure a very particular idea of the museum—most likely a temple-like structure in which objects and texts are arranged for contemplative enjoyment and edification. For us, this vision is misguided. Museum-goers of the future—if they exist at all—will not look at 'our' time and 'our' culture in this way, because the very model of the museum that such a space evokes may be considered part of the Great Derangement. New models and new museological imaginaries are required to escape this predicament.

Speculative design offers one way of thinking through such imaginaries. In their book *Speculative Everything*, Anthony Dunne and Fiona Raby note that

speculative design is not about *predicting* the future but is rather a strategy for using design to 'open all sorts of possibilities that can be discussed, debated, and used to collectively define a preferable future for a given group of people' (2013: 6). Such an approach 'thrives on imagination' (ibid: 2) and recognises that critique must move beyond negativity. In Dunne and Raby's words, speculative design can be 'a gentle refusal, a turning away from what exists, a longing, wishful thinking, a desire, and even a dream' (ibid: 34). While this strategy calls on people to think beyond the limitations of current social, economic, and technological systems, it is also grounded in *and responsive to* the complexities of the present. Indeed, speculative design specifically aims to open up new perspectives on so-called wicked problems—complex issues that seem to have no easy solution such as climate change.

Many of the proposals submitted to the Reimagining Museums competition exemplified this approach. *Museum of Open Windows*, for example—a collaborative project developed by Livia Wang, Nico Alexandroff, RESOLVE Collective (Akil Scafe-smith, Seth Scafe-smith, Melissa Haniff), and Studio MASH (Max Martin, Angus Smith, Conor Sheehan)—imagined a networked infrastructure of repurposed museums enabling citizens and communities to care for the planet. As their project description states:

> Rather than document faraway places ... the *Museum of Open Windows* focuses attention on the nearby and the particular. The museum in this context takes the form of an audio Field Guide directing people on a guided walk of their local environment, encouraging the listener to engage directly with the ecosystem they inhabit and identify signs of a warming climate. With access to expertise and equipment, a community group might "open a window" onto their world by providing realtime footage of a landscape or industrial activity, to be accessed and shared globally with other communities online. They will be able to share quantitative information on water, soil and air quality, as well as more subjective accounts of their environments, redressing the predominance of cold scientific data in this field.

Crucially, by 'uncoupling' the idea of the museum from a specific building or site, the *Museum of Open Windows* asks how communities worldwide might research, catalogue, and ultimately care for their own distinct terrains. The speculative in this context can be understood as a gesture of hybridisation and recrafting. As Dunne and Raby put it, designing for possible futures means embracing 'the many tools available for crafting not only things but also ideas—fictional worlds, cautionary tales, what-if scenarios, thought experiments, counterfactuals, *reductio ad absurdum* experiments, prefigurative futures' (2013: 3). The Field Guide produced by the *Museum of Open Windows* team is one such thought experiment, brought to reality in the here-and-now to help imagine what could be.

Weathering With Us by Isabella Ong and Tan Wen Jun–another proposal sub-mitted to the competition–also evokes the capacity for speculative design to push museums in an entirely new direction. In this case, the museum is a building, only one that might act as a beacon of hope and healing for the planet. Represented as a scale model in the exhibition in Glasgow, *Weathering With Us* imagines a new kind of museum architecture functioning as a huge, rotating sand 'clock,' with a mechanical armature that etches patterns onto a circular sandy landscape. As their project description states, the sand in this scenario is ground olivine, a volcanic mineral found abundantly in the Earth's subsurface:

> When seawater meets olivine, a chemical reaction occurs that pulls carbon dioxide out of the air and the carbon finds its way to the bottom of the sea as the shells and backbones of molluscs and corals, stored as carbon deposits. This process, mineral weathering, constitutes one of the Earth's natural mechanisms to regulate its carbon level and functions as an important carbon sink.

Rotating over a 24-hour cycle, the museum building in this concept would inscribe data patterns onto the sand-scape, from carbon emissions and pollution indexes to meteorological data, translated into a 'collective fingerprint of our ac-tions.' The building itself–the 'armature'–would be split into two parts. On one side, the programmatic functions of a typical museum: galleries, research centres, and a café. On the other, a kinetic mechanism engraving the sand through a maze of walls constantly actuating up and down: 'The experience of walking through this perpetually shifting (albeit very slowly) sand-filled maze would be a contemplative one, as visitors weave around the walls, watching as the sand trickles by on the ground.' This is a fantastical project to be sure, but in this unviability lies a serious message about the potential for museum buildings themselves to be both spaces of poetic reflection and technologies of climate repair, in this case actively removing carbon from the atmosphere.

Understanding museums through the framework of speculative design means challenging the assumptions and orthodoxies guiding work in this field, from narrow concepts of what counts as a museum building to taken-for-granted ex-pectations about how and what museums should collect. Such rethinking is intrinsically oriented towards experimental forms of museological practice–an approach that seems all the more urgent in the face of profound social and en-vironmental change. We should remember however that climate change is also a *historical* concern. As Malm puts it, 'the storm of climate change draws its force from countless acts of combustion over … the past two centuries' (2018: 5). Precarity may end up being a fertile ground to explore possible future worlds, but this must not be at the expense of a deep questioning of what has come before. It is here that the concept of profanation becomes particularly relevant to our own project of 'reimagining' heritage and museums.

FIGURE 5.1 *Existances* by Jairza Fernandes Rocha da Silva, Nayhara J. A. Pereira, Thiers Vieira, João Francisco Vitório Rodrigues, Natalino, Neves da Silva and Walter Francisco Figueiredo Lowande, one of the displays in the *Reimagining Museums for Climate Action* exhibition at Glasgow Science Centre, overlooking the main venue for COP26. Photograph by Jonathan Gardner for RMCA.

Profane Museologies

Profanation shares a certain irreverence with speculative thinking, but it moves towards rebellion and dissent rather than subtle reorganisation or redesign. While this attitude has a particular resonance with work that aims to challenge the temple-like design and experience of museum buildings (see Duncan 1991), our use of the term engages with a broader understanding of 'the museum' as an ontological category.

As we noted earlier, museums resist easy definition. They are composite and multiple, and embrace a multitude of agendas, narratives, and positionalities. Recognising this heterogeneity, we contend that to understand (and potentially redirect) the work museums perform in the world we must first place them under the much broader heading of 'apparatus,' a term Foucault identifies as a 'kind of historical formation, so to speak, that at a given historical moment has as its major function the response to an urgency' (in Agamben 2009: 3). Foucault gathers an expansive set of material and discursive phenomena under this heading, including 'institutions, architectural forms, regulatory decisions, laws, administrative measures, scientific

statements, philosophical, moral, and philanthropic propositions' (ibid). In his essay *What Is an Apparatus?* Agamben somehow extends this even further, arguing that an apparatus can be 'literally anything that has the capacity to capture, orient, intercept, model, control, or secure the gestures, behaviours, opinions or discourses of living beings' (ibid: 14). Here Agamben draws together traditionally Foucauldian spaces such as the prison, the asylum the school, the panopticon, and the factory with more diffuse processes such as writing, literature, agriculture, and navigation. Apparatuses in this sense are not 'a mere accident in which humans are caught by chance, but rather are rooted in the very process of "humanization" that made "humans" out of the animals' (ibid: 16). This is because the central purpose of apparatuses for Agamben is subjectification: the procedure by which a subject may be led to observe, analyse, interpret, and recognise itself as 'a domain of possible knowledge' (Stewart and Roy 2014). It hardly needs stating that there are clear links here with Tony Bennett's understanding of the civilising work of museums in the nineteenth century, which explicitly sought to create subjects of nation and empire (Bennet 1995).

While Foucault defined his own work as an attempt to create 'a history of the different modes by which, in our culture, human beings are made subjects' (1982: 777), Agamben again goes further, suggesting that the incessant process of subjectification effectively separates the world into two vast ontological categories:

> On the one hand, living beings (or substances), and on the other, apparatuses in which living beings are incessantly captured. On one side … lies the ontology of creatures, and on the other side … apparatuses that seek to govern and guide them toward the good.
>
> (ibid: 13)

Ontologically then–and recognising the vast proliferation of museum-like institutions over the past two centuries–museums may be understood as a particularly successful type of apparatus: a mode of 'capturing' and producing subjects that have been deployed, appropriated, and mobilised in diverse contexts around the world (see Harrison 2013). As Clifford argued, 'aspirations of both dominant and subaltern populations can be articulated through this structure, along with the material interests of national and transnational tourism' (1997: 218).

As apparatuses of subjectification, museums may serve many purposes, from buttressing the nation-state and civilising populations to fostering debate and nurturing new ways of being in the world. Understanding museums in this way does not offer a tidy definition of *what a museum is*, but it does help us to grasp the broader implications of historic and contemporary museological praxis. Apparatuses are both ubiquitous and materially specific. They are strategic and concrete interventions that speak to particular relations of power and knowledge. Placing museums in this ontological category helps us to recognise that while they may be put to many different purposes, museums cannot be disentangled from the broader processes of subjectification that model and contaminate 'the life of individuals'

(Agamben 2009: 15). It is here that Agamben's related concept of 'profanation' becomes important. For Agamben, apparatuses serve to remove things from 'common use' (ibid: 17), a term that implies openness and collective possibility. Combatting apparatuses therefore means 'liberating' that which remains captured and separated, a process Agamben explains through the Roman idea of profanation. While 'consecration' designated 'the exit of things from the sphere of human law, "to profane" signified, on the contrary, to restore the thing to the free use of men' (ibid: 18). Such language obviously echoes museological debates around restitution and repatriation, but there is also something much broader at stake in this conceptualisation. To profane museums is to call their very status as apparatuses into question with a view to disentangling the varied partitions and sacrifices they embody and make manifest. As Agamben puts it, 'profanation is the counter-apparatus that restores to common use what sacrifice had separated and divided' (ibid: 19).

The idea of 'restoring' (or indeed never capturing) objects and subjects of knowledge surfaced across many of the concepts submitted to the *Reimagining Museums* competition, from proposals to 'rewild' the museum to new models of distributed collecting. Perhaps the clearest evocation of what we are calling profanation can be found in DESIGN EARTH's animated film *Elephant in the Room*, however. This allegorical tale–created by Rania Ghosn, El Hadi Jazairy, Monica Hutton, and Anhong Li, and narrated by Donna Haraway–imagines one of the stuffed elephants in the American Museum of Natural History coming to life and rampaging through the streets of New York to demand climate justice. In profaning the famous displays of the Akeley Hall of African Mammals, the film invites a 'critical revision of the museum's myriad entanglements with extractivist environmental histories, which have constructed worlds (and worldviews) that perpetuate division, dispossession and violence' (Ghosn et al. 2021: 121). The film's playful and irreverent approach masks a complex message about the need for alternative myths and fables for the climate change era; what the DESIGN EARTH team call a 'praxis of care and response' (ibid). The elephant in this sense profanes the museum to undo its own capture, but also to make visible the very workings of the museum as an apparatus of subjectification. By the end of the film, only the façade of the museum remains: a vast counter-apparatus designed to inspire meaningful climate action.

Conclusions: Modelling Action

Climate change teaches us that cultural, technological, and economic formations are densely interwoven with the atmosphere, which in turn impacts on political and social life at every scale (Guattari 1989). This feedback loop also means that climate action can take many forms. *Project Drawdown* for example identifies a wide variety of 'solutions' to the climate crisis, ranging from the protection of ecosystems to the improvement of health and education across society (Hawken 2017). Typically, the

rhetoric of climate action focuses on reducing greenhouse gas emissions, mitigating against further climate breakdown, and adapting to the challenges of a warming world. Some actions test or exceed these boundaries, however. Economic sanctions, lobbying, civil disobedience, mass strikes, and–for some–withdrawal from the social and political systems that have created the crisis all expand the meaning and scope of 'climate action.' The museum sector already contributes to this work in a number of ways. New museum buildings celebrate their sustainable credentials; curatorial programmes seek to educate people about the causes and consequences of climate change; collecting activities highlight stories of environmental loss and resilience. As heterogeneous sites of cultural production and consumption, museums have also become key battlegrounds in debates over climate inaction. The scope for 'reimagining' museums is therefore wide-ranging and–for some–daunting. When so much is at stake it becomes increasingly difficult to identify specific points where meaningful change can be enacted and measured.

Rather than shy away from this prodigious task, we prefer to expand the contours of the challenge even further. Reimagining museums for climate action is not, ultimately, about museums themselves. It is about the wider social and environmental conditions that museums emerge from and feed back into. The speculative and profane futures we advocate for do not stop at the threshold of the museum (whatever form this might take). Instead, 'rethinking' work in this field should be undertaken primarily in response to–and as an impetus for–further radical change across society. While this may seem like a responsibility museums are ill-equipped to take on, it is our contention that modelling change in this field has the potential to shift debates around climate action more widely. Somewhat paradoxically, this is because museums are so deeply connected to the emergence of climate change in the first place. If more just and sustainable futures can be imagined for *this* field–a field which, we must remember, continues to support and maintain various forms of oppression linked to colonialism, imperialism, capitalism, and nationalism–then the scale and urgency of climate action might be brought into sharper focus for an even broader range of social and political apparatuses.

In this light, reimagining museums for climate action becomes an almost impossibly varied project of material, social, cultural, political, economic, and institutional change. At the level of material and spatial infrastructures, questions of recycling, adaptive reuse, and carbon reduction come to the fore. At the level of systems and policies, new methods of recruitment and governance may be required to enact meaningful change. As inherently relational entities, thinking about museums as catalysts for climate action asks us to consider the extent to which they are embedded in local communities, or networked with each other across regional, national, and planetary scales. Finally, as spaces of experience, education, and narrative, museums have a crucial role to play in shifting subjectivities, which may include challenging individualised and all-too-human notions of this concept. And, of course, all of these are connected from the very outset, feeding into one another in expected and unforeseen ways.

What we also find across much of this work is a recognition–sometimes explicit, sometimes implicit–that the emergence and spread of museums around the world tracks the rise of carbon emissions and environmental degradation in ways that can no longer be ignored. This realisation offers a useful corrective to the optimistic reading of museums as a diverse global phenomenon mentioned earlier. While the global museum 'franchise' described by Janes may be seen as a valuable tool in the fight against climate change on one hand, it can also be read as an artefact of the Industrial Revolution, or of colonialism, or the Great Acceleration. Museums are being called into question in this moment of crisis precisely because they can be seen as both an instrument and a legacy of the processes that have led to Earthwide precarity. Even as they celebrate and promote their capacity to protect, conserve, and 'care for' the planet, museums also embody and in some cases perpetuate the Great Derangement that undergirds climate breakdown. The collective, participatory, and speculative approach developed for the *Reimagining Museums* project provides one example of the kind of transdisciplinary thinking required to overcome this situation, but this should also leave space for something deeper, something that gets at the profound divisions and separations enacted by the museum as an apparatus of subjectification. Agamben's notion of the profane offers one way to think through this epistemic and ontological shift.

Acknowledgements

Reimagining Museums for Climate Action received funding from the Arts and Humanities Research Council (AHRC) as a joint initiative under Rodney Harrison's Heritage Priority Area Leadership Fellowship (AH/P009719/1) and Colin Sterling's Innovation Fellowship 'New Trajectories in Curatorial Experience Design' (AH/S00436X/1). The project was undertaken in partnership with Henry McGhie (Curating Tomorrow) and the Glasgow Science Centre. Rowan Ward was a postdoctoral researcher on the project, which was also assisted by Janna Oud Ammerveld. See www.museumsforclimateaction.org for further information.

Notes

1 In the wake of Agamben's comments on the pandemic, we are mindful of revisiting his work in this context, but we continue to find some purchase in his re-reading of Foucault, even if his much broader biopolitical project must now be called into question.
2 As Candlin notes, this number is significantly less than in previous years (there were 26 permanent closures in 2017 and 16 in 2018), and only one of the closures in 2020 can be linked to the COVID crisis. Emergency funding from the UK government made it possible for most museums to survive the pandemic.
3 Recognising the ways in which this situation hit BAME heritage and museum workers particularly hard, Museum Detox, the UK-based organisation representing museum and heritage professionals who identify as people of colour, established a hardship fund to provide micro-grants to support its members during the pandemic (Museum Detox 2020).

References

Agamben, Giorgio. 2009. *What Is an Apparatus? And Other Essays*. Translated by David Kishik and Stefan Pedatella. Stanford, California: Stanford University Press.

Arfvidsson, Helen and Ann Follin. 2020. Connectedness, consumption and climate change: The exhibition human nature. *Museum Management and Curatorship* 35(6), 684–696.

Azoulay, Ariella Aïsha. 2019. *Potential History: Unlearning Imperialism*. London: Verso.

Bennett, Tony, Fiona Cameron, Nelia Dias, Ben Dibley, Rodney Harrison, Ira Jacknis and Conal McCarthy. 2017. *Collecting, Ordering, Governing: Anthropology, Museums and Liberal Government*. Durham: Duke University Press.

Bennett, Tony. 1995. *The Birth of the Museum: History, Theory, Politics*. London and New York: Routledge.

Breithoff, Esther. 2020. *Conflict, Heritage and World-Making in the Chaco: War at the End of the Worlds?* London: UCL Press.

Brophy, Sarah S. and Elizabeth Wylie. 2013. *The Green Museum: A Primer on Environmental Practice*. Lanham: AltaMira Press.

Callón, Michel, Pierre Lascoumes and Yannick Barthe. 2009. *Acting in an Uncertain World: An Essay in Technical Democracy*. Cambridge, Mass.: MIT Press.

Cameron, Fiona and Brett Neilson (eds.). 2014. *Climate Change and Museum Futures*. New York: Routledge.

Cameron, Fiona, Bob Hodge and Juan Francisco Salazar. 2013. Representing climate change in museum spaces and places. *WIREs Climate Change* 4(9): 9–21.

Candlin, Fiona. 2021. Museum closure during the pandemic. Mapping Museums Blog 25 May 2021. Available online: http://blogs.bbk.ac.uk/mapping-museums/2021/05/25/museum-closure-during-the-pandemic/ [Accessed 30 June 2021].

Candlin, Fiona and Jamie Larkin. 2020. What is a museum? Difference all the way down. *Museum & Society* 18(2), 115–130.

Chakrabarty, Dipesh. 2009. The climate of history: Four theses. *Critical Inquiry* 35, 197–222.

Clifford, James. 1997. *Routes: Travel and Translation in the Late Twentieth Century*. Cambridge, MA: Harvard University Press.

Davis, Joy (ed.) 2020. Museums and climate action [special issue]. *Museum Management and Curatorship* 35(6), 584–704.

DeSilvey, Caitlin and Rodney Harrison. 2020. Anticipating loss: Rethinking endangerment in heritage futures, *International Journal of Heritage Studies*, 26(1), 1–7.

DeSilvey, Caitlin. 2017. *Curated Decay: Heritage Beyond Saving*. Minneapolis & London: University of Minnesota Press.

Duncan, Carol. 1991. Art Museums and the Ritual of Citizenship. In: Karp, Ivan and Steven D. Lavine (eds.) 1991. *Exhibiting Cultures: The Poetics and Politics of Museum Display*. Washington and London: Smithsonian Institution Press, 88–103.

Dunne, Anthony and Fiona Raby. 2013. *Speculative Everything: Design, Fiction, and Social Dreaming*. Cambridge, Mass; London: MIT Press.

Foucault, Michel. 1980. *Power/Knowledge: Selected Interviews and Other Writings 1972–1977*. Edited byColin Gordon. New York: Pantheon Books.

Foucault, Michel. 1982. The subject and power. *Critical Inquiry* 8(4), 777–795.

Ghosh, Amitav. 2016. *The Great Derangement: Climate Change and the Unthinkable*. Chicago and London: The University of Chicago Press.

Ghosn, Rania, El Hadi Jazairy, Monica Hutton and Anhong Li. 2021. Elephant in the room. In: Rodney Harrison and Colin Sterling (eds.) *Reimagining Museums for Climate Action*. London: MfCA, 120–125.

Guattari, Felix. 1989 [2014]. *The Three Ecologies*. Translated by Ian Pindar and Paul Sutton. London & New York: Bloomsbury.

Harrison, Rodney, Caitlin DeSilvey, Cornelius Holtorf, Sharon Macdonald, Nadia Bartolini, Esther Breithoff, Harald Fredheim, Antony Lyons, Sarah May, Jennie Morgan and Sefryn Penrose. 2020. *Heritage Futures: Comparative Approaches to Natural and Cultural Heritage Practices*. London: UCL Press.

Harrison, Rodney. 2013. *Heritage: Critical Approaches*. Abingdon and New York: Routledge.

Harrison, Rodney. 2015. Beyond 'natural' and 'cultural' heritage: Towards an ontological politics of heritage in the age of the anthropocene. *Heritage and Society* 8(1), 24–42.

Harrison, Rodney and Colin Sterling (eds.) 2021. *Reimagining Museums for Climate Action*. London: MfCA.

Hawken, Paul (ed.) 2017. *Drawdown: The Most Comprehensive Plan Ever Proposed to Reverse Global Warming*. New York: Penguin Putnam Inc.

ICOM 2020. *Museums, Museum Professionals and COVID-19*. Paris: ICOM. Online at https://icom.museum/wp-content/uploads/2020/05/Report-Museums-and-COVID-19.pdf.

ICOMOS Climate Change and Cultural Heritage Working Group. 2019. *The Future of Our Pasts: Engaging Cultural Heritage in Climate Action*, July 1, 2019. Paris: ICOMOS.

Janes, Robert R. 2009. *Museums in a Troubled World: Renewal, Irrelevance Or Collapse?* Routledge.

Kendall Adams, Geraldine. 2021. Workforce beard brunt of pandemic. *Museum Journal* 28 May 2021. Availabline online: https://www.museumsassociation.org/museums-journal/analysis/2021/05/workforce-bears-brunt-of-pandemic/ [Accessed 30 June 2021].

L'Internationale (eds.) 2016. *Ecologising Museums*. Paris: L'Internationale.

Malm, Andreas. 2018. *The Progress of This Storm: Nature and Society in a Warming World*. London: Verso.

McGhie, Henry. 2019a. *Museum collections and biodiversity conservation*. Manchester: Curating Tomorrow. Available online: http://www.curatingtomorrow.co.uk/wp-content/uploads/2020/01/museum-collections-and-biodiversity-conservation-2019.pdf [Accessed 30 June 2021].

McGhie, Henry. 2019b. *Museums and the Sustainable Develop Goals: A How-to Guide for Museums, Galleries, the Cultural Sector and Their Partners*. Manchester: Curating Tomorrow.

Morton, Timothy. 2013. *Hyperobjects: Philosophy and Ecology at the End of the World*. Minneapolis: Minnesota University Press.

Museum Detox 2020. Supporting Museum Detox Membership via the Hardship Fund, formerly Coronavirus Emergency Fund. Online at https://www.museumdetox.org/post/supporting-museum-detox-membership-via-the-hardship-fund-formerly-coronavirus-emergency-fund.

Newell, Jennifer, Libby Robin and Kirsten Wehner. 2016. *Curating the Future: Museums, Communities and Climate Change*. London and New York: Routledge.

Þórsson, Bergsveinn. 2018. When matter becomes a monster: Examining anthropocenic objetcs in museums. *Museological Review* 22, 44–53.

Þórsson, Bergsveinn and Nørskov Vinnie (eds.) 2020. Curating climate [special issue]. *Nordisk Museologi* 2020(3), 1–73.

Steffen, Will, Johan Rockströma, Katherine Richardsonc, Timothy M. Lentond, Carl Folkea, Diana Liverman, Colin P. Summerhayes, Anthony D. Barnosky, Sarah E. Cornella, Michel Crucifix, Jonathan F. Dongesa, Ingo Fetzera, Steven J. Ladea, Marten Scheffer, Ricarda

Winkelmann and Hans Joachim Schellnhubera. 2018. Trajectories of the earth system in the anthropocene. *PNAS* 115(33), 8252–8259.

Sterling, Colin and Rodney Harrison. 2020. Introduction: Of territories and temporalities. In: Harrison, R. and C. Sterling (eds.) *Deterritorializing the Future: Heritage in, of and after the Anthropocene*. London: Open Humanities Press.

Sterling, Colin. 2019. Designing 'critical' heritage experiences: Immersion, enchantment and autonomy. *Archaeology International* 22(1), 100–113. 10.5334/ai-401.

Sterling, Collin 2020. *Heritage, Photography, and the Affective Past*. Abingdon and New York: Routledge.

Stewart, Eric and Ariel D. Roy. 2014. Subjectification. In: Teo, Thomas (eds.) *Encyclopedia of Critical Psychology*. New York, NY: Springer. 10.1007/978-1-4614-5583-7_358.

Sutton, Sarah and Cynthia Robinson (eds.) 2020. Museums and Public Climate Action [special issue]. *Journal of Museum Education* 45(1), 1–107.

Till, Jeremy. 2009. *Architecture Depends*. London & Cambridge, Mass: The MIT Press.

Tsing, Anna Lowenhaupt. 2015. *The Mushroom at the End of the World: On the Possibility of Life in Capitalist Ruins*. Princeton and Oxford: Princeton University Press.

UNESCO 2020. Museums around the World in the face of COVID-19. Paris: UNESCO. Online at https://unesdoc.unesco.org/ark:/48223/pf0000373530.

Vidal, Fernando and Nélia Dias. 2016. Introduction: The endangerment sensibility. In *Endangerment, Biodiversity and Culture*, edited by Fernando Vidal and Nélia Dias, 1–48. Abingdon and New York: Routledge.

Wallace-Wells, David. 2019. *The Uninhabitable Earth: A Story of the Future*. London: Penguin.

Yusoff, Kathryn. 2018. *A Billion Black Anthropocenes or None*. Minneapolis: University of Minnesota Press.

6

TOWARDS A WORLD HERITAGE FOR THE ANTHROPOCENE

Cornelius Holtorf

UNESCO World Heritage—A Matter of Trust

According to the Constitution of UNESCO, adopted on November 16, 1945, in response to the death and destruction of World War II that had just ended, 'the purpose of the Organization is to contribute to peace and security by promoting collaboration among the nations through education, science and culture in order to further universal respect for justice, for the rule of law and for the human rights and fundamental freedoms.' In order to realise this purpose, the members of UNESCO committed to maintain, increase, and diffuse knowledge about the peoples of the world, building trust between them, by, among others, 'assuring the conservation and protection of the world's inheritance of books, works of art and monuments of history and science, and recommending to the nations concerned the necessary international conventions.' This formulation prefigured a number of Conventions and initiatives, among them the 1972 World Heritage Convention (UNESCO 1972, Labadi 2013: 26).

By the end of 2022, there were 1154 World Heritage properties inscribed as stipulated by the 1972 Convention. Arguably, it is the most successful among all UNESCO Conventions and is sometimes referred to as its 'flagship' (Rudolff and Buckley 2016: 525). The World Heritage List has a high global profile, and the Convention has been signed and ratified by a current total of 194 states, which is more than the equivalent number for any other UNESCO Convention and indeed one more (!) than UNESCO currently has members. At the same time, the World Heritage Convention faces considerable and often raised problems and challenges of various kinds (see e.g. Bandarin 2007, Askew 2010, Labadi 2013, Ndoro and Wijesuriya 2015, Meskell 2018, Moukala and Odiaua 2019, Wienberg 2021: ch. 6). Some are related to the consequences of a long history of Eurocentrism in heritage

DOI: 10.4324/9781003188438-10

management. It has been argued for some time that seemingly global categories such as the Convention's 'Outstanding Universal Value' (OUV) and the criteria determining it are largely based on Western notions and values of heritage, thus favouring sites in the Global North and associated historical narratives (Cleere 2001, Borck 2019). Many of these issues have already been addressed, with varying success, through the work of the World Heritage Committee, drawing on the Convention and its Operational Guidelines (Labadi 2013: ch. 2, Cameron and Rössler 2013, Rudolff and Buckley 2016).

Other challenges to the World Heritage Convention are about its implementation in practice. For too many of the Convention's States Parties, the act of inscription itself is a matter of competition and prestige. Counting sites has become more important than ensuring conservation of heritage and increasing knowledge about the peoples of the world. This has probably not been contributing to building trust between them. The commonly used chart of top nations by number of World Heritage properties is quite revealing (Figure 6.1). The chart shows several things. Firstly, it uses the nation-state as the underlying parameter emphasising boundaries and reaffirming differences between nations. Secondly, it depicts the absolute numbers of inscribed world heritage properties in each nation rather than, e.g., their number relative to population size. Both aspects illustrate the global significance of UNESCO World Heritage for nation-building (Askew 2010, Labadi 2013: ch. 3, Meskell 2018: ch. 5) and in particular its misappropriation as 'World-level National Heritage' (Yan 2016: 239). This is probably not entirely surprising in a United Nations context which is often more nation-centred than united. But as people(s) and nations are different entities, it is not necessarily in line with the overarching ambition to maintain, increase, and diffuse knowledge about the peoples of the world.

Thirdly, even accounting for unconsidered population sizes, the chart reveals considerable differences in the frequency of world heritage properties which is surprisingly high in Western Europe and the Global North, dominating the top 20 nations, and surprisingly low in the Global South, with not a single nation in this list from Africa. This illustrates global distinctions and the Eurocentric bias of the list mentioned earlier, side-lining the Convention's original ambition to advance global collaboration and equality.

Arguably, the World Heritage Convention's current practices of conservation have far too often been taking an object-centred and nation-state-focused approach. Contrary to the original intentions, world heritage sites are in practice not considered as the world's *shared* protected heritage but frequently championed by their respective nation-states which focus on distinguishing 'our' from 'their' heritage. As Patrick Rhamey (2019: 33) argued, 'states seek status as recognition of their importance' and receiving World Heritage status from UNESCO can attribute such status. Although that may relieve some of their additional needs of recognition and make them more peace-seeking, it can also have the opposite effect. The links between cultural heritage and nationalism are well understood (most recently Bonacchi 2022). For communities, societies, and states, cultural heritage sites can

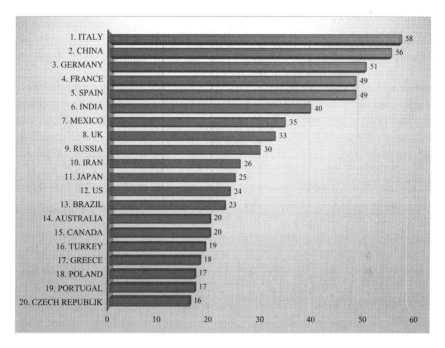

FIGURE 6.1 World Heritage Properties, by number per nation (top 20, August 2022).

become an instrument of committing symbolic violence against perceived rivals and thereby become a driver of conflicts and crises: it can polarise, undermine social cohesion, and increase the risk of violent conflict (EU 2021: 4). Cultural heritage and its need of protection have also been instrumentalised by military leaders to recruit and mobilise troops in ongoing wars (Isakhan and Akbar 2022). Unsurprisingly in this context, the World Heritage Convention has not always been able to relieve global tensions and conflicts between peoples and nations but sometimes become a medium for expressing them. This is sad but, fortunately, also something that can be rectified: after all, according to the famous UNESCO phrase, since wars begin in the minds of humans, it is in the minds of humans that the defences of peace can, and must, be constructed.

There have already been a number of initiatives to make the practice of UNESCO World Heritage more people-centred, e. g. by working more towards communities and their peaceful cohabitation. According to a Resolution of the 20th General Assembly of the International Council on Monuments and Sites (ICOMOS 2020), it is important for ICOMOS not only to honour heritage communities and individuals' rights but also to 'promote people-centred approaches, the connections of people with heritage and places, intercultural dialogue and understanding, sustainability and well-being' in relation to heritage policies and practice. In order to be meaningful, a people-centred approach must go beyond

state paternalism and expert-centred knowledge and judgment. The world heritage sector needs to do more than providing access to properties, disseminating relevant expert knowledge, and merely consulting stakeholders when national expert authorities make decisions.

In 2020, a major initiative 'Our World Heritage' (www.ourworldheritage.org) was launched ahead of the 50th Anniversary of the World Heritage Convention in 2022. The group of people behind this initiative argue that heritage conservation in general and the World Heritage Convention in particular are in crisis and, ironically, themselves endangered. During all of 2021, the initiative mobilised citizens and professionals to renew and reinforce heritage protection, including as many representatives of civil society as possible. But something is wrong when global society is called on to serve the 1972 Convention whose own function is to serve global society. Maybe the time has come to start asking what comes after world heritage as defined by the 1972 Convention and how global heritage in today's world can contribute to building sustained trust and solidarity between people. In other words, we need better reasons for presuming that future generations will look back with gratitude and admiration at our efforts to identify, protect, and conserve the world's outstanding cultural and natural heritage.

Arguably, trust is the most precious and scarce resource within and between human societies today. Closely related to mutual respect, trust determines well-being and quality of life among human beings in a community, a society, a state, or on a planet. According to a recent UN report entitled *Our Common Agenda* (Guterres 2021: 3–4), the world needs to 're-embrace global solidarity' and to 'renew the social contract between Governments and their people and within societies, so as to rebuild trust.' What the world should be measuring to examine the success of the 1972 Convention is thus not the number of world heritage properties per nation or world region but the extent to which heritage and associated cultural processes have been increasing well-being, solidarity, and trust within and between people, societies, and governments around the world. Measuring trust has been the topic of an extensive OECD report which concluded that there is good evidence that survey questions can produce valid data on assessing levels of trust (OECD 2017: 3). Trust is also among the parameters assessed by The World Values Survey (https://www.worldvaluessurvey.org/) and discussed in a recent UNESCO report about cultural indicators for sustainable development (Hosagrahar 2019: 80–82).

The Significance of World Heritage Today

Never has the potential of heritage to contribute actively to managing the relations between present and future societies been more important than now. It seems as if the very existence of a future humanity is at stake in the Anthropocene—whether that may be due to climate change, warfare, environmental pollution, global inequalities, artificial intelligence, nuclear weapons, or new viruses.

When the emerging challenges, or their global consequences, are bigger than humans can control, they demand from them an ability to embrace change, adapt, and develop–cultural resilience for short (Holtorf 2018). Cultural heritage, as we have come to define and manage it until today, cannot provide this resilience and thus meet these challenges, for three main reasons: it often inspires us to think backward rather than forward, it is bound up with conservation when we need to facilitate change, and it promotes distinct identities of cultural groups rather than common human solidarity and mutual trust. Thomas Hylland Eriksen (2019: 6) supported this last point very succinctly when he stated that

> At a time when nativism and divisive identity politics threatens people's autonomy and well-being across the planet, from autochthonism in Africa to militant Islamism in the Middle East and emergent ethnonationalism in Europe, an ontology of social being that does not privilege boundaries and origins over connectedness and impurity is deserving of sustained and systematic attention.

Globalisation has meant that there is an increasing number of people migrating between world regions as global nomads (Vince 2022), whether as refugees, for work or for family reasons, resulting in increasing cultural heterogeneity in many contemporary nation-states. Neighbours in the same area may carry citizenship of different nations, speak a variety of languages, and practice distinct cultural traditions and religions (Colomer and Holtorf 2019: 147–148). As Gaia Vince (2022: 207) pointed out, '[m]igrants are the bridges between cultures, helping us to better understand ourselves as well as each other.' As many contemporary societies are culturally divided and lack much cohesion and integration, cultural heritage is no longer fulfilling the integrating social function which once gave it legitimacy in nation-states (Ashworth et al. 2007). If anything, varieties of cultural and social tribalism distance people from each other and make divisions and violent conflicts between 'us and them' more likely than if they were to meet each other as individual specimen of the same human species inhabiting a single planet (Maalouf 2012; van der Laarse 2019; Vince 2022: 52f.). According to the social anthropologist Sharon Macdonald (2013: 162), it is unclear 'whether it is possible to draw on memory and heritage to form new identity stories that include rather than exclude cultural diversity and "mixed" culture.' These emerging challenges found one expression in the concept of a 'Heritage of World Cultures,' first established in the German city of Mannheim in 2017. The project adapted the idea of a World Heritage championed by global nation-states to the local realities of a contemporary city in which people from 160 cultures meet. In collaboration with representatives of Mannheim's various cultural communities, a list was compiled of 'the most precious and best of what Mannheim's immigration culture has to offer' (http://weltkulturenerbe.de/en/project/).

Despite its timeliness, it may in practice not be easy to replace the idea of national heritage with more cosmopolitan and universal concepts of citizenship, possibly

relating to varieties of global cultural heritage and memory. There are, however, already some discernible trends towards cross-cultural and transnational forms of heritage governance that prioritise development over conservation while side-lining the significance of nation-states (Lafrenz Samuels 2016, 2018; Colomer and Holtorf 2019). The focus of the World Bank on heritage-based international development and the cosmopolitanisation of Holocaust remembrance provide pertinent examples (Lafrenz Samuels 2018: ch. 4; Macdonald 2013: ch. 8). In this situation, at the supranational or transnational levels, a new programme might be needed to spearhead a particular global heritage of all humanity, going beyond the limitations of the existing 1972 UNESCO World Heritage Convention and making progress towards the unfulfilled universalist aspirations of the World Heritage List.

Among others, such a programme could put more emphasis on heritage communities not connected to essentialising concepts of culture and belonging that are often designed to exclude rather than include people. One example is the heritage community of so-called Third Culture Kids (TCKs), i. e. children who spent a significant part of their formative years outside (either or both of) their parents' native culture(s), feeling connected to different places and different traditions while sharing a sense of transience and global belonging. It has seldom been asked how these global nomads relate to cultural heritage (Colomer and Holtorf 2019, cf. Vince 2022). Another example is the kind of heritage emerging in creolized cultural contexts where elements of different origins are mixed and hybridised. Classic examples include creole languages, food, religions, and music (Eriksen 2019). The variety of forms and practices of cultural heritage beyond traditional patterns originally associated with European National Romanticism is large (Holtorf and Fairclough 2013; Lafrenz Samuels 2018). Maybe we should formally be identifying a new kind of global or world heritage that is transnational in character and not employed to bolster national pride and distinction. I agree with Jan Nederveen Pieterse (2001: 220) who argues that hybridity is historically 'unremarkable'; it appears to be 'noteworthy only from the point of view of boundaries that have been essentialized' and that remain being fetishised around the world.

As Annalisa Bolin and I argued in the aftermath of the COVID-19 pandemic, we need to focus on the big picture in the world and address shared human needs:

> What makes us all most resilient, as human beings on this planet, is a culture (in the singular) of global peace, open dialogue, mutual understanding, and continuous collaboration. (…) In the light of the global spread and impact of the Covid-19 pandemic, it is time to remind ourselves once more of the interdependences between all the people and communities on this planet. We are all part of an interconnected humanity. The pandemic has demonstrated a strong need for global solidarity and cooperation. As the virus spreads across the world's societies, many have realized the benefits of a speedy global exchange of accurate information, of mutual support and solidarity between people to address

everybody's needs, and not the least of joint strategies of medical research and the development of a safe vaccine.

(Holtorf and Bolin 2020)

An Alternative World Heritage for the Anthropocene

Advancing shared benefits and interests of the human species means to focus back on the aims of UNESCO as defined in its 1945 Constitution. But it also means to help fulfilling the UN Agenda 2030 advocating sustainable development (UN 2015). Target 11.4 in that agenda calls for safeguarding the world's cultural and natural heritage to build sustainable cities and communities (SDG 11). That means that the United Nations recognises heritage as an intrinsic part of a global agenda for sustainable development.

ICOMOS (2020), in recognising the wider significance of making cultural heritage more people-centred, evoked not only the UN Agenda 2030 but also the UN Declaration of Human Rights and the UN Framework and Convention on Climate Change. The question is though whether the World Heritage Convention as it stands, promoting nation- and object-centred practices, is the right mechanism to achieve these various important ambitions expressed in these documents.

Such is the impact of globalisation that today, more than in any other historic period, states are responsible not only for their own people but also for how their actions affect every living being on the planet we all share (Anholt 2020). The same can be said for the responsibility of archaeologists, historians, and heritage specialists: their remit is larger than the study of one or more distinct past contexts and the care for the remains of those pasts today. Zoltán Simon (2022: 121) argued accordingly that 'as the futures ahead gain a planetary character, our historical understanding cannot escape being planetary too.' Nor can our notion of heritage which must transcend the nation and other narrow frames of meaning. For example, there is a perceived need of cultural heritage research and management to be decolonised, which seems especially urgent in relation to climate change (Simpson et al. 2022). According to my colleague Martin Gren (in conversations in December 2020), such a switch of focus may also mean to abandon the practice of selecting world heritage sites for inscription and instead attend to conserving humanity as a whole—which is more valuable than any site could be and arguably a world heritage in its own right. However, short of abandoning the idea of world heritage properties entirely, we could also try and get better at realising the unique potential of the notion of a global 'world heritage' and in that way advance the prospects of humanity for the future.

One way to adopt a more people-centred approach to world heritage is to introduce participative decision-making in the selection process. In recent years, hugely popular TV programmes, from Pop Idol to the Eurovision Song Festival, have championed various formats of popular voting with great success. There is also a list of the *New 7 Wonders of the World*, attracting 600 million global votes in the

selection of sites and monuments that could communicate 'ideas and concepts that span political, religious and ethical divides and are immediately clear to everyone on our planet' (https://www.new7wonders.com/; Wienberg 2021: 210). Simon Anholt's (2020) establishment of a system for global voting demonstrates that similar practices can be introduced in other sectors without succumbing to populism. In addition, technologies like blockchain could prevent states from unduly influencing popular votes. Such an open and global selection system for world heritage would still reflect 'perceptions, soft power and popularity' of individual nominations but nonetheless fulfil 'the original mandate [of the World Heritage Convention] of bringing the people of the world together in a shared appreciation of our common human heritage,' possibly even 'doing a better job of fulfilling this mandate than the current list' (Simon Anhalt, pers. comm. December 6, 2020).

There is a second important way of people-centring world heritage. If, as I have argued, humanity might indeed be better served by a world heritage that reaffirms the many interconnections and common interests between all the various manifestations of humanity–and indeed between humans and other living beings on this planet, what criteria should we choose for the selection of such a global world heritage?

The World Heritage Convention requires OUV to be identified before any nominated property can be approved for inscription (Labadi 2013: 26–28). This is currently done through reviews of extensive application dossiers and site visits by independent experts. Speculating for a moment–what might a provisional list of alternative criteria for OUV look like that could truly transcend national boundaries and meet the global aspirations of the 1945 UNESCO Constitution and the UN Agenda 2030? The key for achieving this might be to make global qualities transcending more narrow contexts part of the selection process for each site. In this vein, sites to be inscribed on a new World Heritage List could be required to meet at least one of the four criteria:

I to counter significantly suspicion and mistrust between the people of the world;
II to promote in unique ways an understanding of the principles of dignity, equality and mutual respect for all humans and for the human environment;
III to enhance extensively the education of humanity for justice and liberty and peace; or
IV to advance in exceptional ways collaboration among people and nations through education, science and culture.

These formulations are taken almost directly from the 1945 UNESCO Constitution, with the human environment being added from the Agenda 2030.

Are such criteria realistic at all? Probably not in the present context, because the current criteria for OUV and associated processes of assessment and evaluation are far too engrained in the existing practice of the World Heritage Convention. But technically, it might not be more difficult to assess nominated

properties in relation to these four new criteria than in relation to the ten existing criteria that focus mostly on various kinds of historical and natural significance of proposed sites.

Let me give you three concrete examples of possible alternative world heritage sites in the Anthropocene. The first two would meet criterium (II), whereas the final one would meet criterium (IV) as suggested above.

Lego and Other Plastic Trash from the World's Beaches

Under the title 'Lego Lost at Sea,' the English beachcomber and activist Tracey Williams took thousands of pictures of her collection of colourful Lego bricks and other plastic artefacts that had washed up on the world's beaches (Figure 6.2). Originally, much of the Lego came from the cargo ship Tokio Express that on February 13, 1997, lost a container with nearly 5 million pieces of Lego into the Sea off the coast of Cornwall (Male 2020, Williams 2022). But there were many other kinds of plastic trash to be found too.

For Williams, the images she took depict a global legacy of 'artefacts of the Anthropocene' (Male 2020). They illustrate the interface of natural and cultural heritage, but they also tell the story of how global production and trade, consumption, and disposal of artefacts are interconnected through the oceans across which the raw materials, the finished product, and their deteriorating leftovers are shipped or floating. Many million tons of plastic are being produced every year, and it is probably no exaggeration to state that all human beings use plastic in their daily life.

In the form of billions of tiny particles far too much plastic trash eventually ends up in sedimentary deposits at the bottom of the ocean, forming a distinctive geological layer (Farrier 2020: ch. 3). They are not only part of the 'human ecological footprint' but 'they endure, outlive us, and come back at us with a force we didn't realize they had' (Pétursdóttir 2017: 182). It makes sense that plastic has been recognised as an important stratigraphic indicator of the Anthropocene (Zalasiewicz et al. 2016). Recently, archaeologists too have begun to study plastic in the environment, and it is striking how abundant their archaeological distribution already is (e. g. Schofield et al. 2020, Colliander 2021).

Williams' Lego alerts us to the suspicion that much plastic trash in the environment does not permanently end up on beaches at all and will not be found by collectors. It is more than suitable for drawing attention to planetary questions that concern all humanity. 'Lego lost at Sea' can promote in unique ways an understanding of the principle of respect for the human environment and for the underlying issues in human behaviour that over the past few decades have been changing and polluting this environment. Arguably, plastic trash from the world's beaches marks one of the most important global legacies of our age; it forms a kind of distributed world heritage site.

FIGURE 6.2 *Lego Lost at Sea*, by Tracey Williams, beachcomber and author of 'Adrift, the curious tale of the Lego lost at sea' (2022). Several of the artefacts shown are from the container lost by the Tokio Express cargo ship on February 13, 1997, others are up to 60 years old.

Repositories for Nuclear Waste

Every year, the world generates approximately 12,000 tons of high-level nuclear waste, not the least from the hundreds of nuclear power stations in the world. All countries producing nuclear waste are challenged with the task of keeping humans and other forms of life on Earth safe from negative impacts caused by this powerful and hazardous material. Some of the waste generated is long-lived and has high levels of radioactivity requiring solutions for many millennia and up to one million years. Deep geological repositories are currently the method of choice, and countries such as Finland and Sweden have come long in the process of planning and building appropriate disposal sites (Figure 6.3).

FIGURE 6.3 Photomontage of the planned long-term repository for spent nuclear fuel at Forsmark, Östhammar Municipality, Sweden. Image: SKB/Lasse Modin.

These sites, which Peter Van Wyck once called the 'Anthropocene's archive' (Van Wyck 2014), represent a key legacy of the Atomic Age and its supposedly unfailing belief in technical progress. Despite (or precisely because of) the inherent risks that are part of this legacy, they can also memorialise the vibrant anti-nuclear campaigns of the 1970s and 1980s that contributed substantially to the emergence of the global environmental movement. In this sense, nuclear waste can be seen as a kind of cultural heritage (Holtorf 2019, Holtorf and Högberg 2021a).

For Þóra Pétursdóttir (2017: 196), nuclear waste is particularly significant for our world because of the spatially as well as temporally massive distribution of its impact on Earth, rendering it a 'hyperobject.' Some have even called the entire global biosphere 'an archive of nuclear modernity' (Rindzevičiūtė 2022: 22). Even though not all countries have directly contributed to producing this legacy, most have benefited in one way or another from the energy that was produced and possibly also from the nuclear deterrent that may have prevented a major intercontinental war after World War II. By the same token, very many humans have been affected by nuclear testing and the various nuclear accidents and disasters that have occurred, too.

The concern for safe disposal of nuclear waste strongly evokes shared human responsibilities for the future. Out of respect for the well-being of future generations of humans and the entire environment, this potent material needs to be cared

for across many generations. Repositories of nuclear waste, containing a hazardous legacy of the Atomic Age, can promote in unique ways an understanding of the principle of equality and mutual respect for all humans and for the entire human environment. Today, this understanding is further nuanced by the concern for carbon emissions and climate change, to which nuclear energy does not directly contribute. For these reasons, nuclear waste might be seen as a kind of multi-sited world heritage, as the repositories currently being planned and built mark one of the most important global legacies of our age. Interestingly in this context, the largest uranium mine in Europe is already part of the recently inscribed World Heritage property Erzgebirge/Krušnohoří Mining Region crossing the boundary between Germany and Czechia.

Space Messages

A third viable proposal for an alternative world heritage site could be the messages sent during the 1970s on board of the NASA spacecraft Pioneer 10 and 11 and Voyager 1 and 2 into space beyond the solar system. As I discussed elsewhere (Holtorf forthcoming), a deep-space message can transcend the boundaries that are presently dividing humanity. These messages were directed from humanity 'to whom it may concern' in the universe but to some extent, they were simultaneously directed at the human species on Earth itself. Despite significant shortcomings, the messages nevertheless succeeded in representing a unified portrayal of life on Earth and touched many school children and adults around the world. Future space messages, like the one planned but not realised for the New Horizons spacecraft (May and Holtorf 2020: 265; May 2020: 313–315), have exceptional potential to inspire and realise extensive collaboration among nations in education, science, and culture–thus fulfilling my suggested criterium (IV) for alternative world heritage sites.

Concluding Discussion: Taking the Future Seriously

The question of which world heritage can best fulfil the aspirations of UNESCO and other organisations to advance world peace and sustainable development for the future is a question about 'heritage futures,' i. e. a question about the roles of heritage in managing the relations between present and future societies (Holtorf and Högberg 2021b). Although barely discussed until recently, a concern with benefits for the future is not new in heritage conservation. The importance of heritage conservation has always been justified with reference to future generations. As Francesco Bandarin (2007: 192), at the time Director of the UNESCO World Heritage Centre, once observed, '[c]onservation is not for the short term, it would be meaningless. It is for the very long term, for the next and the future generations.' To meet this challenge, the global heritage sector needs training in futures thinking (Holtorf 2022).

As it stands, the UNESCO World Heritage Convention does not convincingly fulfil its most important overarching goal of contributing to future peace and

security in the world. Nor does it sufficiently address the need to advance sustainable global development. I argued that this is largely because of the object-centred and nation-state-focused approach of its practices which are also too much oriented towards protection of the cultural heritage as it is today. It is therefore sensible to consider, as I did in this paper, whether alternative criteria for assessing OUV might be needed that could result in selecting alternative world heritage properties. These criteria should be both more people-centred and more global, addressing the changing needs of humans and other life forms in the Anthropocene. My examples included Lego and other plastic trash from the world's beaches, repositories for nuclear waste, and deep-space messages. All three specific examples could help mobilising people globally in anticipating what lies ahead in the Anthropocene and in caring more for our shared human future on this Earth.

The most important goal of my argument has not been to critique the 1972 World Heritage Convention or to advocate the inscription of altogether different world heritage sites but to advance our understanding and appreciation of heritage futures. Managing the relations between present and future societies means asking what we wish to preserve, what we expect to happen, how we design desirable futures, and how we keep undesirable risks at bay. As my discussion showed, a global world heritage can contribute to this endeavour, but not quite in the current format offered by the World Heritage Convention.

With Jes Wienberg (2021: 207), I am asking: 'Can World Heritage as an idea and a practice be subjected to creative destruction just like other innovations, in other words be replaced by new and better solutions?' My answer is yes, and that is why I would say humanity needs a different world heritage for the Anthropocene. The kind of cultural heritage we need does not preserve important sites of the past but uses heritage to encourage people in the present and future to have the courage to invest trust in other people and collaborate, to take responsibility for humanity and the planet at large, to be creative in imagining future realities, and to be resilient when facing change.

Acknowledgements

I am grateful to Nick Shepherd for the invitation to contribute to this volume; Thomas Hylland Eriksen for discussion and inspiration regarding creolization; Simon Anholt for discussion and inspiration regarding global voting schemes; Martin Gren for conversations about cultural heritage in relation to the Anthropocene; and Tracey Williams for the photograph depicted in Figure 6.2. which was specially prepared for this chapter.

References

Anholt, Simon (2020) *The Good Country Equation*. Oakland: Berrett-Koehler.
Ashworth, Gregory, Brian Graham, and John Tunbridge (2007) *Pluralising Pasts: Heritage, Identity and Place in Multicultural Societies*. London: Pluto Press.

Askew, Marc (2010) The magic list of global status: UNESCO, World Heritage and the agendas of states. In Labadi, S. and C. Long (eds) *Heritage and Globalisation*, pp. 19–44. London and New York: Routledge.

Bandarin, Francesco (2007) Conclusions. In Bandarin, F. (ed.) *World Heritage: Challenges for the Millennium*, pp. 192–196. Paris: UNESCO.

Bonacchi, Chiara (2022) *Heritage and Nationalism. Understanding Populism Through Big Data.* London: UCL Press.

Borck, Lewis (2019) Constructing the future history: Prefiguration as historical epistemology and the chronopolitics of archaeology. *Journal of Contemporary Archaeology* 5(2), 229–238.

Cameron, Christina and Mechtild Rössler (2013) *Many Voices, One Vision: The Early Years of the World Heritage Convention.* Farnham and Burlington: Ashgate.

Cleere, Henry (2001) The *uneasy bedfellows*: Universality and cultural heritage. In Layton, R., P.G. Stone and J. Thomas (eds) *Destruction and Conservation of Cultural Property*, pp. 22–29. London: Routledge.

Colliander, Aura (2021) Muovi on ajassamme muotoutuva kulttuuriperintö. *Turun Sanomat* 25 April 2021. Available at https://www.ts.fi/puheenvuorot/5289306 (accessed 22 March 2023).

Colomer, Laia and Cornelius Holtorf (2019) What is cross-cultural heritage? Challenges in identifying the heritage of globalized citizens. In: Holtorf, C., A. Pantazatos and G. Scarre (eds) *Cultural Heritage, Ethics and Contemporary Migrations*, pp. 147–164. London and New York: Routledge.

Eriksen, Thomas H. (2019) Between inequality and difference: The creole world in the twenty-first century. *Global Networks* 19(1), 3–20.

EU (2021) Concept on cultural heritage in conflicts and crises. Council of the European Union, European External Action Service. 9962/21. Available at https://data.consilium.europa.eu/doc/document/ST-9962-2021-INIT/en/pdf (accessed 22 March 2023).

Farrier, David (2020) *Footprints. In Search of Future Fossils.* London: 4th Estate.

Guterres, António (2021) *Our Common Agenda. Report of the Secretary-General.* New York: United Nations. Available at https://www.un.org/en/content/common-agenda-report/ (accessed 22 March 2023).

Holtorf, Cornelius (2018) Embracing change: How cultural resilience is increased through cultural heritage. *World Archaeology* 50(4), 639–650. Available at 10.1080/00438243.2018.1510340

Holtorf, Cornelius (2019) Cultural heritage, nuclear waste and the future: What's in it for us? In J. Dekker (ed.) *Bewaren of Weggooien?*, pp. 11.01–11.17. Middelburg: Zeeuwse Ankers and COVRA. Available at https://www.zeeuwseankers.nl/app/uploads/2019/12/za_bow_web_final.pdf (accessed 22 March 2023).

Holtorf, Cornelius (2022) Teaching futures literacy for the heritage sector. In Fouseki, K., M. Cassar, G. Dreyfuss and K. Ang Kah Eng (eds) *Routledge Handbook of Sustainable Heritage*, pp. 527–542. London and New York: Routledge.

Holtorf, Cornelius (forthcoming) Challenges. In Quast, P. and D. Duner (eds) *Beyond the Earth. Messaging Across Deep Space and Cosmic Time.* Jefferson: McFarland & Co.

Holtorf, Cornelius and Annalisa Bolin (2020) Corona Crisis, UNESCO and the Future: Do We Need A New World Heritage? *Seeing the Woods*, 25 May 2020. Available at https://seeingthewoods.org/2020/05/25/corona-crisis-unesco-and-the-future-do-we-need-a-new-world-heritage/

Holtorf, Cornelius and Graham Fairclough (2013) The new heritage and re-shapings of the past. In González-Ruibal, A. (ed.) *Reclaiming Archaeology: Beyond the Tropes of Modernity*, pp. 197–210. London: Routledge.

Holtorf, Cornelius and Anders Högberg (2021a) What lies ahead? Nuclear waste as cultural heritage of the future. In Holtorf, C. and A. Högberg (eds) *Cultural Heritage and the Future*, pp. 144–158. London and New York: Routledge.

Holtorf, Cornelius and Anders Högberg, eds. (2021b) *Cultural Heritage and the Future*. London and New York: Routledge.

Hosagrahar, Jyoti ed. (2019) *Culture 2030 Indicators*. Paris: UNESCO.

ICOMOS (2020) People-Centred Approaches to Cultural Heritage. Resolution 20GA/19. Available at https://www.icomos.org/images/DOCUMENTS/Secretariat/2021/OCDIRBA/Resolution_20GA19_Peolple_Centred_Approaches_to_Cultural_Heritage.pdf (accessed 22 March 2023).

Isakhan, Benjamin and Ali Akbar (2022) Problematizing norms of heritage and peace: Militia mobilization and violence in Iraq. *Cooperation and Conflict* 57(4), 516–534.

Labadi, Sophia (2013) *UNESCO, Cultural Heritage, and Outstanding Universal Value: Value-based Analyses of the World Heritage and Intangible Cultural Heritage Conventions*. Lanham: Rowman & Littlefield.

Lafrenz Samuels, Kathryn (2016) Transnational turns for archaeological heritage: From conservation to development, governments to governance. *Journal of Field Archaeology* 14(3) 355–367.

Lafrenz Samuels, Kathryn (2018) *Mobilizing Heritage. Anthropological Practice and Transnational Prospects*. Gainesville: University Press of Florida.

Maalouf, Amin (2012) [1996]. *In the Name of Identity. Violence and the Need to Belong*. New York: Arcade.

Macdonald, Sharon (2013) *Memorylands. Heritage and Identity in Europe Today*. London and New York: Routledge.

Male, Andrew (2020) Monopoly houses, toy soldiers and Lego: the museum of plastic lost at sea. *The Guardian*, 4 April 2020, Available at https://www.theguardian.com/environment/2020/apr/04/monopoly-houses-toy-soldiers-lego-museum-of-plastic-lost-at-sea (accessed 22 March 2023).

May, Sarah (2020) Micro-messaging/space messaging: A comparative exploration of #GoodbyePhilae and #MessageToVoyager. In Harrison, Rodney, Caitlin DeSilvey, Cornelius Holtorf, Sharon Macdonald, Nadia Bartolini, Esther Breithoff, Harald Fredheim, Antony Lyons, Sarah May, Jennie Morgan and Sefryn Penrose, *Heritage Futures. Comparative Approaches to Natural and Cultural Heritage Practices*, 313–324. London: UCL Press.

May, Sarah and Cornelius Holtorf (2020) Uncertain futures. In: Harrison, Rodney, Caitlin DeSilvey, Cornelius Holtorf, Sharon Macdonald, Nadia Bartolini, Esther Breithoff, Harald Fredheim, Antony Lyons, Sarah May, Jennie Morgan and Sefryn Penrose, *Heritage Futures. Comparative Approaches to Natural and Cultural Heritage Practices*, 263–275. London: UCL Press.

Meskell, Lynn (2018) *A Future in Ruins: UNESCO, World Heritage, and the Dream of Peace*. Oxford: Oxford University Press.

Moukala, Edmond and Ishanlosen Odiaua, eds (2019) *World Heritage for Sustainable Development in Africa*. Paris: UNESCO.

Ndoro, Webber and Gamini Wijesuriya (2015) Heritage management and conservation: From colonization to globalization. In Meskell, L. (ed) *Global Heritage: A Reader*, pp. 131–149. Chichester: Wiley Blackwell.

Nederveen Pieterse (Jan 2001) Hybridity, so what? The anti-hybridity backlash and the riddles of recognition. *Theory, Culture & Society* 18(2–3), 219–245.

OECD (2017) OECD Guidelines on Measuring Trust. Paris: OECD Publishing. Available via https://www.oecd-ilibrary.org/governance/oecd-guidelines-on-measuring-trust_9789264278219-en (accessed 22 March 2023).

Pétursdóttir, Þóra (2017) Climate change? Archaeology and anthropocene. *Archaeological Dialogues* 24(2) 175–205.

Rhamey, Patrick (2019) Status and the protection of heritage sites in times of conflict. *Heritage Revivals – Heritage for Peace*, pp. 32–35. Bucharest: Romanian National Commission for UNESCO.

Rindzevičiūtė, Eglė (2022) *Nuclear Cultural Heritage: From Knowledge to Practice*. Concluding Report, AHRC Research Networking Project. Kingston upon Thames: Kingston University London.

Rudolff, Britta and Kristal Buckley (2016) World heritage: Alternative futures. In Logan, William, Mairead Nic Craith and Ullrich Kockel, (eds) *A Companion to Heritage Studies*, pp. 522–540. Chichester etc: Wiley & Sons.

Schofield, John et al. (2020) Contemporary archaeology as a framework for investigating the impact of disposable plastic bags on environmental pollution in Galápagos. *Journal of Contemporary Archaeology* 7(2), 276–306.

Simon, Zoltán B. (2022) Planetary futures, planetary history. In Simon, Z. and L. Deile (eds) *Historical Understanding: Past, Present and Future*, pp. 119–130. London: Bloomsbury.

Simpson, Nicholas P. et al. (2022) Decolonizing climate change-heritage research. *Nature Climate Change* 12, 210–213.

UN (2015) Transforming our World: the 2030 Agenda for Sustainable Development. New York: United Nations. Available at https://www.refworld.org/docid/57b6e3e44.html (accessed 22 March 2023).

UNESCO (1945) Constitution of the United Nations Educational, Scientific and Cultural Organization (UNESCO). London: United Nations. Available at: https://www.unesco.org/en/legal-affairs/constitution (accessed 22 March 2023).

UNESCO (1972) Convention Concerning the Protection of the World Cultural and Natural Heritage. Paris: UNESCO. Available at http://whc.unesco.org/en/conventiontext/ (accessed 22 March 2023).

Van der Laarse, Rob (2019) Europe's peat fire: Intangible heritage and the crusades for identity. In Lähdesmäki, T. et al. (eds) *Dissonant Heritages and Memories in Contemporary Europe*, pp. 79–134. Cham: Palgrave Macmillan.

Van Wyck, Peter (2014) The Anthropocene's Archive. Closing lecture at the conference *Radioactive Waste Management and Constructing Memory for Future Generations*. OECD/Nuclear Energy Association (NEA), 15–17 September 2014, Verdun, France. Summary available at https://www.oecd-nea.org/upload/docs/application/pdf/2020-12/7259-constructing-memory-2015.pdf, pp. 24–25 (accessed 9 March 2022).

Vince, Gaia (2022) *Nomad Century. How to Survive the Climate Upheaval*. Dublin etc: Allan Lane.

Wienberg, Jes (2021) *Heritopia. World Heritage and modernity*. Lund: Lund University Press.

Williams, Tracey (2022) *Adrift. The Curious Tale of the Lego Lost at Sea*. Lewes: Unicorn.

Yan, Haiming (2016) World heritage and national hegemony: The discursive formation of Chinese political authority. In: Logan, W., M. Nic Craith, and U. Kockel (eds) *A Companion to Heritage Studies*, pp. 229–242. Chichester: Wiley Blackwell.

Zalasiewicz, Jan et al. (2016) The geological cycle of plastics and their use as a stratigraphic indicator of the Anthropocene. *Anthropocene* 13, 4–17.

SECTION IV

Heritage Violence and Extractivism

Associated with the work of Alberto Acosta, Naomi Klein, and many others, the concept of extractivism has emerged as a useful term for describing not only the process of removing large quantities of materials for sale on world markets, but also the mentalities and values that authorize such plunder. Set in south-central Turkey, but addressing the Middle East as a whole, Ömür Harmanşah's chapter grapples with emergent forms of heritage violence and extractivism under the current neoliberal regimes in the region. He writes: 'Since the 1990s, Middle Eastern archaeologists working actively in the field have observed an unprecedented disposal of local landscapes under the sovereignty of late capitalism.' This disposal of local landscapes takes many forms: infrastructure projects, the large-scale extraction of resources, and the contracting of the countryside to private companies for mining and quarrying. In the process, there has been a shift in patterns of looting from heritage sites, from low-impact, local practices of treasure hunting to large-scale mechanized practices by professional looters, linked to the 'neoliberalization' of the countryside and the prevalence of other large-scale extractivist activities such as mining and quarrying. As well as describing such processes, Harmanşah does the conceptual work of shaping our understanding of them, via notions of 'heritage violence,' 'heritage injustice,' and 'disposable heritage landscapes.' He writes: 'What is proposed here is fieldwork as political ecology and fieldwork as engaged scholarship that does not shy away from engaging with the local politics that is swarming the Anthropocene landscapes today. The creativity in managing this fieldwork allows us to connect past landscapes to the historical and contemporary politics of heritage.'

Extractivism takes many forms, the kinds of material plunder of heritage landscapes described by Harmanşah, but also other non-material, conceptual, and epistemological forms of plunder. In a hard-hitting and conceptually and

DOI: 10.4324/9781003188438-11

methodologically innovative chapter, Emma Waterton, Hayley Saul, and Divya P. Tolia-Kelly turn the gaze back on the extractivist economies of academic writing and the field of heritage studies itself. They write: 'This chapter seeks to hold the discipline of Heritage Studies to account by asking researchers to prepare the ground for a collective reimagining of their field, led by the work of previously marginalised voices.' Part of the originality of this chapter lies in the deliberate textual and methodological strategies that the authors employ to draw attention to and to challenge these extractive economies. If extractivism is one key conceptual term in their chapter, then coloniality is a second key term. The authors write: 'The impact of Australia's settler colonial history remains a rich, ripe secret in many parts of the country.' There are many wonderful ideas and passages in this chapter. One of these is an extended engagement with the work of ecofeminist Val Plumwood. A second is the notion of heritage as being 'built on' colonialism—which is a much stronger formulation than the usual notion of 'entanglement.' Borrowing from the work of philosopher Achille Mbembe, they describe heritage as a pharmakon 'encapsulating both cure and toxin, remedy and poison.'

7

RURAL LANDSCAPES, EXTRACTION, AND HERITAGE VIOLENCE IN THE MIDDLE EAST

Ömür Harmanşah

Introduction: The Spring of Plato and the Desecration of an Indigenous Heritage Site

The Hittite sacred pool monument of Eflatûnpınarı ('Plato's Spring') in south central Turkey has been one of the most resilient vestiges of Anatolian antiquity in the contemporary countryside: an elegant structure built in ashlar masonry on top of a natural spring near the Beyşehir Lake during the Late Bronze Age (14th–13th c. BCE) (Figure 7.1). It was imagined and built as a site of ritual practice and a portal to the underworld (Glatz 2020: 112; Bachmann and Özenir 2004; Emre 2002: 228–230). The building includes sculptural representations of deities and fabulous creatures of the mountains to mark this portal as a site of apparitions and divine potency, while the ashlar sculpted monument was designed as a mimetic representation of a mountain spring: a contrast to its topographical location in a lowland lake basin. In the past, I have written on the ritual and architectural significance of this structure in antiquity as well as its acquired new meanings in medieval and modern times as it continued to stand resiliently in the everyday rural landscape of Beyşehir Lake as a ruin, associated with the medieval cult of the local saint Eflatûn (Plato) (Harmanşah 2014, 2015: 54–82). In medieval and early modern Anatolia, Konya and Karaman constituted a region which became an intellectual hub for the teachings of Neoplatonism and this overlaps with the creation of a sacred landscape of Plato in the countryside of Konya.

In recent memory, the site of the monument shaded by tall poplars and weeping willows was a much-loved spot for the local community, inhabitants of the villages in the vicinity, who came to collect ice-cold and delicious drinking water from the spring, have a family picnic, wash cars and carpets. Here you had the ideal inter-section of a *heritage place*, deeply meaningful with its historical associations and a refreshing place of contemplation and a source of joy and care for the community.

DOI: 10.4324/9781003188438-12

FIGURE 7.1 Eflatûnpınarı Hittite Spring Sanctuary near Beyşehir, Konya, Turkey. Photograph: Ömür Harmanşah (June 2009).

Following a thorough archaeological study by the researchers from the German Archaeological Institute and Konya Archaeological Museum (Bachmann and Özenir 2004), the local government and the museum of the provincial capital Konya felt encouraged to 'conserve' and 'manage' this monument as 'cultural heritage at risk,' and in preparation for a possible nomination for the UNESCO World Heritage Tentative List.[1] Their physical interventions in 2011–2012 were catastrophic for the local community: the site was fenced, the trees surrounding the monument were cut (I counted 55 cut trees during my visit in 2012), walking paths and odd-looking benches (more at home in an urban environment than a rural landscape) were installed around the monument, turning this lush rural place of belonging into a desolate urban park. Perhaps the most disturbing of all is a set of newly and sharply cut blocks that were lined on top of the existing ashlar courses of the Hittite monument, obscuring the ancient pool structure entirely. The *heritage place* was removed from its integrated and meaningful social life within the contemporary rural landscape and the local community, while it was curated for the rare urban visitors from Konya or Ankara through a set of poorly planned, unprofessionally executed physical interventions.

Studying the meaning and significance of the Eflatûnpınarı monument in the Beyşehir landscape, anthropologists have pointed out that the monument was asso-ciated with the cult of Eflatûn/Plato as the patron saint of Konya, whose tomb was venerated in the urban center of Konya until recently (the building was demolished in the 1920s) and whose rock-cut monastery (Deyr-i Eflâtûn, i.e. monastery of Plato)

right outside of Konya was visited by religious figures such as Mevlana Celalleddin Rûmi (Harmanşah 2015a: 72–75; Yalman 2019). The indigenous storytelling on Eflatûnpınarı suggested that the stone-carved miraculous creatures at the site of the spring, installed by Plato himself, protected and regulated the waters so that the Konya plain would not be flooded. This complex storytelling about the deep history of the monument and the genuine sense of belonging associated with it seems to have been responsible for the preservation of the monument over the centuries.

Eflatûnpınarı is an excellent example to grasp the implications of *heritage at risk discourse*, which nervously displaces heritage from its embedded social relationships and indigenous memory (Rico 2015, DeSilvey and Harrison 2020). Trinidad Rico has recently argued that 'heritage at risk' discourse 'acts as a rationalizing vehicle for other agendas that go unchecked, moving away from site-specific assessments of heritage values and management decisions toward generalized and commonsensical assessments' (Rico 2015: 147). In my conversations with the Director of Konya Archaeological Museum at the time, I was stunned to hear that the museum was also contemplating moving the entire stone monument to the urban center of Konya (more specifically, to the garden of the Mevlana Museum) with a concern to preserve and safeguard it. This twentieth century museum director felt entitled to displace a monument which was built on and made meaningful by the active natural spring and has been part and parcel of a vibrant rural landscape uninterrupted for 2400 years. It is notable that the proposed displacement was justified by the heritage at risk discourse, highlighting the monument's vulnerability and prioritizing the preservation of its built tectonic substance, while there was no expressed no concern or care for the well-being of the local community, their feelings towards this heritage place, or the landscape context as an inalienable asset of a historic monument. The heritage at risk discourse, which can be alternatively characterized as a salvage mentality, leads to a certain form of 'globalization of heritage in the late-modern world' (Harrison 2013: 168).

My observations in this article derive from my own field practice of landscape archaeology and architectural documentation with an eye for the politics of ecology and contested cultural heritage. By cultural heritage in this context, I refer primarily to archaeological artifacts, monuments, sites, landscapes, and other forms of material culture associated with the deep past but very much in the thick (politics) of the present. I include prominently here the ancestral (rural) landscapes of belonging, whether they are agricultural, pastoral, or geological. I find it unproductive and slightly misleading to classify heritage as tangible vs. intangible, because I consider the material worlds of cultural heritage as a sensorial assemblage, layered with materialities and entangled meanings, practices, stories, and histories. The tangible/intangible split seems very much like a Cartesian binary that cuts through an otherwise entangled whole.[2] More specifically, I am interested in the variety of practices of heritage violence in the contemporary Middle Eastern countryside, which I characterize as forms of *heritage injustice*. The debates on heritage justice highlight the intimate connection between human rights and cultural heritage,

characterize heritage work as work towards a form of social justice, and evoke the necessity and potentiality of future considerations of reparations.[3] Thinking about heritage is particularly helpful when justice is not just imagined from the perspective of human individuals and communities, but symmetrically extended to non-human bodies with agency, tangled with human histories, such as a monument, a lake, a river, a mud volcano, or a cultural artifact from the past (Daston 2008; Bubandt 2017; Swanson et al. 2017).

Archaeological Fieldwork as Political Ecology: Documenting Heritage Destruction

In this contribution, I discuss the various forms and levels of heritage violence that is taking place in an accelerated pace in the Turkish countryside in the last two to three decades under late capitalism.[4] Performing archaeological fieldwork in Turkey since the early 1990s, one observes dramatic changes in the overall management of the countryside by the state and, in a related way, the status and the treatment of cultural heritage. In an article on looting in the western Anatolian peninsula, Roosevelt and Luke (2006: 180) report that 'looters in Lydia are generally members of rural agricultural communities who supplement the routine of their more relaxed winter schedules with the occupation of treasure hunting.' The authors come to this conclusion based on their archaeological survey project in the hinterland of Sardis. However, the authors are unable to articulate their methods of collecting this data and arriving at such a conclusion. In the footnote to the quoted statement, the authors state that 'looting occurs at all times of the year but especially in winter and at times of extreme economic hardship' (Roosevelt and Luke 2006: 185: Note 2). But again, it is unclear whether there is a deeply investigative ethnographic work that demonstrates evidence that the looters are from the local community. This contrasting perspective may derive from different definitions of what is meant by 'local.' In this context, 'local' refers to the context of the immediate district and nearby villages, while non-local refers to outsiders who have no sense of belonging to the particular landscape while practicing looting with the interests of private national or multi-national companies. In contrast to Roosevelt and Luke, I argue below that landscape archaeology in the Konya province since 2010 demonstrates a clear shift from local treasure hunting towards non-local looting operations that take place at a much greater (destructive) scale, performed by outsider companies who have access to heavy machinery. This is demonstrated in the ethnographic work of Yalburt Survey Project in a number of concrete examples of looting operations.

Entangled with the recent reconfiguration of the rural landscapes, especially with respect to the changing practices of extraction from state-sponsored to privatized, cultural heritage is increasingly seen as a 'resource' to be excavated, commodified, and processed under the prevalent logics of extractionism under late capitalism, similar to the treatment of minerals or fossil fuels (Bangstad and Pétursdóttir 2022: 6–7). In a

recent forthcoming article, Benjamin Porter defines cultural heritage as a 'non-renewable resource that is not only a wellspring from which communities can materialize their identities but is also an important archive documenting the Middle East's contributions to human history' (Porter 2021: 4). It remains unclear whether those communities engage with their heritage as a 'resource' to be tapped into when an identity boosting is needed, as implied here. It might also be possible to suggest that the modernist-industrialist concept of 'resource' may not universally apply to these world communities, whose lives, practices, and belief systems are more intimately entangled in the complex sensorial and material assemblage that we call heritage.

Therefore, I argue that cultural heritage has been integrated into the regimes of extraction in the late capitalist economies, and this extractive definition of cultural heritage is (and should be) alarming, yet very much understood to be characteristic of the landscapes of the Anthropocene where histories of the natural and the cultural, human and the non-human are inevitably intertwined (Bubandt 2017). Archaeology itself as a discipline that historically served as a state sponsored practice, with its increased focus on salvage archaeology, its curation of sites for tourism, and the demands to supply museums with sensational artifacts, has been drawn into the same logics of extraction. It is my contention that the concept of cultural heritage has been redefined and retooled in the context of the radical changes we have witnessed since the 1990s, associated with the processes that Bruno Latour has defined as the 'New Climatic Regime' entangled with the 'vertiginous explosion of inequalities' (Latour 2018: 1).

With this state of affairs in mind, I ask in this contribution: what is the current state of heritage within the contemporary rural landscapes, which are being disposed of through countless infrastructure projects, unfettered development, and extreme extraction? And how do these ontological and conceptual changes to heritage impact the work of the archaeologists when archaeological assemblages are in such states of material precarity and shift of meaning? What are the possibilities for a new form of fieldwork that would capture and address the harsh politics of heritage destruction that we see in the neoliberal countryside? These are some of the questions I engage in the rest of the paper.

Practices of Heritage Violence in the Neoliberal Countryside

In November 2019, local government authorities in Turkey's modern province of Gümüşhane issued an official excavation license to two men to search for treasure under a small ice lake, called *Dipsiz Göl,* located on the upland plateau of Taşköprü and in the territory of Dumanlı village in the eastern Black Sea region.[5] It may sound slightly absurd to seek a 'treasure' at the bottom of a natural (small and deep) lake, but the urban legend about such a treasure must have been linked with the ruins of the ancient city of Santa nearby and the displaced Pontic Greek orthodox community from this neighborhood. Official 'treasure permits' are frequently issued in Turkey, allowing individuals to seek buried property of displaced and dispossessed peoples,

usually the non-Muslim communities of Greeks, Armenians, Jews, and others (von Bieberstein 2017, 2021). Permits are issued once the site is determined by state archaeologists to include no formal archaeological remains. These archaeological remains are usually understood to belong to prehistoric, ancient, and medieval cultures but not necessarily historical ones such as those dating to the late Ottoman Empire. The Dipsiz Lake was scientifically known to have preserved an invaluable record of the Holocene vegetation and climate in its bottom in the form of stratified pollen deposits, yet this kind of geological and/or vegetation heritage (classified as 'natural heritage') is less effectively protected under the current heritage preservation laws.[6] The excavation of the Dipsiz Lake took place under the protection of the government sponsored military police for four days, despite the protests of the local village community (to whom the lake belonged). The lake was drained and the bottom of the lake was excavated with the use of heavy machinery, completely destroying the ecology of the lake. No treasures were found. The destruction of this local heritage place and its geological record were harshly criticized by the academic community and the public, leading to the suspension of permit granting state officials in Gümüşhane, and the Ministry of Culture and Tourism's reconsideration of its 'treasure permit' issuing processes. The case of Dipsiz Lake is an excellent example of an Anthropocene heritage story, where the natural and the cultural are entangled and confused; no care was offered to the local and indigenous community's sense of belonging and memory, the heritage of departed non-Muslim communities is desecrated, the lake bottom deposits preserving the vegetation and climate history of the region have been destroyed, while the physical operation was literally carried out by the very vehicles and heavy machinery of extractive capitalism, and under the (legal and military) protection of the state. All of this can be summarized as a *deterritorialization* and a dramatic context of heritage injustice in the political space of the Anthropocene landscapes that have been determined to be disposable (Sterling Harrison 2020, Lövbranda et al. 2020). I refer to disposable heritage landscapes as archaeological and historical landscapes that are sacrificed to development, extraction, or other transformative operations in the neoliberal countryside.

Writing on advent of the Anthropocene, Kyle McGee (2016: 272) noted that 'modernity has long drilled the ground to extract precious substances: substances invisible to the surface dweller's naked eye, lodged in the very heart of nature itself.' Digging in the (disposable) landscapes of Anthropocene has now become equated with extraction, accompanied with extractive ethics that bears little responsibility to the integrity of the land or the history of landscapes. Art critic Lucy Lippard has pointed this out in her study of gravel pits and gravel mines recently, writing that 'gravel pits transform the incomprehensibly distant geological past into dubious futures' (Lippard 2014: 14). Lippard's work uses gravel pits to contemplate the radical transformation of the countryside under neoliberal capitalism and the changing politics of land use. In landscapes of neoliberal capitalism, extraction takes the form of thousands of small sand, gravel, and stone quarries across the landscape rented or contracted out to private companies, open pit mines for coal-fired power

plants, looted archaeological sites, illegally excavated deep water wells, and other forms of extraction. Excavation in all of these activities is oriented to obtain things or resource matter, sustaining a powerful form of thing-politics.

Since 2010, Dr. Peri Johnson and I have been co-directing Yalburt Yaylası Archaeological Landscape Research Project ('Yalburt Project') in west-central Turkey, on the western part of Konya province. Yalburt Project is a landscape archaeology, ecology, and settlement history field project, and a diachronic archaeological survey that investigates long-term histories of settlement and land use in the districts of Ilgın and (partially) Kadınhanı. Yalburt Project team has been performing a comparative study of the Holocene and the Anthropocene landscapes, comparing and juxtaposing the ancient (Bronze Age) and contemporary (industrial and post-industrial) infrastructure projects of water management, practices of mining and quarrying, and the agricultural and pastoral use of landscapes. During our fieldwork in the landscapes of Ilgın and Kadınhanı districts of Konya, one striking phenomenon that we observed was the spatial convergence of two distinct practices of digging: the mining operations and the looting of archaeological sites. This is an unsettling aspect of the Anthropocene, as Nils Bubandt put it: 'the increasing impossibility of distinguishing human from nonhuman forces, the *anthropos* from the *geos*.' (emphasis in the original, Bubandt 2017: G122) The looting operations at archaeological sites increasingly look like mining operations, cutting through geological layers of schist and limestone, treating them as cultural deposits. This confounded perspective on what is cultural and what is geological seems to be the hallmark of the Anthropocene. The way we understand cultural heritage today is directly impacted by this conceptualization and this new mode of operation in the countryside.

During the first season of Yalburt Project in July and August 2010, informed by the families at Yalburt Yaylası, the survey team came across a striking example of a looted and destroyed archaeological site: an impressive sinkhole locally known as Şangır Mağaza in the uplands of Büyükoba, only about 2.3 km Northeast of Yalburt Yaylası, where the Hittite sacred pool monument is located. Şangır Mağaza is a collapse sinkhole with a depth of 20 m and an oval diameter of 50–60 m in the midst of an eroded karst upland plateau at the elevation of 1475 m (Figure 7.2). The heavily looted archaeological site in the bottom of the sinkhole offered a rich surface assemblage of terracotta figurines, votive vessels, bone textile production tools, fragments of marble sculpture, an inscribed funerary stele and other architectural fragments, and midden deposits suggesting that the site was a place of ritual practice and cultic significance in antiquity.[7] According to the testimony of the local community at the pastoral settlement of Yalburt Yaylası, several months prior to Yalburt Project team's visit to the site, the sinkhole had been looted in a three-day long operation that involved heavy machinery including a large excavator with a 4-meter wide bucket brought all the way from the capital city of Ankara on a semi-truck belonging to a well-known construction company (whose name was not disclosed to us). The looters dynamited walls of the sinkhole and combed the

FIGURE 7.2 Şangır Mağaza Hellenistic-Roman Sinkhole Sanctuary, near Ilgın, Konya, Turkey. Photograph courtesy of Yalburt Yaylası Archaeological Landscape Research Project. August 2010.

edges of the sinkhole with the excavator's bucket, dug into the cultural (midden) deposits in the bottom of the sinkhole, and damaged the architectural fragments of a small temple. Yalburt Project team's later documentation of the site including the rich collection of artifacts from the disturbed cultural deposits demonstrated that the site is most clearly understood as a sinkhole sanctuary site dating to the Late Hellenistic and Early Roman periods (Johnson forthcoming). Modest structures built around the mouth of the sinkhole may have served as dining rooms, while the cultural deposits at the bottom of the sinkhole suggest extensive feasting and sacrificial activity. Based on Yalburt Project team's report, the site was later registered both as a first-degree archaeological and natural heritage site by the Regional Conservation Council in Konya. The local community reported that the non-local looters who were dressed in military outfits were able to work at the site uninterrupted for several days.

The looting of Şangır Mağaza is not a unique incident in the overall profile of the destruction and disturbance of archaeological sites in the Yalburt Project survey region in the districts of Ilgın and Kadınhanı. Excavation of Roman burials along the Salt Road on the Ilgın plain close to the main Konya-Afyon highway, the excavation of a major Roman sarcophagus at the site of Uzun Pınar near Çavuşçugöl township, dynamiting of a sarcophagus quarry of Üç Pınarlar, the looting of the Neolithic and Chalcolithic remains from the Akpınar cave near the village of Yorazlar (by a fertilizer company from Mersin, using a guano collection

permit), deep excavation of settlement mounds such as Tokar Mevkii and many others that were recorded during the Yalburt Project field seasons from 2010 to 2021 have been determined to be largely the work of organized outside looters equipped with heavy machinery and explosives.[8] This shift from low-impact local practices of treasure hunting to large-scale mechanized practices by professional looters in the last few decades is notable, and clearly linked with the disposal of rural and agricultural landscapes in the neoliberal countryside under the late capitalist regimes. As the regime of the extraction of resources in rural landscapes (notably coal mines, gravel and sand quarries, and marble quarries among others) has been increasingly privatized and less controlled by the state, unchecked excavations by private companies and contractors without any accountability for the environmental impact of such practices are fast transforming the countryside today. The looting operations at major archaeological sites may be understood most clearly in relation to such changing practices of extraction.

Conclusion: New Forms of Fieldwork

Since the 1990s, field archaeologists actively working in the Middle East have witnessed unprecedented disposal of local landscapes under the sovereignty of late capitalism and in the global context of climate change, the ecological crisis, and the Anthropocene.[9] This disposal took place in the form of infrastructure projects, extraction of resources (especially fossil fuels for energy, and stone, sand, and gravel for construction) in massive scales, and more broadly, the contracting of the countryside to small companies for mining and quarrying. I argued in this contribution that such assemblage of extractive operations brought about increased operations of the looting of cultural heritage under this radically new regime of the management of rural landscapes from the 1990s onwards. The heritage landscapes under threat are not limited to the conventional stock of cultural heritage sites, i.e. historic buildings, archaeological sites, museums, and monuments, but also include places of worship, memory, and belonging and places of cultural and religious significance to communities, a cultural geography of heritage grounded in indigenous and local knowledge systems. Increasingly inspired by the debates around the Anthropocene are ancestral agricultural, pastoral, and geological ('shared') landscapes (Harrison 2004). This last aspect of heritage landscapes brings to the foreground the territorial rights of local and indigenous communities for lands that are often deemed to be 'unoccupied' or *terra nullius* in the colonial imagination. In this very context of deterritorialization and dispossession, we are able to speak of a certain notion of heritage justice based on human rights to the environment.

In an earlier article on the Islamic State (ISIS)'s destruction of archaeological sites and museums in Iraq and Syria, I pointed out how the targeted archaeological heritage destruction by this global terrorist organization was accompanied by the burning of agricultural fields to devastate landscapes of livelihood as part of their scorched-earth policy (Harmanşah 2015b: 170). In this chapter, I return to this idea

and argue that in the regions of the global south such as the Middle East, we are living through an extreme episode of heritage violence, heritage injustice, and deterritorialization as part and parcel of a broader transformation of land. This violence can be closely linked to other practices of extraction in the countryside as well as climate change. Deeply rooted narratives of disposability and ruin are propagated by local governments, multi-national corporations, and often supported by academic work, announce particular landscapes to be sacrificed to development, while other landscapes, namely national parks, world heritage sites, or wildlife refuges, are set aside, preserved and curated. In this chapter, I tried to draw attention to this overall state of injustice in the countryside in Turkey and to suggest that such a political ecology of heritage injustice can only be addressed by a new form of politically engaged and on-the-ground fieldwork.

I propose that a radical revision of our methods of practicing archaeological fieldwork is needed to address questions of heritage violence and heritage injustice. In archaeological and ethnographic field projects, we are already seeing the impact of this new state of affairs, in the form of new hybrid field methods such as participatory mapping or radical cartographies (Sletto et al. 2020), public, community-based, and engaged archaeological projects (Atalay et al. 2014) and archaeology of political ecology (Bangstad and Pétursdóttir 2022; Morehart, Millhauser, and Juarez 2018; Ashmore 2018).[10] As these disciplinary trends indicate new fieldwork projects that would be able to address questions of heritage justice and offer a critical decolonial perspective on heritage will require a genuine collaboration with local communities, an explicit and honest understanding of archaeology belonging to our contemporary moment (on 'archaeologies of the contemporary past' see Olivier 2022), and a politically engaged scholarship that addresses the challenges and opportunities brought about by climate change and the Anthropocene. The desperate need for new, unusual cross-disciplinary collaborations emerges out of discussions and debates on the Anthropocene, which requires us to adopt a new form of fieldwork that is collaborative, interventionist, and creative, rather than distanced, 'remotely-sensed' and documentation based. What is proposed here is fieldwork as political ecology and fieldwork as engaged scholarship that does not shy away from engaging with the local politics that is swarming the Anthropocene landscapes today. The creativity in managing this fieldwork allows us to connect past landscapes to the historical and contemporary politics of heritage.

If we consider the powerful stories of the spring sanctuary of Eflatûn Pınarı, the highland glacial lake of Dipsiz Göl, and the sinkhole sanctuary of Şangır Mağaza, as recent, unsettling accounts of heritage injustice in the Anthropocene, and juxtapose them with the globally known destruction of archaeological and historical heritage by ISIS in 2014 and 2015 (Cunliffe and Curini 2018), the Taliban's dynamiting of the Buddhas of the Bamiyan Valley in Afghanistan (Flood 2002) or the work of other extremist groups such as the Hindu nationalist mobs that demolished the Babri Mosque in Ayodhya, India in 1992 (Ratnagar 2004), we have a grim picture at hand. One must add to these landscapes of loss, the wider scale destruction of

archaeological sites caused by hydro-electric dams, urbanization, and other infrastructure projects (Dissard 2011; Shoup 2006). In the next few decades, we will likely see a further acceleration of these processes of increased vulnerability and precarity of heritage in the Middle East, while the new generation of archaeologists will have to face the challenge of such unprecedented undermining of the material past. It is very clear that global heritage conservation programs such as UNESCO's World Heritage List or the remote documentation of archaeological loss through satellite imagery remain too limited in their effectiveness to address the complexity of the precarious conditions in the archaeological field.

Notes

1 The monument was put on the UNESCO World Heritage Tentative List in 2014. See https://whc.unesco.org/en/tentativelists/5912/
2 Having made this point clear, I do admit that the more recent focus on intangible heritage, supported by UNESCO and other heritage organizations have drawn attention to aspects of heritage that are less commonly and less concretely discussed, such as indigenous and local knowledge, indigenous languages, cultural practices, orality and native storytelling accounts of landscapes, place-based music traditions and so on. See discussion in Zehbe 2015 for an understanding of intangible heritage as a set of relationships surrounding human individuals. I also refer here to UNESCO's 2003 *Convention for the Safeguarding of the Intangible Cultural Heritage*. https://ich.unesco.org/en/convention. The convention defines intangible heritage as "the practices, representations, expressions, knowledge, skills – as well as the instruments, objects, artefacts and cultural spaces associated therewith – that communities, groups and, in some cases, individuals recognize as part of their cultural heritage." See also Lafrenz Samuels 2015: 5-6.
3 Azoulay 2019: 58ff. Se also Joy 2020. Heritage justice can be conceptualized similar to climate justice or environmental justice, as a universal human right. Critical to note here is the UNESCO Florence Declaration on Landscape, 2012: https://whc.unesco.org/en/news/943.
4 Much of the existing literature on looting of archaeological sites tend to focus on illicit antiquities trade, the antiquities market and the physical impact of that trade on archaeological sites and landscapes. See e.g. Boz 2018; Roosevelt and Luke 2006; Özgen 2001. In this article, I am focusing instead on the practices of heritage violence, as observed in the field.
5 See the media report by the Turkish Society of Geomorphology (http://jd.org.tr/en/node/162) Trabzon Cultural Assets Regional Preservation Agency and the Provincial office of the Ministry of Environment and Urbanism issued the permit in consultation with the Gümüşhane Museum.
6 This is despite the fact that Turkey is a signatory of the 1971 Ramsar Convention on wetlands. See https://www.ramsar.org/ The mission of the convention has been "the conservation and wise use of all wetlands through local and national actions and international cooperation, as a contribution towards achieving sustainable development throughout the world."
7 The sinkhole is also known as 'Körkuyunun Mağaza". For a preliminary report, see Harmanşah and Johnson 2012: 341-42, and Johnson, forthcoming. Following the work of Yalburt project team, Konya Province Preservation Board for Cultural and Natural Heritage registered the site as a first degree archaeological and natural heritage site.
8 For preliminary field reports for each of these looting incidents, see Field Reports 2010–2018 in https://www.yalburtproject.org/preliminary-reports-and-publications

9 Elizabeth Povinelli refers to this new form of sovereignty "geontopower". See Povinelli 2016. On the linkage between climate change and the destruction of cultural heritage, see Porter forthcoming.
10 See also the special issue "Uneven Terrain: Archaeologies of Political Ecology" guest edited by Christopher T. Morehart, John K. Millhauser, Santiago Juarez in *Archaeological Papers of the American Anthropological Association* 29.1. (2018).

Bibliography

Ashmore, Wendy 2018. Why the Archaeology of Political Ecology Matters. *Archaeological Papers of the American Anthropological Association* 29: 175–184.

Atalay, Sonya, Lee Rains Clauss, Randall H. McGuire, and John R. Welch (eds.) 2014. *Transforming Archaeology: Activist Practices and Prospects.* walnut Creek, CA: Left Coast Press.

Azoulay, Ariella Aïsha 2019. *Potential History: Unlearning Imperialism.* London and New York: Verso.

Bachmann, Martin and Sırrı Özeni 2004. Das Quellheiligtum Eflatun Pınar. *Archäologischer Anzeiger* 1: 85–122.

Bangstad, Torgeir Rinke and Þóra Pétursdóttir 2022. An Ecological Approach to Heritage. In *Heritage Ecologies.*, Torgeir Rinke Bangstad and Þóra Pétursdóttir (eds.). Routledge: London and New York, 3–27.

Boz, Zeynep 2018. *Fighting the Illicit Trafficking of Cultural Property. A toolkit for European Judiciary and Lw Enforcement.* Paris: UNESCO.

Bubandt, Nils 2017. Haunted Geologies: Spirits, Stones, and the Necropolitics of the Anthropocene. In *Arts of Living on a Damaged Planet.* Anna L. Tsing, Heather Swanson, Elaine Gan, and Nils Bubandt (eds.). Minneapolis and London: University of Minnesota Press, G121–G141.

Cunliffe, Emma and Luigi Corine 2018. ISIS and Heritage Destruction: A Sentiment Analysis. *Antiquity* 92: 1094–1111.

Daston, Lorraine 2008. Speechless. In *Things That aTlk: Object Lessons From Art and Science,* Lorraine Daston (ed.), New York: Zone Books, 9–26.

DeSilvey, Caitlin and Rodney Harrison 2020. Anticipating Loss: Rethinking Endangerment in Heritage Futures. *International Journal of Heritage Studies* 26: 1–7.

Dissard, Laurent 2011. Submerged Stories from the Sidelines of Archaeological Science: The History and Politics of the Keban Dam Rescue Project (1967–1975) in Eastern Turkey. Unpublished PhD Dissertation. University of California, Berkeley.

Emre, Kutlu 2002. Felsreliefs, Stelen, Orthostaten: Großplastik als Monumentale Form Staatlicher und Religiöser Repräsentation. In *Die Hethiter und ihr Reich: Das Volk der 1000 Götter.* Kunst- und Ausstellungshalle der Bundesrepublik Deutschland Gmbh. Stuttgart: Konrad Theiss Verlag GmbH, 218–233.

Flood, Finbarr Barry 2002. Between Cult and Culture: Bamiyan, Islamic Iconoclasm, and the Museum. *The Art Bulletin* 84/4: 641–659.

Glatz, Claudia 2020. *The Making of Empire in Bronze Age Anatolia: Hittite Sovereign Practice, Resistance, and Negotiation.* Cambridge and New York: Cambridge University Press.

Harmanşah, Ömür and Peri Johnson 2012. Yalburt Yaylası (Ilgın, Konya) Arkeolojik Yüzey Araştırma Projesi, 2010 Sezonu Sonuçları. In *29. Araştırma sonuçları toplantısı.* Adil Özme (ed). Ankara: T.C. Kültür ve Turizm Bakanlığı Kültür Varlıkları ve Müzeler Genel Müdürlüğü Yayın No: 153/2. Volume 2: 335–360.

Harmanşah, Ömür 2014. Event, Place, Performance: Rock Reliefs and Spring Monuments in Anatolia. In *Of rocks and water: Towards an archaeology of place.* Ömür Harmanşah (ed). Joukowsky Institute Publications 5. Oxbow Books, 140–168.

Harmanşah, Ömür 2015a. *Place, Memory, and Healing: An Archaeology of Anatolian Rock Monuments*. London and New York: Routledge.

Harmanşah, Ömür 2015b. ISIS, Heritage, and the Spectacles of Destruction in the Global Media. *Near Eastern Archaeology* 78.3: 170–177.

Harrison, Rodney 2004. *Shared Landscapes: Archaeologies of Attachment and the Pastoral Industry in New South Wales*. Sydney: University of New South Wales Press.

Harrison, Rodney 2013. *Heritage: Critical Approaches*. Oxon and New York: Routledge.

Johnson, Peri, forthcoming. The Sinkhole Sanctuary at Şangır Mağaza: Local Stories and Continuity in a Sacred Landscape.

Joy, Charlotte 2020. *Heritage Justice*. Cambridge University Press.

Lafrenz Samuels, Kathryn 2015. Introduction: Heritage as Persuasion. In *Heritage Keywords: Rhetoric and Redescription in Cultural Heritage*. Kathryn Lafrenz Samuels and Trinidad Rico (eds.). Boulder: The University Press of Colorado, 3–28.

Latour, Bruno 2018. *Down to Earth: Politics in the New Climatic Regime*. Cambridge (UK) and Medford, MA: Polity.

Lippard, Lucy R. 2014. *Undermining: A Wild Ride Through Land Use, Politics, and Art in the Changing West*. New York and London: The New Press.

Lövbranda, Eva, Malin Mobjörk, and Rickard Söder 2020. The Anthropocene and the Geo-Political Imagination: Re-Writing Earth as Political Space. *Earth System Governance* 4(2020): 1–8.

McGee, Kyle 2016. On the Grounds Quietly Opening Beneath our Feet. In *Reset modernity!* Bruno Latour and Christophe Leclercq (eds.). ZKM Cebter for Art and Media. Cambridge MA: The MIT Press, 272–277.

Morehart, Christopher T., John K. Millhauser, and Santiago Juarez 2018. Archaeologies of Political Ecology –Genealogies, Problems, and Orientations. *Archaeological Papers of the American Anthropological Association* 29: 5–29.

Olivier, Laurent 2022. Cultural Heritage and Memory of the Ecumene in the Age of the Anthropocene. In *Heritage Ecologies*, Torgeir Rinke Bangstad and Þóra Pétursdóttir (eds.). Routledge: London and New York, 81–91.

Özgen, Engin 2001. Some Remarks on the Destruction of Turkey's Archaeological Heritage. In *Trade in Illicit Antiquities: The Destruction of the World's Archaeological Heritage*, Neil Brodie, Jennifer Doole, and Colin Renfrew (eds). Cambridge, U.K.: McDonald Institute for Archaeological Research, 119–120.

Porter, Benjamin 2021. The Climate Crisis, Cultural Heritage, and the Future of Middle Eastern Archaeology. University of California eScholarship Preproof. https://escholarship.org/uc/item/34w048mm

Povinelli, Elizabeth A. 2016. *Geontologies: A Requiem to Late Liberalism*. Durham: Duke Unv. Press.

Ratnagar, Shereen 2004. Archaeology at the Heart of a Political Confrontation: the Case of Ayodhya. *Current Anthropology* 45/2: 239–259.

Rico, Trinidad 2015. Heritage at Risk: The Authority and Autonomy of a Dominant Preservation Framework. In *Heritage Keywords: Rhetoric and Redescription in Cultural Heritage*. Kathryn Lafrenz Samuels and Trinidad Rico (eds.). Boulder: University Press of Colorado, 147–162.

Roosevelt, Christopher H. and Christina Luke 2006. Looting Lydia: The Destruction of an Archaeological Landscape in Western Turkey. In *Archaeology, Cultural Heritage and the Antiquities Trade*, edited by Neil J. Brodie, Morag M. Kersel, Christina Luke, and Katryn Walker Tubb (eds). Gainesville, FL: University Press of Florida, 173–187.

Shoup, Daniel 2006. Can Archaeology Build a Dam? Sites and Politics in Turkey's Southeast Anatolia Project. *Journal of Mediterranean Archaeology* 19: 231–258.

Sletto, Bjørn, Joe Bryan, Alfredo Wagner, and Charles Hale (eds.) 2020. *Radical Cartographies: Participatory Mapping from Latin America*. Austin: university of Texas Press.

Sterling, Colin and Rodney Harrison 2020. Introduction: Of territories and Temporalities. In *Deterritorializing the Future: Heritage in, of and after the Anthropocene*, Rodney Harrison and Colin Sterling (eds). Open Humanities Press, 19–54.

Swanson, Heather, Anna Tsing, Nils Bubandt, and Elaine Gan 2017. Introduction: Bodies Tumbled into Bodies. In *Arts of Living on a Damaged Planet*. Anna L. Tsing, Heather Swanson, Elaine Gan, and Nils Bubandt (eds.). Minneapolis and London: University of Minnesota Press, M1–M12.

von Bieberstein, Alice 2017. Treasure/Fetish/Gift: Hunting for 'Armenian Gold' in Post-genocide Turkish Kurdistan. Subjectivity volume 10, pages 170–189 (2017).

von Bieberstein, Alice 2021. Speculating on Death: Treasure-hunting in Present-day Moush. In *Reverberations: Violence across space and time*. Yael Navaro, Zerrin Özer Biner, Alice von Bieberstein, and Seda Altuğ (eds.) Philadelphia, PA: Pennsylvania University Press, 63–82.

Yalman, Suzan 2019. From Plato to the *Shāhnāma*: Reflections on Saintly Veneration in Seljuk Konya. In *Sacred Spaces and Urban Networks*. Suzan Yalman and A. Hilâl Uğurlu (eds.). Istanbul: ANAMED: Koç University Research Center for Anatolian Civilizations, 119–140.

Zehbe, Klaus 2015. Intangible Heritage: What Brain Dead Persons Can Tell us about (Intangible) Cultural Heritage. In *Heritage Keywords: Rhetoric and Redescription in Cultural Heritage*. Kathryn Lafrenz Samuels and Trinidad Rico (eds.). Boulder: The University Press of Colorado, 181–196.

8

RECKONING WITH EXTRACTIVISM

Towards an Anti-Colonial Heritage

Emma Waterton, Hayley Saul, and Divya P. Tolia-Kelly

The Shoulders on Which We Stand[1]

There are three things to say about the way this chapter is written, all of which have been prompted by the work of Métis/Mischif scholar Max Liboiron,[2] though we recognise that similar calls have emerged elsewhere. Hopefully, they convey our efforts to meaningfully and responsibly engage with the need to reject the extractive

1 The title of our introduction borrows directly from the work of Max Liboiron (2021a: 1) and their description of footnotes as 'representing the shoulders on which I stand and the relations I want to build' (see also note 2).

2 We are grateful to Max Liboiron for writing the chapter 'Engaging' (2020), the Blog Post 'Reading Relations' (with Deondre Smiles, 2021), and, importantly, the monograph, *Pollution is Colonialism*, in which they illustrate so clearly how 'protocols of gratitude and recognition' might play out in academic writing (2021a: 1). We are learning from their work and have enacted some of their reflexive 'response-abilities' here in this chapter. These include engaging with the reader right here in our footnotes in order to better explain our approach and influences. We have also learnt from their practice of identifying, where possible, *all* authors, rather than simply marking out Indigenous authors with their affiliations, the purpose being to de-centre whiteness as the 'unexceptional norm, while deviations have to be marked and named', where the concomitant assumption is that white and settler authors need not introduce themselves (2021a: 3, 112). Liboiron remarks that this practice is hard and imperfect. They are not wrong! We have also struggled with this challenge. In the end, Liboiron adopted the practice of identifying authors in the way they identify themselves. In those instances where an author does not identify themselves or the Land from which they speak, Liboiron uses the following: (unmarked). A similar practice is adopted here for those authors whose work we are particularly indebted to and whose names we call out in our prose. There are other authors whose work we engage with less deeply; for those, we have retained the Chicago 'author-date' in-text style (see note 3).

DOI: 10.4324/9781003188438-13

economies of academic writing and adopt, instead, reciprocal reading, writing, and citational practices. The first thing we want to talk about is our approach to referencing.[3] As we all know, the usual practice in academia is to place those sources that have informed our thinking at the end of a book, chapter, or article, where they linger almost as an afterthought, herded into an alphabetised list of mined texts that seemingly deserve little more than a cursory nod of acknowledgement. As Liboiron observes, this approach is extractive and makes it hard for readers to know and value where ideas really come from.

In response, we introduce the two sources that have most profoundly shaped this chapter here, at its beginning. We start with Michi Saagiig Nishnaabeg writer Leanne Betasamosake Simpson and her 2017 monograph, *As We Have Always Done: Indigenous Freedom through Radical Resistance*, in which she argues that colonialism has always been, and always will be, about extracting, taking, assimilating, and stealing (see also Dang 2021). In the volume's third chapter, which is about centring gender in resurgence scholarship, Simpson writes: 'I understand colonialism as an overwhelmingly dominating force in my daily life that continually attacks my freedom and well-being as kwe[4]' (p. 44). In acknowledging this, she is denying colonialism as a historical 'incident' and insists instead that 'it is a gendered structure and *a series of complex and overlapping processes* that work together as a cohort to maintain the structure' (p. 45, emphasis in original). She goes on to argue that '[t]he state uses its asymmetrical power to ensure it *always* controls the processes as a mechanism for managing Indigenous sorrow, anger, and resistance, and this ensures the outcome remains consistent with its goal of maintaining dispossession' (p. 45, emphasis added). A particularly powerful moment in her book occurs as Simpson shifts towards a discussion of anticapitalism. To introduce this shift, she recounts an interview with Naomi Klein in 2013, during which they discussed extractivism. When asked about Indigenous resistance, Simpson issued the following reply:

> Our elders have been warning us about this for generations now – they saw the unsustainability of settler society immediately. Societies based on conquest cannot be sustained, so yes, I do think we're getting closer to that breaking point for sure [...] But I don't think it matters. I think that the impetus to act and to change and to

3 Referencing in this volume adopts the Chicago 'author–date' in-text style, but in this chapter, we also employ footnotes to speak more directly to readers. This may feel quite disconcerting as we have been taught by various academic structures and conventions to be consistent. Always. Such calls for consistency may need to be challenged, though, particularly if there are opportunities to dislodge colonialist hierarchies of power and alienation.

4 Simpson describes 'kwe' meaning 'woman within the spectrum of genders in Nishnaabemowin, or the Nishnaabe language' (2017: 29). For an in-depth critique of the reduced representation of gender to a binary of male/female and framed by colonialism, readers should consult Sandy O'Sullivan's 2021 article, 'The colonial project of gender (and everything else)', published in a special issue of *Genealogy* titled 'Indigenous Identity and Community'.

transform, for me, exists whether or not this is the end of the world. If a river is threatened, it's the end of the world for those fish. *It's been the end of the world for somebody all along.* And I think the sadness and the trauma of that is reason enough for me to act.

(p. 74, emphasis added)

Our thinking in this chapter is also indebted to the work of Libby Porter, a white settler scholar living and working on stolen land in Naarm/Birrarung-ga (Melbourne), Australia. Drawing on the work of Simpson in her short provocation, 'Against world-killing silence', Porter directly addresses Australia's planning field[5], arguing that both the discipline and profession have been central to the 'work of ending worlds' due to their complicity in deepening the violent conditions of extraction and alienation (2021: 112, 113). Going further, she states:

Whatever I'm writing here, then, can be read as me simply sustaining that commitment to be responsible. Rage is essential, foundational to my being responsible. For shouldn't we be enraged at the ending of worlds? I am reminded that rage is "transformative and world-building" and "propels us well" (Malatino 2019: 122). So while it is not much, this simple commitment, it is whatever it is and might be. I hope it urges you, propels you well, to continue the relentless, often tedious, sometimes dangerous work of holding to account.

(Porter 2021: 112)

Much of Porter's writing rings true for the field of Heritage Studies, which, like planning, has long been implicated in the colonial project, orchestrating as it does which pasts are to be remembered and which are to be erased[6]. In the work of both Simpson and Porter, we see a call to radically rethink how one might go about 'decolonising' heritage praxis when the field is already built on colonialism and, as one of its agents, is so instrumental to its execution. Indeed, we have started to wonder whether Heritage Studies might *turn to 'Critical' Heritage Studies* colonialism to exist as it currently does, meaning, to borrow from Dang (2021: 1004), that it attempts only

5 Though it may already be obvious, we want to acknowledge that we first encountered the influential work of Leanne Betasamosake Simpson through our reading of Libby Porter, who has been writing carefully and responsibly about the politics of urban land in settler-colonial Australia for many years. We read her contribution to the Interface 'Planning Solidarity? From Silence to Refusal', published in 2021 in the journal *Planning Theory and Practice*, as an invitation to hold other fields and disciplines to account.

6 See also 'Decolonizing landscape', an article authored by Tiffany Kaewen Dang, a Cantonese-Vietnamese-Canadian scholar from Treaty 6 Territory in Edmonton, Canada, and published as a commissioned essay in the journal *Landscape* Research in 2021, in which Dang, in a similar way to Porter, interrogates the crucial role the field of landscape studies has played in the processes of European colonialism. The importance of Dang's contribution is reflected in her being awarded the journal's Best Paper Prize by an Early Career Researcher in 2022.

'to mitigate the effects of colonialism rather than strive for the complete abolition of colonial power structures'.[7] Certainly, the turn to Critical Heritage Studies has done little to overhaul the field. Instead, all we seem to have achieved is the creation of the impression that we now stand outside of practices of power and exclusion, rather than being constitutive of them (after Chandler and Chipato 2021). In other words, we have dressed ourselves up as the solution, rather than the problem.

The second thing we want to talk about is our footnotes. Like the practices adopted by Max Liboiron (2021a) and Katherine McKittrick (2021), our footnotes represent our efforts to contextualise, expand, and emplace our work and establish 'good relations'[8] with texts. We have started with references to Porter and Simpson in order to acknowledge that the ideas we present could never be ours alone. Indeed, to borrow from McKittrick (2021: 15), they are built on 'stories, research, inquiries that we do not (and should not claim we) own'. We therefore use our footnotes to acknowledge which, and how, particular pieces of work have informed our thinking in order to represent 'the shoulders on which [we] stand and the relations [we] want to build' (Liboiron 2021a: 1). Much of that work comes from places other than Heritage Studies because, as a field, we have always been very good at reproducing our 'world' around certain bodies and a limited set of experiences, to borrow from British-Australian feminist killjoy Sara Ahmed[9] (2013; see also Mott and Cockayne 2017). Ahmed refers to these efforts of reproduction as techniques of selection or screening, through which 'certain bodies take up spaces by screening out the existence of others' (n.p.). As she goes on to argue, '[i]f you are screened out (by virtue of the body you have) then you simply do not even appear or register to others' (n.p.). In response to such marginalising practices, Liboiron, McKittrick and Ahmed push for a more thoughtful, conscientious and deliberate approach to knowledge systems, where '[c]iting the knowledges of Black, Indigenous, POC, women, LGBTQAI+, two-spirit, and young thinkers is one small part of an anticolonial methodology that refuses to reproduce the myth that

7 In making this argument, Dang is acknowledging the extraordinary influence of Eve Tuck and K. Wayne Yang, particularly their 2012 article 'Decolonization is not a metaphor', in which they argue for an understanding of decolonization as the repatriation of land and life. As they make clear, it is about giving land back. As such, any and all efforts to 'metaphorize' decolonization, as they go on to argue, 'makes possible a set of evasions, or "settler moves to innocence", that problematically attempt to reconcile settler guilt and complicity, and rescue settler futurity' (p. 1).

8 'Good relations', or *miŷo-wîcêhtowin*, is a Cree concept that Margaret Kovach describes as under-pinning holistic, relational knowledge systems. As Margaret Kovach (2009) goes on to argue, it is about being honest about one's purpose and motivations.

9 Both Liboriron and McKittrick draw on the brilliant work of Sara Ahmed, particularly posts on her feministkilljoys blog such as 'Making Feminist Points' and 'White Men'. Ahmed's work is not new to us. We have adopted her thinking on emotion and the 'stickiness' of affect in other work, and have responded to the critical prompts she has issued by thinking hard about the variations and intensities of emotion that emerge through our subjective experiences of heritage. In addition to Ahmed's work on citation practices, Liborion also points readers to the 2017 article 'Citation matters: Mobilizing the politics of citation toward a practice of "conscientious engagement"', by Carrie Mott and Daniel Cockayne.

knowledge, and particularly science, is the domain of pale, male, and stale gatekeepers' (Liboiron 2021a: viii).

The third and final thing we want to foreground is our own positionalities as researchers and writers. Two of us (Emma and Hayley) wrote this as first-generation white women settlers who were living and working on stolen Indigenous Land that always has and always will belong to the Darug Nation.[10] Emma has lived in Australia for a total of 21 years, having migrated there twice, first in the 1990s as a child, after spending nine years in Hong Kong, and again, in 2010, after spending ten years in the United Kingdom. Emma's research has tended to focus on the politics of heritage and understanding the work dominant structures, assumptions, and policies do in terms of marking out who's heritage is included and who's is excluded. Her thinking in this space is indebted to the work and ongoing struggles of First Nations peoples to dismantle those structures and assert their rights and responsibilities to their Country (Sobo et al. 2021). Hayley lived in Australia for eight years. Her research interests in mountain heritage have brought her into conversations with the Indigenous peoples of the Himalayas (most consistently, the Langtangpa). It is a place where climate futures are precarious, but where Indigenous adaptive solutions – informed by very old traditions – are making important strides towards community flourishing, whilst simultaneously mounting a movement for Indigenous inclusion in governance. Both Hayley and Emma have now returned to the United Kingdom.

Divya is a collaborator to this paper in only a small part. She was born in British-colonised Kenya and was exiled by the Kenyan government and has lived in the United Kingdom since 1973. Her positionality is as a Black academic who uses postcolonial and decolonial theory to challenge singular hegemonic accounts of being-in place, histories of place and heritage to pluralise and fracture imperial technologies of seeing and being-in the world from a captivating and reductive academic practice, implicit in colonial extraction and mining of 'others'. As a racialised and colonised person, Divya is conscious of harmful academic tactics and praxis and seeks to be open towards others, their knowledge production and seeks to ensure these persons become part of collaborative praxis, working towards a plurality of voices (see Fagan et al. 2001).

These three things hopefully provide some clarity about how this chapter has been written. But why has it been written and what is it actually about? Following the urging of Porter, it is about holding the field of Heritage Studies to account. Moreover, it is about asking researchers to prepare the ground for a collective reimagining, led by previously marginalised voices. Although the chapter could have arisen out of many different experiences and encounters over the past several years, the following story, about a town called Fitzroy, seems to capture many of the core issues we want to explore.

10 The Darug Nation, a language group of First Nation Australians, are the Traditional Custodians of much of what is today known as the Greater Sydney region.

Act I: Unceded Lands

So much of what Australia's settler-colonial population has come to think and know about themselves and the land on which they live radiate from stories of 'discovery' that centre on the country's unfathomable vastness. While the earliest written texts provide detail on the continent's now densely populated coastal fringe, it is depictions of its interior, where one finds references to a 'heart-breaking wilderness' (2021: 1) and a 'wretched bareness' (2021: 4), that, as Mark McKenna (unmarked) has argued, have been the most enduring (see Langton 2000). The tired clichés that continue to surface in Hollywood hark back to the 'rugged', 'inhospitable' and 'impassable' terrain once described in the diaries of European explorers. William Dampier – buccaneer, botanist, and adventurer – was one of the first Europeans to give 'solidity' to the vast southern continent now known as Australia, gifting it a 'phantom presence' through written descriptions of his visit in 1688, which he published in an account titled *A New Voyage Round the World* (cited in Parker 2019: 11). His observations would play a key role as proselytizer for future European explorations, foreshadowing Cook's infamous voyage to the Pacific and the eventual establishment of a British colony some 100 years later in 1788 (Commonwealth of Australia 2011).

At the time of his 1688 landing, Dampier was crewing the privateer ship *Cygnet*, which anchored for five weeks in what would later be called Karrakatta Bay in Western Australia (Parker 2019). As one of the first Britons[11] to set foot on the continent, he was exploring what the Nyikina people have always called the Moorrool Moorrool,[12] which lies at the mouth of the mighty Martuwarra[13] and is now one of Western Australia's most spectacular tourist destinations. Starting its flow further east in the Wunaamin Miliwundi Ranges,[14] the Martuwarra snakes through 700 kilometres of the so-called West Kimberley region before emptying out into the Indian Ocean. The landscape that lies within its catchment is famous for its towering cliffs, waterfalls, plateaus, and deep gorges, and, due to its promise of oil reserves and agricultural via-bility, has been extensively surveyed by Europeans since the 1880s, including by

11 While William Dampier is heroically remembered as being one of the first Europeans to explore the Australian continent, his arrival commenced a process through which Nyikina people, their neighbours, culture, knowledge and lives were violently pushed into the periphery, with colonial landscape imaging quickly overshadowing Aboriginal occupation and custodianship, which stretches back more than 40,000 years. It remains common to hear references to Australia as a 'young' country, as if the clock only started ticking with the theft of land.

12 Moorrool Moorrool is a large gulf that, since colonisation, has been referred to as King Sound. Where we can, we will prioritise the use of Aboriginal place names, and provide a footnote of explanation/introduction.

13 Martuwarra is the Nyikina people's name for the Fitzroy River, which extends through the Fitzroy Valley, home to five Aboriginal language groups: the Nyikina, Bunuba, Gooniyandi, Walmajarri and Wangkatjungka. The Fitzroy River has many names, such as the Bandaral ngarri, as it is called by the Bunuba people.

14 Once referred to as the King Leopold Ranges, these ranges combine the Wilinggin word Wunaamin with the Bunaba word Miliwundi.

geologists employed by Caltex (Australia) Oil Development Pty (Playford et al. 2014). Such 'discoveries', which unfolded on unceded Indigenous Lands, soon saw the continent's centre 'inscribed with the presence of white Australia' (McKenna 2021: 6).

Today, these landscapes are revered as famous physical reminders of the earth's responses to major geological events, with much of what we see there having been formed in what Western Science calls the Devonian period. Characterised by great carbonate production and extending upwards of 60 million years, that period was responsible for covering the now-dry region with extensive reef assemblages and limestone ranges that for the last 350 million years have found themselves surrounded by a 'sea' of grassland, all the while haunted, to borrow from McKenna (2021: 3), 'by the memory of sea water'. In the millennia prior, ancient reef-builder organisms created 'flat-topped reef-rimmed carbonate platforms, flanked by steeply-dipping marginal-sloped deposits' (Wood 2000: 672) that were so impressive in size, variety, and preservation that, in 2011, they were added to Australia's National Heritage List. Ultimately, however, those reef-systems would not survive. They would be wiped out by a series of global extinction events – caused by sea level change and ocean anoxia – that collectively represent one of the five largest such events in the Earth's history (Playford et al. 2014).

Of course, the Devonian reef system is not the only world to have ended in the region. The above-mentioned 'Age of Discovery' was the starting point of a frenzied period of settler-colonial activity and land grabbing that saw the rapid expansion of European pastoralism, pearling, resource extraction, road- and rail-building, all of which were followed by the establishment of missions and the creation of homesteads (Yu 1994).[15] Famous in this mix is Fossil Down Station, located on Bunuba Country in the central-west Kimberley and acquired in 2015 by mining magnate Gina Rinehart, considered at the time of writing to be the richest person in Australia.[16] Established in 1886 – almost 200 years after Dampier's visit

15 This sort of colonial infrastructure should be understood via the acute observations of Linda Tuhiwai Smith, Ngāti Awa, Ngāti Porou and Māori scholar, who writes: 'The establishment of military, missionary or trading stations, the building of roads, ports and bridges, the clearing of bush and the mining of minerals all involved processes of marking, defining and controlling space. There is a very specific spatial vocabulary of colonialism which can be assembled around three concepts: (1) the line, (2) the centre, and (3) the outside. The 'line' is important because it was used to map territory, to survey land, to establish boundaries and to mark the limits of colonial power. The 'centre' is important because orientation to the centre was an orientation to the system of power. The 'outside' is important because it positioned territory and people in an appositional relation to the colonial centre; for [I]ndigenous Australians to be in an "empty space" was to "not exist"' (1999: 52).

16 Gina Rinehart also has a 50% stake in two other nearby stations, Liveringa and Nerrima. An additional two neighbouring properties, Jubilee Downs and Quanbun Downs, are owned by Australia's second richest person, Andrew Forrest, and are located to the east of the town of Fitzroy Crossing.

and 100 years after the establishment of the first penal settlement in Warrane[17] – it is famous for being the endpoint of the longest droving journey ever to have crossed the continent, with hundreds of cattle moved 5,600 kilometres by the MacDonald brothers (Commonwealth of Australia 2011; Hawke 2013). It also represents the furthermost outpost of an arm of exploration that spread north then westward from Warrane. At the same time, a second arm was snaking its way along 'the southern fringe of the continent, and up the Western Australian coast' (Hawke 2013: 34). The establishment of Brooking Springs Station in 1888 to the immediate west of Fossil Downs completed the 'circle of white settlement' (Hawke 2013: 34).

The region's history of pastoralism remains deeply entangled with Australia's national identity. Steeped in the language of 'struggle' (Mackey 2016), the hard work of pastoralists continues to be highlighted as a key component of the nation's legacy and instrumental to the 'subduing' of the continent. As Goenpul author Aileen Moreton-Robinson of the Quandamooka First Nation argues, such references to hard work and determination played a key role in enabling settlers to mark out the continent as 'their own', thereby ensuring Australia's 'inherited values were racialized (that is, whitened) in the process of becoming a nation' (2015: 25–26). Less frequently called to mind is the fact that those settlement activities relied on the violent dispossession of Aboriginal Lands and the theft of generations of Aboriginal children as Australia's growing population shifted to a non-Indigenous majority (Moreton-Robinson 2015). This 'side' of Australia's history is often quietly ignored, as are the systems of Law and sovereignty that continue to be practiced by Aboriginal peoples across the continent. The Land found at the start of the Bandaral ngarri, for example, belongs to the Bunuba people, with that to the north belonging to the Angajin and Nagarinyin (Pedersen and Woorunmurra 2012).[18] South of the river are the Lands of the Walmajarri. To the east, the area belongs to the Worla, Kija and Gooniyandi and to the west are the Lands of the Warrwa, Nyikina and

17 Warrane is the Gadigal name for what is now known as Sydney Cove, Port Jackson, as described on Barani: Sydney's Aboriginal History website, which can be found here: https://www.sydneybarani. com.au/whats-on-this-website/. It lies on the southern shore of the so-called Sydney Harbour and stretches from the Opera House to the Harbour Bridge.

18 Much of our historical knowledge about the town of Fitzroy comes from two sources: Pedersen and Woorunmurra (2012) and Hawke (2013). Both books were purchased from the town's Visitor Information Centre and are published by Magabala Books, an Aboriginal-owned/led publisher based in Broome, Western Australia. Howard Pedersen is an unmarked author. Banjo Woorunmurra was a Bunuba Elder responsible for the telling of Jandamurra's story so that the Bunaba people 'would never lose [their] history, [their] sense of wonder at the magic and power of [their] Country and the knowledge of the deep injustices inflicted on [their] people from those who invaded [their] Country' (Nyanyijili Thalbagbiya June Oscar, Bunuba leader, cited in Pedersen and Woorunmurra 2012: n.p.). Their resultant collaboration was shortlisted for the New South Wales Premier's Literary Awards and was the winner of the Western Australian Premier's Book Awards, both in 1996. Steve Hawke is also an unmarked author. His monograph, *A Town is Born: The Fitzroy Crossing Story*, was conceived by Bunuba leader, Joe Ross, and is based on the recollections of Bunuba, Walmajarri, Wangkajunga, Nyikina and Gooniyandi Elders and storytellers.

Unggumi (Pedersen and Woorunmurra 2012). None of that mattered to the settlers, of course. By 1829, the region had been claimed by the British and incorporated into their Empire. But settlement was not without resistance and the subsequent slaughter of hundreds of Aboriginal people. Bunuba resistance, aided by the fortress-like complexity of the ancient Devonian reefs, was some of the most revered, particularly that led by Jandamarra, a resistance fighter known to Europeans as Pigeon who, in the 1890s, successfully subdued settler expansion for a ferociously bloody three-year period (Pedersen and Woorunmurra 2012). He was eventually cornered and killed in Baraa (Tunnel Creek) in 1897. Following his death, European settlers moved swiftly to secure Bunuba Lands as their own.

Act II: A Town Is Born

The creation of an ancient Devonian reef, the writings of a young English explorer, Australia's longest overland cattle drive and fierce Bunuba resistance all conspired to put West Kimberley on the heritage 'map'. After decades of relentless dispossession, the region's Indigenous Lands are now predominantly known through Euro-colonial technologies, such as mapping, surveying, resource management and property ownership regimes which, to borrow from Charmaine A. Nelson (2017: 51), might better be understood as occupying part of a broader 'spatial discipline', where disciplining refers to:

> … the ways in which various actors (soldiers, geographers, etc.) used cartography and processes like mapping to exert control over geography, nature, and human inhabitants (often Indigenous peoples) who were regularly seen as expendable or an obstacle to some Eurocentric notion of progress.

It was in this process that settlers made Indigenous Land 'their new home and source of capital', thereby commencing 'a profound epistemic, ontological, cosmological violence' (Tuck and Yang 2012: 5). This enacting of colonial power instigated the creation of the small town of Fitzroy Crossing, which today serves as a hub for the wider Fitzroy Valley. It is one of those Western Australian locations that has the peculiar charm of being closer to Singapore, Jakarta, and Ho Chi Minh City than it does to the nation's capital, which is almost four thousand kilometres to the southeast. Given the Australian penchant for shortening names, the town is often called Fitzroy. It is small and dusty, surrounded by red earth, low-lying hills, and big skies. Much of its surroundings carry visible reminders of the ongoing pastoral industry, along with less visible colonial infrastructures such as national parks. Every ruin left standing, as McKenna (2021: 18) remarks, provides a 'source of white melancholy'. The straight roads are interrupted by occasional gateways adorned either by sun-bleached cows' skulls or rusty metal fragments from the pastoral past, both of which surface like 'faint static in an ocean of Indigenous knowledge' (McKenna 2021: 18).

FIGURE 8.1 The Great Northern Highway as it approaches the town of Fitzroy Crossing.

Source: Hayley Saul.

Geographically, the town sits roughly at the midpoint of a 550-kilometre stretch of road called the Great Northern Highway, which reaches from Derby to Halls Creek in an area often referred to as 'Australia's "last frontier"' (Christen 2006: 82) (Figure 8.1). Originally little more than a bush outpost, the town's population had reached 1,297 by the 2016 national census, split equally between the categories of male and female,[19] and with a median age of 31 (compared to 38 nationally). 61.5% of the township identified as being of Aboriginal and/or Torres Strait Islander origin at a time when only 3.1% of the wider Australian population identified as such. While the town itself sits on Bunuba Country, the Fitzroy Valley remains culturally complex and includes an additional nine language groups: the Kija, Worla, Andajin, Nagarinyin, Gooniyandi, Unggumi, Walmajarri, Nyikina and Warrwa peoples.

19 The standard 2016 Census online form provided only the response options of 'male' and 'female'. Respondents were provided with instructions to call the Census Inquiry Service if they wanted to identify as other than male or female. This gender binary, as Sandy O'Sullivan argues (2021: 1), is part of a broader effort to reduce and erase Indigenous pasts, and to impose on, and commodify, 'not only the bodies of existing Indigenous people, but also past and future Indigenous people'. See their article 'The colonial project of gender (and everything else)' for a more fulsome discussion (see note 4).

The area's traditional laws and lands hinge around the 'living waters' (Rose 2004) of the Bandaral ngarri (or Martuwarra) floodplains, which, for the area's Traditional Owners, 'is everything' (Poelina et al. 2019: 240). As Nyikina Warrwa scholar, Anna Poelina et al. (2019: 240) argue, the river and its floodplains are a 'life-force' brimming with fish and freshwater crocodile, and support a range of flora and fauna including kangaroos, bush turkeys, goannas, emus, lizards, fruits and other wild edibles. They also sustain 'ancestral spiritual beings, cultural heritage, education and health systems' (Poelina et al. 2019: 240). Europeans reached the area quite late in the colonisation process but, with the discovery of fertile lands, it soon became a focus for pastoralists interested in both sheep and cattle. Their arrival was swift and brutal, providing the first layer of a sedimentation of injustice that would be swiftly followed by the establishment of the Kimberley Land Regulations in 1882. Within a year, over 44 million acres of land had been acquired by a mere 77 individuals, with approximately one-third of that land split between only five of them (Smith 2000). Supported by prominent families and growing investment companies, epic droving ventures quickly followed, culminating in the movement of thousands of heads of cattle from Queensland and the Northern Territory to the Kimberley (Smith 2000).

It was in this mix of efforts to accumulate capital that the town of Fitzroy stumbled into being, its surrounding landscapes swiftly and indelibly etched with European patterns of land ownership, wealth, and power, along with lingering feelings of presence and absence (Hawke 2013). Two of the chapter's authors first visited the town in 2014, at the start of what the Bunuba call the Barrangga, or 'the build-up', when the days gradually become hotter and drier, and you can feel in the air a bushfire gathering itself together, readying to rip through the landscape (BDAC n.d.). On their first day, they encountered a man named Jim. He was standing outside the town's convenience store – the IGA[20] Tarunda – with soft hands and a lingering handshake. Later, they would come to realise what he meant when he referred to himself as one of the 'lost people', but in that moment, when they first got alongside Jim and caught a glimpse of a finished life, all they knew was that something had gone terribly wrong. He told them fragments of his story in front of a stranger's car, their bodies huddled together while his eyes strayed elsewhere. It was a story of displacement, loneliness, shame, dread, and yearning, and, in its retelling, it became clear that Jim had no place to go. They found him in that car park looking for comfort, for people, for hope and understanding, all the while trying to ignore the desperate whiffs of what Elspeth Probyn (unmarked; 2004: 328) has described as 'the body's desire to fit in, just as it knows it cannot'.

The seeds of Jim's turmoil – and others like him – took root in the late 1960s with the granting of equal pay for equal work to Aboriginal pastoral workers. Though part of a broader civil rights movement that would come to be

20 IGA stands for Independent Grocers of Australia.

remembered as an integral part of the 1967 Australian Referendum,[21] the decision was nothing short of a hollow victory in that it had astoundingly negative impacts on the economic, political, social and cultural fabric of the area. The granting of equal pay effectively meant awarding Aboriginal pastoral workers, many of whom had previously been paid in food and shelter, a pay increase of an estimated 750% (Hawke 2013). On the basis that station owners could no longer afford to pay them, countless Aboriginal people were permanently discharged from their employ. Pressured to leave their jobs, evicted and, in the process, denied access to their own traditional lands and ways of life, almost two thousand people left various Kimberley stations and took refuge on the fringes of Fitzroy.

In the months that followed, Fitzroy seemed to vibrate with a tension that threatened to rip the town apart (Hawke 2013). By 1969, 'the swathe of cattle stations that formed the southern fringe of pastoral country ... were largely bare of their Indigenous workforce' (Hawke 2013: 161). Basic housing was established with different language groups living together, and the small bush town grew from a pub (the Crossing Inn), a police station and a post office into a township (Hawke 2013). So momentous were the disconnections that took place thereafter that they threatened to permanently transform the relationships between kin, storied landscapes, and ancestors. Large communities of Aboriginal workers and their families must have felt so excluded that any feelings of belonging would surely have come close to evaporating. As Steve Hawke (2013) argues, 'degradation and misery' (p. 190) permeated Fitzroy, threatening to deteriorate into 'an orgy of self-destruction as rampant drinking and alcoholism quickly became a feature of life in the fringe camp' (p. 191). Roots, already physically obliterated, were being further occluded by an ideological imperative to seal off the past from the present on the basis of *terra nullius*.

Act III: Erased, Invisible, But Still Flourishing

The impact of Australia's settler-colonial history remains a rich, ripe secret in many parts of the country. Thus, while histories of dispossession inevitably frame at least part of Fitzroy's story, the town is more commonly understood in ways that seem to deliberately absent or erase structures of colonialism – the 'enterprise of annihilation', to borrow from Palyku novelist Amberlin Kwaymullina (2020) – and instead foreground a discourse of dysfunction, disadvantage and victimhood. This 'narrative of deficiency' is pervasive in Australia and sits alongside an 'authenticity' narrative that simultaneously seeks to suggest that there are gradations of authenticity that diminish as one moves closer to urban centres (Fforde et al. 2013: 162). In this regard, though undeniably remote, those living in Fitzroy appear to be just 'urban' enough to have

21 The 1967 Australian Referendum asked questions about whether or not to remove Section 51 from the Constitution so as to allow the Commonwealth government to legislate on Aboriginal affairs, and whether or not to remove Section 127, and thereby allow Aboriginal peoples to be counted (Peters-Little 2010).

been landed with a sense of deficit and loss, which, though purely conceptual, works to undermine any notions of a 'real' or 'authentic' Other (Byrne 1996; see also Aguiar et al. 2021: n.p.). At the same time, and as so often happens with the union of colonialism and capitalism, cultural traces of Aboriginal connection have been rapidly reduced to estimates of agricultural yield, wherein any evidence of cultural affiliation or claims to Country come to represent a potential cost or loss of value.

But, as Arran Stribbe (unmarked; 2020) argues, other stories are often told between the lines. Indeed, landscapes of marginalisation are also landscapes of emergence or resurgence for those 'within', meaning that places can be erased, invisible *and* flourishing all at the same time (hooks 1990; see Porter et al. 2020). In other words, their seeming despondency harbours powerful 'spaces of resistance' (hooks 1990: 208). This seems to be the case in Fitzroy, which resonates not only with feelings of loss, but with hope and a refusal to be erased. A 'ferment of new ideas and activism' has emerged, meaning the story of Fitzroy, which popularly and politically has tended to revolved around narratives of escalating crime and isolation, is simultaneously one of resilience and strength (Hawke 2013: 191), a story that centres on a knowing and conscious desire to carefully attend to place and restore a sense of belonging, responsibility and connection.

This sense of emergence and resistance is illustrated in several places within close proximity to the town, such as Danggu (Geikie Gorge National Park), Dimalurru (Tunnel Creek National Park) and Mimbi Caves. The first two sit in Bunuba Country and the latter, Mimbi Caves, in Gooniyandi Country to the east. All three have seen the establishment of flourishing Indigenous-owned tourism enterprises that stand as examples of empowerment and resistance. Indeed, as Bunten (2011: 77) argues in a similar context, such tourism provides a way for Indigenous people to 'challenge existing structures of power while asserting their rights to exist in the contemporary world on their own terms', as well as to, as Travesi (2018: 382) adds, represent themselves 'authentically'. Similar acts of empowerment can also be found in the 2016 Fitzroy River Declaration, written by a consortium of Traditional Owners from the Fitzroy catchment who have agreed 'to work together for the river' and establish a new water governance body, the Martuwarra Fitzroy River Council (Poelina et al. 2019). Such positive stories provide a counternarrative to the 'deficit discourse' that has for decades framed Aboriginal identity 'around negativity, deficiency and disempowerment', providing instead insight into the 'innovative reality of contemporary Aboriginal culture' (Byrne 1996: 100; see Poelina et al. 2019; Fforde et al. 2013).[22]

22 Recent doctoral research by Vanessa Whittington provides an in-depth exploration of interpretation strategies and content adopted and presented in a number of protected areas in Australia. Through this research, Vanessa illustrates the various ways in which visitors use heritage tourism interpretation to either challenge or reinforce pervasive deficit discourses about Aboriginal peoples in Australia. At the time of writing, Vanessa's thesis had not yet been completed, but interested readers are encouraged to consult her already published work on visitor responses to the interpretation of Aboriginal cultural heritage in a range of places in Australia.

Nonetheless, tension remains. On the one hand, the area's heritage has achieved recognition at the national and international level, finding its way onto the National Heritage List in 2011 as part of the West Kimberley listing, which recognises its historic, Indigenous and natural values. The Fitzroy River is also listed under the *Aboriginal Heritage Act 1972 (WA)*. The above-mentioned national parks are accompanied by Windjana Gorge National Park and Wunaamin Conservation Park (formerly King Leopold Ranges Conservation Park) and, given the relationship between heritage and tourism, it is hardly surprising that they have come to provide a major drawcard for the region. But, on the other hand, it is only the area's so-called 'natural' assets that are seen to be the key basis for this success. Our surveys with visitors in 2014 revealed that this view was shared by tourists, with the majority (56%) stating they were visiting the nation's 'natural heritage'. Only 16% acknowledged that they were on Aboriginal Country. This practice of erasure is compounded by the national heritage listing itself, which, though referencing Bunuba resistance and Indigenous values, carefully excises the town and the futures it supports from the boundaries of the listing, seemingly with the stroke of a pen. **End Story.**

This Is Not a Story About Fitzroy

It is not only in the discourses of Fitzroy that things are being erased. Such erasures are part-and-parcel of contemporary heritage processes, which, to borrow from Deborah Bird Rose's (unmarked, 1999: 177) reflections on Western thinking more broadly:

> … mistakes its reflection for the world, sees its own reflections endlessly, talks endlessly to itself, and, not surprisingly, finds continual verification of itself and its world view. This is … a narcissism so profound that it purports to provide a universal knowledge when in fact its violent erasures are universalizing its own singular and powerful isolation.

Fitzroy, then, provides an effective foil to think more broadly about the ongoing relationship between heritage and colonialism. This, then, is not a story about Fitzroy but is one about the deliberate obscuring of the work colonialism continues to do in the field of heritage, where tensions between permanence and erasure have long weighed heavy. Heritage, as we currently imagine it, is something we are convinced we want to last and, as such, much of our work revolves around selecting and defining that which is worthy of protection. However, as many scholars remind us, as quickly as some people, places and things are conserved, others are erased and forgotten (Hall 1999; Littler and Naidoo 2005). And while much has been written about the instrumental role played by heritage and its relations (i.e. archaeology and anthropology) in the historical execution of colonialism, far less is said about the fact that the field is still inscribed with coloniality: its processes of exclusion continue to

reiterate white, colonial frameworks and grant them their own sense of permanence. Heritage thus remains 'actively engaged in any number of world-ending activities' (Porter et al. 2020: 112). The paradox, of course, is that in seeking to protect it enacts extinction. To borrow from Cameroonian philosopher Achille Mbembe (2019), heritage can thus be reimagined as pharmakon, encapsulating both cure and toxin, remedy and poison. Or, to again paraphrase Deborah Bird Rose (2011: 11), we can love a thing and still be dangerous to it.

One thing is clear: as the engine of heritage-making turns over, stories and worlds are sucked into the fray and combust. Inevitably, one past emerges at the expense of others, and that narrative victor casts a long shadow. For Australian ecofeminist Val Plumwood (unmarked), such shadows are location-based. Her concept of 'shadow places' draws attention to the apparent singularisation of place, or 'our honouring of place towards an "official" singular idealised place consciously identified with self, while disregarding the many unrecognised, shadow places that provide our material and ecological support, most of which, in a global market, are likely to elude our knowledge and responsibility' (2008: 139; Miller 2020: 157). Places, then, are multiple and intertwined and it is the maintenance of one version of any given place that leads to the marginalisation or destruction of another. Plumwood refers to those so marginalised as 'shadow places', and points to a propensity in western society to disassociate the affective from the economic. As clear components of commodity culture, places of heritage are undoubtedly the charismatic frontage that eclipse those that don't or can't mould into 'neat' and 'nice' narratives that connect past with present and future. It is a 'turning away', to borrow from Rose (2011), that now lies at the core of who we have become: experts of compartmentalised thinking and doing.

Returning to Fitzroy, despite the hopeful tourism-making enterprises on its rural fringe, the town has nonetheless been politically abandoned in many ways, left to linger in shadows cast by neoliberal policies that have seen the slow withdrawal of culturally appropriate support services and an under-investment in Aboriginal well-being. Those shadows were first cast by the colonial logics of agriculture, which started the process of extracting both people and culture from place many years ago. Unfortunately, beef grazing continues to dominate. Indeed, much of the area is cherished by pastoral elites, with nearby stations celebrated and owned by billionaires.[23] Their coveted produce is enjoyed elsewhere, shipped off to China and other international destinations, leaving Fitzroy to be pushed further into the shadows of capital and colonial logics (Haugen Askland 2020). Despite numerous Aboriginal-owned organisations' resistance to the town's historically situated social fractures, it is in part because of the heritagisation of Fitzroy's rural fringe that these efforts can only sit alongside – and in friction with – the challenges facing the town. Even the most popular tourist accommodation, Fitzroy River Lodge, lies on the other side of the river from the town itself, its resort-like restaurant, swimming pool and tennis court

23 Three properties in the area recently sold for an AUD$100 million combined price tag.

meeting the shoreline of the Bandaral ngarri which, upriver, hosts charismatic heritage places like the Crossing Inn and the Pioneer Cemetery, regular recommendations for tourists seeking a 'frontier' experience. No need to ever step foot in the town itself, let alone witness its entrepreneurial Mangkajao Arts studio, which aims to provide the area with a 'busy community hub of ideas and expression, an Indigenous-owned space that invests in culture and art' and is run collaboratively by the Fitzroy Valley community (Cook 2021: 43). No need because the area's celebrated natural beauty can be enjoyed elsewhere. And so, visitors to Fitzroy can almost be forgiven for thinking that the area's history of dispossession never took place or, if it did, it somehow happened by accident (after Simpson 2017). Its very geography invites tourists to look away, thereby allowing 'recognised' heritage to flourish whilst the prospects of the town persistently smoulder alongside.

How implicated is heritage (both its study and management) in the creation of such shadow places? The answer, simply, is very: it is both creator and destroyer of worlds, of pasts and becomings. As fast as heritage is protecting some pasts, it is casting others in shadow, supporting otherwise unsustainable colonial geographies with its proffered sense of permanence (after Aguiar et al. 2021). Plumwood's multiplicity of place, which carries echoes of Frantz Fanon's claim that 'one place holds multiple selves' (Aguiar et al. 2021: n.p.), is muted by a fascination with stasis. Moreover, to borrow from Chandler and Chipato (2021), it assumes that only recognised subjects have something to 'save'. Everything else is left behind. And in this way, the structures of heritage are indivisible from the extractive harms of colonialism and dispossession of lands. They are such long-time bed-fellows that to speak of 'decolonising' heritage requires that we give serious thought to the need not only to *unsettle* heritage but to *dismantle* it completely, for when the foundations of an entire discipline (and now a global 'management' enterprise) trace their roots back to the same body of colonial genocides, tortures, thefts and demolitions, one has to wonder whether 'reform' or 'restructure' are powerful enough ambitions.[24]

To Unsettle

Colonialism is seldom centred in heritage critiques unless such debate is trained on issues of repatriation. This systematic effort to 'look away', as Porter (2021: 113) describes it, often occurs in the service of 'slippery work', in which somebody's 'end of the world' is justified by the hallowed (or hollowed) language of 'sustainability, fairness and equity'. In response, what we propose in this chapter is a shift in

24 As acknowledged in this chapter's introduction, two of us, at the time of writing, were living and working in Australia, a settler-colonial nation. European settlers arrived, invaded and never left. We therefore acknowledge and adopt Tuck and Yang's (2012: 7) insistence that decolonisation, in settler-colonial context, must always 'involve the repatriation of land simultaneous to the recognition of how land and relations to land have always already been differently understood and enacted; that is, all of the land, and not just symbolically'.

praxis, one that sees researchers prioritise becoming good allies and conducting research we can confidently call anti-colonial. As we acknowledged at the outset, this proposition stems from the work of Black Geographers and Indigenous scholars who have been spearheading anti-colonial thinking for some time. One of us (Divya) has been a leader in this area; the other two (Emma and Hayley) can make no such claim.[25] But what does anti-colonial heritage mean in practice? This is a question we have asked ourselves many times: during innumerable 'dog-walk debates', over Zooms that span our awkward time zones, and after several deadline extensions. In the end, our answer has far less to do with the chapter as it has been written and much more to do with the thinking it has allowed us to do.

Our first realisation in this regard is that we are not in a position to 'design' a heritage practice untainted by the insidious injustices of colonial hegemony and associated worldviews. This would be a naive ambition, one that would silence the work that has already been done by many before us, including those scholars with whom we opened this chapter. Our second realisation is that our writing – here and elsewhere – is compromised by the fact that it is 'partly implicated in the very systems of oppression' we had set out to oppose (after Man 2006: 98, cited in Liboiron et al. 2021: 138). In this chapter, for instance, we mistakenly projected settler value systems onto Indigenous Land by describing Fitzroy in geological, chronological, and cartographic terms. In so doing, we inscribed it with coloniality and universality, rather than pluriversality (Mignolo 2018). We have left our error in place because it provides a powerful reminder about our accountabilities and obligations as heritage researchers, and how we must, to borrow from Liboiron et al. (2021: 138), remain mindful of our relations 'in a compromised field'. It also hints at how we might go about changing our practices, cultivating within our scholarship a consistent attention to colonial scaffolding – to the colonial values, concepts, and structures that undergird the academy. What follows is a modest reflection:

Time-space. In Act I, we set the scene for several ends-of-worlds amongst reef structures many millions of years old. It was a device we adopted to invoke a time depth we assumed would de-centre white settler histories and prioritise Indigenous land relations, laws, and epistemologies. It did the opposite and instead exposed the influence of colonial time-space concepts on our scholarly practice, which are rooted in our use of cartesian time classifications and the geological time of natural history, in which 'the Devonian' is placed along a linear date range. This is a notion of time or temporality that seeks to 'settle time as much as space in the project of settler futures'

25 Here, we are very explicitly drawing on the leadership provided by Max Liboiron and their feminist and anti-colonial laboratory CLEAR (https://civiclaboratory.nl/). Influenced by the work of Eve Tuck and Wayne Yang (2012), CLEAR aspires to anti-colonial science (rather than decolonial science) because decolonisation is about the return of Land to Indigenous peoples (see Note 19). They instead use the term 'anti-colonial science', which they describe as identifying and countering 'colonial values, concepts, and structures within science and the university … with the final goal of doing science differently' (CLEAR 2017).

(Sammler and Lynch 2021). In so doing, we perpetuated a taming of those rocky places, holding them in a colonial grip that operates according to a singular set of temporal principles and renders geology indifferent to other planetary beings. As the environmental humanities scholar Nigel Clark (unmarked, 2011: 52) has argued, it has been the practice of positivist Science to pave the way for entitlements to the Earth's gifts, geology being one of them. Positioning geological places within long, homogenous timelines, undifferentiated by human-scale events, makes it easier to take for granted those gifts that are offered, 'the extraction of which', to borrow from Tuck and Yang (2012: 4), 'continues to fuel colonial efforts'.

As heritage scholars, we need to be 'doubly attentive' to such colonial narratives and their continuity and seek to disrupt them (after Macoun and Strakosch 2013). In this example, we should have been accountable to Bunuba relations with their Land and described aspects of it, such as Danggu, as it had been introduced to us: as animate, relational, and intertwined with stories of ancestors and Creation. As uninvited guests on Bunuba Country, we can only know certain things. For example, we know that 'Old Man Rock', which sits near the western edge of Danggu, was created when a Bunuba Elder toppled into the water and drowned in the Dreaming. We were told this by our Bunuba guide. Before sinking to the riverbed, he sighed and sneezed; his breaths can still be heard when the gorge is quiet. Dreamtime is immanent in every moment, with 'geological time' folding in on itself and losing its linearity with each audible breath. In addition to centring Indigenous Knowledge and Indigenous conceptions of land, '[r]ecalling and affirming creation stories', as Alex Moulton (2021: 8) points out, simultaneously 'calls attention to legal discourses and cultural practices that rely on the subjugation and denial of Indigenous land claims for the settler colony to exist'. This example tells us that we need to keep working on how we pluralise our relationships with, and understand, the past, and that we need to develop better relations. Key here is the development of an ethics of reciprocity, through which we, as researchers, attend to 'the way our existence is interdependent with networks of relations with other humans and non-humans. It is a practice of considering our actions – including in our research – for all the communities with which we are in relation and on which our being depends' (Rosiek et al. 2020: 340). Moreover, anti-colonial heritage practice requires that we attend to the credulity of other explanatory values, without expectation that they will, or should, resemble the time-space logics of Imperial origin, nor be forced through any other form of Eurocentric lens (after Dei 2006).

Cosmologies and co-production. As Subhadra Das and Miranda Lowe (unmarked, 2018) remind us, there are culturally sanctioned ways of seeing and classifying the world, and the sciences that can trace their roots to the Enlightenment represent powerful modes of constructing a reality. This way of seeing is founded on a very particular (and usually positivist) ontology that has consistently and persistently 'erased the scientific contributions of people of colour' (Das and Lowe 2018: 8). As Das and Lowe (2018: 8) go on to argue, such processes of omission were 'central to the colonial project'. Accounting for different ontologies, epistemologies, standpoints and axiologies demands that we

engage with the legitimacy of cosmologies that construct alternative realities and explain different origins, obligations and workings of the universe. Emily Dawson (unmarked, 2018) takes this further, emphasising that inviting people of colour, Indigenous people and minority ethnic groups to participate in practices that produce heritage knowledge without fundamentally reimagining those practices in accordance with anti-colonial cosmologies is woefully inadequate. Instead, co-production of knowledge is needed, and, for those elements of the heritage and archaeology discipline that lean into the natural sciences, this includes expanding the scope of their methods, or stepping aside, to foreground the praxis of Indigenous scientists and other knowledge-holders, as Leanne Simpson (2004: 381) has argued

> Academics who are to be true allies to Indigenous Peoples in the protection of our knowledge must be willing to step outside of their privileged position and challenge research that conforms to the guidelines outlined by the colonial power structure and root their work in the politics of decolonization and anticolonialism.

The Bunuba, for example, understand bushfire dynamics through Dreamtime knowledge of how the fire was created, through their relationships, and through their obligations to those relationships. As it was explained to us, the old crocodile man, Lullangarra, used to keep control of firesticks for himself. The other animals plotted to steal the sticks but only Gid Gunya, 'black kite man', was brave enough. Diving down into the waters of Bandaral Ngarri, he stole the sticks, rose to the surface and flew away, setting light to the land as he went. We were told to look for Gid Gunya during any bushfires. There, we would see him tending to it, spreading fire by carrying burning sticks into dry brush. While Western science explains this as a hunting strategy, through which the black kite transfers bushfire in order to drive out a steady supply of insect prey, Bunuba explanations derive from a more holistic and relational understanding of Country. Gid Gunya works on behalf of other animals, initiating a flourishing of Country. Fire-adapted seeds are stimulated and germinate, producing fresh greens for the kangaroos that move back in after the fire has passed, the charred offerings providing nutrients to the soil and burnt logs new shelters for small animals. We were told the above two narratives on a Bunuba-led tour of Danggu. The stories also feature in literature co-produced by Bunuba community members about the national park. They are retold as part of a method of knowledge-exchange in Aboriginal and Torres Strait Islander cultures: yarning. Bwgcolman woman, Lenore Geia, beautifully describes the importance of storytelling when she says, in a paper written with Barbara Hayes and Kim Usher (both unmarked), that '[y]arning almost always contains the threads of Aboriginal and Torres Strait Island history as it moves into the present tense, its parameters within present time is filtered through the memories of the past as the two move simultaneously and at points collide and reveal [s] fragments of the future' (Geia et al. 2013: 15).

There are many examples in which heritage sites in Australia, particularly national parks, have opened themselves up to methods of co-production, such as

Danggu and Uluru-Kata Tjuta National Park. But they seem to be the exceptions rather than the rule. At the same time, as Walgalu-Ngunnawal and Wiradjuri archaeologist Rob Williams notes, sacred places are being desecrated daily as the nation pursues its reputation as the only developed nation on the WWF's list of deforestation hotspots (Williams 2021). Williams calls attention to the ongoing destruction of scarred trees and grandmother trees in the Marrambidya (Murrumbidgee River) in order to extend farmland, calling out the 'sick indifference' that developers and the government have towards Aboriginal heritage. Similarly in 2020, 1200 Australian academics petitioned the government to halt the destruction of Djab Wurrung sacred trees, though they were too late for the 350-year-old 'Directions Tree' that was felled to make way for a highway (Malins et al. 2020). A recent enquiry has revealed that, in the same year, mining company Rio Tinto blew up a series of 46,000-year-old sacred rockshelters at Juukan Gorge in Western Australia, in spite of objections by the area's Traditional Owners (Kemp et al. 2021). These are not examples of co-production. Far from it. Activating an anti-colonial heritage practice means centring approaches that do not assume 'access to land as a resource' (Liboiron et al. 2021: 140) or that are 'territorially acquisitive in perpetuity' (Coulthard 2014: 125). It means de-centering the hegemony of Enlightenment sciences, capitalism, and its 'development' logics and attending to both the lives and movements of human and more-than-human beings with whom we share space as part of a process of resisting colonialism (Todd 2016).

Frontierism: In closing, we reflect on how the writing of this chapter has highlighted the pernicious nature of what Liboiron (2021b) calls 'firsting' in academia, which is stitched into that very 'basic' desire to be innovative and original. This quest to be first, to discover and explore, can of course be traced right back to its imperial and colonial roots, as Red River Metis scholar Zoe Todd has argued. Heritage Studies, itself so intimately connected with the colonial 'Age of Discovery', is also awash with the proprietary processes of classification and the assignation of value, through which some people, places or things are valorised while others are erased. These, as Liboiron (2021b) reminds us, are part-and-parcel of the act of taking. As they go on to argue

> … firsting creates a world where some forms of knowledge and knowers are, indeed, first and only to know a thing or a place. This requires the erasure of other worlds, other knowledges and knowers in that place. To extend the concept of worlding, firsting is the making of colonial worlds, a technique that naturalizes the dispossession of Indigenous peoples from land.

In addition to attending to colonial narratives and their continuity, heritage scholars must also place themselves in 'better relations' (Liboiron 2021a,b) with the already existing and expansive literature in this area, giving full credit to – by quoting and citing – sources and ideas authored by marginalised Black, Indigenous, two-spirit and young thinkers. Todd (2016: 8) makes this plain when arguing that, '[b]ecause we still

practice our disciplines in ways that erase Indigenous bodies within our lecture halls in Europe, we unconsciously avoid engaging with contemporary Indigenous scholars and thinkers while we engage instead with 80-year-old ethnographic texts or two-hundred-year-old philosophical tomes'. As Elizabeth Carlson (white settler, 2017: 505) urges, we must resist these 'hegemonic pressures and maintain a higher anti-colonial ethic'. Carlson goes on to argue that there can be no 'individual scholarship when we understand ourselves and our knowledges to have been constructed re-lationally' (p. 506). In addition to the work of Max Liboiron, Sara Ahmed, and Zoe Todd, an important guide for us when it comes to writing and citational practice is Katherine McKittrick and her recent monograph, *Dear Science and Other Stories* (2021), particularly the chapter 'Footnotes (Books and Papers Scattered About The Floor', in which she conceives of citations as a way to 'share how we know' (2021: 17, emphasis in the original) rather than an opportunity to authorise our own work. We found this chapter, which revolves around stories that centre Black life and Black experiences, to be crucial reading for better understanding how citational practices can be 'tasked to resist racial and gendered violence through the sharing of ideas' (2021: 30). 'We are doing our very best work', McKittrick argues, when 'we are acknowledging the shared and collaborative intellectual praxis that makes our research what it is' (p. 31). To close, we reiterate the sentiments of Zoe Todd (2016: 19), who suggests 'every time you want to cite a Great Thinker who is on the public speaking circuit these days, consider digging around for others who are discussing the same topics in other ways'.

References

Aguiar, Chowdhury, Afsheen Chowdhury, Misha Falk, Lizzy Hinds-Heuglin, Aakriti Kapoor, Yaniya Lee, Katherine McKittrick, Milka Njoroge, Channon Oyeniran, Nat Rambold and Victoria Valliere. 2021. "Impermanence: On Frantz Fanon's Geographies." *Antipode Online*, https://antipodeonline.org/2021/08/18/frantz-fanons-geographies/

Ahmed, Sara. 2013. "Feministkilljoys." https://feministkilljoys.com/. Accessed 25 October 2021.

Bunuba Dawangarri Aboriginal Corporation (BDAC) (n.d.) "Bunuda Seasonal Calendar." Available online: https://www.bushheritage.org.au/places-we-protect/western-australia/bunuba. Accessed 1 July 2021.

Bunten, A. C. 2011. *The Paradox of Gaze and Resistance in Native American Cultural Tourism: An Alaskan Case Study. In Great Expectations: Imagination and Anticipation in Tourism.*edited by J. Skinner and D. Theodossopoulos, (pp. 61-82). New York, Oxford: Berghahn Books.

Byrne, Denis. 1996. "Deep nation: Australia's acquisition of an Indigenous past." *Aboriginal History*, 20: 82–107.

Carlson, Elizabeth. 2017. "Anti-colonial methodologies and practices for settler colonial studies." *Settler Colonial Studies*, 7(4): 496–517.

Chandler, David, and Farai Chipato. 2021. "A call for abolition: The disavowal and dis-placement of race in Critical Security Studies." *Security Dialogue*, 52(1), suppl: 60–68.

Christen, Kimberly. 2006. "Tracking properness: Repackaging culture in a remote Australian town." *Cultural Anthropology*, 21(3): 416–446.

Clark, Nigel. 2011. *Inhuman Nature: Sociable Life on a Dynamic Planet*. London: Sage.

CLEAR. 2017. "Anti-colonial Science." Available online: https://civiclaboratory.nl/2017/12/29/feminist-anti-colonial-science/. Accessed 28 October 2021.

Commonwealth of Australia. 2011. "Inclusion of a Place in the National Heritage List: The West Kimberley." Available online: https://www.environment.gov.au/system/files/pages/ed0b4e39-41eb-4cee-84f6-049a932c5d46/files/10606305.pdf. Accessed 30 June 2021.

Cook, Belinda. 2021. "The Mangkaja x Gorman Collection: A new wave of Indigenous art and fashion collaboration." *Artlink*, 41(1): 40–47.

Coulthard, G. 2014. *Red Skin, White Masks: Rejecting the Colonial Politics of Recognition*. Minneapolis: University of Minnesota Press.

Dang, Tiffany Kaewen. 2021. "Decolonizing landscape." *Landscape Research*, 46(7): 1004–1016.

Das, Subhadra, and Miranda Lowe. 2018. "Nature Read in Black and White: decolonial approaches to interpreting natural history collections." *Journal of Natural Science Collections*, 4–14.

Dawson, Emily. 2018. "Reimagining publics and (non) participation: Exploring exclusion from science communication through experiences of low income, minority ethnic groups." *Public Understanding of Science*, 27(7): 772–786.

Dei, G. 2006. "Black-Focused Schools: A Call for Re-Visioning." *Education Canada*, 46: 27–31.

Fagan, R., Howitt, R., Suchet-Pearson, S., Adams, M., Abayasekara, G., Cook, R., Edwards, M., Eggleton, K., Harwood, A., Jackson, S. A., and Sharpe, S. 2001. Nourishing Conversations in the Co-construction of Knowledge. In A. Bartlett & G. Mercer (Eds.), *Postgraduate Research Supervision: Transforming (R)Elations* (pp. 261–275). Peter Lang.

Fforde, Cressida, Lawrence Bamblett, Ray Lovett, Scott Gorringe, and Bill Fogarty. 2013. "Discourse, deficit and identity: Aboriginality, the race paradigm and the language of representation in contemporary Australia." *Media International Australia*, 149(1): 162–173.

Geia, Lynore, K. Barbara Hayes, and Kim Usher. 2013. "Yarning/Aboriginal storytelling: Towards an understanding of an Indigenous perspective and its implications for research practice." *Contemporary Nurse*, 46(1), 13–17.

Hall, Stuart. 1999. "Whose heritage? Un-settling 'the heritage', re-imagining the post nation." *Third Text*, 13(49): 2013.

Haugen Askland, Hedda. 2020. "Extraction and emotion at the Australian coal frontier." *Polar Record*, 56(e5). Available online. 10.1017/S0032247420000078. Accessed 29 October 2021.

Hawke, Stephen. 2013. *A Town is Born: The Fitzroy Crossing Story*. Broome: Magabala Books.

hooks, bell. 1990. *Yearning: Race, Gender and Cultural Politics*. Boston, MA: .South End Press

Kemp, Deanna, Bronwyn Fredericks, Kado Muir, and Roger Barnes. 2021. "Fixing Australia's shocking record of Indigenous heritage destruction: Juukan inquiry offers a way forward." *The Conversation*, https://theconversation.com/fixing-australias-shocking-record-of-indigenous-heritage-destruction-juukan-inquiry-offers-a-way-forward-170212. Accessed 28 October 2021.

Kwaymullina, Ambelin. 2020. *Living on Stolen Land*. Broome: Magabala Books.

Langton, Marcia. 2000. "Homeland: Sacred visions and the settler state." *Artlink* 20(1): 11–16.

Liboiron, Max. 2020. "Exchanging." In *Transmissions: Critical Tactics for Making and Communicating Research*, edited by Kat Jungnickel, 89–92. Cambridge, MA: MIT Press.

Liboiron, Max. 2021a. *Pollution is Colonialism*. Durham, N.C.: Duke University Press.

Liboiron, Max. 2021b. *Firsting in Research*. Available online: https://discardstudies.com/2021/01/18/firsting-in-research/. Accessed 29 October 2021.

Liboiron, Max, and Deondre Smiles. 2021. "#Collabrary: A methodological experiment for reading with reciprocity." Available online: https://civiclaboratory.nl/2021/01/03/collabrary-a-methodological-experiment-for-reading-with-reciprocity/. Accessed 27 October 2021.

Liboiron, Max, Emily Simmons, Edward Allen, Emily Wells, Jessica Melvin, Alex Zahara, Charles Mather, and All Our Teachers. 2021. "Doing ethics with cod." In *Making and Doing: Activating STS through knowledge expression and travel*, edited by Gary Downey and Teun Zuiderent-Jerak, 137–153. Cambridge, MA: MIT Press.

Littler, Jo and Roshi Naidoo (eds.) 2005. *The Politics of Heritage*. London: Routledge.

Mackey, Eva. 2016. *Unsettled Expectations: Uncertainty, Land and Settler Decolonization*. Halifax and Winnipeg: Fernwood Publishing.

Macoun, Alissa, and Strakosch, Elizabeth. 2013. "The ethical demands of settler colonial theory." *Settler Colonial Studies*, 3, 426–443. 10.1080/2201473x.2013.810695.

Malins, Peta, Crystal McKinnon, Kim Kruger, and Paola Balla. 2020. "An open letter from 1,200 Australian academics on the Djab Wurrung trees." *The Conversation*, https://theconversation.com/an-open-letter-from-1–200-australian-academics-on-the-djab-wurrung-trees-149147. Accessed 28 October 2021.

Mbembe, Achille. 2019. *Necropolitics*. Durham, N.C.: Duke University Press.

McKittrick, Katherine. 2021. *Dear Science and Other Stories*. Durham, N.C.: Duke University Press.

McKenna, Mark. 2021. *Return to Uluru*. Charlton: Black Inc.

Miller, Fiona. 2020. "Exploring the consequences of climate-related displacement for just resilience in Vietnam." *Urban Studies*, 57(7): 1570–1587.

Mignolo, Walter D. 2018. "Foreword: On pluriversality and multipolarity." In *Pluriverse: The Geopolitics of Knowledge*, edited by B. Reiter, ix–xv. Durham, N.C.: Duke University Press.

Moreton-Robinson, Aileen. 2015. *The White Possessive: Property, Power and Indigenous Sovereignty*. Minneapolis: University of Minnesota Press.

Mott, Carrie, and Daniel Cockayne. 2017. "Citation matters: Mobilizing the politics of citation toward a practice of "conscientious engagement." *Gender, Place & Culture*, 24(7): 954–973.

Moulton, A. A. 2021. "Black monument matters: Place-based commemoration and abolitionist memory work." *Sociology Compass*, e12944. 10.1111/soc4.12944.

Nelson, Charmaine. 2017. "Interrogating the colonial cartographical imagination." *American Art*, 31(2): 51–53.

O'Sullivan, Sandy. 2021. "The colonial project of gender (and everything else)." *Genealogy*, 5(3): 67.

Parker, Katherine. 2019. "Chasing legacies: William Dampier and Joseph Banks in comparative perspective." *Journal for Maritime Research*, 21(1–2): 5–22.

Pedersen, Howard, and Banjo Woorunmurra. 2012. *Jandamarra and the Bunuba Resistance*. Broome: Magalaba Books.

Peters-Little, Frances. 2010. "Remembering the Referendum with compassion." In *Passionate Histories: Myth, Memory and Indigenous Australia*, edited by Frances Peters-Little, Ann Curthoys, and John Dooker, 75–98. ANU E-Press, available online: http://press-files.anu.edu.au/downloads/press/p70821/pdf/book.pdf?referer=342.

Playford, Phil, Roger Malcolm Hocking, and Anthony Edward Cockbain. 2014. "Devonian Great Barrier Reef of the Canning Basin, Western Australia: The evolution of our understanding." *Journal of the Royal Society of Western Australia*, 97: 153–172.

Plumwood, Val. 2008. "Shadow Places and the Politics of Dwelling." *Australian Humanities Review*, 44: 139–150.

Poelina, Anne, Katherine Taylor, and Ian Perdrisat. 2019. "Martuwarra Fitzroy River Council: An Indigenous cultural governance approach to collaborative water governance." *Australasian Journal of Environmental Management*, 26(3): 236–254.

Porter, Libby. 2021. "Against world-killing silence", *Planning Theory and Practice*, 22(1): 111–115.

Porter, Libby, Julia Hurst, and Tina Grandinetti. 2020. "The politics of greening unceded lands in the settler city." *Australian Geographer*, 51(2): 221–238.

Probyn, Elspeth. 2004. "Everyday shame." *Cultural Studies*, 18(2): 328–349.

Rosiek, Jerry Lee, Jimmy Snyder, and Scott Pratt. 2020. "The new materialisms and Indigenous theories of non-human agency: Making the case for respectful anti-colonial engagement." *Qualitative Inquiry*, 26(3–4): 331–346.

Rose, Deborah Bird. 2004. "Fresh water rights and biophillia: Indigenous Australian perspectives." *Dialogue* 23(3): 35–43.

Rose, Deborah Bird. 2011. *Wild Dog Dreaming: Love and Extinction (Under the Sign of Nature)*. University of Virginia Press.

Sammler, K.G. and Lynch, C. R. 2021. "Apparatuses of observation and occupation: Settler colonialism and space science in Hawai'i." *Environment and Planning D: Society and Space*, 39(5):945–965.

Simpson, Leanne, R. 2004. "Anti-colonial strategies for the recovery and maintenance of Indigenous Knowledge." *The American Indian Quarterly*, 28(3&4): 373–384.

Simpson, Leanne Betasamosake. 2017. *As We Have Always Done: Indigenous Freedom through Radical Resistance*. Minneapolis: University of Minnesota Press.

Smith, Pamela. 2000. "Station camps: Legislation, labour relations and rations on pastoral leases in the Kimberley region, Western Australia." *Aboriginal History*, 24: 75–97.

Sobo, E.J., Lambert, M., and Lambert, V. 2021. "Land acknowledgments meant to honor Indigenous people too often do the opposite – erasing American Indians and sanitizing history instead", The Conversation. Available online https://theconversation.com/land-acknowledgments-meant-to-honor-indigenous-people-too-often-do-the-opposite-erasing-american-indians-and-sanitizing-history-instead-163787 Accessed 24 March 2023.

Stribbe, Arran. 2020. *Ecolinguistics: Language, Ecology*. London: Routledge.

Todd, Zoe. 2016. "An Indigenous feminist's take on the Ontological Turn: 'Ontology' is just another word for colonialism." *Journal of Historical Sociology*, 29(1): 4–22.

Travesi, Celine (2018). "Knowing and Being Known. Approaching Australian Indigenous Tourism Through Aboriginal and Non-Aboriginal Politics of Knowing." *Anthropological Forum*, 28, 275–29210.1080/00664677.2018.1486285.

Tuck, Eve, and K. Wayne Yang. 2012. "Decolonization is not a metaphor." *Decolonization: Indigeneity, Education and Society*, 1(1): 1–40.

Williams, Rob. 2021. "Will your grandchildren have the chance to visit Australia's sacred trees? Only if our sick indifference to Aboriginal heritage is cured." *The Conversation*, https://theconversation.com/will-your-grandchildren-have-the-chance-to-visit-australias-sacred-trees-only-if-our-sick-indifference-to-aboriginal-heritage-is-cured-163581. Accessed 28 October 2021.

Wood, Rachel. 2000. "Palaeoecology of Late Devonian back reef: Canning Basin, Western Australia." *Palaeontology*, 43(4): 671–703.

Yu, Peter. 1994. "The Kimberley: From welfare colonialism to self-determination." *Race and Class*, 35(4): 21–33.

SECTION V

Anti-Racism, People's Heritage, and 'Difficult Heritage at the Door'

The murder of George Floyd in Minneapolis, USA, in May 2020 crystalized a sense of outrage at the racism that remains an embedded part of so many societies. A trio of papers takes up the theme of anti-racist struggles in the context of contested urban memorial landscapes. Laura McAtackney gives an account of the role of social media and the struggle for online social justice in Ireland in the wake of the murder of George Floyd. She notes that among the many profound changes wrought by the Covid-19 pandemic were the pivot towards online environments and the emergence of social media, not just as a distraction, but as a 'crucial communication tool.' Within this context, she looks at three case studies: the increased circulation of 'Irish slave' memes on social media in the wake of anti-racism protests in Ireland, the debate over the *objet d'art* at the front entrance to the Shelbourne hotel in Dublin, and the online platform *Black and Irish* launched on social media in June 2020. Among the many strengths of this chapter is the nuanced manner in which McAtackney unfolds Ireland's particular postcolonial conjuncture—as a former colonized territory now grappling with contemporary anti-black racism.

Writing from the USA, Christopher N. Matthews begins by noting that: 'Heritage sites and historical monuments are contested spaces and recent global conflicts over their meanings have reached levels not seen before.' He writes: 'The current moment illustrates the significance of heritage sites and acts but also a raw sense of frustration with worn out notions that the everyday struggles experienced by most people are not important, at least not important to the narratives of the nation.' His chapter takes the form of a powerful and impassioned argument in favor of a 'People's Heritage,' 'that recognizes the historical significance of our times, especially our traumas.' In support of this argument, Matthews gives an account of the recent struggles around the Confederate memorials along Monument Avenue in Richmond, Virginia. In the summer of 2020, anti-racism

DOI: 10.4324/9781003188438-14

protesters gathered to rededicate Lee Circle (named for Confederate General Robert E. Lee) as Marcus-David Peter Circle in honor of one of the many victims of police violence. They also set out to reimagine this memorial public space via a set of performative interventions. Addressing heritage professionals directly, Matthews concludes: 'The question now is whether those who make a living doing heritage work will also prioritize the use of heritage spaces for community healing to begin. If not, then we and they need to step aside to allow those who cultivated a way to articulate and address the historical traumas that have harmed them as victims of the US's heritage to take the lead in what our heritage becomes.'

From social media and urban memorial landscapes, the third chapter in this section looks at street names and the manner in which 'difficult heritage' is managed and debated in universities. Duane Jethro and Sharon Macdonald take us to Berlin and the case of M_Straße (name redacted), a street that contains both the Institute for European Ethnology and the Centre for Anthropological Research on Museums and Heritage—the institutional home of both authors in the period of the events that they describe. They note that: 'The Black Lives Matter (BLM) protests triggered by the killing of George Floyd … brought with them a heaving sense of uncertainty associated with dramatic social change. They also prompted a new level of attention to a matter of difficult heritage at our door.' Macdonald has herself been a key figure in defining and discussing the notion of difficult heritage, an important conceptual tool in the discussion around heritage and the politics of memory. Part of the interest of the events narrated in this chapter is the manner in which the gaze is turned back on the university as institution, and on the risky and sometimes precarious relationship between scholarly work and activism around difficult heritage issues. Describing this relationship as 'fraught' the authors nevertheless conclude: 'Addressing "difficult heritage at the door" presents an opportunity to work with and through debates in ways that can positively contribute to public engagement and enrich teaching and research at the same time.'

9

HERITAGE, SOCIAL JUSTICE AND BLACK LIVES MATTER IN IRELAND DURING COVID-19

Laura McAtackney

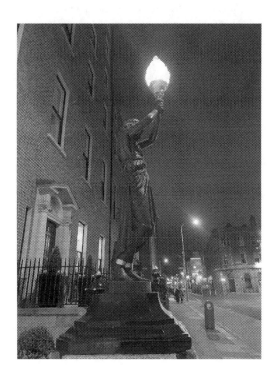

FIGURE 9.1 Nineteenth-century French statue of a Nubian princess, which was removed from (and later returned to) the front entrance of the Shelbourne Hotel in Dublin in the wake of the global #BLM protests in 2020.

DOI: 10.4324/9781003188438-15

Since the global nature of the COVID-19 pandemic became apparent with its spread from China to Europe–and the subsequent classification of a global pandemic in March 2020 (WHO 2020)–we have witnessed incredible changes that have most notably impacted the most socially marginalized and vulnerable, especially in the so-called Global South (UNDP 2020). Initially, it was notable that the so-called Global North had significant problems with managing the virus, especially in more neoliberal and free market nations where the populace had little experience of constraining themselves for the public good. In comparison, some Global South countries, especially those more embedded in social development approaches, adapted well to the impacts of the pandemic through communal actions (Patel 2021). Over time the enduring but fluctuating nature of the pandemic has revealed fractures and pressures across almost all societies, especially as governments have attempted to navigate protecting the vulnerable while also facilitating some form of (primarily economic) 'normal' life. During this extraordinary period of uncertainty and upheaval, physical isolation, lack of movement, and government tracking of citizen movement have become notable and not-uncontroversial features of many of our lives. While aspects of 'normality' have continued, restarted, been reconceptualized as online and/or have reacted or shaped in myriad ways, it remains unclear how long-term these deviations from our previous experiences will be and what changes may remain with us. Media organizations have been quick to predict that the pandemic has 'changed the world forever,' (Dans 2020) but historians who have studied previous pandemics–especially the 1918 flu pandemic–have shown that the ongoing and long-term impact of a pandemic is not predictable, straightforward or universal (Rogers 2021).

The ongoing and fluctuating nature of the pandemic means it is not entirely clear how the world will emerge or be changed by it. New variants are constantly emerging–and are often concurrent–in various parts of the globe, and the uneven roll-out of vaccination programs means that it is still unclear how efficient and long-term they will be on a global basis. While Global North countries have seen a rise in vaccine-hesitancy, global inequalities have been writ large through the simultaneous hoarding of vaccines and notable delays in their distribution through to the Global South. It is against this background of stark inequalities, ongoing insecurity, and the new normal of a truly global pandemic that my heritage-related musings are grounded. It is difficult to write about a moving moment but already it is clear that how we understand and interact with the world is being challenged if not changed by the pandemic.

While the virus is affecting individuals and societies in myriad ways, it is clearly playing a role in highlighting and exacerbating the underlying tensions and in/equalities that already pre-existed. It is not a coincidence that COVID-19 has provided the backdrop, if not the impetus, to a number of social justice protests, most famously in response to the brutal murder of George Floyd in May 2020, which began in the US and extended into wider #BlackLivesMatter (#BLM) protests in many countries with Black minority populations. While these protests

have taken on a different character due to the pandemic—with online and socially distanced protests being prominent (Nakhaie and Nakhaie 2021)—they have also been enhanced by racial inequalities in Global North countries being laid bare by the pandemic, including the differential health outcomes for 'Ethnic Minority' groups in many countries (Gilbert et al. 2021). The pandemic has also resulted in opportunism by the Far Right to extend their reach by stoking fears and uncertainties about the impact of the virus and vaccine, economic insecurity, and distrust of government (Far Right Observatory 2020). Most notably, in the Global North the far right has aligned with covid-denial and anti-vaxx conspiracy theorists (Buranyi 2020) and there have also been a number of concerns that elected, populist governments have been misusing the pandemic for their political advantage and in doing so endangering public health (Orzechowski, Schochow, and Steger 2021). It is within this deeply unstable situation that I have been considering the role of heritage during the pandemic and how we might engage with it as researchers.

Heritage during COVID-19

Recognizing our wider social context is an important starting point because heritage does not exist outside of society. While heritage can be many things to many people—extended, extrapolated, used, and abused to the point that Laurajane Smith could legitimately suggest 'There is, really, no such thing as heritage' (2006, 11)—at its essence heritage is about people and how they connect to, understand and make meaning of their cultural and natural world. Broadly conceived there have been a number of repercussions of the ongoing pandemic on heritage as a concept, organization, and initiative; a few notable examples will be briefly considered in this section. The impact of the pandemic has been clearly seen in the funding precarity and insecurity of heritage in many societal contexts. As heritage and tourism are often closely aligned, there is no doubt that widespread restrictions on communal gatherings and travel have left heritage as one of the sectors hardest hit globally by the pandemic. Many heritage organizations have acted swiftly to reconfigure to outdoors, socially distanced, and online activities. They have utilized digital platforms to allow for continued audience engagement and access to materials and performances and in doing so have highlighted the important role heritage plays for the wider public (ICCROM 2020). The swift creation of initiatives that engage with the pandemic from a specifically heritage angle, such as the *Viral Archive*, has seen researchers use social media to crowd-source pandemic-related material culture from the public to recording and analysis (Viral Archive ND). The community archaeology company, DigVentures, has not simply engaged with the pandemic as a source of material culture but has strategized to counter one of its most notable side-effects—social isolation—by creating virtual citizen archaeology projects. Their response to the initial lockdown phase was to facilitate members of the public to excavate their own back gardens and share findings with an engaged, online community (ArchaeoBalt 2020).

Despite their best efforts, heritage and cultural organizations have seen drastic funding and subsidy cuts across the board (Kennedy and Minguez Garcia 2020) that cannot be simply answered by moving their operations online. In many countries, the squeeze on economic resources has resulted in devastating financial cuts as governments pivot to finance public health and subsidize the public sector and industry. For example, in Mexico the Ministry of Culture lost 75% of its funding in the initial months of the pandemic, putting all its cultural institutions in jeopardy (Mistry 2021). But the biggest impact has been on independent and freelancer actors, who have often been left with little or no support from national governments (UN News 2020). On a more structural level, the financial changes necessitated by the pandemic have opened up wider debates about what is considered important to fund, retain and potentially abandon sustainably moving forward. In some countries, these conversations have been overtly political, including in England where heritage debates–labeled as 'culture wars'–are largely focused on how and why the national past is remembered–and commemorated–in the present. These debates have been re-ignited by social justice protests during the pandemic, most notably the toppling of the statue of slaver Edward Colston into Bristol Harbour at the climax of a #BLM protest in June 2020. Interestingly, the statue–complete with graffiti from the toppling event–was eventually, if not uncontroversially, moved into the M Shed heritage venue for recontextualized display in June 2021 (Selvin 2021). Government pushback at grassroot actions has resulted in political interventions to ensure controversial statues to colonizers are subject to 'retain and explain' policies (Harris 2021) and there have been attempts to shut down and prevent future funding for projects such as *Colonial Countryside*, which was documenting and communicating links between National Trust properties and colonial wealth (Doward 2020). In Denmark, Far Right campaigners against race, historic colonialism, gender, and migration scholarship have been agitating in the media for political control of university researcher activities since an artistic 'happening' led by Art Academy department Head Katrine Dirckinck-Holmfeld resulted in a bust of King Frederik V being deposited into a Copenhagen Canal in the autumn of 2020 (Buckley 2021). The pressure on academics has resulted in demands from parliament that universities curtail so-called 'academic activism' (Friis and Legarth Sandorff 2021). These examples are indicative of how intense social pressure felt in many countries during the pandemic has created various pressure points that have precipitated myriad actions and counter-actions. There are heritage implications for many of these actions, as the public and politicians pivot from concern with how we navigate the present to heated debates about how we know and understand the past.

From a personal point of view, a significant change that has been enforced by the pandemic–and has had a huge impact on many heritage researchers–is our lack of physical interaction with the outside world during periods of lockdown or limited movement. As someone who does not live in a country I actively research in, it has been a learning curve to move and adapt to new ways of engaging with heritage

issues that have long concerned me. For me, this has mainly taken the form of a pivot online in order to view how heritage debates are being shaped and interacted with by various actors from academics, journalists, activists, and members of the public as social media has been repositioned from a distraction to a 'crucial communication tool' (Shu-Feng et al. 2021, e176). The importance of the social media pivot online has been recognized and acted on by many heritage organizations, especially those who faced extensive lockdowns in the early months of the pandemic. Kate Guest has revealed how Historic England responded to the lockdown by reformatting its existing 'Heritage Online Debates' to communicate crowd-sourced examples of how the pandemic was impacting heritage organizations in order to maximize dissemination of the challenges they faced to a wider public (2021, 9). She has argued that sharing challenges online had multiple repercussions: from communicating the experiences of the pandemic to a broad audience, providing inspiration and support to heritage organizations and advertising the types of supports organization were entitled to, as well as pressuring the government to do more (Ibid, 10–11).

Clearly, the reasons to move to social media are many and complex, my experiences started as skeptical as to the importance of heritage in the face of wider social justice debates prompted by the pandemic in general and the revealing of its inequalities in particular. I was not sure how much social media could make any difference and, more particularly, I was pessimistic that wider, global reactions to inequalities would be translated into significant conversations that dovetailed with heritage. I wondered, would there be any deep or meaningful discussions on contemporary and historic inequalities in Ireland and would heritage bring anything to these discussions? What has unfolded since 2020 has surprised, educated, enlightened, and, at times, depressed me. The rest of this chapter will present some reflections on how the pandemic has shaped, and in many ways exposed, the unequal experiences in Ireland–especially, in terms of acknowledging and acting against racism–and how heritage has, at times, found its place in these online conversations.

Online Social Justice and Heritage in Ireland During the Pandemic

This section opens with a positional reflection on the subject of racial social justice and Ireland during the pandemic. I write this section from the position of a white, settled, Irish-born person. While I self-identify as part of the Catholic minority community in Northern Ireland–and I have experienced discrimination due to my background–I have never experienced Ireland from the perspective of being a person of color, a visible minority or a migrant. My comments on how race, social justice, and heritage have intersected online are from the perspective of white privilege. I am aware of my position as a white, critical heritage scholar. I have completed research on anti-Black racism and legacies of colonialism but I have no lived experience other than an active desire to be an anti-racist comrade.

Ireland is an interesting case in terms of historic and contemporary studies of race and racism, due to what Gardner (2009) has identified as its unusual experiences of being the subject of colonial racism in the past through to its present-day situation as a hegemonic 'white' European nation. Gardner has noted Ireland was one of the early targets of modern European colonization due to the early seventeenth century English conquest, which saw the Irish racialized to justify their subjugation but this was at 'an embryonic stage when there is racism without "race."' He then moves to what he views as 'the contemporary norm, in which there is "racism without racists,"' which is essentially reducing contemporary racism to the structural racism of neoliberal visa regimes and discriminatory citizenship practices that have existed in Ireland since at least the 1980s. (Gardner 2009, 14). It is important to note that mired within Ireland's neoliberal visa regimes is a dehumanizing and exceptionally cruel refugee-handling system–Direct Provision–which separates refugees and undocumented migrants from the rest of society, prohibits them from accessing work, and even disallows them from making their own food (Gessen 2019). The treatment of thousands of incredibly vulnerable people–mostly people of color–continues alongside a painfully slow process for applying for leave to remain; a process that can take decades (Ní Chiosáin 2016). Racist structures are not ephemeral concepts, they have real-world repercussions, including high mental health diagnoses and suicide rates amongst those incarcerated in Direct Provision (Ní Raghallaigh and Thornton 2017). The shameful conditions of Direct Provision stand in stark contrast to the huge profits the private contractors who facilitate the daily running of Direct Provision have amassed through these for-profit ventures (Deegan 2021). Ultimately, while there is some validity to Gardner's distinctions, I argue they bypass the lived experiences of people of color in Ireland, including those who are not in Direct Provision. Indeed, a broad spectrum of people of color in Ireland has been vocal in sharing their more intimate and personal experiences of racism in Ireland since George Floyd's murder heightened public consciousness (the details of this will be explored in the next section). Added to this underlying post/colonial, neoliberal context, Ireland is one of the few countries in Europe without an electorally-successful Far Right. This situation is for a variety of reasons, and it does not mean that the Far Right do not have a significant presence in Ireland, but essentially the core political parties in Ireland are populist, paternalist, and nationalist, which leaves little room for the Far Right to gain votes (Gardner 2009, 10). This combination of historical and contemporary factors has resulted in an environment in which racism enacted against traditional (Travellers) and emerging (migrants from the Global South) minorities are prevalent but widely denied or minimized. Despite the desire to reduce racism to structure–and in doing so absolving people–it is evident that racism did and does exist in Ireland at a structural level but also at an everyday and interpersonal level (INAR 2020).

The murder of George Floyd in Minneapolis, USA, in May 2020, had a significant impact on Ireland, as it did in many white-majority countries with long-term denial of anti-Black racism (Fanning 2012, 8–29). Initially, George's death, and the resultant

#BLM protests, prompted carefully-choreographed street protests in cities across Ireland that mirrored those seen in the USA. Liam Kennedy has argued that the protests in Ireland constituted mixed responses that used the broader messaging and aesthetics of #BLM–largely adopted from social media–while referencing experiences of racism specific to Ireland, especially the much-criticized Direct Provision asylum system (2020). Since that initial social justice protest, a number of directly and tangentially connected issues related to historic and contemporary racism have arisen on social media, which have been high-profile enough to reveal to the wider, whiter public the existence and experiences of racism. This includes the social media uproar–including direct parallels made with the murder of George Floyd–around the highly publicized killing of Black Irish man George Nkencko, who was shot dead after being pursued by *Gardaí* (Irish police) in the wake of a mental health crisis (McNamee 2021). The Nkencko family's ongoing demands for justice–and the resultant negative and positive reactions on social media, including orchestrated campaigns to spread misinformation about the dead man–have dented a lot of the 'white innocence' (Wekker 2016) that previously dismissed anti-Black racism as an experience of the United States rather than of Ireland. Due to the pandemic lockdowns, many of these discussions, debates, and protests have taken part online and have included media activity, public-facing online opinion pieces, and online academic seminars. It has provided the possibility to meaningfully dissect the complex place that Ireland occupies in global discussions on the relationship between colonial legacies and contemporary racism. Many of these discussions intersect in interesting ways with wider critical heritage studies discourse and so I will consider how anti-racism, social justice activism, and heritage have come together online in compelling and sometimes unexpected ways during the pandemic.

'Irish Slave' Memes

In the wake of the anti-racism protests in Ireland, there were a number of points of departure that occupied social media debates on Ireland's historic and contemporary experiences of racism and anti-racism. Initially, this took the form of a recurring counter-action: the increased circulation of 'Irish slave' memes on social media. Internet memes are, broadly speaking, a phrase, image or video that is created and then spread through the internet causing large numbers of people to replicate and share them (Castaño Díaz 2013, 96). Successful memes rely on encapsulating shared cultural norms and attitudes that can be extremely broad or specifically appeal to niche groups. The circulation of so-called 'Irish slave' memes is now a longstanding counter-action when experiences of anti-Black racism become a discussion point on mainstream and social media (McNulty 2020). The 'Irish-slave' memes originated within white supremacist online networks in the US, and have moved through various history and heritage groups onto the (sometimes) unsuspecting general internet user.

These memes were originally a North American phenomenon that were intended to derail conversations about anti-Black racism through misrepresenting

and conflating historic African-American experiences of enslavement with poor white experiences of indentured servitude (see Hogan 2020). Most commonly, they are a mix of text and images that present deliberate distortions of historic Irish experiences of discrimination and hardship in the early colonial period (there is also a Scottish version (Mullen 2016)). Their aim has been to misuse the undoubtedly difficult experiences of poor white people by exaggerating the numbers involved and sensationalizing experiences to diminish and sideline discussions on Black enslavement and its ongoing impacts at times when the conversations are of heightened relevance. 'Irish slave' memes originally started circulating online in significant numbers in 2013 (Amend 2016) and often escalate in popularity around St Patrick's day as well as times when anti-Black racism is prominent in public discourse (Perry 2018). Due to the nature of the internet, they have by now widely circulated beyond North America, Liam Hogan has shown they are particularly popular in white settler colonial societies—as well as the UK and Ireland—and have become more mainstream alongside the Far Right politics of Donald Trump and Brexit since 2016 (Hogan 2016).

It was, therefore hardly surprising to see 'Irish slave' memes resurface again as a reaction to #BLM protests in 2020 but, in my experience of researching and writing about them since 2016 (Hogan, McAtackney, and Reilly 2016), they had a lot less reach and impact than in previous incarnations. This may be explained by meme fatigue—'the state or condition of being tired of seeing a particular or overexposed meme' (Urban Dictionary 2013)—but we must also acknowledge the canny work of researchers, such as Liam Hogan, who has presented his critiques in social media-friendly formats such as open access publications (Hogan 2020) and Twitter threads so they can be utilized by social media users as easy-to-locate counterarguments to fake histories. Hogan's work has been picked up by the mainstream media a number of times and is, by this stage, largely uncontested, at least by academics (although this was not always the case). Alongside the uptick in 'Irish slave' memes circulated online on Irish twitter, this was the first occasion when a number of established Irish historians were at the forefront of online discussions about the accuracies, or not, of this myth. It was notable that academics who had hitherto refrained from commenting—or publishing public-facing articles—were writing twitter threads and public-access articles (including Kelly 2020) and engaging in extensive online debates on twitter, in particular, on the nature of the Irish colonial experience. One cannot be sure whether this would have happened in a non-pandemic alternative reality but it seems plausible that the pandemic move to online lives ensured many academics were more attuned to using social media and proactively decided to utilize it to contradict fake histories in contrast to their previous silence.

Irish Statue Toppling

As already noted, Ireland has a complex colonial legacy due to it being colonized at an early stage by its nearest neighbor—England, later Britain—to the extent it was

considered a 'laboratory for Empire' (Ohlmeyer 2005) but at various points in that long, unequal relationship, Irish individuals and groups within society were able to benefit from and exploit colonialism. It is not a straightforward story and likewise nor has been the fate of Ireland's once extensive colonial material remains. While Ireland had an abundance of colonial-era statues to British figureheads (such as Queen Victoria and the Duke of Wellington) up to limited independence (26 counties of the island of Ireland became the Irish Free State in 1921), many have been removed or destroyed, sometimes with notable reluctance, in the 100 years since independence. Statues of Queen Victoria have had some of the most con-voluted post-independence trajectories in Ireland, including one version that was buried at University College Cork only to be excavated in time for the visit of Queen Elizabeth II in 2011 (Murphy 2011). The long-unwanted statue of Queen Victoria situated at the seat of Irish government at Leinster House since 1908 was only removed from the site under pretext of a carpark extension in 1948. By 1967, it was in storage at Royal Hospital Kilmainham, an old British soldiers' hospital and retirement facility, alongside other colonial-era statues that had similarly fallen out of favor. The Leinster House Queen Victoria now sits in a square in Sydney, Australia. Many others were helped to their final resting place by sticks of dynamite planted under the cover of darkness (RTE 1967). While there are a small number of contentious, colonial-era statues still in situ –including the slavery-supporter Irish nationalist John Mitchel in Newry, Northern Ireland (Corr 2020)–they tend not to be the focus of debates on historic colonialism or contemporary experiences of racism.

In the wake of the anti-racist protests in Ireland in 2020, a statue issue did arise through an unlikely and previously unconsidered avenue: decorative statues of two Nubian princesses and their torch-bearing slaves lighting the front of the exclusive Shelbourne hotel in Dublin (Heyward 2020). These *objet d'art*–rather than colonial statuary–date to the so-called 'Egyptomania phase' that swept Europe in the nine-teenth century (Colla 2007) and in the intervening years had receded into the background of the hotel's entrance before they were removed on 27 July 2020. The General Manager's official statement indicated it 'had been coming for a number of weeks given what has been happening in the world,' (McGreevy 2020), which clearly referenced the #BLM protests as an initiating point for the hotel's alteration. The removal sparked a significant mainstream and social media debate despite the fact 'no one seemed to notice them until they were gone' (Heyward 2020) and heritage issues were of central importance in how this debate unfolded. Online conversations prompted by this act included some of the well-worn tropes of 'culture wars'–that removal was erasure, an attack on Irish cultural heritage and involved #BLM debates being imported to Ireland (Linehan 2020)–but there were also nuanced and measured discussions about how statues of enslaved women may or may not be relevant to contemporary African-descended women's experiences in Ireland today.

Academics took a prominent role in the online debates and it was notable how different disciplinary perspectives, claims of expertise, and lived experience were utilized to argue their cases and were subsequently picked up by social and

mainstream media. This was a case in which the mainstream media reacted to social media discussions—and frequently used twitter soundbites and commentators in their reporting—rather than leading and directing the discussions. From a heritage perspective, it was clear that more traditional materialist perspectives—focused on the historical origins and intentions of the manufacture and installation of the statues—came into conflict with more constructivist heritage approaches that allowed for the statues to have changing meaning and contemporary relevance. Art Historian Kyle Leyden widely publicized a detailed historical background for the statues, including their manufacture in France during the Egyptomania phase, which he used to argue that the statues were unrelated to the Transatlantic slave trade and therefore were irrelevant to issues connected to #BLM (McGreevy 2020). Irish heritage agencies, including Dublin City Council planning office and the Irish Georgian society, followed this materialist interpretation of the statues and were swift to demand their restoration to the façade of the hotel, which was ultimately completed in December 2020 (McGreevy and Kelly 2020). In contrast, constructivist perspectives were provided by some Black Irish commentators such as Dr Ebun Joseph, a lecturer in Black Studies at University College Dublin, who articulated the view that restoring the statues was a 'missed opportunity' for Ireland to engage with the statues as a contemporary issue (O'Donnell 2020). My perspective, as a critical heritage scholar, was presented in a number of twitter threads that emphasized the need to expand our understandings of colonialism beyond the TransAtlantic slave trade. From a constructivist point of view, I argued that the statues must be understood in their contemporary context and this means listening to Black Irish women in dealing with this issue. Due to my twitter threads, I was contacted and then interviewed for *Atlas Obscura* who wanted to explore the potential connection of these statues to contemporary experiences of racism in Ireland. In the resultant article, I was quoted as stating 'Black Lives Matters is seen as an American problem, not our problem … But once it's about an object—here in Dublin, instead of there—suddenly Irish people don't think these statues are racist, and that we don't have these issues,' (Heyward 2020) which is an opinion I continue to hold.

Watching and contributing to this (online) debate from Denmark was an important turning point for me in realizing that utilizing social media from a physical distance had a potential role to play in these emerging conversations, especially in pandemic circumstances. From a heritage perspective, I was surprised by the lack of constructivist perspectives displayed by heritage organizations in Ireland—and how most Irish academics followed narrow, materialist reading of the statues—which indicated how little critical heritage studies had impacted Irish heritage sectors and how keen many people were to downplay contemporary racism in Ireland. But the biggest learning curve for me was to carefully listen to the varied perspectives of Black women in Ireland. In contrast to Dr Joseph's arguments, the broadcaster and author Dr Emma Dabiri reiterated through various twitter conversations that she thought the focus on the 'Shelbourne statues' was a distraction from dealing with the experiences of contemporary racism in Ireland.

Black and Irish (Online) Experiences

Irish Times columnist Una Mullally suggested in March 2021 that the protests prompted by the murder of George Floyd in 2020 have been a turning point for Black Irish people in that they 'marked a new era of black Irish visibility, largely youth-led, dovetailing with a cultural moment across Irish music especially' (2021). There is considerable truth to this claim if one looks to the online platforms that have developed since that time and that continue to flourish. *Black and Irish* was launched on social media on June 3, 2020 in direct response to the growing interest in race and racism in Ireland as a result of the protests that originated in the US (Black and Irish 2021). Their approach has been to utilize the individual experiences and perspectives of individuals who identify as Black or Mixed Race Irish to share a variety of stories primarily on social media–facebook, Instagram, and twitter–to the general public. This strategy ties in with the Irish Network Against Racism (INAR), who have stated their most recent outputs have been directly reacting to the widening discussions on racism in Irish society. They have especially been keen to communicate the everyday, insidious experiences of what they called 'silent racism' (Ibid 2020) experienced by many visible minorities in Ireland. While each story published by *Black and Irish* is specific to the individual there has been a wide range of perspectives displayed–both positive and negative–and there has been a degree of strategic curation of individual stories to maximize public interest through creating timely posts–eg to coincide with Pride or the Tokyo Olympics (2021). It is interesting that within the thematic collections posted online, there has been a strong emphasis on Black Irish contributions to culture and heritage, especially music and language.

In the short number of years, since *Black and Irish* was launched, they have gained significant social media followers (over 16,000 people on facebook and 53,000 on instagram) and have diversified considerably, indicating the group's creators have been adept in using social media for impact and reach. Their formats now include podcasts, mentoring networks, and merchandizing while the content of their broadcast has moved from protests and discussing experiences of racism to educating the wider public on the nuances of Black Irish culture. There is a significant connection to heritage themes and issues in the contents of these diversification strategies, which can especially be identified in the podcast series. Having now completed multiple series with the Irish national broadcaster, RTÉ, there is clearly a strategy of balancing the desire to educate the public on negative realities and ongoing challenges for Black Irish people, including racism in schools and systemic racism, and the more positive messaging of the contributions of Black Irish people to Irish culture and heritage. The podcast has placed a particular emphasis on Black Irish representation in the Arts and the burgeoning Black Irish music scene, with episodes dedicated to rising stars, the use of accents, and what defines an 'Irish' musician (Black and Irish Podcasts 2021).

Alongside the success of *Black and Irish*, interest in Black Irish experiences and perspectives has continued to maintain a heightened presence beyond the initial

phases of the pandemic and are especially prominent online. In July 2021, the Irish National Terminology Database, *Foras Na Gaelige*, which governs additions to the national language, announced they have officially replaced the traditional *Gaelige* word for a non-white person–'*fear dubh*' (which when capitalized also means 'the devil') or '*duine gorm*,' (which literally means 'blue person')–with '*duine de dhath*,' which translates to English as 'person of color.' While Donncha O Croninin, the chief terminologist, has publicly acknowledged the change reflects Ireland as a multi-cultural society, there has been a public emphasis placed on the role of Ola Majekodunmi. As a board member and daughter of Nigerian migrants to Ireland (Carroll 2021), she has been central in selecting this term. The implications of this change are not simply acknowledging that *Gaelige* must evolve as a living language to become more inclusive but also includes a recognition that Black Irish people have, what Homi Bhabha (2014) has called the 'right to narrate'–that is, a right to be heard, recognized, and represented but also to perform, transform, and bring about change.

Conclusion

Initially, I was not optimistic that social media would provide a significant outlet to challenge perspectives on Irish identity and heritage during the lockdowns and pandemic, despite the pivot online, but I have been generally surprised. This does not mean that there have not been issues with how the Irish media and public have reacted to having what Gloria Wekker has coined their 'white innocence' (2016) disrupted. As noted already, there has long been a general minimizing of contemporary racism in Ireland, rather Irish people have emphasized their experiences of colonialism as if that somehow stops white Europeans from imbibing colonial messages. This stance can be seen in terms of heritage and the lack of nuanced engagement with the issue of the Shelbourne statues, especially the inability of heritage bodies to see how they reveal not only Irish entanglements with various forms of European colonialism but also acknowledging the changing meanings of such statues. Likewise, systemic racism continues to exist with the Direct Provision asylum system ongoing, although it is now planned to be abolished by 2024 (Thornton 2020). Black men, in particular, continue to be the focus of over-surveillance, police violence and social media innuendo in Ireland. The death of George Nkencho in late 2020 continues to be investigated but it was notable that social media displayed a range of reactions, from demands to abolish the *Gardaí* to the creation and circulation of memes with deliberate mistruths and lies about the deceased (MacNamee 2021).

The main positive factor that has developed since 2020 is the growing confidence of young, Black Irish people, in particular, in using social media to present their experiences, hopes, and fears for their future in Ireland to a significant audience. The discussions on racism prompted by the murder of George Floyd in Minneapolis have reverberated in Ireland in ways that have not previously been imagined and

they continue to inspire new conversations, which have also largely taken place online, but also in academic fora. At least, part of the reason for the intensity and longevity of these discussions must be attributed to the move online and the importance placed on social media, especially during the initial months of the pandemic (Shu-Feng et al. 2021). While not all these discussions have been positive–the largely anonymous trolling of white supremacists and racists has accompanied almost all these debates and discussions on social media–there have been significant changes. This is especially in terms of acknowledging and incorporating Black Irish experiences and perspectives into mainstream Irish society and now there must be concerted moves to reconsider what was, and is Irish heritage. This includes taking a critical heritage approach to heritage as an evolving aspect of the present rather than a material relic of an imagined past.

References

Amend, Alex. 2016. How the Myth of the "Irish slaves" became a Favorite Meme of Racists Online. *Southern Poverty Law Centre*. 19 April 2016. (Accessed July 2021). https://www. splcenter.org/hatewatch/2016/04/19/how-myth-irish-slaves-became-favorite-meme-racists-online

ArchaeoBalt. 2020. ArchaeoTourism and Social Media Round Table. 21 January 2021 (Accessed July 2021) https://www.youtube.com/watch?v=pPDZsq__KnY

Black and Irish. ND. Home. (Accessed July 2021) https://www.blackandirish.com/

Black and Irish. 2021. Black and Irish 1 Year Anniversary. 3 June 20201. (Accessed July 2021) https://www.facebook.com/BlackandIrish/videos/399587071192209

Black and Irish Podcasts. 2021. Black and Irish Podcast (Accessed July 2021) https://www. rte.ie/radio/podcasts/series/33229-black-irish/

Buckley, Cara. 2021. The Sinking of a Bust Surfaces a Debate over Denmark's Past. *The New York Times*. 9 February 2021 (Accessed July 2021). https://www.nytimes.com/2021/02/09/arts/design/frederik-v-bust-denmark.html

Buranyi, Stephen. 2020. How Coronavirus has Brought Together Conspiracy Theorists and the Far Right. *The Guardian*. 4 September 2020 (Accessed July 2021). https://www. theguardian.com/commentisfree/2020/sep/04/coronavirus-conspiracy-theorists-far-right-protests

Carroll, Rory. 2021. 'Duine de Dhath': New Phrase for 'Person of Colour' Added to Irish Lexicon. *Irish Times*. 13 July 2021. (Accessed July 2021) https://www.irishtimes.com/culture/duine-de-dhath-new-phrase-for-person-of-colour-added-to-irish-lexicon-1.4619400

Castaño Díaz, Carlos M. 2013. Defining and Characterizing the Concept of Internet Meme. *Revista CES Psicología* 6(2): 82–104.

Colla, Elliott. 2007. *Conflicted Antiquities: Egyptology, Egyptomania, Egyptian Modernity*. London: Duke University Press.

Corr, Shauna. 2020. Statue of Slavery Supporter John Mitchel in Newry Should be Pulled Down, Say Campaigners. *Belfast Live*. 10 June 2020 (Accessed July 2021). https://www. belfastlive.co.uk/news/belfast-news/john-mitchel-statue-newry-should-18392253

Dans Enrique. 2020. The Pandemic Really Has Changed the World Forever. *Forbes*. 26 July 2021 (Accessed July 2021) https://www.forbes.com/sites/enriquedans/2020/07/26/the-pandemic-really-has-changed-the-worldforever/?sh=2d5447b736a6

Deegan, Gordon. 2021. Profits More than Double at Direct Provision Firm to EUR1.98m. *The Irish Times*. 20 December 2021. https://www.irishtimes.com/business/profits-more-than-double-at-direct-provision-firm-to-1-98m-1.4760446#:~:text=Accumulated%20profits%20at%20the%20end,%E2%82%AC183%20million%20last%20year.

Doherty, Gabriel. 2020. Claims That Ireland is in Disgrace for Slave Trade is Utterly Misleading, says Historian Gabriel Doherty. *Gript*. 23 June 2020 (Accessed July 2021) https://gript.ie/claiming-that-ireland-shares-in-the-disgrace-of-slavery-is-utterly-misleading-says-historian-gabriel-doherty/

Doward, Jamie. 2020. I've been Unfairly Targeted, says Academic at Heart of National Trust 'Woke' Row. *The Guardian*. 20 December 2020. (Accessed July 2021). https://www.theguardian.com/uk-news/2020/dec/20/ive-been-unfairly-targeted-says-academic-at-heart-of-national-trust-woke-row

Fanning, Bryan. 2012. *Racism in Ireland*. Manchester: MUP.

Far Right Observatory. 2020. COVID-19, Conspiracy and Ireland's Far Right. 20 April 2020. https://farrightobservatory.medium.com/covid-19-conspiracy-and-irelands-far-right-3501e07b6756

Friis, Rasmus and Jakob Legarth Sandorff. 2021. Researchers: Political Offensive Against "Pseudoresearch" is Prejudiced and Dangerous. 22 March 2021. *Uniavisen*. https://uniavisen.dk/en/researchers-political-offensive-against-pseudoresearch-is-prejudiced-and-dangerous/

Gardner, Steve. 2009. Ireland: From Racism Without "Race" to Racism Without Racists. *Radical History Review*. (104): 41–56.

Geesan, Masha. 2019. Ireland's Strange, Cruel System for Asylum Seekers. *The New Yorker*. 4 June 2019. https://www.newyorker.com/news/dispatch/irelands-strange-cruel-system-for-asylum-seekers

Gilbert, Keon L., Ruqaiijah Yearby, Amber Johnson and Kira Banks. 2021. For Black Americans, Covid-19 is a Reminder of the Racism of US Healthcare. *The Guardian*. 22 February 2021. (Accessed July 2021) https://www.theguardian.com/commentisfree/2021/feb/22/black-americans-covid-19-racism-us-healthcare

Guest, Kate. 2021. Heritage and the Pandemic: An Early Response to the Restriction of COVID-19 by the Heritage Sector in England. *The Historic Environment: Policy and Practice* 12(1): 4–18.

Harris, Gareth. 2021. Fuelling Culture War, UK Government Forms New 'Retain and Explain' Board for Controversial Monuments. *The Art Newspaper*. 17 May 2020. (Accessed July 2021). https://www.theartnewspaper.com/news/uk-culture-secretary-fuels-culture-war

Heyward, Guilia. 2020. A Dublin Hotel Removed Four Statues and Sparked a Historical Debate. *Atlas Obscura*. 31 August 2020 (Accessed July 2021). https://www.atlasobscura.com/articles/shelbourne-hotel-statues-dublin

Hogan, Liam. 2020. All of My Work on the "Irish Slaves" Meme (2015–2020). (Accessed July 2021). https://limerick1914.medium.com/all-of-my-work-on-the-irish-slaves-meme-2015-16-4965e445802a

Hogan, Liam. 2016. Two Years of the 'Irish Slaves' Myth: Racism, Reductionism and the Tradition of Diminishing the Transatlantic Slave Trade. *Open Democracy*. 7 November 2016. (Accessed July 2021) https://www.opendemocracy.net/en/beyond-trafficking-and-slavery/two-years-of-irish-slaves-myth-racism-reductionism-and-tradition-of-diminis/

Hogan, Liam, Laura McAtackney and Matthew C. Reilly. 2016. The Irish in the Anglo-Caribbean: Servants of Slaves? *History Ireland*. (Accessed July 2021) https://www.

historyireland.com/18th-19th-century-history/18th-19th-century-social-perspectives/the-irish-in-the-anglo-caribbean-servants-or-slaves/

ICCROM. 2020. Heritage and Pandemics: Accessing Heritage During a Pandemic. ICCROM Lecture Series. 12 June 2020. (Accessed July 2021). https://www.iccrom.org/lecture/heritage-and-pandemics-accessing-heritage-during-pandemic

INAR. 2020. Understanding Racism: Defining Racism in an Irish context. (Accessed July 2021). www.inar.ie

Kelly, Brian. 2020. 'Irish Slaves': Debunking the Myth. *Rebel News*. 2 July 2020 (Accessed July 2021). http://www.rebelnews.ie/2020/07/02/irish-slaves-debunking-myth/

Kennedy, Liam. 2020. George Floyd: Race and Protest in Ireland. UCD Clinton Institute (Accessed July 2021) https://www.ucdclinton.ie/commentary-content/raceandprotestinireland

Kennedy, Rebecca and Barbara Minguez Garcia. Heritage in Crisis: COVID Adverse Economic Impacts. ICCROM. 9 April 2020 (Accessed July 2021) https://www.iccrom.org/heritage-crisis-covid-adverse-economic-impacts

Linehan, Hugh. Shelbourne Statues: will we ever see them on St Stephen's Green Again? Irish Times. 1 August 2020. https://www.irishtimes.com/culture/heritage/shelbourne-statues-will-we-ever-see-them-on-st-stephen-s-green-again-1.4317789

MacNamee, Garreth. 2021. FactCheck: No, George Nkencko Was Not a Convicted Criminal Out on Bail for Attacking His Girlfriend. *Thejournal.ie*. 4 January 2021 (Accessed July 2021). https://www.thejournal.ie/george-nkencho-32-convictions-factcheck-5315584-Jan2021/

Mistry, Elizabeth. 2021. Mexico's Culture Crisis: Pandemic Leads to Budget Cuts That Leave Many Workers Unpaid While Vanity Projects Receive Millions. *The Art Newspaper*. 11 March 2021. (Accessed July 2021). https://www.theartnewspaper.com/news/cultural-budget-cuts-trigger-existential-crisis-in-mexico

McGreevy, Ronan. 2020. Shelbourne Hotel Removes 153-Year-Old Statues of Slave Girls from its Plinth. *Irish Times*. 28 July 2020 (Accessed July 2021). https://www.irishtimes.com/news/ireland/irish-news/shelbourne-hotel-removes-153-year-old-statues-of-slave-girls-from-its-plinth

McGreevy, Ronan and Olivia Kelly. 2020. Dublin City Council Begins Action Against Shelbourne Hotel for Removing Statues. *Irish Times*. 6 August 2020 (Accessed July 2021). https://www.irishtimes.com/culture/heritage/dublin-city-council-begins-action-against-shelbourne-hotel-for-removing-statues-1.4323697

McNeil, Kate. 2020. The Knife's Edge: Balancing Health and the Economy During Covid-19. University of Cambridge Centre for Science and Policy. 30 July 2020 (Accessed July 2021) https://www.csap.cam.ac.uk/news/article-achieving-wellbeing/

McNulty, Tim. 2020. Editorial: Cromwell and the 'Irish Slave' Meme Are Derailing Attempts to Combat Racism Online. *Redaction Report*. 6 July 2020 (Accessed July 2021) https://redactionpolitics.com/2020/07/06/cromwell-irish-slave-meme-blm-racism-attempts-to-combat-racism-online/

McGreevy, Ronan. 2020. Shelbourne Hotel statues restored to front of Building. Irish Times. 15 December 2020. https://www.irishtimes.com/culture/heritage/shelbourne-statues-will-we-ever-see-them-on-st-stephen-s-green-again-1.4317789

Mullally, Una. 2021. Emma Dabiri and Hazel Chu: 'This is a Real, Important Moment in Ireland'. *Irish Times*. 27 March 2021 (Accessed July 2021). https://www.irishtimes.com/culture/books/emma-dabiri-and-hazel-chu-this-is-a-real-important-moment-in-ireland-1.4514803

Mullen, Stephen. 2016. The Myth of Scottish Slaves. *Sceptical Scot*. 4 March 2016 (Accessed July 2021). https://sceptical.scot/2016/03/the-myth-of-scottish-slaves/

Murphy, John A. 2011. The Story of Queen's Victoria's Statue at University College Cork. 20 May 2011 (Accessed July 2021) https://www.youtube.com/watch?v=vnIdp2d7brA

Nakhaie, Reza and F.S. Nakhaie. 2021. Black Lives Matter Movement Finds New Urgency and Allies Because of COVID-19. *The Conversation*. 5 July 2020 (Accessed July 2021). https://theconversation.com/black-lives-matter-movement-finds-new-urgency-and-allies-because-of-covid-19-141500

Ní Chiosáin, Bairbre. 2016. Ireland and its Vulnerable 'Others': The Reception of Asylum Seekers in Ireland. *Études Irelandaises* 41(2): 85–104.

Ní Raghallaigh, Muireann and Liam Thornton. 2017. Vulnerable Childhood, Vulnerable Adulthood: Direct Provisions as Aftercare for Aged-Out Separated Children Seeking Asylum in Ireland. *Critical Social Policy* 37(3): 386–404.

O'Donnell, Dimitri. 2020. Historic Statues to be Restored to Front of Shelbourne Hotel. RTE. 24 September 2020. (Accessed July 2021). https://www.rte.ie/news/dublin/2020/0924/1167307-shelbourne-statues/

Ohlmeyer, Jane. 2005. A Laboratory for Empire? Early Modern Ireland and English Imperialism. In Kevin Kenny (ed) *Ireland and the British Empire*. Oxford: OUP.

Orzechowski, Marcin, Maximilian Schochow and Florian Steger. 2021. Balancing Public Health and Civil Liberties in Times of Pandemic. *Journal of Public Health Policy*. 42: 145–153.

Patel, Leila. 2021. COVID-19: Global South Responses Have Shown Up Social Policy Challenges – and Strengths. *The Conversation*. 25 May 2021 (Accessed July 2021) https://theconversation.com/covid-19-global-south-responses-have-shown-up-social-policy-challenges-and-strengths-161288

Perry David M. 2018. No, the Irish Were Not Slaves Too. *Pacific Standard*. 15 March 2018 (Accessed July 2021). https://psmag.com/social-justice/the-irish-were-not-slaves

Rogers, Kristen. 2021. Life After the 1918 Flu has Lessons for our Post-Pandemic World. *CNN*. 28 June 2021. (Accessed July 2021) https://edition.cnn.com/2021/06/28/health/changes-after-covid-pandemic-1918-flu-wellness-scn/index.html

RTE. 1967. Queen Turns Green at Royal Hospital. (Accessed July 2021). https://www.rte.ie/archives/2017/0110/843928-queen-victoria-in-kilmainham/

Selvin, Claire. 2021. Toppled Statue of Slave Trader Goes on Vie in Bristol, Generating Controversy. *Art News*. 8 June 2021 (Accessed July 2021). https://www.artnews.com/art-news/news/edward-colston-statue-m-shed-museum-bristol-1234595170/

Shu-Feng, Tsao, Helen Chen, Therese Tisseverasinghe, Yang Yang, Lianghusa Li and Zahid A. Butt. 2021. What Social Media Told us in the Time of COVID-19: A Scoping Review. *The Lancet Digital Health* (3): e175–194.

Thornton, Liam. 2020. The Abolition of Direct Provision Cannot Come Quickly Enough. *Irish Times*. 9 June 2020 (Accessed July 2021). https://www.irishtimes.com/opinion/the-abolition-of-direct-provision-cannot-come-quickly-enough-1.4273758

United Nations Development Programme (UNDP). 2020. Coronavirus Vs Inequality: How We'll Pay Vastly Different Costs for the COVID-19 Pandemic (Accessed July 2021) https://feature.undp.org/coronavirus-vs-inequality/

United Nations News. 2020. Culture in Crisis: Arts Fighting to Survive COVID-19 Impact. 22 December 2020. (Accessed July 2021) https://news.un.org/en/story/2020/12/1080572

Urban Dictionary. 2013. Meme Fatigue. 11 August 2013. (Accessed July 2021) https://www.urbandictionary.com/define.php?term=Meme%20fatigue

Viral Archive. (Accessed July 2021) https://twitter.com/Viral_Archive

Wekker, Gloria. 2016. *White Innocence: Paradoxes of Colonialism and Race.* Duke University Press.

World Health Organisation (WHO). 2020. WHO Director-General's Opening Remarks at the Media Briefly on COVID-19 – 11 March 2020. https://www.who.int/director-general/speeches/detail/who-director-general-s-opening-remarks-at-the-media-briefing-on-covid-19---11-march-2020 (Accessed July 2021).

10

A PEOPLE'S HERITAGE

Engaging the Traumas of Marginalization

Christopher N. Matthews

> This is how one pictures the angel of history. His face is turned toward the past. Where we perceive a chain of events, he sees one single catastrophe which keeps piling wreckage upon wreckage and hurls it in front of his feet. The angel would like to stay, awaken the dead, and make whole what has been smashed. But a storm is blowing from Paradise; it has got caught in his wings with such violence that the angel can no longer close them. This storm irresistibly propels him into the future to which his back is turned, while the pile of debris before him grows skyward. This storm is what we call progress.
>
> (Walter Benjamin, *Theses on the Philosophy of History*, 1969:257)

> For those of colour, that summer was intensely felt.
>
> (Tony Kushner, *The Summer of 2020*:514)

What would it look like if heritage–the way we identify ourselves and our communities as products of the past–was something the people controlled? What would it mean if we could tell our own stories about our collective national identities? These questions, for me at least, are antithetical to the way we are trained to engage heritage. The most profound distinction is that these sorts of questions show we do not have to accept or adopt the heritage narratives we receive. Heritage (i.e. those objects and stories worth saving, preserving, and passing along to the future) is usually presented as beyond dispute or as fact. It is presented such that our job as public visitors as well as scholars is to learn the stories and accept their general significance. In this paper, I suggest that we could approach heritage differently–not just with a critical lens looking for errors, omissions, and potential replacements, but to look more closely at the structures that designate some people as storytellers and the rest of us as receptors and propagators. What if everyone had the power to define and create heritage in the United States? What if we could do

DOI: 10.4324/9781003188438-16

so in the ways Benjamin's angel of history is denied: by 'stay[ing], awaken[ing] the dead, and mak[ing] whole what has been smashed?'

This chapter considers these possibilities by looking at the case of Monument Avenue in Richmond, Virginia. Until recently, Monument Avenue was home to a set of memorials honoring the Confederacy erected during the Jim Crow era. From its founding in 1890 to today, this heritage site has produced a series of contested histories tied to American racism that have challenged the nation's heritage. While the wreckage caused by this site continued to build for over a century, as the original racist narrative was fortified and reproduced, something quite different began to take shape in June 2020. I see this revolutionary process as 'a people's heritage.' I reference here the sorts of 'people's' movements embodied by Howard Zinn's *A People's History of the United States* as well as a range of poor people's and global social movements focused on 'pushing back against the unrepresentative and undemocratic nature of decision-making' across a wide-range of political issues (STWR 2008, Barber 2020, Zinn 1999). Whether this transformative opportunity for a new kind of memorialization and history-making will survive is not yet known, but I argue it has real value and that heritage professionals can support this effort by reconceptualizing what heritage is, how it is produced and authenticated, and why it matters.

Why Monument Avenue?

This paper follows quite a bit of research and theorizing as well as many popular actions investigating and challenging public monuments like those in Richmond (e.g. Beetham 2016, Blight 2001, Chaudhuri 2016, Doss 2010, Fairbanks 2015, Loewen 1999, Mullins 2021, O'Connell 2020, Osborne 2017, Starzmann 2016). The main theme to these discussions has been how to reconcile the persistence of monuments to troubling histories, such as the racism of African American slavery, in the present. How can we progress towards an antiracist future while monuments to racism in the past still stand? How can we embrace multiracial democracies when our landscapes contain works produced in the name of white supremacy? Confederate monuments (as well as those dedicated to colonizers and slave traders) have thus been disparaged, attacked, disfigured, and removed (Green 2020, Kushner 2020, Ortiz 2020, Ortiz and Diaz 2020). While these monuments are flashpoints for people to assert a new politics, thus far there has been little in the way of a fleshed-out discourse over what this politics will be. In most cases, the acts of destruction in which monuments are taken down are noteworthy moments, but what to do with the physical and discursive spaces these actions open up awaits our attention.

Suggestions for what do to with confederate and other similar monuments include providing statements of context so that they can be preserved but better understood as a product of their time, as artifacts of a period we have collectively surpassed (Robinson 2017). Others have suggested monuments be removed and

warehoused in museums where a similar contextual treatment could be applied (Itzkowitz 2020). Finally, some have argued the monuments be destroyed and where appropriate melted down so the source metals could be recast into new works better reflecting our collective contemporary selves (Medina 2021). Regardless of the desired result, the goal was always to remove the monuments and to do so with haste. Yet, as African and African American Studies Professor, Geoff Ward, noted 'this is a familiar U.S. scenario … seeking to quickly move on and declare matters settled rather than dealing with issues and really processing traumas' (Ortiz 2020). Is there not a way for this moment to be defined and understood so that we can not only celebrate the transformative events of today but also reckon with the legacies of violence and hate of American racism (and other negative forces of modernity) that are the actual substance of our troubled inheritance?

Particular actions initiated during the 2020 global antiracist protests show that some of those working to remove the statues and monuments have begun to articulate a deeper interrogation of the past and what counts as our heritage going forward. Notably, these efforts do not come from the institutions that typically dominate the heritage discourse (museums, universities, government agencies, and heritage experts) but from the protester communities themselves. These nonexperts (from the perspective of the heritage industry) are able to capture the spirit of the protests not only because they are part of it but also because they understand that this insider position is essential to telling the story. For one, they demand that we recognize that lives are on the line. They know that most heritage work tends to stabilize and memorialize narratives which removes the passion of the moment in favor of a more secure representation of events. Second, activists put the emotion of the people at the center of the narrative. It is not what happened as much as what was felt that they seek to remember. For the wrecking storms of racism, colonialism, slavery, and violence remain unchecked if the feelings these histories produce do not have a presence in the way we look back on the past. The struggle for survival and the emotional toll this work requires is the basis of a people's heritage (Kushner 2020).

In the following, I present a history of Monument Avenue in Richmond that culminates with what I believe is a prime example of a people's heritage. This story could have been written about a lot of places where troubling monuments disgrace public space but Monument Avenue's extended history from its origin as a monument to the Confederacy to the ways it was demolished, discussed, and reimagined in 2020 provide a unique case for reflecting on how heritage has and can serve communities, including those seeking to be seen and heard through protest.

Creating a "Monument Avenue"

Monument Avenue is located on the west side of Richmond, the capital city of Virginia. It is a broad boulevard that provided space for a series of public monuments to the Confederacy stretching altogether over a mile in length. At the outset,

I think it is important to note that it is not often the case that heritage associations constitute the names we assign to places. More often heritage happens in places and those place names become the names we use to know or at least use as a short hand for heritage sites (e.g. Gettysburg, the World Trade Center, Little Big Horn, etc.). In post-Confederate Richmond, however, the city's elite wanted to memorialize the role their city and many of its leading citizens played during the Civil War. The initial impetus for building a monumental landscape came after former Confederate General Robert E. Lee died in 1870, a passing that led to a popular desire to honor his life. It was not until 1887 that Southerners agreed that Richmond (as the former capital of the Confederacy) was the most appropriate city for an official monument to Lee. By that time, city leaders, including Lee's nephew and then Governor Fitzhugh Lee, had also selected a site for the monument. It would stand within a traffic circle leading to a new development planned for wealthy Richmonders 'seeking the fresh air and less congested settings of the outskirts of city' (NHL Nomination 1997:30). The centerpiece of the new neighborhood would be Monument Avenue itself, a 140-foot-wide boulevard with a broad grassy median lined by four rows of maple trees. By 1929 five monuments to Confederate leaders (Lee, J.E.B. Stuart, Jefferson Davis, Stonewall Jackson, and Matthew Fontaine Maury) were erected at key intersections along the Avenue's one-and-half-mile length. The new neighborhood was to provide 'Richmond with more than just a site for the monument—it would also be a showplace for Richmond's taste and wealth ... this new stretch of boulevard would announce Richmond's intentions of maintaining its role as the leading city of the South' (NHL Nomination 1997:28).

The fashioning of Monument Avenue overlapped Confederate heritage with urban development, real estate investment, and wealth accumulation, as well as civic pride at local, regional, and national levels. Still, it is notable that the initial spark for this work was a desire to memorialize Lee and Richmond as a representation of the Confederacy, a.k.a. 'the Lost Cause.' The placement of heritage at the starting point of the process to expand the city is worth considering. We can observe one view of this event through the words of African American newspaper editor John Mitchell, Jr. who presciently editorialized in the *Richmond Planet*, that building monuments to the Confederacy would institute a 'legacy of treason and blood' passed down to subsequent generations (NHL Nomination 1997:33). Nevertheless, his was a minority opinion, as the erection of the statue was widely celebrated in the white community.

On May 7, the day that had been set aside to haul the statue's parts to the site, a crowd estimated at twenty thousand came to help. As evidence of their enthusiasm, the citizens of Richmond would pull it to the site themselves. Beginning with about one hundred yards of rope for each of the four wagons, and then with the addition of another 300 feet of rope, they hauled the sculpture through town. The ropes were cut into segments and taken home as souvenirs.

The dedication ceremony on May 29, part of a Confederate Reunion, was attended by a crowd estimated at between 100,000 and 150,000—more than the entire population of Richmond. About 25,000 people marched in the parade, which was four miles long.

(NHL Nomination 1997:33)

For these revelers, remembrance of the Confederacy expressed even in the prosaic materiality of segments of rope used to pull the statue, was paramount in the minds of those constructing what would become Monument Avenue. It was to be an elite space made meaningful by the presence of Confederate heritage. The expansion of this memorial to the Confederacy over the next 40 years as the neighborhood grew shows how sustained this commitment to Southern heritage was for Richmond's whites. Arguably, this commitment was not challenged until 1996 when the city erected a statue honoring local African American tennis hero Arthur Ashe. Yet, the Ashe monument was an addition not a correction and arguably served to reinforce the permanence of the monumental Confederate landscape as much as it may have challenged the monolithic white history thus far produced.

Defending the Bodies of Heritage

Flash forward to 2015. That was the year a 21-year-old white man murdered nine Black parishioners at their church in South Carolina. The assailant claimed he intended to start a race war and was famously depicted in a photo posing with a pistol in one hand and a Confederate flag in the other. This appalling event shocked the country and led to a nationwide program to remove Confederate flags and symbols from public spaces including from several state houses across the South. This story reached Richmond and the Virginia Governor's office as a result. There, among other issues, Governor McAuliffe declared that he would recall state-issued license plates depicting the flag as part of an insignia of the Sons of Confederate Veterans (Vozella and Portnoy 2015). Interestingly, when asked about what he would do about Monument Avenue, McAuliffe chose to exclude the statues from the effort to minimize public celebration of the Confederacy. While he saw the flag as a 'divisive symbol,' the statues were something else: 'I mean, Robert E. Lee, Jefferson Davis, these are all parts of our heritage ... And the people that were in that battle, the Civil War, many of them were in it obviously for their own reasons that they had for that. But leave the statues and those things alone' (Kamisar 2015).

The ease with which McAuliffe could parse the Confederate flag as a symbol from the monuments erected to Confederate military leaders suggests something about the slippery power of what he describes as 'heritage.' I see a distinction here between heritage as expressed in state symbols as opposed to human bodies and lives. The flag is an impersonal thing, even though it embodies the Lost Cause, white Southern culture and pride, and antiblack racism. As such, it is relatively easy to remove and replace. Conversely, as McAuliffe put it, the statues on Monument

Avenue stand in for human beings (Lee and Davis) who are a distinct part of 'our' (his state's) heritage. The statues are portraits of persons to be engaged not as flat symbols of the Confederacy but as three-dimensional historical figures who had 'their own reasons' for fighting in the war. The persistent sculpted presence of their humanity assigns them to a different heritage space that minimizes their representation of the same troubles embodied by the flag. By distancing memorialized people from the meaning of their actions, heritage on Monument Avenue sustains racism (and other forms of violence) because it allows us to easily separate the honored people from their actions more so than we can with an impersonal flag. This thought applies equally to the development of Monument Avenue self-consciously as 'Monument Avenue' in 1890. A constructed memory of Lee and the Confederacy thirty-plus years after the end of the Civil War drove the desire to create a new space to memorialize the Lost Cause (Brundage 2005, Foster 1987, NHL Nomination 1997). Heritage in this embodied form requires time to pass, so memories are distanced and reified into stable, shared cultural meanings and identities. As time passes, that is, history, nuance, and critique are replaced with unquestioned, justified, and defensible origin stories that drive what McAuliffe and many others cite as 'heritage.'

The defensibility of Confederate heritage was made clear in 2017 at the Unite the Right rally in Charlottesville, 60 miles west of Richmond. This gathering of far-right extremist groups was an organized defense of Confederate heritage, as protestors came to Charlottesville to defend another statue of Robert E. Lee under the threat of removal. After local activists spray-painted 'Black Lives Matter' on the statue's pedestal in the aftermath of the 2015 church shootings in South Carolina, support grew among Charlottesville citizens for the statue to come down. Then, in 2017, the city council voted to remove the statue but that decision was quickly challenged in the courts, so the statue remained. Public debate brewed online for months leading up to the Unite the Right rally in August, when the debate exploded into real life.

The fight to save the Lee statue in Charlottesville drew many well-known leaders of the far right. These included avowed white supremacists such as Richard Spencer, Mike 'Enoch' Peinovich, and Michael Hill. The organizer of the rally was Charlottesville resident Jason Kessler, who gained notoriety for his defense of the statue and arguments that those who opposed it were 'anti-white' (Fortin 2017). He is also known for an image showing him proudly waving a Confederate flag at the rally. These leaders saw the Lee statue as a touchstone for their broader racist agenda and they and their followers appealed to Southern heritage to make their case. Many carried signs proclaiming that 'Confederate History Matters,' 'All History Matters,' and 'Hands Off Our History.' Such placards sought to claim a meaningful identity based in Confederate heritage that should be protected from criticism and removal. In fact, organizers urged their followers to be prepared to defend themselves from counter-protestors who sought to tear down their history. One young

man took this literally and used his car as a weapon to run over counter-protestors killing one and injuring many others (Romo 2018).

The rally was a national news story. It was treated as a sign of a growing dis-affection among some younger white American conservatives with liberal policies they interpreted as favoring people of color at their expense. Yet, the removal of a statue of Confederate General Robert E. Lee was the siren song that drew thou-sands of these protestors to Charlottesville. They came to march, to chant, to protest, and, for some, to riot and cause harm. Underneath this, though, was a desire to preserve a heritage that reinforced their sense of identity and their social power.

The general response to the Charlottesville riot was outrage, especially by those on the left. Most critics felt that the discourse over southern Confederate heritage was anachronistic, reflecting a persistent racism inherent to the alt-right that should be condemned. President Trump's post-mortem assertion that there were bad people on 'both sides' fueled this outrage, leading many to continue to protest against the monuments, which at times led to unrest and violence across the country. In Richmond, protests once again focused on Monument Avenue, especially the statue of Robert E. Lee. To control crowds and limit violence, Governor McAuliffe ordered that no gatherings of more than 500 people would be permitted on the grounds of the Lee statue and that any gathering of more than 10 people would require a permit (Haag 2017). McAuliffe once again put the power of his office behind the preservation of southern Confederate heritage, though in this instance he asserted this was to 'balance First Amendment [free speech] rights and ensure that all Virginians remain safe.' Even though McAuliffe fought to preserve the status quo, support for the original meanings of Monument Avenue was starting to crumble.

The mayor of Richmond, Levar Stoney, argued that the statues should remain but that his Monument Avenue Commission should be allowed 'to provide context and interpretation to the statues that currently stand down on Monument Avenue' (Robinson 2017). Such context would explain that the statues reflected the time of their construction and should be evaluated with that in mind. Stoney argued for this addendum even while admitting publicly that the statues are 'very offensive' and that 'they're a shameful representation of the past that we all disagree with.' The appearance here is an attempt to placate 'both sides' by letting the statues remain while at the same time expressing disgust over their existence. A more powerful statement came from Jack and Warren Christian, descendants of Confederate General Stonewall Jackson, who called for removing the statue of their ancestor and the other Confederate monuments. 'In making this request,' they wrote, 'we wish to express our respect and admiration for Mayor Stoney's leadership while also strongly disagreeing with his claim that "removal of symbols does [nothing] for telling the actual truth [nor] changes the state and culture of racism in this country today." In our view, the removal of the Jackson statue and others will necessarily

further difficult conversations about racial justice. It will begin to tell the truth of us all coming to our senses' (Christian and Christian 2017).

The Christians identify that the presence of southern Confederate monumental heritage on the Richmond landscape has ramifications that reach beyond those who cite them as 'heritage, not hate.' They recognize that the symbolic meaning of the statues is not just what was intended by those who supposedly sought to honor Confederate leaders but also those who have been harmed and offended by the way the monuments stand for the antiblack racism undeniably tied to any Confederate memory. Instead, they see a need for us to have the difficult conversations about racial justice that will lead us to come to our senses. Honorable as this stance seems, it hard not to see the Christians adopting the sort of paternalism that whites across the political spectrum fall back on in the discussion of Confederate monuments. Who needs these conversations? Why are they difficult? Who among 'us all' needs to come to their senses? I think it is obvious that the Christians are speaking about white people, but, unfortunately, they are not clearly speaking to them. Stepping back from naming whites as perpetrators, and thus the people who truly need to confront their own racial reality, almost entirely undermines the power of their message (Bernbeck and Pollack 2007). Effectively, the Christians come off the same as McAuliffe and Stoney. They all would have liked to see changes on Monument Avenue but they prefer it be peaceful, permitted, and contextualized in a way that the statues would either remain or be removed as a way of improving or at least not harming the majority community. Fortunately, there have been other responses to Monument Avenue in Richmond that demand more.

Rumors of War

'This story begins with my seeing the Confederate monuments. What does it feel like if you are black and walking beneath this? We come from a beautiful, fractured situation. Let's take these fractured pieces and put them back together' (VMFA 2019). This indirect reference of Benjamin's angel of history is from artist Kehinde Wiley, who is well-known for portraiture in which he uses classical forms, allusions, and techniques historically found in paintings of white people expressed instead through modern, urban Black subjects. His point is that 'the visual vocabulary and conventions of glorification, history, wealth and prestige' have been monopolized in the representation of whites. Shifting the subjects from whites to Blacks juxtaposes the 'old' inherited by the 'new'—who often have no visual inheritance of which to speak and 'position young black men within the field of power' (Kehinde Wiley Studio 2021). Wiley brought this approach to art to Richmond in his sculpture *Rumors of War* which stands in front of the Virginia Museum of Fine Arts (VMFA), two blocks south of Monument Avenue.

Wiley created *Rumors of War* after seeing the Confederate statues on Monument Avenue in 2016 when the museum staged a major show of his work. Inspired by critiques of Confederate memorials that coalesced after 2015 as well as his own

experience as an African American man, Wiley took the opportunity to speak back to the heritage made material in equestrian statues of Lee and the others. *Rumors of War* does this explicitly by copying the pose of the horse and rider found in the statue of General J.E.B. Stuart but replacing Stuart with a young African American man wearing a hoodie, jeans, Nike sneakers, and dreadlocks tied into a pony-tail. As the museum describes, 'proudly mounted on its large stone pedestal, the bronze sculpture commemorates African American youth lost to the social and political battles being waged throughout our nation' (Virginia Museum of Fine Arts 2019).

In many ways, *Rumors of War* rehabilitates the heritage narrative of Monument Avenue by creating a counterpoint where Confederate heritage is rejected and replaced. Wiley's work thus mirrors the removal of Confederate flags from southern state houses a few years earlier. While removing the flags was a profound development in which an object of hate was rejected, it was also a shockingly easy thing to do and, in the end, did not truly challenge the viability of the symbol among those who embraced it. Recall that the Unite the Right organizer Jason Kessler as well as dozens of other protestors proudly carried Confederate flags despite the fact that a white supremacist mass murderer embraced it two years before. I think we see something similar in the mounting of *Rumors of War* at the VMFA. What is new about the sculpture is the subject, an African American man put in place of what we are used to seeing: someone not only white but also wealthy, powerful, and historically significant. The structure and framework of the art are unchanged, meaning that the traditions we are used to seeing when presented with white wealth, power, and history (i.e. white heritage) remain intact. This is very much Wiley's intent, but I am less certain of its effect.

Rather, I see in *Rumors of War* a validation of much of the problematic implicit meanings that give Monument Avenue its lasting power as a heritage site. These are based on the idea that heritage is an objective thing that can be produced in statues, landscapes, and other intentional forms which obscure the social relations that produced them. I do not see the difficult conversations, as the Christians called for, since all of the statues, including *Rumors of War*, are presented as complete. For example, like the thousands who celebrated in the streets when the Lee statue was erected in 1890, a video of the unveiling of *Rumors of War* in 2019 shows a multi-racial but mostly white public in Richmond celebrating a victory that this new statue reflects (VFMA 2019). Yet, there was no battle over this statue for which a victory celebration was warranted. It stands on private property and was commissioned and funded by a high-end elite arts institution. The victory came at no social cost, which is pretty much the same price paid for removing Confederate flags or by Stonewall Jackson's descendants when they asked their peers to engage in work that would allow them to come to their senses.

Truly, too much of this heritage discussion has assumed too much about the people involved. For one, whites are treated as unaware of their privilege and power, both as the majority community in the state and nation as well as the beneficiaries of the policies and practices of a racist society. To imagine whites are

unaware of their privilege is to act as if racism really can function without racists (Bonilla-Silva 2006). This is not to say that all white people are racists but those who are not racist and even those who claim to be antiracist are aware that they have the choice to embrace the changes that would dismantle racism and their own privilege or to stand aside and let racism be reproduced. Most often, white people do nothing to address racism because that is the easier choice that benefits them most. Conversely, the other narrative embodied in these monuments, both 'old' and 'new,' is that African Americans are innately disempowered. Certainly, the survival of the Confederate monuments for over a century assumes Black power-lessness, since regardless of claims that they reflect Southern heritage, everyone knows that this includes slavery and antiblack racism at its heart. Sadly, a similar standpoint is voiced in the descriptions of *Rumors of War* where the use of a Black male subject is meant to compensate for African Americans, 'who often have no visual inheritance of which to speak' and especially Black youths 'lost to the social and political battles being waged throughout our nation' (VFMA 2019). The premise here is that without their representation in the forms of historic glory and power long deployed by whites that African Americans do not have a history. This, thankfully, has been remedied by an African American artist backed by a powerful white institution who saw a low-stakes chance to enter a popular and powerful conversation about heritage in relation to the statues on Monument Avenue. What I think we learn most of all from *Rumors of War* is that it will take more than dressing up the old as new to expose that which lies buried in the Confederate statues along Monument Avenue. This becomes evident as the history of the Monument unfolds again during the antiracist protest of 2020.

"Liberated by the People"

Spurred by the dreadful murder of George Floyd by Minneapolis Police, a new voice for heritage in Richmond (though truly speaking to the whole world) emerged during the summer of 2020. Facing anew the centuries of police and vigilante racial murders absorbed by the African American community, protestors returned to Monument Avenue to resume their public objection to the Confederate monuments and the racist heritage they represent. This time energy was focused on frustration with inaction on the question of why monuments based on antiblack racism would continue to stand. Protestors exposed that this heritage was complicit in the killing of George Floyd, Brianna Talyor, Ahmed Aubery, and thousands of other African American victims of violence since their lives and deaths are embedded in not only Confederate heritage but also the broader and longer-lasting heritage of a state and country that would tolerate racism in both official (in) action and in celebratory monumental form. With this understanding, there was no tolerance for ambivalence or playing to both sides. It was time for the Confederate statues to come down and they did, except for one.

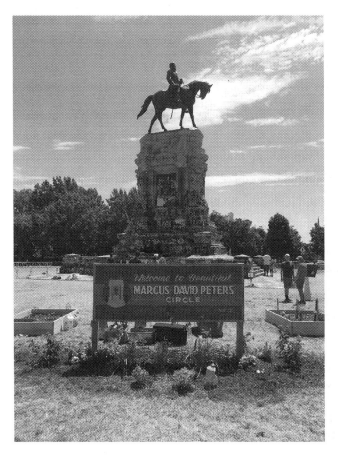

FIGURE 10.1 Sign designating Marcus-David Peters Circle, Liberated by the People MMXX. Photograph: Christopher Matthews.

As a result of the protests, the statues of J.E.B. Stuart, Stonewall Jackson, Jefferson Davis, and Matthew Fontaine Maury were removed. These were on city-owned property, so their removal was a local decision. The statue of Robert E. Lee remained in place longer because it required state approval and action. While many were frustrated by its survival, what happened to the Lee statue and the surrounding traffic circle presents a powerful lesson in what happens to heritage when it is taken from official authorities and put in the people's hands (Figure 10.1).

The most distinctive change to Lee Circle was its informal rededication as Marcus-David Peters Circle. Less than a month after George Floyd's murder, local protesters mounted a sign on the circle welcoming visitors to 'Beautiful Marcus-David Peters Circle, Liberated by the People, MMXX' (Kolonich 2020). Peters had been the victim of a police shooting in 2018. He was a biology teacher who had 'a mental health crisis when he was seen unclothed and unarmed, running onto

Interstate 95/64 in downtown Richmond, where he was hit by a car and then rolled on the pavement.' When police confronted Peters, who was clearly injured and suffering, they attempted to subdue him by taser but, when that failed, they shot him. He died the next day. State attorneys later declared the shooting justified and filed no charges against the officers who killed him.

Recognizing the local significance of this event and the parallels to the murder of George Floyd, 'the people' took to Monument Avenue to seize the space and change the narrative. The goal remained the removal of the Lee statue, but other actions taken since then illustrate how heritage takes on a different form when it emerges as the result of a people's movement. For one, the monuments themselves have been transformed by spray paint. Whether these are overt statements of disgust such as tags on the Jackson monument declaring that he was a 'racist traitor' and calling for to 'end white supremacy' to other statements supporting protestors such as innumerable versions of 'Black Lives Matter' or 'BLM,' as well as 'Color is Not a Crime,' 'No Justice, No Peace,' and 'Proverbs 29:16' [When the wicked thrive, rebellion increases; but the righteous shall see their downfall]. Pronounced as well were statements declaring, 'We are not Leaving!'

To ensure their presence was visible beyond the protest actions, members of the Peters Circle community contributed labor and resources to provide a new structure to the space. Two portable basketball hoops were set up in the green spaces surrounding the statue as a distinct expression of Black recreation and liberation. Raised garden beds were built to highlight food injustice as a part of the racist infrastructure the Confederate monuments created. A free community 'radical library' providing books on protest movements and racial justice helped educate the community. In adjacent green areas, musicians, dancers, and visual artists contributed their talents to beautifying the space through an African American aesthetic ignored by the monuments, the wealthy people living in the surrounding neighborhood, and the VFMA. Peters Circle also became a site of multiple memorials to the ongoing atrocity of police violence against communities of color. These memorials were created by community members who found the Circle to be an appropriate and welcoming place to mark the frustration, sadness, and pain they felt because of the violent killings of George Floyd, Marcus-David Peters, and so many others murdered for the crime of being Black in America. These memorials were enlarged over time as other community members left flowers, notes, stuffed animals, and related objects, demonstrating their support for the emotional toll that goes into publicly recognizing loss of loved ones and community.

This community space for developing a critically alternative people's heritage did not emerge without struggle. At one of the first protests in June, police used excessive force including tear gas grenades and rubber bullets to disperse protestors who were legally gathered while kneeling peacefully and chanting 'Hands up, Don't Shoot.' Even though Richmond Police later apologized for their inappropriate action, protestors continued to be met with tear gas, rubber bullets, arrests, and harassment over the following months. Later in the year,

counter-protestors used a chainsaw to tear down the Marcus-Davis Peters welcome sign and then posted an image of it draped in a confederate flag on social media. Pro-Trump caravans drove by the circle during the election season, shouting and jeering at the community and in one instance fired a gunshot and struck one protestor with a vehicle. Then, in January 2021, the City of Richmond erected fencing around the circle preventing protestors and community members for caring for the site (Almore 2021a).

Chronicler and 'de facto "curator" of the memorials at Marcus-David Peters Circle,' Beth Almore highlights the conflicts that became clear between old and new meanings of heritage at the site. This emerged when elite organizations, including the VFMA, began to take an interest in the site and claim a place for their expertise. This came to pass in December 2020 when the new Governor of Virginia Ralph Northam announced the state would earmark $11 million in support of the Reimagining Monument Avenue Initiative, a program led by the Virginia Museum of Fine Arts (Dafoe 2020, Northam 2020). In an open letter to the Museum published on January 26, 2021, Almore (2021b) wrote:

> Tending to the memorials was a grassroots effort. Over the last few months, many community members – of all ages, ethnicities, races, and religions – stepped in to clean, tidy, decorate, and maintain the memorials. We do not consider these items state property. We recognize that this is the standard in museum work – for example, when items are left at the Vietnam War Memorial in D.C., those items become property of the U.S National Park Service. Quite frankly, we do not trust the motives behind collecting items at MDP and stashing them away in archival locations. Hiding them in a basement or cold storage is in direct opposition to the reasons why people left those items. For eight months many of us have wondered – often aloud – when would representatives of the museums come to Marcus-David Peters Circle, speak to local protest leaders and community organizers, and ask: *'How would you like us to support the work you are doing here?'* …*We believe that the hundreds – or even thousands – of community members who painted, reported, projected, performed, marched, were teargassed, were shot at point blank range by rubber bullets, were beaten, and were arrested should have as much say as wealthy donors and members of academia who were completely absent and dismayingly silent during the uprising.*
>
> (emphasis in original)

These words are a clear statement of what makes a people's heritage. And, in this instance, we can see exactly the process by which a people's heritage can form—through the collective grassroots action of people rejecting existing heritage narratives—as well as how a people's heritage is typically stamped out. In Richmond, the Governor, the Mayor, state representatives, and arts elites along with wealthy donors who received a tax write off for their gifts coalesced to appropriate a notion of racial justice created by and for others. As Almore (2021b) further writes,

We are less interested in the concerns that might be at the forefront of museum curators' minds (preservation, 'fossilizing' a space to trap it in the past like an insect in amber). We are more interested in a space that continues to evolve as an active community-led space, the purpose of which is to protest extrajudicial police executions. Any efforts to remove signs and symbols which interrogate and speak out against extrajudicial executions from the center of the narrative are not acceptable. We feel - strongly - that *the space has already been reimagined*, by thousands of community members.

(emphasis added)

It is surprising that these words need to be written. How could anyone who had seen Peters Circle whether in person or online not recognize the space had already been reimagined? How could the museum, its donors, and its political supporters be so blind to this? If anything, with Almore's leadership we can see exactly how the Confederate monuments and Monument Avenue survived as long as they did, especially during the last five years since the mass murder of African American church members in South Carolina. These elites have no sense of the trauma that exclusive heritage sites and narratives reproduce among those whose lives are not represented. Yet, Confederate monuments do more to Black Richmonders than fail to provide a way for these people to see themselves in public space. They promote a hierarchy of historical and cultural value (i.e. a heritage) in which their suffering–past and present–is the fuel that raises monuments to white supremacy while they watch. To fail to see that the protestors at Peters Circle have not already reimagined and enacted a new heritage for the city is essentially the same as calling for the statues to remain. To dismiss their emotional appeals that their pain be recognized and their counternarrative embraced is the same as saying the monuments really are just 'heritage, not hate.'

What is a People's Heritage?

Based on this rapid recounting of the history of Monument Avenue in Richmond since the 1890s and especially since 2015, I think we can see what constitutes a people's heritage. It is primarily a form of heritage-making liberated from those who have controlled the historical narratives for too long. For one, a people's heritage is grassroots. It is by and for common people, who not only seek out narratives with meaningful connections for themselves but also spaces with openings in which they contribute to crafting new narratives collectively. In this way, a people's heritage is inclusive but also ongoing.

Second, a people's heritage is explicitly about healing and restorative justice. In the case of Monument Avenue, the target for revision is clear: public monuments to white supremacy and antiblack racism that the majority community have fought to defend despite a growing antiracist sentiment in the city and the nation. Other monuments and heritage sites may be less obviously traumatic to people excluded and harmed by

the narrators they face. In such cases, heritage narratives still need to be interrogated in terms of who values them and why they choose to do so. Historic frontier forts and urban factories provide spaces for recognizing the overlooked presence of people whose lives were interrupted and debased, if not ended, by the march of progress that created these now historic places. Most historic houses across the United States stand as proxies for the wealthy and prominent white men who happened to live there. These homes also sheltered women, children, servants, and, often, enslaved persons whose absence from the narratives of the site is not just a lost opportunity but an essential failure to challenge what and why we preserve such sites in the first place.

Third, a people's heritage is intentionally designed to meet the needs of those struggling today. Again, the stark difference between the beneficiaries and victims of America's racist heritage embodied by the original statues on Monument Avenue is clear. Yet, every heritage act has its feet squarely placed in the present. When Virginia's Governors, both past and present, declared their support for the creation and preservation of the Confederate monuments they did so in and for their current historical moments. They saw the chance to ensure their own popularity by referencing and protecting the Confederate past for political gain. A people's heritage works much the same way but from the bottom up. The Marcus-David Peters Circle community did not form solely to tear down the monuments but to seize a heritage space that currently reflected painful issues and personal losses so these could be made public and shared with others who also needed to heal.

Arguably, the painful memory and experience of racism for US residents is our national heritage, and it requires a nationwide effort to identify and remedy spaces where this harmful force persists. The people of Richmond who created Marcus-David Peters Circle have demonstrated one way to do this and what comes next, which is to seize these spaces so a people's heritage can be built. The question now is whether those who make a living doing heritage work will also prioritize the use of heritage spaces for community healing to begin. If not, then we and they need to step aside to allow those who cultivated a way to articulate and address the historical traumas that have harmed them as victims of the US's heritage to take the lead in what our heritage becomes. These counter-heritage voices ultimately reveal Benjamin's (1969:257) message that the debris before us results from a single catastrophe that has harmed us all. To know this history, as the history of 'progress' or 'modernity,' opens new paths toward empathy and shared understanding, and we need to feel how others feel if we hope to end the violence that currently disables us.

Acknowledgements

I want to thank Ellen Chapman, Paul Mullins, Elizabeth Baughan, Zoë Burkholder, Nick Shepherd, and the members of the NYC Historical Archaeology writing group for their helpful comments and critical suggestions on earlier drafts of this essay. All errors, omissions, and oversights of facts and reason remain entirely my own responsibility.

References

Almore, Beth. 2021a. A Timeline of Marcus-David Peters Circle. *Monumental Memorials at Marcus-David Peters Circle, Richmond, VA: A digital and IRL community space to memorialize the victims of extrajudicial executions of US residents by law enforcement.* Accessed July 13, 2021. https://monumentalmemorials.blogspot.com/p/a-timeline-of-marcus-david-peters-circle.html.

Almore, Beth. 2021b. Open Letter to The Director Of The Virginia Museum Of Fine Arts. *Monumental Memorials at Marcus-David Peters Circle, Richmond, VA: A digital and IRL community space to memorialize the victims of extrajudicial executions of US residents by law enforcement.* Accessed July 13, 2021. https://monumentalmemorials.blogspot.com/2021/01/open-letter-to-director-of-virginia.html.

Barber, William J. 2020. *We Are Called to Be a Movement.* Workman Publishing Company, New York.

Beetham, Sarah. 2016. From Spray Cans to Minivans: Contesting the Legacy of Confederate Soldier Monuments in the Era of "Black Lives Matter". *Public Art Dialogue* 6(1):9–33.

Benjamin, Walter. 1969. *Illuminations: Essays and Reflections.* Shocken Books, New York.

Bernbeck, Reinhard and Susan Pollack. 2007. Grabe, wo du stehst!': An Archaeology of the Perpetrators. In *Archaeology and Capitalism: From Ethics to Politics*, Yannis Hamilakis and Philip Duke, eds., pp. 217–233. Left Coast Press, Walnut Creek, CA.

Blight, David W. 2001. *Race and Reunion: The Civil War in American Memory.* The Belknap Press of Harvard University, Cambridge, MA.

Bonilla-Silva, Edward. 2006. *Racism without Racists: Color-Blind Racism and the Persistence of Racial Inequality in America.* Rowman and Littlefield, Lanham, MD.

Brundage, W. Fitzhugh. 2005. *The Southern Past: A Clash of Race and Memory.* The Belknap Press of Harvard University Press, Cambridge, MA.

Chaudhuri, Amit. 2016. The Real Meaning of Rhodes Must Fall. *The Guardian*, March 6, 2016. Accessed February 2, 2022. https://www.theguardian.com/uk-news/2016/mar/16/the-real-meaning-of-rhodes-must-fall.

Christian, Jack and Warren Christian. 2017. The Monuments Must Go: An open letter from the great-great-grandsons of Stonewall Jackson. *Slate*, August 16, 2017. https://slate.com/news-and-politics/2017/08/stonewall-jacksons-grandsons-the-monuments-must-go.html.

Dafoe, Taylor. 2020. Virginia's Governor Wants to Spend $11 Million to Reimagine a Confederate Monument-Lined Promenade in Richmond. *Artnet News*, December 16, 2020. https://news.artnet.com/art-world/virginia-governor-reimagine-confederate-monument-avenue-1932060.

Doss, Erika. 2010. *Memorial Mania: Public Feeling in America.* University of Chicago Press, Chicago.

Fairbanks, Eve. 2015. The Birth of Rhodes Must Fall. *The Guardian*, November 18, 2015. https://www.theguardian.com/news/2015/nov/18/why-south-african-students-have-turned-on-their-parents-generation.

Fortin, Jacey. 2017. The Statue at the Center of Charlottesville's Storm. *The New York Times*, August 13, 2017. https://www.nytimes.com/2017/08/13/us/charlottesville-rally-protest-statue.html.

Foster, Gaines M. 1987. *Ghosts of the Confederacy: Defeat, the Lost Cause, and the Emergence of the New South, 1865 to 1913.* Oxford University Press, New York.

Green, Hilary. 2020. Shifting Landscapes and the Monument Removal Craze, 2015–20. *Patterns of Prejudice* 54(5):485–491.

Haag, Matthew. 2017. Virginia Restricts Protests at Lee Monument in Richmond After Clashes. *The New York Times*, November 20, 2017. https://www.nytimes.com/2017/11/20/us/robert-e-lee-monument-richmond-virginia.html.

Itzkowitz, Laura. 2020. What Should Happen to Confederate Statues in the U.S. *Architectural Digest*, June 24, 2020 https://www.architecturaldigest.com/story/what-should-happen-to-confederate-statues-in-the-us#:~:text=The%20National%20Trust%20now%20supports,can%20be%20contextualized%20and%20reinterpreted.

Kamisar, Ben. 2015. Va. Gov: Leave Confederate Statues alone. *The Hill*, June 24, 2015. https://thehill.com/blogs/ballot-box/246012-va-gov-leave-confederate-statues-alone.

Kehinde Wiley Studio. 2021. About Kehinde Wiley. Accessed July 13, 2021. https://kehindewiley.com/

Kolonich, Eric. 2020. Space Around the Lee Statue has been Informally Named for a Black Man who Lost his Life at the Hands of Police. *Richmond Times-Dispatch*, June 26, 2020. https://richmond.com/news/local/space-around-the-lee-statue-has-been-informally-named-for-a-black-man-who-lost/article_1b48d63f-e932-5edc-8d0b-0e3289ac71bb.html

Kushner, Tony. 2020. The Summer of 2020: Memorialization Under Covid-19 and Black Lives Matter. *Patterns of Prejudice* 54(5):513–535.

Loewen, James W. 1999. *Lies Across America: What Our Historic Sites Get Wrong*. The New Press, New York.

Medina, Eduardo. 2021. Charlottesville's Statue of Robert E. Lee Will Be Melted Down. *New York Times* December 7, 2021. https://www.nytimes.com/2021/12/07/us/robert-e-lee-statue-melt-charlottesville.html.

Mullins, Paul R. 2021. *Revolting Things: An Archaeology of Shameful Histories and Repulsive Realities*. University Press of Florida, 2021.

National Historic Landmark Nomination. 1997. Monument Avenue Historic District. U.S. Department of the Interior, National Parks Service, National Register of Historic Places Registration Form. Virginia Department of Historical Resources. Accessed July 13, 2021. https://www.dhr.virginia.gov/historic-registers/127-0174/.

Northam, Ralph S. 2020. Governor Northam Announces $25 Million Investment in Historic Justice Initiatives. *Office of the Virginia Governor*, December 11, 2020. https://www.governor.virginia.gov/newsroom/all-releases/2020/december/headline-886217-en.html

O'Connell, Heather A. 2020. Monuments Outlive History: Confederate Monuments, the Legacy of Slavery, and Black-White Inequality. *Ethnic and Racial Studies* 43(3):460–478.

Ortiz, Aimee and Johnny Diaz. 2020. George Floyd Protests Reignite Debate Over Confederate Statues. *New York Times*, June 3, 2020. https://www.nytimes.com/2020/06/03/us/confederate-statues-george-floyd.html.

Ortiz, Erik. 2020. These Confederate Statues were Removed. But Where Did They Go? *NBC News* September 20, 2020. https://www.nbcnews.com/news/us-news/these-confederate-statues-were-removed-where-did-they-go-n1240268.

Osborne, James F. 2017. Counter-Monumentality and the Vulnerability of Memory. *Journal of Social Archaeology* 17(2):163–187.

Robinson, Mark. 2017. Mayor Stoney: Richmond's Confederate Monuments Should Stay With Context Added: Commission's mission remains the same. *Richmond Times-Dispatch*, August 14, 2017. https://richmond.com/news/local/city-of-richmond/mayor-stoney-richmond-s-confederate-monuments-should-stay-with-context/article_b8cbb743-410f-520f-9197-2a58450d128a.html.

Romo, Vanessa. 2018. Charlottesville Jury Convicts 'Unite The Right' Protester Who Killed Woman. *NPR*. December 7, 2018. https://www.npr.org/2018/12/07/674672922/james-alex-fields-unite-the-right-protester-who-killed-heather-heyer-found-guilt.

Starzmann, Maria T. 2016. Engaging Memory: An Introduction. In *Excavating Memory: Sites of Remembering and Forgetting*, Maria T. Starzmann and John R. Roby, eds., pp. 1–23. University Press of Florida, Gainesville.

STWR. 2008. People's Movements: Key Facts and Resources. Share the World's Resources. Accessed July 13, 2021. https://www.sharing.org/information-centre/articles/peoples-movements-key-facts-and-resources.

Virginia Museum of Fine Arts. 2019. Sculpture Created by Kehinde Wiley for VMFA. About VMFA. Accessed 13 July 2021. https://www.vmfa.museum/about/rumors-of-war/

Vozella, Laura and Jenna Portnoy. 2015. Virginia's McAuliffe Plans to Phase Out Confederate Flag License Plate. *Washington Post*, June 23, 2015. https://www.washingtonpost.com/local/virginia-politics/virginias-mcauliffe-plans-to-phase-out-confederate-flag-license-plate/2015/06/23/bb8a1738-19b0-11e5-93b7-5eddc056ad8a_story.html

Zinn, Howard. 1999. *A People's History of the United States*. Harper Collins, New York.

11

DIFFICULT HERITAGE AT THE DOOR

Doing Heritage Research in Precarious Times

Duane Jethro and Sharon Macdonald

FIGURE 11.1 Truth, justice and implicatedness, Berlin. The quotation on the building in the background, the Federal Ministry of Justice, is attributed to Albert Einstein. It says, "When it comes to truth and justice, there is no difference between small and big problems". Photograph by Duane Jethro, June 30, 2020.

DOI: 10.4324/9781003188438-17

Introduction

The Black Lives Matter (BLM) protests triggered by the killing of George Floyd in May 2020 in the US brought with them a heaving sense of uncertainty associated with dramatic social change. They also prompted a new level of attention to a matter of difficult heritage at our door. Already energised by local German activist groups, our local difficult heritage became a focus of renewed public debate about everyday racism, problematic commemorative forms, and other legacies of the German colonial past. The difficult heritage we refer to is the name of the street, which we will here only designate as M_Straße, in order not to reproduce its widely recognised racism, in which the Institute for European Ethnology (IfEE), and the Centre for Anthropological Research on Museums and Heritage (CARMAH), where we work or have worked, are situated. Located in the district of Mitte, M_Straße has for years been called out as racist by activists and city re-sidents. The intensified debate about the street name played directly on existing uncertain distinctions in public heritage disputes and in the world of scholarship at the time. The issue of the name became increasingly hard to sidestep. We and our colleagues were confronted with a challenging question: how could we address issues of difference and cultural heritage that arose in sometimes fiercely contested museum and heritage settings elsewhere when our place of work was now en-tangled in these very issues? This is the difficult heritage at our door.

This case is just one example of how universities themselves are now also sites of fraught heritage contestation. Other instances include the dispute over the statue of Cecil John Rhodes at the University of Cape Town and at Oriel College, Oxford; the David Hume Tower at Edinburgh University; and Kroeber Hall at UC Berkeley; as well as many other buildings named after slaveholders in the US. Further cases concern contested heritage in University collections, such as Ishi at the Peabody Museum, and human remains held in many university collections, including those in Berlin. This chapter profiles the response to the fraught issue of our street name as 'difficult heritage' (Macdonald 2009). Specifically, it explores the implications of thinking with difficult heritage as a concept and the possibilities for mobilising engaged anthropology as a response to the blurring of scholarly work and public engagement which face colleagues around the world.

Our reading is set against a background of developments specific to Germany where the lines between scholarship and public engagement are increasingly scram-bled. 'The Mbembe Affair' of April 2020, as coined by the German media in ref-erence to the controversy surrounding the Cameroonian philosopher Achille Mbembe, devolved from a public interrogation of whether assumed comparisons made by the philosopher between the Holocaust and South African apartheid denied the former's singularity, into a discussion about whether post-colonial critique was anti-Semitic (see Rothberg 2020). Academia was further politicised when the Network for Scientific Freedom was established in Germany. 400 professors, doctors, and scientists pledged their support for its manifesto that aimed to 'oppose all efforts to

restrict the freedom of research and teaching for ideological motives' and open space for debate without 'fear of social and professional costs' (Netzwerk Wissenschaftsfreiheit 2021). Contemporary heritage debates–and thus heritage research and researchers–are especially likely to be politicised. In Germany, the Humboldt Forum, a vast heritage complex encompassing various exhibition spaces, is a notable example of this (see von Bose 2013; 2016; Macdonald 2022). The building's history as a reconstructed Prussian castle and the fact that it includes objects from the contested national ethnographic collections has drawn attention to questions of Germany's colonial legacies, ethnographic collections, race, and difference. The Forum's virtual opening, held in 2020, and its physical opening, beginning in 2021, have been occasions for the voicing of further controversy (Deutsche Welle 2021; Greenberger 2021; Hilden et al. 2021; Jethro 2021).

In contexts such as these, scholarly research could easily be construed as–and take the form of–activism. Scholars are increasingly more likely to get involved in public debate about heritage matters and engagement–indeed, this is often required by universities and research funders–which also means that their actions may be construed as activism, whether or not this is a label that they wish to embrace themselves (see Satia 2022). Researchers who cast a critical lens on national narratives designed to inspire pride, such as histories of scientific discovery, trade, and economic progress, for example, have increasingly found themselves exposed to sharp public and professional criticism. For example, Professor Corine Fowler, historian and author of *Green Unpleasant Land: Creative Responses to Rural England's Colonial Connections*, has received hate mail and even death threats due to her academic work (Fazackerley 2021). As she put it to a journalist, 'Academics working in the humanities have begun to be personally targeted … I think we should all be worried when academics are targeted in this way, when the evidence can't be disputed' (Doward 2020). Perhaps misrepresented and even vilified, the perspectives of academics risk being challenged as unpatriotic, and their scientific credentials called into question (Rutherford 2021; Gopal 2021). While it is increasingly important, perhaps even demanded, that scholars working on heritage-related themes take public positions on current political issues as part of their social engagement work, doing so may expose them to professional risks such as being dismissed as 'mere activists' and thus as lacking in scholarly rigour. Such dilemmas are especially evident in research on difficult or contested heritage, as the field is, by definition, one that is concerned with divergent values and agendas.

In this chapter, we reflect on the debate we are implicated in and the way our Institute has engaged with it. Our analysis below departs from a reflection on 'difficult heritage,' a concept Sharon Macdonald originally formulated especially in relation to Germany's Nazi past, but that is widely applicable. She then reflects on the difficult heritage of the disciplines of anthropology and ethnology and the name of the Institute in which we work or have worked. Following this, Duane Jethro profiles the strategies that colleagues in the Institute developed as an engaged

response to the debates about the M_Straße name and mobilization to change it. What the case we discuss shows is a blurring of the lines in scholarly and public engagement. This can be seen, we suggest, as precarious. Precariousness and precarity, Judith Butler points out, are different, 'the former referring to the unavoidable vulnerability that is a condition of our sociality and the latter, to specific ways that socio-economic and political institutions distribute the conditions of life unequally' (Millar 2017, 4). Our invocation of precariousness parses an entwined sense of heightened conceptual and political risk that arises in the blurred space between scholarship and public engagement with heritage matters. In saying that, we do not draw an equivalence with the sometimes life-threatening risks activists or affected communities have to face in their struggles for social and historic justice. Ours is also not an argument about scholars as activists. Instead, it is about how increasingly this distinction is politicised, the risks that come with that shift, and ways of negotiating them. Heritage scholarship has always been in some way political. But with increasing public challenges of colonial legacies, its public political significance is accentuated. A revised appraisal of difficult heritage provides an opportunity for viewing these contestations as an opening to working with and through difficult heritage in ways that can positively contribute to public heritage engagement and enrich teaching and research at the same time.

Difficult Heritage

The term 'difficult heritage' has been deployed by Sharon Macdonald to refer to 'a past that is recognised as meaningful in the present but that is also contested and awkward for public reconciliation with a positive, self-affirming contemporary identity' (2009: 1). Such a past, she explained, 'may also be troublesome because it threatens to break through into the present in disruptive ways, opening up social divisions, perhaps by playing into imagined, even nightmarish, futures' (ibid.). Such pasts, including those in which one's own shameful history of perpetration was involved, were, she observed, increasingly being put on public display. At least, they were so in some countries, especially Germany.

This displaying of dirty historical washing in public began in the second half of the twentieth century. It did so alongside a growing sense of precarity, bound up with disillusionment with modernity, the nation-state, and industrial-capitalism. Two world wars in less than half a century, deploying ever more lethal techniques of killing, had reached deeply into civilian life, leaving millions dead and maimed. The development and use of the atom bomb made the world's future feel so much more precarious: imminent destruction became a much-feared and real possibility. Furthermore, the Holocaust shook to the core any faith that rationality and progress would eradicate brutality and violence (Baumann 1989). It is in many ways not surprising that attempts to publicly address shameful pasts were especially developed in Germany. As a perpetrator of such a colossal atrocity, which, in the world's first international trials, was made public on a global stage, Germany in some ways had

little choice but to acknowledge its terrible past. This was not done without reluctance and even resistance; and many other countries refused and largely continue to refuse to publicly acknowledge their roles as perpetrators of crime and atrocity (Buruma 1994; Mihai & Thaler 2014). Prompted first by the allies, then intensified by activists (often history students) and artists, and increasingly becoming accepted in the mainstream, Germany came to commemorate more and more sites of its difficult heritage.

In doing so, it played a part internationally in rethinking and reshaping what could be meant by heritage–expanding it to a more critical rather than largely celebratory and affirmative practice (Neiman 2019). The fact that the National Socialists had themselves engaged in extensive heritage-making was put under the spotlight, raising uncomfortable questions about who–including which academic disciplines–had contributed to this and how. New forms of pedagogy were developed to work out how best to deploy history, memory, and the built relics of National Socialism and the Holocaust in service of protecting the future–under the motto *Nie wieder!* Never again! A new term, *Mahnmal*, was coined to refer to a specific kind of monument (*Denkmal*–the root here is *denken*, to think) that could act as a warning (*mahnen* = to warn) to the future. And innovative, often artistic, forms of memorialising, including *Gegendenkmäler* (counter monuments) were created (Tomberger 2017; Young 1994). Developed alongside and as part of this more critical heritage practice was the idea that bringing such pasts out into the open could have value in itself–that it could contribute to public education and debate, promoting reflexivity about contemporary society. Addressing difficult heritage thus became more accepted and even respected internationally, indeed, coming to act as a sign of honesty and moral trustworthiness (Macdonald 2016). Perhaps inevitably, this opened the door to it being deployed cynically, with it also, sometimes simultaneously, being subject to attempts to sanitise or contain it (ibid.). Nevertheless, difficult heritage constitutes a significant form of heritage that has continued to expand as more and more histories of wrongdoing and atrocity are brought into the public realm, and with them, a continuing potential to highlight not just histories of inequity and violence but their continuations into the present.

Researching Difficult Heritage

There remains a considerable amount of difficult heritage to research, as well as questions about the challenges that different histories pose. Critical scrutiny of the academy itself, especially as part of decolonization initiatives, has put the question of academic or intellectual heritage itself firmly under the spotlight. This is particularly so for our own disciplines of anthropology and religious and cultural studies, though none can go unexamined. This is not entirely new, of course. In Germany, in the aftermath of World War II, disciplines including archaeology and *Volkskunde* (folklore) were identified as having played key roles in helping establish Nazi racist ideologies (Arnold 2008; Heilfurth & Templer 1968). The university department at

the Humboldt-Universität zu Berlin, in which we have been working, is one that has links with a precursor called *Volkskunde* (Imeri et al. 2010; IfEE 2020). In its new founding after German Reunification in 1990, however, it was named the Institute of European Ethnology (*Institut für Europäische Ethnologie*) in order to avoid what was seen as a discredited disciplinary designation. Many other former institutes or Chairs of *Volkskunde* did likewise. Some, however, kept this name, as did the organization to which many colleagues in departments not just of *Volkskunde* but also of European Ethnology and associated subjects belong, namely, the *Deutsche Gesellschaft für Volkskunde* (German Association of Folklore). Others adopted different appellations, one of which was Empirical Cultural Studies (*Empirische Kulturwissenschaft*).

Following longstanding criticism, in September 2021, the *Deutsche Gesellschaft für Volkskunde* voted to change its name–to the *Deutsche Gesellschaft für Empirische Kulturwissenschaft* (literally, the German Society for Empirical Cultural Studies, though the Society's journal gives the English name of *Journal for Cultural Analysis and European Ethnology*) (d-g-v.de 2020). The change was predated by a similarly named organization, the *Deutsche Gesellschaft für Völkerkunde,* changing its name in 2017–to the *Deutsche Gesellschaft für Sozial- und Kulturanthropologie* (the German Association for Social- and Cultural Anthropology) (Dilger et al. 2017). *Völkerkunde* is often translated as 'ethnology,' with the word *Ethnologie* sometimes being used interchangeably, and might be roughly glossed as the study of peoples. *Ethnologie* was also considered but ultimately rejected, for the renaming. The classical division of labour between *Völkerkunde/Ethnologie* and *Volkskunde/ Europäische Ethnologie* is that while the latter focuses on the peoples of Europe, *Völkerkunde,* and *Ethnologie* traditionally looked elsewhere. Despite the fact that these names and the divisions they inscribe have long been discussed as problematic by scholars, they have continued to be widely used. The dropping of the term *Völkerkunde,* and the rejection of *Ethnolgie,* were made alongside, and as part of, wider public attention to Germany's colonial history, a development in which activist and media attention to ethnographic museums (usually called *ethnologische Museen* or *Museen für Völkerkunde*) and the cultural heritage–increasingly subject to calls for a return to countries of origin–that these hold, played a significant role.

Such scrutiny of disciplines and their heritage is also part of closer entanglements and more intensive engagements between the academy and the wider public sphere, and greater public awareness of contentious heritage. This is reflected not just in wider attention to disciplinary histories and legacies but also in researchers getting involved in heritage-making in various ways (Macdonald 2022). None of this is unprecedented and it is certainly not restricted to Germany. Indeed, what is happening in Germany gains further traction from parallel developments elsewhere, and it simultaneously feeds into these. In its extent, however, this feels like a distinctive development in which previous borders between heritage activity inside and outside academia have become even more permeable. An increasing blurring of lines between research and political engagement, between academia and activism,

leads to new challenges for how to work, including with–and for–whom. In the midst of sometimes very differently positioned and vocal actors–and in fast-changing and complicated political contexts–researching heritage can even feel precarious in distinctive ways, as we try to negotiate routes into and through it. Certainly, this has been our experience of conducting heritage research in Berlin in recent years. Along with other colleagues in CARMAH, and especially its *Making Differences* project, we have attempted to not just chart the heritage debates and developments underway but also to act within them. That is, we have tried practically, as well as through *post hoc* reflection and writing, to make a difference (CARMAH 2020; Macdonald 2023). We now turn to one especially close-to-home example of this, also involving other colleagues in the Institute of European Ethnology– the difficult heritage at our door.

A Neighbourhood Initiative

The M_Straße underground station was one of the first sites to be defaced in the June 2020 BLM protests in Berlin. Splashed with red paint, the eponymously named underground station name was 'replaced' with that of George Floyd's. Street signs in the surrounding area were also daubed in red paint. The word *Mohr* translates to the English word Moor, and is referred to by the German official dictionary Duden as *veraltet, heute discriminierend*, or anachronistic and discriminatory. The history of the street name's designation is fiercely contested. Officially designated in 1707, the name's origins have been variously linked to the coerced or welcomed presence of black Africans in Berlin in the eighteenth century, as well as to the royal urban history of Berlin and the German slave trade (see van der Heyden 2008; Jacobs and Sprute 2019). While the debate was longstanding, in June 2020 media attention and pressure on city authorities ramped up. Media articles appeared for and against the M_Straße's renaming, with activists, scholars, and politicians waging a battle of arguments in Berlin's leading print publications. In August 2020, the city's transport authority also made the surprise announcement that it would officially change the underground station name to Glinka Straße, to huge praise and criticism, but then quickly back-tracked when Glinka's anti-Semitic past was pointed out by the press.

Public activist debate over the M_Straße can be traced back to exclusions and othering that occurred immediately after German reunification. Activists representing Germans with an African background or with an African migrant background vocally raised concerns about racist and colonial commemorations in Berlin. They drew attention to street signs, such as those in the so-called African Quarter (*Africanisches Viertel*), which honoured figures involved in the colonial enterprise. The M_Straße fits within this critique as a name that had historic links to early German involvement in the slave trade. As Afro-Germans pointed out, further, they experienced the name as patently racist. The street name was problematic they argued, because of its ties to the slave trade, everyday racism as a colonial legacy and

its unproblematic official legitimation through the use of public signage. They argued that it should be renamed, instead, after the esteemed eighteenth century philosopher Anton Wilhelm Amo. A scholar of Ghanaian descent, Amo graduated with a degree in Law from the University of Halle, with a thesis titled *The Rights of Moors in Europe*. Later he was awarded the degree of Doctor of Philosophy from the University of Wittenberg. He ascended to the rank of Professor at the University of Halle, but departed for Ghana later in life and subsequently died in relative obscurity (see Lochner 1958, Abraham 1964; Sephocle 1992). By advocating for this new name, activists hoped to stake a public claim for recognition, not only of Amo as an intellectual figure, but also to a black German intellectual tradition in the city.

It was in this atmosphere of heated public debate, in the summer of 2020, that the IfEE issued a public statement, titled, 'No Racism at Our House Door' signed on behalf of the then-director of the Institute, Regina Römhild. It declared support for activist calls for renaming M_Straße to Anton Wilhelm Amo Street (*Straße),* and announced the intention to work collaboratively with neighbours and other groups to establish a place of memory and learning. IfEE was not only taking a position on the issue of the street name, but was doing so in a public and active way as an initiator of neighbourly action. Established in 1994, the IfEE settled at M_Straße 40/1 in 2004. The IfEE gave particular attention to cultural difference and dynamics in European society. Much of its research orientation was towards culture in the everyday urban setting of Berlin, and branched into research topics around gender, race and migration, heritage, and memory, which often had a topical, current, public dimension. It was precisely the entanglements between history and the present, scholarship, and society, that the IfEE referenced as a starting point for its public statement in June 2020. As the opening sentences of the announcement put it 'Many colleagues and students at our institute are very unhappy that our street is still called M_Straße–although this name degrades Black people from today's point of view and although activists have been protesting against it for decades. For us, as European ethnologists, this address carries a special irony due to the history of the discipline and our current scientific self-image.' The notice was published and attracted over 100 signatures from scholars and interested parties across the world. Organisations and institutions on the street also came forward in support of the initiative. In establishing a coalition of interested parties and especially neighbours who could raise their voices and engage with the street name, IfEE, therefore, mobilised a broad alliance of local participants in a process of civic engagement around a heritage dispute.

It was the first time in recent memory that the IfEE or any anthropology department in Berlin had officially spoken out publicly as an institution and neighbour about this street name. Up until that point, the public debate waged in the press was largely between neighbour associations and residents, amateur and university employed historians, and activist NGOs. That is despite there being a significant, long-stirring on-going internal discussion and engagement with

emplacement on M_Straße. Besides staff debate and discussion, students frequently raised the issue of the street name as a matter of concern. Protest banners were periodically hung at the IfEE building entrance to this effect. The issue of the street name was integrated into teaching, with students enlisted to participate in re-searching the history of the name and the issues of race, difference, and culture it raised. One such teaching initiative resulted in the production of a statement and information board, which were mounted at the entrance to the building. It was complemented by an exhibition that provided a brief history of the area, the Aryanisation of the building during Nazi times, and an account of the German history of the figure of the Moor. These initiatives, then, show a long, on-going engagement in and through teaching in the IfEE with the difficult business of the problematic street name, engagement that would continue through and after the new support for renaming.

While the Neighbourhood Initiative was timed to segue with the BLM protests, the discussion within the institute was not spontaneous. This conversation had been initiated in 2019. Open, internal dialogue about IfEE's position on the street name being held among staff. These inputs were used to build consensus, which the then director, Regina Römhild, used to initiate discussions with neighbours and other interested stakeholders. The summer events of 2020 were therefore opportune for going public with an initiative that had been building up for some time. A short publicity campaign was begun, through which colleagues actively entered the public debate. The director Regina Römhild and Silvy Chakkalakal, another member of the academic staff, gave interviews to the German press, about the issue, broadcasting information about the statement, explaining where we were coming from, and adding anthropological nuance to the public debate (Nitzsche 2020; Thewalt 2020). Duane Jethro also engaged with the press and spoke about heritage dynamics in South Africa as a point of comparison for the debates occurring in Berlin (Kopp 2020; Tagespiegel 2020). The publicity campaign was a site of risk-taking, of staking opinions on matters of research, but also of public anthropology and education. While facing potential public criticism for being political as scien-tists, participation in the campaign was inspired by a genuine concern for adding anthropological nuance to a debate in which we were very much entangled. It was also about broadcasting anthropological perspectives on commemorative culture that arose out of our experience, teaching, and research, and which attempted to move the debate beyond narrow polarising positions. Taking the present as our point of departure for thinking about how heritage was culturally constructed and contested, we wanted to provide a different set of perspectives that could move beyond the tropes of history as closed, heritage as unchanging, and notions of erasure that had framed the debate up until that point.

In a further attempt to directly engage the street, press, and the public, a walking press conference was planned as a rallying event on Friday, August 20, 2020, under the title *Dekoloniale Flaneur*. Framed as a decolonial walk, the intention was to publicise the problem of the street name, further affirm and build local solidarity and

draw attention to the historic significance of Anton Wilhelm Amo. The *Dekoloniale Flaneur* was planned as a multi-sited, multicultural engagement with the history of the street. On a warm Friday evening, about 100 people, comprised of staff, students, neighbours, and members of the press, gathered and walked along the length of M_Straße. Stations of input and reflection were plotted along the length of the street from the U-Bahn station M_Straße to the front door of the IfEE, where the group stopped and took in inputs, speeches, and greetings from neighbours, staff, students, activists, and cultural organisations on and beyond the street. Near the end of the walk, a performance of poetry was read out near the Federal Ministry of Justice, also located on the M_Straße. Organised by a core group of members, including staff and graduate students, the Dekolonial Walk was, therefore, a bold way of going public as a mode of engaging public anthropology and the commitments made in the initial statement. It was also about walking the public through a street which they may have been familiar with through news reports but which they had perhaps never fully experienced. It was a way of showing what was at stake. What had made the event especially celebratory was the surprise overnight news that, following the sustained pressure and lobbying in recent weeks, the district council had voted to officially rename the street Anton-Wilhelm-Amo-Straße.[1]

The celebrations of the renaming continued over the weekend and more opportunity arose for publicity. On Sunday the 23rd of August, Berlin activist NGOs staged their annual Street Renaming Festival, only this time referring to it as Amo-Fest after Anton Wilhelm Amo. It was a festival of counter-narratives against the M_Straße Street name, that had been held for almost a decade before already. It was always timed to coincide with the annual day of the emancipation of slavery. Amo-Fest 2020 was held around the corner from the IfEE itself, with the stage setup at the Hausvogtei Platz, within view of the Federal Ministry of Justice. The IfEE director Regina Römhild and Duane Jethro provided inputs about the Neighbourhood Initiative and how the IfEE, as one player among many, was contributing to change. Here we participated as public actors, bringing scholarship to a public stage, and linked in with a tradition, indeed an existing heritage, of activist public engagement in the form of the Amo-Fest. The *Dekolonial Flaneur* can be seen as linked to, but also needs to be distinguished from, this existing activist tradition of walking engagement with traces of the colonial past in Berlin's streets. The walking press conference as decolonial engagement is a demonstration of the ways in which existing blurred distinctions between scholarship and public engagement could, in some ways, be stepped into and walked out. Difficult heritage, it seems, demands ever more such forms of engagement that make public the muted, obviously political nature of heritage work.

Conclusion

The renaming is to be celebrated. Yet the legacy of the name and the undercurrents of race, difference, and heritage are still very present and unresolved. The engaged

scholarly work continues at the Institute. The *Dekoloniale Flaneur* was observed again in 2021 and in 2022, and the planning of an Amo Salon in the building foyer continues and networking with neighbours in the street is on-going. This work was not without its risks. Colleagues who openly engaged with the media about their positions on the street name were especially exposed: in one case a member of the public took the time to single out a colleague for hate mail. Taking positions comes with the precarity of being misinterpreted and being reduced to slogans that can stir strong and hurtful responses from members of the public. The value of engaged scholarly work as a mutually enriching project of trafficking insights from the field into the classroom and writing, can get then lost in the public game of negotiating narrow, seemingly opposing positions of patriotism and protest.

As we have tried to stress, the turn to difficult heritage in the twenty-first century was indelibly bound up with a sense of precarity in which older certainties were destabilised. Heritage itself was rethought as a form and practice engaging a much greater range of people and pasts, including pasts that some would much prefer to be forgotten. While the continued and continuing expansion of heritagization of disturbing pasts can be seen in part as a normalising of difficult heritage (Macdonald 2016), it surely also indexes continuing and even growing senses of living in precarious times. More and more histories of suffering, inequity, and violence–including on our doorsteps and within the academy itself–have been and are being revealed and made visible, as heritage.

Which–and whose–pasts come to the fore at particular times, what specific difficulties they pose, and for whom, vary widely. Each is a node within a particular mix of local, national, and transnational actors and actions. Further exploring these specificities, as well as why some difficult pasts gain hold and others do not, remains a task for future work on difficult heritage. There is little doubt that there will be many more cases to come, as well as further layers of information and complexity added to those already in the public domain. All of these will demand not just rethinking of the specific detail of each case but also of what kinds of difficulties–and what kind of heritage–is involved. Moreover, they will provoke further questions about how, as researchers and members of the public, to engage with heritage and heritage-making. Just as those earlier precarious times brought difficult heritage onto the agenda, the intensive and fluid engagements of our current precarious times create new difficulties and require further rethinking in order to address these. By doing so, we contribute to a wider rethinking of heritage–and of heritage-making–for the present and indeed the future.

Crucially, the academy itself has come under closer scrutiny. Decolonization initiatives have, for example, drawn academic and intellectual heritage itself into the spotlight as a political rather than purely intellectual or scholarly matter. Intense reevaluation of disciplines and their heritage is also part of closer entanglements and more intensive engagements between the academy and the wider public sphere, and greater public awareness of contentious heritage. It is therefore also due, in part, we have tried to emphasise, to researchers being engaged in heritage-making in various

ways through the course of their research. These trends in disciplinary reappraisal and even renaming have also occurred in our own academic disciplines of anthropology and religious and cultural studies.

These dynamics are certainly not new. During the twentieth century, in places such as the US and South Africa, where access to higher education was based on race, universities became sites of political action. During the Rhodes Must Fall protest movement in 2015 and Fees Must Fall in 2016 in South Africa, scholars were also drawn into a crisis of race and access to higher education and required to take public positions. The university's sovereign status as a place of objective knowledge and learning was questioned, while academic standing was, significantly, not called into disrepute. In the rebuilding of the academy in Germany following, first, World War II and the Holocaust, and then the German Democratic Republic, many academic reputations fell and the universities were significantly unsettled, leaving nevertheless a strong legacy of commitment to rigorous and often reflexively ethical scholarly practice. The recent examples of difficult heritage we discuss above, then, are not without precursors.

For us, however, the debate about the street on which we work or have worked brought these issues home in a substantive way. Insofar as the activist initiative to rename M_Straße has been officially approved, and scholars were not significantly threatened, it seems a relatively low-stakes example. But risks vary depending on the context. Yet across contexts where heritage themes are being researched scholars are increasingly having to find ways of navigating questions of being implicated. Taking situatedness seriously, engaged scholars in our Institute contributed to the amplification of an existing call for change, and they were aware of crossing certain conventional boundaries. Organising a walking press conference, and initiating neighbourly action for change are just some site-specific approaches to addressing the difficult heritage at our door. It is work that is imperfect, unfinished and on-going.

Universities across the world face heritage dilemmas of their own. In their own particular context, instances of institutional difficult heritage raise social, political, and scholarly issues that require careful negotiation. Anthropological heritage research and critical heritage studies more widely bring approaches to difficult heritages that can contribute not only intellectually but also practically and positively to these public debates. Such engagement can also feed back into research, teaching anthropology, and the very doing of heritage. The difficult heritage at our door can, therefore, be seen as a threshold, a precarious cross-over point, that brings with it uncertainty, but also possibilities for revitalisation, renewal, and resilience in the future.

Note

1 As of April 2021, according to official communication from the Mitte district municipal office, the renaming was scheduled to take place in October 2021, but the process has been stalled due to lawsuits initiated to contest the renaming process. Email communication, 27 April 2022.

References

Abraham, William. 1964. 'The life and times of Anton Wilhelm Amo'. *Transactions of the Historical Society of Ghana* 7: 60–81.

Arnold, Bettina. 2008. 'The past as propaganda. Totalitarian archaeology in Nazi Germany'. In Tim Murray & Christopher Evans (eds) *Histories of archaeology. A reader in the history of archaeology*, pp.120–144. Oxford: Oxford University Press.

Baumann, Zygmunt. 1989. *Modernity and the holocaust*. Ithaca, NY: Cornell University Press.

Buruma, Ian. 1994. *The wages of guilt: memories of war in Germany and in Japan*. New York: Farar, Straus & Giroux.

CARMAH. 2020. 'Making differences: transforming museums and heritage in the 21st Century'. Accessed at https://www.carmah.berlin/making-differences-in-berlin/, 1 June 2021.

Dilger, Hansjörg, Birgitt Rössler-Rössler & Olaf Zenker 2017 'Umbennenung der deutschen Gesellschaft für Völkerkunde e-V. in die deutsche Gesellschaft für Sozial- und Kulturanthropologie e-V. am 6.10.2017 in Berlin'. *Zeitschrift für Ethnologie*, 142 (1): 133–140.

Doward, Jamie. 2020. 'I've been unfairly targeted, says academic at heart of national trust "woke row"'. The Guardian Online, 20 December. Accessed at https://www.theguardian.com/uk-news/2020/dec/20/ive-been-unfairly-targeted-says-academic-at-heart-of-national-trust-woke-row, 1 May 2022.

Deutsche Welle. 2021. 'Looted boat to be shown at Berlin's Humboldt forum'. Accessed at, https://www.dw.com/en/looted-boat-to-be-shown-at-berlins-humboldt-forum/a-57506803, 1 June 2021.

d-g-v.de. 2020. 'Aufruf?Umbenennung'. Accessed at https://www.d-g-v.de/wp-content/uploads/2020/08/Aufruf_Umbenennung.pdf, 1 June 2021.

Fazackerley, Anne. 2021. '"I had death threats to my life": how mob attacks on social media are silencing UK teachers'. *The Guardian Online*, 26 June. Accessed at https://www.theguardian.com/education/2021/jun/26/i-had-threats-to-my-life-how-mob-attacks-on-social-media-are-silencing-uk-teachers, 1 May 2022.

Gopal, Priyamvada. 2021. 'Why can't Britain handle the truth about Winston Churchill?' *The Guardian online*, 17 March, accessed at https://www.theguardian.com/commentisfree/2021/mar/17/why-cant-britain-handle-the-truth-about-winston-churchill, 29 April 2022.

Greenberger, Allan. 'Berlin Museum wont show Benin bronzes, begins to pursue return of artefacts'. Accessed at https://www.artnews.com/art-news/news/humboldt-forum-benin-bronzes-return-process-1234587480/, 1 June 2021.

Heilfurth, Gerhard & William Templer. 1968. 'The Deutsche gesellschaft für Volkskunde: its history, significance and objectives'. *Journal of the Folklore Institute*, 5 (2/3): 241–248.

Hilden, Irene, Harriet Merrow & Andrei Zavadski. 2021. 'Present imperfect: the digital opening of the Humboldt Forum'. Accessed at https://boasblogs.org/de/dcntr/present-imperfect-future-intense/, 29 April 2022.

Imeri, Sabine, Wolfgang Kaschuba, Michi Knecht, Franka Schneider & Leonore Scholze-Irrlitz. 2010. 'Volks- und Völkerkunde an der Berliner Universität bis 1945'. In Heinz-Elmar Tenorth (ed.) *Band 5. Geschichte der Universität Unter den Linden 1810–2010*, pp. 303–319. Berlin: DeGruyter.

IfEE. 2020. https://www.euroethno.hu-berlin.de/de/institut/ueber/standort-geschichte

Jacobs, Christian & Paul Sprute. 2019. 'Placing German colonialism in the city: Berlin Postkolonial's tour in the African quarter'. *Global Histories: A Student Journal* 5 (2): 110–117.

Jethro, Duane. 2021. 'Eine verpasste Chance Ein enttäuschter Blick aus Südafrika auf die digitale Eröffnung des Humboldt Forums'. *Südlink* (March): 35–36.

Kopp, Christian. 2020. 'Bedeutung von Worten ändert sich'. Taz Online, accessed at https://taz.de/Strassenumbenennung-in-Berlin-Mitte/!171320, Accessed 1 June 2021.

Lochner, Norbert. 1958. 'Anton Wilhelm Amo: A Ghana scholar in eighteenth century Germany'. *Transactions of the Historical Society of Ghana* 3 (3): 169–179.

Macdonald, Sharon. 2009. *Difficult Heritage. Negotiating the Nazi past in Nuremberg and beyond.* London: Routledge.

Macdonald, Sharon. 2016. 'Is difficult heritage still difficult? Why public acknowledgement of past perpetration may no longer be so unsettling to collective identities'. *Museum International* 67 (1–4): 6–22.

Macdonald, Sharon, (ed.). 2022. *Doing Diversity in Museums and Heritage. A Berlin Ethnography.* Bielefeld: Transcript.

Macdonald, Sharon. 2023. 'Perspectivity and anthropological engagements in heritage-making. Challenges from the Humboldt Forum, Berlin'. In Emma Gilberthorpe and Fedinand de Jong (eds) *Anthropological Perspectives on Global Challenges.* London: Routledge.

Mihai, Mihaela & Mathias Thaler, (eds). 2014. *On the uses and abuses of political apologies.* Houndmills: Macmillan.

Millar, Kathleen M. 2017. 'Toward a critical politics of precarity'. *Sociology Compass* 11 (6): e12483.

Neiman, Susan. 2019. *Learning from the Germans. Race and the memory of evil.* New York: Farrar, Straus & Giroux.

'Netzwerk Wissenschaftsfreiheit'. Accessed at https://www.netzwerk-wissenschaftsfreiheit. de/en/home-2/, 1 June 2021.

Nitzsche, Boris. 2020. 'Der Kampf um Straßennamen ist ein Zeichen von lebendiger Geschichte'. Accessed at https://www.hu-berlin.de/de/pr/diversitaet/der-kampf-um-strassennamen-ist-ein-zeichen-von-lebendiger-geschichte, 1 June 2021.

Rothberg, Michael. 2020. 'Spectres of comparison: on the Mbembe Affair'. Accessed at https://www.goethe.de/prj/zei/en/pos/21864662.html, 1 June 2021.

Rutherford, Alexandra. Winter 2021. 'Going public: Mobilizing, materializing, and contesting social science history'. *Journal of the History of the Behavioral Sciences* 57: 5–11.

Satia, Priya. 2022. 'Britain's culture war: Disguising imperial politics as historical debate about empire'. *Journal of Genocide Research* 24 (2): 308–320, DOI: 10.1080/14623528. 2021.1968137

Sephocle, Marilyn. 1992. 'Anton Wilhelm Amo'. *Journal of Black Studies* 23 (2): 182–187.

Tagespiegel. 2020. 'Der Anthropologe Duane Jethro erklärt im Interview, warum sich Vertreter der Humboldt-Uni'. Accessed at, https://www.tagesspiegel.de/berlin/umbenennung-der-mohrenstrasse-man-muesste-an-jedem-strassenschild-eine-informationstafel-anbringen/26072280.html

Tomberger, Corinna. 2017. *Das Gegendenkmal. Avantgardekunst, Geschichtspolitik und Geschlecht in der bundesdeutschen Erinnerungskultur.* Bielefeld: transcript.

Thewalt, Anna. 2020. 'Aktivisten feiern Umbenennung der Mohrenstraße'. Accessed at https://www.rbb24.de/politik/beitrag/2020/08/protest-berlin-lustgarten-mohrenstrasse-decolonize.html, 1 June 2021.

van der Heyden, Ulrich. 2008. *Auf Afrikas Spuren in Berlin: Die Mohrenstraße und andere koloniale Erblasten.* Berlin: Tenea.

Von Bose, Friedrich. 2013. 'The making of Berlin's Humboldt-forum: negotiating history and the cultural politics of place'. *Darkmatter Journal,* 11 November 2013. Accessed at https://s3.amazonaws.com/arena-attachments/480616/015783aec7fd1429edce1a72a7821030.pdf, 1 June 2021.

von Bose, Friedrich. 2016. *Das Humboldt-forum: Eine ethnographie seiner plannung.* Berlin: Kulturverlag Kadmos.

Young, James. 1994. *The texture of memory: Holocaust memorials and meaning.* New Haven: Yale University Press.

SECTION VI

Coloniality, Peace Building, and Social Justice

Cristóbal Gnecco's beautiful, meditative chapter–styled as 'entries in an apocryphal diary'–turns around the open wound of coloniality. He writes: 'The history of coloniality is not a mere anecdote simply garnished with grandiose symbols that claim to last forever; it is a living monster that still carries with it the horrors of racism, segregation and unequal access to the many assets to which we are all entitled.' Drawing inspiration from the work of Walter Benjamin and the Critical Theory school, he offers a series of observations and vignettes: an account of the removal of a statue of Sebastián de Belalcázar in Popayán, the southern Colombian city in which he lives; an account of a current project on the transnational Inca Road (Qhapaq Ñan) system; and the books he is currently reading. Written against the backdrop of events in contemporary Colombia, Gnecco's chapter is both a sweeping indictment of the effects of patrimonialization ('heritagization'), and a call to action. His intertextual method mixes passages of text, memories, and descriptions of daily routines within the framework of a set of diary entries 'in the time of Covid.' His core argument is that the virus–a 'tiny invisible monster'–conceals a greater catastrophe, the ongoing violence of the *pachacuti*–the world-ending violence unleashed by the Spanish conquistadors–a violence whose effects recapitulate through time.

In an important, collectively authored chapter Cressida Fforde, Steve Hemming, Merata Kawharu, Lia Kent, Laura Mayer, Daryle Rigney, Laurajane Smith, and Paul Tapsell explore the relationship between heritage and peace building in settler colonial states. They begin by noting: 'The problem of how to achieve a reconciled nation (or many nations) is ever present in debate and analysis of political and cross-cultural relations in settler-colonial nation states.' They point out the relative lack of attention given to 'the contribution heritage brings to peace building,' and they note that in settler colonies the continuity and severity of colonialism tends to be

DOI: 10.4324/9781003188438-18

dismissed. At the heart of their chapter is an account of the often disjunctive relationship between Western and Indigenous conceptions and practices of heritage, in a context in which Western conceptions of heritage have historically acted as an extension of settler-colonial power. In the first of two conceptually and politically incisive interventions in the chapter, Paul Tapsell and Merata Kawharu reflect on the ritualized role of taonga in establishing, maintaining, and changing cross-cultural relations between authorities and communities in Aotearoa New Zealand. In the second, Steve Hemming and Daryle Rigney describe how Ngarrindjeri knowledge about and relationships towards their traditional lands and waters, and vision statements like the Ngarrindjeri Vision for Country, can act as 'an antidote to destructive and invasive heritage assessments, "site" recordings, archaeological discourse, binary logics and stories of extinction.' The chapter concludes with a thoughtful and critical discussion of New Materialist and Posthuman conceptions of heritage. As an exercise in multivocality and competing conceptions of heritage, the chapter itself becomes a performative instance of peace building through shared authorship.

12
ENTRIES IN AN APOCRYPHAL DIARY
Heritage, Crisis, Turbulent Times

Cristóbal Gnecco

Between 2020 and 2021, founding events happened rapidly in Colombia: social protest exploded in the streets, political consciousness as transformation acquired the prominence it never had, and the symbolic horizon of history as future was the target of unusual attention. This is an apocryphal diary that someone–sometimes I think me–wrote in the retrospective moment, in the lived moment. It deals with what someone thought, felt, acted, read. It deals, ultimately, with his place in the plot of the whirlwind of events of those two revealing years.

September 15, 2020

The Misak people took action against a living symbol of colonial violence. Today they took down the statue of Sebastián de Belalcázar in Popayán, the southern Colombian city where I live and from where I write, which had been installed atop a pre-Hispanic pyramid in 1940 to commemorate the 400th anniversary of its founding. The decision to install the statue of a Spanish conquistador on a pre-Hispanic pyramid was a deliberate act of affirmation of the Hispanic, Catholic, and white legacy–of a single story told by the victors that, as it often happens, silenced the history of the defeated. That decision occurred when feudal relations still dominated in the region, but times have changed. There is no longer a single history, a single heritage, a single collective project. Heritage has been shown not to be something natural, timeless, or stable. The history of coloniality is not a mere anecdote simply garnished with grandiose symbols that claim to last forever; it is a living monster that still carries with it the horrors of racism, segregation, and unequal access to the many assets to which we are all entitled. Taking down the statue brings to the fore what happened centuries ago and is still happening today;

DOI: 10.4324/9781003188438-19

it calls into question what we are as a society, and what we have done–or have not done–to heal wounds that are still bleeding.

September 18, 2020

I feel unease at the fall of Belalcázar, not because I disagree with what the Misak has done–quite the contrary, I find their action bold and worthy of admiration–but because I had felt the same anger towards what the statue represented, even knowing the events surrounding its infamous installation in the Morro de Tulcán, yet I did nothing against it. I just cursed and passed by. The Misak shows the way to the cowards. Not that I was taken aback by what happened; it is simply that it should have occurred long before.

October 10, 2020

During the past days, I have been thinking about Latin America. Most of the nation-states created around here shared four characteristics: their founding literatures is the epic, a narrative of utter violence and destruction of the others; they were master-minded by liminary elites who did not consider themselves either Europeans or Indians, but who had it clear that their rights were those of the former; their liminarity was resolved by crafting an ontological place, *mestizaje*, a eugenic tool for partici-pating, and winning, the racial war they unleashed; and the resulting national societies excluded Indigenous and afro-descendent societies right from the start, considering them to be 'problems' to be dealt with. Such a hideous legacy is still with us, sup-ported and nourished constantly by racism, the most enduring of all stories ever enacted in the region. Yet, the racial war was not settled back then. It still goes on and is being fought at great cost. Heritage is but one of the places where it unfolds.

October 11, 2020

Years ago, I visited the island of Providencia, a Colombian possession not far from the Atlantic coast of Nicaragua. The local inhabitants are descended from enslaved people brought from Jamaica to grow coconuts and cotton and speak a variant of Creole English. Their memories are tied to the Caribbean, to slavery, to Africa. Yet, in the central square of Santa Isabel, the little village that serves as the island's main hub, there is a statue of Francisco de Paula Santander, a Colombian politician and lawyer who fought the war of Independence from Spain. Santander, a white fellow from a country located more than 1,000 kilometers away and who happens to 'own' the island by a mere historical accident, means nothing to the locals. But national histories are bizarre, stupid, and violent. They posit what to remember and what to forget. Do they succeed? It depends on how you see it. The people from Providencia have not forgotten where they come from (historically) and who they are. Santander's lonesome statue is a reminder of the incongruences of national histories and of the horrors they conceal.

October 28, 2020

I am thrilled in writing up my research on the heritage meanings accorded to the Qhapaq Ñan, the extensive pre-Hispanic road system in South America declared world heritage seven years ago. When I finish the book, if I ever finish it, I will call it *The Ruin of the Qhapaq Ñan* because the road is sold to tourists as a ruin testifying to the grandiosity of times past, but also because the heritage process is the ruin of the Qhapaq Ñan–as a metonymic effect, of course, because the ruin is that of the people who suffer the effects of the heritage action–. But this pun is nothing to laugh about. There is much at stake because the patrimonialization of the road is violent. The politics of naming, of which it partakes, is imbricated in the politics of accumulation. Naming places as heritage is caught up in the (re)production of broader processes of fetishization that seek to obliterate modern relationships of dispossession. In Pomata, in the southern shore of Titicaca Lake, a few steps from the border with Bolivia, I asked about the Inca road. No one knew anything. I asked about the Qhapaq Ñan. Much less. I went to the police station. They had no idea. I went to the municipality, where the man responsible for the institutional image told me that he had heard about the matter but that he did not know anything precise. Then he remembered that another official might know better. He called him. He knew better. The Inca road, the portentous Qhapaq Ñan of UNESCO, to which he took me, is a few blocks from where we stood. It is the modest trail that links Pomata with Sisipampa, on the other side of the hill, perhaps from times so old that they are no longer remembered. It is the trail used by the locals to go from one place to another. The trail, simply. Nothing about the Incas or the Qhapaq Ñan–a nothing that exposes the hierarchy of naming. The State, with its monopoly on violence and on definitions of legality, plays a crucial role in supporting and promoting these processes of dispossession.

October 29, 2020

The story that goes from the uprising of Manco Inca and Tupac Amaru to the Taki Unquy, from José Miguel Condorcanqui to Juan Santos Atahualpa, is the story of the struggle for the restitution of the world as it was until the *pachacuti* unleashed by the Spaniards began. Chronicler Martín de Murúa (2001, 211) translated *pachacuti* as 'to turn around the land' (meaning transforming it) and 'to take away and to disinherit,' the inversion of order. The patrimonialization of the Qhapaq Ñan, with its violent accumulation by dispossession, is a continuation of the *pachacuti* by other means.

October 30, 2020

Heritage does not just name; it also creates trademarks, of which it makes exclusive use. The brand, the logo, the image, is a characteristic of the nation-state. The overarching presence of the logo in heritage matters is achieved through a desacralization of sites of memory, expressed in photos, posters, stamps, luxury books,

what have you. The conversion into a logo operates at a comprehensive level that is not limited to the production of goods for tourist consumption. Its effect is more profound. The strength of heritage is not its mere existence somewhere, but its presence as an emblem and as a logo everywhere. Its strength lies in its generalized reproducibility.

October 31, 2020

A while ago, I went with my friends Carina Jofré and Mauricio Lucero to the north of San Juan province, in Argentina, looking for the stretches of the Qhapaq Ñan that had been included in the nomination as world heritage. We didn't find them, maybe because they are not there or because their traces are so meager as to be unnoticeable. The road eluded us, went into hiding. But the trip through those beautiful places of the Argentine Republic was worth it. Then we convinced ourselves (we finished convincing ourselves) that heritage is an idea, not so much something that can be seen or touched or sold. The idea is powerful and causes tremendous movement and activity. So much so that thousands of people in various countries are at its service. What is this idea so mighty, so seductive, so useful? It is the idea that heritage is something good, necessary, of indisputable importance, whose existence is so obvious that it does not require discussion; it is the idea that a life in common is cemented by transcendent things-signs, such as heritage assets, which are beyond us, above us, but which explain us, embrace us, and summarize us. The idea is relevant and productive well beyond itself. Patrimonialization–the conversion into heritage of something that, until then, was not–prepares the ground, and cleanses the image, for the concrete appearance of the ontology of modernity, that which speaks of the inevitability of development; of the separate character of nature of culture; of nature as a differentiated place where there are resources to exploit; of the centrality of *Homo* in its known variants, but above all that which defines it as an economic animal. It is a directional and teleological idea, fundamental for the legitimacy of the (curious, imprecise, and incomplete) unifying rhetoric of (post)national states –despite, or perhaps thanks to the fact that its heritage sense is purely national– but, above all, it is an idea that accompanies, when it does not advance, the expansion of that ontological (and economic) frontier.

November 2, 2020

The power of patrimonialization is its ability to neutralize (if not to eliminate) the *real* historical meanings of the goods turned into heritage while at the same time delivering them to consumption as culture in a space emptied of historicity–and I put *real* in italics not for alluding to the modern naturalization of the real but to its meaning prior to the heritage action–. That is why patrimonialization is capable of taking something like the Qhapaq Ñan, which belonged to a world subjected and

trampled by the Spanish conquest, but still feared, and placing it in an aseptic and harmless space which tourists attend with an unprepared and innocent manner as if they were going to a Sunday party. This double operation–to neutralize a certain sense of the political, and to deliver to the cultural market–has been successful worldwide. This emptying of historicity, thus putting the past beyond the political, makes the heritage industry a superb ally of governmentality in the era of multi-cultural neoliberalism and, above all, a fundamental spearhead in the modern ontological crusade. For that reason, if not for others, heritage has acquired a decisive impulse that is gaining more and more momentum–because, moreover, it is invoked from a humanistic rhetoric that has not lost its appeal as an alternative (although it is not) to the excesses of modernity–. The essential humanism of heritage, as it is promoted from transnational spheres and which many countries and their societies adopt without hesitation, circulates through activities that transform a good into a commodity for the market of cultural industries.

November 3, 2020

I invest much time in reading what I write, changing a word here, adding another one there, delving around an idea that extends intertextuality, that enchanted world that has no end and and, presumably, neither beginning. As I go over the slowly growing manuscript–a living creature that I am afraid of ending because it may stop breathing–I notice that the racial story is an all-embracing topic that crosses my text and, needless to say, the 'reality' of all heritage processes. It baffles me to see it everywhere in what I write. Is it an obsession or an effect of the archive? It may be both, for they are related. I am obsessed with the way certain stories cross the times without much change, if any. If I am to explain the pervasiveness of the racial story in my text, I would say that heritage incites a profuse tension between presence (of the visitor), race and segregation/ degradation. The commodification activated by heritage–but also its participation in the advance of the modern ontological frontier–is not restricted to the production of things; it also produces identities, sometimes decidedly other. It is not only heritage that is commodified (it is pro-duced as a thing that circulates to be consumed), but also the social identities that constitute it, surround it, validate it as authentic. Tourists construct their experience (of short and long duration) from selected fragments of others. Given the inequalities in the geographies of wealth, such a selectivity avoids discussing race relations. Not even so-called experiential tourism–or community or cultural or ethnic tourism; the adjective is interchangeable–counteracts the evasions of power and race, because it stages local communities according to Western stereotypes. The local inhabitants impacted by heritage are (re)converted into the other archetype of national times: the primitive, the pre-modern, the savage. The other inhabits an arrested time, a cold time, a time that does not move, but that has to be constantly re-created. For this reason, the *alter* created by heritage is sent to the past with the inestimable help of archaeological narratives that speak of disappearance,

replacement, migration, catastrophe–in short, of times gone by that are also, of course, other times, with all the burden of denial of coevalness that one can imagine–but also times of others, in which case we are already talking about incessant appropriation and dispossession.

December 1, 2020

What can now be expected in terms of heritage, when the nation has been abandoned as an idea-goal only to be replaced by that amorphous thing, a multi-cultural society? If the national 'us' shared a heritage because there was only one to be shared, inherited from/ by the national society and demarcated by the concerted work of the historical disciplines, what kind of heritage does the multicultural 'us' share? Could this be a sort of an umbrella heritage, recognized and accepted as a common asset by everyone, no matter how diverse, and under which more specific, circumscribed, and exclusive heritages thrive? If so, what does a plurality of heritages do to an idea that owed its very existence to its discreteness and exclusivity? Does it explode, enlarge, collapse it? What does heritage mean, now that it seems fuzzier than ever?

December 15, 2020

> For how long now have we not nibbled
> At the immediate past in this fashion, words,
> Regretting our ignoble faculty of failing,
> Slipping between whose fingers?
> Melting between whose lips?
> The disabused ruins of history's many
> Many costumes we discarded.

Why did I just remember this poem by Lawrence Durrell (1982, 68)? I read it many years ago and it lay forgotten in some distant fold of my memory. But it was not that far removed, after all, for when I write this diary invaded by heritage, it suddenly pops up. Writing summons the strangest connections between apparently disparate entities, which flash at the moment of their encounter.

April 28, 2021

Social sectors of various kinds–students, indigenes, peasants, unions–have started a nation-wide strike today. The immediate cause is a tax reform that sought to burden the poor and the middle class while exempting corporations and the wealthiest echelons of society. The stupidity of the reform, in a country whose economy has been hit hard by the measures taken to keep the pandemic at bay, to no avail, has not prevented many from seeing that the causes of the strike are more

profound, structural, and far-reaching: rampant poverty, lack of work opportunities, limited public education, corruption, racism. Things have worsened in the last three years because the government has refused to implement important measures contemplated in the peace accords signed in 2016 between the State and the Armed Revolutionary Forces of Colombia, not even a much-needed agrarian reform. In a country governed by blind, small-minded, and criminal elites even liberal reforms (in land tenure, in history) have the seal of communism.

May 4, 2021

The national strike also targets heritage referents. The statue of Julio Arboleda, a conservative politician and slaver owner of the mid-nineteenth century, has also been knocked down in Popayán. Arboleda had a prominent place near the city center, by the Humilladero bridge, one of the architectural wonders of the old quarter. It always enraged me that a ruthless aristocrat who shipped his slaves to sell them in Peru when he learned that slavery was to be abolished in Colombia had a plaza, a statue, a memory. He should be remembered, yes, but at the forefront of the museum of infamy. His fall is a continuation of the racial war by other means, a war that will not stop as long as racism lingers beside the idea of a single history.

May 9, 2021

The president of Colombia, a mediocre and dangerous right-wing extremist, has used *Fragmentos*, a counter-heritage monument erected in Bogotá by artist Doris Salcedo, for a meeting with catholic priests–with the non-undisclosed aim of enlisting them in the official ranks summoned to curtail the social protests that have greatly intensified. Salcedo's impressive installation is a floor of metal plates made from the melted guns of the guerrillas and hammered by the women victim of sexual abuse during the decades-long war between the State and the FARC. In an interview with the online magazine *Hyperallergic*[1] Salcedo expressed that *Fragmentos* had been 'abusively utilized'; further, a work then in exhibition–*Salam Tristesse Irak 2016–2020*, by Francis Alÿs, which reflects on war, pain, and resilience–was covered with white cloth for the meeting. The silencing of disobedient histories still goes on. In 2019, the newly appointed director of the National Center of Historical Memory stated that there has been neither war nor conflict in Colombia but only the legitimate state repression of criminal gangs. As a result, the international Network of Places of Memory cancelled the membership of the Center because of its utter disregard for the Colombian conflict and its thousands of casualties.

May 27, 2021

After almost of month of strikes, Colombia has exploded. The social protests have been met with furious police violence, causing hundreds of dead, injured, and disappeared.

May 28, 2021

The national strike consumes my attention, my feelings, my sympathy. Yet, I also follow the dramatic news about the current peak of the pandemic. The death toll caused by the virus is one of the highest in the world. The virus has created the sense that suddenly, out of nowhere, an invisible, tiny monster has endangered our lives, our economies, our futures. Yet, the current virus crisis, although it is so disruptive and catastrophic, conceals a deeper, more structural crisis that has been with us for quite a long time and that has been thoroughly naturalized and, thus, made invisible: the crisis brought about by modernity-coloniality, which set in motion a great transformation. Time, society, knowledge, the economy, the state, the individual … all were deeply transformed. The modern individual, for instance, was crafted out of nothing. It did not exist, so it had to be made up from scratch. Free will, autonomy, self-regulation, rights, political participation, were among the characteristics that were made to define the new individual. This great transformation, however, came at a great cost. Take the individual, again. Its creation was enacted at the expense of the sense of community, threatening, when not banishing, basic centuries-old moral values such as solidarity and the common good. The transformation brought about by modernity is structural and never ending. Capitalism, after all, thrives in a world in motion; it despises stillness and lack of movement. The crisis created by modernity-coloniality also defines it. What amazes me is that at the same time, modernity-coloniality bypasses crisis, as if it were an alien circumstance brought about by exterior forces. It expels crisis to its margins and delegates in each field of knowledge the way to deal with it.

May 29, 2021

The virus and the strike with their trail of hope and violence conjoin to forge a sense of crisis; all seems ephemeral, fragile, transient. And we feel anxious, uneasy, sad. Yet, the virus and the strike as a crisis actually end up serving as decoys, diverting analytical attention from where it should be more productively (politically) focused in the long run: modernity (or postmodernity, for that matter) as a structural crisis. But these turbulent times serve something good, after all: they show how the routinization of crisis hides its terrible effects. Heritage impacts the lives of so many people and communities worldwide, assaulting their places of memory and disrupting their social fabric, and yet it is routinely promoted as natural, good, and transcendent. We can profit from this turmoil to unlearn heritage. Indeed, what we need is a global debate about learning to unlearn what we have been taught to learn. We need more history, more scandal. Would it not be an important move to put heritage into the unlearning machine?

June 1, 2021

This morning I readied the trappings for the pleasure of reading: a cup of coffee, yellow highlighters, a pencil, my favorite sofa, Bach, and the book I was about to

read, which had been waiting on the shelf. I knew I had to read it, but the moment had not materialized yet. I had already read it, but eons ago and with other concerns in mind. This reading would thus be new. The book was published so long ago, in 1944, that is not fashionable any longer. But *Dialectic of Enlightenment* (Horkheimer and Adorno 2022) is amazingly insightful, innovative, and bold. When Horkheimer and Adorno defined cultural industries for the first time, their intention was not apologetic, but critical: they wondered what the hell was wrong with the order of capital to make it turn its attention (and its greed) to something as venerable as culture, and they found the answer, like Benjamin, in the technical possibilities of reproduction. If culture was reproducible *en masse* (and for the masses), why not make it a commodity? The masses, as they would later say, are not the measure, but the ideology of cultural industries.

June 2, 2021

It is not surprising that heritage is a cultural industry and that its belonging to that field is what defines it. The past (and time, too, but it is better to call it only 'the past' to pin down heritage parlance) is a target of industrial intervention, which acts from the outside to measure, weigh and sell heritage 'assets.' It also parasitizes the past, which exists in the present as a fixed, detained, timeless essence—and whose existence is guaranteed by being precisely that: past. Its being as a commodity is limited by Horkheimer and Adorno's principle of 'always the same,' which means that its usefulness (not to mention its meaning) is measured by its ability for incessant reproduction in the market. The indiscriminate shuffling between the past and culture (as an industry) defines, freezes, and specifies the contours of heritage that, moreover, does not catch anyone's attention because of its novelty, but because it is scandalous predictability. The secret of the heritage industry is iteration (and stereotyping): it is not its limit, but rather its necessity. The culture sold (and consumed) in the Qhapaq Ñan is no longer even a simple commodity; it is a commonplace due to its iteration under the same precepts—which here are as simple as the sum of exoticism, historical charm, bucolicism–. It is that sea of unanimity and predictability (of mass reproduction) which renders this vernacular and local road easily readable (and consumable) as a global commodity: it is an aporistic expression of the authentic, but disappeared; it is a game that cancels out times and spaces (it is a no-place, but also a no-time); it is a concrete abstraction in which the transformative character of history is subjected to simulacrum and, consequently, is emptied of any trace of historicity.

June 4, 2021

Two decades ago, Jesús Martín (2000) mused about an apparent paradox: postmodern presentism marches side by side with a heritage boom. He explained this weird phenomenon by the irruption of the commodity form in things historical,

one of the few cultural realms capitalism had so far spared. Had Martín written his reflections nowadays he would have noted that there is a third member in the equation: postheritage, a global, widespread movement, albeit unorganized, that challenges institutional heritage sites, policies, and projects. The prefix 'post' implies a departure from heritage. It is not a better alternative (more open, more democratic, more plural), but a beyond–such that 'it would not make sense if there were not a behind,' to remember Julio Cortázar (1963, 99)–. The 'post' advances a distance that is no longer epistemological, but ontological: it is not about a different version of heritage (as if there were just one heritage reality, but interpreted in many ways), but about its dissolution in a sea of ontological conflicts. The retention of the noun, although preceded by the prefix that modulates and undoes it, is perhaps a concession to usage that could be better specified as post~~heritage~~. It involves two related movements: the first, de-patrimonialization, is a critical reading of heritage, the position that overflows it; the second, post-patrimonialization, is the constitution of what is beyond, the creative position. Both movements show that heritage has created conflicts everywhere: dispossession (territorial, it is true, but also in other areas of culture); breakdown of social fabrics; complicity with the modern-colonial (onto)logic, especially, but not exclusively, with development and extractivism; and alterization.

June 5, 2021

A basic component of the ontological furthering of which heritage partakes is the naturalization of the inevitability of development, of extractivism, of its violation of socio-natural rights. The heritage discourse, but also the discourse of the historical disciplines that feed it (such as archaeology), flags and supports the teleological sense of history. Development/progress uses heritage as a mirror. Furthermore, the heritage industry is extractive: it does not extract traditional products, but new ones, so-called 'heritage values,' from their places of origin in networks of relationships whose importance is not only historical. In the process, it transforms places of memory into archaeological and–later–heritage sites. It uproots historical senses of origins, destinies, differences, and power struggles; their historicity is veiled by their reification. By eradicating historical referents from their traditional networks of relationships, the heritage industry makes them available for possession by the ontology of modernity. Traditional semiotic dimensions are torn from social wholes, not only rhetorically but also as lived experiences. Heritage extractivism resonates with a very strong echo within the other extractive industries and signals their simultaneous concurrence in the rhetoric of development; it also points out its purely industrial character. Patrimonialization and development appear on the scene together, and not by chance: heritage actions translate the brutal predatory action of extractivism into 'culture,' sweetening it. The protection of heritage and knowledge of the past legitimizes the outrageous and de-structuring presence of development in people's daily lives.

June 6, 2021

Heritage must be understood (and measured) in its relation to development and, therefore, to its consequences. The latter, the consequences, are many and large in scale, preventing heritage from professing innocence. In several countries (this is the case of Latin America) heritage is closely linked to extractivism, responsible for a large part of the contemporary non-armed attacks against life (and not only human life) and cultural survival. If extractivism threatens life, it follows that heritage, which supports and legitimizes it, also does so.

June 7, 2021

The events against heritage that I have registered in this diary are part of the postheritage trend, which is forming around, but it is not limited to, two fundamental issues: (a) undoing museums; and (b) positioning local knowledge. The first issue is being carried out through the Indigenous demand for the restitution of human bodies unearthed and exhibited. Restitution addresses the violence that has been exerted on the bodies of the archetypal other of the nation from a heritage perspective. Eugenic and extermination policies were not enough; the 'remaining' bodies were turned into objects of research and exhibition. The bodies of the others–turned into natural objects–became part of the collections of curiosities offered for the national spectacle: measured and classified, the Indians were collected and exhibited alongside birds, fossils, minerals, plants. The naturalization of the others had a grotesque component–which does not exclude but exacerbates, other types of violence–that put the ancestors (not just humans) in museum showcases. Struggles for restitution rebuild the worlds that have been brutally trampled on. However, what to do with the restituted bodies when there are no territories safe from dispossession? That is why the people and communities imagine, claim, and enunciate in these bodies their territories of struggle and healing; restitution is not only about bodies, it is also about territories–or rather about territories-bodies, enunciating their relational nature–. The matter can go further, however; the challenge to the national story goes as far as the destruction of the museum. After all, the museum's survival shows its inability to establish relationships that are not national or, at best, multicultural. Yet, museums have also been ambushed: that modern institution is being used to stage history and worldviews away from the canons of modernity. It is no longer the unifying narrative of the nation, nor the innocuous multicultural narrative of diversity, but contested ways of narrating and presenting historical events–those events that had no place in the official museum and that the national and post-national narratives had silenced–. The stories of museums of memory, of transgender, of the green movement, of women, recount history in a different way. They are sites of counter-memory, which is also staged in the streets. Walls have become the new centers where graffiti enacts history otherwise.

June 9, 2021

In the prologue to *Memory, History, Forgetting* Paul Ricœur (2004, xv) writes: 'I continue to be troubled by the unsettling spectacle offered by an excess of memory here, and an excess of forgetting elsewhere, to say nothing of the influence of commemorations and abuses of memory–and of forgetting–.' But Ricœur was wrong: it is not a matter of excesses and abuses and how to control them as if memory and forgetting had a fair measure that could be found somehow. (In a middle point, forged with humanism, tolerance, and democracy? In a common, yet comprehensive and nuanced, story?) Rather, they both participate in huge onto-logical conflicts, increasingly visible, increasingly productive. Those conflicts de-center the modern-colonial to explore its echoes, its residues, its implications, its shadows.

June 23, 2021

News in today's *El País*, the Madrid newspaper, alludes to other fallings, this time in Bogotá: those of Simón Bolívar from a conjoined monument known as *Los Héroes*, and those of Spain's Catholic Monarchs, who for decades have had their statues on the highway leading to the airport. The news ended with this summary conclusion: 'The protests in Colombia left an unexpected effect: a series of bare pedestals and an urban landscape that tries to resignify itself.' Bare pedestals and urban resignification look like an odd couple, given that modernity filled our cities with the bulky footprints of its conception of history: the statues and monuments it erected ev-erywhere were prominent atop quite visible, not bare, pedestals. But this bareness is telling: the heritage that modernity invented is now stripped of its pomposity and reduced to the tricky nothing from where it emerged. These turbulent times are indeed producing yet another victim that no one expected.

Note

1 https://hyperallergic.com/645108/colombian-government-exploited-doris-salcedo-art-to-denounce-nationwide-protests/

References

Cortázar, Julio. 1963. *Rayuela*, Sudamericana: Buenos Aires.

Durrell, Lawrence. 1982. *Poemas escogidos*. Madrid: Visor.

Horkheimer, Max and Theodor W. Adorno. 2022. *Dialectic of enlightenment*. Palo Alto: Stanford University Press.

Martín, Jesús. 2000. "El futuro que habita la memoria". In *Museo, memoria y nación*, edited by Gonzalo Sánchez and María Emma Wills, 33–63. Bogotá: Museo Nacional.

Murúa, Martín de. 2001. *Historia general del Perú*. Madrid: Dastin.

Ricœur, Paul. 2004. *Memory, history, forgetting*. Chicago: University of Chicago Press.

13

HERITAGE, RECONCILIATION AND PEACEBUILDING IN AUSTRALIA AND NEW ZEALAND

Cressida Fforde, Steve Hemming, Merata Kawharu,
Lia Kent, Laura Mayer, Daryle Rigney, Laurajane Smith,
and Paul Tapsell

Introduction

The problem of how to achieve a reconciled nation (or many nations) is ever present in debate and analysis of political and cross-cultural relations in settler-colonial nation-states. For First Nations peoples, invasion and colonisation have led to generations of precarious lives. We are a group of First Nations and non-Indigenous scholars with an interest in the relationship between heritage and reconciliation in Australia and New Zealand.[1] This chapter begins a consideration of this relationship with the intention to prompt new questions about heritage in settler-colonial nation-states and how concepts of heritage and heritage-making, their social meaning, and the resulting management and education approaches can contribute to building new, healthy and just cross-cultural relationships.

One of the observations fundamental to contextualising our work is that while much has been written about issues of heritage in relation to conflict (e.g. Gerstenblith, 2015, Stone 2016), as Walters et al. (2017: 1) point out, 'the contribution heritage brings to peacebuilding has been largely ignored'. Whether it is found, say, in war museums, memorials or sites of military importance, the heritage of conflict is familiar, common, and everyday. In contrast, the heritage of peacebuilding is notable by its absence (Gittings 2012, Lehrer 2010, van den Dungen 2017). This imbalance is informative in itself. Indeed, scholarship on heritage and peacebuilding has asked whether the dominance of heritage associated with conflict and conflict commemoration is actually a significant barrier to building cultures of peace (van den Dungen 2017).

While scholarship that considers the relationship between heritage and peace is markedly rare (for exceptions see, Hemming & Trevorrow 2005; Walters et al. 2017), heritage is nonetheless often invoked in the context of post-conflict

DOI: 10.4324/9781003188438-20

development by intergovernmental agencies, NGOs and governments as a potential source of social healing, particularly in the form of memorials. Similarly, as will be shown below, while the past and its meaning-making through heritage is implicit in much of the reconciliation literature, there is little explicit analysis of this connection and thus the role of heritage in building peaceful relationships is not well understood.

Recent international scholarship on heritage and peacebuilding offers insights, particularly in the museum profession (e.g. Apsel 2015, Dean 2013, Fromm, et al. 2014, Wilson 2016, Walters et al. 2017). For example, some peace museums are concerned with the history of peacemaking and peacemakers, providing 'a much-needed alternative depiction of historical reality that shows the triumph of empathy, kindness, nonviolence, understanding, reason and tolerance' (van den Dungen 2017: 14). Others are established for the express purpose of resolving current or future conflict and do so by displaying objects that are closely connected with peace cultures (Gachanga 2017). As shown in the work of Kenya Peace Museums, heritage can be used to reduce tension, highlight and value peace over conflict, and foster dialogue.[2]

Most of the emerging scholarship on heritage and peacebuilding considers post-conflict situations in which the original presence, continuing legacy, or threat of future violence is acknowledged. However, in countries today marked by 'settler colonialism's historical continuity' (Edmonds 2016: 2), the severity of colonialism continues to be dismissed, and there is little awareness in the settler population of its inherent violence over a long duration, and the conflicts that occurred. In Australia, a national narrative of peaceful settlement continues to prevail, while in New Zealand a discourse of negotiated settlement or acquisition of land through 'fair purchase' continues. Both have been identified as fundamental barriers to reconciliation and, concomitantly, highlight the importance of heritage in maintaining dominant foundation narratives but also its consequent potential to counter and disturb them. Here, the relationship between heritage, identity, emotion, privilege and reconciliation is plain. Understanding the role of heritage in both maintaining the status quo *but also changing it* has significant salience for rethinking heritage from a standpoint of peacebuilding and what role heritage management can play in building cultures of reconciliation.

There is a significant dichotomy between the high volume of state-sanctioned heritage and associated rituals associated with an international military endeavour, and the lack of authorised heritage associated with the use of force in the colonial era and Indigenous resistance to it. Heritage as meaning-making associated with the violence of the colonial experience is fundamentally required as part of truth-telling, as is apparent in recent reconciliation debates in Australia, not least in the 2017 *Uluru Statement from the Heart* (see below). However, there is a lack of knowledge about how to manage such heritage in ways that foster reconciliation. How to display objects arising out of persecution in ways that will encourage a reduction in prejudice has received scholarship, particularly in relation to war

museums, the Holocaust and slavery (e.g. Bardgett 2012, Logan and Reeves 2009, Macdonald 2010, Smith 2010, Smith et al. 2011). It reveals that there may not be a clear relationship between exposure to such heritage and achievement of reconciliation aspirations.

Heritage and Reconciliation – Interconnections

One first step in considering how to raise the pre-eminence of reconciliation in thinking about heritage and *vice versa* is to explore their inter-relationship in theory and practice. An intrinsic complexity is that people (including within our team) understand these terms differently and can disagree about definitions and praxis. Recognising this diversity and finding a way through it, is an important element of understanding the relationship between heritage and reconciliation. The terms 'heritage' and 'reconciliation' – are sites of deep contestation in themselves. What they are, how they should be understood and thus best approached continues to be discussed and debated. Heritage and reconciliation can both be subject to dynamics of power and discourse that may contribute to underlying causes of continuing injustice (see Worby and Rigney 2006). Western concepts of heritage and associated legislative mechanisms have been critiqued as at odds with, and antagonistic towards, Indigenous world views (Deloria 1992, Watkins 2001, Smith and Wobst 2005, Hemming and Rigney 2010, González-Ruibal 2019, Grey and Kuokkanen 2019), appropriating and/or ignoring Indigenous approaches to what some in the West may deem 'heritage', and imposing disciplines of management, representation and notions of expertise, that adhere more to processes and practices that maintain inequality than those which foster reconciliation.

Yet to focus our analysis solely on the role that the current dominant ways of understanding and 'doing' heritage continues to be at odds with a reconciled future is to be drawn into scholarly territory that persists in only exploring the relationship between heritage and conflict. The actions that flow from rethinking heritage from a stand-point of reconciliation are not only about ending or transforming heritage theories and practice that are explicitly or implicitly harmful. They are also concerned with advancing understanding of how heritage can actively help foster reconciliatory actions and cultures. It is this aspect that we seek to explore. Fundamental to this approach is to start to understand relevant Western and Indigenous intellectual traditions concerning heritage and peacebuilding. While there is a growing body of work from Indigenous and indigenist scholars that seeks to navigate the imposition of Western concepts of heritage and assert healthy caring for country regimes that are self-determining in nature (e.g. Hemming, Rigney and Berg 2019), there is as yet only minimal explicit consideration of how heritage and peace are interlinked in Indigenous epistemology and what insight this can bring to contemporary reconciliation challenges and approaches (e.g. Bignall, Hemming and Rigney 2016, Hemming & Rigney 2019). In the reconciliation literature, some scholars argue that understandings of and approaches to reconciliation might be

pushed in radically new directions through engagement with Indigenous knowledges. This may force theory to confront questions of human-centrism, colonial erasure and structural violence and engage more deeply with questions of *relationality* (see Brigg 2016, Randozzo 2021). For Indigenous peoples in settler states questions of justice, recognition, respect, repatriation, reparation and the assertion of ways of being that counter fundamental western binaries such as past/present, nature/human and living/non-living are being used to frame political responses, negotiations and published work dealing with the relationship between constructs of heritage, peace-making and wellbeing (e.g. Byrd 2011, Whyte 2013, Povinelli 2016, Rifkin 2016, Fforde, McKeown and Keeler 2020, Martuwarra RiverOfLife et al. 2021).

To commence theorising the relationship between heritage and reconciliation, in the next section, we briefly consider the main approaches to reconciliation. We then provide some first-stage insights into heritage and peacebuilding within Maori and Ngarrindjeri philosophies, before considering how this inter-relationship might also be identified within the major Western debates over definitions of heritage in a range of social and political contexts.

Reconciliation

Despite various attempts to theorise reconciliation (e.g. Hamber and Kelly 2004, Bloomfield 2006), the concept remains contested and situational (Worby and Rigney 2006; Wallis, Jeffery and Kent 2016: 161). Broadly speaking, reconciliation can be understood as 'the process of addressing conflictual and fractured relationships', including relationships between individuals, groups and communities and their relationship with the state (Hamber and Kelly 2004: 3). In the context of conflict, it is often viewed as key to achieving 'positive peace' – i.e. a socially just peace, in contrast to a simple 'negative' peace – i.e. the cessation of hostilities (Wallis, Jeffery and Kent 2016: 161). Leading peace research scholar John Paul Lederach regards reconciliation as critical to a transformative approach to building peace (Lederach 1997, Paffenholz 2013: 15). Rather than regarding conflict as something to be *resolved*, Lederach's understanding of peacebuilding rests on the idea of conflict *transformation*. Peacebuilding entails efforts 'to transform the underlying structural, cultural and relational roots of violent conflict' (Darweish and Rank 2012: 3, Lederach 1997.) The relational aspects of reconciliation are thus, on this reading, at the heart of peacebuilding (Paffenholz 2013: 15).

Analysis of reconciliation in Australia or New Zealand has become less popular in recent times with more focus on truth, justice, decolonising and treatied relationships (although see Smith 1999, Hemming 2006, Worby and Rigney 2006, Hattam et al. 2007, Probyn-Rapsey 2007, Muldoon and Schaap 2012, Short 2016, Maddison 2017). The concept of reconciliation has also been extensively critiqued in settler-colonial contexts because it implies the presence of a pre-existing just or peaceful relationship (Short 2012). As Ernesto Verdeja (2017: 228) argues, the

historical wrongs committed in the context of settler colonialism complicate questions of reconciliation due to 'the passage of time and the birth of new generations whose connection to past harms is often only tenuous or otherwise highly complex, although the legacies of these harms continue to shape contemporary social relations'. Reconciliation emerges as central in debates over 'assimilation, political autonomy and the nature of social unity' (Verdeja 2017: 229). In the settler-colonial context, the key questions for reconciliation shift towards 'historical memory, collective identity and contemporary relations of power shaped by the past' (Verdeja 2017: 229; Blustein 2008). In this conceptualisation, the supreme relevance of heritage clearly emerges, although it is not explicitly considered.

Scholarship on reconciliation in the context of settler colonialism has been marked by a division between those promoting normatively 'thick' (or communitarian) accounts of reconciliation and those who are sceptical of such accounts. For proponents of 'thick reconciliation, the end goal is the creation of a harmonious social order through healing and reciprocal justice' (Verdeja 2017: 229, Frayling 2009). 'Thick' approaches to reconciliation have been criticised for promoting a *non-political* account of coexistence that emphasises substantial social harmony – including a shared identity and agreement on basic ethical values – and occludes fundamental disagreements (Verdeja 2017, Maddison 2017). It is argued that the emphasis on social harmony works to obscure past and ongoing colonial injustices. In Australia, for instance, some have argued that reconciliation is a 'further stage in the colonial project of assimilating the Aboriginal population into the colonising society' (Muldoon and Schaap 2012: 535). At the other end of the spectrum are those who advance an *agonistic* understanding of reconciliation. Agonistic theorists argue for the need to keep open 'political spaces in which conflict can be engaged'. The aim of an agonistic reconciliatory engagement is not to avoid or bracket conflict but rather to 'transform actually or potentially violent conflict into non-violent forms of social struggle and social change' (Ramsbotham 2010: 53; Maddison 2017: 158). The hope is that divided societies will 'find new ways of respecting old adversaries' (Maddison 2017: 156). Agonistic accounts of reconciliation have been critiqued for reducing reconciliation to a question of power relations. As Verdeja (2017: 231) argues, agonism undermines the possibility of 'establishing a critical position from which to examine responses to the past'. Verdeja's critique has salience if heritage is a response to – or use of – the past. Equally, approaches to understanding heritage (see below) highlight heritage's interconnection to (and role within) power relations. From whichever perspective, opening a space to consider the relationship between heritage and reconciliation seems necessary and timely. Verdeja's (2017: 231) comment that it becomes difficult to distinguish 'between normatively defensible versions of reconciliation that advance the claims of Indigenous groups versus those that privilege state power and majority culture', finds some similarity in discussions within Critical Heritage Studies that seek to challenge the 'authorised heritage discourse' (Smith 2006), as it does also to work by Indigenous and indigenist scholars.

Some scholars have attempted to navigate a pathway in between 'thick' and 'agonistic' accounts by proposing key reconciliation *principles*. Verdeja (2017), for instance, proposes an account of political reconciliation in settler-colonial societies rooted in *mutual respect*. Mutual respect 'requires opening to public debate those political practices, fundamental values and even collective identities that are of shared relevance' to Indigenous-majority group relations (Verdeja 2017: 231). This approach has potential in the heritage field both theoretically in terms of understanding whether and how heritage is used in this context, and practically in terms of how disparate understandings of heritage may facilitate such debate. The latter requires, of course, deep understanding of competing conceptualisations of heritage and its values and a close inspection of previous uses of heritage that aimed at such an outcome.

For Verdeja, mutual respect might be fostered through three elements, and again, heritage can be seen to be central to all of them. First, through 'critical reflection on the past – an investigation of past injustices, their present legacies, and their relationship to contemporary political values, power relations and identities' (Verdeja 2017: 232). Second, by 'creating a space for the moral recognition of victims and their descendants' by 'reinterpreting historical narratives of past injustices through the explicit acknowledgement of the communities that suffered' (Verdeja 2017: 234). The third component of mutual respect involves political participation, which requires 'securing political voice for marginalised groups', and ensuring 'formal access to and actual participation in political governance and decision-making institutions' (Verdeja 2017: 236).

Indigenous scholars have also considered key principles of reconciliation and key stages in the reconciliation process. For Canadian Indigenous scholar Marlene Brant Castellano, a member of the Mohawk nation, a first step involves the acknowledgement that 'some fundamental value of society has been violated that demands a corrective response' (2011: 384). Thus, reconciliation requires '*acknowledgement*, naming the harmful acts and admitting that they were wrong; *redress*, taking action to compensate for harms inflicted; *healing*, restoring physical, mental, social/emotional, and spiritual balance in individuals, families, communities, and nations; and *reconciliation*, accepting one another following injurious acts or periods of conflict and developing mutual trust' (Castellano 2011: 383, original emphasis). These components are reflected somewhat in Reconciliation Australia's five critical dimensions of reconciliation: Race Relations; Equality and Equity; Institutional Integrity; Unity; and Historical Acceptance.

In Australia, the *Uluru Statement from the Heart* (2017) is one of the most significant recent developments in thinking and action about reconciliation processes.[3] Undertaken in the context of previous official deliberations concerning constitutional reform which have recently included a major focus on formal recognition of Aboriginal and Torres Strait Islander people in the constitution, the *Statement* results from the work of the Referendum Council, set up in December 2015 jointly by the Australian Prime Minister and the Opposition Leader.[4] A key focus of the *Statement*

is political participation and truth-telling. This powerful document has two main (but interconnected) proposals. First, it supported a permanent Voice to Parliament in the form of a representative Aboriginal and Torres Strait Islander body. Second, it called for a Makaratta Commission 'to supervise a process of agreement-making between governments and First Nations and truth-telling about our history'.[5] Makaratta is a word in the Yolngu language of East Arnhem (Northern Territory, Australia), whose primary meaning is an act of peacemaking or reconciliation. It has been used since the 1980s to describe the process of treaty-making. The proposed Makaratta Commission would be akin to a Truth and Reconciliation Commission. Though central to other TRC processes in, for example, Canada and South Africa, the word 'Truth' is notably absent in official Reconciliation processes in Australia. The dialogues and discussions facilitated by the Referendum Council saw such truth-telling as an essential part of reconciliation. The *Statement* itself, the processes and deliberations that led to its formation, and the subsequent responses by parliamentarians and others to its release are all information about the relationship between heritage and reconciliation and form critical areas for future analysis, not least in order to provide useful information for those crafting potential Makaratta Commission processes in the future.

A common thread across all summations is the need to acknowledge past injury. Heritage, therefore, is clearly front and central, and it is surprising that its explicit role and potential has not been explored previously. From the above starting points, there are a number of ways in which heritage is potentially linked to reconciliation processes. For example, heritage in various manifestations can help to open up space for the discussion of historical injustices that have been silenced or repressed. It can provide a space for the acknowledgement of past injury and its ongoing ramifications in the present. For Indigenous nations and communities, secure (and sometimes exclusive) 'heritages' are required to allow them to continue to be themselves – they are crucial resources for encounters with settler communities. These 'heritages' can include Old People (human remains) and items of cultural property held in museums, records of languages stored in settler-colonial archives, 'ancient' rock art located in caves threatened or destroyed by mining companies, sacred Country named and managed as landscape, natural resources, national parks or other settler-colonial constructions. Securing recognition of Indigenous values, understandings and ownership of these forms of 'heritage' are central to the contemporary political work of First Nations peoples and crucial sites of diplomacy, peacemaking and potentially reconciliation.

To continue to explore the relationship between heritage and reconciliation we now consider some different understandings and approaches to these concepts and how they may inter-relate. To do so, we offer first-stage insights into Maori scholarship on such matters alongside work over the past two decades by Ngarrindjeri[6] nation research teams. We then turn to major debates about heritage in the Western canon. As noted above, terms such as 'heritage' and 'reconciliation' hold different meanings to different people and may be used in various different

ways. Our object here is not to seek a unified agreement on 'what heritage is'. Instead, the intention is to provide the reader with a degree of entrée into the concept across and within different knowledge systems and, then, to consider inter-relations with notions of reconciliation and peacebuilding.

Peacebuilding and Taonga – Reflections From Aotearoa New Zealand

In this section, Paul Tapsell and Merata Kawharu reflect on the ritualised role of taonga in establishing, maintaining, and changing cross-cultural relationships between authorities and individuals. This reflection points to both how Western conceptualisation of 'collections' and 'museums' that now hold taonga are at once a world apart from the Maori worldview, but may also provide, in a very pre-Indigenous 'traditional' sense, a key to understanding (and deploying) the role of symbolic resources such as taonga in forging new relationships in the contemporary context.

For Māori, if we start with definitional issues about heritage, we begin with whakapapa, or genealogy, or the structural layering of the universe, which connects us to the realms of the distant past and to atua (gods), but also to foundation an-cestors (tupuna) and to those of the whenua, the earth, thereby grounding us as early or first peoples to this land, to the environment and living organisms. This principle alone underpins the resonance of kin groups (hapū) with our ancestral landscapes, which in turn qualifies our custodial roles in relation to the environment around us. It is also common to talk about coming from the earth, and if we go back far into our origin stories, we come to ancestral figures like Tumutumuwhenua (male) who for Ngāti Whātua manifested physically as a caterpillar or as a log, or Hineahuone, who herself was formed from the earth. These and other kōrero (stories) are metaphorical allusions to the strong connectedness between the spiritual and the temporal, between the past and the present, and between the social and the environmental realms. Identity and notions of place, standing and peace are formed from these relationships (Kawharu 2009, Kawharu and Newman, 2018). We memorialise ideas about connectedness to place in stories (kōrero), proverbs (pe-peha), whaikōrero (formal speeches on marae), karanga (formal calls on marae), taonga (ancestral treasures) and in ancestral places throughout our landscapes na-tionwide. But if we are to talk about heritage and peace cross-culturally, there are contested political spaces between the Indigenous peoples – Māori – and the settler state – the Crown – in our country, regarding the same lands. Contestation grew post-1840, the year when more than 500 chiefly leaders throughout the nation assigned their marks to copies of a Treaty written in English and in Māori, first signed in Waitangi, promising the protection of the continued exercise of their chiefly leadership and sovereignty or rangatiratanga.

Not only did the Crown politically subjugate its Indigenous hosts under Treaty promises of protection, claiming also their hosts had willingly surrendered absolute sovereignty to the Queen of England, it also assumed (en)title(ment) across

66 million acres of land. Wars of resistance were fought, but they were ultimately futile. Thousands of ancestrally embedded sites of memory were invaded, captured and repurposed for colonial development such as for farms, towns, railways, roads or other public works. The colonial unsettling of kin communities across Aotearoa New Zealand by the Crown continues to be a traumatic legacy lived in various degrees of agonism by descendants today.

Yet post the nineteenth-century land wars, time and again Māori leaders found resilience and courage to pave new pathways within a new colonial regime. Despite the fact that they were on the cusp of losing their lands, they nevertheless retained their mana, or strength and identity. So, on their terms, taonga – the tangible markers of heritage – were prestated[7] to the Crown to demonstrate honour, and to symbolise an intent to negotiate peace and find a way to hold on to lands (Tapsell 2003). Crown officials and representatives were not unaware of what taonga symbolised and in the moment appeared to accept such prestations accordingly (Tapsell 2003). However, no sooner than accepted, the intent of such taonga prestations were subverted, lands were taken through the courts and laws, and the symbols themselves were decontextualised, eventually becoming misremembered objects of colonial domination. These many hundreds of prestated taonga instead became prisoners of war, devoid of source narratives, and incarcerated within museums. Ironically, New Zealand's four metropolitan museums are still using taonga to narrate their version of a contested heritage from a space of memorialised safety, often beyond the reach of the source communities from which the taonga originated.

For Māori, taonga are ancestral moments that collapse time through which descendants and estates become one identity. There is nothing more prestigious or meaningful than prestation of such powerful symbols binding people and lands. However, when held by the Crown, taonga were transformed into objects representing conquest, rendering mute their intended symbolism of peace, healing and partnership. The final irony of course being held and displayed in colonial museums, especially those memorialising world wars, like the Auckland War Memorial Museum. Taonga, like Pūkaki ended up in such a place, his real intent of gifting to the Crown obscured for 120 years (Tapsell 2003). Each taonga of his status that was prestated to the Crown in the early years of civil unrest not only symbolised chiefly authority, but are also enduring symbolic site of negotiated peace and forgiveness. They each directly link the heritage and memories of a source kin community to their surrounding and mostly alienated estates, but all the while being held in a foreign building, under a foreign value system on the lands of another kin group be it in Auckland or elsewhere in the world.

In the New Zealand context, the restoration of mana is also the reactivation of taonga, not least those held by museums, as the legitimate sites of heritage. This includes, for example, the return gifting of taonga to source communities as the first step in correcting the power imbalance, restoring mana for both parties, for which all New Zealand can continue the narrative of heritage now in a contemporary

context from a place-based space of peace and forgiveness. Pukaki has shown the way (Tapsell 2003, 2006, 2017) and represents a model of partnership and reconciliation that is possible between hapū and the Crown today. On a nationwide scale, Treaty claim settlements have shown how heritage and reconciliation defined from claimant perspectives is front and centre to settlements, enshrined in laws, and recognised in novel outcomes ranging from forests' and waterways' recognition of legal personhood (Morris and Ruru, 2010), to the restoration of place names, dual (new) place names, to co-managed sites of significance [e.g. Orākei (Kawharu, 2005: 158–159), among other things. Pukaki and Treaty claims settlements have modelled heritage and peacebuilding relationships for more than three decades. We have more to do. But our grounding in whakapapa, our custodial heritage values are important as we tackle the challenges of our times, not least climate change, pollution and biodiversity losses, as well as heal from the socio-economic trauma of our past.

Ngarrindjeri Nation Re-Building, Heritage and Peace-Making

In this section, Steve Hemming and Daryle Rigney reflect on Ngarrindjeri practice in the sphere of heritage and peace-making. Fundamental contributors to Ngarrindjeri intellectual and practical work in the space of nation-building, they have undertaken significant effort over the past 30 years to both understand the ways in which Western concepts of heritage and the practice of heritage management can impede nation building, and to open up a space in which Ngarrindjeri world views about, and responsibilities towards their traditional lands and waters can be pre-eminent in resetting relationships with the State and Crown.

We start this discussion of the Ngarrindjeri nation's recent experiences with heritage and peace-making by asking the following question. Why does the concept of heritage and the way that it is deployed in a variety of Australian settings such as cultural heritage management, natural resource management, water management and many others open potential for Indigenous nations and peoples to pursue and guide peace-making agendas? Importantly, Australian Aboriginal heritage protection and management regimes enshrine a contradictory chink in the supposedly finished story of a 'settled' Australia. Through legislation, they recognise that other systems of law and tradition, Indigenous ones, have survived colonisation and are materialised as valuable things, places and landscapes – 'heritage'. The opportunity to negotiate a just settlement and Indigenous nationhood from this legal and political contradiction is foundational in the story of Ngarrindjeri nation (re)building, diplomatic work, and historic treaty negotiations (Ngarrindjeri Nation 2007, Hemming and Rigney 2008, Hemming, Rigney and Berg 2011, 2019). Ngarrindjeri have worked hard to resist and transform their violent encounters with Museums, CHM, NRM, and other forms of planning, research and management, into safe, more peaceful relations guided by hard-fought contract law agreements and nation-to-nation negotiations. From a Ngarrindjeri perspective, the Australian

state is a foreign power without a lawful and respectful relationship with First Nations, and from the 1980s, Ngarrindjeri leaders have joined other First Nations in the pursuit of a treaty or treaties as the only resolution of this unjust occupation.

Since the 1967 Referendum, a key moment on the Australian Indigenous journey towards self-determination, Ngarrindjeri, like so many other Indigenous nations in Australia, have struggled to assert their interests in a settler society grounded in what Aileen Moreton-Robinson has termed 'the possessive logic of patriarchal white sovereignty' (Moreton-Robinson 2004).[8] Scholarly work has been crucial in supporting Ngarrindjeri leadership in the development of effective political and diplomatic strategies required to engage with complex colonising practices such as CHM and NRM as they intrude into Ngarrindjeri lives and seek to re-conceptualise and control Ngarrindjeri Yarluwar-Ruwe (Sea Country, lands, waters, spirit, and all living things) (e.g. Hemming and Rigney 2010, Bignall, Hemming and Rigney 2017, Hemming, Rigney and Berg 2019). This work gathered pace in response to the SA Government's use of a Royal Commission to investigate Ngarrindjeri women's and men's sacred beliefs about their lands and waters in the traumatic and famous Hindmarsh Island Bridge heritage case (see Stevens 1995, Simons 2003). The Royal Commission found that Ngarrindjeri and their supporters had fabricated sacred traditions to stop a major bridge development – fabricated a heritage site. Ngarrindjeri leaders did not accept this decision. In 2009 they negotiated a Kungun Ngarrindjeri Yunnan Agreement (KNYA - Listen to Ngarrindjeri people) with the Crown in the Right of South Australia, which included formal registration of the 'heritage' site known as the 'Meeting of the Waters' and an apology for the government's treatment of Ngarrindjeri laws and traditions during the Hindmarsh Island (Kumarangk) controversy (KNYA 2009). In 2010 a ceremony was staged on Ngarrindjeri Country and SA government Minister Paul Caica delivered the public apology. A local park was created, named Jekejere,[9] and a memorial constructed to mark the event. This memorial includes the original promises made to Indigenous people by King William IV of Great Britain and Ireland in the 1836 *Letters Patent* that established the Colony of South Australia (Berg 2010, Hemming, Rigney and Berg 2019).

A little earlier in 2007, once again on Ngarrindjeri Country, the Ngarrindjeri Nation and the South Australian Government jointly launched a historic 'conciliatory' document – the Ngarrindjeri Nation Yarluwar-Ruwe Plan: Caring for Ngarrindjeri Sea Country and Culture (Ngarrindjeri Nation 2007). The Yarluwar Plan was the first Indigenous nation plan developed in South Australia. It includes Ngarrindjeri laws and traditions, a vision for Country, Ngarrindjeri diplomatic and political engagement mechanisms, and a Proclamation of Ngarrindjeri Dominium.[10] As a strong statement of Ngarrindjeri rights, identity, authority and responsibility, but as a conciliatory document it charts a vision for future, just collaborations between Ngarrindjeri and non-Indigenous institutions, governments, business and individuals. The Plan begins with the following Ngarrindjeri Vision for Country explaining Ngarrindjeri philosophy, ways of being and lawfulness and

identifies conditions for peaceful, respectful relations between Ngarrindjeri and non-Indigenous people. It is an antidote to destructive and invasive heritage assessments, 'site' recording, archaeological discourse, binary logics and stories of extinction.

Ngarrindjeri Vision for Country

> Our Lands, Our Waters, Our People, All Living Things are connected. We implore people to respect our Ruwe (Country) as it was created in the Kaldowinyeri (the Creation). We long for sparkling, clean waters, healthy land and people and all living things. We long for the Yarluwar-Ruwe (Sea Country) of our ancestors. Our vision is all people Caring, Sharing, Knowing and Respecting the lands, the waters and all living things. We ask non-Indigenous people to respect and understand our traditions, our rights and our responsibilities according to Ngarrindjeri laws and to realise that what affects us, will eventually affect them.
>
> (Ngarrindjeri Nation 2007: 5)

The later Premier of South Australia, then Minister of the Environment, the Honourable Jay Weatherill launched the Yarluwar-Ruwe Plan on behalf of the SA Government. Ngarrindjeri leaders see the Plan as a constitutional document and part of the developing heritage of Ngarrindjeri peace-making. A decade on Ngarrindjeri leaders were sitting down with the same SA Government to begin negotiations for a historic treaty between the Ngarrindjeri Nation and the Crown in the Right of South Australia (Rigney et al. 2021). Ngarrindjeri's decision-making principles, grounded in Ngarrindjeri law and experience have guided this ongoing process of peace-making with settler government and non-Indigenous interests. The Ngarrindjeri Vision for Country articulates many of these principles of lawfully Speaking as Country known as Ngarrindjeri Yannarumi. Over the last decade, Ngarrindjeri leaders and supporters have been making plain their application of Yannarumi methodology to engagements with non-Indigenous interest in areas such as water planning, business development, research programs, repatriation and education (e.g. DEWNR and NRA 2016, Bignall, Hemming and Rigney 2016, Rigney et al. 2018, Hemming et al. 2020a, 2020b).

Key Debates in Heritage Studies

This section considers key definitions and associated debates in the predominantly Western canon of Heritage Studies to continue to explore how heritage can be used in peacebuilding and reconciliation initiatives. The five debates centre on the material and managerial definition of heritage; the 'heritage industry' debate; heritage as an educational resource; heritage as 'heritage making'; and Posthumanism/New Materialism/heritage futures.

The first of these definitions is the default or 'common sense' position that heritage is the valuable material remains of the past that the present has inherited to pass on to the future. While this is a common view that informs much heritage management and discussion, its limits must be clearly understood in the context of unpacking the relationship between heritage and reconciliation. As much of the Heritage Studies literature has pointed out, this definition is minimal and problematic because it embeds a range of not only Eurocentric but also class, gendered and racial assumptions and readings about the nature of history, historical consciousness and collective memory (e.g. Samuel 1994, Hall 1999, Graham et al. 2000, Meskell 2002, Littler and Naidoo 2004, 2005, Ashley and Frank 2016; among others). Framed by what Smith (2006) has defined as the 'authorised heritage discourse' (AHD), this definition, enshrined in UNESCO conventions and western national legislation, owes much to the disciplinary interests of archaeologists, architects and art historians as well as social elites concerned with ensuring that material of importance to their interests was protected. This discourse stresses the materiality of heritage, the importance of expertise as stewards of the past and future, and the innate and universalised value of things. Community commentators and activists have challenged this discourse and Indigenous perspectives (e.g. Langford 1983, Tapsell 2003, Marrie 2009, Hemming and Rigney 2010, Bigenho and Stobart 2016, among others) offer notable critiques. Additionally, the international recognition of intangible cultural heritage, following years of lobbying and negotiations within UNESCO by largely non-Western actors, have brought further challenges to material-based definitions (see Smith and Akagawa 2009, Lixinski 2011, 2019, Smith 2015, Hafstein 2018).

Of importance in the context of heritage and peacebuilding is the tendency for the AHD to stress the universal value of heritage and its ability to represent and speak to nationalising collective narratives. The use of heritage to foster national and international collective identity is also claimed to promote wellbeing and peace. For example, UNESCO's vision for the World Heritage List to promote "sustainable development, social cohesion and world peace" (UNESCO 2008: 27) is built directly on such assumptions (Meskell 2018). However, the use of heritage to nurture consensus in national and international identity-making has now been extensively critiqued for its exclusionary nature, its tendency to maintain monolithic identity building, and either ignore or assimilate diversity (Hall 1999, Littler and Naidoo 2004, Bigenho and Stobart 2016, Grey and and Kuokkaneh 2020). Because dominant (and often deficit) discourse about Indigenous peoples privileges nation-state foundation narratives over those defined by the Indigenous experience, it is unsurprising that these are expressed through heritage and its management regimes. Indigenous-defined 'heritages' and related values and understandings are actively muted. If working within this definition, influencing the AHD (or who controls and validates it) is thus central to any large-scale heritage and reconciliation initiative, though the challenge of doing so is substantial. A crucial point to be raised here is that if heritage is to be engaged for peacebuilding, whose notion of peace is

advocated and for what purpose? How do we recognise and proportion power differentials in reconciliation practices?

Linked to the above definition and associated debates, and important for understanding how heritage can be used (or not) to change narratives, are underlying assumptions about the educational value of heritage. Within the AHD, these values are simply assumed to be inherent in heritage sites and objects. Consequently, their management and preservation are ultimately the education of 'the public' about the meaning of heritage for the present and future. Heritage as an educational 'tool' is strongly intertwined with the history and development of museums as regulatory institutions of the conduct of citizens (Bennett 1995, Hooper-Greenhill 2007). As Smith (2021), drawing on Biesta (2013, 2015), has argued, heritage and museums become particularly useful in neo-liberal practices that stress 'the duty' of citizens to engage in 'life-long learning'. Work by some scholars, however, has revealed that learning is not a primary or sole use of heritage. Instead, heritage is also routinely used to reinforce and affirm the narratives and the social and political values that underpin those who engage with it (Doering and Pekarik 1996, Pekarik et al. 1999, Pekarik and Schreiber 2012, Smith 2010, 2021). Even in contexts where heritage is actively used to challenge dominant narratives, preconceived prejudices and ideological commitments will tend not only to be maintained but also be vigorously defended (Smith 2010, 2021). Theorisations about the interconnection between heritage and reconciliation that build on uncritical assumptions of the educational value of heritage risk simply reinforcing the *status quo* of received knowledge about the past and its meaning for the present (see Rigney and Hemming 2014, Rigney et al. 2018, Smith 2021).

Also of salience is the growing body of work that investigates how heritage is intimately emotional. This has found that one of the uses of heritage, whatever its form, is to facilitate the emotional investment people have in specific memories, identities and historical narratives (Smith and Campbell 2016). This investment can be as equally made through community assertions of pride and self-esteem and uncritical reinforcements of privilege (Smith 2021). Agonistic struggles over power and privilege are inevitably emotionally driven and negotiated (Mouffe 2013, 2019). Such work indicates that the emotional power of heritage should be central to theorisations of peace and reconciliation building, as consideration of emotion facilitates the identification of what may be at stake for different interest groups in this process. This approach also draws attention to the complex diplomacy and negotiation required to support relationships that enrich and respect differences and multiple ways of being (see Bignall 2010, 2014, Bignall, Hemming and Rigney 2017). Such diplomacy and negotiation can use (or create) rituals that are in themselves heritage, and have tangible and intangible heritage associated with them or created by them.

Tunbridge and Ashworth (1996) and Graham et al. (2000) have argued that heritage is inevitably dissonant and contested and at the heart of its role in identity building, is that heritage will both include and exclude; what is one group's heritage

will not be another's. More importantly, what one group may define as uplifting heritage may be equally experienced as oppressive by other groups. This approach has significant implications for rethinking heritage from a standpoint of reconciliation and points to the need, discussed above, for mutual respect to underpin heritage-making. Although recognition of dissonance does not preclude opportunities for understanding the potential co-creation of heritage within and for genuine reconciliation processes.

Conflicts over the interpretation of heritage and the role it is put to in contemporary society has underpinned a further definition of heritage and its re-theorisation as 'heritage making' or as a verb (Harvey 2001), as an act of communication (Dicks 2000) and a set of practices around the cultural production of meaning in and for the present (Kirshenblatt-Gimblett 1998, Smith 2006, Macdonald 2013). Smith (2006, 2021), in particular, has argued that all heritage is intangible, not simply because social and cultural context gives meaning to material heritage sites and objects (see also Munjeri 2004), but expressly because heritage is a set of affective performances and practices in which the past is brought to the present to address contemporary social issues and political problems. Overall, Smith argues, heritage is a process about mediating and negotiating cultural change. Material heritage sites and objects and intangible heritage events are understood as cultural tools used to facilitate this process. Heritage is thus made in and for the present. This theorisation has significant potential for building cultures of peace, as it recognises the dynamic nature of heritage as a process essential to cultural change. It encourages focus on what people *do* with things (rather than on the things themselves) as the means of opening up space for change. This position would also hold that a continuing understanding of heritage solely as sites and things (as with the first definition above) is not able to contribute significantly to the active use of heritage in reconciliation.

Smith (2021) has also argued that heritage is a resource of power, and is a focus of agonistic expressions of ongoing struggles for recognition and redistribution (Fraser 1995, 2001). This rests not simply on the power given to expressions or concepts of heritage to represent and legitimise identity claims, but also to underpin social and cultural reflexive self-esteem, or self-recognition, necessary not only to those groups mounting claims for recognition and redistribution but crucially also for those required to reassess their privileged positions to facilitate redistribution (2021: 47–9). Struggles for recognition are always ongoing (Tully 2000). Likewise, struggles for peace and reconciliation may be understood as an ongoing project of heritage making. The meaning of the past is used to facilitate, legitimise, and regulate practices in agonistic situations. In such a conceptualisation, there will always be contest and dissonance; neither peace nor reconciliation can be achieved without engaging with the dissonant nature of heritage or the interrogation of the tensions between different legacies of historical and contemporary social and political experiences of privilege and disadvantage. Nor can this be practised

without engaging with varying conceptualisations of heritage, how it is valued, and how and why it is used in different social and cultural contexts.

A fifth set of debates about heritage have attempted to re-theorise the materiality of heritage. Framed by ideas from the New Materialisms, Critical Posthumanities and Assemblage theories and often addressing the future consequences of heritage on what some have called the 'Anthropocene', this debate is concerned with what some see as the deprivileging of material heritage (Harrison 2013, Olsen 2013, Stirling 2020). Early examples of this work in critical Heritage Studies drew on Actor-Network theorists such as Bruno Latour (see Latour 1999, 2005, Harrison 2013), and the theorisation of the material, or the non-human, as actants or agents in complex and shifting networks of relations, so that heritage becomes less a symbolic representation of human identity and concerns and rather an affective quality in social interactions (Harrison 2013: 31).

For some, including Ngarrindjeri researchers and their colleagues, approaches framed by these newer theoretical approaches have potential to be used strategically to open spaces for non-Western conceptualisations of 'heritage' that are useful for progressing Ngarrindjeri rights in, for example, nation (re)building initiatives (Hemming et al. 2016, Byrne 2020, Sterling and Harrison 2020, Sterling 2020). Ngarrindjeri view these approaches as enabling a platform for dialogue with State and Crown around heritage matters in a manner that frames Ngarrindjeri world views in a heritage 'language' that government authorities can understand. For Ngarrindjeri initiatives in this domain, these newer approaches have the potential to connect more easily (and thus usefully) with Indigenous ways of being that privilege interconnection, relations and critiques of binaries such as human/nature, living/non-living, and primitive/modern. The avenues opened up by New Materialism, critical Posthumanism, Assemblage theories and related theoretical traditions, find resonance with scholarship in the reconciliation, environmental studies and Indigenous nation (re)building literature, and it is this engagement that has received attention in Ngarrindjeri nation (re)building work (e.g. Hemming and Rigney 2008, Hemming and Rigney 2010, Bignall, Hemming and Rigney 2016, Hemming, Rigney and Berg 2019).

For others, this fifth set of debates is fundamentally problematic to maintaining critical analysis and understanding of heritage (Campbell and Smith 2016; Smith 2021), and thus also as a means of progressing First Nation rights. As some Indigenous scholars have pointed out, there is nothing 'new' in these approaches; Indigenous knowledge takes the agency of non-human material as a given (Todd 2016; Hazard 2019; Rosiek et al. 2020; Hokowhitu 2021; among others). Others have observed that within New Materialisms/Posthumanism, there is a tendency to take the Indigenous emphasis on particular relationships and generalise them in ways that not only does violence to Indigenous knowledge but also facilitates what Hokowhitu (2021: 172) refers to as *cōgitātiō nullius*. The politics of citation is significant here, as Rosick et al. (2020: 332) note, the debate inevitably reaches for Deleuze rather than Deloria, and the European academy makes 'legitimate' that

which is re-rendered as simply 'tradition', 'totemism' or 'animism' within a re-making of Western centricity (Hokowhitu 2021: 175, 186). Questions of race and racism (and, for that matter, gender, class, and other structures of prejudice and exclusion) are notably absent in this debate (Tompkins 2016; Anderson 2020). Indeed, as Hazard (2019: 630) has observed, the conceptualisation of material agency, particularly about ideas of the body, share all too much in common with previous nineteenth-century racist projects. Any conceptualisation of heritage in peace and reconciliation-making needs not to assimilate knowledge while providing equitable space and respect for diversity and difference.

Linked to the issue above, New Materialism/Posthumanism is concerned with emergent meaning and new ways of 'being' as actants enter into dialogical relations with each other (Harrison 2013: 31–2; Pétursdóttir and Olsen 2018). This analysis also aims to open up new possibilities to reconsider the future; the focus on the emergent actively seeks to address human actions on the non-human in the context of climate change and the Anthropocene (Pétursdóttir 2020). While having ethical appeal, this focus can obscure issues of power and politics as there is a significant logical fracture line in how these ideas are applied to heritage (Smith 2021). The turning away from supposed anthropocentrism is both ironically anthropomorphic in its execution and belies the ethical aims of engaging with human activities on the non-human. This effectively works to abrogate human agency from responsibility as it elevates the non-human world to the focus of analysis (Ingold 2014; Rekret 2018). Finally, the future orientation of this debate tends to disregard the present. Our engagement with the past, however, is always in the present. This is not to say that resetting agendas for the future is not central to peacebuilding. Still, the present is where issues of injustice are experienced and where past legacies continue to shape these experiences. Analysis of power and structures of oppression, often absent in New Materialisms/Posthumanism, are integral sites of analysis to processes of reconciliation and peacebuilding.

Conclusion

Reconciliation is an ongoing, multilayered and complex process of creating new, equitable, respectful and dignified relationships between Indigenous and non-Indigenous peoples. We recognise that reconciliation necessarily involves engaging with the ongoing legacies of past harm in the present, and engaging with Indigenous knowledges. We also recognise that what many Indigenous peoples seek is 'not a transition towards a shared, integrated society, but a transformation of that society such that their sovereignty as distinct and self-governing peoples is recognised' (Maddison and Shepherd 2014: 268).

Key to a deep exploration of the connections between heritage and reconciliation is the need to look holistically at heritage and understand its social role for both conflicted parties. In the reconciliation context, it is fundamental that heritage practices and analysis must engage directly with issues of power, colonialism, racism

and other forms of prejudice, and provide an open space for considering the different and diverse ways that heritage is actively valued and understood in the present. It needs to embrace the dissonant and agonistic nature of heritage, as a failure to do so will reinforce dominant narratives and experiences. It needs to leave room for identifying what is at stake for differing interest groups in this process.

Overall, heritage can be usefully framed as a performance or practice of meaning-making in which the past is deployed to do social and political work in the present. Heritage as sites, objects and places or as intangible expressions can be understood as locations and activities that facilitate this work in many ways. Understanding and analysing the different ways heritage is thus used requires respect for the diversity of both Indigenous and non-Indigenous knowledge and values. It involves participation in that diversity without assimilation or appropriation. The work of performing heritage is to render heritage (whatever its form or expression) as a resource of power and influence in peacebuilding and reconciliation processes. It is a resource in struggles over recognition and redistribution (Smith 2021). An important focus of analysis is understanding how power is brought to bear through heritage to facilitate or inhibit these processes in different cultural and social settings.

Understanding how colonial assumptions and power/knowledge are challenged and re-asserted in these struggles and negotiations is critical. Reconciliation and peacebuilding through heritage is a continuous process that responds to and mediates the challenges of changing, diverse and conflicting present-day experiences, power structures and aspirations for the future by different interest groups. It is predicated on an explicit political affirmation that social justice is part of the social and political work of heritage-making. The interests, including those of expert communities that intersect with heritage making, have a clear responsibility to work toward an equitable and sustainable human future.

Notes

1 This chapter is the result of an ongoing project funded by the Australian Research Council (DP200102850). While we share co-authorship of the overall chapter, the section on Maori philosophies is contributed by Paul Tapsell and Merata Kawharu, the section on Ngarrindjeri approaches is contributed by Steve Hemming and Daryle Rigney, the section on concepts of heritage in the Western canon is contributed by Laurajane Smith, and the section on reconciliation is led by Lia Kent. Cressida Fforde provided the overview and general structuring of the chapter as well as contributions in various sections, and Laura Mayer provided support throughout.

2 The Community Peace Museums and Heritage Foundation directs thirteen community peace museums across Kenya. These collect and exhibit 'African peace heritage' and enable 'community access to resources and management of traditional peace materials' (Gachanga 2017: 127). Their collections are composed of tangible and intangible objects, including oral histories, peace artefacts, and symbols for peace, such as peace trees used in reconciliation ceremonies (Gachanga 2017: 128–129). Importantly, community peace museums actively use heritage to resolve community conflicts (e.g. Gachanga 2017: 129–130).

3 For information about the Uluru Statement see: https://www.aph.gov.au/About_Parliament/Parliamentary_Departments/Parliamentary_Library/pubs/rp/rp1617/Quick_Guides/UluruStatement (accessed 20 April 2022) https://www.nma.gov.au/defining-moments/resources/uluru-statement-heart (accessed 20 April 2022) https://fromtheheart.com.au/why-does-the-voice-matter/ (accessed 20 April 2022)

4 Seeking to gain the fullest national expression of Indigenous views on changes to the constitution, the Council held 13 First Nations Regional Dialogues attended by 1200 delegates in total and received the views of a further 200,000 people (both Indigenous and non-Indigenous people) through various channels including social media, surveys and written submissions.

5 https://ulurustatement.org (accessed 20 April 2022)

6 Ngarrinderi Yarluwar-Ruwe (Country) is located in southern South Australia along the lower reaches of Australia's longest river – the Murray (see Ngarrindjeri Nation and Hemming 2019).

7 Ceremonial presentation of a taonga in a ritualised context by which the receiver is honour-bound to uphold the intent – future-focused obligation – of the gift, cross-generationally.

8 The 1967 Referendum was staged buy the Commonwealth government to ask voting Australian citizens about proposed changes to the Constitution that included Aboriginal people in census counts and moved the Aboriginal affairs responsibility to the Commonwealth Government (Attwood and Markus 2007).

9 Jekejere is the name of one of the Ngarrindjeri creation ancestors important to the area where the Hindmarsh Island bridge was built.

10 The Proclamation was hand-delivered to Her Excellency Marjorie Jackson Nelson, Governor of South Australia, by four Ngarrindjeri leaders, George Trevorrow, Matt Rigney, Tom Trevorrow and Ellen Trevorrow on the 17 December 2003 for presentation to the State Government.

References

Agrawal, A. 1995. 'Dismantling the divide between Indigenous and scientific knowledge'. *Development and Change* 26(3): 413–439.

Aikawa-Faure, N. 2009. 'From the proclamation of masterpieces to the Convention for the Safeguarding of ICH'. In Smith, L. and Akagawa, N. (eds.), *Intangible Heritage*. London: Routledge.

Anderson, E. 2020. 'Reading the world's liveliness: Animist ecologies in Indigenous knowledges, new materialism and women's writing'. *Feminist Modernist Studies*, 3(2): 205–216.

Apsel, J. 2015. *Introducing Peace Museums*. London: Taylor and Francis.

Ashley, S. and Frank, S. 2016. 'Heritage-outside-in'. *International Journal of Heritage Studies*, 22(7): 501–503.

Attwood, B. and Arnold, J. (eds.) 1992. *Power, Knowledge and Aborigines,* A Special Edition of the *Journal of Australian Studies*. Bundoora: La Trobe University Press in association with the National Centre for Australian Studies and Monash University.

Attwood, B. and Markus, A. 2007. *The 1967 Referendum:* Race, *Power and the Australian Constitution*. Canberra: Aboriginal Studies Press.

Bardgett, S. 2012. 'The material culture of persecution: Collecting for the Holocaust Exhibition at the Imperial War Museum. In Were, G. and King, J (eds.), *Extreme Collecting: Challenging Practices for 21st Century Museums*. Berghahn Books, pp. 19–36.

Barsalou, J. and V. Baxter 2007. 'The urge to remember. The role of memorials in social reconstruction and transitional justice'. *Stabilization and Reconstruction Series*, no. 5.

Bell, D. 1998. *Ngarrindjeri Wuruwarrin: A World That Is, Was, and Will Be.* North Melbourne: Spinifex Press.

Bell, D. 2008. *Kungun Ngarrindjeri Miminar Yunnan: Listen to Ngarrindjeri Women Speaking.* North Melbourne: Spinifex Press.

Berg. S. 2010. *Coming to Terms: Aboriginal Title in South Australia.* Adelaide: Wakefield Press.

Bennett, T. 1995. *The Birth of the Museum: History, Theory, Politics.* Routledge.

Biesta, G. 2013. Interrupting the politics of learning. *Power and Education,* 5(1): 4–15.

Biesta, G. 2015. Freeing teaching from learning: Opening up existential possibilities in educational relationships. *Studies in Philosophy and Education,* 34: 229–243.

Bigenho, M. and Stobart, H. 2016. 'The Devil in nationalism: Indigenous heritage and the challenges of decolonisation'. *International Journal of Cultural Property,* 23: 141–166.

Bignall, S. 2010. *Postcolonial Agency: Critique and Constructivism.* Edinburgh: Edinburgh Press.

Bignall, S. 2014. 'The collaborative struggle for Excolonialism'. *Settler Colonial Studies,* 4(4): 340–356.

Bignall, S., Hemming. S., and D. Rigney 2016. 'Three ecosophies for the Anthropocene: Environmental governance, continental posthumanism and Indigenous expressivism'. *Deleuze Studies,* 10.4 (2016): 455–478.

Bloomfield. D. 2006. 'On good terms: Clarifying reconciliation'. Berghof Report no 14, Berghof Research Centre for Constructive Conflict Management.

Blustein, J. 2008. *The Moral Demands of Memory.* Cambridge: Cambridge University Press.

Burridge, N. 2009. 'Perspectives on reconciliation and Indigenous rights'. *Cosmopolitan Civil Societies,* 1(2): 111–129.

Braidotti, R. 2013. *The Posthuman.* Cambridge: Polity Press.

Braidotti, R. and Bignall, S. (eds.) 2019. *Posthuman Ecologies: Complexity and Process after Deleuze.* New York and London: Rowman & Littlefield.

Brigg, M. 2016. 'Engaging Indigenous Knowledges: From Sovereign to Relational Knowers'. *The Australian Journal of Indigenous Education,* 45(2): 152–158. 10.1017/jie.2016.5.

Byrd, J. 2011. *The Transit of Empire: Indigenous Critiques of Colonialism.* Minneapolis: University of Minnesota Press.

Byrne, D. 2020. 'Divinely significant: towards a post secular approach to the materiality of popular religion in Asia'. *International Journal of Heritage Studies,* 26(9): 857–873.

Campbell, G. and Smith, L. 2016, June. Keeping Critical Heritage Studies Critical: Why 'Post Humanism' and the 'New Materialism' Are Not So Critical. In Unpublished Conference Paper, Association of Critical Heritage Studies Conference, Montreal. https://anu-au.academia.edu/LaurajaneSmith.

Castellano, M. B. 2011. 'A holistic approach to reconciliation: Insights from Research of the Aboriginal Healing Foundation'. In Castellano, M. B., et al. *From Truth to Reconciliation: Transforming the Legacy of Residential Schools.* Aboriginal Healing Foundation.

Darweish, M. and Rank, C. (eds). 2012. *Peacebuilding and Reconciliation: Contemporary Themes and Challenges.* Pluto Press, 1–12.

Dean, D. 2013. 'Museums as sites of historical understanding, peace, and social justice: Views from Canada'. *Peace and Conflict:Journal of Peace Psychology,* 19(4): 325–337.

Deloria, V. Jr. 1969. *Custer Died for Your Sins: An Indian Manifesto.* London: Macmillan.

Deloria, V. 1992. 'Indians, archaeologists, and the future'. *American Antiquity,* 57(4), 595–598.

DeSilvey, C. 2017. *Curated Decay: Heritage Beyond Saving.* Minneapolis: University of Minnesota Press.

DEWNR and NRA (Department of Environment, Water and Natural Resources and Ngarrindjeri Regional Authority) 2016. *The Kungun Ngarrindjeri Yunnan Agreement*

(KNYA) – Listen to Ngarrindjeri People Talking – Report 2014–2015. Adelaide: Government of South Australia. https://www.environment.sa.gov.au/files/sharedassets/public/corporate/about_us/knya-taskforce-2014-15-rep.pdf

Dicks, B. 2000. Heritage, Place and Community. Cardiff: University of Wales Press.

Doering, Z. D. and Pekarik, A. J. 1996. 'Questioning the entrance narrative'. The Journal of Museum Education, 21(3): 20–23.

Dungen, P v.d. 2017. 'The heritage of peace: The importance of peace museums for the development of a culture of peace'. In Walters, et al. (eds.), Heritage and Peacebuilding. Newcastle: Boydell Press, pp. 7–16.

Edmonds, P. 2016. Settler Colonialism and (Re)conciliation: Frontier Violence, Affective Performances, and Imaginative Refounding. London: Palgrave Macmillan.

Fforde, C., Keeler, H., and McKeown, T. (eds.) 2020. The Routledge Companion to Indigenous Repatriation: Return, Reconcile, Renew. New York: Routledge.

Fromm, A. B., Rekdal, P. B., and Golding, V. 2014. Museums and Truth. Newcastle upon Tyne: Cambridge Scholars Publishing.

Fraser, N. 1995. 'From Redistribution to Recognition? Dilemmas of Justice in a 'Postsocialist' Age'. New Left Review, (212, July): 68–93.

Fraser, N. 2001. 'Recognition without ethics?'. Theory, Culture and Society, 18(2–3): 21–42.

Frayling, N. 2009. Toward the Healing of History: An Exploration of the Relationship Between Pardon and Peace. In J. Quinn (ed). Reconciliation(s): Transitional Justice in Postconflict Societies. McGill: Queen's University Press.

Gachanga, T. 2017. 'Transforming conflict through peace cultures'. In Walters, et al. (eds.). Heritage and Peacebuilding. Newcastle: Boydell Press, pp. 127–135.

Gentry, K. and Smith, L. 2019. 'Critical Heritage Studies and the legacies of the late-twentieth century heritage canon'. International Journal of Heritage Studies, 25(11): 1148–1168.

Gerstenblith, P. 2015. 'The destruction of cultural heritage: A crime against property or a crime against people'. John Marshall Review of Intellectual Property Law. 15(336): 335–393.

Giblin, J. D. 2014. 'Post-conflict heritage: Symbolic healing and cultural renewal'. International Journal of Heritage Studies, 20(5): 500–518.

Gittings, J. 2012. The Glorious Art of Peace: From the Iliad to Iraq. OUP.

González-Ruibal, A. (2019). 'Ethical Issues in Indigenous Archaeology: Problems with Difference and Collaboration'. Canadian Journal of Bioethics, 2(3):334–43 10.7202/1066461ar.

Graham, B. J., Ashworth, G. J., and Tunbridge, J. E. 2000. A Geography of Heritage: Power, Culture and Economy. London: Arnold Publishers.

Grey, S., and Kuokkanen, R. (2019). 'Indigenous governance of cultural heritage: searching for alternatives to co-management.'. International Journal of Heritage Studies, 26(10):919–941. 10.1080/13527258.2019.1703202.

Hafstein, V. Tr. 2018. Making Intangible Heritage: El Condor Pasa and Other Stories from UNESCO. Bloomington: Indiana University Press.

Hall, S. 1999. 'Whose Heritage? Un-settling 'The Heritage', Re-imaging the Post-nation'. Third Text, 13(49): 3–13.

Hamber, B. and Kelly, G. 2004. 'A working definition of reconciliation'. Democratic Dialogue.

Hamber, B., Sevcenko, L., and Naidu, E. 2010. 'Utopian dreams or practical possibilities: The Challenge of evaluating memorialization in societies in transition'. International Journal of Transitional Justice, 4: 397–420.

Hammami, F. and D. Laven 2017. 'Rethinking heritage from peace: Reflections from the Palestinian–Israeli context'. In Walters, D., et al. (eds.), *Heritage and Peacebuilding*. Newcastle: Boydell Press, pp.137–148.

Harris, J. 2010. 'Memorials and trauma'. In Broderick, M. and Traverso, A. (eds.), *Trauma, Media, Art: New Perspectives*. Newcastle: Cambridge Scholars Publishing.

Harrison, R. 2013. *Heritage: Critical Approaches*. London: Routledge.

Harrison, R., Bartolini, N., DeSilvey, C., Holtorf, C., Lyons, A., Macdonald, S. May, S., Morgan, J., and Penrose, S. 2016. 'Heritage futures'. *Archaeology International*, 19: 68–72.

Harrison, R., Desilvey, C., Holtorf, C., Macdonald, S., Bartolini, N., Breithoff, E., Fredheim, H., Lyons, A., May, S., Morgan, J., and Penrose, S. 2020. *Comparative Approaches to Natural and Cultural Heritage Practices*, London: UCL Press.

Harrison, R. and Sterling, C. (eds.) 2020. *Deterritorializing the Future: Heritage in, of and after the Anthropocene*. London: Open Humanities Press.

Hattam, R., Rigney, D., and Hemming, S. 2007. 'Reconciliation? Culture and Nature and the Murray River'. In Potter, E., Mackinnon, A, McKenzie, S., and McKay, J. (eds.), *Fresh Water: New Perspectives on Water in Australia*. Carlton, Victoria: Melbourne University Press, pp. 105–122.

Harvey, D.C. 2001. 'Heritage pasts and heritage presents: Temporality, meaning and the scope of Heritage Studies'. *International Journal of Heritage Studies*, 7(4): 319–338.

Hazard, S. 2019. 'Two ways of thinking about New Materialism'. *Material Religion*, 15(5): 629–631.

Healy, C. 2008. *Forgetting Aborigine*. Sydney: UNSW Press.

Hemming, S. 1993. 'Camp Coorong – Combining race relations and cultural education'. *Social Alternatives*, 12(1): 37–40.

Hemming, S. and Trevorrow, T. 2005. 'Kungun Ngarrindjeri Yunnan: Archaeology, colonialism and re-claiming the future'. In Smith, C. and Martin Wobst, H. (eds.), *Indigenous Archaeologies: Decolonising Theory and Practice*. London: Routledge, pp. 243–261.

Hemming, S. 2006 'The problem with Aboriginal heritage'. In Worby, G. and Rigney, L.-I. (eds.), *Sharing Spaces: Indigenous and non-Indigenous Responses to Story, Country and Rights*. Perth: API Network, pp. 305–328.

Hemming, S. and Rigney, D. 2008. 'Unsettling sustainability: Ngarrindjeri political litera-cies, strategies of engagement and transformation'. *Continuum: Journal of Media & Cultural Studies*, 22(6): 757–775.

Hemming, S. and Rigney, D. 2009. 'Encountering the common Knobby Club Rush: Reconciliation, public art and whiteness'. In Hosking, S., Hosking, R., Pannell, R., and Beirbaum, N. (eds.), *Something Rich & Strange: Sea Changes, Beaches and the Littoral in the Antipodes*. Kent Town, SA: Wakefield Press, pp. 264–277.

Hemming, S. and Rigney, D. 2010. 'Decentring the new protectors: Transforming Aboriginal heritage in South Australia'. *International Journal of Heritage Studies*, 16(1–2): 90–106.

Hemming, S., Rigney, D., and Berg, S. 2011. 'Ngarrindjeri futures: Negotiation, govern-ance and environmental management'. In Maddison, S. and Brigg, M. (eds.), *Unsettling the Settler State: Creativity and Resistance in Indigenous Settler-State Governance*. Sydney: Federations Press, pp. 98–113.

Hemming, S. and Rigney D. 2016. *Restoring Murray Futures. Incorporating Indigenous knowl-edge, values and interests into environmental water planning in the Coorong and Lakes Alexandrina and Albert Ramsar Wetland*. Adelaide, South Australia: Goyder Institute for Water Research Technical Report Series No. 16/8.

Hemming, S. and Rigney, D. 2019. 'Towards Ngarrindjeri Co-management of *Yarluwar-Ruwe* (Sea Country – Lands, Waters and All Living Things)'. In Mosely, L., Ye, Q., Shepherd, S., Hemming, S., and Fitzpatrick, R. (eds.), *Natural History of the Coorong, Lower Lakes, and Murray Mouth Region (Yarluwar-Ruwe)*. Adelaide: Royal Society of South Australia, Adelaide University Press, pp. 501–522.

Hemming, S., Rigney, D., Bignall, S., Berg, S., and Rigney, G. 2019. 'Indigenous nation building for environmental futures: *Murrundi* flows through Ngarrindjeri country'. *Australasian Journal of Environmental Management*, 26(3), 216–235, DOI: 10.1080/14486563. 2019.1651227

Hemming, S., Rigney, D., and Berg S. 2019. 'Ngarrindjeri nation building: Securing a future as Ngarrindjeri Ruwe/Ruwar (Lands, waters and all living things)'. In Nikolakis, W., Cornell, S., and Nelson, H. (eds.), *Reclaiming Indigenous Governance: Reflections and Insights from Australia, Canada, New Zealand, and the United States*. Tucson, USA: The University of Arizona Press, pp. 71–104.

Hemming, S., Rigney, D., Sumner, W., Trevorrow, M., Rankine, Jnr. L., and Wilson, C. 2020a. 'Returning to Yarluwar-Ruwe: Repatriation as a Sovereign Act of Healing'. In Fforde, C., Keeler, H., and McKeown, T. (eds.), *The Routledge Companion to Indigenous Repatriation: Return, Reconcile, Renew*. New York: Routledge, pp. 769–809.

Hemming, S., Rigney, D., Grant, R., Sutherland, L., Wilson, H. Overdevest, N., Della-Sale, A., and Maxwell, S. 2020b. *Translating Ngarrindjeri Yannarumi into Water Resource Risk Assessments*. Adelaide, South Australia: Goyder Institute for Water Research Technical Report Series No. 20/09. ISSN: 1839-2725.

Hewison, R. 1987. *The Heritage Industry: Britain in a Climate of Decline*. London: Methuen.

Hicks, D. 2011. *Dignity: The Essential Role It Plays in Resolving Conflict*. New Haven and London: Yale University Press.

Högberg, A., Holtorf, C., May, S., and Wollentz, G. 2017. 'No future in archaeological heritage management?' *World Archaeology*, 49(5): 639–647.

Hokowhitu, B. 2021. 'The emperor's 'new' materialisms: Indigenous materialisms and *disciplinary colonialism'*. In Hokowhitu, B, Moreton-Robinson, A., Tuhiwai-Smith, L., Anderson, C., and Larkin, S. (eds.), *Routledge Handbook of Critical Indigenous Studies*. London: Routledge, pp. 171–189.

Hooper-Greenhill, E. 2007. *Museums and Education: Purpose, Pedagogy, Performance*. London: Routledge.

Impunity Watch. 2015. 'Memory for Change': Memorialisation as a Tool for Transitional Justice Asia Exchange Report.

Ingold, T. (2014). 'Is there life amidst the ruins?' *Journal of Contemporary Archaeology*, 1–2: 231–235.

Kawharu, M. 2009. 'Ancestral landscapes and world heritage from a Māori viewpoint'. *The Journal of the Polynesian Society*, 118(4): 317–338.

Kawharu, H. 2005. *A Reconstruction of Maori Text. Waitangi Revisited: Perspectives on the Treaty of Waitangi*. Michael Belgrave, Merata Kawharu, and David Williams, eds. Oxford University Press.

Kawharu, M and Newman, E. 2018. Whakapaparanga: Social structure, leadership and whāngai. Te kōparapara: An introduction to the Māori world. 48–64.

Kelly, G. P. 2002. 'Developing a community of practice: Museums and reconciliation in Australia'. In Sandell, R. (ed.), *Museums, Society, Inequity*. London: Routledge, pp.

Kirshenblatt-Gimblett, B. 1998. *Destination Culture: Tourism, Museums, and Heritage*. Berkeley: University of California Press.

Kungun Ngarrindjeri Yunnan Agreement (KNYA). 2009. Ngarrindjeri Tendi Incorporated, Ngarrindjeri Heritage Committee Incorporated and Ngarrindjeri Native Title Management Committee for and on behalf of the Ngarrindjeri people and the Crown in right of the State of South Australia represented by the Minister for Environment and Conservation, the Minister for Aboriginal Affairs and Reconciliation, the Minister for the River Murray, and the Minister for Agriculture, Food and Fisheries (5 June 2009).

Krmpotich, C. 2014. *The Force of Family: Repatriation, Kinship, and Memory on Haida Gwaii*. University Toronto Press.

Langford, R. 1983. 'Our heritage- your playground'. *Australian Archaeology*, 16: 1–6.

Latour B 1999. *The Politics of Nature: How to Bring the Sciences into Democracy*. Cambridge, Massachusetts: Harvard University Press.

Latour, B. 2005. *Reassembling the Social: An Introduction to Actor-Network-Theory*. Oxford: Oxford University Press.

Lehman, G. 1995. *Aboriginal Interpretation of the Tasmanian Wilderness World Heritage Area: A Strategy for Interpreting the Culture and Heritage of Tasmanian Aborigines*. Hobart: TALC.

Lederach, J. P. 1997. *Building Peace: Sustainable Reconciliation in Divided Societies*. Washington: United States Institute of Peace Press.

Lehman, G. 1996. *Aboriginal Management in the Tasmanian Wilderness World Heritage Area*. Hobart: TPWS.

Lehman, G. and Bonyhandy, T. 2018. *The National Picture: The art of Tasmania's Black War*. Canberra: NGA.

Lehrer, E. 2010. 'Can there be a conciliatory heritage?' *International Journal for Heritage Studies*, 16(4–5): 261–288.

Littler, J. and Naidoo, R. 2004. 'White past, multicultural present: Heritage and national stories'. In Brocklehurst, H. and Phillips, R. (eds.), *History, Nationhood and the Question of Britain*. Basingstoke: Palgrave Macmillan.

Littler, J. and Naidoo, R. 2005 (eds.). *The Politics of Heritage: The Legacies of 'Race'*. London: Routledge.

Lixinski, L. 2011 'Selecting heritage: The interplay of art, politics and identity'. *European Journal of International Law*, 22(1): 81–100.

Lixinski, L. 2019. *International Heritage Law for Communities: Exclusion and Re-imagination*. Oxford: Oxford University Press.

Logan, W. and Reeves, K. 2009. *Places of Pain and Shame: Dealing with 'Difficult Heritage'*. London: Routledge.

Logan, W. 2013. Australia, Indigenous peoples and World Heritage from Kakadu to Cape York. *Journal of Social Archaeology*, 13(2): 153–176.

Logan, W. 2015. 'Remembering wars in Vietnam: Commemoration, memorialization and heritage management'. In Reeves, K., Bird, G., James, L., Stichelbaut, B., and J. Bourgeois (eds.), *Battlefield Events: Landscape, Commemoration and Heritage*. London: Routledge, pp. 217–234.

Lowenthal, D. 1985. *The Past is a Foreign Country*. Cambridge: Cambridge University Press.

Lowenthal, D. 1998. *The Heritage Crusade and the Spoils of History*, 2nd edn. Cambridge: Cambridge University Press.

Lowenthal, D. 2006. 'Heritage wars'. *Spiked* online: http://www.spiked-online.com/articles/0000000CAF.htm [accessed 1 June 2011].

Lowenthal, D. 2009. 'On arraigning ancestors: A critique of historical contrition'. *North Carolina Law Review*, 87: 901.

Maddison, S. 2017. 'Can we reconcile? Understanding the multi-level challenges of conflict transformation'. *International Political Science Review*, 38(2): 155–168.

Maddison, S., and Shepherd, L. J. 2014. Peacebuilding and the postcolonial politics of transitional justice. *Peacebuilding*, 2(3): 253–269. 10.1080/21647259.2014.899133.

Macdonald, S. 2010. *Difficult Heritage: Negotiating the Nazi Past in Nuremberg and Beyond*. London: Routledge.

Macdonald, S. 2013. *Memorylands: Heritage and Identity in Europe Today*. London: Routledge.

McNiven, I. J., and Russell, L. 2005. *Appropriated Pasts: Indigenous Peoples and the Colonial Culture of Archaeology*. Rowman Altamira.

Marrie, H. 2009. 'The UNESCO Convention for the Safeguarding of the Intangible Cultural Heritage and the Protection and Maintenance of the Intangible Cultural Heritage of Indigenous Peoples'. In Smith, L. and Akagawa, N. (eds.), *Intangible Heritage*. London: Routledge, pp. 169–192.

Morris, J.D.K. and Jacinta, R. 2010 'Giving voice to rivers: Legal personality as a vehicle for recognizing Indigenous peoples' relationships to water?' *Indigenous Law Review*, 14: 49-62.

Meskell, L. 2002. 'Negative heritage and past mastering in archaeology'. *Anthropological Quarterly*, 75(3): 557–574.

Meskell, L. 2013. 'UNESCO and the fate of the World Heritage Indigenous Peoples Council of Experts (WHIPCOE)'. *International Journal of Cultural Property*, 20: 155–174.

Meskell, L. 2018. *A Future in Ruins: UNESCO, World Heritage, and the Dream of Peace*. Oxford: Oxford University Press.

Mouffe, C. 2013. *Agonistics: Thinking the World Politically*. London: Verso.

Mouffe, C. 2019. *For a Left Populism*. London: Verso.

Muldoon, P. and Schaap, A. 2012. 'Aboriginal Sovereignty and the Politics of Reconciliation: The Constituent Power of the Aboriginal Embassy in Australia'. *Environment and Planning D*, 30: 534–550.

Munjeri, D. 2004. 'Tangible and intangible heritage: From difference to convergence'. *Museum International*, 56(1–2): 12–20.

Moreton-Robinson, A. 2004. 'The possessive logic of patriarchal white sovereignty: The High Court and the Yorta Yorta decision'. *Borderlands E - Journal*, 3(2): 1–9.

Nakata, M. 2007. *Disciplining the Savages, Savaging the Disciplines*. Canberra: ASP.

Ngarrindjeri Nation 2007. *Ngarrindjeri Nation Yarluwar-Ruwe Plan: Caring for Ngarrindjeri Sea Country and Culture*, prepared by the Ngarrindjeri Tendi, Ngarrindjeri Heritage Committee and Ngarrindjeri Native Title Management Committee on behalf of the Ngarrindjeri Nation. Ngarrindjeri Land and Progress Association, Camp Coorong, Meningie, SA.

Ngarrindjeri Nation & Hemming, S. 2019. 'Ngarrindjeri Nation Yarluwar-Ruwe Plan: Caring for Ngarrindjeri Country and Culture: Kungun Ngarrindjeri Yunnan (Listen to Ngarrindjeri People Talking)'. In Mosely, L., Ye, Q., Shepherd, S., Hemming, S., and Fitzpatrick, R. (eds.), *Natural History of the Coorong, Lower Lakes, and Murray Mouth Region (Yarluwar-Ruwe)*. Adelaide, SA: Royal Society of South Australia Inc., Adelaide University Press, pp. 3–21.

Ngarrindjeri Regional Authority (NRA) and the Minister for Sustainability, Environment and Conservation (SEC), 2014. *Ngarrindjeri Speaking as Country Deed*, 27 December 2014.

Olsen, B. 2013. *In Defense of Things*. Lantham: AltaMira Press.

Paradies, Y 2006. 'A systematic review of empirical research on self-reported racism and health'. *International Journal of Epidemiology*, 35(4): 888–901.

Paffenholz, T. (2013). 'International peacebuilding goes local: analysing Lederach's conflict transformation theory and its ambivalent encounter with 20 years of practice'. *Peacebuilding*, 2(1):11–27. 10.1080/21647259.2013.783257.

Pekarik, A. J., Doering, Z. D., and Karns, D. A. 1999. 'Exploring satisfying experiences in museums'. *Curator: The Museums Journal*, 42(2): 152–173.

Pekarik, A. J. and Schreiber, J. B. 2012. 'The power of expectation'. *Curator: The Museums Journal*, 55(4): 487–496.

Perry, S. 2019. 'The enchantment of the archaeological record'. *European Journal of Archaeology*, 22(3): 354–371.

Pétursdóttir, P. 2020. 'Anticipated futures? Knowing the heritage of drift matter'. *International Journal of Heritage Studies*, 26(1): 87–103.

Pétursdóttir, P. and Olsen, B. 2018. 'Theory adrift: The matter of archaeological theorising'. *Journal of Social Archaeology*, 18(1): 97–117.

Povinelli, E. A. 2016. *Geontologies: A Requiem to Late Liberalism*. Durham and London: Duke University Press.

Probyn-Rapsey, F. 2007. 'Kin-Infused Reconciuliation: Bringing Them Home, Bringing Us Home'. *Australian Humanities Review*, 47, http://australianhumanitiesreview.org/2007/08/01/kin-fused-reconciliation-bringing-them-home-bringing-us-home/

Randozzo, E. 2021. 'The Local, the "Indigenous" and the Limits of Rethinking Peacebuilding', *Journal of intervention*, 15(2):141–160.

Ramsbotham, O. 2010. *Transforming Violent Conflict: Radical Disagreement, Dialogue and Survival*. London:Routledge.

Read, P. 2008. 'The Truth that will set us all free'. An uncertain history of memorials to Indigenous Australians. *Public Hist Rev*, 15: 30–46.

Rekret 2018. 'The head, the hand, and matter: New materialism and the politics of knowledge'. *Theory, Culture & Society*, 35(7–8): 49–72.

Rifkin, M. 2016. 'On the (geo)politics of belonging: Agamben and the UN Declaration on the Rights of Indigenous Peoples'. *Settler Colonial Studies*, 6(4): 339–348. 10.1080/2201473X.2015.1090527

Rigney, D. and Hemming, S. 2014. 'Is "Closing the Gap" Enough? Ngarrindjeri ontologies, reconciliation and caring for country'. *Educational Philosophy and Theory*, 46(5): 536–545.

Rigney, D., Bignall, S., and Hemming, S. (2015) Negotiating Indigenous modernity. Kungun Ngarrindjeri Yunnan – Listen to Ngarrindjeri speak. *AlterNative*, 11(4): 334–349.

Rigney, D., Hemming, S., Bignall, S., Maher, K. 2018. 'Ngarrindjeri Yannarumi: Educating for transformation and Indigenous nation (re)building'. In McKinley, E. and Smith, L. (eds.), *Handbook of Indigenous Education*. Singapore: Springer.

Rigney, D., Vivian, A., Hemming, S., Berg, S., Bignall, S., and Bell, D. 2021. 'Treaty as a technology for Indigenous nation building'. In Smith, D., Wighton, A., Cornell, S., and Delany, A. V. (eds.), *Developing Governance and Governing Development: International Case Studies of Indigenous Futures*. New York: Rowman and Littlefield, pp. 119–140.

RiverOfLife, M., Pelizzon, A., Poelina, A., Akhtar-Khavari, A., Clark, C., Laborde, S., Macpherson, E., O'Bryan, K., O'Donnell, E., and Page, J. 2021. 'Yoongoorrookoo, the emergence of ancestral personhood'. *Griffith Law Review*. 10.1080/10383441.2021.1996882

Rosiek, J.L., Snyder, J., and Pratt, S.L. 2020. 'The new materialisms and Indigenous theories of non-human agency: Making the case for respectful anti-colonial engagement'. *Qualitative Inquiry*, 26(3–4): 331–346.

Russell, L. 2001. *Savage Imaginings: Historical and Contemporary Constructions of Australian Aboriginalities*. Melbourne: Australian Scholarly Publishing.

Samuel, R. 1994. *Theatres of Memory: Past and Present in Contemporary Culture*. London: Verso Books.

Scham, S. and Yahya, A. 2003. 'Heritage and Reconciliation'. *Journal of Social Archaeology*, 3(3): 319–416.

Short, D. 2016. *Reconciliation and Colonial Power: Indigenous Rights in Australia*. London: Routledge.

Short, D. 2012. 'When sorry isn't good enough: Official remembrance and reconciliation in Australia'. *Memory Studies*, 5(3): 293–304.

Simons, M. 2003. *The Meeting of the Waters: the Hindmarsh Island Affair*. Sydney: Hodder Headline.

Smith, C., Burke, H., Ralhp, J., Pollard, K., Gorman, A., Wilson, C., Hemming, S., Rigney, D., Morrison, M., McNaughton, D., Domingo, I, Moffat, I., Roberts, A., Koolmtrie, J., Willika, J., Pamkal, B., and Jackson, G. 2019. 'Pursuing social justice through collaborative arcaheologies in Aboriginal Australia'. *Archaeologies*, 10.1007/s11759-019-09382-7

Smith, C. and Wobst, H. M. (eds.) 2005. *Indigenous Archaeologies: Decolonizing Theory and Practice*. London: Routledge.

Smith, L. and Akagawa, N. (Eds.) 2009. *Intangible Heritage*.London: Routledge.

Smith, L. 2004. *Archaeological Theory and the Politics of Cultural Heritage*. London: Routledge.

Smith, L. 2006. *Uses of Heritage*. London: Routledge.

Smith, L. 2010. 'Man's inhumanity to man' and other platitudes of avoidance and mis-recognition: An analysis of visitor responses to exhibitions marking the 1807 bicentenary'. *Museum & Society*, 8(3): 193–214.

Smith, L. 2015. 'Intangible Heritage: A challenge to the authorised heritage discourse?' *Revista d'etnologia de Catalunya*, 40: 133–142.

Smith, L. 2021. *Emotional Heritage: Visitor Engagement at Museums and Heritage Sites*. London: Routledge.

Smith, L. and Campbell, G. 2016. 'The elephant in the room: Heritage, affect and emotion'. In Logan, W., Nic Craith, M., and Kockel, U. (eds.), *A Companion to Heritage Studies*. Chichester: Wiley-Blackwell.

Smith, L., Cubitt, G., Fouskei, K., and Wilson, R. (eds.) 2011. *Representing Enslavement and Abolition in Museums: Ambiguous engagements*. New York: Routledge.

Smith, L.T. 1999. *Decolonizing Methodologies: Research and Indigenous Peoples*. London: Zed Books.

Solli, B. 2011. 'Some reflections on heritage and archaeology in the Anthropocene'. *Norwegian Archaeological Review*, 44(1): 40–54.

Somjee, S. 2017. 'A conversation with Sultan Somjee: Conflict and peacebuilding in Kenya'. In Walters, et al. (eds.), *Heritage and Peacebuilding*. Boydell Press, pp. 71–76.

Sterling, C. 2020. 'Critical heritage and the posthumanities: Problems and prospects'. *International Journal of Heritage Studies*, 26(11): 1029–1046.

Sterling, C. and Harrison, R. 2020. 'Introduction: Of territories and temporalities'. In Harrison, R. and Sterling, C. (eds.), *Deterritorializing the Future: Heritage in, of and after the Anthropocene*. London: Open Humanities Press, pp. 19–54.

Strakosch, E. 2010. 'Counter-Monuments and Nation-Building in Australia'. *Peace Review*, 22(3): 268–275.

Stevens, I. 1995. *Report of the Hindmarsh Island Bridge Royal Commission*. Adelaide: SA Government Printer.

Stone, P. and MacKenzie, R. 1990. *The Excluded Past: Archaeology in Education*. London: Routledge.

Stone, P. 2016. 'The Challenge of Protecting Heritage in Times of Armed Conflict'. *Museum International*, 67(1–4): 40–54.

Sutton, P. 2010. 'Mediating conflict in an age of Native Title'. *AAS*, 2010/1: 4–18.

Tapsell, P. 2003. Partnership in museums: A tribal Maori response to repatriation. In Fforde, C., Hurbert, J., and Turnbull, P. (eds.), *The Dead and their Possessions*, London: Routledge, pp. 302–310.

Thornton, R. 2002. 'Repatriation as healing the wounds of the trauma of history: Cases of Native Americans in the United States of America'. In Fforde, C., Hubert, J., and Turnbull, P. (eds.), *The Dead and Their Possessions*. London: Routledge, pp. 17–24.

Todd, Z. 2016. 'An Indigenous feminist's take on the oncological turn: 'Ontology' is just another word for colonialism'. *Journal of Historical Sociology*, 29(1). 10.1111/johs.12124

Tompkins, K. W. 2016. 'On the limits and promise of new materialist philosophy'. *Lateral*, 5.1 10.25158/L5.1.8

Tunbridge, J. and Ashworth, G. 1996. *Dissonant Heritage: The Management of the Past as a Resource in Conflict*. Chichester: J. Wiley.

Tully, J. 2000. 'Struggles over recognition and distribution'. *Constellations*, 7(4): 469–482.

UNESCO World Heritage Centre 2008. *World Heritage Information Kit*. Paris: World Heritage Centre. http://whc.unesco.org/documents/publi_infokit_en.pdf

Verdeja, E. 2017. 'Political reconciliation in postcolonial settler societies'. *International Political Science Review*, 38(2):227–241.

Wallis, J., Jeffery, R., and Kent, L. 2016. 'Political reconciliation in Timor Leste, Solomon Islands and Bougainville: the dark side of hybridity'. *Australian Journal of International Affairs*, 70(2):159–178. 10.1080/10357718.2015.1113231.

Walters, D., Laven, D., and Davis, P. (eds.) 2017. *Heritage and Peacebuilding*. Newcastle: Boydell Press.

Walters, D., Laven, D. and Davis, P. 2017 'Introduction'. In Walters et al., *Heritage and Peacebuilding*. Newcastle: Boydell Press, pp. 1–4.

Watkins, J. 2001. 'Yours, mine, or ours? Conflicts between archaeologists and ethnic groups', in T. Bray (ed). *The Future of the Past: Archaeologists, Native Americans, and Repatriation*. New York: Garland Publishing.

Williams, P. 2007. *Memorial Museums: The Global Rush to Commemorate Atrocities*. NYU.

Wilson, K. M. 2016. 'Building memory: Museums, trauma, and the aesthetics of confrontation in Argentina'. *Latin American Perspectives*, 43(5): 112–130.

Worby, G. and Rigney, L.-I. (eds.) 2006. *Sharing Spaces: Indigenous and non-Indigenous Responses to Story, Country and Rights*. Perth: API Network.

Whyte, K.P. 2013. 'On the role of traditional ecological knowledge as a collaborative concept: A philosophical study'. *Ecological Processes*, 2(1), 7. 10.1186/2192-1709-2-7

Wright, P. 1985. *On Living in an Old Country*. London: Verso.

SECTION VII

Unsettled Urbanisms and Emergent Internationalisms

The Covid-19 pandemic has notoriously thrown into question foundational understandings about urban life, in particular, as Sybille Frank, George Krajewsky and Jochen Schwenk–the authors of the carefully argued chapter that opens this section–put it: 'the modernist notion that urbanism, and ultimately gains in civilization, can be derived from a particular structure of the urban (large, dense, heterogenous)'. They argue further that the pandemic has made visible long-standing blind spots in the heritage of urbanity. These include deeply embedded technoid fantasies of feasibility and control, and a focus on technical infrastructures at the cost of the people who work to ward off risk. In particular, they focus on 'a silent group that has hardly played a part in the discourse on cities and heritage so far', but whose importance has been made manifest by the pandemic: essential workers. They note that while the heritage of labor has largely been reduced to industrial workers and adjoining sectors under organized capitalism, new forms of precarious labor have emerged under conditions of disorganized flexible capitalism. They write 'Disturbingly, it is precisely the sectors in which essential workers seek to earn a living (delivery services, waste collection, care work in hospitals, kindergartens or old people's homes, cleaning, teaching, etc.) that are dominated by non-standard occupations'. Turning to the question of heritage futures, they argue that the challenge for a Critical Heritage Studies project going forwards will be to embrace the heritage of people and groups who do not have access to the representational political system.

In a wide-ranging chapter, Tim Winter moves quickly and incisively through a number of geopolitical contexts to unfold 'the history of cultural internationalism and its world ordering possibilities'–and to point to emerging trends and possible futures. The core arguments presented by Winter include the idea of 2020 being in many ways a watershed year; the manner in which #BLM has resulted in a decisive

DOI: 10.4324/9781003188438-21

mainstreaming of concerns around coloniality and racism; the retreat of the Western democracies from multilateralism and international engagement; the concomitant tilt toward Asia and the rise of competing civilizational narratives; and the renewed salience of heritage in this transformed cultural, geopolitical, and geoeconomic landscape. At the core of this account is the manner in which China is remaking the geopolitical and geoeconomic landscapes of the twenty-first century, in part through its ambitious and far-reaching Belt and Road Initiative. Reviewing these various developments, Winter writes 'Societal crises spawn hostility, resentment and suspicion … Covid-19 arrived at a time when various forms of populist nationalism were gaining ascendency across a significant number of countries. Such challenges … mean that a commitment to international dialogue and collaboration is as important now as it was at any point during the twentieth century'.

14

UNSETTLING THE HERITAGE OF URBANITY

Urbanism and Urban Space in Pandemic Times

Sybille Frank, Georg Krajewsky, and Jochen Schwenk

Introduction

Since 2020, the COVID-19 pandemic has drastically disrupted everyday urban life. With urban provinces shut down, globally enacted orders of social distancing (which actually aimed for physical distancing) and the extensive closure of public life, the urban fabric seemed to dissolve into many monadic islands of private homes–at least for those who could afford this luxury. The attempts to contain the highly infectious and deadly SARS-CoV-2 virus have seriously questioned the foundations of urbanism. Almost from one day to another, the features of urban spaces recurred as sources of individual risk, rather than enablers of rationalisation, civility, and social emancipation–as they are often imagined.

Soon after the first lockdowns, debates about the 'end of urbanism' (as we knew it) started in the field of urban studies (Höhne and Michel 2021). Scholars discussed the effects of lockdowns, the substantial record of urban pathologies, and shifts in urbanism discourse (e.g. Keil 2020, Löw and Knoblauch 2020, McFarlane 2021).[1] Like most observers, we do not claim that the characteristics of urbanism as a way of life disappeared during the pandemic. We argue that the global challenges to contain the COVID-19 outbreak have reminded us of the often understated entanglement between city dwellings and pathogens (Gandy 2021). The pandemic has shifted our attention to the silenced and forgotten aspects of both urbanism as a way of life and urban space, that lie at the heart of the modern idea(l) of urbanity. From a heritage studies point of view, such a perspective raises several interesting questions: How have pandemics been commemorated in urban space? How does the current pandemic influence ideas about urban space and urbanism that have constituted a powerful body of material and immaterial heritage so far? And to what extent do we

DOI: 10.4324/9781003188438-22

need to adjust the normative idea(l) of urbanity and its heritage in order to render current debates in Critical Heritage Studies (Harrison 2010, Smith 2012) even more critical and comprehensive?

The aim of this chapter is to discuss the heritage of urbanity in the light of the current COVID-19 pandemic. In doing so, we draw on different debates in urban studies and memory/heritage studies. In the following section, we will briefly reconstruct the conceptualisation of, and the connection between the urban and urbanism that fed into the normative concept or idea(l) of urbanity. We will continue to examine how this idea(l) has been challenged by the COVID-19 pandemic over the past two years. We will demonstrate that the strategies to contain viral transmission reveal the (materialised) heritage of urban pathologies and inform sceptical urbanity discourses and biopolitical forms of urban governance. Lastly, we will evaluate which aspects of the record of urban pathologies/pandemics are commemorated or forgotten in urban space, and which aspects of urbanism as a way of life have been picked up by activist groups and heritage studies. We will end this chapter with a critical reflection on the heritage of urbanity as an idea(l), whose long-standing blind spots have become visible during the pandemic, and discuss how a stronger emphasis on these blind spots could inform future heritage studies and practice.

The Urban, Urbanism, and the Idea(l) of Urbanity

To get an idea of what can be called the heritage of urbanity, it is helpful to conceptually distinguish three different levels: The urban, urbanism, and urbanity. In order to determine the urban, one can refer back to the classical definition of the city as formulated by Louis Wirth (1938). He conceptualised the city as a 'relatively large, dense, and permanent settlement of socially heterogeneous individuals' (Wirth 1938, 8). As a large, dense and heterogeneous space, the urban is the foundation of everything else. It is the basis of urbanism and urbanity.

Urbanism then refers to the specific 'way of life' (Wirth 1938) that emerges in urban space. Georg Simmel, for example, argued that the modern metropolis leads to a cognitive overload of urban dwellers (Simmel 2005, 25). The urban lifestyle then is a specific way of responding to the excessive nervous stimulation in the habitat of the modern city. Following Simmel, it is characterised above all by a detached conduct, which can be observed in relation to both things and people. On the one hand, Simmel asserts that city dwellers protect themselves from over-stimulation by adopting a 'blasé attitude' (Simmel 2005, 26) toward things. As a result, the peculiarities of things lose importance, while the question of quantifi-cation comes to the fore. For Simmel, this transformation of qualities into quantities (Simmel 2005, 25) is an essential feature of urbanism. Modern rationalism rests on it, as does the expansion of the money economy (Simmel 2005, 25). Conversely, rationality and the money economy refer back to the large, dense, and heteroge-neous space of the modern city.

On the other hand, Simmel argues that city dwellers also behave in a distanced manner towards their fellow human beings. He characterises city dwellers by a reserved and aversive attitude towards others (Simmel 2005, 27). Since city dwellers cannot get involved with every individual, they distance themselves socially. This demarcating behaviour has various effects: Following German urban theorist Hans Paul Bahrdt the social life of city dwellers is characterised by the distinction between public and private spheres (Bahrdt 2006, 81–130). While emotional closeness and intimacy have their place in the private sphere, the public sphere is the place of dispassionate interaction with the many others, with strangers. Therefore, social integration in large cities is mostly integration through weak ties. Georg Simmel describes the public life of city dwellers as a life in different, partly overlapping social circles (Simmel 2005, 29). Subsequently, Louis Wirth even speaks of a segmented personality of city dwellers, which varies according to social context. Comprehensively shared values and belief systems thus lose their significance. The urban lifestyle is secular[2] (Wirth 1938, 15) and cosmopolitan (Simmel 2005, 29). In the metropolis, people with different religious beliefs may live together peacefully. As the lowest common denominator common interest gains importance. Utility becomes the decisive factor of social ties (Wirth 1938, 13). This is also promoted by the money-mediated rationality of the urban lifestyle: the urban society is a utilitarian society. It is marked by 'the intellectually calculating economic egoism' (Simmel 2005, 26). For the individual, this loose integration is associated with gains in freedom. At the same time, individuals compete with other individuals to attract attention on the stage of the urban public sphere. There is a 'spirit of competition' (Wirth 1938, 15) that encourages individuals to behave extravagantly and capriciously (Simmel 2005, 30). 'Personal freedom' (Simmel 2005, 28) and expressive individuality are thus also characteristic of the urban lifestyle.

Although urban theorists like Simmel and Wirth are at pains to point out the ambivalences of the urban lifestyle in terms of social anomy and psychical illnesses (Simmel 2005, 27; Wirth 1938, 23), a modernist attitude predominates, which sees urbanism primarily as a gain in civility. This concerns, first of all, a typically distanced attitude and behaviour. It makes it possible for strangers to live together in spite of great spatial proximity and different values and norms, oriented solely to common interests. Gains in personal and expressive freedom as well as the segregated personality are understood as civilisation advances. On a similar vein, the money economy, i.e. money-mediated exchange on the market, through which the members of urban society ultimately articulate and satisfy their needs, is seen as progress.

However, cities are not only real but also imaginary places. The built environment of the city is loaded with ideas, ideas about its meaning. Therefore, the city has a double existence: as a topographic historical place made of stones and concrete and as an imaginary place made of ideas, reflecting the general idea of the city in a certain time and society. Urbanity is one of these ideas. Urbanity picks up on this description of 'urbanism as a way of life' (Wirth 1938). It refers

to the modernist notion that urbanism, and ultimately gains in civilisation, can be derived from a particular structure of the urban (large, dense, heterogeneous). In short, urbanity is an ideology promising that the desired civilising effects of urbanism can be achieved through the design of the urban. The problem is that this concept of urbanity has strong biases. The description of the urban lifestyle is based primarily on a bourgeois perception of the world, which does not take up the perspective of the working class (Engels 1993), women (McDowell 1983), the colonised (Yeoh 2001), or the LGBTQ community (Doan 2011) accordingly. Nevertheless, architects, urban planners, and urban theorists have sought (and continue to seek) ways to realise the civilisational gains associated with urbanism.[3] As a regulative idea(l), this ideological notion of urbanity has become the guiding principle for action. It became hegemonic not only in Euroamerica, but also spread globally in the context of colonial domination (King 2005; Ha 2014)–often with the help of force (Lanz 2015, 76). The modern–that is, large, dense, and heterogeneous–metropolis has thus become the normative standard against which all large cities must implicitly or explicitly be measured. Urbanity, that means, the normatively charged idea of a specific interplay of the urban and urbanism, is what we discuss here as (immaterial) heritage.

COVID-19 and the Blind Spots of Urbanity

The COVID-19 pandemic has interrupted everyday urban life on an unprecedented scale. Never before in human history has an epidemic affected so many regions and people around the globe at the same time. The extent of this viral outbreak is obviously linked to the current quantitative level of urbanisation and global interconnection, which significantly accelerates microbial traffic of pathogens (Ali and Keil 2008, 11). Moreover, the current COVID-19 pandemic funda-mentally questions the qualities of urban spaces, urbanism, and the heritage of urbanity as it is typically imagined by urban experts.

Based on two containment strategies we will discuss how urban spaces have been re-evaluated as a source of risk. However, this re-evaluation does not mean that the characteristics of urbanism described by Wirth and Simmel have disappeared. It rather reminds us of the fundamental entanglement between city dwelling and pathogens and biopolitical urban discourses that have re-occurred as a 'dark side' of urbanity.

Re-Evaluation of Urban Spaces: Avoiding Density and Limiting Heterogeneity

Since physical proximity of individuals is a key condition for the reproduction of pathogens–especially respiratory viruses–high densities of individuals raise the threat of infection and exponential spread of the virus in the population (Wolf 2016, 962). Consequently, most of the implemented measures to contain the virus tried to

increase physical distance between individuals and reduce the density of people congregating (Höhne and Michel 2021, 142). From an individual perspective, avoiding density promised protection against infections. Life far from densely populated urban centres appeared to be desirable, especially since the positive assets of urbanism, like cultural activities and short distance to the workplace, became obsolete and risky (Höhne and Michel 2021, 143).

In the eyes of public health experts, population density is also considered as a potential risk. Large and densely populated settlements where humans and other species live close to each other seemed to be particularly prone to infectious disease outbreaks (Wallace 2016). Public health studies have provided evidence that health conditions and life expectancy of people living in densely populated areas with low living standards are significantly lower than in the average population (Mercado et al. 2007, 7). But while the correlation between low income and health status seems valid, statistical population density rather appears as a secondary effect. Studies on infectious diseases in global cities indicate that economic status, the capacities of the public health system, required mobility and social organisation of communities are more crucial factors than built density. Thus, the transmission of pathogens is mostly defined by overlapping patterns of social inequality, infrastructural facilities, global connectivity, and urban governance decisions. Since urban centres have been equally affected by viral infections as peripheral or suburban spaces over the course of multiple waves of infection, urban scholar Roger Keil understands the COVID-19 pandemic as a disease of multiple densities of today's extended urbanisation (Keil 2020, 1286). What we see is a mostly messy correlation depending on multiple factors, when it comes to the explanation of virus transmission (McFarlane 2021, 4).[4]

Another strategy to contain the COVID-19 pandemic is to drastically reduce the number of everyday encounters in cities and elsewhere. Since casual contact between individuals in public transport, shopping facilities, and workplaces could accelerate the risk of an uncontrolled viral transmission, health experts perceived public spaces as dangerous zones that needed to be regulated (Höhne and Michel 2021, 144). The typically fluid encounters in urban space were paused by measures of isolation (or quarantine) for those who were (possibly) infected, limitations of the number of contact persons, or curfews. This led to a spatial separation of social life. Under early lockdowns, the use of public space was mostly reserved for organising vital services, like food provision or health emergencies. For weeks, private and family and shared homes became the nuclei of social life (Craig 2020, 684), sadly accompanied by the rise of domestic violence and psychological illness as an effect of social isolation (Kofman and Garfin 2020, 199).

At the same time, the COVID-19 pandemic limits the typical heterogeneity of everyday encounters in cities. Wirth and Simmel defined the quality of the urban against the background of densely populated public spaces and the permanent encounter of strangers. Under these circumstances, social interactions typically exceed the direct social milieu of mundane everyday life and allow city dwellers to

identify with various overlapping social circles. As mentioned earlier, the mode of social integration predominantly depends on relatively weak social ties like in workplace and business associations, political manifestations, or cultural consumption. Certainly, the vision of crowded urban spaces and high numbers of daily encounters seems risky during a raging pandemic. Most of the places that accommodate weak social ties between city dwellers were shut down—at least for those who could shift their workplace to their homes.

However, from a sociological point of view, the range of social interactions is unlikely to be reduced. While some features of urban space—density and heterogeneity—have temporarily been re-evaluated as risks by individuals and urban experts, urbanism as a way of life is still in place. For the moment, the structural integration of individuals into a money-mediated economy, as well as the rationalisation of social interactions and the expressive individualism in urban societies, remains untouched by the pandemic. One could even argue that the distant behaviour and segregated personality associated with urbanism fits well to the challenges of a pandemic. In a longer perspective though, it could rather be the social segregation of urban areas, much intensified during the pandemic due to urban dwellers' reduced action scopes on the one hand and the enhanced appreciation of dwelling spaces and residential quarters on the other, that limits social heterogeneity, than the temporally limitation of social encounters. Up to this point, it remains an open empirical question though whether the pandemic will cause sustainable change in urban social behaviour and integration.

Return of Sceptical Urbanism Discourses and Biopolitical Urban Governance

More obviously, the disruption of the urban fabric by the pandemic highlights the preconditions of urbanism. Not only do the features of urban space enable urbanism and inform the idea of urbanity. Multiple urban infrastructures are constantly working to ward off the risk of infectious diseases in cities. During the pandemic, the people operating these infrastructures came under the spotlight. Nurses, care workers, medical doctors, pharmacists, and cleaners working at the brink of collapse during spiking infection curves reminded us of the fragility of the public health status. Even more troubling, make-shift cemeteries and crematories uncovered the crucial logistic behind dying and burials in cities. Not least, employment sectors providing for urban lifestyles—from seasonal harvesters and lorry drivers (who were sometimes awarded unexpected visa privileges) to supermarket staff, parcel or food delivery, and public transport services—were suddenly labelled essential workers. Those people took considerable health risks during the pandemic, while still being low-paid. The pandemic thus revealed that urban infrastructures and the people operating them contribute to urbanism as much as the density and heterogeneity of urban spaces.

The record of human history shows that epidemics consistently plunged urban societies into deep crises (Scott 2017, 93–115). Plague epidemics that kept recurring over centuries have vastly depopulated cities in Europe and Asia. Pathogens, like measles, pox, and influenza entering the Western hemisphere alongside the Spanish invaders almost completely extinguished the indigenous American societies (Mann 2005). The rapidly industrialising cities of the nineteenth century were hit by deadly outbreaks of cholera in London between 1846 and 1860 or Hamburg in 1892. The latter triggered the implementation of large-scale urban infrastructures like sanitation and ventilation that enabled the growth of the industrialised cities (Höhne and Michels 2021, 146). In this sub-ground-level perspective, urbanity appears differently. The urban is no longer a driving force of civility and social emancipation, it is rather considered as a constant risk that needs to be governed and contained.

The COVID-19 pandemic thus updates a quite familiar sceptical discourse on urbanism. From early on, urban crises have been accompanied by moralising debates about the allegedly immoral character of proletarianised urban populations. Cities were perceived as sick and chaotic molochs (Engels 1993). The fear of density can thus be considered a founding theme of modern urban planning. In line with urbanist ideas underlying Ebenezer Howard's 'Garden-City,' the engineer-oriented Cerda-Plan in Barcelona or the 'Neues Bauen'-movement (Roskamm 2017, 64, Aibar and Bijker 1997, 13), modernist architects like Le Corbusier objected to the alleged poor, insanitary and chaotic living conditions of crowded industrial cities and promoted their ideas of functionally segregated, rationally planned, liveable spaces. Through this, urban planners staged themselves as omniscient doctors of urban society who diagnose urban pathologies and provide profound cures (Roskamm 2017, 266).

At the same time, biopolitics has re-entered the field of urban governance. Michel Foucault defined biopolitics as a type of governing that is not directed towards the bodies of individuals, but towards the population as an entity (Roskamm 2021, 207). The containment of urban epidemics by methods of spatial separation and control of bodies during Plague epidemics in Europe laid the foundation of a disciplinary regime and manifested the idea of a totally governed society, Foucault claims (Foucault 1991). Over the past pandemic years, questions of public health, models of infection rates, and controlled mobility shaped urban governance once again (Roskamm 2021, 208). Through this, the risks of urban life have retaken the centre of urban governance, rather than the creative potentials of urbanity (Reckwitz 2017).

Principles of biopolitical urban governance and the avoidance of density are manifest in the material outlay of today's cities. It envisions a different idea of urbanity, uncovering its blind spots. If we understand urbanity as an ideology that is constituted by the interplay between normative ideas of the urban and urbanism, the COVID-19 pandemic re-evaluates the urban as a source of risk; and urbanism as something that needs to be provided and governed with the help of urban

infrastructures. Ultimately there are two complementary stories of urbanity: the story of civility and the story of mastering infectious risks.

Pandemics, the Heritage of Urbanity, and Heritage Studies

After having dwelled on the manifold ways the characteristics of urban space, urbanism as a way of life and urbanity as an idea(l) have been challenged by the pandemic from an urban studies perspective, the following sections will address the heritage of urbanity from a heritage studies point of view. Generally, we can distinguish two trends that have shaped both recent academic and professional debates on urban heritage as well as urban heritage-making practices: (1) a discourse (itself being fuelled by the sceptical urbanism debates outlined before) that highlights the achievement of modern urban planners to design urban space in such a way that the risks entailed by large cities as dense and heterogeneous settlements are tamed, and (2) a discourse that tacitly builds on urbanism as a way of life by demanding (or celebrating) more heterogeneity, tolerance, and democracy in heritage-making processes. We argue that both discourses are blind in one eye though, as they only address the 'bright' side of urbanity, stressing its civilisatory gains, while obscuring its risks and its mundane socio-spatial foundations. We will underpin this argument by looking into how pandemics as a recurring companion of human life in dense and heterogeneous urban spaces are commemorated and how heritage-making, that has indeed become more multivocal and heterogeneous in the past, and debates in heritage studies one-sidedly draw on ideas of urbanism.

Commemorating Pandemics Control Instead of Pandemics

Given that the entanglement of big, dense, and heterogeneous urban settlements and the spread of pathogens considerably influenced modern urban planning and thus deeply shaped both the materiality and governance of modern cities, how have the victims of past pandemics been commemorated in urban space? Memory studies scholar Astrid Erll has offered valuable insights regarding this question. She writes:

> We could have seen it coming: 2014–2016 Ebola, 2015–2016 Zika virus, 2015 MERS, 2009/10 Swine Flu, 2004 Avian Flu, 2002/3 SARS (i.e. SARS-CoV, the first SARS coronavirus), since 1980 AIDS (HIV), 1977/78 Russian Flu, 1968–1970 Hong Kong Flu, 1957/58 Asian Flu. Pandemics are no surprises coming out of the blue, but recurring events. But not so in European consciousness.
>
> (Erll 2020, 863f.)

For Erll, the striking amnesia of the long history of pandemic diseases in modern (urban) Europe has two reasons. First, pandemics in Europe have been 'projected on the premodern Self' (Erll 2020, 864). This means that devastating infectious

diseases like the Plague that had infested Europe in the sixth, thirteenth to fifteenth, and nineteenth centuries and took a toll of altogether more than 100 million people worldwide, were declared as belonging to 'former times'–thus ignoring the fact that the Plague is still active in areas such as the Tropes, subtropics, as well as in parts of the US. Second, the recent pandemics have been projected on 'the cultural and geographical Other' (Erll 2020, 864). This is not only expressed by names such as 'Russian Flu,' 'Hong Kong Flu,' or 'Asian Flu' but also by attempts of politicians such as Donald Trump to frame SARS-CoV-2 as the 'Chinese virus' (Erll 2020, 867). Designations of such kind blame the allegedly 'uncivilised' cultural Other to be the source of, and thus the geographic entity responsible for the outbreak and spread of the deadly virus. The example of the so-called Spanish Flu (1918–1920) shows how problematic and misleading naming pandemics after their presumed geographical origins is though: Drawing on Spinney (2018, 63), Erll reminds us that '[t]he Spanish Flu got its name because in 1918 Spain was the first European country to acknowledge its influenza epidemic, while other European powers were covering up their casualties as part of wartime censorship' (Erll 2020, 867).

As regards the question of pandemics and urban heritage, the Spanish Flu is an interesting case. Caused by an influenza virus, the Spanish Flu was the most devastating pandemic of the twentieth century. Estimations of how many people it killed worldwide range from 20 to 100 million. By this, the Spanish Flu took more lives than the First World War altogether (17 million, Tucker 2005). It is striking that, while urban landscapes around the world are full of imposing memorials to the First World War, its soldiers and its dead, the tragedy of the Spanish Flu and its victims is hardly commemorated–even though the pandemic had a socially transformative power quite equal to the Great War (Huf and Mclean 2020, 28). In Australia, for example (where the Spanish Flu was as deadly for Australians as the Great War), 62,000 monuments to soldiers that fought in the First World War can be visited, compared to 'fewer than a dozen public Australian monuments to the dead of that pandemic' (Huf and Mclean 2020, 28).

Erll (2020, 865) explains this astonishing memory gap by pointing to a range of commemorative deficits of the pandemic compared to the war: the first deficit was a lack of 'discreteness' that occurred because the virus had not been discovered yet at the time, thereby making the Spanish Flu an unintelligible disease. Hence it also lacked 'narrativity': narrations always need a clear start or origin, storyline, and end. Moreover, pandemics are characterised by a lack of 'tellability' as the Spanish Flu did not offer heroic stories such as those offered by fights on war battlefields (Erll 2020, 865). On a similar vein, the pandemic 'was not a sudden dramatic event like [natural] disasters, no traditional heroes emerged, and it did not leave a visible legacy of destruction–except, of course death, and rises in the number of single parents and orphans' (Spanish Flu historian Mary Sheehan, quoted after Huf and Mclean 2020, 28f.). In addition, the Spanish Flu lacked evaluative qualities (that are mostly associated with human-made disasters), as well as archival sources (Erll 2020, 865). While the histories of the First World War, and later the Second World War, were

taught at schools and universities, based on military archives, and became the subject of many media transmissions such as books, films and paintings, the pandemic–largely based on family memories–lacked such sources and thus public attention (Erll 2020, 865).

These commemorative deficits, combined with the described tendencies to displace the presence of pandemics to other times or places, are not only typical for the situation in Europe but for most parts of the world. Therefore, if we look into the spread of pathogens as a heritage of urbanity, it is, if at all, the successful fight against deadly diseases–or, with a view to pandemics, pandemics control–that is commemorated in urban space, but not its victims and those who cared for them. In the past decades, accordingly, many modernist urban planning schemes have entered the heritage lists worldwide, such as Brasilia in Brazil, New Lanark in Scotland, Asmara in Eritrea, or Bauhaus sites in Germany, all of which are listed as UNESCO World Heritage. On the same token, modern hygienic infrastructures, such as the water management system of Augsburg, have achieved World Heritage status. Many streets, squares, and public institutions across the globe have been named after architects, urban planners, engineers, and doctors to honour them for having advanced epidemic control in the past. By way of contrast, the Spanish Flu and other pandemics as socially transformative and potentially deadly experiences that vastly shaped, and often ended, the ordinary lives of millions of people–and those caring for them such as relatives and essential workers–have neither been allocated a place in urban space, nor on heritage lists, and have thus been widely forgotten.

Celebrating Heterogeneity and Activism Instead of Listening to Silence

After having dwelled on this forgotten 'dark side' of the heritage of urbanity and the exclusive ideal of urbanity that is commemorated in urban space, what can be said, conversely, about the idea(l) of urbanism as a way of life that is both based on and allowing for social emancipation and tolerance?

As pointed out earlier, Louis Wirth defined urbanism as 'a distinctive mode of human group life' and thus as a specifically urban lifestyle (Wirth 1938, 4). Related to the notion of size, Wirth observed that '[l]arge numbers involve [...] a greater range of individual variation' (Wirth 1938: 11). He continued to argue that the experience of density and heterogeneity in big cities permits urban dwellers to approach this greater variation in a composed way: 'The confrontation of diverging personalities and ways of life generally creates a relativistic approach and a feeling of tolerance towards differences [...]' (Wirth 1938, 15).

Since 1938, when Wirth wrote his seminal text, ongoing urbanisation processes, as well as growing international migration in the context of globalisation, have led to an ever-rising individualisation and differentiation of the urban population that also involved further social and ethnic diversification. Since 2007, the majority of the world's population lives in cities (United Nations Population Division 2022),

which has initiated a debate on 'planetary urbanisation' (Brenner and Schmid 2012). In light of this 'success story' of urban settling, we feel tempted to take up the 'relativistic approach' and 'feeling of tolerance towards differences' (Wirth 1938, 15) that Wirth so prominently described as characteristics of urbanism as a way of life in order to confront it with recent claims of (Critical) Heritage Studies 'to promote a new way of thinking about and doing heritage' (Smith 2012). What insights can be gained if the much-acclaimed founding manifesto of the Association of Critical Heritage Studies of 2012, calling for '[d]emocratising heritage by consciously rejecting elite cultural narratives and embracing the heritage insights of people, communities and cultures that have traditionally been marginalised in formulating heritage policy' (Smith 2012), is interpreted against the background of advancing urbanisation and thus a related spread of urbanism as a way of life?

Considering the increased global relevance of cities as human habitats, we would like to draw attention to a recent trend in heritage debates and heritage-making which, following Nancy Fraser, can be referred to as 'subaltern counterpolitics' (Fraser 1990, 67). Fraser observed in 1990 that diverse 'subordinated groups' (Fraser 1990, 64) were about to establish a multiplicity of public arenas in order to articulate their interests. She observed at the time that these groups included 'women, workers, peoples of color, and gays and lesbians' (Fraser 1990, 67). Since then, even more 'subordinated groups' that had often been marginalised for decades, if not centuries, have become politically active. Interestingly, they particularly fought for having their heritage represented in urban space, thus demonstrating that they understood heritage-making as a vehicle for their own self-recognition as a group, and for their recognition in the present society (Smith 2007, Frank 2020). Accordingly, in Montevideo, Uruguay, the 'Plaza de la Diversidad Sexual' has hosted a memorial since 2004, initiated by activists, that commemorates the persecution of lesbian, gay, bisexual, and transgender people and calls for respecting sexual diversity in the present. In Berlin, a memorial to the Sinti and Roma persecuted and murdered under the rule of National Socialism in Germany and other European countries between 1933 and 1945 was inaugurated next to the Reichstag building, home of the German parliament, in 2012. Since 2015, the Australian city of Melbourne has assembled the city's aboriginal heritage sites, which had been systematically wiped out after the European invasion of Australia in the late eighteenth century, on a website and made them visible in public space through information boards and artistic projects. Last but not least, a recent wave of subversive actions of urban fallism (Frank and Ristic 2020), connected with the Black Lives Matter movement, attracted considerable attention in 2020. By contesting, transforming, or pulling down statues of colonial rulers and white supremacists from their pedestals, activist groups, globally connected via social media, protested against racism in South Africa (Shepherd 2020) or the United States (Mitchell 2020), advocating for 'the city as a place of civility and democracy' (Frank and Ristic 2020, 557).

What do we learn from these examples? The cases from Montevideo, Berlin, and Melbourne demonstrate that, in increasingly heterogeneous urban communities, a growing tolerance and openness towards heritage-making–or, in the case of Fallist actions, heritage-unmaking–practices of marginalised cultural, social, and ethnic groups in urban space (and thus, in Wirth's words, towards variations and socio-cultural differences) can indeed be observed–at least in democratic societies. The reported acts of heritage-(un)making have served sexual and social minorities, as well as marginalised racial or ethnic communities, to push for public recognition of their own group in the mainstream urban society. In light of the swelling numbers of well-connected activist groups in cities around the world, the core features of urbanism as conceptualised by Georg Simmel, Louis Wirth, and Hans-Paul Bahrdt–expressive personal freedom, tolerance, and rational deliberations in public space as main ingredients of urban (bourgeois) culture–are hence on the rise. Cities thus qualify as the most promising places in which Critical Heritage Studies' claim to 'vigorously question the conservative cultural and economic power relations that outdated understandings of heritage seem to underpin and invite the active participation of people and communities who to date have been marginalised in the creation and management of 'heritage' (Smith 2012) are translated into action.

But this is just part of the story. As gratifying as they may be, the recent triumphs of heritage activists (and Critical Heritage scholars researching them) should not tempt us to prematurely give ourselves a pat on the back. On the contrary, heritage scholars should debate whether the biases implicit in urbanism as an immaterial component of the heritage of urbanity have been adopted by Critical Heritage Studies too easily. Is it by coincidence that the Critical Heritage Studies Manifesto of 2012 demands the participation of the marginalised in the 'creation and management of "heritage",' calling for an integration of these groups 'in formulating heritage policy' and for 'increasing dialogue and debate between researchers, practitioners and communities?' (Smith 2012) Integration, participation, creation, management, dialogue–all these are terms appealing to those who have the capacities and knowledge to tie in the communal representational political system with their activist agendas (Young 2000). They envision those (formerly) 'sub-alterns' who have the time and skills, or at least the potential, to get involved in counterpolitics (Fraser 1990) and to organise lobby groups and/or protests in public space to influence the local polity. In short, they privilege those who embody urbanism as a way of life by drawing on a certain 'civilised' behaviour, that is a certain way of (rationally) articulating oneself in the public realm.[5]

Given the celebratory undertone with which heterogeneous processes of political articulation in cities are often commented on, there is a danger that the other part of the story, the so far silenced side of urbanism as the immaterial component of the heritage of urbanity, slips under the radar. Urbanism as a way of life, as the current pandemic has uncovered, heavily relies on reproductive and care work in private homes. It relies on critical infrastructures such as hospitals, parcel services, waste

collection, and supply chains of all kinds. It has become obvious that it is exactly such mostly low-paid but very busy essential workers who ensure the continuous functioning of the city–and this does not only apply in times of a pandemic. As such, rethinking heritage in precarious pandemic times raises our awareness for the blind spots of (Critical) Heritage Studies that have, by explicitly embracing political articulation and researching various forms of activism, one-sidedly relied on the heritage of urbanity as an idea(l), potentially losing silent groups without such lobbies and capacities out of sight.

Conclusions and Prospects

In this chapter, we discussed the unsettling impact of the COVID-19 pandemic on the heritage of urbanity. First, we clarified the meaning of 'heritage of urbanity' by distinguishing the concepts of 'the urban, 'urbanism, and 'urbanity'. We argued that the 'heritage of urbanity' is constituted by the normative notion that civilising effects ('urbanism' as a way of life) can be achieved through the targeted shaping of 'the urban', i.e. by urban planning. Second, we considered the effects of the pandemic on 'the urban' and 'urbanism'. We used our insights as a kind of epistemological filter to highlight a repressed side of urbanity. Third, we shifted our attention from urban studies to heritage studies and discussed gaps in both heritage-making and heritage studies in order to demonstrate that these gaps correspond to the repressed side of urbanity, or, in other words, that (even critical) heritage studies and practice tacitly rely on an exclusive concept of urbanity and the public realm. In this conclusion, we ask what can be learned from these findings with a view to the 'heritage of urbanity', and what this could mean for future heritage studies. Answers need to be given on two different levels.

The Silenced Heritage of Urbanity

The normative ideal of urbanity is an immaterial heritage. The idea that the urban can be planned along the lines of density and heterogeneity in such a way as to produce the civilising effects of urbanism is a legacy that haunts the modern city like a spectre. It is commemorated in theoretical texts and debates as well as practically whenever planning is done in its spirit. The normative Idea(l) of urbanity is characterised by its boundless optimism which represses epidemiological and hygienic risks by interpreting them as technically solvable problems. Thus, technoid fantasies of feasibility and controllability form its core. They have an effect on the urban insofar as it is designed according to these fantasies. Largeness, density, and heterogeneity can only exist at the price of their technical control.

The urban is both the starting and end point of urbanity's planning fantasies. It provides the starting point for the alleged civilising effects of urbanism. As a built history, it confirms feasibility by telling a story of ongoing victories over the many risks to which cities are permanently exposed. As such–in the sense of technical

infrastructures–the urban forms a material urban heritage. It is commemorated in museums and monuments. But someone is missing: people–especially the essential workers of our days. It is precisely these people who, through their work, confront the risks of urban space in order to ward them off, who are not remembered. There are no museums for them and only very few monuments. It has become particularly evident in the pandemic that it is the hospital staff, the cleaners, the sales clerks, or the public transport and delivery staff whose work–in contrast to that of urban planners–is not publicly commemorated.

Finally, there remains urbanism as the actual or hoped-for rational, blasé, and detached behaviour that is to emerge from urban space. This behaviour, in turn, forms an intangible urban heritage that is routinely practised in the mundane life of city dwellers. In the course of the pandemic, it may have experienced a resurgence insofar as it is precisely distanced social behaviour that serves as a backbone of infection control. Urbanism also structures theoretical texts and recent calls by Critical Heritage Studies though. While the elitist Authorised Heritage Discourse (Smith 2006) may have lost parts of its power, Critical Heritage Studies' mission to support the marginalised in representing their heritage in public space runs the risk of neglecting those silent groups who operate our cities, albeit without having access to the representational political system, to forms of public dialogue, or, in short: to the privileges of urbanism as a way of life.

Prospects for Future Critical Heritage Studies

The global spread of the SARS-CoV-2 virus has thus revealed blind spots in both the heritage of urbanity and Critical Heritage Studies. In the past decade, Critical Heritage Studies have emphatically focused on the struggles for public recognition of various subordinated groups, such as women, industrial workers, the LGBTQ community, and people of colour. Through this, they have offered many valuable insights into how a multiplicity of public arenas, and ultimately a post-bourgeois public sphere (Fraser 1990), has gained shape. Notably, the pandemic has reminded us that the post-bourgeois public sphere is by no means post-civic or post-rational. The expansion of the virus has drawn attention to the multitude of essential workers who silently upheld urban critical infrastructures even during lockdowns and curfews, taking high personal risks to ward off risks from other people. The con- tinuous and hence increasingly 'loud' silence of these workers, who were rapidly awarded the status of system relevance, uncovered how much they lacked the capacities of political articulation and self-expression that Critical Heritage Studies have so vigorously promoted–just because they do not have the time or skills, and/ or because their jobs are too demanding.

This insight could be an incentive for Critical Heritage Studies to further widen their scope on subaltern groups by including hitherto overlooked forms and con- ditions of labour and exploitation of workforce. So far, heritage studies and practice have committed themselves to promoting the heritage of blue-collar industrial

labour that still is underrepresented on heritage lists (Shackel, Smith and Campbell 2011). Scholars and experts deservingly called attention to the hard (re)production work conducted by working-class males and females in the past and criticised that their experiences of class were subdued by elitist notions of heritage and reduced to emotions of nostalgia and loss (Smith 2020). They denounced how the few heritage sites designated to labour urged workers, who had often lost their jobs in the course of deindustrialisation, 'to emulate the forms of cultural consumption of the middle classes' (Smith, Shackel and Campbell 2011, 14)–with the effect that both workers' self-recognition as a group and their pride as members of the working-class was downplayed, devalued, and negated. Against this background, scholars summoned working-class people's capacity 'to speak for themselves' (Smith, Shackel and Campbell 2011, 3). Hence, the pandemic has illuminated how much organised labour, and in particular blue-collar labour in mines or the iron and steel industries, have dominated Critical Heritage Studies' research agendas. While the heritage of labour has largely been reduced to industrial work and adjoining sectors under organised capitalism, new forms of labour under conditions of disorganised, flexible capitalism–the inextricable companion of deindustrialisation–have escaped notice.

As such, rethinking heritage in precarious times directs our attention to precarious labour. Organised (industrial) labour was based on reliable standard employment (permanent, full-time, including social security and health insurance) and supported by trade unions that regularly negotiated wage increases and holiday pay, whereas today non-standard work is on the rise. Disturbingly, it is precisely the sectors in which essential workers seek to earn a living (delivery services, waste collection, care work in hospitals, kindergardens or old people's homes, cleaning, teaching, etc.) that are dominated by non-standard occupations. This means that important tasks are performed by either subcontracted temporary workers or freelancers who are appointed for limited projects ('gigs'). These workers often earn less than the minimum wage, are expected to pay for their work equipment and lack both job and social security. No small number of them are migrants whose residence status is dependent on occupation. As these essential workers are forced to compete for the next hiring or gig, feelings of class, solidarity or pride are beyond their reach, as much as resources to self-organise as a group. It might be argued that the COVID-19 pandemic has laid the foundation, at least for those in system-relevant occupations, to enhance bargaining power, and to build their own public arena to strive for social recognition. But even if this was the case, the appeal to Critical Heritage Studies sustained in this chapter to embrace subalterns who do not have the capacities to speak for themselves in the public sphere, remains valid.

It can be noted that over the course of the past pandemic years, there have been quite a few initiatives to commemorate the diverse experiences of the COVID-19 pandemic. First, the victims of the pandemic have come into focus. State-organised memorial ceremonies like the artistic intervention 'In America: Remember' during which more than 670,000 flags, each representing a person that died from COVID-19 in the United States, were installed in the Mall of Washington, D.C.

(Hartigan 2021), or the digital memorial ceremony held by the German Federal President in April 2021 (Kraft 2022), transmitted the idea of a collective tragedy to be overcome by national mourning (Mazzucchelli and Panico 2021, 1424). Furthermore, there is a growing number of more nuanced bottom-up initiatives to commemorate the victims of the COVID-19 pandemic (Mazzucchelli and Panico 2021, 1424). Other initiatives seek to capture individual experiences under lockdown, such as the photographic project 'Picturing Lockdown' by Historical England in the UK (Adams and Kopelman 2022, 5). In Germany, many public archives have issued calls for collecting personal experiences (for example the 'coronaarchiv', https://coronarchiv.blogs.uni-hamburg.de). These are important steps to keep and document the diverse heritages of the pandemic with the help of low-threshold visual and digital platforms. But what is still missing is a deeper appreciation of those who kept (urban) society running. The public applauding for essential workers that had temporarily become a routine during the first months of the pandemic has not entered the practices of COVID-19 heritage-making yet.

Notes

1 The debate on the 'end of urbanism' in the German journal 'sub\urban' was highly instructive for our discussion (Höhne and Michel 2021, Roskamm 2021, Souza 2021, Strüver 2021).
2 Which turned out not to be true (Lanz 2015, 82; Berking, Steets and Schwenk 2018).
3 Today, a rising number of urban planners and architects actively seek to reach out to hitherto excluded groups in order to include their specific requirements in their ideas and projects. Nonetheless, the idea that urbanism can be achieved through planning remains dominant.
4 This doesn't mean that proximity can be downplayed as a factor of transmission. But there is a predominantly sceptical evaluation of urban density in the light of the pandemic amongst urban scholars.
5 Fraser (1990, 58) speaks of a 'post-bourgeois model of the public sphere.' With this expression, she denotes a public sphere that, unlike the bourgeois public sphere described by Habermas (1992), consists of multiple discursive arenas. Its protagonists are the subalterns. Taking up Frasesr's diagnosis, Critical Heritage Studies have avowedly sought to investigate the heritage-making of marginalised groups as an important part of these new subaltern public arenas. We argue, however, that participation in the public sphere, be it a bourgeois or a post-bourgeois one, generally requires certain (civic) capacities and conditions to be met. Moreover, we call attention to the fact that the post-bourgeois public sphere continuously changes shape in correspondence to shifting patterns of oppression.

References

Adams, Tracy, and Sara Kopelman. 2022. "Remembering COVID-19: Memory, Crisis, and Social Media." *Media, Culture & Society* 44 (2): 1–20.
Ali, S. Harris, and Roger Keil, eds. 2008. *Networked Disease: Emerging Infections in the Global City*. Oxford: Wiley.
Aibar, Eduardo, & Bijker, Wiebe E. (1997). "Constructing a City: The Cerdà Plan for the Extension of Barcelona." *Science, Technology, & Human Values*, 22, 3–3010.1177/016224399702200101.
Bahrdt, Hans Paul. 2006. *Die moderne Großstadt*. Wiesbaden: VS Springer.

Berking, Helmuth, Silke Steets and Jochen Schwenk, eds. 2018. *Religious Pluralism and the City. Inquiries into Postsecular Urbanism.* London: Bloomsbury.

Brenner, Neil, and Christian Schmid. 2012. "Planetary Urbanisation." In *Urban Constellations*, edited by Matthew Gandy, 10–13. Berlin: Jovis.

Craig, Lyn. 2020. "Coronavirus, Domestic Labour and Care. Gendered Roles Locked Down." *Journal of Sociology* 56 (4): 684–692.

Doan, Petra, ed. 2011. *Queerying Planning. Challenging Heteronormative Assumptions and Reframing Planning Practice.* London: Routledge.

Engels, Friedrich. 1993 [1885]. *The Condition of the Working Class in England.* Oxford: Oxford University Press.

Erll, Astrid. 2020. "Afterword. Memory Worlds in Times of Corona." *Memory Studies* 13 (5): 861–874.

Foucault, Michel. 1991 [1975]. *Discipline and Punish. The Birth of the Prison.* London: Penguin Books.

Frank, Sybille. 2020. "Stadt und Heritage, Stadt und Erbe." In *Stadtsoziologie und Stadtentwicklung. Handbuch für Wissenschaft und Studium*, edited by Ingrid Breckner, Alfred Göschel and Ulf Matthiesen, 515–525. Baden-Baden: Nomos.

Frank, Sybille, and Mirjana Ristic. 2020. "Urban Fallism. Monuments, Iconoclasm and Activism." *City* 24 (4): 552–564.

Fraser, Nancy. 1990. "Rethinking the Public Sphere: A Contribution to the Critique of Actually Existing Democracy." *Social Text* 25/26: 56–80.

Gandy, Matthew. 2021. "The Zoonotic City: Urban Political Ecology and the Pandemic Imaginary." *International Journal of Urban and Regional Research (Early View)*: 1–18.

Ha, Noa. 2014. "Perspektiven urbaner Dekolonisierung: Die europäische Stadt als, Contact Zone." *sub\urban. Zeitschrift für Kritische Stadtforschung*, 2 (1): 27–48.

Habermas, Jürgen. 1992. *The Structural Transformation of the Public Sphere. An Inquiry into a Category of Bourgeois Society.* Cambridge: Polity.

Harrison, Rodney. 2010. "Introduction." In *Understanding the Politics of Heritage*, edited by Rodney Harrison, 1–4. Manchester: Manchester University Press.

Hartigan, Rachel. 2021. "The epic COVID-19 memorial on the National Mall, in one stunning photo.", *National Geographic*, September 30, 2021. https://www.nationalgeographic.com/culture/article/epic-covid-19-memorial-national-mall-one-stunning-photo.

Höhne, Stefan, and Boris Michel. 2021. "Das Ende des Städtischen? Pandemie, Digitalisierung und planetarische Enturbanisierung." In *sub\urban. Zeitschrift für kritische Stadtforschung* 9 (1/2): 141–149.

Huf, Ben, and Holly Mclean. 2020. *Epidemics and Pandemics in Victoria. Historical Perspectives.* Research Paper 1. Melbourne: Department of Parliamentary Services, Parliament of Victoria.

Keil, Roger. 2020. "The Density Dilemma: There Is Always too Much and too Little of It." *Urban Geography*, 41 (10): 1284–1293.

King, Anthony. 2005. "Postcolonial Cities/Postcolonial Critiques: Realities and Representations." In *Die Wirklichkeit der Städte*. Sonderband Soziale Welt 16, edited by Helmuth Berking and Martina Löw, 67–83. Baden-Baden: Nomos.

Kofman, Yasmin B., and Dana Rose Garfin. 2020. "Home Is Not Always a Haven: The Domestic Violence Crisis amid the COVID-19 Pandemic." *Psychological Trauma: Theory, Research, Practice, and Policy* 12 (1): 199–201.

Kraft, Caroline. 2022. "Trauern heißt Lernen." *die tageszeitung*, 17 March 2022. https://taz.de/Kollektive-Trauer-in-Zeiten-der-Pandemie/!5837070/.

Lanz, Stephan. 2015. "Über (Un-)Möglichkeiten, hiesige Stadtforschung zu postkolonialisieren." *sub\urban. Zeitschrift für Kritische Stadtforschung* 3 (1): 75–90.

Löw, Martina, and Hubert Knoblauch. 2020. "Dancing in Quarantine: The Spatial Refiguration of Society and the Interaction Orders." *Space and Culture* 23 (3): 221–225.

Mann, Charles C. 2005. *1491: New Revelations of the Americas Before Columbus*. New York: Knopf.

Mazzucchelli, Francesco, and Mario Panico. 2021. "Pre-emptive Memories: Anticipating Narratives of COVID-19 in Practices of Commemoration." *Memory Studies* 14 (6): 1414–1430.

McDowell, Linda. 1983. "Towards an Understanding of the Gender Division of Urban Space." *Environment and Planning* 1: 59–72.

McFarlane, Colin. 2021. "Repopulating Density: COVID-19 and the Politics of Urban Value." *Urban Studies* (June 2021): 1–22.

Mercado, Susan, Kirsten Havemann, Mojgan Sami and Hiroshi Ueda. 2007. "Urban Poverty: An Urgent Public Health Issue." *Journal of Urban Health* 84 (1): 7.

Mitchell, Mary Niall. 2020. "'We Always Knew It Was Possible'. The Long Fight Against Symbols of White Supremacy in New Orleans." *City* 4 (4), Special Feature: Urban Fallism. Monuments, Iconoclasm and Activism: 580–593.

Reckwitz, Andreas. 2017. *The Invention of Creativity: Modern Society and the Culture of the New*. Cambridge: Polity.

Roskamm, Nikolai. 2017. *Die unbesetzte Stadt. Postfundamentalistisches Denken und das urbanistische Feld*. Basel: Birkhäuser.

Roskamm, Nikolai. 2021. "Urbanistische Heimsuchungen." *sub\urban. Zeitschrift für kritische Stadtforschung* 9 (1/2): 205–211.

Scott, James. 2017. *Against the Grain. A Deep History of the Earliest States*. New Haven/London: Yale University Press.

Shackel, Paul A., Laurajane Smith, and Gary Campbell. 2011. "Labour's Heritage." *International Journal of Heritage Studies* 17 (4): 291–300.

Shepherd, Nick. 2020. "After the #Fall: The Shadow of Cecil Rhodes at the University of Cape Town." *City* 24 (4), Special Feature: Urban Fallism. Monuments, Iconoclasm and Activism: 565–579.

Simmel, Georg. 2005 [1903]. "The Metropolis and Mental Life." In *The Urban Sociology Reader*, edited by Jan Lin and Christopher Mele, 24–31. London/New York: Routledge.

Smith, Laurajane. 2006. *Uses of Heritage*. London: Routledge.

Smith, Laurajane. 2007. "Empty Gestures? Heritage and the Politics of Recognition." In *Cultural Heritage and Human Rights*, edited by Helaine Silverman and D. Fairchild Ruggles, 159–171. New York: Springer.

Smith, Laurajane. 2012. *Association of Critical Heritage Studies Manifesto*. https://www.criticalheritagestudies.org/history.

Smith, Laurajane. 2020. "Industrial Heritage and the Remaking of Class Identity. Are We All Middle-class Now?" In *Constructing Industrial Pasts: Heritage, Historical Culture and Identity in Regions Undergoing Structural Economic Transformation*, edited by Stefan Berger, 128–145. London/New York: Routledge.

Smith, Laurajane, Paul A. Shackel, and Gary Campbell. 2011. "Introduction. Class Still Matters." In *Heritage, Labour and the Working Classes*, edited by Laurajane Smith, Paul Shackel, and Gary Campbell, 1–16. London/New York: Routledge.

Souza, Marcelo Lopes de. 2021. "Die COVID-19-Pandemie bedeutet nicht das Ende des Städtischen (aber vielleicht den Beginn eines besseren Verständnisses unserer Welt)." *sub\urban. Zeitschrift für kritische Stadtforschung* 9 (1/2): 151–157.

Spinney, Laura. 2018. *Pale Rider. The Spanish Flu of 1918 and How It Changed the World.* London: Vintage.

Strüver, Anke. 2021. "The End of Care-less Capitalism (as We Knew It)?" *sub\urban. Zeitschrift für kritische Stadtforschung* 9 (1/2): 165–170.

Tucker, Spencer C. 2005. *The Encyclopedia of World War I. A Political, Social and Military History.* Volume 1. Santa Barbara: ABC-Clio.

United Nations Population Division. 2022. "Urban population (% of total population)." *World Urbanization Prospects: 2018 Revision.* https://data.worldbank.org/indicator/sp.urb.totl.in.zs.

Wallace, Rob. 2016. *Big Farms Make Big Flu: Dispatches on Infectious Disease, Agribusiness, and the Nature of Science.* New York: Monthly Review Press.

Wirth, Louis. 1938. "Urbanism as a Way of Life." *The American Journal of Sociology* 44 (1): 1–24.

Wolf, Meike. 2016. "Rethinking Urban Epidemiology: Natures, Networks and Materialities." *International Journal of Urban and Regional Research* 40 (5): 958–982.

Yeoh, Brenda. 2001. "Postcolonial Cities." *Progress in Human Geography* 25 (3): 456–468.

Young, Iris Marion. 2000. *Inclusion and Democracy.* Oxford/New York: Oxford University Press.

15

COVID-19, BLACK LIVES MATTER, AND HERITAGE FUTURES

Tim Winter

Introduction

By now the trope has become familiar, COVID-19 did not change the world, but accelerated various trends that were already underway. As the broader implications of the pandemic began to be understood, such arguments were offered for a wide gamut of issues, ranging from economic inequality and the forms of intersectional violence it creates, to the ongoing rise of state surveillance. The question is how does the issue of accelerated change pertain to heritage.

In Europe and North America, much of the discussion concerning the impact of COVID-19 on the cultural sector focused on the collapse of revenue streams for museums and heritage sites, and the implications that held for employment and institutional viability. A few international news channels reported on the situation in the Pacific, or the impact of collapsing tourism economies around world heritage sites in the world's least developed countries. Within the heritage profession, UNESCO was among those using social media to raise awareness about such issues, and the impact of COVID-19 on livelihoods. It was a crisis for cultural heritage, after all, where nothing was bombed, looted, or erased. However, I would argue that in the liberal democracies of the West, accounts of how COVID-19 impacted and transformed sites and discourses of cultural heritage at the global level were overshadowed by another transnational phenomena, that of the Black Lives Matter (BLM) movement. In Europe and North America 2020 seemed to mark a watershed in public and university-based debates about memory, power, and empire in relation to questions of social justice (Lynch 2021; Yeats 2021) Mainstreaming such issues is long overdue, given that postcolonial studies–analyses which I absorbed at the graduate level in the UK in the 1990s–has advanced such debates within the academy for several decades now. But as we know, BLM activism has

DOI: 10.4324/9781003188438-23

successfully forced important questions into the public sphere about statues and monuments, museum collections and questions of restitution and interpretation, and the need to decolonise knowledge production, whether it be in school and university curricula, or in popular culture representations. In this chapter, I suggest the historical co-occurrence of these two phenomena, COVID-19 and BLM, is likely to have unexpected consequences for the governance and production of heritage in different parts of the world, and indeed accelerate trends that were already underway. In the spirit of how this book was conceived as a series of thought-provoking, big-picture discussions, this chapter does not offer a precise roadmap for understanding future developments. Instead, it seeks to raise themes and issues that are impossible to fully anticipate, but undoubtedly have a bearing on how we need to critically theorise and investigate culture and cultural heritage in the coming years. What I have in mind here then are some ongoing trends in internationalism and how this relates to a shifting geopolitical landscape that is leading to new forms of heritage production and politics.

COVID-19 and the Burden of History

Over the past century or so, a number of Western liberal democracies have developed a strong culture of internationalism. This is evident in the legal, governmental, and institutional frameworks for cultural heritage and its protection and conservation, which now operate at multiple scales internationally. My personal reading of developments since early 2020–developed through a series of one on one discussions, participation in web-based seminars and reading of published material–leads me to believe that a number of institutions and university-based programs in Europe and the United States have turned away from international issues to give greater priority to 'domestic' concerns (see e.g. Caradonna 2021; Decolonizing Museums 2021; Ludwisiak 2021; Quinn 2021; van der Leeuw-Roord 2021). Perhaps, the most obvious indicator of this was the rushed withdrawal of the United States from Afghanistan in August 2021. Various commentators noted this would hold long time implications for the archaeology and the preservation of the country's cultural assets (Mileson 2021).

Various factors drive this. Most obviously, lockdowns and closed borders led to greatly diminished revenue streams, whether it be student numbers in the case of universities, or, for cultural sector institutions, reduced numbers of paying visitors and declining market-based assets. Both COVID-19 and BLM also meant existing programs were expected to more directly speak to public debates 'at home.' Museums have set about 'decolonising' their collections and for various funding bodies priorities understandably turned to supporting research and public outreach initiatives regarding the long-term survival of the arts and cultural sector, and debates about public history. For many, the running and development of inter-national collaborations was also curtailed by imposed travel restrictions, meaning that international projects were either 'put on ice' or permanently cancelled

through 2020–2021. More broadly, across a number of countries, notably the UK and Australia, shrinking GDPs, depictions of a fiscal 'crisis' and resultant budgetary deficits were also cited as reasons for significant reductions in governmental spending on international aid (Clare 2021; Wintour 2021; Worley 2021). In the United States, commitments to international engagement also pivoted around the worldviews of two presidents and their inner circle of advisors. The arrival of Joe Biden to the White House in early 2021 seemed to restore certain international commitments, previously abandoned by the Trump administration. But at the time of writing the degree to which the different branches of government and the philanthropic sector in the US will prioritise culture at the international level remains unclear. For entirely understandable reasons, many institutions turned their attention and resources to public health and the rehabilitation of economies.

In stepping back to consider this situation, I would suggest what we see today is a significantly different picture of internationalism than that of the post-Cold War era. In the wake of the collapse of the Soviet Union, the previous geographies of aid and co-operation arranged around alliances and blocs gave way to a global preservation sector that came to be increasingly oriented around and by the values and ideals of the West, namely liberal democratic modes of political governance, human rights, free market capitalism, and 'good governance.' In different ways, and in different configurations, these values have influenced and oriented global heritage discourses since then. This includes the gradual development of an intellectual mapping between global, national, and localised heritage governance structures in relation to the flows and forces of global capital. Policy frameworks capable of responding to the generation of capital wealth through the exploitation of culture and nature as resources seem a perennial challenge, despite, and perhaps because of, the decades of 'sustainable balance' rhetoric propagated by an ever-growing industry of heritage consultancy. The disappearance of cruise ships from Venice canals on the back of COVID-19, and the protests that met their return in mid-2021, offers a case in point of how this remains a significant and complex issue. Indeed, tourism and the governance of historically significant cities are among the areas where conflicting ideas and priorities continually converge, meaning that debates and norms around heritage preservation have evolved in contested and convoluted ways over time. The minimal attention given to local community interests in the face of materials conservation has, to varying degrees, given way to a language of sustainable development, community participation, and so forth. These new priorities have come to be enshrined in the UN Sustainable Development Goals, or SDGs. This means that the preservation of cultural heritage has been folded into other priorities of global governance, including gender equity, poverty reduction, youth education, and other rights-based discourses. Since the early 1990s, many of these agendas and developments have been spearheaded by countries in the West. Of course, the notable exception here is Japan, which has approached culture and heritage as a productive platform for diplomacy and national recognition since the 1990s. It remains to be seen whether this retreat from

internationalism among European countries and the US, precipitated by COVID-19 and other issues, will be reversed in the coming decade. But in the discussion below I map out some developments that point to a distinct uptick in the commitment to internationalism from various countries in the so-called Non-West to argue that this will have tangible impacts on the international heritage governance landscape and its funding structures.

Here then, a third component is crucial to this picture, that of the steady shift towards Asia in the global power landscape. Over the past 30 years or so, discourses in the West around this issue have moved away from an admiration for the region's so-called tiger economies to a more circumspect language of rising great powers. First and foremost in this regard is the double-digit growth that China sustained over a prolonged period, propelling it to the status of the world's second-largest economy in 2010 (Associated Press Tokyo 2010; Lee 2019). Observers of such matters anticipate China will surpass the US economy sometime in the late 2020s (Elliott 2020). Such shifts in the global economy have spawned a new geopolitical environment, and as the world attempts to lift itself out of the pandemic the types of alliances and blocs more familiar to the Cold War era seem to be forming. In June 2021 President Biden travelled to the UK for the G7 meeting, signalling the return of the United States in its provision of leadership in international affairs, notably NATO alliance building, vaccine rollouts, and climate change mitigation. Against a backdrop of post-Brexit tensions, he also used the event to announce his desire to see an international infrastructure initiative established, one that would rival China's Belt and Road Initiative (BRI). B3W, an acronym for the awkwardly titled Build Back Better World, was interpreted by news outlets as a 'play on China's BRI' (Sanger and Landler 2021). It will be a few years before it's clear whether this proposal materialises into a meaningful architecture of trade, finance, and infrastructure development in ways that parallel with Belt and Road.

In response to COVID-19, China's BRI has evolved rapidly. The vast majority of Western scholarship and media coverage has interpreted BRI as a trans-Eurasian infrastructure, trade, and logistics initiative. Missing from such accounts is the analysis of the numerous education, medical, cultural, legal, scientific, and digital platforms of co-operation established within the BRI framework. COVID-19 greatly amplified the significance of both the Digital Silk Road and Health Silk Road architectures, both of which were established a few years earlier. Much of the attention on the latter has focused on mask diplomacy and vaccine rollouts, but the long-term implications of these initiatives are likely to be profound (Wong 2020). China's Health Silk Road builds on a history of medical diplomacy and by levelling criticisms at rich Western governments for their reluctance to donate to and support the developing world, China seized the opportunity to proclaim global leadership in ways that signposted their commitment to state-led healthcare that at once both aligns with the World Health Organisation's core principle of 'Health For All' and offers an alternative to neoliberal modes of public goods delivery (Tillman, Ye and Yang 2021). By mid-2020, such forms of co-operation were integrated into

CIDCA, the China International Development Cooperation Agency and the AIIB, Asian Infrastructure Investment Bank, both of which now fund a broad array of capital-intensive projects, primarily around infrastructure. A visit to the 'projects' pages of the websites of both these organisations reveals the staggering levels of funding now moving between Belt and Road partner countries across multiple sectors (Asian Infrastructure Investment Bank 2021; China International Development Cooperation Agency 2021). This is in addition to the hundreds of billions of dollars allocated to Belt and Road infrastructures since 2013, as China seeks to build multiple platforms of connectivity across the continents of Eurasia and Africa, and the oceans that surround them.

A New Road of Internationalism

I cite such developments as they form the backdrop against which we need to examine some key developments in heritage at the international level, how it is framed, how it is preserved, and what values and ideals it is proclaimed to advance. This is not a wholesale revolution, but China's rapidly growing footprint in international heritage governance is a trend that is likely to continue, and the developments in the West noted earlier mean we need to look at such trends in relation to questions and possibilities of world ordering. Over the course of two recent books, I have set out to show how China's BRI, an initiative that now incorporates in excess of 80 countries, constitutes a vast platform of heritage diplomacy and cultural sector co-operation (Winter 2019, 2022). Framed and branded as a 'revival' of the Silk Roads for the twenty-first century, Belt and Road has rapidly introduced discourses of 'shared heritage' that are unprecedented in scale. Silk Road discourses have also been integrated into and helped drive a key domestic priority for Xi Jinping, that of the 'China Dream of Great Rejuvenation' (Carrai 2021; Zhu and Maags 2020). This ostensibly involves connecting the modern political and geographic entity that is China with a Sino-civilisational past in ways that build a grand arc of history built on multiple dynasties (Millward 2020). It is a narrative through which a patriotism towards a national culture is being nurtured. Here then the concept of the Silk Road makes an interesting and distinct contribution. First, it gives new potency to particular dynasties that are narrated around ideas of exchange and openness. This is significant in the context of Belt and Road, where the state projects the idea that the country succeeds and is enriched in multiple ways when it engages with, and learns from, the outside world. Second, by constructing a narrative of transregional historical connectivity spanning oceans and continents, the Silk Road places China at the centre of world affairs, an historical imagination that is then tied to ideas of fulfilled destinies and the country's current directions as a 'rising power.' But the Silk Road is also proving significant in internationalising China's interests in various domains of culture and heritage. As I have documented elsewhere, we are beginning to see a meaningful growth in the number of international collaborations established under a Silk Road umbrella

(Winter 2019, 2020). These range from land-based and underwater archaeology, to the scanning of objects and manuscripts in museums, libraries, and archives, to collaborations for the conservation of architectural structures and those cultural practices and traditions now designated as intangible heritage. In the space available here I want to highlight a number of themes that make such developments significant.

The first relates to the geostrategic nature of the Silk Roads narrative within the broader architectures of Belt and Road connectivity. The global trend of the past few decades has been the increasing integration of heritage into processes of urban regeneration, creative economy planning, state-led regional development, poverty reduction programs, and the multitude of infrastructure projects familiar to the development of tourism industries. Belt and Road represents a regional architecture that advances such trends on a massive scale. I argued in *Geocultural Power* that multi-billion-dollar infrastructure initiatives in countries in Southeast Asia, East Africa, Central Asia, and the Mediterranean include airports, hotel districts, cruise-ship ports, and retail quarters that are being constructed in anticipation of long-term tourism growth (Winter 2019). Stitching these various projects together into a single foreign policy architecture has also meant promoting these countries as 'destinations' back in China. Prior to the COVID-19-induced closure of borders, the number of outbound Chinese tourists had reached historically unprecedented levels at around 140 million per year (Hutton 2019). In the wake of Belt and Road's launch in 2013, the UNWTO launched a number of Silk Road tourism initiatives, in large part to capitalise on this fast-growing market. A report outlining the development of a Maritime Silk Road cruise-ship tourism industry, for example, identified over 110 potential locations for cruise-ship port development (UNWTO 2019; Whats in Port 2019).

In July 2021 the city of Quanzhou was listed as a world heritage site. This gives visibility to China's place in world maritime histories and signals histories of connectivity between East Asia, the Arabian Peninsula, and beyond. Given the methodological nationalism that has shaped so much modern historiography, the relationship between oceans and world history is a topic that too often remains overlooked. European narratives of oceanic history understandably suffer from the familiar problems of Eurocentrism, that of over-representing European histories and experiences. This is perhaps most evident in accounts of the Indian Ocean region, where depictions of the past foreground events that relate to the European exploration of the region from the early sixteenth century onwards. In the past few decades, countless books, documentaries, movies, exhibitions, and research projects in Europe and elsewhere have depicted the 'age of discovery' or the 'age of empire' as part of a larger global history centred around the rise of the West. Obviously, oceans and seas figure heavily into the nostalgia for empire and trade riches in Britain, France, Netherlands, Portugal, and Spain. By extension, in Europe, the Mediterranean marks an informal frontier, a region beyond which little attention is given to pre- or non-European histories of the ocean. The listing of Quanzhou

then, along with sites like Lamu in Kenya or Melaka in Malaysia, two other coastal world heritage sites, constitute the foundations for building alternative narratives of world history in the public domain. Crucially, though, I link such possibilities to COVID-19 and shifts in the global economy to argue that there are forces at play pushing new narratives into the space of transnational memory production. Today the southern Chinese city of Guangzhou leads a 26-city alliance designed to promote Maritime Silk Road history and heritage. Over time this will undoubtedly lead to multiple collaborations between governments, universities, and cultural institutions across a number of countries, all under a banner of Silk Road internationalism. I would argue such developments are significant as they have the potential for initiating bigger conversations about non-European histories that are not framed in relation to white, imperialist histories of subjugation. To use Chakrabarty's (2009) aphorism, they put in play non-Eurocentric histories that 'provincialise' Europe in world history in highly productive ways, and in a way that decolonisation, BLM projects that take Europe as their primary point of focus simply cannot.

Internationalism between Competition and Collaboration

Many other examples could be cited to illustrate how China's Silk Road internationalism is forging ties between heritage and infrastructure development. Through the BRI, China is advancing a foreign policy that has world-ordering implications. It would be a mistake however to think that China is alone in seeding funds for such projects. Across a number of regions, Belt and Road has added momentum to an international relations dynamic whereby states seek power through multi-sector, transboundary connectivity. The template for this was obviously established over the course of the past two centuries and the globalisation of the 1990s significantly advanced the geopolitical importance of international connectivities through finance, trade, labour mobility, and so forth. But what we see in Belt and Road, and the regional architectures that have emerged in response, is both a return to high-modernist forms of development that privilege the delivery of infrastructure and hardware as the primary public goods, and, simultaneously, the addition of new forms of digital and cultural connectivity as state strategy. Financing for this comes from multilateral banks, such as the Asian Infrastructure Investment Bank and World Bank, bilateral loans, sovereign wealth funds, and private investors. Oriented around multiple modes of connectivity, such developments constitute a powerful and complex political economy of heritage production. It is, of course, a space of competition and contested claims, and as India, Russia, Turkey, and Arab countries look to secure influence and win friends within their respective regions we are seeing important developments in the use of history and culture within international affairs.

Crucial here then is a second factor, that of civilisation. The Silk Roads revival discourse has led to a dramatic shift in the use of civilisational discourses within

international diplomatic contexts. In addition to promoting ideas about a grand civilisational heritage at home, China has instigated various platforms for a 'dialogue of civilisations.' Most notable here was the 2019 International Conference on Dialogue of Asian Civilizations, held in Beijing. In April 2021, plans were announced for a second Dialogue of Civilizations conference in the coming years (CGTN 2021a). But beyond these headline-grabbing events, Silk Road internationalism has led to a wave of cultural sector collaborations between China and Belt and Road partner countries, including Egypt, Greece, Iran, Sri Lanka, Tunisia, and others. These range from museum exhibitions to cultural performances, to conferences and symposia, through to archaeological research projects. Running through these is a discourse of shared civilisational values, intercultural tolerance, and mutual respect. Crucially here, such framings of civilisation are often celebrations both of grandiose pasts and a resilience against Western power in modern times. In the case of Egypt or Iran, these cultural and political affinities are built around the struggle to resist and overcome episodes of European colonialism. Elsewhere though, the political references may be more recent, with the 'humiliations' suffered by Greece at the hands of EU or by Iran through US sanctions, being two such examples.

These developments are part of a fascinating and important trend towards South-South co-operation. Within political geography and development studies, South-South co-operation has emerged as a concept for understanding shifts in the international aid landscape, and associated modes of developmental co-operation between those countries identified by the OECD (Organization for Economic Cooperation and Development) as lying in the Global South. In the past decade or so, the scale and scope of South-South co-operation has increased significantly and in tracking such processes through the lens of international finance and funding, Emma Mawsdley argues relationships are formed around a sense of shared historical and geopolitical positioning. With Western aid from high-income countries described as overly interventionist and thus neo-imperial, countries like India and China are leveraging their Global South credentials to construct a different discourse of co-operation. Mawdsley (2019, 266) explains that relationships are built around 'powerful discourses of empathy and solidarity, shaped by Third World-ist, socialist, non-aligned and colonial/post-colonial positionalities.' Civilisational discourses and evidence of shared histories thus constitute the foundations—cultural, religious, linguistic—upon which claims of affinity and solidarity can be constructed. This means that China is not alone in its attempts to build historical narratives that are designed to reach across national borders. In India, the election of Narendra Modi as Prime Minister in 2014 gave further political authority to Hindu populism. As various observers have documented, Modi's (re)construction of India as a Hindu nation anchored in a civilisational discourse is aggressively cast in the politics of Hindutva; an ideology that uses a politically and culturally conservative vision of Hindu culture, which demands assimilation by Muslims and other minorities into a majoritarian national identity (Banerjee and Copeman 2020; Drusche 2020).

But this now has international reach through collaborative projects that promote certain ideas of an Indian civilisation in 'revival.'

In Russia, Vladimir Putin has cemented public support in part by couching his agenda within a framework of Eurasianism. In the 1920s Eurasianism developed as a largely emigre movement emphasising the uniqueness of a Russian culture that combined Slavic and non-Slavic traditions. By casting Eurasia as a single civilisational zone, 'Eurasianists also stressed the Asiatic ingredient of Russian culture and ethnicity' (Bassin 2008; Shlapentokh 1997, 129). As such ideas resurfaced in the 1990s, Aleksandr Dugin and his followers reframed Eurasianist discourses vis à vis a Western civilisation that pivoted around Atlantic capitalism. Neo-Eurasianism also left behind ideas of Eurasia as a single civilisation in favour of a unified 'political and ideological principle' (Bassin 2008, 286). For Clowes (2011, xiv) then, Dugin 'developed a Russocentric dream of a future Eurasian imperialist state system, centering in Moscow and the Russian north and Siberian east.' Of relevance here though are the arguments raised by Arnold and Stachelski (2020) in their introduction to a book of translated essays published by Eurasianists in the first half of the twentieth century. They suggest that Western scholars need to appreciate how the significance of Eurasianism in Russian society extends beyond state ideology. They indicate its deep influence continues to be felt across 'numerous civilizational vectors, ranging from art and aesthetics to literature and linguistics' (Arnold and Stachelski 2020, 11–12). It is an argument that suggests Putin's vision of Eurasianism resonates at multiple social and cultural levels, and thus extends beyond the ultraconservative ideas of Dugin, to which it is often tied within Western political commentary.

In the case of Turkey, ethnocultural geographies and visions of history have also been front and centre of the AK Parti under the leadership of Recep Tayyip Erdoğan. The party's formulation of populist politics has been firmly rooted in a nostalgic depiction of glorified Ottoman rule. In his book examining Erdoğan's use of historical narratives, M Hakan Yavuz (2020) argues that neo-Ottomanism attempts to solve problems of social cohesion and a crisis of identity in the country, primarily what constitutes 'Turkishness.' But as Yavuz points out, doctrinal pride for an imperial Ottoman past has increasingly influenced Turkey's foreign policies, and its conduct in regional wars, aid in Africa, and conduct with neighbours across the Mediterranean. Gabriela Özel Volfová (2016) also considers such processes, emphasising there are distinct ambiguities in these reconstructions, indicating that neo-Ottoman discourses and the impact they might have on foreign policies can potentially be read in three ways: first, that the Ottoman empire is portrayed as the centre of world civilisation; second, as an Islamic Empire; and third, as a multicultural empire. She suggests that the ways in which these come to be deployed alter depending on the context. What is clear, however, is that Erdoğan's neo-Ottoman nostalgia involves the ongoing interweaving of narratives of civilisation, regionalism, and national identity in an attempt to secure regional influence.

Such examples are offered to illustrate a landscape of competition and collaboration, as countries manoeuvre to secure influence in their respective regions. This is not entirely new of course, but today Eurasia is a region where rising and competing powers strategically build narratives of history around routes, connectivities and flows, and civilisational glories (Winter 2022). COVID-19 added further instability to world affairs and it would be foolish to attempt to precisely map the alliances and political relations through which narratives of 'shared pasts' and discourses of civilisation might be built by these different countries. The case of India can help briefly illustrate the issues I have in mind. In recent years, discourses of a civilisational past have increasingly turned to the maritime domain and the ocean-based connections to East Africa and Southeast Asia. For example, in early 2021, the Indian Council of World Affairs hosted a conference on the need to develop 'a maritime consciousness' in the Indian civilisational and historical imaginary. Various factors are driving funding and support for such events. Most obviously, government foreign policies that have evolved from Look East to Act East, and beyond, were conceived in order to improve security, diplomatic, and trade relations with regional neighbours, an issue that gained further precedence after the launch of BRI. Equally important though is the nature of political and cultural relations with neighbouring countries and the diplomatic sensitivities of pushing certain narratives of history and culture through international collaborations. In Southeast Asia, Hinduism and Buddhism remain viable, albeit fragile, frameworks for presenting a Greater India history to expert and public audiences. In contrast, however, precarious and intermittently violent relations with Pakistan mean that few if any heritage diplomacy projects emerge between the two countries showcasing the influence of Hindu and Buddhist cultures. This has interesting implications for the political project of tracing the roots of Indian history back to the Indus Valley Civilisation, and most notably the archaeological sites of Harappa and Mohenjo-Daro, both of which lie in Pakistan. As 'cradles' of civilisation, the two sites are crucial to the Hindutva movement, and misleading 'out of India' theories of the Aryan race that are advanced by certain groups in an effort to 'indigenise' Hindu culture (Etter 2020). The case of India and its regional context is merely one example that points to the ways in which discourses of 'civilisational revival,' the 'civilisational state,' and a 'dialogue of civilisations' is a significant and complicated politicisation of history and heritage spanning across regions and populations with diverse religious and cultural affiliations.

Back to the Future

Societal crises spawn hostility, resentment, and suspicion. The global nature of the pandemic means these sentiments will likely shape world and regional affairs for some time to come. COVID-19 also arrived at a time when various forms of populist nationalism were gaining ascendency across a significant number of countries. Such challenges, together with the prolonged closure of international borders in the wake

of COVID-19, mean that a commitment to international dialogue and collaboration is as important now as it was at any point during the twentieth century. In the discussion here then I have highlighted some factors which now influence the degree to which institutions, scholars, and governments from different regions are engaged in international projects and collaborations. To clarify, in no way I arguing we are seeing a simple 'retreat of the West' and the complete disengagement of institutions in Europe, the United States and elsewhere from international affairs. But if we look back over the history of cultural internationalism and its world-ordering possibilities, as discussed by scholars such as Akira Iriye (1997, 2002), then there are discernible trends and events that lead to some regions and countries gaining ascendency in the agenda of ideas. Nineteenth-century European empires were the structural conditions within which modern forms of internationalism emerged. COVID-19 doesn't wipe away that legacy. However, my observations here seek firm ground in the manifest shifts we are witnessing in the geopolitical order today. BLM goes to the heart of some of THE meta-narratives of Western Civilization. It foregrounds questions about progress concerning race and class, and the presence of lingering neo-imperialist attitudes and the structural conditions they produce.

There is a body of research that highlights THE growing impact Non-Western actors are having on the UN system (Piccone 2018; Taskien 2020). This is clearly evident in the case of UNESCO, to which China has become the largest financial contributor at 15.5% of regular budget in 2020. It is also the biggest donor to its world heritage program at over 19%, and now contributes around 20% to UNESCO's annual Intangible Cultural Heritage Fund (UNESCO 2020). To give context to these numbers, France, Britain and the UK all contribute less than 6% each to UNESCO's regular budget. As others have documented, the United States has withdrawn its funding contributions altogether. In this regard, I would argue we are seeing a similar story to that of the 1990s, wherein significant increases in funding from Japan led to greater influence in the organisation and the ability to steer global policy by securing senior leadership positions, including that of Director General. Observers of today's global governance landscape are divided on how to interpret China's growing engagement with multilateral and inter-governmental institutions, and the degree to which Beijing wants to challenge or undermine the values and ideals which currently orient the activities of the so-called international community. But I would suggest that it is unlikely we will see China's internationalist ambitions pivoting around the promotion of democracy, liberalism, or rights-based approaches to heritage and culture. For those interested in the future of international heritage governance, its paradigms and its priorities, such issues will be worth studying, particularly given the country's rapid economic rebound in 2021 and its apparent commitment to cultural internationalism. In all the commentary about the withdrawal of the US from Afghanistan, it went unnoticed in the West that China's strategic interests in the country have led to new bilateral agreements around heritage cooperation (CGTN. 2021b). Such initiatives should be situated within the broader contexts I have outlined here to substantiate the claim that a

new research paradigm is needed, one that grapples with the ways in which today's multipolar world is characterised by an overlapping convergence of politically forceful claims about history and culture.

There is a growing body of literature contemplating heritage futures, an important debate that has been led by Rodney Harrison (2020). COVID-19 served as a powerful reminder of the pitfalls of predicting futures and this collection was conceived with such challenges in mind. In contributing to this discussion, the themes I raise here are reflections on the forces at play in a shifting power landscape, and how COVID-19 and the momentum that gathered around the BLM movement connect with such changes. We know empire, nationalism, competitive state power, and internationalism have all been pivotal forces shaping the nature of heritage in the modern era. In this regard, little will change in the future. But COVID-19 occurred at a moment when the debates and narratives about history, culture, and memory looked very different in different parts of the world. It will be interesting to see the degree to which these public debates find points of convergence and dialogue. If black lives really do matter, then the discussion needs to move far beyond those issues associated with white history and historiography. In reflecting on these events and convergences, my intention is not to artfully prescribe futures. Instead, I raise themes and questions that require greater discussion if we are to make sense of the unsettling and transformative forces we are experiencing today, and their possible long-term implications.

References

Arnold, Jafe and John Stachelski, ed. 2020. *Foundations of Eurasianism—Volume 1.* Tucson: PRAV Publishing. Kindle.

Asian Infrastructure Investment Bank. 2021. "Our Projects." Accessed June 15, 2021. https://www.aiib.org/en/projects/list/index.html.

Associated Press Tokyo. 2010. "China Overtakes Japan as World's Second-Largest Economy." *Guardian,* August 16, 2010. https://www.theguardian.com/business/2010/aug/16/china-overtakes-japan-second-largest-economy.

Banerjee, Dwaipayan and Jacob Copeman. 2020. "Hindutva's Blood." *South Asia Multidisciplinary Academic Journal* 24/25. 10.4000/samaj.6657.

Bassin, Mark. 2008. "Eurasianism 'Classical' and 'Neo': The Lines of Continuity." *Slavic Eurasian Studies* (17): 279–294.

Caradonna, Vittoria. 2021. "'All the Things Happening Outside of the Museum Push Me Back In': Thinking Through Memory and Belonging in Amsterdam's Tropenmuseum." *International Journal of Heritage Studies.* 10.1080/13527258.2021.1910064.

Carrai, Maria. 2021 "Chinese Political Nostalgia and Xi Jinping's Dream of Great Rejuvenation." *International Journal of Asian Studies* 18 (1): 7–25.

CGTN. 2021a. "China to Host Second Conference on Dialogue of Asian Civilizations." *CGTN,* April 20, 2021. https://news.cgtn.com/news/2021-04-20/China-to-host-second-Conference-on-Dialogue-of-Asian-Civilizations-ZBKGa7q4Fy/index.html.

CGTN. 2021b. "In Asia First, China Inks Bilateral Cooperation Agreements on Heritage Conservation with Afghanistan, Pakistan." *CGTN,* May 12, 2021. https://news.cgtn.

com/news/2021-05-12/China-expands-action-to-safeguard-heritage-with-Afghanistan-Pakistan-10cr1JCYvBK/index.html.

Chakrabarty, D. 2009. *Provincializing Europe: Postcolonial Thought and Historical Difference.* Princeton: Princeton University Press.

China International Development Cooperation Agency. 2021. "Our Work." Accessed June 15, 2021. http://en.cidca.gov.cn/ourwork.html.

Clare, Angela. 2021. "2021–22 Foreign Aid Budget." Parliament of Australia. Last Modified June 7, 2021. https://www.aph.gov.au/About_Parliament/Parliamentary_Departments/Parliamentary_Library/pubs/rp/BudgetReview202122/ForeignAidBudget.

Clowes, Edith. 2011. *Russia on the Edge: Imagined Geographies and Post-Soviet Identity.* Ithaca: Cornell University Press.

Decolonizing Museums. 2021. "Settler Colonialism, Slavery, and the Problem of Decolonizing Museums: A Virtual International Conference Organised and Hosted by the University of Penn Museum–October 20–23, 2021." Accessed June 22, 2021. https://decolonizingmuseums.com/.

Drusche, Audrey. 2020. "Hindutva's Dangerous Rewriting of History." *South Asia Multidisciplinary Academic Journal* 24/25. 10.4000/samaj.6636.

Elliott, Larry. 2020. "China to Overtake US as World's Biggest Economy by 2028, Report Predicts." *Guardian*, December 26, 2020. https://www.theguardian.com/world/2020/dec/26/china-to-overtake-us-as-worlds-biggest-economy-by-2028-report-predicts.

Etter, Anne-Julie. 2020. "Creating Suitable Evidence of the Past? Archaeology, Politics, and Hindu Nationalism in India from the End of the Twentieth Century to the Present." *South Asia Multidisciplinary Academic Journal* 24/25. 10.4000/samaj.6926.

Harrison, Rodney. 2020. "Heritage as Future-Making Practices." In *Heritage Futures: Comparative Approaches to Natural and Cultural Heritage Practices*, edited by Rodney Harrison, Caitlin DeSilvery, Cornelius Holtorf, Sharon MacDonald, Nadia Bartolini, Esther Breithoff, Harald Fredheim, Antony Lyons, Sarah May, Jennie Morgan, and Sefryn Penrose, 20–50. London: UCL Press.

Hutton, Mercedes. 2019. "How 'the China Tourism Miracle' had Boomed Over the Past 20 Years." *South China Morning Post Magazine*, May 1, 2019. https://www.scmp.com/magazines/post-magazine/travel/article/3008294/how-china-tourism-miracle-has-boomed-over-past-20.

Indian Council of World Affairs. 2021. "Media Release on ICWA International Conference on K. M. Panikkar and the Growth of a Maritime Consciousness in India, 23–24 March 2021." Media Releases. Last modified 26 March 2021. https://www.icwa.in/show_content.php?lang=1&level=2&ls_id=5931&lid=4097.

Iriye, Akira. 1997. *Cultural Internationalism and World Order.* Baltimore: John Hopkins University Press.

Iriye, Akira. 2002. *Global Community.* Berkeley: University of California Press.

Lee, Yen Nee. 2019. "Here Are 4 Charts that Show China's Rise as a Global Economic Superpower." *CNBC*, September 23, 2019. https://www.cnbc.com/2019/09/24/how-much-chinas-economy-has-grown-over-the-last-70-years.html.

Ludwisiak, Malgorzata. 2021. "How Museums Could Reimagine Themselves in the Aftermath of the Black Lives Matter and Rhodes Must Fall Movements." Artnet. Last modified April 15, 2021. https://news.artnet.com/opinion/museums-after-blm-1959349.

Lynch, Jessica. 2021. "'Interrupt the Status Quo': How Black Lives Matter Changed American Museums." *Student Research Submissions* 397: 1–38.

Mawdsley, Emma. 2019. "South–South Cooperation 3.0? Managing the Consequences of Success in the Decade Ahead." *Oxford Development Studies* 47 (3): 259–274.

Mileson, Vanessa. "An Ode to Afghan Cultural Heritage." Impact. Last modified December 3, 2021. https://impactnottingham.com/2021/12/an-ode-to-afgan-cultural-heritage/.

Millward, James October 9, 2020. "We Need a New Approach to Teaching Modern Chinese History: We have Lazily Repeated False Narratives for too Long." *James A. Millward* (blog), https://jimmillward.medium.com/we-need-a-new-approach-to-teaching-modern-chinese-history-we-have-lazily-repeated-false-d24983bd7ef2.

Piccone, T. 2018. "China's Long Game on Human Rights at the United Nations." *Foreign Policy at Brookings*. Washington D.C.: Brookings.

Quinn, Ben. 2021. "V&A Insists it has 'Responsibility' to Tell Truth About Collections." *Guardian*, June 28, 2021. https://www.theguardian.com/artanddesign/2021/jun/28/va-insists-it-has-responsibility-to-tell-truth-about-collections.

Sanger, David and Mark Landler. 2021. "Biden Tries to Rally G7 to Counter China's Influence." *New York Times*, June 12, 2021. https://www.nytimes.com/2021/06/12/world/europe/biden-china-g7.html.

Shlapentokh, Dmitry. 1997. "Eurasianism: Past and Present." *Communist and Post-Communist Studies* 30 (2): 129–151.

Taskien, Mika-Matti. 2020. "On Building a Community of Shared Future for the United Nations: Analysis on China's Performance in the United Nations General Assembly 2013–2018." Masters thesis, University of Helsinki. https://helda.helsinki.fi/handle/10138/314319.

Tillman, Henry, Ye Yu, and Yang Jian. 2021. *Health Silk Road 2020: A Bridge to the Future of Health for All.* Shanghai: China Investment Research and Shanghai Institutes for International Studies.

UNESCO. 2020. "Status of Contributions to the Regular Budget as at 17 December 2020." Accessed December 19, 2020. http://www.unesco.org/new/en/member-states/mscontent/status-of-contributions/.

UNWTO. 2019. *The 21st Century Maritime Silk Road–Tourism Opportunities and Impacts.* Madrid: UNWTO.

Van der Leeuw-Roord, Joke. 2021. "Decolonizing Cultural Institutions in the Netherlands." Euro Clio. Last modified May 18, 2021. https://www.euroclio.eu/2021/05/18/decolonizing-cultural-institutions-in-the-netherlands/.

Volfová, Gabriela Özel. 2016. "Turkey's Middle Eastern Endeavours: Discourses and Practices of Neo-Ottomanism under the AKP." *Die Welt des Islams* 56 (3–4): 489–510.

Whats in Port. 2019. "Interactive World Cruise Map." Accessed May 18, 2019. http://martello.carto.com/viz/35925a0a-5c50-11e4-a4e6-0e4fddd5de28/embed_map.

Winter, Tim. 2020. "Geocultural Power: China's Belt and Road Initiative." *Geopolitics* 26 (5): 1376–1399.

Winter, Tim. 2019. *Geocultural Power: China's Quest to Revive the Silk Roads for the Twenty-first Century.* Chicago: University of Chicago Press.

Winter, Tim. 2022. *The Silk Road: Connecting Histories and Futures.* New York: Oxford University Press.

Wintour, Patrick. 2021. "Britain's Aid Cuts: What's Been Announced so Far." *Guardian*, May 1, 2021. https://www.theguardian.com/global-development/2021/apr/30/britains-aid-cuts-whats-been-announced-so-far.

Wong, Brian. 2020. "China's Mask Diplomacy." *Diplomat*, March 25, 2020. https://thediplomat.com/2020/03/chinas-mask-diplomacy/.

Worley, William. 2021. "Donor Cuts Slashed Humanitarian Aid in 2020, Despite Increased Need." *Devex*, June 22, 2021. https://www.devex.com/news/donor-cuts-slashed-humanitarian-aid-in-2020-despite-increased-need-100198.

Yavuz, M. Hakan. 2020. *Nostalgia for the Empire: The Politics of Neo-Ottomanism*. Oxford: Oxford University Press.

Yeats, Christine. 2021. "Should They Stay or Should They Go?: Contested Statues." *Public History Review* 28: 1–3.

Zhu, Yujie and Christina Maags. 2020. *Heritage Politics in China: The Power of the Past*. London: Routledge.

SECTION VIII

Heritage Futures and 'News from Nowhere'

Many of the chapters in this volume are concerned with the manner in which the concatenating set of contemporary crises cause us to rethink heritage ideas and practices–and what this means for the future of heritage. We close with two powerful chapters by heritage scholars writing from very different worlds of practice, for whom the question of heritage futures is a central concern. Writing from the heart of the pandemic in southern Africa, Jesmael Mataga makes an impassioned case for the need to rethink heritage in the direction of the local, the immaterial, the non-official, and the spiritual–away from global discourses and practices of heritage. In this way, the traumatic break occasioned by the pandemic becomes a generative moment, forcing a reset, and inviting us to learn and think from Africa, and from the experiences of trauma and precarity. Mataga writes 'African heritages have always been in a state of precariousness owing to the effects of socio-political instabilities but more so due to marginalisation, dispossession and devaluation triggered by universalised conceptions and post-colonial heritage governmentalities'. One of the effects of these inherited conceptions of heritage has been to introduce a disjuncture 'between the seeing of sites as "monuments" by institutions, disciplines and heritage management agencies' and the local communities living in relation to those same sites–for whom they are frequently understood as sacred sites. Drawing on the work of Alejandro Haber, Innocent Pikirayi, Webber Ndoro, Joost Fontein, and many others, Mataga describes a countervailing, 'people-centered' approach to heritage. He writes 'The unravelling of mainstream heritage conservation and the shift to a people-centred approach or the idea of valuing heritage for its "livingness" implies thinking and approaching heritage sites and places not from a materialistic conception but from a people centred position that prioritises embodied values, cultural values, symbolism and contemporary practices'. In a confident assertion of place, he echoes Achille Mbembe in asserting:

DOI: 10.4324/9781003188438-24

'it is the global South that affords privileged insight into the workings of the world at large'.

David Harvey's chapter provides the perfect close to this volume, at times impassioned and angry, but also quietly optimistic, and doing what heritage does best: looking forward by looking back. Like Mataga, he begins by arguing that 'The Corona experience ... has brought into question some fundamental elements of heritage and the relationship between past and present'. His chapter turns around an extended reading of William Morris's socialist science fiction novel *News from Nowhere* (1890). 'Nowhere' is a post-catastrophe 'future world': 'a pastoral Utopia in which the system of industrial capitalism, private property and global empire is but a distant (bad) memory ... and society has learnt to live in symbiosis with nature and the rhythm of the seasons.' Harvey's core argument is in defense of utopian thinking which 'has the power to transcend lived reality and prompt change by reconceptualizing the current order'. In this context, he explores the potential of heritage as a form of radical nostalgia 'which acts as a provocation towards building a transformative politics in the here-and-now'. Set against the backdrop of Harvey's daily routine under lockdown–walks in the forest, texts to friends–his chapter is at once deeply humane and quietly radical in its endorsement of heritage as a realm of practice able to open a space of possibility by imagining futures outside–or after–capitalism, racism, extractivism, and patriarchy.

16

COVID-19 AND HERITAGE IN SOUTHERN AFRICA

Precariousness, Resilience, and the Future of Heritage

Jesmael Mataga

> The search for alternative acts of thinking requires the exploration of other ways of speaking of the visual, of sounds, of the senses, and it requires thinking as philosophically and historically as possible about the precariousness of life in Africa, the intensive surfaces of power, and the various ways in which events coexist with accidents. Achille Mbembe 2021: 33.

Will the Sun Rise Again?

The two images (Figures 16.1 and 16.2) were part of an exhibition, '*Will the Sun Rise Again,*'[1] curated in 2020 by the National Art Gallery in central Harare, Zimbabwe. The exhibition was developed as a platform for artists to display the works that they have produced during the COVID-19 lockdowns across the globe and to reflect on the future of the creative sector post COVID-19. With works by a selection of relatively young Zimbabwean artists, the exhibition focused on COVID-19 and its effects–but also looked towards the future. For me, it is Lin Barrie's *To touch … or not to touch*[2] and *Hands on hearts*[3] that stirred my attention in the way it held the effects of COVID-19 against the motif of resilience drawing from idioms of the Hlengwe people–a minority cultural group from South Eastern Zimbabwe. Barrie's '*To touch … or not to touch*' depicts a displaced handshake, while her '*hand on heart*'–derived from '*Kusheweta*' a traditional greeting from the Hlengwe minority group–shows silhouettes of two human figures with hands on their hearts. Juxtaposed against each other, the two pieces show that amid the COVID-19 restrictions, as we take our hands off each other, and as our physical interaction is obstructed, we are left to interact with our hearts. Devoid of physical

DOI: 10.4324/9781003188438-25

FIGURE 16.1 *"Do Not Touch"* by Lin Barrie. National Art Gallery Zimbabwe, 2020. Photograph: National Gallery of Zimbabwe.

FIGURE 16.2 *"Hands on Hearts"* by Lin Barrie. National Art Gallery Zimbabwe, 2020. Photograph: National Gallery of Zimbabwe.

contact, human interactions move to the emotional–representing humaneness, compassion, solidarity, and empathy. It is a reaffirmation of the resiliency of the human spirit amid adversity and calamity. Amidst adversities, fears, disillusionments, and uncertainties caused by the global pandemic, the two pieces invite us to look beyond our position of vulnerability. The analogy is quite poignant in how we think about heritage now and in the future–looking beyond the limits of the present and imagining the future. In this essay, I hold the motif of precariousness and that of resilience in the same frame–as a way to imagine the heritage futures on the continent and in the world.

The effects of the pandemic show us that we may never think of or approach heritage in the same way. Thanks to lockdowns, travel restrictions, social distancing, and other limits to physical interaction, aspects of heritage that normatively underpin how we have thought about, preserved, and used natural and cultural heritage have been disrupted. These prescripts inadvertently disrupted the taken-for-granted elements related to heritage–its materiality, aesthetics, physical access, engagement, and forms of visitation. Amid COVID-19 restrictions, it was clear that somethings shifted and that we can never think of, define or use heritage the same way. As the normative values get challenged and tested, could recourse to spirituality and long-held notions of heritage offer us alternative ways to look at heritage, beyond its materiality? Rather than relying on the material manifestations, the universalised values, and visitations, perhaps the future of heritage lies in the local, rather than the global, in the non-official rather than the official and institutionalised, and in the non-material as opposed to the absolute physical. Can we draw on long-held local and Indigenous knowledge(s), conceptions and practices to rethink heritage, its meanings, and values for a post-COVID world? Without romanticizing them, can the African experiences of natural disasters, famine, conflict, and other forms of trauma, reshape global heritage practice and theorisation of heritage–a theory and practice from positions of calamity, pain, loss, and resilience.

Ground Zero: Precariousness and Resilience

Disasters cause trauma–collective and personal traumas. I spent half a decade of academic life in the vaults of the Jagger reading room at the University of Cape Town (UCT) main library. There was always an inviting and enigmatic quietness which made working in this space an awe-inspiring experience as one perused, engaged with, and imbibed pages of histories, experiences, and stories embedded in the archival fragments of time. On April 18, 2021, a fire gutted this important section of the UCT Libraries, one of the most extensive collections of African Studies material in the world, named after J.W. Jagger, a benefactor of UCT libraries in the early twentieth century. The inferno partly destroyed the library, burning and damaging the rich special archival collections. In the days and weeks following the fire, we watched and mourned the damage and as restoration efforts gathered momentum, we reflected on our collective loss and trauma. In the

following months, after the outpourings of sadness and grief at the loss, felt from all parts of the world, a salvage process brought together thousands of volunteers and well-wishers from all over the world, all in an empathetic resolve to rise from the ashes, rather than being wholly overwhelmed by the calamity. The restoration and refurbishment project continues as I write today and there is hope.

As in the April 2021 Cape Town fire, COVID-19 and its ramifications have called for reflection on the fragility of aspects of our lives that we have valued but have taken for granted. In a sense, COVID-19 was a ground zero moment, one of untoward calamity but also an opportunity to start over, and to reflect. All humanity felt the effects of COVID-19, yet due to global inequalities, it is had more disastrous ramifications on Africa and other less developed continents. In Mid- June 2021, a '3rd wave' hit the world, and followed by a 4th wave in 2022, where deadlier variants, Delta and Omicron respectively, wreaked more havoc, showing how difficult it was for scientists to predict or control the pandemic. Amid this uncertainty, the statistics provided by Oxford University exposed the stark realities and contradictions of exacerbated global economic inequities. While the effects of the pandemic were projected to be accentuated in middle to low income countries, these countries were receiving very limited supplies of the manufactured vaccines.[4] In the midst of heightened global socio-economic inequalities and as vaccine related nationalisms spread globally, at a local level state monopoly of dealing with the pandemic flounder, forcing societies in Africa to make recourse to home-based solutions and locally procured remedies to navigate deadly effects of the COVID-19 calamity.

The effects of COVID-19 on arts, cultural, and heritage institutions was quite immediate leading to de-institutionalisation–a process that weakens traditional institutions, such as museums, cultural centers, theatres, cinemas, mainly due to the effects of the pandemic on financial resources (Pasqualucci 2021). Institutions struggled under COVID-19-induced austerities resulting in the closure of heritage sites, world heritage sites, memorials, and other places. As global travel halted, tourism numbers dwindled, heightening the financial stress and imposing impediments on conservation work. World heritage sites, historic sites, places, and museums all over the world have remained closed, and devoid of the usual throngs of visitors. Round-the-clock lockdowns, travel bans, and social distancing, have negatively affected preservation efforts and the usual forms of visitations that sustain these sites and places, financially and otherwise. Reports by ICOM[5] and UNESCO[6] laid bare the general economic malaise caused by COVID-19 globally. For Africa, and other low-income states, COVID-19 further undermined governments' ability to finance conservation, resulting in lack of capacity for heritage institutions to perform their normal duties.

For museums and heritage sites in Africa, the already existing crises, political instability, and socio-economic challenges make the effects of the pandemic more pronounced. For instance, in 2021,[7] of the 53 properties on *List of World Heritage in Danger*, Africa has 30% (second after the Middle East). The main threats include war

and conflict, neglect/abandonment, economic development activities, climate change, and increased urbanisation. Given this unevenness, the effects of COVID on low-income countries would always be more pronounced–as it would in regions ravaged by conflict, security problems, and funding problems–as governments prioritised procurement of vaccines, capacitating their health systems and ensuring food security. Thus, compared to other continents, although Africa had the lowest numbers of infections, the effects of the pandemic on society have been much more pronounced.

Heritage Matters: Global Discourses, Local Experiences

In Africa, heritage still matters. It remains a persistent source for the negotiation and creation of authority, and for the (re)asserting of claims by various stakeholders. It is deployed not only by states and by state institutions, but is also claimed by local communities, minorities, and Indigenous communities to validate socio-political claims. In Africa, these variegated claims make heritage highly valued, largely political, and highly contested (Peterson and Gavua 2015; Shepherd 2008; Herwitz 2012). Writing emerging from the African continent in the last few years is testimony to the varied, if sometimes conflictual and highly contested uses of heritage on the continent. Here, the value of heritage as a vehicle for local use is evident not only in the way it always features as central to public discourses and debates, but also in it being seen as redemptive–socially and economically.

I see African heritages as having always been in a state of precariousness. This is caused by the fragilities engendered by lopsided global interactions–slavery, colonialism, apartheid, and Euro-American conceptions of heritage. These global imperatives have marginalised local practices, oftentimes resulting in the 'mis-recognition of community heritage' (Waterton and Smith 2010) or in disillusionment stemming from 'unfulfilled promises' around community participation (Chirikure 2013; Chirikure et al. 2010). Thus, the main challenges bedevilling heritage management practices are related to the legacies of colonialism and universalised approaches to heritage preservation, which have caused disjuncture between heritage practices and local communities. The resultant disjuncture created artificial binaries between the material and the immaterial/spiritual, the natural versus the cultural, and the expert against Indigenous communities (Chirikure 2013; Keitumetse 2016; Pwiti 1996; Ndoro 2005, Fontein 2006). Such disjunctures exacerbate the effects of other documented threats to heritage on the continent, such as military conflict and terrorism in certain regions of Africa. Other documented issues affecting heritage in Africa include aspects such as illicit trafficking, climate change, lack of funding, neglect, and the increasing divergence between heritage preservation and economic development activities (Baillie and Sørensen 2020).

Although global heritage practices as framed and influenced by organisations like UNESCO and others have had a homogenising influence on how nations

approach heritage, there is an emerging paradigm shift in thinking about global heritage practices. These emerging critiques challenge universalised conceptions of heritage in preference for local values, knowledge, and practices (Baillie and Sørensen 2020; Brumann 2021; Higgins and Douglas 2021; Haiming 2018; Ndoro and Wijesuriya 2015; Waterton and Watson 2013; Holtorf and Fairclough 2013; Gonzalez-Ruibal 2013; Labadi and Long 2010; Silva 2015; Fontein 2000). In the same vein, in the past few years, writing on heritage in Africa has also taken a 'community' turn, and is now encapsulated in the calls for the decolonisation of disciplines, institutions and practices related to heritage. Framed as 'community archaeology,' 'community heritage' or 'indigenous heritage,' this turn is encapsulated in the persistent search for participatory practices in the discipline of Archaeology, in museums, and in the management of natural and cultural heritage (Ndoro, Chirikure and Deacon 2018; Schmidt 2017; Schmidt and Pikirayi 2016; Keitumetse 2016; Peterson, Gavua and Rassool 2015; Meskell 2013; Pikirayi 2011; Chirikure and Pwiti 2008).

In response to global heritage discourses, this emerging body of work challenges global and expert conceptions and governance of heritage while calling for the adapting of local knowledge and practices. In the last two decades, writing and commentary by academics, archaeologists, and heritage managers in Southern Africa show—on the one hand—the increasing desire for integrating local communities and their knowledge and practices, but on another hand, the complexities and challenges implicit in the management and protection of heritage on the continent.[8] There are increasing calls for a move towards decolonizing heritage practice through foregrounding local conceptions and local ways of knowing (Chririkure 2021; Schmidt 2017; Schmidt and Pikirayi 2016; Keitumetse 2016).

Among this growing corpus of analyses on heritage from Africa, three recent books are notable: *Managing Heritage in Africa: Who cares* (Ndoro, Chirikure and Deacon 2018), *African Heritage Challenges: Communities and Sustainable Development* (Baillie and Sørensen 2020), and *Great Zimbabwe: Reclaiming a 'Confiscated' Past* (Chirikure 2020).[9] What these volumes foreground is that in Africa, heritage has persistently remained a central aspect of social, political, and economic life, whose production and preservation brings various stakeholders in conversation—from the state, to local communities, to international organisations such as UNESCO—sometimes in divergent and conflictual ways. It is persistently invoked by local communities to lay claims to resources, citizenship and belonging and is expected to contribute to dealing with economic and social challenges. The analyses show how universalised practices affect heritage regimes and highlight the challenges and contradictions, but also foreground the resilience of local conceptions and practices of heritage. They analyse state-supported management systems, their links to capital interests, and the limited benefits for local communities (Ndlovu 2021). These contests and disjunctures reiterate the persistent value that is accorded to heritage on the content. Yet, this is also fodder for how the African experiences can influence global approaches.

The contemporary, and historical precariousness related to heritage are points of learning–a chance for re-imagining the future in a world changed by a global pandemic. As we rethink how heritage will or should look like, as influenced by the traumas of COVID-19, aspects to reframe include the intersection between the global versus the local, and the relationship between experts and communities. While world heritage 'governmentalities' have been approached as universal and homogenous, at a local level heritage remains a contested field. Conceptualisations of materiality, space, and value set out by universalising heritage preservation practices have not been totally homogenising. Experiences and influences from outside of the Euro-American geographic regions are foregrounded as a crucial influence on how we think about heritage. In response to universal approaches, this body of work emphasises the value of knowledge embedded within traditional and Indigenous communities and their contribution to sustainable heritage preservation solutions and management.

The need to focus on local contexts and 'traditional' systems is highlighted as the recommended strategy for challenging homogeneous and universalised heritage preservation practices. Given the restrictions imposed by COVID-19, the suggestion of re-entering the local makes much more practical sense for the ways we approach heritage. As international mobility and access gets curtailed, practicalities of accessibility and closeness become more valuable in sustaining heritage globally. Contemporary cultural heritage practices often fail to capitalise upon local knowledge and traditional skills and undervalue the potential con-tribution of local communities in finding creative and resourceful solutions to the issues they are confronting. Yet, the knowledge within traditional and indigenous heritage allows communities to participate in homegrown solutions that facilitate sustainable heritage preservation, while at the same time allowing communities to address contemporary challenges such as climate change, conflict, and poverty among others. Perhaps this is the future of heritage preservation–the interplay between conservation, and the economic and social community development of local communities? Perhaps a way of living and dealing with the limits of materiality and physical access could be to borrow from African relationships to nature and culture that are based on the abstract, the spiritual, and the sacred?

The Future of Heritage: People, Pastness and Epistemic Plurality

Neil Silberman has recently argued that one of the lasting impacts of COVID-19 will be the rethinking of the concept of 'heritage' itself, especially:

> Its dependence on the principle of physical preservation and expert curation … the sheer physicality of cultural heritage–whether as artifacts, artistic representa-tions, or architectural assemblages … the modern cult of monuments. (2021:3–4)

These have been the bedrock of the preservation of natural and cultural heritage, propelled by large international organizations, and global legislative instruments. This way of looking at heritage relies heavily on access, forms of visitations, and interactions with that which is material and physical. Yet, COVID-19 has taught us that we have to live with the prospect of lack of physical access, and the challenges of immobility and hence relate with heritage from a perspective of non-materiality. The pandemic has catalysed forms of disentanglement—separating humanity from physical spaces and extricating people and experts from physical interaction with heritage. This rupture forces us to look beyond the fetish of materiality, and to consider the other ways of looking at, relating to, and using heritage. Amid COVID-induced restrictions—closures, the inaccessibility of sites, and the inability to experience or work with the materiality of places, sites, and objects—recalling the immaterial becomes fundamental in thinking about how we relate to and understand heritage now and in the future. For most of Africa, one aspect that emerged in the postcolonial period was increasing requests by local communities to re-establish links with heritage sites. Claims by local communities whose practices have been marginalised, are rooted in demands for access and for use. Against the fetish of materiality, local communities deploy their long-held practices, invoking the sacred aspects of sites and places. They use their ancestral and spiritual associations to sites, objects, and landscapes to demand an alternate way of relating to and using, these sites and places. This is heritage enacted and valued through rituals, taboos, regimented access/use, and forms of visitations, making the 'spirit of the People' the 'nerve of heritage' (Munjeri 1995:52).

The enduring significance of sacred sites, landscapes, and places is reflected in the way in which local communities have persistently claimed them, oftentimes resulting in contests over their use and custodianship (Munjeri 2002). Examples of the disjuncture between the seeing of sites as 'monuments' by institutions, disciplines, and heritage management agencies, against the sites being seen as sacred are replete in most parts of Africa. Increasing demands for access to sites for rituals and other traditional and religious activities is a feature of the present moment, where local communities foreground their histories and cultural and religious practices to lay claim to access, and the use and ownership of heritage sites. Such claims are encapsulated in pointing to ancestral graves, rituals, and inferences to the historical ownership and custodianship of sites (Fontein 2006; Pwiti et al 2007; Manyanga 1999, 2003; Nyathi and Ndiwini 2005; Nhamo, Sætersdal, and Walderhaug 2007; Mataga and Chabata 2008). The resultant claims, counterclaims, and disjuncture between experts and local communities, based on the spiritual and religious aspects of heritage are well documented in Southern Africa (Fontein 2006; Ndoro 2005; Pwiti and Mvenge 1996). This disjuncture, propelled by inherited regimes of care, is seen as the biggest challenge in heritage management in post-colonial Southern Africa (Chirikure and Pwiti 2008; Pwiti and Ndoro 1999; Pwiti 1996, Pwiti and Mvenge 1996). In spite of attempts to find common ground, this divergence in the

way local communities see heritage sites–against expert conceptions of heritage–remains a perpetual challenge in heritage management practice in Southern Africa,

There is an emerging paradigm shift in global heritage discourse in writing about the heritage that considers the need for foregrounding local values and practices (Higgins and Douglas 2021; Ndoro, Chirikure and Deacon 2018; Silva 2015; Waterton and Watson 2013; Sinamai 2020; Schmidt and Pikirayi 2016; Haiming 2018.). Commentary on the development of heritage in Africa points to a 'decolonial' turn encapsulated in a persistent search for local communities and the foregrounding of participatory approaches when working with local heritage. The emphasis is on the integration or adoption of local ways of knowing into disciplinary practices and heritage management systems (Chirikure 2020; Schmidt and Pikirayi 2016; Pikirayi 2009, 2011, 2015). This re-centering of people and their long-held forms of knowledge is seen as being central to the sustainable preservation of natural and cultural heritage (Jopela 2018; Joffroy 2005; Munjeri 2002; Mumma 2003, 2005; Jopela, Nhamo and Katsamudanga 2012). This integration of traditional management systems and local ways of knowing is seen as important to the management, interpreting, and use of heritage sites and to epistemic decolonisation across the southern African region (Chirikure 2020; Jopela 2018;). Within museums, this search for local communities is also seen as a way to deal with the inherited legacies of colonial modernity and its skewed knowledge production processes that rendered local cultures as collectable yet unknowable. The processes of redefining, unraveling, and decolonizing museums is seen in the increasing global calls for repatriation of objects and in the efforts at (re)defining the museum and refashioning its inclusive social role (Mbembe 2021; Hicks 2020; Vawda 2019; Sandahl 2019; Rassool 2018, Mataga and Chabata 2012).

Notwithstanding the influence of global intergovernmental organizations as the guardians of 'official' heritage–and their role in the preservation, governance, and promotion of heritage–the destabilisation caused by COVID-19 suggests that the making of heritage should be embedded in the activities of non-state players. The financial downturns caused by COVID-19 have shown us how vulnerable formal systems can be. As normative preservation routines remained suspended, the role of practices that exist outside official discourses–and recourse to heritage practices embedded within local confines–became elevated. The invocation of ancestral landscapes and sacred sites presents an opportunity for relating to heritage in a different way. Rather than focusing on the materiality of sites, local practices prefer to derive their values from a different archive, and on notions of the sacred, ritual, myth, and oral narratives of origin, to lay their claims (Wijesuriya 2007; Carmichael et al. 1994; Kawharu 2009; Munjeri 1995, 2009; Fontein 2006, Ndoro 2005). Against material conceptions, local communities value personal involvement, group experiences, localness, and stories–a heritagisation based on local ideals–'linked to very particular intellectual and cultural contexts' (Holtorf 2017: 497), and a past 'portrayed and evoked in … daily lives' (Holtorf, 2013a: 63). This influences the

fluidity of ideas of value, use, authenticity construction, and the (re)fabrication of heritage objects, places, and practices–focusing on people, functions, and sustainable use and preservation.

This 'people' in heritage preservation discourse and practices is also partly reflected in interventions such as the 2003 UNESCO *Convention for the Safeguarding of Intangible Cultural Heritage*. In the constructing and implementation of the 2003 UNESCO convention, the world woke up to the idea of how ordinary communities assign meanings and functions to heritage places and practices. The convention's focus on social practices, oral traditions and expressions, language, performing arts, rituals, festive events, and traditional craftsmanship, echoes the 'people' dimension of heritage (Ruggles and Silverman 2009; Munjeri 2009). As with UNESCO's emphasis on intangible cultural heritage, ICCROM's 'living heritage' and its 'people-centred' conservation programmes, reiterate the social value of heritage and its importance to contemporary life (Court and Wijesuriya 2015; Stanley-Price et al 2005). The unravelling of mainstream heritage conservation and the shift to a people-centred approach–or the idea of valuing heritage for its 'livingness'–implies thinking and approaching heritage sites and places not from a materialistic conception but from a people-centred position that prioritises embodied values, cultural values, symbolism, and contemporary practices (XU 2018; Wijesuriya, 2007). The emerging 'Critical Heritage Studies approach' has forcefully highlighted this people-focused dimension–foregrounding the need to move from looking at heritage only as material 'things,' to a focus on 'the discourse of heritage' and the various ways in which societies use heritage (Harrison 2018; Harrison 2013; Smith 2006). As pointed out by Rodney Harrison, critical approaches to heritage unravel the relationship between heritage and the experience of late modernity, while also 'reorienting heritage so that it might be more productively connected with other pressing social, economic, political and environmental issues of our time' (Harrison 2013; 2020). In the era of Covid-19, these approaches are also being re-emphasised through the marketing of heritage as 'experience' and through the increased use of virtual media in the exhibition and interpretation of heritage (Harrison 2018: 1367).

While the academic conversations continue, it is also imperative for heritage management institutions to work with local communities in different ways. We have seen in many parts of Africa how local communities foreground the abstract, the spiritual, and the sacred. For local communities, heritage sites and objects are part of their life, and they find value in relating to these sites and objects through everyday rituals–even when this seems to compromise the preservation values as envisaged by experts. Against institutional practices, local communities 'usher in the ontologically different: sacred sites, ancestry, territory,' oftentimes resulting in contestation (Gnecco 2013:11). In Southern Africa, this disjuncture is partly manifested in the #RhodesMustFall activities, and the persistent contestations related to colonial and apartheid monuments (Shepherd 2020, Nyamnjoh 2013; Chipangura 2015). As heritage institutions and experts endeavor to preserve the

colonial fabric of monuments, statues, or sites–seen by some as 'heritage that hurts' (Muringaniza 2004)–local communities point to alternative sites, places, narratives, and practices. Communities make recourse to ancestors, rituals, and traditions, allowing for embodied relations to sites, places, and landscapes–revealing the complex relationships between people, nature, and culture. As communities challenge 'the tyranny of materiality' (Sinamai 2019), they point to shrines and ancestral graves, deploying unwritten cultural practices, traditions, and rites in curating their own historical and cultural past–in this way validating claims for local, individual, family, or group associations with place, rather than global or national values.

How then does all this influence how we think about heritage now and in a post-pandemic future? Perhaps as argued by Denis Byrne, COVID-19 will forever alter how we define or relate to heritage by forcing us to 'resist the tendency of heritage discourse to reduce culture to things, to counter its privileging of physical fabric over social life,' a move counter to the reification or 'thingification of culture' (Byrne 2009:229). This 'new heritage' emanating from the experience of the pandemic, dwells much less in the objects of heritage and much more in a view of heritage as 'the interaction between people and their world, and between people themselves' (Holtorf and Fairclough, 2013:198). A poignant observation by Neil Silberman is that COVID is pushing us to 'shift from products to process' because,

> ... what will emerge as a major theme of cultural heritage initiatives in the post-COVID era will be an emphasis on processes of collective memory rather than things. Localism will be an increasing element in cultural heritage appreciation ... cultural heritage will be where people live, not where people visit. Meaningful local memories will become more resonant and powerful than expert-defined 'outstanding universal values' (2021: 7)

The events and experiences with COVID-19 and its ramifications on heritage should certainly be seen as a way to write the world from an African worldview and to confidently re-insert Africa into the contemporary social theory and epistemic reorientation–theorising from positions of pain, precariousness, and uncertainty. These are values, approaches, and worldviews related to heritage that those regions outside of Europe have clamored for, as more relevant ways to live and work with heritage in its diverse articulations. Experiences from outside of Euro-America are central to adding diversity and challenging entrenched 'global heritage knowledge templates' (Sinamai 2020). COVID-19 has given the impetus to acknowledge local ways of relating to sites, challenging the hegemony of universalised worldviews. This will lead to the decolonisation and democratisation of knowledge production, as we begin to 'write outside of the hegemonic structures of disciplinary languages, codes and standards,' and to consider 'alternative ways of writing that derive writing and narratives from epistemologies ... and subjectivities that have always existed at the borderlands of knowledge production' (Haber 2012:62). The call in this chapter is that experiences of COVID-19 in Africa, should act as an impetus to adopting

'multidisciplinary approaches to decolonised pasts,' allowing us to theorise from an African experience (Manyanga and Chirikure 2017)–and thus making sure that it is 'the global South that affords privileged insight into the workings of the world at large' (Mbembe 2021).

Notes

1 Zimbabwe National Art Gallery, 2020. *Will the sun rise and shine again post COVID-19?* NAGZ: Harare, Zimbabwe.
2 The text explaining the piece *"Do not Touch"* remarked that "The handshake that we take for granted as a mark of trust and friendship is no longer safe. Hands are pulled apart with the mantra, Don't Touch!". (*Will the sun rise and shine again post COVID-19?*. NAG: Harare, Zimbabwe 2020. (online at http://www.nationalgallery.co.zw/index.php/see/whats-on/running-exhibition/161-will-the-sun-shine-again?showall=) (Accessed 15 March 2021).
3 The text describing the piece *"Hands on hearts"* read, "The Hlengwe people of South East … use the "hand on heart" greeting. *'Kusheweta'* … The sun WILL rise again post COVID … The human spirit, in conjunction with the natural world, WILL prevail". (See, *Will the sun rise and shine again post COVID-19?*. NAG: Harare, Zimbabwe 2020. Online at http://www.nationalgallery.co.zw/index.php/see/whats-on/running-exhibition/161-will-the-sun-shine-again?showall=) (Accessed 15 March 2021).
4 As of Mid-June 2021, statistics showed that 51% of people who had received at least one dose of a coronavirus vaccine were from high-income countries, and at least 48% were from Europe and North America, while only 0.8% of people in low-income countries had received at least one dose. Less than 2% of the vaccines found their way to low/middle income countries. (See *Our World in Data project,* University of Oxford. https://ourworldindata.org/covid-vaccinations (Accessed 14 June 2021).
5 A report published by ICOM in 2020 in May 2020, showed that 95% of institutions were at some point forced to close because of COVID-19. See ICOM Report on *COVID-19 and Museums,* https://icom.museum/wp-content/uploads/2020/11/FINAL-EN_Follow-up-survey.pdf (Accessed 11 March 2021).
6 UNESCO produced a series of report on the effects of COVID-19 on World Heritage Living Heritage, Cultural and Creative Industries, Cities, Culture and Creativity, and Museums. The report *"Museums Around the World in the Face of COVID-19"* published in May 2020, also shows the grim picture of how heritage sites have been negatively affected by the pandemic around the world. https://unesdoc.unesco.org/ark:/48223/pf0000373530 (Accessed 11 March 2021). The UNESCO report on Word Heritage Sites showed that 90% of countries with World Heritage properties had closed or partially closed them and 71% closure of sites by February 2021. Visitors to World Heritage sites dropped by 66% in 2020 and an average of 40% of permanent staff were made redundant. (See UNESCO 2021: "'World Heritage in the face of COVID-19', Paris: UNESCO. Online at https://en.unesco.org/news/disruption-and-resilience-unesco-reports-reveal-new-data-impact-covid-19-culture (Accessed 18 June 2021).
7 Statistics on the list of heritage in danger 2021. World Heritage Centre for 2021. https://whc.unesco.org/en/list/stat/#s7, (Accessed 18 June 2021).
8 A brief glance at literature show a wide proliferation of academic and professional commentaries on this search for the local in archaeology, museums an heritage management, particularly in post 2000 Zimbabwe (See, Fontein 2000; Chirikure, S., and G. Pwiti. 2008. Pwiti, G., A. Nhamo, S. Katsamudanga, and A. Segobye. 2007. Pikirayi, I. 2011. Ndoro and Pwiti, 2001 Pikirayi 2009, 2011, 2015(Fontein 2006; Pwiti, G., A. Nhamo, S. Katsamudanga, and A. Segobye. 2007, Manyanga1999, 2003; Nyathi, P., and B.

Ndiwini. 2005 Nhamo, Sætersdal, and Walderhaug 2007 Murimbika, M. 2006; Mataga and Chabata 2008).

9 This section is derived in part from published reviews of recent publications on heritage in Africa. See Jesmael Mataga (2020): Managing Heritage in Africa, Heritage & Society, DOI: 10.1080/2159032X.2020.1805191, available at 10.1080/2159032X.2020.1805191. Mataga J. 2021. African Heritage Challenges: Communities and Sustainable Development, edited by Baillie Britt, and Sørensen Marie Louise Stig. Palgrave Macmillan. 2020. 363 pages. (Hardcover), 99,99 €, ISBN 978–981-15–4365-4, *International Journal of Heritage Studies*, DOI 10.1080/13527258.2021.1941201, Online at 10.1080/13527258.2021. 1941201. Mataga J. 2021b. *Great Zimbabwe: Reclaiming a 'Confiscated' Past.* Shadreck Chirikure. 2020. Routledge. (ebook), ISBN 9780367409999. £33.29. 311pp. International Journal of Heritage Studies, DOI 10.1080/13527258.2021.1941200. Online at 10.1080/13527258.2021.1941200.

References

Baillie, B., and Sørensen, M.L.S. 2020. Heritage Challenges in Africa: Contestations and Expectations. In Baillie, B., and Sørensen, M.L.S. (eds). *African Heritage Challenges: Communities and Sustainable Development.* Singapore: Palgrave Macmillan. 1–43.

Brumann, C. 2021. *The Best We Share: Nation, Culture and World-Making in the UNESCO World Heritage Arena.* Oxford: Berghahn books.

Byrne, D. 2009. A Critique of Unfeeling Heritage. In L. Smith and N. Akagawa, (eds). *Intangible Heritage.* London: Routledge. 229–252.

Carmichael, D.L., Hubert, J., Reeves, B., and Schancheet A. (eds). 1994. *Sacred Sites, Sacred Places.* London: Routledge.

Chipangura, N. 2015. The Love and Hate Relationship of Colonial Heritage: Exploring Changes of the Heritage Archive in Zimbabwe, *Journal of Hate Studies*, 13(1): 43–60.

Chirikure S. 2020. *Great Zimbabwe Reclaiming a 'Confiscated' Past.* London/NY: Routledge.

Chirikure, S. 2013. Heritage Conservation in Africa: The Good, the Bad, and the Challenges. *South African Journal of Science*, 109(1/2): 1–3.

Chirikure, S. 2021. *Great Zimbabwe: Reclaiming a 'Confiscated' Past.* New York: Routledge.

Chirikure, S.C., Manyanga, M., Ndoro, W., and Pwiti, G. 2010. Unfulfilled Promises? Heritage Management and Community Participation at some of Africa's Cultural Heritage Sites. *International Journal of Heritage Studies*, 16 (1–2): 30–44.

Chirikure, S., and G. Pwiti. 2008. Community Involvement in Archaeology and Cultural Heritage Management: An Assessment from Case Studies in Southern Africa and Elsewhere. *Current Anthropology* 49(3): 467–485.

Court, S., and Wijesuriya, G. 2015. *People-Centred Approaches to the Conservation of Cultural Heritage: Living Heritage.* Rome: ICCROM.

Fontein, J. 2006. *The Silence of Great Zimbabwe: Contested Landscapes and the Power of Heritage.* Harare: Weaver Press.

Fontein, F. 2000. *UNESCO, Heritage and Africa: An Anthropological Critique of World Heritage.* Centre of African Studies: University of Edinburgh.

González, R. A. (ed.) 2013. *Reclaiming Archaeology: Beyond the Tropes of Modernity.* New York: Routledge.

Gnecco, C. 2013. Digging Alternative Archaeologies, in González-Ruibal, A. (ed), *Reclaiming Archaeology*, London: Routledge. pp. 67–78.

Haber, A. 2012. Un-Disciplining Archaeology. *Archaeologies*, 8(1): 55–66.

Haiming, Y. 2018. *World Heritage Craze in China: Universal Discourse, National Culture, and Local Memory.* Oxford: Berghahn.

Harrison, R. 2018. On Heritage Ontologies: Rethinking the Material Worlds of Heritage. *Anthropological Quarterly*, 91(4): 1365–1384.

Harrison, R. 2013. *Heritage: Critical Approaches*. Abingdon: Routledge.

Harrison, R., DeSilvey, C., Holtorf, C., Macdonald, S., Bartolini, N., Breithoff, E., Fredheim, H., Lyons, A., May, S., Morgan, J., Penrose, S., Högberg, A., and Wollentz, G. 2020. *Heritage Futures: Comparative Approaches to Natural and Cultural Heritage Practices*. London: UCL Press.

Herwitz, D. 2012. *Heritage, Culture, and Politics in the Postcolony*, New York: Columbia University Press.

Hicks, D. 2020. *The Brutish Museums: The Benin Bronzes, Colonial Violence and Cultural Restitution*. London: Pluto.

Higgins, V., and Douglas, D. (eds). 2021. *Communities and Cultural Heritage Global Issues, Local Values*. London and New York Routledge.

Holtorf, C. 2017. Perceiving the Past: From Age Value to Pastness. *International Journal of Cultural Property*, 24: 497–515.

Holtorf, C. 2013a. The Past People Want: Heritage for the Majority? In Scarre, G. and Coningham, R. (ed). *Appropriating the Past: Philosophical Perspectives on the Practice of Archaeology*. Cambridge: Cambridge University Press. 63–81.

Holtorf, C., and Fairclough, G. 2013. The New Heritage and Re-Shapings of the Past. In Gonz Lez-Ruibal, A. (ed). *Reclaiming Archaeology: Beyond the Tropes of Modernity*, London: Routledge. 197–210.

Joffroy, T. (ed) 2005. *Traditional Conservation Practices in Africa*. Rome: ICCROM.

Jopela, A. 2018. Reorienting Heritage Management in Southern Africa: Lessons from Traditional Custodianship of Rock art Sites in Central Mozambique. In *Managing Heritage in Africa Who Cares?* Edited by Ndoro, W., Chirikure, S., and Deacon, J. London: Routledge.

Jopela, A., Nhamo, A., and Katsamudanga, S. 2012. Tradition and Modernity: The Inclusion and Exclusion of Traditional Voices and Other Local Actors in Archaeological Heritage Management in Mozambique and Zimbabwe. In *One World, Many Knowledges: Regional Experiences, Regional Linkages*, edited by Halvorsen, T. and Vale, P.. Cape Town: The Southern African-Nordic Centre, 175–192.

Kawharu, M. 2009. Ancestral Landscapes and World Heritage from a Māori Viewpoint. *Journal of the Polynesian Society*, 118(4): 317–338.

Keitumetse, S.O. 2016. *African Cultural Heritage Conservation and Management: Theory and Practice from Southern Africa*. Switzerland: Springer.

Labadi, S., and Long, C. (eds). 2010. *Heritage and Globalisation*. London: Routledge.

Manyanga, M. 1999. The Antagonism of Living Realities: Archaeology and Religion. *Zimbabwea*, 6: 9–15.

Manyanga, M. and Chirikure, S. (eds). 2017. *Archives, Objects, Places and Landscapes: Multidisciplinary Approaches to Decolonised Zimbabwean Pasts*. Cameroon: Langaa RPCID.

Mataga, J. 2021. *Great Zimbabwe: Reclaiming a 'Confiscated' Past*. Shadreck Chirikure. 2020. Routledge. (ebook), ISBN 9780367409999. £33.29. 311pp. International Journal of Heritage Studies, DOI 10.1080/13527258.2021.1941200. Online at 10.1080/13527258. 2021.1941200.

Mataga, J., and Chabata, F.M. 2012. The Power of Objects: Colonial Museum Collections, Collectors and Changing Contexts. *International Journal of the Inclusive Museum*, 4(2): 81–94

Mataga, J., and Chabata, F.M. 2008, Preservation of Spiritual Heritage in Zimbabwe: The Case of Gomba / Mazowe Landscape. *Zimbabwean Prehistory*, 28: 50–58.

Mbembe, A. 2021. *Out of The Dark Night: Essays On Decolonization*. New York: Columbia University Press.

Meskell, L. 2013. A Thoroughly Modern Park Mapungubwe, UNESCO and Indigenous Heritage. In *Reclaiming Archaeology: Beyond the Tropes of Modernity*, edited by Gonzalez-Ruibal, A. 197–210. London: Routledge.

Mumma, A. 2003. Community-Based Legal Systems and the Management of World Heritage Sites. *World Heritage Papers*, 13: 43–44. Paris: UNESCO.

Mumma, A. 2005. The Link between Traditional and Formal Legal Systems. In Ndoro, W. and Pwiti, G. (eds). *Legal frameworks for the Protection of Immovable Cultural Heritage in Africa*, Rome: ICCROM, 22–24.

Munjeri, D. 2009. Following the Length and Breadth of the Roots: Some Dimensions of Intangible Heritage. In Smith, L. and Akagawa, N. (eds). *Intangible Heritage*. London and New York: Routledge, 131–150.

Munjeri, D. 2002. Smart Partnership: Cultural Landscapes in Africa. *World Heritage Papers* 7, 134–142. Paris: UNESCO.

Munjeri, D. 1995. Spirit of the People. Nerve of Heritage. In Munjeri, D., Ndoro, W., Sibanda, C., Saouma-Forero, G., Levi-Strauss, L., and Mbuyamba (eds). *African Cultural Heritage and The world Heritage Convention*. Harare: UNESCO & NMMZ, 52–58.

Muringaniza, J.S. 2004. Heritage that Hurts: The Case of the Grave of Cecil John Rhodes in the Matopos National Park, Zimbabwe. In Forde, J.H., and Turnbull, P. (eds). *The dead and their possessions: Repatriation in principle, policy and practice*. London: Routledge, 18–30.

Nyamnjoh, F.B. 2013. *#RhodesMustFall: Nibbling at Resilient Colonialism in South Africa*. Bamenda: Langaa Research and Publishing.

Nyathi, P., and B. Ndiwini. 2005. A Living Religious Shrine Under Siege: The Njelelle Shrine/king Mzilikazi's Grave and Conflicting Demands on the Matopo Hills Area of Zimbabwe. In Stovel, H., Stanley-Price, N., and Killick, R. (eds). *Conservation of Living Heritage*. Rome: ICCROM, 58–68.

Ndlovu, N. 2021. Heritage and Sustainability: Challenging the Archaic Approaches to Heritage Management in the South African Context. In Baillie, B., and Sørensen, M.L.S. (eds). *African Heritage Challenges: Communities and Sustainable Development*. Palgrave Macmillan, 201–234.

Ndoro, W., and Wijesuriya, G. 2015. Heritage Management and Conservation: From Colonization to Globalization. In Meskell, L. (ed.). *Global Heritage: A Reader*. Malden, MA: Wiley-Blackwell, 131–149.

Ndoro, W. 2005. *The Preservation of Great Zimbabwe: Your Monuments Our Shrine*. Rome: ICCROM.

Ndoro, W., Chirikure, S., and Deacon, J., (eds). 2018. *Managing Heritage in Africa Who Cares?* London and New York: Routledge.

Ndoro, W., and Pwiti, G. 2001. Heritage Management in Southern Africa: Local, National and International Discourse. *Public Archaeology*, 2(1): 21–34.

Nhamo, A., Sætersdal, T., and Walderhaug, E. 2007. Ancestral Landscapes: Reporting on Rock Art in the Border Regions of Zimbabwe and Mozambique. *Zimbabwea*, 9: 43–62.

Pasqualucci, L. 2021. The De-institutionalisation of Culture as an Imaginary Future of Museums, *ICOM news*, May 26, 2021. Available online at https://icom.museum/en/news/de-institutionalisation-of-culture-as-an-imaginary-future-of-museums/ (Accessed 05 June 2021).

Peterson, D.R., Gavua, K., and Rassool, C., (eds). 2015. *The Politics of Heritage in Africa: Economies, Histories, and Infrastructures.* Cambridge and London: Cambridge University Press.

Pikirayi, I. 2009. What Can Archaeology do for Society in Southern Africa? *Historical Archaeology,* 43(4): 125–127.

Pikirayi, I. 2015. The Future of Archaeology in Africa. *Antiquity,* 89(345): 531–541.

Pikirayi, I. 2011. *Tradition, Archaeological Heritage and Communities in the Limpopo Province of South Africa.* Addis Ababa: OSSREA.

Pwiti, G. 1996. Let the Ancestors Rest in Peace? New Challenges for Cultural Heritage Management in Zimbabwe. *Conservation and Management of Archaeological Sites,* 1(3): 151–160.

Pwiti, G., Nhamo, A., Katsamudanga, S., and Segobye, A. 2007. Makasva: Archaeological Heritage, Rainmaking and Healing in Southern Africa with Special Reference to Eastern Zimbabwe. *Zimbabwea,* 9: 103–111.

Pwiti, G., and Ndoro, W. 1999. The Legacy of Colonialism: Perceptions of the Cultural Heritage in Southern Africa with Special Reference to Zimbabwe. *African Archaeological Review,* 16(3): 143–153.

Pwiti, G., and Mvenge, G. 1996. Archaeologists, Tourists, and Rainmakers: Problems in the Management of Rock Art Sites in Zimbabwe, a Case Study of Domboshava National Monument. In Pwiti, G., and Soper, R. (eds). *Aspects of African Archaeology: Papers from the 10th Congress of the Pan-African Association for Prehistory and Related Studies.* Harare: University of Zimbabwe Publications, 817–824.

Ruggles, D., and Silverman, H. 2009. *Intangible Heritage Embodied.* Springer-Verlag New York.

Silva, K.D. 2015. Paradigm Shifts in Global Heritage Discourse. *Space and Communication,* 1(1): 1–15.

Schmidt, P.R. 2017. *Community-based Heritage in Africa: Unveiling Local Research and Development Initiatives.* London and New York: Routledge.

Schmidt, P.R. and Pikirayi, I. (eds). 2016. *Community Archaeology and Heritage in Africa: Decolonizing Practice.* London: Routledge.

Stovel, H., Stanley-Price, N. and Killick, R. (eds) 2005. *Conservation of Living Religious Heritage.* Rome: ICCROM.

Rassool, C. 2018. Building a Critical Museology in Africa. In Laely, T., Meyer, M. and Schwere, R. (eds). *Museum Cooperation Between Africa and Europe: A New Field for Museum Studies.* Bielefeld and Kampala: Transcript Verlag and Fountain Publishers, xi–xii.

Rassool, C. 2015. Re-storing the Skeletons of Empire: Return, Reburial and Rehumanisation in Southern Africa. *Journal of Southern African Studies,* 41(3): 653–670.

Sandahl, J. 2019. The Museum Definition as the Backbone of ICOM. *Museum International,* 71(1–2): vi–9.

Shepherd, N. (2020) After the #fall. *City,* 24(3–4): 565–579, DOI: 10.1080/13604813.202 0.1784579

Shepherd, N. 2008. Heritage. In Shepherd, N. and Robins, S. (eds). *New South African Keywords.* Johannesburg: Jacana Media, 116–128.

Sinamai, A. 2020. We are Still Here: African Heritage, Diversity and the Global Heritage Knowledge Templates. *Arch,* 16: 57–71.

Sinamai, A. 2019. The Tyranny of Materiality: Sacred Landscapes, Tourism and Community Narratives. In Comer, D., and Springer, W.A. (eds). *Feasible Management of Archaeological Heritage Sites Open to Tourism.* Cham: Springer, 45–56.

Smith, L.J. 2006. *The Uses of Heritage*. London: Routledge.

Waterton, E., and Watson, S. (eds). 2013. *Heritage and Community Engagement Collaboration or Contestation*. London: Routledge.

Waterton, E., and Smith, L. 2010. The Recognition and Misrecognition of Community Heritage. *International Journal of Heritage Studies*, 16(1–2): 4–15.

Wijesuriya, G. 2007. Conserving Living Taonga: The Concept of Continuity. In Sully, D. (ed.). *Decolonising Conservation-Caring for Maori Meeting Houses outside New Zealand*. Walnut Creek, California: Left Coast Press, 59–69.

Vawda, S. 2019. Museums and the Epistemology of Injustice: From Colonialism to Decoloniality. *Museum International*, 71(1–2): 72–79.

Xu, Y. 2018. Living heritage conservation: From commodity-oriented renewal to culture oriented and people-centred revival. Paper presented at *The 18th International Planning History Society Conference* - Yokohama, July 2018.

17

DREAMING OF UTOPIA IN TIMES OF TROUBLE

Nowherian Heritage Inspiration and Radical Nostalgia during Lockdown

David C. Harvey

Introduction

Sometimes I feel a queasiness, as though I am at sea. I am a bad sailor! Sometimes, it is a feeling of vertiginous anxiety that one might experience when peering over a cliff edge–or, maybe it is a sense of being hemmed in? Marooned in uncharted territory, I have lost my bearings; unmoored and disconnected. The Pandemic has disorientated me in so many ways. The sense of both constraint and detachment, nausea and of being unbalanced is both metaphorical and viscerally real. A rupture that I am struggling to comprehend.[1]

Perhaps it is a moment of rupture that provides an opportunity (Levebvre 1991; Halvorsen 2015)? Certainly, I feel that I have had some moments of clarity–a feeling that I finally *'get it'*–and a strange joy comes over me. But I think I am scared by what I find.

These emotions and senses have been felt both spatially and temporally, and also by many, perhaps even most people in the world. With the world literally *disconnected* in so many ways, the Corona experience has brought a heightened awareness of global connections, set within extremely local experiences. An event that feels both sudden and inexorably slow.

Living in Denmark, it is normal to feel a re-assuring sense of security–one that is even marketed as a part of *hygge*; a feeling of communal cosiness and wellbeing that I can never entirely separate from a feeling of being smothered by a gigantic continental quilt in the form of an all-encompassing Nordic security blanket. A cosiness that comes with being insulated from unappealing thoughts and feelings. As a non-Danish citizen living in Denmark in the 2020s, however, I know that things are never that simple.[2]

DOI: 10.4324/9781003188438-26

But things feel different this time. Or, maybe not *different*; just an unignorable demonstration of wider human (and non-human/more-than-human) relations. Tapping into Peter Høeg's (1997) sense of magical realism, the outside world is unstoppably seeping through the high walls that usually protect Danish dreams.[3] Such freezing and thawing of time and space seems to have caused a disruption not in a sense of *change*, but rather, a realisation of present and ongoing dissonance–a realisation of antecedent disparities and existing inequalities that can no longer be ignored.

In many ways, the temporal dissonance is perhaps resonant with what Shepherd (2020) has described as a *slow catastrophe*.[4] A calamity that seems both jarringly inevitable but inextricably slow, so as to enable–even *demand*–a deeper self-reflection of *where it all went wrong* at the same time as the calamity is unfolding. The car crash is inevitable, and we are both experiencing and witnessing the disaster unfolding, in the past, present and future all at once. So, maybe nothing has really changed–yet. Likewise, the connection between ourselves and others in the world has not really transformed–yet.

It is a case, rather, that the determinates and experiences of these connections have been laid bare. According to Freedland (2020, 2) the Coronavirus 'did not remake the global landscape so much as reveal what was already there, or what was taking place just below the surface … it has amplified it, sometimes distorting it, [and] sometimes illuminating it in alarming detail'.[5] The experience has made clear and made explicit, the political tensions between the common (feel-good-and-fictional) rhetoric of being *All in This Together* on national and even global scales, and the operation of gross inequalities and existential precarity of quotidian lives.

As with so many disasters, there has been a disproportionate effect on the poor and marginalised; the old and the infirm (Chakrabarty 2018; Shepherd 2020, 11). Drawing on Shepherd's (2020) work on the Cape Town water crisis, the 'politics and poetics' of the coronavirus experience is 'both intimate, embodied and subjective, as well as being mediated by infrastructures, policies, and social, political and economic concerns.' Likewise mirroring Shepherd, through an up-close and personal reflective analysis–of *WhatsApp* conversations, walks in the park, and bed-time readings–we can try and find an anchor point for the present, and a window onto a hopeful possible future.

Message to WhatsApp 'Exeter Friends' Group:

March 17, 2020: Something of a reneging of responsibility from UK govt … Suggestions to NOT go to pubs and cafés, but not officially closing them either, which leaves all those businesses high and dry. At least the Danish government has been very clear that THEY are taking responsibility (and will cover wages of people forced off work).

FIGURE 17.1 Message in the sand, Aarhus, around March 12, 2020. Author's photograph.

March 11, 2020: Covid-19. Hjælp! SOS

Today is my *halvtredsindstyvende* birthday.[6] *Hjælp!* A catastrophe is unfolding.

At 8 pm, there is an official announcement by the Danish Government that much of the country is to be shut down with immediate effect.[7] The national borders will close imminently. I speak to family and friends in the UK and decide to stay in Denmark. The next day, for the first of umpteen times, I go for a walk to stretch my legs and reflect on what is happening. Through a park and some forest, and down to the beach, where I see a message that someone has made in the sand (see figure 17.1).

I sit on a bench in the park and exchange *WhatsApp* messages with friends in the UK. No shut down there, though my sister is a GP and has been made the Covid Resilience Officer for her district. I sit on this bench on most days over the coming weeks, texting with my 'Exeter Friends' *WhatsApp* group. I get a bit cross with my friends in the UK who don't seem to be taking this seriously. The UK Government has already decided to write off care home residents and the over 65s, but still haven't announced a lockdown. Is it complacency? Or is it calculation?

> **March 21, 2020:** Very difficult conversation with my sister last night. They have been working to try and 'increase capacity'–but there are also instructions from above **First**, 'increasing capacity' means sending as many patients home as possible–and she says that it is clear that there will be many deaths as a result. **Second**, anyone in a care home will not be admitted to a hospital or get extra support. Care homes will be largely left to their own devices since capacity will be too stretched to cope with these people who have a lower chance of pulling through (so, that's written off many aged and disabled people straight away). **Third**, people over 65 more broadly might get a hospital bed, but ventilators and ICUs are for the under 65s only. There won't be enough to go around and people aged 64 and under are a better bet to support. **Very sorry for the gloom** ... Was wondering whether to pass

> this on (I don't want to spread rumours), but my sister was in tears at this real meeting yesterday, so I think the information is correct and that you should know.

In heritage terms, the reaction from the UK Government to the impending catastrophe can be seen as a sort of nostalgic gothic-horror re-enactment effort to *KEEP CALM AND CARRY ON.* This episode of heritage-in-the-making drew on Second World War symbolism of 'Blitz Spirit.' An imagined sense of national exceptionalism was mixed with stoic faith that such stiff-upper-lipped fortitude would see us through the crisis.[8] The warming glow of a nation under siege from an unseen enemy fitted well in the immediate post Brexit context. The instruction towards personal bodily habits seemed to take responsibility away from Government, as *hand washing* became both a literal instruction and a metaphorical central plank of Government policy. Banging together pots and pans at 7 pm every Thursday to 'support the NHS' (together with the implicit suggestion to check on your neighbours to make sure they are playing their part) drew from a well-practised tradition of heritage re-enactment; a weekly nostalgic performance of community spirit.[9] Heritage is central in the messaging, central in the activities, and central in the practices—on a personal, communal, and national level.

> **March 21, 2020:** Sounds harsh, but stay clear of all family gatherings for now. Sorry.
>
> **March 22, 2020:** I don't want to 'nanny on' about this, but while the UK seems to be about a week or ten days ahead of DK in terms of infections, it is about a week or ten days BEHIND in terms of response ...
>
> **March 22, 2020:** I have no evidence as to what is the right thing to do, but sitting in Europe, watching the UK stagger into what could be a massive crisis is really sad—UK government seems to be way behind everyone in terms of offering proper advice. I really hope I'm wrong and needlessly alarmist!

On the March 22, the day after my message to friends imploring them to stay clear of family gatherings, the UK Government announces a national lockdown. Categories and distinctions between workers and publics took on a new form. Rather than white collar and blue collar, working class or middle class, professional or manual, in all its variegated regional and spatial complexity, distinctions were now forged along issues of whether people could work from home or not, between key workers, whether they be hospital consultants or supermarket delivery drivers, and between those needing to shield or care for those shielding. And the differentiation between those that *have* (a garden, a nest egg, a supportive family, a job, good underlying health, or a bike) and those that *have not*, were laid increasingly bare.

Looking back over a year later, I can now see that I was not 'needlessly alarmist.' I reflect on how many tens of thousands of lives might have been saved if the UK Government had acted more swiftly; if care home residents hadn't been written off so easily[10]; thinking back and trying to imagine a different scenario. *What if?*

Reflecting on the lessons that might be learned; that mix together a nostalgia for *how things were*, with a determination that we should not (and never) *go back*. A longing for 'normality,' but not the old normality of pre-existing relations, habits, and practices, but a new normal. In other words, a total transformation.

Heritage lies at the heart of this thinking; between, against, and across notions of past, present, and future; here and there; then and now. In these times of the coronavirus pandemic, it was ideas of heritage, connecting past, present and future in dissonant and jarring arrangements that could be witnessed in *Black Lives Matter* (BLM), Extinction Rebellion (XR), and #*Fallism*–as well as in rising populism and immanent climate crisis. None of these issues were new, but coronavirus somehow brought existing arrangements, anxieties, disparities, and tensions to the surface. The idea that we are *all in this together* is fiction. Who counts as a key worker can be reappraised, at least in terms of who gets to receive some heartfelt applause. But the underlying (unequal) relations refuse to shift as the winners and losers become clearer. The wealthiest in the world will become wealthier. Sitting on a sunny bench in a park in Aarhus, Denmark, in March 2020, I am close to tears. ***Just how screwed-up a world are we making?!***

Heritage as a Futuristic Activity, and the Science Fiction of the Future-Past

Just how screwed-up a world are we making–has been a central theme in many notable science fiction novels, with contemporary speculation about the future-past providing a fertile ground; whether HG Wells's *War of the Worlds* or *The Time Machine*, Martin Bradbury's *Martian Chronicles*, J.G. Ballard's *Hello America*, or Pierre Boulle's *La Planète de Signes* (perhaps better known in its Hollywood version of *The Planet of the Apes*). A familiar trope of contemporary concerns and anxieties being cast as a central theme of how future generations will relate to 'us'–their ancestors–and an implied message that we should act now in order to be a 'good ancestor' to the people of tomorrow.[11] Founded upon assumptions that future generations will appreciate, therefore, together with anxieties about our legacy and posterity, heritage has always been a futuristic activity.

A central theme within much of this heritage-science fiction literature is the entanglement of different histories, spaces, experiences, and perspectives, which seems entirely appropriate during the coronavirus pandemic. The ambition is paralleled within Heritage Studies literature that seeks to trouble linear conceptions of time through the open-ended and ongoing analysis of monuments and landscapes in association with the beliefs, memories, and expectations that are adhered to them (Bender 1998; Holtorf 2000–2005; Edmonds 2006; Whyte 2009; Harvey 2010).

Intellectually, the project of disrupting chronological sequence and making space for multiple and subjective meanings can be seen within the tradition of *histoire croisée*–or 'entangled histories'–which provides space for relational reflexivity, messiness, and ambiguity (see Werner and Zimmerman 2006; Harvey 2011). Beyond academia, however, such entanglements of space-time, experience, memory, and progressive ambition, can be witnessed within BLM and #Fallism movements (Frank and Ristic 2020; Olusoga 2020). Mistaking the making of history for 'the past,' reactionary commentators have criticised these efforts for supposedly seeking to 'change history.' More accurately, however, such concerns towards social justice, redress, and acknowledgement–*room to breathe*–should frame these movements as a wilful and reflexive disruption of authoritarian desires for tidy envelopes of time that are packaged up, sealed off, and unavailable for prospective memory work. Addressing the concerns of Massey (1995), this is a much more radical history, refusing simple temporal continuity or a spatial simultaneity without time-depth.

The sense of ambition and hope, alongside the anger at ongoing injustice, which can be seen through these academic, popular, and activist movements, seems to point towards something more purposefully productive than much of the post-apocalyptic or dystopian science fiction literature; something more buoyant, sanguine, anticipatory, and bold, rather than downbeat warnings of *just how screwed-up a world are we making*. Whether the mechanism is militarism or a nuclear war (*Planet of the Apes* film, and *The Martian Chronicles*), or warped science and genocide (*La Planète de Signes* book, and *War of the Worlds*), or one of climate change and global environmental degradation (*Hello America*, and *The Day After Tomorrow* film), there is always an implicit instruction as to what we should do now in order to be 'good ancestors' for the people of tomorrow; what we must change now in order to avoid turning the world into a horrible place.[12]

In the midst of a coronavirus lockdown, I didn't want to read about post-apocalyptic science fiction, so I reached for a different sort of heritage-science fiction novel, which stood out as unreservedly hopeful, setting out a utopian possibility rather than dystopian warning. This was William Morris's *News from Nowhere* (1890/1993).

News from Nowhere, and the Need for Some Radical Nostalgia in Times of Pandemic

During the 2020 lockdown in Aarhus, I walked with William Morris. *News from Nowhere* is a powerful declaration of how heritage can help to imagine a future transformed–the *new normal* that everyone seems to be talking about. In Morris's socialist-Utopian novel, the narrator, William Guest, wakes up from a deep sleep to find himself in a future post-revolutionary world in which the human 'instinct for freedom' has prevailed. Through conversations with some new-found friends, William Guest discovers that he has travelled into the future, where a new normal

reigns. Morris uses the description of William Guest's experiences as a prompt–even a provocation–to the reader to reflect critically on the state of normality in the present. For Morris's readers, this contemporary normal was Britain in 1890; a world in which inhumanity, alienation, and deep inequality are accepted as inevitable and unchangeable. Many novels that are set in the future, depict a high-tech, fast-paced, and hyper-modern future normality, but Morris's future normality is founded upon a nostalgic and homespun invocation of a re-imagined deep past. In other words, rather than working through sketching a dystopian world that might happen if we do not make changes now, *News from Nowhere* works through sketching a possible world that might ensue if we strive for transformation now; the promise of a proverbial 'carrot,' rather than the threat of an imagined future 'stick.'

In *News from Nowhere*, the community Guest encounters are no longer alienated from the environment but has learned to live in symbiosis with the rhythm of the seasons, realising a communality and deeper attachment to a sense of place.

> I went out a-doors, and after a turn or two round the superabundant garden, … I walked up-stream a little, watching the light mist curling up from the river till the sun gained power to draw it all away; saw the bleak speckling the water under the willow boughs … heard the great chub splashing here and there at some belated moth or other, and felt almost back again in my boyhood (Morris 1890/1993, 178).

William Guest's walk along the river symbolises a journey through time; a return to Eden–that 'superabundant garden' of boyhood–and a world before the forbidden fruit of capitalism and imperialism took hold (See Laurent 2009, 55; Steer 2008). As I walk through Marselisborg Forest in Aarhus during the Spring of 2020, I stop for 20 minutes to watch a heron stand perfectly still while we both survey the serenity of a small pond; I sit on a fallen tree trunk in the midst of a carpet of wood anemones and celandines, striving to make the most of the sunlight on the forest floor before the beech trees above turn this woodland world into a luminous green. The leaf litter around me is alive with scurrying mice and patrolled by diligent blackbirds. As someone who was able to work from home on full pay during the lockdown, I was one of many millions who took the opportunity to reacquaint themselves with the wonders of 'nature' during their lunchtime breaks. In the back garden or the local park, around the margins, the world seems to be more alive than ever. Like many others, I was also forced to re-assess the definition and supposed virtue of wealth, and reconceive the value of different jobs and professions–over who the key workers in society really were.

In Morris's *News from Nowhere*, the utopian future comes after a conflict, in which the formidable power of a reactionary right-wing press that manipulates public attitudes, plays a considerable role. As the 'Great Change' finally took hold, Morris writes that:

The ordinary newspapers gave up the struggle [...] and only one very violent reactionary paper (called the *Daily Telegraph*) attempted an appearance, by attempting to cast "the rebels" in good set terms for their folly and ingratitude in tearing out the bowels of their "common mother", the English Nation (Morris 1890/1993, 149. Italicisation and parenthesis as in the original).

Following the media coverage of Government activity in the UK during the present pandemic, the accusation that any criticism of Boris Johnson or Government policy was a direct attack on the British people seems to have become more prevalent.[13]

When the conflict was really bogus, it was seen how little of any value there was in the old slavery and inequality [...] The spirit of the new days, or our days, was to be delight in the life of the world; intense and overweening love of the very skin and surface of the earth on which man [*sic.*] dwells [...] this, I say was to be the new spirit of the time (Morris 1890/1993, 157–158).

One of the striking elements of life under coronavirus lockdown for many people has been a renewed interest in craft, art, and creative practice, in handy-skills, gardening, DIY, mending, making, brewing, and sourdough baking. The joy of working with and using one's hands; walking or cycling instead of driving; of time well spent rather than time supposedly saved through mechanised travel and speed.

In the half-century that followed the Great Change [...] machine after machine was quietly dropped under the excuse that the machines could not produce works of art, and that works of art were more and more called for (Morris 1890/ 1993, 201).

Life during the pandemic has displayed, often in an extreme manner, the perverse inequalities and disparities that have long existed and normalised in a taken-for-granted manner. On the other hand, the pandemic has also shown a strong appetite for a different way of life–a new normal–in which value systems are re-orientated; relations between people, between people and things, and between human and more-than-human worlds are to be valued differently. And for those privileged enough to have the time and resources to do so, the pandemic has provided the space to demonstrate what this 'new normal' might look like. In other words, for people who are well enough resourced and protected, these yearnings for something better have been channelled through creative practices, walking, and reading. For the vulnerable, and the many without such resources of time, capital or opportunity, the stark realities of everyday inequality and disadvantage have revealed the existing social, political, and economic relations to be wanting. It is within this context that we should view developments of BLM movements for instance–as connected to gross inequalities and injustices operating in plain view.

When William Guest's new friend, Dick, talks about the remains of Westminster Abbey and central London, he talks about how it was all 'spoiled centuries ago,' before the 'Great Clearance [...] of the beastly monuments to fools and knaves.' (Morris 1890/1993, 69) Thus, the Jingoism and imperial endeavour–as well as the monuments and celebration of those events–are portrayed as a distant and disturbing memory of a decadent past, 'when Africa was infested by a man named [Henry Morton] Stanley' (Morris 1890/1993, 126).[14] Despite him sometimes being invoked as an uber-preservationist, therefore, William Morris could see the necessity of destroying the statues and other monuments that celebrated–and thus tacitly or explicitly supported–systems of inequality and colonialism. For a 'Great Change' to occur, a 'Great Clearance' of 'beastly monuments to fools and knaves' would be necessary.

News from Nowhere is an exercise in utopian thinking, as a means to try and transcend lived reality and prompt change by reconceptualising the current order, and building transformative politics (Lewis 1987; Bonnett 2010; see also Bloch 1995). In other words, Morris's writings do not seek to ignore the injustices and disparities that were contemporary to his time. On the contrary, he seeks to display these injustices more starkly, while attempting to suggest that a different world is possible.

Morris is clear in his critique of the condition of the world in his own times of the later nineteenth century, as being riven with inequality and hypocrisy:

> In times of inequality, it was an essential condition of the life of [...] rich men that they should not themselves make what they wanted for the adornment of their lives, but should force those that made them, whom they forced to live pinched and sordid lives; and that as a necessary consequence the sordidness and pinching, the ugly barrenness of those ruined lives, were worked up into the adornment of the lives of the rich (Morris 1890/1993, 212–213).

During the pandemic, the richest men on earth have seen their monetary wealth increase to unimaginable levels.[15]

In a manner that is patently connected with a processual understanding of heritage, Morris challenges the glorification of the past. In Jan Holm's (1993, 18) words, Morris 'unmasks a nationalistic nostalgia that cannot see through the pretence of wealth and power,' as one that fails to 'take into account the great sorrow and pain that made the glamour of the rich possible.' *News from Nowhere* draws into consideration the tension between, the designs of the nation-state to enclose the past, and to normalise one version of history while concealing other perspectives and experiences. This theme has become increasingly central since 2020, through BLM protests over racial injustice and the toppling of certain statues. Those that seek to protect Confederate and colonialist statues, and talk of these protests as 'trying to change history,' wilfully misunderstand history. For those protesting, the writing, rewriting, and making of history is seen as a valuable and powerful heritage

resource, which can challenge coloniality, oppression, and injustice. In other words, an appreciation of how the past, and our purposeful relation, both *to* and *of* the past can become a transformational resource of new and more just possibilities and imaginaries.

William Morris's *Nowhere* is situated firmly in the future and works through a distinctly 'productive,' or even 'radical' nostalgia, which acts as a provocation to-wards building transformative politics in the here-and-now.[16] As Bonnett (2010, 8) notes, a desire to 'overcome alienation and return humanity to authenticity' has always been an important element of radical and critical ambition. Rather than a sort of sentimental illness or stubborn act of resistance for those privileged enough to be able to mourn a past that probably never was, for Bonnett (2006; 2010) and others, nostalgia can be a site of creativity, danger, and transgression. In this vein, therefore, it is important to recognise that acts of what might seem to be nostalgic reverie, are not anti-political and should not be reduced to being seen as a tool of mere 'resistance (Bonnett 2010, 8).' Rather than a warning, therefore, radical nostalgia should be seen as a prompt, and as a dynamic process that can shape human activity at times of stress or rupture (see Bonnett and Alexander 2013, 394).

The coronavirus pandemic has caused an existential 'moment of rupture' (Lefebvre 1991). According to Lefebvre, it is at such moments that possibilities are open; an opportunity to imagine a different world. This is not an exercise in wishful thinking; indeed, as newspapers, politicians, and commentators who point vaguely to the sunlit uplands of a return to normal in supposed post-Covid times testify, it is those who are focussed on a normal that is unchanged by present experience that are guilty of sentimental dreaming. Rather than be seduced by the 'hazy images of tomorrow's bright new world' (Bonnett 2010, 9), a radical nostalgia, based upon experience and memory can be used to help forge a truly new normal, which is not bound to present relations of inequality and injustice.

As a corollary to imagining a radical new normal, we can draw inspiration from Chatterton and Pusey's (2020) outlining of three 'styles of resistance' to con-temporary global neoliberal relations. First, they point to the importance of small actions, and connected minor or mundane resistance work that, for me, is reminiscent of James Scott's notions of 'everyday resistance.' Secondly, Chatterton and Pusey (2020) point to the significance of direct activism to oppose capitalism and neoliberal impositions today, as opportunities arise. Lastly, they point to attempts to 'live beyond capitalism,' in order to enact future possibilities. Translating these ideas into the realms of heritage practice, I see these three elements as mapping on to past, present and future activities. In other words, the small actions of everyday and mundane resistance convey a sense of quotidian continuity and articulation of *pastness*, sometimes almost for the sake of it, and even within a seemingly futile context. A repeated walk, a careful attentiveness to the world around us–to the unfurling of leaves on trees–what Morris (1890/1993, 158) talks about as 'delight in the life of the world.' Reflective of Chatterton and Pusey's (2020) opportunistic and direct activism of the moment, heritage activism

of the present can perhaps be illustrated within the BLM movement and toppling of statues; actions that are motivated by, and responding to, specific instances of injustice, and involving a conscious *use of pastness* to say something new and to strive for social justice in the present. While these critical elements of heritage activism are important, the enactment of a future possibility through the purposeful invocation of a different future is also vital. This is the world that is conjured in Morris's *News from Nowhere*:

> Go back again, now you have seen us, and your outward eyes have learned that in spite of all the infallible maxims of your day, there is yet a time of rest in store for the world, when mastery has changed into fellowship [...] Go back again, then, and while you live you will see all round you people engaged in making others live lives which are not their own, while they themselves care nothing for their own real lives [...] Go back and be the happier for having seen us, for having added a little hope to your struggle. Go on living while you may, striving, with whatsoever pain and labour needs must be, to build up little by little the new day of fellowship, and rest, and happiness.
>
> Yes, surely! and if others can see it as I have seen it, then it may be called a vision rather than a dream (Morris 1890/1993, 228).

Going for a walk in a park in Aarhus does not make me a radical anti-capitalist. Indeed, such everyday actions as sourdough baking, walking, and birdwatching can be seen, perhaps, as badges of privilege, available as they are, only to those with a high level of resources and opportunities, especially during a coronavirus pandemic. They illustrate existing inequality. As Halvorsen (2015, 414) has noted, however, there is an 'under-valorisation of everyday practices of social reproduction and care, in comparison to the desire to take space for high energy *political work* ... and a tendency to side-line mundane everyday practices through a privileging of masculinist *activism*.' (italicisation as in the original) While the tearing down of a monument to a racist or trader in enslaved people is vital, going for a walk can also be important, especially when it draws from historically resilient senses of collective identity.[17]

Postscript

Writing this in January 2022, this week has seen total deaths from Covid in the UK pass 150,000–an event that was largely ignored by the media, who seemed much more interested in whether a tennis star could defend his Australian Open Tennis championship title.[18] Meanwhile, the Danish government have underlined their commitment to one of the toughest immigration policies in the world.[19] But in many ways, there is nothing really 'new' here; just more manifestations of the consequences of global inequality and stories of how these inequalities are dealt with both through formal regulation and media management. If there is a

specifically 'new' element to this, then perhaps it can be recognised by the addition of the phrase '*and medical*' to the existing description of global governance networks comprising a 'Military Industrial Complex' (MIC). Famously coined by Dwight D Eisenhower in the early 1960s, the MIC describes the unwritten alliance of big defence businesses and governments to promote massive state spending on arms, and the concomitant controlling of populations through fear of nuclear war. As an increasingly large proportion of state spending is sucked into the 'Corona Industry.' often with very little oversight of how public money is allocated, I would suggest that the 'Military and Medical Industrial Complex' (MMIC) might be a useful concept. If a large proportion of a country's economy is dependent on the coronavirus being a 'thing'—with billions of dollars of public money funnelled through private corporations into mass testing and vaccination and PPE protection, not to mention increased opportunities for surveillance and control—then many vested interests will not want to see it disappear.

Hand-in-hand with these developments, however, are 'moments' in which one can see the vestiges of an alternative world. In the UK, the 'Colston four,' who were being prosecuted by the British Government for their part in toppling the statue of the slave trader, Edward Colston, were acquitted. While the four defendants were undertaking direct action of an overt nature, the jury who acquitted them represents the power of ordinary citizens taking the progressive view that the crime was being committed by the statue rather than the topplers.[20] This suggests that there is an increasing acceptance, within the orbit of the understandings, experiences, and lives of ordinary citizens that for the 'Great Change' to occur, then it is ripe time for a 'Great Clearance' of the 'beastly monuments to fools and knaves' (Morris 1890/1993, 69). Both through high-energy political and activist work, and also through everyday practices and understandings, therefore, change is coming.

And now, the world had grown old and wiser, and I was to see my hope realised at last (Morris, 1890/1993, 169).

Notes

1 David Harvey wishes to acknowledge the supportive conversations that he had with friends and family members during the early phases of Covid, which directly led to the reflections contained in this Chapter, especially with former colleagues of Exeter University's Cultural and Historical Geography Research Group. A first iteration of these reflections within an academic context was aired at the Group's online 'Lockdown Workshop' (May 2020), to which David was invited as an 'Emeritus' group member.

2 Alongside feel-good things like *hygge* and happiness, Denmark has become increasingly well known as a country where non-Danes are systematically marginalised through, for instance the 'jewellery law', which confiscated valuables from asylum seekers or the banning of burqas. Most recently, the Danish government has declared that Syria is a safe country to repatriate women who arrived in Denmark after fleeing the Syrian Civil War (see, for instance McKernan 2021).

3 In Høeg's (1997) *History of Danish Dreams*, an aristocratic estate is depicted in suspended animation, sealed off from the present.
4 Shepherd draws from Nixon's notion of *slow violence*.
5 See also, Horton (2020).
6 Look it up on Google Translate – I don't want to talk about it.
7 https://www.dr.dk/om-dr/nyheder/dr-markerer-aarsdagen-nedlukningen-af-danmark (last accessed 17th May 2021).
8 It was striking that when Boris Johnson was hospitalised, his survival was often put down to him being a 'fighter', suggesting that those who succumbed to the disease were not fighters – perhaps they were 'losers'. Survival was down to individual attitude rather than government action.
9 For instance, to begin the centenary commemoration of the UK's involvement in the First World War on 4th August 2014, *Lights Out* was such a heritage spectacle, involving a national dimming of lights at exactly 10 pm. See https://www.1418now.org.uk/commissions/lights/ (last accessed 17th May 2021). See, also Harvey (2017), for a critical review of this event.
10 It seems that the decision to write off care homes had been taken many days before the UK Lockdown was even announced, let alone implemented.
11 See Höbjerg and Holtorf's (2015) suggestion that heritage work is all about 'trying to be a *good ancestor*'.
12 In *La Planète de Signes*, Pierre Boulle exclaims that 'I am confiding this manuscript to space not with the intention of saving myself, but to help, perhaps to avert, the appalling scourge that is menacing the human race. Lord have pity on us'.
13 It is also striking that Boris Johnson is an ex-journalist of the *Daily Telegraph!*
14 The publication of *News from Nowhere* in 1890, coincided with the public sensation of Henry Morton Stanley's controversial expedition to chart the Ruwenzori region of East Africa. See also, Holm (1993).
15 In the USA, for instance, billionaires have increased their wealth by 55% during the pandemic (Institute for Policy Studies 2021).
16 For work on radical nostalgia, productive nostalgia, mobile nostalgia and counter memory, see work by, among others, Blunt (2003), Legg (2005; 2011), Bonnett (2006; 2010), Bonnett and Alexander (2013), and Smith and Campbell (2017).
17 See Mackenzie and Dalby (2003, pp. 310–11) also, Robertson (2008), Atkinson (2008), and Harvey (2010).
18 See https://www.theguardian.com/world/2022/jan/08/uk-first-country-in-europe-to-pass-150000-covid-deaths-figures-show (last accessed 10th January 2022); https://www.theguardian.com/australia-news/2022/jan/10/novak-djokovic-wins-appeal-against-decision-to-cancel-his-australian-visa (last accessed 10th January 2022).
19 See https://www.stm.dk/statsministeren/nytaarstaler-siden-1940/mette-frederiksens-nytaarstale-1-januar-2022/ (last accessed 10th January 2022).
20 See https://www.theguardian.com/uk-news/2022/jan/05/four-cleared-of-toppling-edward-colston-statute (last accessed 10th January 2022). Labour MP, Clive Lewis, suggested that "Today's verdict makes a compelling case that a majority of the British public want to deal with our colonial and slave trading past, not run away from it" (quoted in Gayle 2022). See also, https://www.theguardian.com/commentisfree/2022/jan/10/colston-four-britain-apology-for-past (last accessed, 10th January 2022).

References

Atkinson, David. 2008. "The heritage of mundane places." In *The Ashgate Research Companion to Heritage and Identity*, edited by Brian Graham and Peter Howard, 381–396. Albershot: Ashgate.
Bender, Barbara. 1998. *Stonehenge: Making Space*. Oxford: Berg.

Bloch, Ernest. 1995. *The Principle of Hope, Volume 1.* Cambridge: MIT Press.

Blunt, Alison. 2003. "Collective memory and productive nostalgia: Anglo-Indian home-making at McCluskiegang." *Environment and Planning D: Society and Space* 21: 717–738.

Bonnett, Alastair. 2006. "The nostalgias of situationist subversion." *Theory, Culture and Society* 23, no. 5: 23–48.

Bonnett, Alastair. 2010. *Left in the Past: Radicalism and the Politics of Nostalgia.* New York and London: Continuum Press.

Bonnett, Alastair, and Catherine Alexander. 2013. "Mobile nostalgia: Connecting visions of the urban past, present and future amongst ex-residents." *Transactions of the Institute of British Geographers* 38, no. 3: 391–402.

Chakrabarty, Dipesh. 2018. *The Crises of Civilization: Exploring Global and Planetary Histories.* Oxford: OUP.

Chatterton, Paul, and Andre Pusey. 2020. "Beyond capitalist enclosure, commodification and alienation: Postcapitalist praxis as commons, social production and useful doing." *Progress in Human Geography* 44, no. 1: 27–48.

Edmonds, Mark. 2006. "Who said romance was dead?." *Journal of Material Culture* 11, nos. 1–2: 167–188.

Frank, Sybille, and Mirjana Ristic. 2020. "Urban fallism: Monuments, iconoclasm and activism." *City: Analysis of Urban Change, Theory, Action.* DOI: 10.1080/13604813.2020. 1784578.

Freedland, Jonathan. 2020. "The magnifying glass: How Covid revealed the truth about our world." *The Guardian,* December 11, 2020. https://www.theguardian.com/world/2020/dec/11/covid-upturned-planet-freedland

Gayle, Damian. 2022. "BLM protesters cleared over toppling of Edward Colston statue." *The Guardian,* January 5, 2022. https://www.theguardian.com/uk-news/2022/jan/05/four-cleared-of-toppling-edward-colston-statute.

Halvorsen, Sam. 2015. "Taking space: Moments of rupture and everyday life in Occupy, London". *Antipode* 47, no. 2: 401–417.

Harvey, David C. 2010. "Broad down, Devon: Archaeological and other stories." *Journal of Material Culture* 15, no. 3: 345–367.

Harvey, David (2011). "Some Thoughts on the Big and Small Matters of Medieval Geographical Knowledge." *Dialogues in Human Geography* 1, no. 2: 186–190. 10.1177/2043820611404485.

Harvey, David C. 2017. "Critical heritage debates and the commemoration of the First World War: Productive nostalgia and discourses of respectful reverence during the Centenary." In *Heritage in Action: Making the Past in the Present,* edited by Helaine Silverman, Emma Waterton, and Steve Watson, 107–120. Chun, Switzerland: Springer.

Harvey, David C. and Jim Perry. 2015. "Heritage and climate change: The future is not the past." In *The Future of Heritage as Climates Change: Loss, Adaptation and Creativity,* edited by David C. Harvey and Jim Perry, 3–22. London: Routledge.

Holm, Jan. 1993. "The old Grumbler at Runnymede." *Journal of the William Morris Society* 10, no. 2: 17–21.

Holtorf, Cornelius. 2000–2005. *The Monumental Past: Life Histories of Megalithic Monuments.* Toronto: E-Monograph.

Horton, Richard. 2020. "Covid 19 has exposed the reality of Britain: Poverty, insecurity and inequality." *The Guardian,* September 8, 2020. https://www.theguardian.com/commentisfree/2020/sep/08/covid-19-britain-poverty-insecurity-inequality-fairer-society.

Høeg, Peter. 1997. *A History of Danish Dreams*. London: Vintage.

Institute for Policy Studies. 2021. *Billionaire Pandemic Wealth Gains*, (Report, April 15, 2021). ips-dc.org/wp-content/uploads/2021/04/IPS-ATF-Billionaires-13-Month-31-Year-Report-copy.pdf.

Laurent, Béatrice. 2009. "Landscapes of *Nowhere*." *Journal of the William Morris Society* 18, no. 2: 52–64.

Lefebvre, Henri. 1991. *The Production of Space*. Oxford: Blackwell.

Legg, Stephen. 2005. "Contesting and surviving memory: Space, nation and nostalgia in *Les Lieux de Mémoire*." *Environment and Planning D: Society and Space* 23: 481–504.

Legg, Stephen. 2011. "Violent memories: South Asian spaces of postcolonial anamnesis". In *Cultural Memories: The Geographical Point of View*, edited by Peter Meusburger, Michael Heffernan, and Edgar Wunder, 287–303. Chun, Switzerland: Springer.

Lewis, Roger C. 1987. "*News from Nowhere*: Arcadia or Utopia." *Journal of the William Morris Society* 7, no. 2: 15–25.

Mackenzie, A. Fiona and Simon Dalby. 2003. "Moving mountains: Community and resistance in the Isle of Harris, Scotland, and Cape Breton, Canada." *Antipode* 35: 309–333.

Massey, Doreen. 1995. "Places and their pasts." *History Workshop Journal* 39, no. 1: 182–192.

McKernan, Bethan. 2021. "Denmark strips Syrian refugees of residency permits and says it is safe to go home." *The Guardian*, April 14, 2021. https://www.theguardian.com/world/2021/apr/14/denmark-revokes-syrian-refugee-permits-under-new-policy.

Morris, William. 1890/1993. *News from Nowhere and Other Writings*. London: Penguin.

Olusoga, David. 2020. "The *Statue Wars* must not distract us from a reckoning with racism." *The Guardian*, June 14, 2020. https://www.theguardian.com/global/2020/jun/14/statue-wars-must-not-distract-reckoning-with-racism-david-olusoga

Robertson, Iain, ed. 2008. *Heritage from Below*. Aldershot: Ashgate.

Shepherd, Nick. 2020. "Slow catastrophes: Cape Town water and Anthropogenic climate change". In *Catastrophes in Context*, edited by Felix Riede. New York: Berghahn Books.

Smith, Laurajane, and Gary Campbell. 2017. "Nostalgia for the future: Memory, nostalgia and the politics of class". *International Journal of Heritage Studies* 23, no. 7: 612–627.

Steer, Phillip. 2008. "National pasts and imperial futures: Temporality, economics and empire in William Morris's *News from Nowhere* (1890) and Julius Vogel's *Anno Domis: 2000* (1889)". *Utopian Studies* 19, no. 1: 49–72.

Werner, Michael and Bénédicte, Zimmerman. 2006. "Beyond Comparison: Histoire croisée and the Challenge of reflexivity." *History and Theory* 45:30–50.

Whyte, Nicola. 2009. *Inhabiting the Landscape: Place, Culture and Memory 1500–1800*. Oxford: Oxbow Press.

CONCLUSION

When the Taps Run Dry/Why We Need Heritage

Nick Shepherd

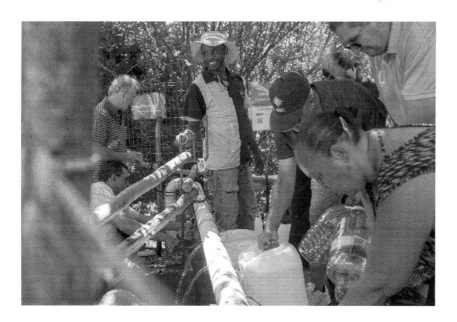

FIGURE 18.1 March 2018, the Spring Street water point. Photograph: Dirk-Jan Visser.

DOI: 10.4324/9781003188438-27

Cape Town, 'Day Zero'

In early-2018 I was in Cape Town, South Africa, doing work on the 'Day Zero' drought that held the city in its grip and threatened catastrophically to disrupt city water supplies. After three years of failed winter rains, the dams supplying the city's water were at a critically low level. On January 15, 2018, the Mayor of Cape Town called a press conference in which she announced that, based on current daily consumption, the city would run out of water on April 22nd. On that day–'Day Zero,' as it came to be known–city officials would be forced to turn off the piped water infrastructure. The city's three-and-a-half million residents would have to queue for a daily ration of 20 liters of water at one of 200 'Points of Distribution' (PoD's), emergency distribution centers dotted around the city (Robins, 2019; Shepherd, 2019, 2021). This dramatic announcement was quickly picked up by the global news media. That same day, Aryn Baker reported for *Time* magazine: 'Cape Town is 90 days from Running Out of Water: After three years of unprecedented drought, the South African city of Cape Town has less than 90 days worth of water in its reservoirs, putting it on track to be the first major city in the world to run out of water' (Baker, 2018).

Many commentators did the math and predicted anarchy come Day Zero. Between ten and twenty thousand people would descend on each PoD every day. Armed guards would be needed to keep order and weed out water cheats. Twenty liters equates to twenty kilograms, a heavy load to carry. How would the elderly and infirm manage? What about family members collecting water for four or five people? Without a developed public transport network, there would be difficulties getting to and from the PoD's. Without water, schools and businesses would be forced to close. Shutting down the water infrastructure would also shut down the city's sewerage system, raising fears of a public health emergency. On January 18th, Trevor Nace covered events for *Forbes* magazine under the headline: 'Mad Max Scenario: Cape Town Will Run Out of Water in Just 90 Days.' Nace wrote: 'The severe water shortage is due to a three year, once in a millennium drought ... Most climate models predict that as global temperatures continue to warm, South Africa will continue to receive less and less precipitation' (Nace, 2018). On January 22nd, Helen Zille, Premier of the Western Cape region and thus the highest-ranking local politician, wrote in the popular online news site *The Daily Maverick*: 'The question that dominates my waking hours now is: When Day Zero arrives, how do we make water accessible and prevent anarchy? ... As things stand, the challenge exceeds anything a major city has had to face anywhere in the world since the Second World War or 9/11. I personally doubt whether it is possible for a city the size of Cape Town to distribute sufficient water to its residents, using its own resources, once the underground waterpipe network has been shut down' (Zille, 2018).

This scenario would present an extraordinary challenge for any city, but Cape Town is far from being a run-of-the-mill city. On March 7th 2018, the publication *Business Tech* reported that Cape Town is the 15th most violent city in the world

(Business Tech, 2018). In terms of absolute numbers of homicides per year, as opposed to the murder rate per 100,000 residents, Cape Town stood third in the list of the 50 most violent cities, with just two cities–Caracas in Venezuela, and Fortaleza in Brazil–reporting more homicides in the year 2017–18. Much of this violence is driven by extreme social inequality. According to *Census 2011*, Cape Town had at that point in time 1.068 million households. Of these, 12% lived in 'informal structures,' shacks made of corrugated iron and salvaged materials. Nearly 36% of households lived below the poverty line, nominally set at an income of less than ZAR3500 (about €200) *per household* per month. A household typically consists of four to five persons (City of Cape Town, 2012). According to the *State of Cape Town Report 2016*, youth unemployment in the city was estimated at between 45 and 46% (City of Cape Town, 2016)–an extreme figure by any standards. And then there is the inevitable other face of Cape Town, a city of opulent living conditions and extraordinary natural beauty, keyed-in to global tourist circuits and real estate markets. The *Knight Frank Prime Global Cities Index* 'enables investors and developers to compare the performance of prime residential prices across key global cities' by measuring the top 5% of the housing market. For the second quarter of 2017, Cape Town was the ninth most profitable city in the world in which to invest in real estate, ahead of Melbourne, Paris, and Hong Kong, and just behind Berlin (Knight Frank, 2017). In 2014, *The New York Times* declared Cape Town the best place in the world to visit (Khan, 2014). In 2016, the British publication *The Telegraph* published '22 reasons why Cape Town is the world's best city,' based on a poll of *Telegraph Travel* readers (The Telegraph, 2016).

Such statistics paint a picture of a city not so much divided, as fantastically at odds with itself. I lived in Cape Town on-and-off for thirty years, first as a student, later as a researcher at the University of Cape Town. I can think of no other city which presents such starkly divided and disjunctive scenarios, vistas, and living conditions–the stately homes of Constantia and Bishops Court and the seaside villas of Clifton and Camps Bay, contrasted with the windswept shack-lands of Khayelitsha and the dystopian ganglands of the cynically named 'Lavender Hill' and 'Ocean View.' Much of this contemporary social inequality has deep historical roots. Founded by the Dutch East India Company as a way station in the seventeenth century and run as a slave economy, the layered histories of the Cape include the genociding of the Indigenous Khoisan population, a lengthy period as a British colony, and nearly five decades of apartheid rule. The contemporary spatial layout of the city remains largely unreconstructed and conforms to the apartheid blueprint of racially segregated residential areas (Shepherd, 2019, 2021). I was interested in tracking the events around Day Zero as a way of understanding what happens when the 'climate shocks' of the Anthropocene are layered onto societies characterized by high levels of social inequality and historical injustice–as is the case in so many parts of the world. Understanding Cape Town and South Africa as a microcosm–and as what Jacques Derrida describes in a celebrated essay on apartheid as an 'intensification' of forces and dynamics present in more expansive

forms elsewhere (Derrida, 1985)–I was interested in what we can learn about human adaptability and resilience. As a long-time city resident with deep affective ties to place, I was interested in putting a human face on a crisis presented via such spectacular narratives in the global media.

Competing Narratives

The combination of endemic violence, absolute poverty, and extreme social inequality made the Day Zero/ Mad Max narrative compelling. In fact, from the outset, there was a second, competing narrative in media reports on Cape Town's water crisis. This was contained not so much in the words of these reports, as in the photographs that accompanied the words. Many of these showed people standing in line to fill plastic water containers from the natural springs that occur on the lower slopes of Table Mountain–a valuable supplement to the piped water supply. Images of Cape Town residents queuing for water became a visual trope for the crisis as a whole and were widely reproduced (Robins, 2019; Shepherd, 2019, 2021). Part of the fascination of these images was the inter-race, inter-class nature of the queuing multitudes: white middle-class matrons, black and Coloured workers from nearby construction sites, domestic workers on their lunchbreak, and businesspeople in suits. In March 2018, I visited the 'Spring Street' water point to talk with voluntary organizer Riyaz Rawoot. Early in the crisis, Rawoot gave up his day job to voluntarily manage the Spring Street water point, which was attracting increasing numbers of people as the drought took hold (Robins, 2018). When Rawoot took over the management of the site, the water issued from a single pipe, allowing one container at a time to be filled. Rawoot improvised a solution using PVC-piping, cable times, and wooden poles, allowing sixteen containers to be filled at once. He laid out an orderly system of ques and invited unemployed people from the nearby business district to act as porters, ferrying heavy water containers for a small fee. Importantly, this single story of improvisation, solidarity, creativity, and patience was repeated at the level of individual households for the duration of the crisis. Many middle- and working-class householders responded by changing habits and using improvised technology and small 'hacks' to reduce household water consumption. Common household practices involved taking a quick shower standing in a plastic tub to catch the runoff, then using this water to wash clothes or flush the toilet (usually limited to a single flush per day). Mobilizing around saving water involved transforming relationships to a previously taken-for-granted resource. An *NBC News* report published at the height of the crisis quotes 26-year-old Sitara Stodel: 'I'm constantly thinking about running out of water and worrying about "Day Zero." I'm even having nightmares about wasting water. The other day I had a dream that I took a long shower by mistake' (Monteiro, 2018).

Ultimately, the reduction in water consumption achieved at the household level proved decisive. In a widely quoted set of figures, average daily water consumption in Cape Town dropped from around 1.2 billion liters per day in February 2015, to

between 510 and 520 million liters per day (MLD) in early-2018, a reduction of almost 60%. Most of the saving (400 MLD) was achieved in a single year, between February 2017 and February 2018 (Shepherd, 2019, 2021). By comparison, at the height of the 2015 drought, California residents achieved a 27% reduction in consumption, and in response to their 'millennium drought' Melbourne residents took 12 years to reach a percentage reduction similar to that of Cape Town (Robins, 2019). Robins notes that this drop in water consumption is especially significant when we consider that 70% of water usage in the city is residential–in other words, the savings were achieved at the level of the individual household. City officials were able to extend the period of water rationing beyond the April deadline until the winter rains brought relief in early-June 2018, and the threatened shutdown of the water infrastructure was averted, at least for the present.

Water as a Social Leveler

I have presented the story of Day Zero here in condensed, almost fabular, form because I think that it offers a set of generalizable insights about how we respond in times of great uncertainty–the very situation that now faces so many of us in so many different parts of the world. The events around Day Zero speak to the kind of existential choices that we will face–or are already facing–when we experience our own 'Anthropocene moment,' that moment when the unthinkable happens and a taken-for-granted infrastructure fails, or future horizons and options foreclose and we are faced with the prospect of 'life without the promise of stability' as Anna Tsing (2015) has it. Such moments come in many forms–flood, fire, drought–and their knock-on effects are myriad: food shortages, population movements, and the suspension of everyday life as we enter a 'strange new world' (Tsing 2015). As culture-bearing beings we rely on narrative and on the forms that our cultures give us to make sense of events, especially unexpected and unprecedented events. To understand this is to understand the power of forms. It is also to understand that we live our lives, in the first instance, as an act of imagination. Three different and competing narratives emerged under the pressure of events around Day Zero. The first was the Mad Max narrative that emerged in newspaper coverage of the drought and was picked up by some local politicians and wealthy city residents. This pre-dicted anarchy and social breakdown, with predatory gangs taking advantage of ordinary householders in a dog-eat-dog world–a kind of middle-class nightmare. This narrative is familiar to us as a Hollywood trope, the plot line of any number of climate change-linked films premised on 'the coming Apocalypse.' This Apocalypse narrative is deeply rooted in Christian religiosity and in cultural imaginaries in the West–it is also deeply problematic and pessimistic, becoming nothing less than a kind of death cult.

A second narrative around Day Zero was the technocratic narrative put out by city officials, focused on technical solutions and top-down 'management' of the crisis. It took the form of daily briefings and a welter of information and numbers:

dam levels, consumption figures, and rainfall statistics. At its most concrete, it took the form of the ambitious and ultimately fantastical plan to 'roll out' 200 'Points of Distribution' to service the water needs of a city of three-and-a-half million people–with associated infographics, calculations around wait-times, and wrangling over the siting of the PoD's (Shepherd, 2019, 2021). As with the previous narrative, we can recognize the deep roots and appeal of the technocratic narrative. It speaks from within a certain kind of modernity in which all problems are ultimately solvable based on science and ingenuity (Ernsten, this volume). This narrative has become ubiquitous in solutions-oriented climate change debates, whose premise is that we can engineer our way out of trouble (Shepherd et al., 2022). As things turned out, neither of these two narratives played much of a role in the eventual run of events around Day Zero. Rather, there was a third narrative–one that it is more difficult to name because the available narrative lines are less readily apparent–but which turns out to be of great importance.

This third narrative turns around the role of ordinary householders finding solutions to reduce water consumption at the local level, using unspectacular technology and improvised hacks (buckets, tubs, PVC piping, soda bottles), jointly taking responsibility for reducing consumption as an act of solidarity and will. This narrative speaks of the cumulative effects of myriad small actions, insignificant in themselves, but extraordinary and paradigm-shifting when added together. It also speaks of the power of imagination. To achieve this concerted action at the household level, residents first needed to change their relationship to water–and to do so in ways that are intimate and embodied. It had to *feel* wrong to take a long shower, or wash your hair more than once-a-week, or use potable water to flush the toilet. Not least, this third narrative invokes an intriguing possibility in opposition to the Mad Max narrative–the idea of water as a social leveler. For Cape Town, a city built on racial slavery, colonialism, and apartheid residential segregation–which presents as stark a juxtaposition of poverty and privilege as it is possible to find in any city in the world–the importance of this possibility cannot be overstated. This third narrative and its associated moments of learning also offer lessons that might apply to a broader context–even to be generalizable as we face the myriad challenges brought on by the climate emergency. The insights that it offers include the following: first, top-down technocratic solutions are unlikely to succeed in themselves. Second, solutions work best when people understand that they can make a difference individually, through their everyday choices and actions. Third, any solutions need to be a collective effort. Fourth, acts of collective will begin as acts of imagination: we need to feel differently about certain things–water, topsoil, plastics, fossil fuels–and imagine our lives based on a different relationship to these things. And fifth, none of this means anything unless we foreground questions of social justice and read contemporary climate events through the lens of history, and through the deeply inscribed historical injustices that have created the contemporary world.

Difficult Choices: Turning Inwards or Turning Outwards?

Aside from the interesting question of finding narrative frameworks and plot lines to fit the events around Day Zero, city residents were presented with a sharpened set of existential choices when it came to orienting their own strategies in response to the drought. These might be stated in terms of the following conundrum. In a time of critical resource scarcity such as was the case with Cape Town's Day Zero drought, are you better off putting your faith in high walls, electrified fences, and private stockpiles of water–such as many of the city's wealthier residents were doing? Could you rely on your relative wealth to get you through the crisis, as it had through the social and political upheavals of the past? Or would you be better off pursuing a different strategy: putting your faith in a developed social network, offering favors to friends and neighbors and ex-pecting favors in return, relying on people to tell you where ques are shortest or which shops still stock water? The Cape Town residents that I spoke with, many of them friends and relatives, discussed these two choices at length as they described their own struggles to cope with the shortage of water. One of them described these choices as the difference between 'what you have' versus 'who you know.' More memorably, one resident described this as the difference between 'turning inwards' versus 'turning outwards'–where turning inwards involved putting up the walls and placing one's faith in inherited wealth and relative privileged, and turning outwards involved collective action, solidarity, and dialogue. Here again, a number of useful and potentially generalizable observations can be made. First, the option of turning inwards was only available to the relatively wealthy, those whose privileged position already allowed for high walls, electrified fences, private boreholes, and the like. Second, the option of turning outwards is by far the preferred option in terms of the option that holds the possibility of the greatest good for the greatest number of people. Third, ultimately it was the second option, involving solidarity and collective action, that proved decisive in intervening in the water crisis in Cape Town and averting the threatening prospect of Day Zero.

I think that it becomes relatively uncomplicated to take an overarching lesson from the scenario that I have presented here around Cape Town's Day Zero drought. Sticking with the fabular form, and allowing for many qualifying factors, it might be stated in the following way. In times of uncertainty and danger–in pre-carious times–we tend to respond in one of two ways: either we turn inwards, or we turn outwards. Turning inwards involves falling back on the relative safety and familiarity of the clan, the ethnic group, and the nation–in other words, on in-group identities defined through exclusion. The politics of the inward turn takes many forms, depending on context. At a general level, it involves rejuvenating and giving play to essentialized tropes of identity and their inevitable 'other': the stranger/ migrant/ outsider as threat and pollution. In the worlds of practice with which I am familiar, it expresses itself in the politics of walls and fences:

xenophobia, racism, Islamophobia. Many of us have viewed with alarm the rising tide of fascism, authoritarianism, and isolationism–and the populist appeal of demagogues and 'strong wo/men' who promise to purify the nation from within and face down the dangers from without. In some contexts, the inward turn involves a marshalling of the forces of whiteness and patriarchy, pushing back against the gains of Feminism and anti-racism (Matthews, this volume). In others it involves doubling down on extractivist policies and practices, moving to corral the earth's remaining resources for the use of the few (Harmanşah, this volume).

Many of these ideas, practices, and policies are heritage-facing. In fact, historically, heritage has provided an indispensable arena for affective attachments and monumental displays linked to the idea of the nation–as well as providing essential tropes, images, narratives, and plot lines (Gnecco, this volume; Holtorf, this volume). It has become almost axiomatic that historically, the rise and ubiquity of heritage is inseparable from the rise of nationalism in the West and the modern nation-state. Modern Western states exported heritage ideas and institutions as part of the apparatus of the colonial state so that heritage tropes have become the dominant means globally through which to imagine national distinctiveness–with all the kitsch theatricality of monuments, memorials, parades, 'national dress,' and ethnic display (Gnecco, this volume; Schofield and Ugwuanyi, this volume). The fact that heritage sites, images, and constructs invite deep affective attachment has made them an indispensable part of the apparatus of demagoguery, fascism, and ultra-nationalism (Kaya, 2020; Reynie, 2016). There is something atavistic and deeply human in the desire to turn inwards in a moment of danger–deeply human in the worst sense, in resorting to deeply socially and culturally coded responses that are no longer fit-for-purpose, and that evolved to take care of a very different set of dangers buried deep in our past. Faced with a collective action problem like the climate emergency, not only are such impulses not effective, but they send us into a death spiral of mutual competition, suspicion, and conflict (Ghosh, 2016; Scranton, 2016).

The second strategy–turning outwards in a moment of uncertainty and danger–involves placing one's faith in dialogue, solidarity, multi-lateralism, and collective action. It involves thinking outside of the in-group–or using the in-group as a basis for evolving forms of inter-cultural and interspecies connection, reciprocity, and exchange. Centrally, it involves developing forms of empathy and shared accountability that make us jointly responsible for the well-being of others (other people, other beings) (Ernsten, this volume; Schofield and Ugwuanyi, this volume). In immediate ways, it involves supporting and reviving often fragile multilateral institutions and forums through which we encounter one another around shared interests and challenges–for example, climate, heritage, and trade (Holtorf, this volume). The political expression of turning outwards frequently happens above and below the level of the state: in global solidarity mass actions like #BlackLivesMatter, in the global youth strikes for climate action, in protest actions in support of women's rights and human rights in Iran at the date of writing, and in

many other social movements, political actions, and multilateral organizations (Matthews, this volume; McAtackney, this volume; Jethro and Macdonald, this volume; Winter, this volume). With deep roots in the political left, there is now a rich body of work in mainstream academia that gives detail to such notions, in fields as diverse as STS, Environmental Humanities, the Climate Action debate, Posthuman Studies, decolonial thinking and practices, and many others. Concepts such as multi-species relations of care, relational ontologies, more-than-human worlds, and pluriversal worlds, provide a rich emergent vocabulary through which to rethink and reimagine the idea of the human (Butler, this volume; Ernsten, this volume; Schofield and Ugwuanyi, this volume). Many of these ideas and concepts are heritage-facing. Some draw from local and Indigenous knowledge and ontologies to rethink theories of relatedness, reimagine relationships of care, and challenge the binarism of modern Western thinking–and by extension, the disciplinary knowledge apparatus to which it gives rise, including Heritage Studies (Fforde et al., this volume; Gnecco, this volume; Waterton et al., this volume). The binary violence of separating culture from nature, head from heart, and thinking from imagining becomes, in these terms, a foundational epistemic violence that authorizes colonialism, racial slavery, patriarchy, capitalist extractivism, and the war on nature (Waterton et al., this volume). Reorienting our thinking and practice away from these technocratic death logics involves a wholesale revisioning of 'knowing' and 'being.' It also takes heritage in a different direction, by drawing on a different archive, the archive of non-Western, non-modern, local, traditional, and Indigenous thinking and practice–however provisional and unsatisfactory these terms might be.

Drawing from the arguments presented by the chapters in this volume and extending some of these arguments through the short account that I have given here of Cape Town's Day Zero drought, it becomes possible to state two strong conclusions that emerge from the collective endeavor in this volume–in addition to the rich set of conclusions and insights offered by each of the chapters. First, the *political* struggle of the contemporary moment is the struggle for multilateralism, dialogue, and collective action in the face of those who would use a historical moment of uncertainty and danger for narrowly sectarian ends–the responses which I have characterized here as turning outwards versus turning inwards. It is also the struggle for social justice, solidarity, and restitution in the face of the manifest injustices of the past, many of which are compounded by contemporary events. From a heritage perspective, the question of relevance becomes: *How do we use heritage perspectives and understandings in support of open, creative, inclusive, just, and sustainable futures?* In other words, how do we use heritage perspectives in support of the broad set of strategies and responses that hold the possibility of the greatest good for the greatest number of people? Moreover, how do we do this in the context of 'the moment of the now,' a world in which, to greater and lesser degrees, precarity has become a universal human condition.

Heritage against the Grain

Posing questions such as these offers a rich, open-ended, and future-oriented agenda for the field of Heritage Studies. Moreover, the core duty of care, deep timelines, and invitation to think in both immediate and abstract terms offered by the field of Heritage Studies means that it is uniquely placed to deal with the scale and ambition of such questions. However, a second, inevitable conclusion follows. It is this: setting such an agenda for Heritage Studies involves, in many ways, re-thinking heritage against the grain of its own history. Many authors have made the point that modernist framings of heritage have historically overwhelmingly been in support of notions of national destiny and exceptionalism—and this remains by far the dominant form in which we encounter heritage tropes and images today (Gnecco, this volume; Holtorf, this volume). Dominant framings of heritage—authorized heritage discourse, in the felicitous phrase of Laurajane Smith—turn around the concept of authenticity, in a hermeneutic loop in which to be deemed as heritage is both to require and confer authenticity as a core attribute (Smith, 2007). Falling back on fixed, essentialized identities and innate values—and operationalized around a set of key binaries (cultural versus natural, tangible versus intangible)—such conceptions of heritage almost by definition orient us towards in-group identities and the set of responses characterized here as the inward turn. However, if this is generally the case, then it is not inevitably the case, and the chapters in this volume offer many fine, subversive uses of heritage that think and practice against the grain to unsettle traditions, deconstruct national historiographies, act in support of Indigenous claims to territory and sovereignty, support process of restitution, reveal hidden histories, and grapple with the nature and effects of the climate emergency. Mapping an agenda for heritage against the grain involves picking up on a substantial and growing body of work, much of it gathered under the heading of Critical Heritage Studies—but by no means confined to the Critical Heritage Studies project. On the one hand, this involves opening the repertoire of heritage to focus on forms that are less concerned with national sites and symbols. This might include, for example, the heritage of human rights, the heritage of anti-racist and anticolonial struggles, the heritage of peacemaking, the heritage of the extraordinary vaccination campaigns of the twentieth and twenty-first centuries, the heritage of labor rights and workplace reforms, transgender heritage, the heritage of the struggle to protect biodiversity and threatened habitats, and the heritage of science itself and the extraordinary advances in knowledge that it has enabled, understood as shared human achievement.

On the other hand, it involves working conceptually to reframe core heritage attributes and ideas. There are many examples of conceptually exciting projects that rework notions of authenticity and value, to focus instead on everyday, ubiquitous, inauthentic, and 'found' heritage, include drift matter and anthropogenic debris (Holtorf, this volume). Other projects rework conceptions of time and the inbuilt historicity of authorized heritage discourse to focus on contemporary heritage,

future heritage, and heritage-in-the-making (Bezerra, this volume; Harvey, this volume). Still others contest the anthropocentric framing of dominant conceptions of heritage and put into play ideas of multi-species heritage, more-than-human heritage, and posthuman heritage (Ernsten, this volume; Schofield and Ugwuanyi, this volume). Some of the most conceptually exciting and important work in this direction comes out of the growing salience and visibility of perspectives from the global south (Bezerra, this volume; Fforde et al., this volume; Mataga, this volume; Waterton et al., this volume). A growing body of work contests the universalist framings of authorized heritage discourse and global heritage protocols, in favor of local understandings of heritage, practices of stewardship, and research priorities and agendas (Bezerra, this volume; Mataga, this volume). This body of work also alerts us to the life-worlds and institutional contexts of practice in the global south–and to the interests and concerns that preoccupy researchers and students. Allied to this, has been the growing salience, visibility, and importance of local, traditional, and Indigenous knowledge, practices, and perspectives. Many of these contest universalist frameworks and understandings of heritage, with the added dimension that they invite us to think and practice outside of modern, Western understandings of time, place, personhood, and relationality–and to consider and take seriously other ways of knowing and being (Fforde et al., this volume; Waterton et al., this volume). Many commentators have made the point that the roots of Anthropogenic climate change and the contemporary climate emergency lie in a set of mentalities and values that came to the fore in early modern Europe through a complex set of social, political, economic, and cultural processes including the Enlightenment, rapid industrialization, the secularization of knowledge and science, racial slavery, colonialism, and imperialism, and many other historical processes (Shepherd et al., 2022). These mentalities and values were exported globally as part of historical processes of colonialism and imperialism, obliterating much of what lay in their path. Their contemporary legacy lies in two directions. On the one hand, they underwrite, authorized, and enable the relentless extraction of 'resources,' destruction of habitats, and the war on nature that has brought us to the current impasse (Harmanşah, this volume; Waterton et al., this volume). On the other hand, they are foundational to the forms of knowledge reproduced through university-based disciplinary knowledge systems, and to contemporary ways of being. Trying to find solutions to the climate emergency by thinking and practicing from within these forms of knowledge and ways of being becomes a perverse exercise, filled with dissonance, magical thinking, and dismay, in which we ask deeply entrenched mentalities and values to think/ practice over/ against themselves (Ernsten, this volume). Non-Western, non-modern ontologies and epistemologies offer an enormously important and exciting set of riches, not because they offer a blueprint for alternative living, but because they offer clues, beacons, and points of inspiration that, interpreted correctly, offer a way out of the maze. The growing focus on local and Indigenous knowledge and practice feels like an overdue, necessary historical corrective, whose implications are profound.

Heritage and Hope

This volume sets out to grapple with somber and difficult subjects. One of the interesting, affirming, and slightly surprising, features of reading the full set of chapters is that they overwhelmingly conclude by pointing in the direction of hope. As a way of closing this volume on a similar hopeful note, it is worth reminding ourselves of the extraordinary 'work' that heritage does as a concept and as a field of practice. Much of this 'work' is directed towards interpolating our individual lives into larger collective wholes. On the one hand, ideas and practices of heritage suture our individual experiences into the collective life of the clan, the nation, the cluster of nations, the social movement, or the global community of activists–in other words, into larger collective wholes. On the other hand, they suture the span of our individual life into the timeline of history, such that we think of ourselves as part of a tradition based on a continuity of memory and experience. Moreover, they do this in ways that feel immediate and real (Lowenthal, 2015). To 'suture' is a medical term meaning, literally, to close a wound–but it is used here as an idea-concept to indicate the bringing together, the joining of the individual to the whole (other words might be to graft, to enfold, to interpolate). As a cultural and social meaning-making process working across both time and space, this heritage work is extraordinarily powerful. Conceptions of heritage gather in a host of associated ideas, affects, and practices: ideas of home and belonging, notions of community, conceptions of identity, ideas around aspirational futures, hopes, and dreams. Heritage also acts as a powerful mediator of memory and experience, providing frameworks through which to make sense of our individual life as part of collective experience. Not least, the language of heritage gives us a register through which to address high-level, abstract aspirations, concerns, hopes, and fears–to dwell in the existential, as it were–and to do so in ways that feel immediate and relatable. Part of the power of heritage is its ability to shuttle between the highbrow and the homely (the pyramids, your grandparents' teapot), and to invite deep affective attachments (Lowenthal, 2015). The work of suturing is also the work of translation, bringing abstract concepts and propositions to ground, in the immediacy of lived experience. All of which is to say that outside of philosophy (arguably incorrigibly highbrow) and religion (arguably inherently divisive) the language of heritage offers one of the few culturally available registers through which to address 'ultimate' things: the meaning of the human, our hopes for the future, our duty of care towards the earth and its beings. Heritage presents us with a vernacular, secular language through which to address questions and concerns that, for a previous generation, might have been addressed through the register of the sacred.

The climate emergency and the ongoing struggle for social and environmental justice present us with the kind of existential challenge for which, in quite specific ways–culturally, temperamentally, institutionally–we seem to be unprepared. It becomes vital that we find a language through which we can talk about ultimate things, not in an abstract way, but in relation to our individual lives, and the

changes small and large that we will choose to make, and that will be compelled upon us. Our world is changing quickly, in ways that many of us are just beginning to understand. As we exile ourselves from the Holocene–the garden in which our civilization flowered–and embark on an ambiguous new epoch, we will need to be resilient, adaptable, creative, and kind.

References

Baker, A. (2018, January 15). Cape Town Is 90 Days from Running Out of Water. *Time Magazine*. Retrieved from http://time.com/5103259/cape-town-water-crisis/

BusinessTech. (2018, March 7). Cape Town Is One of the Most Violent Cities in the World. *BusinessTech*. Retrieved from https://businesstech.co.za/news/lifestyle/230123/cape-town-is-one-of-the-most-violent-cities-in-the-world/

City of Cape Town (2012). 2011 Census. *Strategic Development Information and GIS Department, City of Cape Town*. Retrieved from http://resource.capetown.gov.za/documentcentre/Documents/Maps%20and%20statistics/2011_Census_Cape_Town_Profile.pdf

City of Cape Town (2016). State of Cape Town Report – Overview with Infographics. *Development Information and Geograhic Information Systems Department*. Retrieved from http://maitcid.co.za/wp-content/uploads/2017/01/State-of-Cape-Town-Report-2016.pdf

Derrida, J. (1985). Racism's Last Word. *Critical Inquiry* 12(1): 290–299.

Ghosh, A. (2016). *The Great Derangement: Climate Change and the Unthinkable*. Chicago: University of Chicago Press.

Kaya, A. (2020). *Populism and Heritage in Europe: Lost in Diversity and Unity*. Oxford: Routledge.

Khan, S. (2014, January 12). 52 Places to Go in 2014. *New York Times*. Retrieved from https://www.nytimes.com/interactive/2014/01/10/travel/2014-places-to-go.html

Knight Frank (2017). *Knight Frank Prime Global Cities Index, Second Quarter 2017*. Retrieved from https://content.knightfrank.com/research/323/documents/en/prime-global-cities-index-q2-2017-4862.pdf

Lowenthal, D. (2015). *The Past Is a Foreign Country–Revisited*. Cambridge: Cambridge University Press.

Monteiro, Catie. (2018, January 29). Water Crisis Grips Cape Town after South African Drought Stretching Years. *NBC News*. Retrieved from https://www.nbcnews.com/news/world/water-crisis-hits-cape-town-south-africa-day-zero-looms-n841881

Nace, T. (2018, January 18). Mad Max Scenario: Cape Town Will Run Out of Water in Just 90 Days. Retrieved from https://www.forbes.com/sites/trevornace/2018/01/18/mad-max-scenario-cape-town-run-out-water-90-days/#4859f9675414

Reynie, D. (2016). The Specter Haunting Europe: Heritage Populism and France's National Front. *Journal of Democracy* 27(4): 47–57.

Robins, S. (2018, June 4). The Kildare Road Spring: A Place Buried Under Concrete. *Daily Maverick*. Retrieved from https://www.dailymaverick.co.za/article/2018-06-04-the-kildare-road-spring-a-place-buried-under-concrete/

Robins, S. (2019). "Day Zero", Hydro-citizenship and the Defense of the Common in Cape Town: A Case Study of the Politics of Water and Its Infrastructures (2017–2018). *Journal of Southern African Studies* (JSAS) (in print). ISBN 1465–3893; DOI 10.1080/03057070.2019.1552424

Scranton, R. (2016). *Learning to Die in the Anthropocene.* San Francisco: City Lights.

Shepherd, N., W. Carmen, J.B. Cohen, M. Chundu, C. Ernsten, O. Guevara, F. Haas, S.T. Hussain, F. Riede, A.R. Siders, C. Singh, P. Sithole, A. Troi. (2022). *White Paper: The Role of Cultural and Natural Heritage for Climate Action.* International Co-Sponsored Meeting on Culture, Heritage and Climate Change. ICOMOS, UNESCO and the IPCC.

Shepherd, N. (2019). Making Sense of "Day Zero": Slow Catastrophes, Anthropocene Futures and the Story of Cape Town's Water Crisis. *Water* 11(9): 1744.

Shepherd, N. (2021). Cape Town Water: Notes on Urban Dwelling in the Anthropocene. *Space and Culture* 23. 10.1177/1206331221997695

Smith, L. (2007). *Uses of Heritage.* Oxford: Routledge.

The Telegraph. (2016, July 16). 22 Reasons Why Cape Town is the World's Best City. *The Telegraph.* Retrieved from https://www.telegraph.co.uk/travel/destinations/africa/south-africa/galleries/reasons-why-cape-town-is-the-best-city-in-the-world/

Tsing, A. (2015). *The Mushroom at the End of the World: On the Possibility of Life in Capitalist Ruins.* Princeton: Princeton University Press. p. 5.

Zille, H. (2018, January 22). From the Inside: The Countdown to Day Zero. *Daily Maverick.* Retrieved from https://www.dailymaverick.co.za/opinionista/2018-01-22-from-the-inside-the-countdown-to-day-zero/

INDEX

Aboriginal Heritage Act 1972 156
Aboriginal pastoral workers 154
academic activism 172
academic sociability 19, 22
activism 168, 206, 272–275
Adorno, T. W. 229
African Quarter (*Africanisches Viertel*) 210
Agamben, G. 94, 104–105, 107, 107n1
agonism 237, 241
AHD *see* authorised heritage discourse
Ahmed, S. 146, 146n9, 163
AIIB *see* Asian Infrastructure Investment Bank
Aka (green snake) 60, 62
Akpugoeze 60, 62, 68
Ala 62
Allier 81–82
Almore, B. 198, 199
Amo, A. W. 211, 213
Anadu, P. 68
Anholt, S. 118
Anthropocene 2, 3, 9, 57, 67, 75, 134–135, 248; archive 121; world heritage for 117–119
Anthropogenic climate change 2, 4, 6–7, 341
Anthropogenic stressors 59, 67, 68
anti-flood measurements 79
anti-racism protests in Ireland 167, 175
Anzaldua, G. 7
Aotearoa New Zealand 240–242
Apocalypse narrative 335

apocryphal diary, entries in 221–232
archaeological fieldwork as political ecology 132–133
Archambault, J. S. 27, 28
arche-pharmacologies 39
Arnold, J. 290
Ashe, A. 190
Ashworth, G. 246
Asian Infrastructure Investment Bank (AIIB) 286, 288
Atlas Obscura 178
Aubery, A. 195
Australia 233; Ngarrindjeri nation re-building, heritage and peace-making 242–244; reconciliation in 236–240; settler-colonial history 154
authenticity 47–48, 154, 308, 325, 340
authorised heritage discourse (AHD) 237, 245
Awka 60, 62, 68

B3W 285
Bahrdt, H.-P. 265, 274
Baker, A. 332
Baker, L.R. 62, 68
Barthe, Y. 95
Bartholomeus, V. 78
Belém, city of 26
Belt and Road connectivity 287
Belt and Road Initiative (BRI) 285, 286, 291
Benjamin, W. 187, 193

Bennett, T. 104
beyondness 45
Bezerra, M. 15
Biden, J. 2, 284, 285
Biesta, G. 246
biophilia 27
biopolitical urban governance 268–270
biopolitics 269
Black and Irish (online) experiences 167,
 179–180
Blackbourn, D. 74
#BlackLivesMatter (#BLM) 1, 4, 8, 168,
 170–171, 172, 175, 176, 177, 178,
 205, 261, 283, 282, 292, 338
blasé attitude 264
Blitz spirit 36, 319
BLM movement *see* Black Lives Matter
 movement
blood-and-soil rhetoric 7
Bolin, A. 116
Bonnett, A. 325
book-dossier 42–43, 45
Brandão, C. R. 19
Brazilian educational process during Covid-
 19 pandemic 17–29
Breithoff, E. 67
Brexit spirit 36
BRI *see* Belt and Road Initiative
Bubandt, N. 135
Buddhism 291
Bunten, A. C. 155
Butler, B. 15
Butler, J. 8, 207
Byrne, D. 309

Callón, M. 95
Caltex (Australia) Oil Development Pty 149
Candlin, F. 97, 107n2
Cape Town 332–334, 337
Capuano, L. 41
Cardoso, R. 20
Carlson, E. 163
CARMAH *see* Centre for Anthropological
 Research on Museums and Heritage
Castellano, M. B. 238
Centre for Anthropological Research on
 Museums and Heritage
 (CARMAH) 205, 210
Chakkalakal, S. 212
Chakrabarty, D. 75, 91, 99, 288
Chandler, D. 158
Charlottesville riot 192
Chatterton, P. 325

China Dream of Great Rejuvenation 286
China International Development
 Cooperation Agency (CIDCA) 286
Chipato, F. 158
Christian, J. 192, 193, 194
Christian, W. 192, 193, 194
CIDCA *see* China International
 Development Cooperation Agency
Cioc, M. 74
city dwellers 265
City of Richmond 197–198, 199
Clark, N. 160
Clemens, D. 82
Clifford, J. 97, 104
climate action 106
climate change: anthropogenic 6–7; carbon
 emissions and 122; consciousness of
 94; and heritage 9
climate crisis 91, 95, 96, 99, 100, 105, 320
climate emergency 2, 6, 7, 8, 10, 91, 95,
 336, 338, 340, 341, 342
Clowes, E. 290
Cockayne, D. 146n9
cōgitātiō nullius 248
Cohen, K. 76
Cold War 285
colonialism 4, 8, 144, 145, 158, 173,
 177, 180
Colston, E. 172, 327
commemorating pandemics control
 270–272
community archaeology 171, 304
community heritage 303, 304
Community Peace Museums and Heritage
 Foundation 250n2
competition and collaboration,
 internationalism between 288–293
Confederate flag 190, 191, 194, 198
Confederate History Matters 191
conflict transformation 236
conservation 55, 59–63, 65, 66
Contemporary cultural heritage
 practices 305
contemporary moment 2, 10, 138, 339
Cook, B. 148
#CORONASPEAK 36, 37
coronavirus pandemic *see* COVID-19
 pandemic
Cortázar, J. 230
Cosmologies 40, 41, 160
COVID-19 pandemic 1, 2, 5, 15, 18, 28, 50,
 116, 167, 170, 263–264, 276–278,
 282, 299; and blind spots of urbanity

266–270; and burden of history 283–286; competition and collaboration, internationalism between 288–293; global discourses, local experiences 303–305; heritage during 171–173; internationalism, new road of 286–288; online social justice and heritage in Ireland during 173–175; people, pastness and epistemic plurality 305–310; precariousness and resilience 301–303; teaching during 17–29
Covid heritage imperatives 33; authenticity 47; book-dossier 42–43; heritage 44–45; heritage beyond power 40–41, 49; heritage care and/as object-work 38–40; making life worth living 50–52; as new heritage pharmacologies of care 35–37; as overturning 34–35; positions 49; recognition 45–46; refugeeness 45; 'ruins' 43–44; stateless heritage 37–38; stateless heritage, exhibiting 41–42; tangible and intangible heritage 47–48; trajectories 48–49; universalism 46–47
Covid spirit 36
Covid syndrome 37
Covid Wars 36
Crenshaw, K. 24
Critical Heritage Studies 274, 276–278, 278n5
Croninin, D. O 180
Crutzen, P. 91
cultural heritage 66, 68, 113, 115, 117, 123, 131–133, 135, 137; defined 133

DAAR see Decolonize Architecture Art Research
DaMatta, R. 26
Dampier, W. 148
Dang, T. K. 145, 145n6, 146n7
Darwin, C. 63, 64, 65, 66, 67, 68, 69
Das, S. 160
Davis, J. 196
Dawson, E. 161
'Day Zero' drought 332–334, 335
DDT see dichlorodiphenyltrichloroethane
decisive events 1
Decolonize Architecture Art Research (DAAR) 15, 34–35, 38, 39, 46; book-dossier 42, 45; interventionism 50, 51; nomination

process 42; nomination project 46; powerful 'provocation' 41; 'provocation' 41; 'Stateless Heritage' exhibition 37
defending the bodies of heritage 190–193
deforestation 21
Dekoloniale Flaneur 213
Deleuze, G. 40
Denmark 3, 172, 178, 316, 318, 320
de Paula, C. 26
Derrida, J. 38, 40, 333
DESIGN EARTH 105
DeSilvey, C. 65, 66
Deutsche Gesellschaft für Sozial- und Kulturanthropologie 209
Deutsche Gesellschaft für Volkskunde 209
Devonian reef system 149
Dheisheh Refugee Camp 45
'diagnosticians-symptomatologist', citizens as 35, 36, 38, 40, 42, 49
dichlorodiphenyltrichloroethane (DDT) 65
difficult heritage 44, 204–208; neighbourhood initiative 210–213; researching 208–210
digital exclusion 20
Digital Silk Road architecture 285
DigVentures 171
Dipsiz Göl 133
Dipsiz Lake 134
Dirckinck-Holmfeld, K. 172
Directions Tree 162
Direct Provision 174
dissonant heritage 44
Driessen, C. 82
drinking river's water 83–85
Dunne, A. 94, 100–101
Durrell, L. 226
Dussel, E. 7
Dutch Cultural Heritage 76

education system in Brazil, precariousness of 18, 21
educação vigiada 20
Eflatûn Pınarı 138
Eflatûnpınarı ('Plato's Spring') 129–132
Egyptomania phase 177
Elephant in the Room (animated film) 105
Emergency Remote Teaching (ERT) model 18, 19, 22
emotional closeness and intimacy 265
Engert, K. 59
epistemic plurality 305–310
Eriksen, T. H. 115

Erll, A. 270–271
ERT model *see* Emergency Remote
 Teaching model
Escobar, A. 7, 56, 75, 83
Eurasia 291
Eurasianism 290
Eurocentric doctrines 47
Eurocentrism 111, 287
European National Romanticism 116
extractionism 132
extractivism 8

#Fallist movements 4
Fanon, F. 4
fantasy landscape 80–83
Faria, L.S.P. 21
Far Right 174
Fforde, C. 250n1
Figueira, P. 26
first nature 78
Fitzroy River 156, 157
Fitzroy River Declaration (2016) 155
flagship 111
Floyd, G. 167, 170, 174, 180, 195, 197, 205
Foucault, M. 91, 94, 103, 104, 107n1, 269
Fraser, N. 273, 278n5
Freedland, J. 317
Freire, P. 23, 25
Future for a Gravel River (1991) 80
futuristic activity, heritage as 305–310, 320–321

Galapagos Conservation Trust 65
Galápagos 63–65, 67
Galápagos sea lion (Zalophus wollebaeki)
 food chain 66
Gardaí 175
Gardner, S. 174
Geia, L. 161
Ghosh, A. 91, 100
Ghosn, R. 105
Glas, P. 78
Global economic recession 6
globalisation 115, 117
Global North countries 170
Global South countries 170
global voting 117
Graeber, D. 37
Graham, B. J. 246
grain, heritage against 340–341
Great Derangement 100, 107
Group activities 23
Guest, K. 173
Guest, W. 321–322

Haber, A. 297
Habermas, J. 278n5
Halberstam, J. 85
Halvorsen, S. 326
Haraway, D. 55
Harmanşah, Ö. 127
Harrison, R. 9, 59, 67, 78, 91, 98, 293, 308
Harvey, D. 6, 9, 327n1
Haus der Welt Kulturen 75
Hawke, S. 150, 154
Hazard, S. 249
Health Silk Road architecture 285
Helmer, W. 80, 81–83
Hemming, S. 242, 250n1
heritage 44–45
heritage, need for 3–7
'heritage beyond power' 40–41, 49
Heritage Education (HE) 18, 19, 23
heritage futures 122–123
Heritage Futures programme 65
heritage injustice 131
heritage-in-the-making 4, 6, 7
heritage pharmacology 35–37, 38, 40
heritage studies, key debates in 244–249
Heritage Studies agenda 2
heritage violence, in neoliberal countryside
 133–137
HE *see* Heritage Education
heterogeneity and activism 272–275
Hill, M. 191
Hindu culture 289
Hinduism 291
Høeg, P. 317
Hogan, L. 176
Hogberg, A. 9
Hokowhitu, B. 248
Holm, J. 324
Holocene 6
Holtorf, C. 9, 15, 320
hooks, b. 23, 29n2
hope, heritage and 342–343
Horkheimer, M. 229
Hutton, M. 105
hyperobject 121

IfEE *see* Institute for European Ethnology
Igbo communities 60, 62
Imerienwe 60
INAR *see* Irish Network Against Racism
India 289–290
Indian Council of World Affairs 291
Indigenous-defined 'heritages' 245
indigenous heritage 304

indigenous heritage site, desecration of 129–132
Ingold, T. 59, 75
in-person classes 23
Institute for European Ethnology (IfEE) 205, 211–212
intangible heritage 47–48
intellectually calculating economic egoism 265
internationalism, new road of 286–288
Ireland 169; Black and Irish (online) experiences 179–180; COVID-19 pandemic, heritage during 171–173; 'Irish slave' memes 175–176; Irish statue toppling 176–178; online social justice and heritage in Ireland during the pandemic 173–175
Irish Network Against Racism (INAR) 179
'Irish slave' memes 175–176
Irish statue toppling 176–178
Iriye, A. 292

Jackson, S. 192, 196
Jagger, J.W. 301
Janes, R.R. 97, 107
Jazairy, El Hadi 105
Jeker 73
Jerusalem Syndrome (JS) 49
Jethro, D. 168, 206, 212, 213
jewellery law 327n2
Johnson, P. 135
Johnston, B.R. 74
Jones, S. 58
Joseph, E. 178
Joy, C. 139n3
JS see Jerusalem Syndrome

Kawharu, M. 240, 250n1
Kehinde Wiley Studio 193
Keil, R. 267
Kennedy, L. 175
Kessler, J. 191
Klein, N. 144
Knight Frank Prime Global Cities Index 333
KNYA see Kungun Ngarrindjeri Yunnan Agreement
Körkuyunun Mağaza 139n7
Kungun Ngarrindjeri Yunnan Agreement (KNYA) 243
Kwaymullina, A. 154

Lagwa 60, 62
landscape, fantasy 80–83
Larkin, J. 97
Lascoumes, P. 95

Latour, B 2, 133, 248
learning 19
Lee, R. E. 189, 190, 192
Lee Circle 168, 199
Lefebvre, H. 325
Leff, E. 75
Lego and other plastic trash 119
Leyden, K. 178
Li, A. 105
'Liberated by the People' 195–199
Liboiron, M. 143, 143n2, 144, 146, 159, 159n25, 162, 163
Lippard, L. R. 134
living 63–67
living community 58
'living heritage' approach 58
lockdown 5
Lorenzo, R. 22
Lorimer, J. 82
Lowe, M. 160
Luke, C. 132

Maasverbetering (Meuse improvement) project (1870–1942) 80
Macdonald, S. 115, 168, 206, 207
Mad Max narrative 334, 335, 336
Mahnmal 208
Makaratta Commission 239
Malm, A. 96, 102
Maori scholarship 239–240
Marcus-David Peters Circle 168, 196–198, 200
Martuwarra Fitzroy River Council 155
Martín, J. 229–230
Martín, R. I. 26
Massey, D. 321
Mataga, J. 297–298
Matthews, C.N. 167
Maury, M. F. 196
Mawdsley, E. 289
Mbembe, A. 157, 205, 297
'The Mbembe Affair' 205
McAtackney, L. 167
McAuliffe, T. 190, 192
McDonald's 97
McGee, K. 134
McGhie, H. 98
McKenna, M. 148, 149, 151
McKittrick, K. 146, 163
Menezes, A.C. 27
Meuse, decolonizing heritage along 73; drinking river's water 83–85; fantasy landscape 80–83; ruined river 76–80

MIC *see* Military Industrial Complex
Middle East 129; archaeological fieldwork as
 political ecology 132–133; new
 forms of fieldwork 137–139; Plato's
 Spring and desecration of indigenous
 heritage site 129–132; practices of
 heritage violence in neoliberal
 countryside 133–137
Mignolo, W. 7, 75
Military and Medical Industrial Complex
 (MMIC) 327
Military Industrial Complex (MIC) 327
Miller, D. 23
Misak people 221
Mississippi: An Anthropocene River (2019) 75
Mitchel, J. 177
Mitchell, J., Jr. 189
MMIC *see* Military and Medical Industrial
 Complex
modelling action 105–107
Modi, N. 289
'moment of the now' 1–3
monitored education 20
Monument Avenue 199; creating 188–190;
 need for 187–188
Monument Avenue Commission 192
Moorrool Moorrool 148
Moreton-Robinson, A. 150, 243
Morris, W. 321–326
Morton, T. 96
Mott, C. 146n9
Moulton, A. A. 160
moving object-relations 40
M_Straße 168, 205, 207, 210, 211
Mullally, U. 179
Murúa, Martín de 223
Museology 24–25
Museu Amazônico (Amazonas) 25
museum climates 95–99
Museum Detox 107n3
Museum of Open Windows 101
museums 24–25, 93–107, 188, 231, 234,
 240, 241, 246
Museu Paraense Emílio Goeldi (Pará) 25

Nace, T. 332
Nara Conference (1994) 47
narratives, competing 334–335
National Socialism in Germany 273
native heritage 44
Natural and cultural heritage 93
Nederveen Pieterse (Jan) 116
Nelson, C. 151

neo-Eurasianism 290
neoliberal countryside, heritage violence in
 133–137
neo-Ottomanism 290
Netherlands 82
New Materialism/Posthumanism 249
new pharmacologies of care 35–37
New Zealand 233; peacebuilding and taonga
 240–242; reconciliation in 236–240
Ngarrindjeri nation re-building, heritage and
 peace-making 242–244
Ngarrindjeri Yannarumi 244
Ngāti Whātua 240
Nigeria 55, 59–60, 180
Nkencko, G. 175
Nogueira, D. 24
Northam, R.S. 198
nuclear waste, repositories for 120–122

Oates, J. 68
object-relations 39–40
Object-work 40
Odo 63
Odo forest (*Ohamu Odo*) 62
OECD *see* Organization for Economic
 Cooperation and Development
Ohamu 63
Olubode, O.S. 68
Omicron 37
Ong, I. 102
online education 20, 22
online social justice and heritage in Ireland
 during the pandemic 173–175
organised conservation 59
Organization for Economic Cooperation
 and Development (OECD) 289
O'Sullivan, S. 144n4, 152n19
Our World Heritage 114
Outstanding Universal Value (OUV)
 112, 123
OUV *see* Outstanding Universal Value
Overmars, W. 81

Padian, K. 69
Palestinian refugees 38, 46
pandemic sociability 19, 29
participative decision-making 117
Pará State, Covid-19 in 18
pastness 305–310
pastoralism 150
patrimonialization 219, 223, 224, 230
peacebuilding 233–235, 236, 238; and
 taonga 240–242

peace-making, Ngarrindjeri nation re-
building and 242–244
Pedersen, H. 150n18
Peinovich, M. 'Enoch' 191
people's heritage 186, 199–200; defending
the bodies of heritage 190–193;
'Liberated by the People' 195–199;
Monument Avenue, creating
188–190; Monument Avenue, need
for 187–188; *Rumors of War*
193–195
Perry, J. 6, 9
personal intimacy 20
personal protective equipment (PPE) 36
Peters, M. 81
Petti, A. 49
Pétursdóttir, Þóra 121
pharmakon 38, 39
pharmakonic milieu 39
pharmakonic object(s) 39
pharmakonic 'moving objects' 39
Phoa, Li An 84–85
Pieterse, J. N. 116
Plague epidemics 269
Plastic Pollution-free Galapagos 66
Plato's Spring 129–132
Pleistocene rewilding 82
Plumwood, V. 157, 158
Poelina, A. 153
'Points of Distribution' (PoD's) 332
political authoritarianism 2
political decolonization 2
political ecology, archaeological fieldwork as
132–133
population density 267
Porter, B. 133
Porter, L. 145, 145nn5–6, 146, 147, 155, 158
posthumanism, heritage and 57;
conservation 59–63; living 63–67
Poulios, I. 58
Povinelli, E.A. 140n9
PPE *see* personal protective equipment
precariousness 7–9; and resilience 301–303
precarity 93–95
Pritchard, S. 78
Probyn, E. 153
profane museologies 103–105
profane *see* speculative and profane
Public Culture and Heritage 3
Public Health Emergency of International
Concern 1
Pusey, A. 325
Putin, V. 2, 290

Qhapaq Ñan 223, 224

Raby, F. 94, 100–101
Randeraad, N. 75, 84
reckoning with extractivism 143–163
recognition 45–46
reconciliation 235–240
recursive gaze 28
Red River 162
refuge crisis 50
refugee condition 43, 45
refugee heritage 44, 45, 47, 48, 50
refugeeness 45
Reimagining Museums for Climate Action
competition 91, 95, 96, 98, 100, 101
remote education 20, 22
remote teaching 19, 20
Renes, H. 74
resilience, precariousness and 301–303
rethinking heritage 9–10
Rewilding 82
Rhamey, P. 112
#RhodesMustFall 4, 308
Rico, T. 131
Ricoeur, P. 232
Rigney, D. 242, 250n1
Rinehart, G. 149
River Care: Policy, Participation and Protest 75
river heritage 73; drinking river's water
83–85; fantasy landscape 80–83;
ruined river 76–80
Rivierpark Maasvallei 79
RIWA-Maas 78
RMCA project 96
Robins, S. 335
Römhild, R. 211, 212, 213
Roosevelt, C.H. 132
Rose, D.B. 156, 157
Rosiek, J.L. 248
ruined river 76–80
The Ruin of the Qhapaq Ñan 223
'ruins' 43–44
Rumors of War 193–195
Russia 290
Russian Federation forces 2

Sacred groves 62
Sandoval, C. 84
Şangır Mağaza 136
Santos, A.C. 27, 28
SARS-CoV-2 virus *see* COVID-19
pandemic
saudades 27

sceptical urbanism discourses 268–270
Schürkmann, C. 59
SDGs *see* Sustainable Development Goals
second nature 78
Segata, J. 28
settler-colonial history of Australia 154
Shepherd, N. 82, 317
silent racism 179
Silk Road 286–287
Silk Road internationalism 288
Simmel, G. 264, 265, 266, 267, 274
Simon, Z.B. 117, 118
Simpson, L.B. 144, 144n4, 145, 145n5
Simpson, L.R. 161
Smith, L. 245, 246, 247, 250n1, 340
social interactions 267–268
socialisation 21
social isolation 22, 25, 26, 28, 171, 267
social leveller 1
South Africa 3, 212, 215, 273, 332
Southern Africa, COVID-19 and heritage in
 299; global discourses, local
 experiences 303–305; people, pastness
 and epistemic plurality 305–310;
 precariousness and resilience 301–303;
 Will the Sun Rise Again? 299–301
space messages 122
Spanish Flu 271
speculative and profane 93; heritage,
 museums, and precarity 93–95;
 modelling action 105–107; museum
 climates 95–99; profane museologies
 103–105; speculative worlds 99–102
speculative worlds 99–102
Spencer, R. 191
Spinney, L. 271
Spolar, C. 24
Stachelski, J. 290
Starbucks 97
stateless heritage 37–38, 41–42
'*Stateless Heritage*' exhibition 37
Sterling, C. 91, 98
Stiegler, B. 37–40, 50
Stiegler's thesis 38
Stoermer, E. 91
Stoney, L. 192
Strang, V. 74
Strauss, B. 77
Stribbe, A. 155
Stuart, J.E.B. 194, 196
subordinated groups 273
Sudan 8
Sundberg, J. 59

Sustainable Development Goals (SDGs) 98, 284
sustainable management practises 21

Talyor, B. 195
tangible and intangible heritage 47–48
Tanimola, A.A. 68
Tan Wen Jun 102
taonga, peacebuilding and 240–242
Tapsell, P. 240, 250n1
TCKs *see* Third Culture Kids
Teaching 19
teaching during the pandemic 17–29
terra nullius 137, 154
The Telegraph 333
Third Culture Kids (TCKs) 116
third nature 78
Till, J. 98
Tlostanova, M.V. 75
Todd, Z. 162, 163
trajectories 48–49
Tranchot map of 1805 81
Travesi, C. 155
Trump, D. 192, 271
Tsing, A.L. 8–9, 55, 78, 84, 99, 335
Tuck, E. 146n7, 158n24, 159n25, 160
Tunbridge, J. 246
Turkishness 290
'turning inwards' versus 'turning outwards'
 336–339
20th General Assembly of the International
 Council on Monuments and Sites
 (ICOMOS 2020) 113

UCT Libraries *see* University of Cape Town
 Libraries
Ugwuanyi, J.K. 55, 58
Ukraine 2, 7, 8, 51
Uluru Statement from the Heart 238
UNESCO (United Nations Educational,
 Scientific and Cultural Organisation)
 34, 39, 139n2, 282, 292
UNESCO-IHP *see* United Nations
 Educational, Scientific and Cultural
 Organization International
 Hydrological Programme
UNESCO Syndrome 35, 41
UNESCO World Heritage 15–16, 111–114
UNESCO World Heritage Convention 58,
 122–123
United Nations Educational, Scientific and
 Cultural Organization International
 Hydrological Programme
 (UNESCO-IHP) 74

universalism 46–47
Universidade Federal do Pará 19
University of Cape Town (UCT)
 Libraries 301
UN/UNESCO Syndrome 43
UNWTO 287
urbanity 263; biopolitical urban governance
 268–270; commemorating
 pandemics control 270–272;
 COVID-19 and blind spots of
 266–270; Critical Heritage Studies
 276–278; heterogeneity and activism
 272–275; re-evaluation of urban
 spaces 266–268; sceptical urbanism
 discourses 268–270; silenced
 heritage of urbanity 275–276; urban,
 urbanism, and idea(l) of 264–266
Utopia 316; futuristic activity, heritage as
 320–321; March 11, 2020: Covid-
 19 318–320; need for radical
 nostalgia in times of pandemic
 321–326

vaccines 5, 8, 36, 170, 302
van der Loo, F. 81
van Rijswick, M. 81
Van Wyck, P. 121
Vera, F. 82
Verdeja, E. 236, 237, 238
Victoria, Queen 177
Vince, G. 115
Viral Archive 171
Virginia Museum of Fine Arts (VMFA)
 193, 198
VMFA *see* Virginia Museum of Fine Arts
Volfová, G.Ö. 290
Volkskunde 209

Wallace-Wells, D. 96
Walters, D. 233
water as a social leveler 335–336
weather extremes 79

Wekker, G. 180
Western liberal democracies 283
WHC *see* World Heritage Convention
white innocence 175
WHO *see* World Health Organisation
Wienberg, J. 123
Williams, R. 162
Williams, T. 119
Windjana Gorge National Park 156
window, heritage from 21–28
Wirth, L. 264, 265, 266, 267, 272,
 273, 274
WNF *see* World Nature Fund
Woorunmurra, B. 150n18
World Health Organisation (WHO) 36
world heritage 111; for Anthropocene
 117–119; Lego and other plastic
 trash 119; nuclear waste, repositories
 for 120–122; significance of
 114–117; space messages 122; taking
 the future seriously 122–123;
 UNESCO World Heritage 111–114
World Heritage Committee 112
World Heritage Convention (WHC) 46,
 111, 112–114, 118
World Heritage Listing 39
World Heritage Site 39
World Heritage Status 39
World Nature Fund (WNF) 82
Wunaamin Conservation Park 156
Wunaamin Miliwundi Ranges 148

Yalburt Survey Project 132
Yalburt Yaylası Archaeological Landscape
 Research Project ('Yalburt
 Project') 135
Yang, K. W. 146n7, 158n24, 159n25, 160
Yavuz, M. H. 290

Zehbe, K. 139n2
Zille, H. 332
Zinn, H. 187

Printed in the United States
by Baker & Taylor Publisher Services